ART OF THE
WESTERN WORLD

July 27th, 1998.

Peter Ba...

ART OF THE
WESTERN WORLD

EDITED BY DENISE HOOKER

B⊕XTREE

4
A CHANNEL
FOUR BOOK

Published in association with Norwich Union

First published in Great Britain in 1989 by Boxtree Limited
Text and artwork copyright © Boxtree Limited 1989
Based on *Art of the Western World*, a TVS production for Channel 4

First published in paperback 1991
Reprinted in 1994

The publishers would like to thank the production team of
Art of the Western World, and in particular
Tony Cash, Jane Alexander and Jackie Unsworth

A CIP catalogue entry for this book is available
from the British Library

ISBN 1–85283–951–1

Copy-edited by Graham Eyre and John Gilbert
Picture research by Christopher Walker
Art Editor Cherriwyn Magill
Design by Elaine Hewson
Maps by John Hutchinson
Illustrations by Sally Holmes

Typeset by Bookworm Typesetting, Manchester
Origination by Reprocolor Llovet, Barcelona
Printed and bound by Dai Nippon in Hong Kong for

Boxtree Limited
Broadwall House
21 Broadwall
London
SE1 9PL

FRONT COVER PICTURE: Pierre-Auguste Renoir, Luncheon of the
Boating Party, 1881. Oil on canvas, 130 × 173cm. The Phillips
Collection, Washington DC.

CONTENTS

A note on the text and illustrations

Each chapter contains two double page features which
illustrate and examine pivotal works of the period in
detail. These features are complementary to the main
body of the text.

INTRODUCTION

This book brings together distinguished art historians whose specialist interests span Western art from Classical antiquity to the present day. Unlike previous histories of art written from a single viewpoint, the writers of this volume introduce the reader to the diversity of approaches now current within art history, ranging from detailed analyses of different styles and techniques to a greater concern with the subject matter of works of art and their original contexts. Whatever the difference of emphasis among contributors, they share a common purpose to present artistic movements and individual works of art and architecture within their social, political and historical framework, as both a product and an expression of their time.

When we see art objects displayed in galleries and museums, we are invited to respond to them on a purely aesthetic level, but most art throughout history has been in various ways functional, embodying social, political and religious ideals and aspirations. 'Art for art's sake', or as a means of self-expression, are relatively recent concepts. The nature and purpose of a work of art is closely connected to its market. The writers of this book look at questions of patronage and the different kinds of art produced for state and church, for public and private consumption, for individual commissions or a speculative art market.

The quest of artists for social status is a recurrent theme. They struggled to free themselves from medieval guild restrictions and to raise the status of painting and sculpture from an artisanal craft to a liberal art. By the sixteenth century, artists of the stature of Leonardo, Raphael and Michelangelo were courted by popes and princes; Titian, who was knighted by the Emperor Charles V, compared himself to the Supreme Creator. In the seventeenth century Rubens and Velázquez were similarly knighted and entrusted with official missions and court appointments.

It was not until the end of the eighteenth century that the Romantic notion of the artist as a social outsider gained prominence. The formation of the *avant-garde* in the latter part of the nineteenth century, which went hand in hand with the expansion of art dealing, liberated artists from the official Salon system and allowed them a greater degree of independence and freedom to experiment than ever before. Since then the artist has increasingly become a social critic, questioning the institutional frameworks of contemporary society and culture. Women artists challenge previous assumptions about gender in art, alerting us to the fact that, throughout art history, painting and sculpture implicitly assume a male viewer.

All art feeds on other art, ranging widely in time and across cultures for its sources. Just as we now take it for granted that there is no such thing as objective history, only different interpretations, so art too is continually subject to reassessment and reinterpretation by successive generations. This book makes us aware that certain underlying preoccupations and stylistic tendencies reappear in different guises throughout the history of Western art.

John Boardman traces the origin of the Western tradition back to ancient Greece. Although Greek art initially had much in common with that of the older civilisations of the East and Egypt, around 500 BC it rapidly created and perfected a totally new idiom, based on standards and proportions and the idealisation of the human figure, which together with the characteristic forms and orders of Greek architecture was to be adapted and developed to suit the purposes of its successors until our own day. From Phidias to Picasso to post-modern architecture, a fascination with the Classical legacy is a constant feature of Western art.

It was said that Rome conquered Greece and was in turn conquered by Greece. So powerful was the influence of Greek culture and philosophy that the Romans, the first art collectors, came to think that the noblest sentiments and ideals could best be expressed through Greek imagery and took Greek art and architecture as their models. At the same time they also developed their own style of 'Roman Realism', a more descriptive, literal

mode of representation. Throughout the subsequent history of Western art these two stylistic currents, Classical idealism and realism, remain in a constant creative tension. Added to this, Richard Brilliant tells us, was the new abstract, symbolic mode of composition of the later Roman world, which anticipated the non-illusionistic, dehumanised, symbolic art of the Middle Ages.

The Christianisation of antiquity following the conversion of Emperor Constantine in AD 312 helped ensure its survival; for during the centuries-long turmoil of the Dark Ages the Church cast itself in the role of guardian of Classical values against the invading barbarian hordes. William Clark reminds us that the Arabs too played their part in the preservation of Classical culture. But, as Paul Crossley demonstrates, the early Middle Ages had an almost entirely pragmatic attitude to antiquity, plundering its rich artistic legacy of motifs and compositions, as well as its architectural heritage, to solve the needs of the present.

It was not until the Renaissance – the rebirth of antiquity – that there was any systematic attempt to recover and emulate the art and learning of the Classical past. There was a fresh spirit of enquiry; a belief in change and progress. John White stresses that for the artists of fifteenth-century Florence, it was not just a question of merely copying the outer forms of the art and architecture of the past. They sought to understand its underlying principles and emphasised 'space and light, perspective and proportion and anatomy, and . . . the theoretical basis of representation'. There was a new focus on humanity; the human form acquired great significance not only for its own sake but as an expression of man's spirituality, his individuality and his emotions. A. Richard Turner defines the hallmark of the High Renaissance as the 'affirmation of spiritual strength housed in beautiful flesh'. This acquires a special meaning in relation to Venetian painting, which celebrated the sensuousness of the flesh and of oil paint itself. David Rosand argues that if Michelangelo's marble statue of David stands as the symbol of Renaissance Florence, the Venetian equivalent would be a painting of a reclining female nude such as Titian's *Venus of Urbino*.

In the early sixteenth century Pope Julius II began an ambitious building programme to rival the splendours of ancient Rome – to evoke a Rome reborn, just as ancient Rome had itself sought to re-embody Athens. It was ancient Rome which provided the basic source of inspiration and information for artists from the Renaissance onwards. Jeremy Wood shows how in the seventeenth century artists representing such diverse tendencies as the Baroque sculptor and architect Bernini and the Classicist painter Poussin could find common ground in their respect for ancient Roman sculpture and their admiration for Raphael. Despite the repeated invocations of the authority of ancient Greek architecture, Robin Middleton reveals that no artist or architect had sketched or even visited a Greek temple until Soufflot travelled south of Naples in 1750 to Paestum. Similarly, artists such as Poussin and Claude were more concerned with an idealised vision of the Classical past than any faithful evocation of Athens and the Attic landscape.

Discussion of northern European art centres on realism: the careful observation and detailed depiction of the visible world. But both Catherine Reynolds and Ivan Gaskell caution us against a too literal reading of this apparent realism, which reproduces the appearance of reality by a skilful amalgam of artistic conventions and choice. Such works should be seen as naturalistically plausible rather than accurate representations.

In nineteenth-century France the issue of the relationship between art and everyday life was particularly controversial. Should art portray contemporary society or idealised visions? John House explains how Realism became the source of fierce critical debates and had broader political implications. The artist is not simply a blank eye registering and recording optical impressions but a shaping, organising intelligence whose choices tell us a great deal about the society in which he is working and his own attitudes towards that society.

With the Impressionists' preoccupation with the effects of light, the main focus of interest became not so much the subject matter as the manner of painting. Formal experimentation

took precedence over content. This was part of a broader shift towards modernism: the belief that art is primarily self-referential, concerned above all with the frank expression of its materials and medium. But Griselda Pollock warns us that the formalist interpretation of early modernism is partial and ignores why this radical shift of artistic priorities occurred. The late nineteenth century in France was an era of great and uncontrolled social change: rapid industrialisation, the expansion of the city, and the rise of new social classes. Artists across the political spectrum needed novel styles of painting to deal with their experience of the new and the modern.

Modernism took many different forms in the early twentieth century. The Cubism of Picasso and Braque was rapidly recognised as a modern realism offering a new way of looking at and representing the world; whereas abstract artists such as Mondrian, Malevich and Kandinsky rejected material reality in their spiritual quest for a metaphysical Ideal. After the First World War the question of art and its public function became a key issue. Christopher Green traces the increasingly explicit association between *avant-garde* art and architecture and revolutionary aspirations in society. But, ironically, the new Soviet society proved even more hostile to the *avant-garde* than the old liberal democracies of Europe. In the inter-war years realism, which was espoused by both the left and the right, became the great adversary of modernism; and together with Neoclassicism it was the officially-sanctioned art form of the Soviet Union and the Nazi state.

In the late twentieth century realism has taken on new connotations. Rosalind Krauss argues that in our image-saturated society, the traditional relation between reality and its representation has been reversed. Artists reveal the way in which images precede and construct contemporary reality: our emotions, desires, and knowledge of events in the real world are so determined by media and advertising images that life now imitates art.

We have come full circle from a world in which there were so few images that the sculptured western portal of the church at Vézelay would have had the force of a vision to the illiterate pilgrim of the twelfth century, to one in which images are so all-pervasive that they are in danger of replacing reality, of literally mediating our experience of life and the world around us. The one constant throughout this whole history of the art of the Western world is the undisputed power of the visual image.

<div align="right">Denise Hooker</div>

1
GREEK ART

JOHN BOARDMAN

The twentieth-century Westerner views the art of ancient Greece through eyes schooled by knowledge of its later development and legacy, and accustomed to its present-day setting in museums or as landscaped, romanticised ruins. It is easy to believe that it presents a unified style, expressed in the columnar façades which adorn our public buildings, respectable nudity, and a sort of sublime, idealised realism which set standards for centuries to come and still lies at the core of our Western culture. In all this there are elements of truth, but later centuries took what they wished from the Classical tradition, often either ignoring or misunderstanding the intentions of its creators. The modern historian of Greek culture no longer sees it in simple terms of a highly educated and literate society, mainly occupied with a philosophical search for Truth, Beauty and Democracy, and conducting itself in some kind of sanitised environment of sunshine and wisdom. He is better aware of the need to study it with less passion, more honesty, and to assess it in ways familiar in the cultural studies of other, even modern, periods; to evaluate its social record, the role in it of the family, slaves, women. And the archaeologist/art historian assesses Greece's achievement with better understanding of its place in the history of all the lands bordering the Mediterranean; can gauge what is new, what is borrowed in this 'Classical Ideal'; may even aspire to judge its art in terms approaching those in which it was conceived by its artists and understood by their public.

Classical Greece was one of the youngest of the Mediterranean cultures, and not even the first to have flourished in the land of Greece (pl. 3). Through most of the second millennium BC, 'Minoan' kings, not themselves Greek-speakers, had built palaces, as that of Knossos, on the island of Crete, while the Greeks of the mainland, the 'Mycenaeans', built their palatial castles at Mycenae and Tiryns. The culture they shared was a brilliant one and could match, on a somewhat reduced scale, that of the contemporary, more powerful and older, cultures of Mesopotamia and Egypt. By the eleventh century BC this culture had collapsed and the arts that its palace-centred society had fostered disappeared with that patronage. There was continuity of population, language and, it seems, religion, through the succeeding dark ages, but little continuity in art forms, and the resurgent 'Geometric' culture of Greece, which reached its height in the eighth century, can be treated virtually as a new start. From this time on until what is known as the Hellenistic period (mainly the third to first centuries BC, after the death of Alexander the Great and before Roman control was dominant) there was a rapid development in the arts which took them far beyond anything achieved in other ancient cultures, from the almost abstract Geometric, through the Archaic pattern (mainly seventh- and sixth-

THRACE

PHRYGIA

MYSIA

LYDIA

CARIA

RHODES

Pergamum

Ephesus

Troy

AEGEAN SEA

DELOS

Knossos

CRETE

MACEDONIA

Pella

Thessaloniki

Vergina

Mount Olympus

THESSALY

Larissa

EPIRUS

AETOLIA

Thermopylae

Delphi

BOEOTIA

EUBOEA

Thebes

Marathon

Athens

Piraeus

Tiryns

Mycenae

PELOPONNESE

Olympia

Sparta

MEDITERRANEAN
SEA

SITES OF
ANCIENT GREECE

century) to the idealising and growing realism of the Classical (fifth and fourth centuries) and the exuberant confidence of the Hellenistic, out of which were fashioned the early imperial arts of Rome. The measure of the difference that this record offers from that of the older civilisations of the East and Egypt must be readily apparent to anyone familiar with the tomb paintings of Egypt or the great reliefs from the Assyrian palaces. Greek art was not 'better', but, starting from forms very like those of other cultures, it changed rapidly and struck out in totally new directions. These proved more fruitful for its successors, who chose to adapt and develop the Greek manner rather than seek a totally new idiom, at least until modern times.

In the course of this notable and rapid progress how do we discern and define 'Greek art'? No one period or style is more Greek than another, nor are the styles of the end of the sequence noticeably more influential than those of earlier days. And what were the reasons for this rapid and revolutionary progress? Here some of the answers are definable, since we can see that in the Geometric period, near the start, it was the arts and technology of the Near East that provided the stimulus and models for progress, and there is sense in calling the seventh-century arts 'orientalising'. Before the end of that century closer contact with Egypt introduced Greek artists to concepts in which lay the foundations of Greek monumental sculpture and architecture. From this point on it was the Greeks themselves, their society and their exceptional (for antiquity) view of the relationship of men with each other, with the foreigner, with their gods, that must have determined the course of change. In ancient Greece man, the measure of all things, was also the measure of his gods, fashioned in man's image, and was the focus of interest for artists. Lacking, perhaps for historical reasons, the constraints imposed by imperial bureaucracy, and developing instead a society of autonomous city states, the Greeks may have been more aware of the part the individual could play in the destiny of his family and of his city. Attention to human problems and potentials led their philosophers and eventually their leaders to a concept of the communion of man, and contributed an important element to the ethos of the religion that was to dominate the later history of the West.

If we have to define common characteristics in Greek art that transcend periods and styles, we turn to concepts which are not generally those with which we most readily associate Greek art today. Instead we observe that there was always an overriding interest in proportion and pattern, at whatever scale and in whatever medium; that the human, rather than the divine or abstract or images of the natural world of animals and landscape, lay at the heart of their achievement; that realism was an almost accidental additive and not at first sought after for its own sake; that their narrative arts were not mere story-telling. In most of this we observe qualities which are no less apparent in their literature.

There is one other factor which is unfamiliar to the modern art-lover. All Greek art was functional. The function may sometimes have been to influence or thank a god; or for self-glorification; or to endue an artefact with magic powers; or to tell a story with the aim of pointing a moral or illustrating a contemporary problem. 'Art for art's sake' was not an ancient Greek concept; there were no 'art-collectors' in the modern sense until the Romans, looting Greece, began to be systematic about what they stole and how they intended to display it, and when the cult of the individual spread from emperor or general to artist and patron. This is not to say that artists were not proud of their skills. They began to place their signatures on their works (though only in a minority of cases) almost as soon as the Greeks had learnt their alphabet from the East (in the eighth century). Sometimes these signatures are nearly as conspicuous as the inscriptions declaring the donor or subject of a dedication or monument, and they are not confined to the monumental but occur often, too, on painted clay vases, good and bad.

Finally, before we survey the three principal genres of Greek art – sculpture, painting and architecture – it is as well to remember that our record is not as complete as it can be for later centuries in the West. Much that we have of Greek art has come from excavations (or plundering) of the last 200 years and very little survived above ground except for some architecture, saved either because it was in a remote and inaccessible place (as in the case of the temple of Apollo at Bassae in Arcadia, or the temples on the swampy and overgrown colonial Greek site at Paestum in Italy), or because the building was adapted to new uses (some temples, such as the Parthenon, were converted into Christian churches). Marble could be claimed for the lime kiln; artefacts of gold, silver and bronze could be melted down; wood and textiles do not survive except in conditions of extreme damp or dryness. Nor are there contemporary records of any significance about what is missing, except for some tantalisingly concise temple inventories or mere titles of books by

3. *Map of the most important sites of ancient Greece showing the extent of Greek influence throughout the Aegean.*

13

4. *Marble kouros, from Tenea (S. Greece), c. 550 BC. Glyptothek, Munich.*

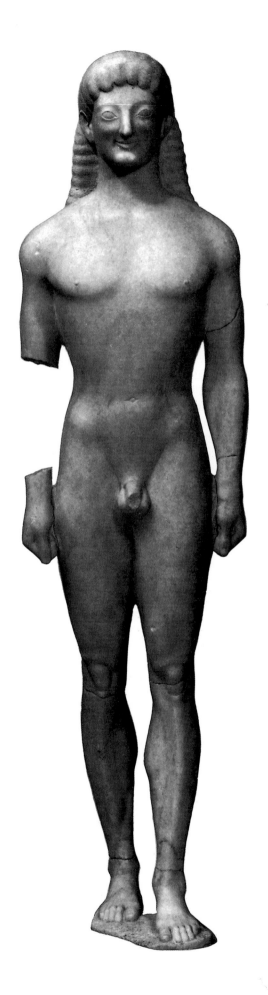

artists about their own works or by art-historians. We can learn much from the Roman Pliny's writings; however, he did not write a history of art but an encyclopaedia which included an account of works of art according to their materials rather than their artists or dates. And many of the finer works of Classical Greek sculpture we can glimpse only through copies of them made for the Roman market. So the odds are against us in any attempt to recapture either the appearance of the finest arts of Greek antiquity, or what they meant to the societies which they served. In some respects it is easier to judge how they were understood and used by their successors, the subjects of many of the following chapters in this book.

EARLY SCULPTURE

The still, chaste and utterly white marble forms of naked goddesses or lithe athletes which people many a gallery of Greek art belie their original appearance and leave the viewer quite unable to envisage them in their original setting. Until about 500 BC (and let us not be misled by the convenience of such round numbers) Greek sculpture was governed by principles of composition and execution broadly shared by other cultures, and indeed to a large degree derived from them. The main function of free-standing statues was to serve as cult images within a temple, and the more primitive of these were probably fairly shapeless, wooden torsos dressed for festive occasions; others, representing a god or attendant to a god, served as dedications in sanctuaries offered by grateful mortals, and by the end of the seventh century they could replace simpler stone or wooden grave-markers and come to 'represent' the dead in an impersonal way. In the round or in relief they decorated temple buildings too, and relief sculpture in particular developed for gravestones or for votive plaques showing gods or worshippers.

The earliest stone figures have a very Eastern aspect. An example is the Auxerre goddess (pl. 1), a statuette now in the Louvre, executed in fairly soft limestone and with bright colours (mainly now missing). They seldom achieved life size until the example of Egyptian art, observed closely by Greeks from the mid seventh century on, persuaded them not only to attempt the larger scale (and even to practise it for figures more than twice life size) but to execute it in the harder white marble available to them on the Greek islands (and later exploited on Mount Pentelicum near Athens too) in far more difficult and painstaking techniques. These new figures

are most familiar to us as the standing youths, *kouroi* (pl. 4 for example). They are lively without being lifelike. The quaint 'archaic smile' may have been introduced to meet the problem of carving the transition between lips and cheek, but was then retained, presumably because it seemed to enhance the quality of the figure as an image of 'man', and the addition of similar realistic details led the artists in an unpremeditated way towards more realistic detail.

The women are usually dressed, the men naked. Such nudity, a continuing and influential theme, was a feature of Greek life as well as art which foreigners (to Greeks the 'barbarians' or bar-bar-talkers) found unpleasing but of which the Greeks were clearly proud. Sport was important to them – not team games in which national or city pride was at stake, but sports practised in the interests of individual fitness (which had military value) and its display in honour of a god (at festivals such as that of Zeus at Olympia – the original Olympics had quite a different ethos from the modern). For sport the Greeks competed and exercised naked. Moreover, it is clear that in everyday life the young male took no trouble either to overdress or to hide parts of his body which the Roman and Christian world have judged shameful (*pudenda* – 'shameful things').

The Egyptians had taught the Greeks how to lay out large figures for carving from simple grids drawn on the surface of the marble block, on which the squares could be counted for parts of the body, thus ensuring regularity of proportion but also stereotyping figures and poses. The Greeks soon varied the proportions, and adjusted the way in which parts of the body were shown, from simple patterns which only approximated to life to those which were closer to live forms. This was not a search for realism, but a search for a more effective realisation of a human figure which gradually came closer to life without positively attempting to copy it. All still depended far more on formulae and traditional forms than on direct observation of a model, which came slow and late to the Greek artist. The male body, especially the athlete's body, presents patterns of surface musculature that inspired the patterning of the naked marble figures, and as time passed these forms were made more lifelike. The whole figure, however, was rigid, immobile, balanced evenly on its feet, arms at its sides. Only in relief work were more lively poses attempted, such as we see more readily in painting, and even these figures appear mannered in their basic poses of attack or dance or veneration. In the figures of women the artist saw pattern only in dress, and

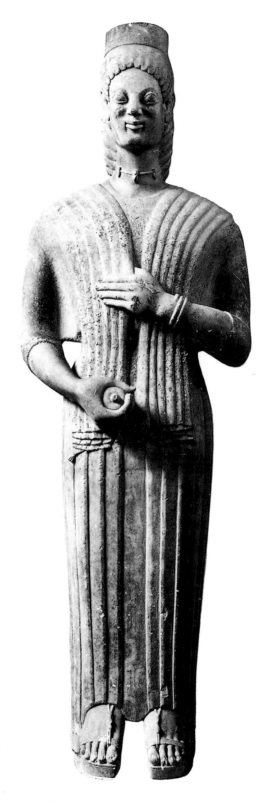

5. *The Berlin goddess. Marble figure of a woman, from Keratea (near Athens), c. 570–560 BC. Staatliche Museen, East Berlin. A tomb marker which had been taken down, presumably in time of threat, and buried wrapped in lead.*

the maidens, *korai*, which could serve as dedications or grave-markers like their brother *kouroi*, offer barely feminine forms beneath increasingly complicated patterns of pleats and folds, deliberately varied by draping from one shoulder, or by drawing a skirt tight across the thighs. Plate 5 shows a comparatively early Athenian example.

15

In this early period bronze was used for vessels, or for small solid figurines of animals or gods, but by about 500 BC life-size hollow figures were being cast. The technique involved the creation of the full figure in clay, which was coated in hard wax to the desired thickness. The whole was then covered in a clay mantle. The wax was melted out and replaced by molten bronze – the 'lost wax' (*cire perdue*) technique practised in many different periods and places. The development of the technique in Greece, however, contributed to a basic revolution in the sculptor's art which was to set it suddenly on to a new course and to transform the way in which man could portray himself. In some respects this is the true beginning of Western art, since only now did the Greeks create and perfect an idiom which was quite foreign to the arts of other parts of the ancient world but which lies at the heart of the Classical tradition. It did not, of course, depend solely on technical innovation. This simply facilitated and may have hastened the expression of something that we can see Greek artists approaching without understanding in the previous century.

We may judge the extent of the change by comparing the *kouros* in plate 4 with the Riace bronze (pls 7–9) made barely fifty years later. While the marble stands rigid, immobile, balanced and symmetrical, the bronze is relaxed and lifelike. It is not only that the details of the anatomy are clearly dependent on observation from life, but the whole structure of the body is now understood. The weight of the body is borne mainly on the straight right leg, the left leg is relaxed, and, answering the pose, the right hip is raised. The shoulders rise or fall with the spear and shield (both now missing) carried by either hand, and turn gently with the turned head. The marble was a sum of patterns executed on the surface of a stock model. The bronze, we sense, starts from an understanding of the structure of the body, and the function of its skeleton and muscles. Now, this is not the sort of effect that can be achieved by hacking into a block of marble with the guidance of a conventional grid and set of measured patterns; it can, however, readily be achieved by a modeller in clay (which was how the bronze began) and this freedom of composition must surely have expedited the sculptor's search for a more effective expression of the human body – a *functionally* more effective expression since the bronze is a 'real' warrior, to any eyes of any period, in a way that the marble is *not* a 'real' youth.

For whom were the marble and bronze made? The marble marked a grave at Tenea in southern Greece; it would have been paid for by the dead man's family, and its base (now missing) would have recorded his name and possibly his father's name and that of the sculptor. The bronze is of unknown origin, but one suggestion (which, even if incorrect, would apply to a very similar figure) is that it is from the group dedication made by Athens at Delphi in the mid fifth century to commemorate success over the Persians – a state dedication, not a personal monument.

CLASSICAL SCULPTURE

Greece of the seventh and sixth centuries was a country of independent city states, seldom banding together in leagues, many of them ruled by 'tyrants', most of whom had dynastic pretensions though they shunned the title 'king'. Their courts attracted artists and they sponsored important public works, such as temples, on which sculptors also worked. At the end of the sixth century Athens ousted her tyrant family and created a form of democracy, with magistrates and even generals appointed by lot and final decisions left to the voice of the people in assembly. The vote was confined to the male free population; women and slaves were excluded. The young democracy stood alone against the Persian invader at Marathon in 490 BC, and went on to emerge as the dominant Greek state after the Persians had been finally repulsed from mainland Greece. Athens subsequently formed a league to drive the Persians from eastern Greek lands (now western Turkey) – a league that became an empire. The state became a patron of the arts and in the mid century the statesman Pericles persuaded Athens to use league funds to rebuild the temples of their city and countryside that had been devastated by the Persian invasion of 480–479 BC. The new programme included the building and sculptural embellishment of the Parthenon, which was built, complete with its sculpture, in some fifteen years.

In the previous decade a new temple of Zeus had been built at Olympia with marble sculptures in the new style. The revolution in representation of the human form, a change which we have associated with sculpture in bronze, worked as effectively in marble only because the techniques of preparation for marble statues were also adjusted. The figures were based on clay models, usually of life size, which could then be copied directly into marble by masons. They were then finished by the master sculptors, who had created the clay models in exactly the same way as they made models for bronzes. This helps account for the stylistic similarity of bronze and

marble figures, despite the obvious differences in techniques of production after the original model had been formed. The Olympia sculptures are innovative in their attempts to portray emotion and differing ages. The sculptures created for Pericles' Parthenon, designed by his master sculptor Phidias, are of a different quality. Their 'classic' calm looks somewhat deadpan after what the Olympia Master seemed to be promising for Greek sculpture, yet they more truly reflect a basic preoccupation with standards and proportions, a form of idealising and generalising the human figure which can have little to do with expressing the individual in either appearance or mood. This is what we see in the Parthenon's marble pedimental figures (pl. 6), and notably on the frieze which encircled the centre block of the building, the *cella*, where the young horsemen of Athens are perhaps literally heroised by this idealising presentation (pl. 26).

We seem to know so much about the Parthenon, its sculptures and architecture, yet it remains an enigma – a temple without a cult. Its sculptures tell the familiar stories of myth, yet seem also to relate to Athens' own recent history. The famous frieze can be taken by some as representing at least two different processions, and probably several different occasions and settings,

and by others as a unified whole reflecting a real occasion made heroic by the role of its participants in the fight for Greek freedom against the Persians. Contemporary writers tell us nothing, yet every Athenian must have understood the building's message. Later writers virtually ignored all its surviving decoration, but do describe its cult statue.

There was no little civic pride in the Periclean rebuilding programme for the temples of Athens and the countryside. The Parthenon must have been as much a war memorial and statement, through its sculpture, of Athens' claim to be leader of the Greeks, as it was a monumental thanksgiving to the goddess who had protected the city. The depiction of mortal Athenians (however we identify them) on its frieze links it more intimately to the life and fortunes of the city than does the heroic and divine subject matter of the decoration for other temples in Greece.

It was the Parthenon style which later artists were to accept as the 'classic', the model. A contemporary of Phidias, called Polyclitus, an artist who worked mainly in southern Greece, established his own canon of proportions for the human figure (somewhat stockier than the Phidian) which he wrote about in a book called the *Canon* and expressed in a figure of a youth bearing a

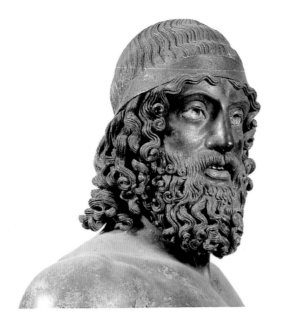

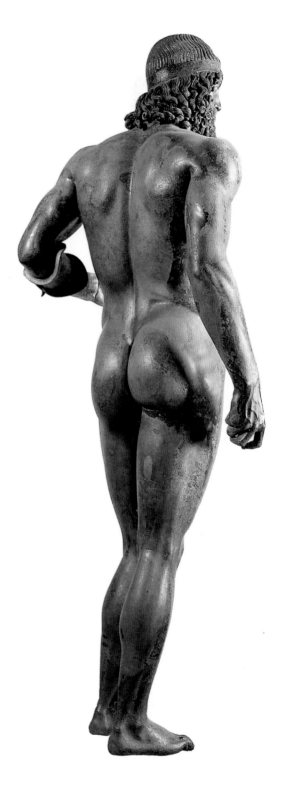

BRONZE WARRIOR FROM RIACE

Ancient shipwrecks have proved the principal source for original bronze statues of the Classical period. Most of the vessels were probably carrying cargoes of loot from Greece to Italy. Any bronze statue that had survived on land was too readily claimed for the melting pot, in every period, so we have to rely on the accidents of antiquity for information about the major genre in Classical statuary.

This bronze warrior is one of a pair of broadly similar figures discovered off Riace, near the straits between Sicily and Italy, in 1972. His shield and the spear he was probably holding in his right hand are missing. His lips were cast in copper, which would have showed reddish against the 'brassy' bronze that originally resembled a golden tan; his nipples, too, were copper, and his teeth silvered. He stands little over life-size, as was common with figures intended to represent heroes or gods, and seems originally to have worn a kind of wreath, no doubt in precious metal. His companion, in a similar pose, was helmeted and is a somewhat older, less aggressive figure. Their nakedness is conventional and expressed the Greek athletic ideal in art as well as life, since the Greek male was un-

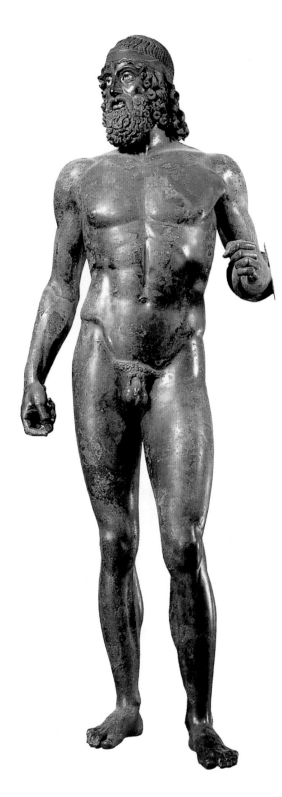

concerned about baring his body.

Such finds present considerable problems of identification. For their date we rely on observation of style (discussed in the main text) and technique. We cannot be certain that the figures belong together, although this seems highly probable; nor whether there were others in the group, which must surely have been the case. They were taken, then, from a group of mid-fifth-century statues on some Greek site, but from which? Ancient authors mention possible groups at Delphi and Olympia but we can have no reason to believe that they included all, or that the Riace figures did not come from some other site, never described for us in ancient texts, nor excavated to reveal the figures' original bases. One popular suggestion is that they are from a group known to have been dedicated by the Athenians at Delphi to commemorate their success at Marathon (though executed long after) and showing Athenian heroes and gods as well as the victorious commander, Miltiades. The Riace bronzes must be from a group of this general type even if not from the Delphi dedication, which had been one of the first commissions of the famous sculptor Phidias. Whatever uncertainty lingers over their source and authorship, they remain invaluable examples of the very best in Greek statuary dating from the period just before the full Classical, between the architectural marbles of Olympia and the Parthenon sculptures (also designed by Phidias).

They make a remarkable impression on the modern viewer, regardless of explanatory information as to their place in the history of Greek sculpture. This is due in part to their size, to their rather startling but not embarrassing nudity, and to the sculptor's success in conveying through pose and expression a majestic presence which must have been no less effective in antiquity than it is today.

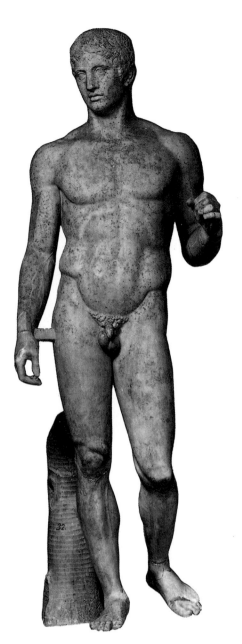

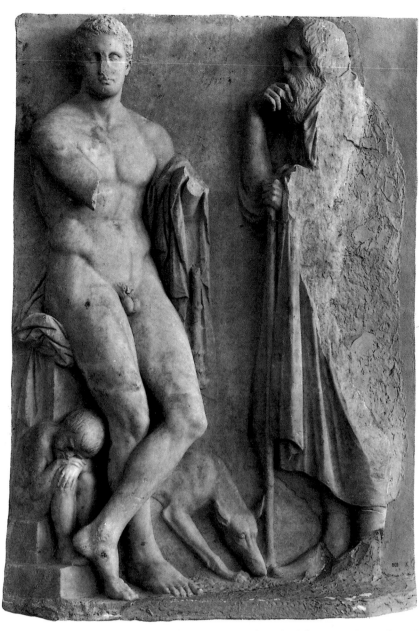

ABOVE 10.
POLYCLITUS:
Doryphoros (spear-
bearer); *imperial Roman
marble copy of a bronze
original of c.440 BC.
Museo Nazionale,
Naples.*

spear, the *Doryphoros*, which we know from mar-
ble copies of the Roman period (pl. 10; the
copyist in marble has to introduce supporting
struts, and often tree trunks beside legs, to sup-
port figures whose original models could stand
untrammelled in bronze). Here the relaxed, bal-
anced pose of the Riace bronze had been further
refined in a virtually contrapuntal composition of
limbs and torso: the right arm and leg are
straight, but the arm is relaxed, the leg tense to
bear the figure's weight; the left arm and leg are
bent but here it is the arm that is tense, the leg re-
laxed. Later sculptors go further, with figures
shifting their weight on to other objects (as the
leaning figure of a youth on the gravestone from
Athens, pl. 11). Gone too is the almost obses-
sional frontal view for free-standing statues, and

the figures are designed with no single preferred
viewpoint. They seem to inhabit their own space,
which is no longer defined by a wall or niche.
This is the contribution of the fourth century,
especially associated with the name of Lysippus.
A slightly older artist, Praxiteles, began a trend
away from bronze back to marble for some major
figures, exploiting the flesh-like qualities of the
material (previously mainly disguised by paint)
in studies of the female nude, a genre which we
naturally associate with Greek art but which was
a comparatively late invention. It was designed
for the portrayal of goddesses, a naked Aphrodite
or her partly dressed divine kin, but the model
was life and rich stories about the morals and
beauty of the artist's model begin with Praxiteles
and his Phryne. His Aphrodites were the inspira-

tion for thousands of marble copies, for temples, houses or gardens, in later centuries (see for example pl. 12), and have become for most people archetypal 'Greek art'.

Lysippus was favoured by Alexander the Great (356–323 BC) and made sculpture portraits of him. With Alexander Greek arms and influence burst from the shores of the Mediterranean to embrace the whole of the old Persian Empire and reach even to India. At the same time the autonomy of the Greek city states was severely curtailed by the new imperialism. Artists could look to royal patronage now; there were new capitals to be planned and embellished with fine building, and sculpture groups of the families of new Greek dynastic rulers take their place in

Greek sanctuaries beside the older commemorative groups of gods and heroes. One result of the new mood was the practice of realistic portraiture. Earlier portraits were no more than idealised studies, usually of the long or recently dead, and greater realism had been inhibited by concern for the ideal and general rather than the individual. Characterisation, ethnic if not individual, appeared before Alexander, as in the study of a Carian prince from the tomb of Mausolus (pl. 13). In their work for Alexander and his successors, sculptors sought a blend of realism with interpretation of the character of their subjects.

After Alexander's death his empire was divided into smaller kingdoms based on cities such as Pergamum and Alexandria, each of them providing patronage for architects and artists. Hellenistic art elaborates on the classic themes, and adds a new intensity of expression. The most characteristic of Hellenistic sculpture is to be found in its royal portraiture, its rather mannered, swathed women, and in the strong emotional impact which can be achieved by a degree of exaggeration and emphasis in anatomical studies, as on the great frieze showing the fight of gods and giants from the altar of Zeus at Pergamum (pl. 14). The deliberate strength of emotional impact in these figures stands in dramatic contrast to the calm, almost indifferent mien of earlier, Classical figures of the Parthenon period.

We can only mourn what we have lost of original Greek sculpture. The most expensive works were colossal figures of gold and ivory which served as cult statues (the Athena for the Parthenon was 12 m high), executed by the major artists of their day but as much displays of wealth as of finesse, so far as we can judge. Luckily, shipwrecks have yielded several fine bronze statues which never reached their intended homes – most of them from ships carrying Roman loot. But in what has survived we also lack detailed knowledge of various important aspects of their original appearance. We seldom know exactly how or where they were displayed, to what extent their setting may have determined appearance, or could have been designed to set them off most effectively. Marble sculpture was usually painted, although seldom has sufficient been preserved for a photograph to give an adequate idea of the original effect. Women's flesh would have been whitened on Archaic statues, not left in the plain marble, but the practice must surely have been abandoned as soon as the feminine nude became an important sculptural subject in the fourth century. Men's flesh was ruddy or brown, garments were coloured and decorated with

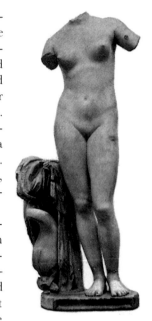

ABOVE 12. *Aphrodite. Roman copy of a marble original of c.100 BC. Museo Nazionale Romano, Rome.*

OPPOSITE RIGHT 11. *Marble gravestone from Athens, near the Ilissos, c.340 BC. National Museum, Athens. The dead youth is characterised as an athlete, contemplated by his sorrowing father (?) and accompanied by his dog and a sleeping slave boy.*

LEFT 13. *Marble statue of a Carian prince, c.350 BC. British Museum, London. One of a series of over-life-size statues which decorated the tomb of King Mausolus (pl. 31).*

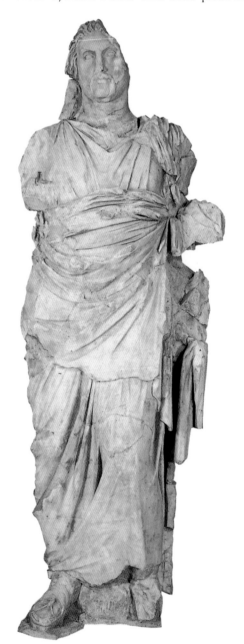

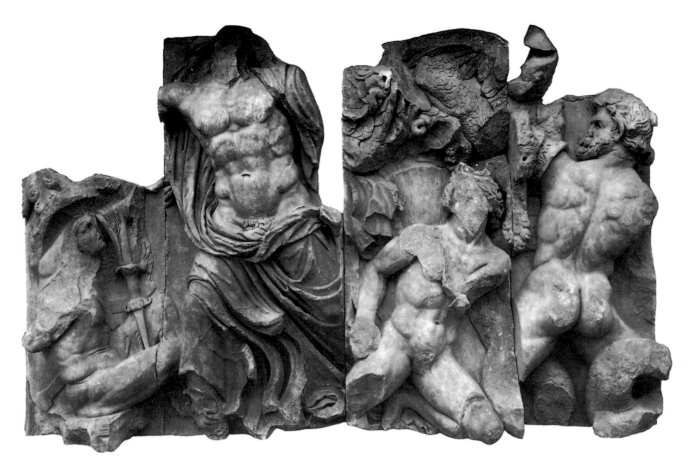

14. *Detail of the fight of gods and giants, from the Great Altar of Zeus at Pergamum, c.160 BC. Staatliche Museen, East Berlin. Zeus is the central figure; the giant beside him has been struck down by his thunderbolt.*

ornate hems and patterns. Virtually none of this is preserved, and its lack led Renaissance artists to leave plain their classicising works and thus accustom us to a false view of Classical sculpture.

Before we turn from sculpture to other arts a word should be said about sculpture-related crafts, sometimes in precious materials. Decorative relief attachments to gold, silver and bronze vessels take the form of appropriate heads or figures for the embellishment of the furniture for a drinking-party or a religious festival. In the Hellenistic period relief-decorated gold and silver plate was important and comparatively plentiful; earlier plate was plainer and served as much for bullion as to delight the eye. Gem, and later cameo, cutting provided settings for finger rings or pendants. The techniques of cutting the hard stones, usually quartzes, and in the Hellenistic period even harder stones such as sapphire and emerald, were exacting, and the craft attracted the best artists. The Victory building a trophy on the chalcedony gem in the British Museum (pl. 15) achieves on a stone barely 3 cm high a sculptural rendering of the figure and action no less authentic than any at life size in other media. This, with the cognate art of cutting dies for coinage, was practised throughout the Roman period and revived by the Renaissance.

DRAWING AND PAINTING

The development of the arts of drawing and painting in Greece presents a stylistic progression in step with that of sculpture, but the critical change, heralding styles which we would recognise as Western, came later, at the end of the fifth century BC. The change is marked less by advances in rendering the human figure (though this can be dramatic enough, as we shall see) than in new approaches to composition, shading and colour. From earlier years we have only descriptions of paintings on walls or on wooden panels, and for much of the period need imagine nothing much more elaborate than what we can see on the painted clay vases, which we shall consider shortly. However, in the second quarter of the fifth century we hear of major wall paintings depicting important mythological themes such as the Sack of Troy, and historical events such as the Battle of Marathon, destined for the walls of public buildings rather than temples. In these frieze-like compositions, it seems, the figures were set up and down the field, with no indication of perspective, but allowing greater freedom in the expression of the interrelationship of figures and groups than had been possible in the earlier scenes, where they were bound to a single ground line. This is not a style of mural decoration with

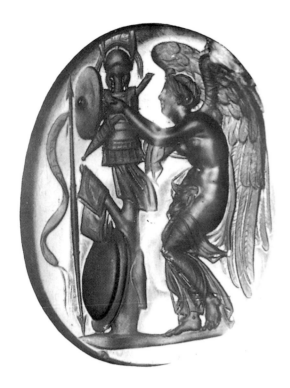

through its use of imagery or attribute telling or recalling more of the event than a momentary action, and alluding thus to past and future and purpose, is met also in non-Greek arts, but never in so sophisticated a manner. In this use of art, too, the Greeks left an important legacy for the West.

The vase paintings provide, at least until the end of the fourth century, a continuous commentary on contemporary styles and interests. Thus, the Geometric arts of the eighth century, with their subtle abstraction of the human figure and incipient depiction of narrative, are most readily judged from the great grave-marking vases from Athens (see for example pl. 16), as is the succeeding 'orientalising' style of the seventh century, with its monster, animal and floral decoration inspired by Eastern arts (pl. 17 shows an example

LEFT 15. *Victory building a trophy. Chalcedony engraved gem, c.350 BC. British Museum, London.*

BELOW 16. *Clay crater from Athens, c.740 BC. National Museum, Athens. The scene shows the conveying of a dead man to the grave. The vase itself served as a grave marker.*

which we are much familiar, or which we readily associate with Greek art. In antiquity such paintings were highly praised, down to the Roman period, but it may be significant that the style was not one which later copyists ever seemed to wish to perpetuate.

We can get a good idea of these Archaic and earlier Classical styles of drawing from the decoration of vases. Unlike most other early cultures, the Greeks found clay vessels a satisfactory medium for elaborate painted decoration. This allows us to judge the style and subjects of paintings in media that have not survived, and, since there are tens of thousands of existing examples, depicting a vast range of subjects, we are also able to judge the Greeks' own view of themselves and their uses of narrative art in absorbing detail. The 'story-telling' aspect of Greek art is one we associate most readily with vase painting, but we need to remember that it was practised to no less effect, and probably with greater purpose, in temple decoration. 'Greek myth' was, to the Greeks themselves, more 'myth history', their own distant past, accessible through the links of family or place or religion. The stories held messages, no less in art than in the way they were used by the great tragedians of fifth-century Athens to explore moral and even political dilemmas. And the Greeks lived very much in a world of images, so it is as important for us to understand the 'grammar' of their narrative art as to understand that of their poetry. The idea of a single panel or frieze devoted to a single story, yet

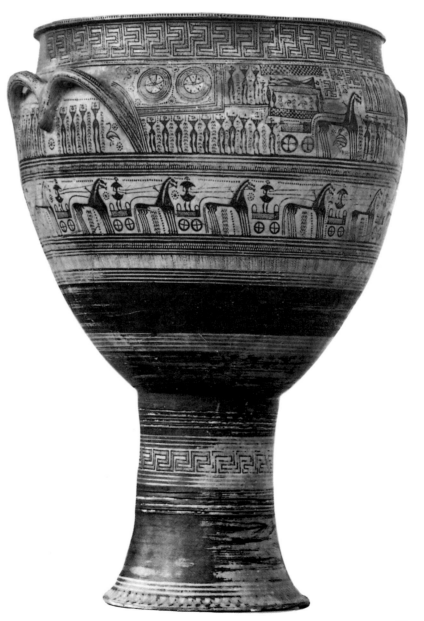

OPPOSITE 18. AMASIS PAINTER: *Athenian black figure amphora, showing Dionysos and women, c. 540 BC. Cabinet des Médailles, Paris.*

from the Greek islands). This was the period of Greek colonisation, sending settlers to distant shores of the Mediterranean, Spain, Italy, Sicily and North Africa, and into the Black Sea, establishing new city states to fend for themselves in a sometimes hostile environment, but also to spread Greek culture and something of the flavour of Greek art into communities used to very different idioms of visual expression. All this we judge better from the dispersal and styles of Greek painted pottery than from major arts, but by the Classical period several of the colonial cities could vie with or excel the homeland cities in wealth, and this was expressed in expensive works of architecture and sculpture.

Corinth was an important colonising and pottery-making city in the early period. Athens had taken a lead in the decoration of Geometric vases, and took the lead again in the sixth century in the 'black-figure' technique, in which the figures are painted in silhouette in the lustrous black slip, and detailed with incisions and modest patches of

colour (mainly red and white). Some of the painters are master-draughtsmen (pl. 18); others are hacks. Before the end of the sixth century painters in Athens perfected a new technique, 'red-figure', where the figures are reserved in the red clay and the background painted black; details are then added with the brush, not the graver, and there tends to be less colour but more subtle attention to anatomical detail, so that the drawn figures match closely the contemporary works of sculpture in the realism of their poses (pl. 19). Wall and panel paintings of the day must have presented figures much like these, but outline-drawn on a white ground, not with the rather inhibiting black ground, and with a greater range of colour. Some wood and clay panels of Corinthian style of the late sixth century give us an idea of what must have been a commonplace form of minor decoration, and they show nothing that we might not have guessed from contemporary vase painting.

By the end of the fifth century we can see how much the style of drawing has changed (pl. 20). The figures are fuller, more realistic, deliberately attempting sculptural effects. Occasionally other media, such as painting and drawing on ivory (pl. 21), leave an impression of how the new drawing-styles could be exercised on more luxurious works than clay vases. But by this date new modes of painting on walls and panels had introduced styles which the vase-painter could not emulate. These we have to judge from descriptions and may hope to glimpse something of their effect only in some Roman wall paintings which may loosely depend upon them. We hear of the rendering of the fullness of bodies by chiaroscuro shading and colour, and a degree of realism that could give rise to anecdotes about birds flying down to peck at painted grapes. Panel compositions of this style, with narrative or still-life subjects, replace the multi-figure friezes of the early Classical walls, and we may be sure that it is with these panels, by artists such as Zeuxis in the years around 400 BC, or Apelles in Alexander's day, that 'Western' painting was born.

It is only in recent years that original paintings of the mid-fourth century and later have been recovered, and these enable us to judge the revolutionary new styles. They are from the painted tombs of northern Greece, in the kingdom of Macedonia, not least from the tomb of Philip II, Alexander's father, and from nearby burials in the royal tumulus and burying-ground at Vergina (pl. 2). Their 'modernity' is striking. In some of them, especially hunting-scenes, we may detect an interest in landscape which was lacking

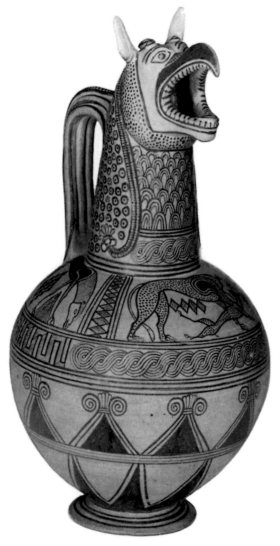

17. *Clay jug from Aegina, c. 650 BC. British Museum, London. The neck, in the form of a griffin's head, copies a familiar bronze type of eastern inspiration.*

hitherto in Greek art, but which will be further developed in the Hellenistic period, when we can judge it only by what we see on some marble reliefs or what may be copies of Hellenistic paintings on the walls of houses in Pompeii and Rome.

There is one other medium in which the painting-styles of antiquity may be reflected, and that is mosaic. There were simple pattern mosaics on some late-fifth-century Greek floors, but it is in the northern Greek palaces of the fourth century that we first find mosaic-decorated floors with large figure panels which must closely resemble or even copy panel paintings (see pl. 22). Some are signed, but we cannot tell whether these must be judged as original mosaic compositions, or as copies, too, of the original painter's own signature. They are composed of small coloured pebbles set in plaster, sometimes with areas outlined by strips of lead or clay. With the Hellenistic period the pebbles are replaced by square *tesserae* of stone, clay (and later glass) which offer a greater colour range and, where very small pieces are used, can create fine gradations of shading and colour with a painterly effect.

Greek painting is the most tantalising of the Classical arts. The works did not survive into far later centuries, as did the sculpture and architecture, yet it seems that in general appearance and principles of composition (other than true perspective, for which we have to wait for Roman works) it was strikingly similar to painting styles in Europe 2,000 years later.

ARCHITECTURE

Greek architecture may give the impression of being one of the most conservative of the arts. Its emphasis on proportion and formulaic pattern recall the principles of Greek sculpture, not surprisingly, and even in antiquity commentators were led to believe that in some respects the Greeks had conceived architectural forms in terms of the proportions of the human body. Two basic 'orders' were evolved, the Doric and the Ionic, from quite disparate sources. They were employed, sometimes in contrast, in essentially the same way, to determine the proportions and appearance of a columnar façade. The Doric (pl. 25), with its baseless columns, sharp-fluted shafts, spreading cushion capitals, and the entablature pattern of metope panels, is a sophisticated rendering into stone of basically wooden forms, devised by the end of the seventh century BC and thereafter changing only in detail. The architects worked less from detailed plans than from predetermined proportions which were generally applied throughout the building, from its ground plan to the shape of minor mouldings; these determined the spacing and height of columns, the shapes of ceiling coffers, steps, windows, doors. What may seem an almost mechanical system was individualised both by choice of proportions (not the same for every building and with appreciable changes as time passed) and rendering of detail. The earlier Doric buildings, such as some of the temples in colonial Italy (pl.

19. EUPHRONIOS: *Detail of Athenian red figure calyx crater, showing the death of Sarpedon, c. 510 BC. Metropolitan Museum of Art, New York. The body is carried by the figures of Sleep and Death watched by Hermes.*

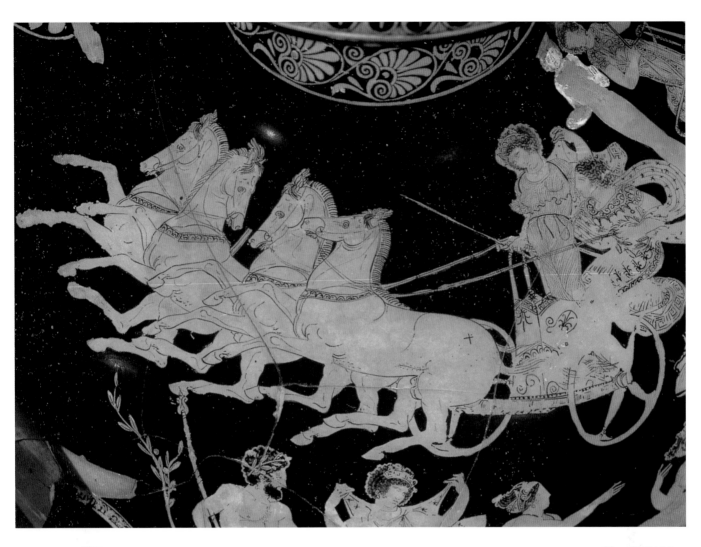

23), introduce a certain elasticity of form in their bulging columns. Later, greater subtleties of outline and plan were devised (as for the Parthenon, pl. 28) to correct the optical distortions created in close views of such massive structures; these are comparable with 'corrections' used by Greek sculptors to allow for different viewpoints of a figure or face, from three-quarters or below.

The Ionic order (pl. 24) is an orientalising style, developed from floral capitals, which become the familiar volutes topping shafts with blunt-edged flutes and subtly moulded bases. Upperworks are plainer than the Doric, but the frieze, decorated or not, was a speciality of the Ionic order. The column shafts are slimmer than the Doric and the contrast was effectively employed, sometimes in single buildings, such as the monumental entranceway to the Acropolis at Athens (the Propylaea). On the Erechtheum, the Ionic temple which stands to the north of the Doric Parthenon only a few yards away, the contrast in orders must have been deliberate (pl. 30).

ABOVE 20. MEIDIAS PAINTER: *Athenian red figure hydria, showing the rape of the daughters of Leucippus (detail), c.410 BC. British Museum, London.*

LEFT 21. *Fragment of a painted ivory plaque from a tomb at Kul Oba (S. Russia). c.400 BC. Hermitage Museum. St. Petersburg. The whole scene showed the Judgement of Paris.*

THIS PAGE 22. GNOSIS: *Mosaic showing a stag hunt, in the palace at Pella (N. Greece), c. 300 BC.*

OPPOSITE PAGE

BOTTOM LEFT 23. *Temple of Hera (the 'Basilica' temple) at Paestum (S. Italy), c. 550 BC.*

TOP RIGHT 24. *The Ionic order. Column from temple on the Ilissus, Athens.*

BOTTOM RIGHT 25. *The Doric order. Capital from The Hephaisteion, Athens.*

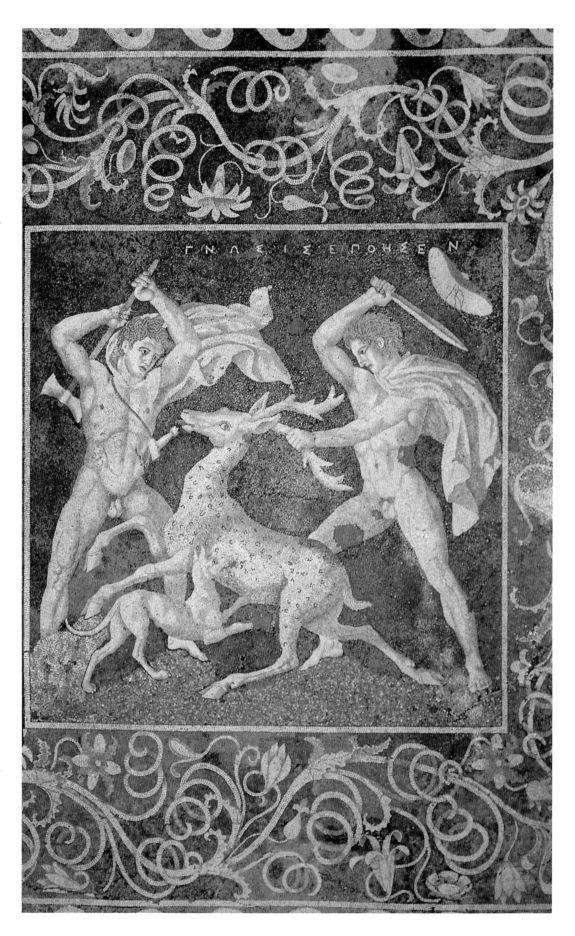

Temples are showplaces of civic or dynastic piety and pride, often built to commemorate military success, but essentially still serving as the house, *oikos*, of the god, where the cult statue stood as a physical symbol of the god's presence at ceremonies conducted in his honour. The temples were not churches for congregations, and sacrifices took place at the altar outside. Their function was therefore very different from that of a church and they were often the only monumental building in any town. For the Classical temples white marble was generally employed, painted in its mouldings and possibly even over parts of its walls to offset the glare of direct sunlight. The buildings are of no great engineering subtlety or even precision of measuring, but miracles of fine masonry and exquisite detail. Once the idiom of the orders was adopted, change came slowly. A new column capital for Ionic façades was invented, the floral 'Corinthian' (pl. 29), which was more versatile than the Ionic, being four-sided. While the Greeks understood the use of the arch and vault, they seemed to avoid the curvilinear in their formal architecture until well into the Hellenistic period. They used sun-dried bricks for their houses, but it was for the Romans to exploit the architectural merit of brick, cement and dome.

Temple buildings were also the setting for sculpture, but the sculpture was strictly subordinated to the architecture, which provided awkward areas of pediment or panel, sometimes frieze, to be decorated, and is very different from the all-over relief decoration of Egyptian and Mesopotamian palaces and temples.

The columnar façades came to be applied to other public buildings – colonnaded shops and offices (*stoai*), even monumental tombs. The greatest of these (pl. 31) was devised for the non-Greek king of Caria (in south-west Turkey), Mausolus, and provided the model for many later 'mausolea', down to twentieth-century war memorials. Town planning was a Classical invention, associated with the name of Hippodamus, who worked in the later fifth century. Some older cities had been laid out on a rectilinear grid system, generally when they were new foundations or were being rebuilt after a disaster. Hippodamus used the rectangular modules created by the grid, as individual units or combined in blocks, to create more logical plans for complexes of public and domestic buildings. Traffic control was of as little importance as the grand vista, and planning for visual effect was reserved for some of the more ambitious Hellenistic sanctuary areas or palatial cities, such as Pergamum. In a sanctuary, as at Olympia, the layout was a haphazard accumulation of buildings of many different periods, each new one designed with a view to its relationship to its neighbours but following no predetermined plan and sometimes even changing the main focus of worship and religious or fes-

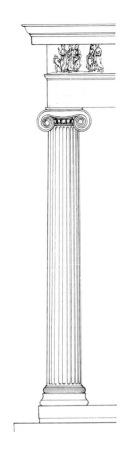

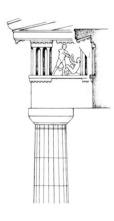

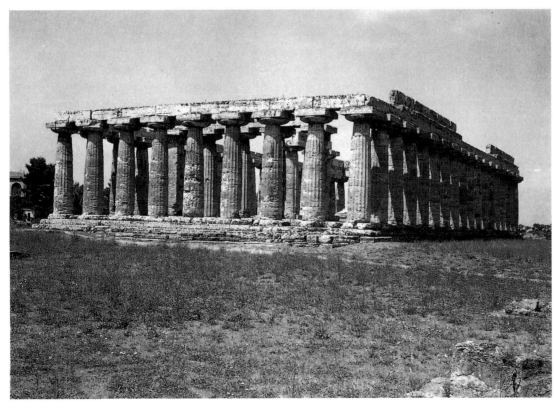

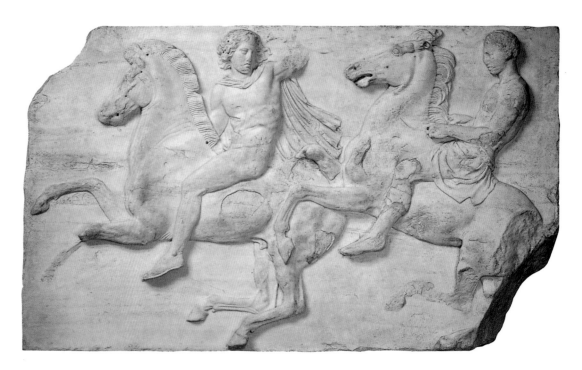

THE PARTHENON

The familiar column-bound box and gabled roof of a Greek temple represents the most conservative form of the most conservative of all Greek arts (see plan *below*). The Parthenon, built between about 450 and 438 BC, was an exceptional building in many ways but it conforms in overall appearance. The broad façade of eight columns, instead of the usual six, gives it a relatively dumpy outline when seen today head-on or from the air; but in antiquity, when it could be viewed only from the surface of the Athenian Acropolis on which it stood, or from the city below, its breadth strengthened the impression of dominance and protection. Any danger of heaviness in build is eliminated by the subtle refinements in all its parts, which dictated that there should be no straight lines in what other-wise seems a most rectilinear building. The line of steps from which the columns rise curves imperceptibly down towards the corners of the building; the column shafts themselves taper gradually up, while the corner columns are a trace plumper than their neighbours; and whereas the columns lean gently in, the upperworks lean gently out.

The main room of a Greek temple (the *cella*) was not for a congregation, but for the cult statue, in this case a 12 metre high gold and ivory statue of Athena. The Parthenon also had a rear room or Treasury, which is exceptional; the roof of this appears to have been supported by four Ionic columns, slenderer than the Doric. Sacrifices took place at the altar before a temple front (in the east) and here again the Parthenon is unusual in having no altar, since the old altar of the earlier temple to the goddess was used. The building is as much a memorial to the Athenians' successes against the Persians, both in their solitary stand at Marathon and later as self-appointed guardians of Greek affairs, as a temple to the city goddess. It was financed from surpluses in payments

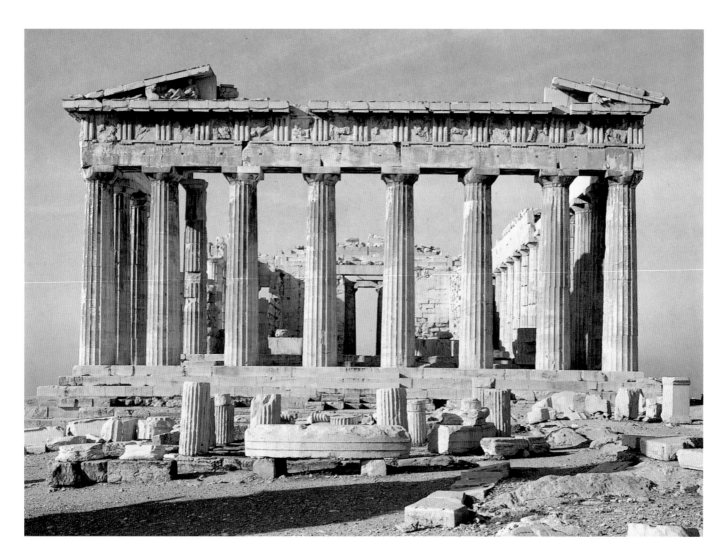

made to Athens by members of the league of states against the Persians, which were effectively the Athenian 'empire'.

The Parthenon had more lavish architectural sculpture than most Greek temples. The pediments on the east front commemorated Athena's birth, attended by the Olympian gods (pl. 6), and those on the west her acquisition of the land of Athens, in dispute with Poseidon. The metopes – square panels around the building, over the columns – had mythological subjects reflecting the recent wars and victories of the Greeks over the barbarians: fight with the Amazons, centaurs, Trojans and the battle of the gods and giants. The frieze (*above opposite*), showed a version of the procession in honour of the goddess at the state festival. Here the main body of the procession consists of cavalry and chariots. It is most unusual to place such a non-divine subject on a temple, but it may imply a desire to heroise the men who had fought for their city and for Greece.

The Parthenon represents the high point of Classical style. It is relatively so well preserved because the building was turned into a Christian church, then a mosque, and, despite an explosion and depredations, remained largely intact until the beginning of the nineteenth century. Lord Elgin brought much of its sculpture to Britain where it was acquired by the British Museum. What was left has suffered from damage inflicted both by man and by pollution.

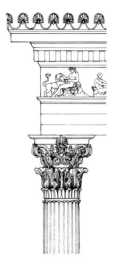

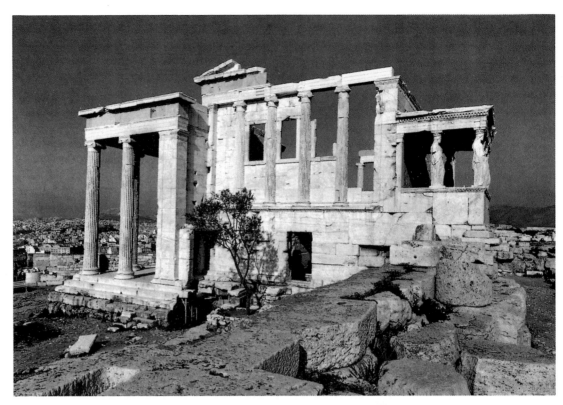

ABOVE 29 *The Corinthian order. Capital from the Choragic Monument of Lysicrates, Athens.*

ABOVE RIGHT 30. *The Erechtheum on the Acropolis at Athens, c.410 BC.*

OPPOSITE 31. *Reconstruction of the tomb of Mausolus, king of Caria (the 'Mausoleum'), at Halicarnassus (SW. Turkey), mid-4th century B.C. (Drawing by Peter Jackson.)*

tival activity. Such buildings were showplaces of Greek art, close to being museums or galleries in the modern sense, but not designed for that purpose, although a room in the gateway to the Athenian Acropolis was designated a picture gallery (*pinakotheke*).

THE SPREAD OF HELLENISM

With Alexander's successors, their capitals at Alexandria, Pergamum, and new foundations in the Greek East, Greek artists found new patrons. They were ready and anxious to promote works of art and architecture to glorify themselves and their families rather than simply their cities, which had been the prime motive of the state-sponsored projects of the Classical city states and democracies. Rich families could aspire to comparable display, but in the utensils and ornaments created for the populace we can sense already a preference for mass production – pottery from the mould rather than individually painted is an obvious example. There had always been shoddy work produced in Greece, and the development of Greek art is not told in terms of a progression from experiment to perfection, from incompetence to technical bravura. At every stage the artists were limited by the possibilities of their materials and the technology they could command; in every period they were constrained by the function of the works they created and they expressed themselves within limits imposed by

the conventions of their society and its religion. This is a very limited freedom and possibly it proved an ennobling discipline; there is nothing either anarchic or inevitable about the history of Greek art. Hellenistic Greece sees an appreciable shift in the application of these conventions and their force; some of the Hellenistic princes came close to being identifiable as art connoisseurs.

Rome's involvement with Greece was not a matter of cold-blooded conquest for the sake of gain. The Greek colonies of Italy had been Rome's neighbours, generally unfriendly, for generations, and the portable creations of Greek art had already formed the taste of the peoples of central Italy. But the land of Greece itself, the Classical treasures of its sanctuaries and the palatial wealth of its new rulers, inspired by the practices of the Persian Empire that they had displaced, offered something richer. The loot which Roman generals brought back to grace their triumphal processions through the streets of Rome included more than a display of precious metals. For M. Fulvius Nobilior's triumph in 187 BC after his defeat of the Greeks of Aetolia the procession included '285 bronze statues, 230 marble statues, arms, weapons, and the other spoils of war in great number'. The flow of works of Greek art to the West was followed by Greek artists to serve new patrons and to help fashion a sequel to that tradition which had evolved in Greek lands over the past five centuries.

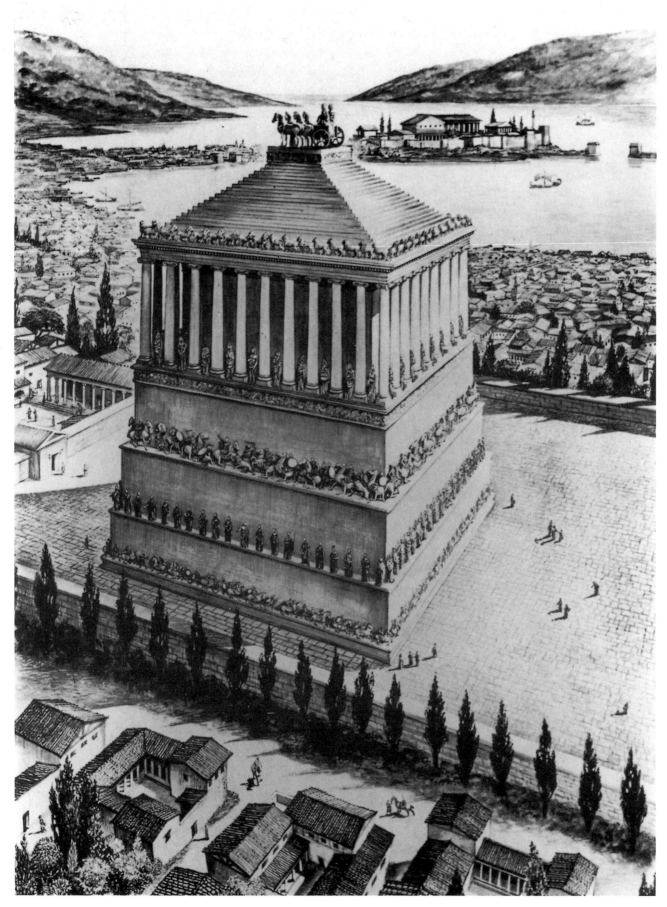

2
ROMAN ART

RICHARD BRILLIANT

INSET 32. *Portrait bust of the* Little Hunt Mosaic *the Emperor Decius, AD 250. Capitoline Museum, Rome.*

OPPOSITE 33. *Detail of the* Little Hunt Mosaic *from the Imperial Villa of Casale, Piazza Armerina, Sicily, 3rd-4th centuries AD.*

'I waged many civil and foreign wars on land and sea throughout the world, and as victor was merciful to all citizens who asked for it. With new laws I brought back many exemplary practices of our ancestors and by my own actions I provided other worthy models for posterity. I assisted the public treasury with my own money and whenever the taxes were insufficient I distributed grain and money from my own holdings to as many as 100,000 persons. I restored many ancient buildings, repaired and rebuilt roads, bridges, and aqueducts, and I built new temples, public buildings, and the Forum Augustum. I also gave gladiatorial games and naval shows.... I eliminated the pirates from the sea and extended the territory of the provinces on whose borders were people not subject to our rule. I brought peace to Gaul, Spain, and Germany, pacified the Alps and Dalmatia, sent victorious armies into Ethiopia, Arabia, and Armenia, added Egypt to the empire, founded colonies all around the Mediterranean, and received embassies from the kings of India and Persia. ... After I had brought an end to civil war I returned the supreme power to the Senate and the Roman People, for which the Senate named me Augustus [27 BC], and because of my virtue, clemency, justice, and piety. After this, I came before everyone in authority....'

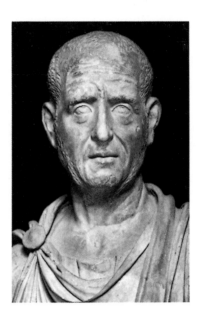

(From *The Achievements of the Divine Augustus [Res Gestae Divi Augusti]*, left with his will at his death on 19 August, AD 14, and soon published in inscriptions)

Under Augustus, the first Roman emperor (31 BC-AD 14), the Roman state was a fully organised, vast empire, extending from Mesopotamia to the English Channel, from the North Sea to the Sahara and ruling over peoples with different cultures, languages and religious beliefs. The unifying authority of Roman law covered this diversity under the mantle of the Roman Peace (*Pax Romana*), which brought security to all and the much-desired amenities of civilisation. Economic dependency and a single currency, the Roman army, the great network of roads, and common civil institutions served to hold the Empire together for centuries. With perhaps 100 million inhabitants at the time of the Emperor Trajan, early in the second century AD (pl. 35), the wealth of the Empire reached many, if not all, and embellished its cities and towns with great monuments and powerful images.

The Roman Empire rested firmly on the institutions and achievements of the Republic, which had endured almost 500 years before the advent of Augustus. The Roman Republic came into existence in the late sixth century BC, following the expulsion of the kings, many of whom were of Etruscan origin. Political power was exercised through the votes of propertied male

34

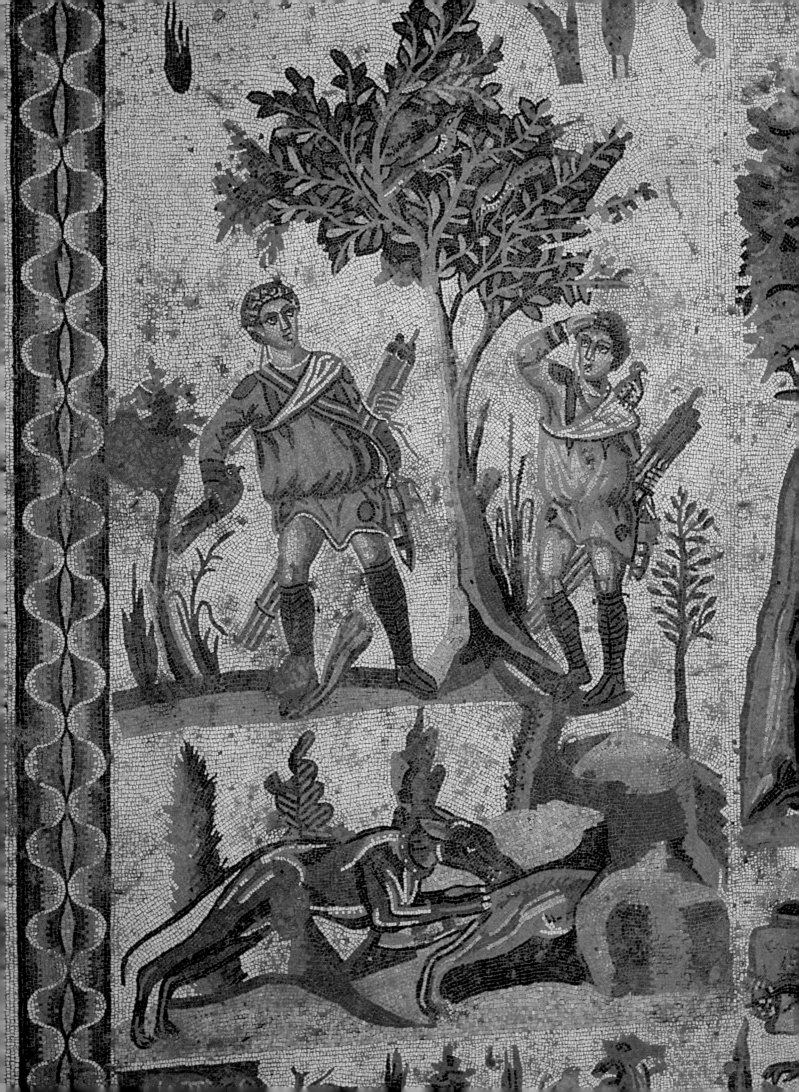

OPPOSITE 34. *View of the Roman Forum from the Capitoline Hill looking down the Via Sacra (Sacred Way) towards the Arch of Titus and the Arch of Constantine.*
On the left: in the foreground the Arch of Septimus Severus, then the the porticoed Temple of Antoninus and Faustina, the surviving north aisle of the Basilica of Maxentius with three vast vaulted niches (also known as the Basilica of Constantine), and the Colosseum.
On the right: the Basilica Julia, the Temples of Vesta, Dioscuri, and the three remaining pillars of the Temple of Castor and Pollux.

citizens, led by the members of great families who contested for the highest office, the consulship. These leaders sought to play prominent roles as benefactors of Rome, especially in war and in the construction of public works, such as roads, aqueducts and large public buildings. It is during the heyday of the Roman Republic from the fourth to the second century BC that its government could be summed up in the famous words, *Senatus Populusque Romanus* (SPQR: the Senate and the Roman people), marking the effective collaboration between the Senate leadership and the Roman people as free citizens. In the first century BC the growing wealth of the powerful, the increasing importance of a large standing army, and the demands of administering most of the lands around the Mediterranean, by then under Roman domination, put unbearable strains on the Republican form of government, better suited to a small city state. An authoritarian, centralised regime, focused on a single leader, slowly took shape to meet the needs of tens of millions of people incorporated within the extensive boundaries of the Roman Empire.

Conquest of this vast territory had begun when the Romans of the Republic moved out from their small city on the river Tiber and incorporated their Latin neighbours into their state. By the fourth century BC the Romans had thrown off Etruscan domination and had taken over their cities and territories. Victory in the Punic Wars with Carthage led in the third and second centuries to Roman control of Italy and of commerce in the western Mediterranean, to Roman settlements in North Africa, Spain and southern France, and to interference in the affairs of Greece and the Hellenistic kingdoms of the eastern Mediterranean. By the first century, Rome was the leading power in and around the Mediterranean basin and had become the ultimate recipient of its wealth. Great captains and politicians – Marius, Sulla, Pompey, Julius Caesar, Mark Antony and Octavian-Augustus – contended for the control of that power through political action and civil war, leading eventually to the exhaustion of the Republican institutions and to the imperial resolution in the person of Augustus, the first among equals in the Senate and the emperor of all Rome.

The ancient Roman Forum (pl. 34) was the site of the great social and political struggles of the Republic during the five centuries of its history. Here were many of the most sacred shrines of the state; here victorious generals were received in triumph; here Roman lawyers argued their cases in public and began the formal development of Roman case law; here in the second century BC Tiberius and Gaius Gracchus tried to make access to political power and landownership available to a greater number of Roman citizens; here Cicero and Caesar and Mark Antony spoke of ancient glories and of the necessities of contemporary politics. Here was the Senate (the Curia) and the seat of government. Indeed, many of the powerful Republican leaders and their families commissioned the temples, shrines and public buildings which surrounded the Roman Forum, and thereby proclaimed their patriotism and their generosity for all to see, and respect. Augustus retained the Roman Forum as the symbolic centre of the city and of the Empire, but he rebuilt most of the Republican monuments so magnificently that he substituted his own presence for that of the ancients. Later Roman emperors, even Constantine, followed his example, and put their own mark on this ancient place.

Augustus also built a forum of his own, the Forum Augustum, as a symbol of his victorious but peaceful regime. He filled it with images taken from the great Roman past and with architectural and figural references to himself and to the imperial family as continuators of that tradition in the present and in the future. True to his boast in the *Res Gestae* that he had found Rome a city of brick and left it a city of marble, the entire complex of the Forum Augustum gleamed with shiny veneers of costly white marble, mostly from the new Italian quarries at Carrara, and with marble statues and architectural ornaments that directly invoked the spirit of ancient Greece, especially of Classical Athens. Here, as in the poetry of Virgil, Augustan Rome was presented as the legitimate heir and reimbodiment of Athens, as the new centre of Classical Graeco-Roman civilisation. The claim was a fair one, and had its origins not only in Roman pride and achievement but also in the powerful effect of Greek culture, philosophy and art on the Roman mind since the late third century BC, when Roman exposure to the Greek world began in earnest. It was said that Rome conquered Greece and was in turn conquered by Greece. Many Romans became convinced that the expression of the noblest sentiments, of the noblest ideals in art, required some form of Greek imagery, of Greek models in art and architecture.

The more than life-size marble statue of Augustus from Prima Porta (pl. 36) is fully in keeping with this attitude and this Graeco-Roman ideal. Discovered in the nineteenth century in the villa of Livia, Augustus' powerful wife, the statue

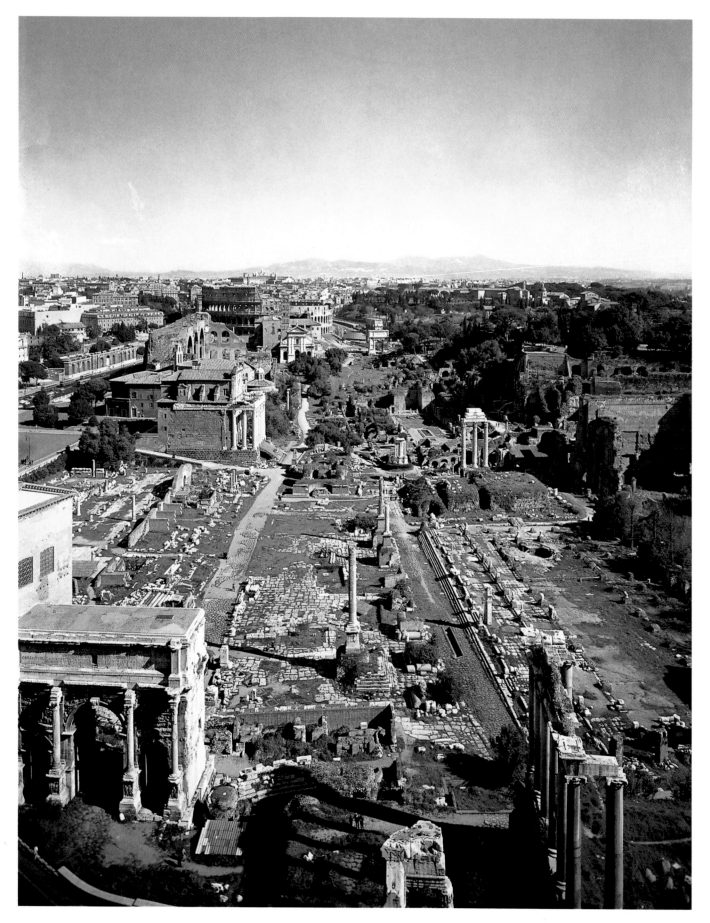

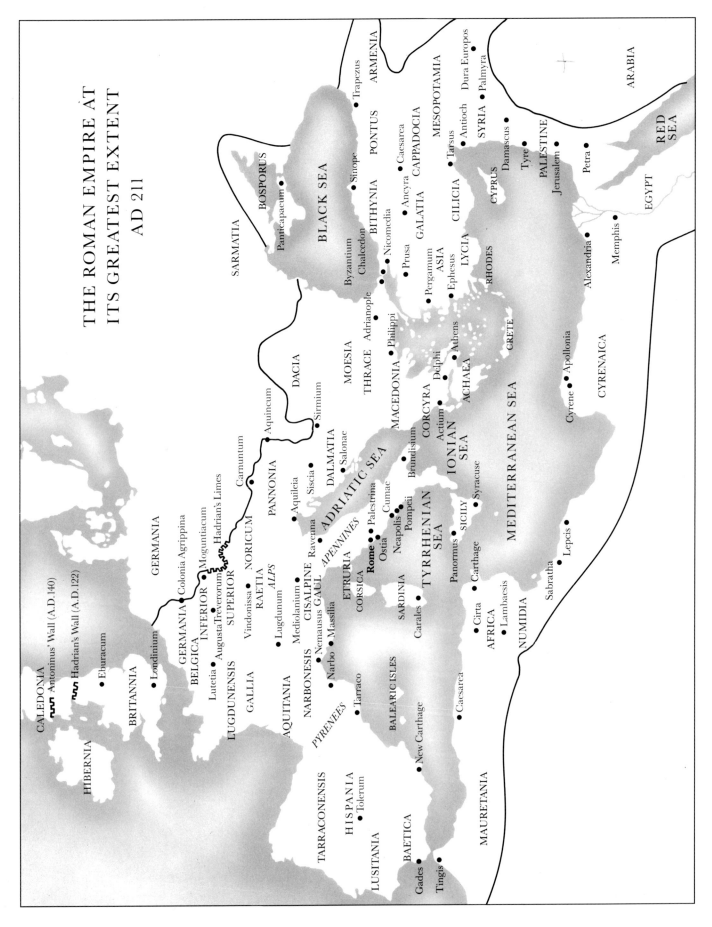

THE ROMAN EMPIRE AT
ITS GREATEST EXTENT
AD 211

ARMENIA

ARABIA

RED
SEA

Trapezus

MESOPOTAMIA Dura Europos

PONTUS Antioch Palmyra

BOSPORUS Sinope BITHYNIA CAPPADOCIA Damascus SYRIA

Caesarea Tarsus PALESTINE

Panticapaeum Chalcedon Nicomedia Ancyra CILICIA CYPRUS Tyre

BLACK SEA Byzantium GALATIA Jerusalem Petra

SARMATIA Prusa ASIA LYCIA

Pergamum Ephesus RHODES EGYPT

Adrianople Philippi Memphis

MOESIA THRACE Alexandria

Athens

Delphi CRETE

Sirmium DACIA MACEDONIA Actium ACHAEA

Aquincum CORCYRA CYRENAICA

Carnuntum Salonae Brundisium IONIAN SEA MEDITERRANEAN SEA Cyrene Apollonia

PANNONIA DALMATIA ADRIATIC SEA

Aquileia Siscia Syracuse

Hadrian's Limes NORICUM Ravenna APENNINES Palestrina SICILY

RAETIA Cumae Lepcis

GERMANIA Vindonissa ALPS CISALPINE ETRURIA Rome Neapolis TYRRHENIAN Panormus Carthage Sabratha

Moguntiacum SUPERIOR Lugdunum Mediolanium GAUL Ostia Pompeii SEA

Colonia Agrippina Augusta Treverorum Nemausus CORSICA SARDINIA Cirta Lambaesis

GERMANIA BELGICA Massilia AFRICA NUMIDIA

INFERIOR Lutetia Narbo Carales

GERMANIA LUGDUNENSIS GALLIA AQUITANIA NARBONESIS Caesarea

Londinium Tarraco

Eburacum PYRENEES BALEARIC ISLES

Antoninus' Wall (A.D.140) BRITANNIA New Carthage

CALEDONIA Hadrian's Wall (A.D.122) TARRACONENSIS

HIBERNIA HISPANIA MAURETANIA

LUSITANIA Tolerum

BAETICA

Gades Tingis

38

once bore the traces of paint on the cuirass (breastplate), suggesting with other details of carving that the work probably copied a bronze original, now lost. On the basis of the portrait type and the style, the original statue has been dated to a time shortly after 27 BC. The marble copy may have been made after Augustus' death in AD 14.

Augustus, who was of medium height, often sickly, and in 27 BC no longer young, appears in the statue as an athletic, even heroic figure whose youthful form, proportion and stance were derived from the *Doryphoros* (pl. 10), a famous statue by the fifth-century Greek master Polyclitus that was long appreciated as the absolute embodiment of the male ideal in Classical Greek art. Yet, however idealised the youthful face might be, the portrait is still sufficiently detailed to be recognisably of Augustus, and the statue is full of signal references to the emperor himself: the dolphin

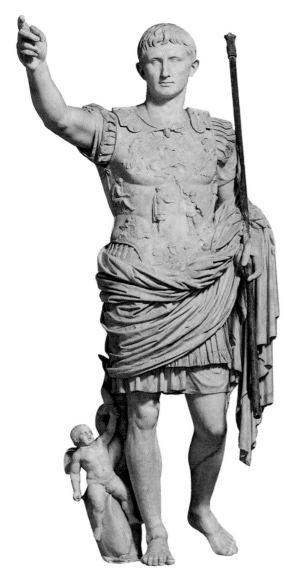

and putto along his leg refer to the goddess Venus, to whom he is related through his divine, adoptive father Julius Caesar, deified by the Senate after his death; the allegorical and historical motifs on the cuirass invoke both his universal power and recent historical events on the Eastern frontier. And the viewer is compelled to notice the powerful gesture of Augustus' uplifted right arm, a gesture of formal address (*adlocutio*) directed to him and to the unseen audience of Romans. In the Prima Porta Augustus the unknown sculptor has found a way to adapt the Greek tradition to a Roman purpose, to set an ideal image into a historical frame, and to make of an artwork an effective instrument of authority. Whatever the artistic source, the process is Roman, and so too the statue.

Many of the same elements are visible in the composition of the Ara Pacis Augustae, the Altar of Augustan Peace, consecrated in 13 BC and completed four years later. Erected at the edge of the Campus Martius in Rome, the ancient centre of Roman military tradition, the marble altar, now restored, marked Augustus' return to Rome after settling affairs in Spain and Gaul. The Senate, perhaps with Augustus' connivance, took this opportunity to extend the monument, moving from a specific dedication to a general statement about the *Pax Augusta* that applied to the whole Roman world. Once again, the form of an open altar emulates Greek examples, and the sculptural style of the dignified long processional reliefs on the side (pl. 37) consciously refers to Athenian monuments, most particularly to the Parthenon frieze, which is a similarly idealised

OPPOSITE 35. *The Roman Empire, AD 211.*

LEFT 36. *Marble statue of Augustus from Prima Porta, early 1st century AD. Vatican Museums, Rome.*

ABOVE 37. *Ara Pacis Augustae. Relief showing imperial procession and floral frieze, 13–9 BC. Rome.*

image of the body politic. The Ara Pacis processional reliefs – classicising, restrained in modelling and dependent on slow linear rhythms – invoke the prestigious prototype but, at the same time, offer an acute, specific depiction of the members of the imperial family, including Augustus, Livia and Augustus' heir, Agrippa, and their companions and attendants at the consecration ceremonies in 13 BC. These historical personages, individually portrayed (even if not all the individuals can be identified today), together constitute a potent image of an idealised leadership and of an imperial dynasty, representative of the Augustan age. A similar conflation of idealised forms and naturalistic observation occurs in the large floral relief set below the imperial procession. There, a spreading carpet of growing, flowering plants, filled with small animals and birds, offers the promise of nature's bounty, guaranteed by the *Pax Augusta*, in a lyrical spirit reminiscent of Virgil's *Eclogues* and especially of Horace's *Odes*, book IV, including his 'Centennial Hymn' of 17 BC. Observant but detached, Roman art in the time of Augustus exhibits a certain elegant restraint, as if the roughness of the natural world and of human affairs had to be subjected to firm, almost dispassionate control, lest stability be lost.

In the first century AD the Empire and its citizens prospered under the rule of the Julio-Claudian emperors – Tiberius, Caligula, Claudius and Nero (AD 14–68) – who derived their legitimacy from Augustus. The Roman world was largely at peace and people had become accustomed to the idea of empire, under the rule of a benevolent, fairly responsible autocrat, and to the sacrifice of their old liberties. New cities were founded in the western provinces – North Africa, Spain, Gaul, Britain, Germany – and rapid urbanisation helped create a demand for architects and builders and for a construction industry, capable of large-scale projects which utilised stone, brick and concrete in vast amounts. Widespread commerce led to the growth of shipping and to the rapid development of ports; the shipment of grain, wine and oil brought about the industrialised production of fired clay containers in huge numbers; the mining of metallic ores intensified, as did the manufacture of utilitarian and luxurious objects in metal, armaments, and bronze, silver and gold coins. All this economic activity stimulated the rapid growth of wealth, concentrated to a degree among the great magnates, powerful senatorial families and the imperial house, but also widely diffused throughout Roman society. A much

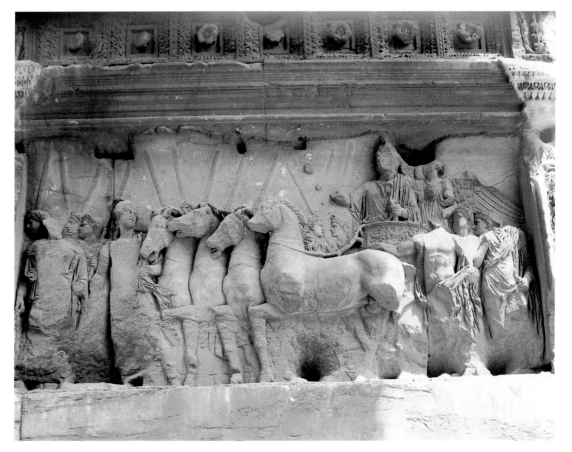

38. *Arch of Titus. Relief showing triumphal procession of the emperor, AD 81. Rome. The arch was built to commemorate the capture and sack of Jerusalem. The headless Titus stands in his chariot.*

larger portion of the Roman population could now afford decent housing, good clothing and a proper diet; more people had money to decorate their houses, purchase works of art, commission artists and dedicate monuments to the gods, the emperors, their friends and themselves.

For the urban poor, conditions were hard; some escaped into the army, or to the colonies in the provinces, or into mystical religions and cults – many of them, such as the cult of Isis and Christianity, of foreign origin. In Rome the hardship of poverty was somewhat alleviated by an ample supply of fresh water – public fountains, baths and latrines; by the free distribution of foodstuffs (grain and oil) to Roman citizens; and by public entertainments in the theatre, the chariot races in the circus, and gladiatorial contests and wild-animal shows in the amphitheatre. The provision of bread and the circus – the Circus Maximus held about 250,000 spectators by Trajan's time – enabled the emperors to keep the urban poor under control. Costly programmes of public works were paid for by the emperors and other public benefactors, responsible for some of the greatest monuments of Roman urban architecture.

For many the Empire had come to be a better place to live; even the barbarians on the frontier thought so. Not everyone, however, was satisfied; some wanted to return to the Republic, and others sought the greatest prize of all, the supreme power, for themselves. Nero was murdered in AD 68, a short period of civil war followed, and Vespasian, a Roman general, became emperor in AD 70. The favourite of the Roman armies in the East, who imposed their choice on the Senate, Vespasian founded the Flavian dynasty, and his sons, Titus and Domitian, succeeded him. The new emperor was of simple Italian stock, no patrician but a new man who had risen from rank to rank in the army and from one public office to another; his ultimate popularity depended on his success as a general, especially on the victory won with the help of Titus in the bitter war against the Jews in Judaea. Father and son celebrated their triumph in Rome in AD 71, thereby confirming their right to rule because victory had been given through them to Rome by the gods.

More than twenty years later Domitian commemorated their earlier victory by erecting a triumphal arch in honour of his deceased brother Titus as a magnificent entrance into the Forum Romanum (pl. 34). One of the reliefs from the inside passageway of the arch (pl. 38) represents the triumph of Titus, who is shown riding in his

39. Portrait bust of an unknown Flavian lady, c. AD 90. Capitoline Museum, Rome.

triumphal chariot, crowned by Victory and accompanied by the gods, personifications of the Roman state and dignitaries. Despite the formal, almost sacred nature of the triumphal procession – as formal as that on the Ara Pacis but less formalised – the ancient sculptor has invented a composition which suggests the real presence of strongly plastic forms moving in an actual space. He achieved this effect through deep cutting, an arc-like disposition of figures, and the skilful use of overlap, thereby creating the impression that the procession passes before the spectator's eyes, perpetually enacting the triumphal event of AD 71.

Like Vespasian himself, Flavian sculptural style is characterised by great vigour and a certain realistic directness. It depends on a virtuoso technique of carving with preference for the immediate rather than the remote, for strength rather than elegance, for descriptive reality rather than abstract idealism. It also encompasses a delight in the physical properties of beauty, as in the superb portrait of a Flavian lady of the court (pl. 39). The tactility of smooth skin and curling hair play against each other with great effect; the ringlets, probably once painted and cut into the marble by the running drill, create a successful illusion of the lady's hair, teased into shape by a hot curling-iron, an inconvenience only to be borne by a fashionable woman putting on her best 'face'.

Augustan and Flavian sculpture represent two

different formal alternatives adopted by Roman artists, the one dependent on Classical Greek models, the other on Hellenistic works. Roman art will oscillate between these alternative styles until the time of Constantine; together they constitute a recurrent Greek revival, a recognisable mode for expressing allegorical meaning in works of art or the aspirations of the political and intellectual elite. This mode is not exclusive, however, because another mode also makes its appearance in Roman art, not dependent on Greek models and often presented in opposition to it. That mode, sometimes called 'Roman realism' or 'Roman popular art', has its origins in the Republican period and appealed to those levels of Roman society which were less deeply Hellenised – to the so-called Roman middle class and to the provincials, especially in the West. It was particularly adapted to represent the bald facts of ordinary human life and the hard, detailed facts of Roman history directly and informatively. This 'Roman' mode informs a large number of Roman portraits with an explicit sobriety and explicit, descriptive detail; old Romans are truly old and look so, women are not especially beautiful, and, as for children, they are literally chips off the old block; such portraits typically appear on grave monuments, which emphasise recognisability, plainness of feature the social status of the deceased, and worthy deeds.

This descriptive, literal mode has its own long history in Roman imperial art and had its own class following. It was often associated with traditional 'old Roman' or Republican values, a sober morality, and a belief in the worthiness of the actual individual and of the real record of how things were and looked for all posterity. Unexpectedly, perhaps, the most complete realisation of this 'Roman' mode is to be found in the reliefs of the Column of Trajan (pl. 42), one of the greatest of all Roman public monuments.

THE LATER EMPIRE

'In the second century of the Christian era, the Empire of Rome comprehended the fairest part of the earth, and the most civilised portion of mankind. The frontiers of that extensive monarchy were guarded by ancient renown and disciplined valour. The gentle but powerful influence of laws and manners had gradually cemented the union of the provinces. Their peaceful inhabitants enjoyed and abused the advantages of wealth and luxury. The image of a free constitution was preserved with decent reverence: the Roman senate appeared to possess the sovereign authority, and devolved on the emperors all the executive powers of government. During a happy period (AD 98–180) of more than fourscore years, the public administration was conducted by the virtues and abilities of Nerva, Trajan, Hadrian, and the two Antonines (Antoninus Pius and Marcus Aurelius).'

(Edward Gibbon, *The Decline and Fall of the Roman Empire*, 1776, ch.1)

After the political murder of the autocratic Domitian, the Senate chose one of their own members, the aged Nerva, as emperor, but he lacked popular and army support and was soon forced to adopt Trajan as his co-ruler and heir. This initiated the dynasty of the elect, when each emperor chose his successor not by the accident of birth but by merit, until Marcus Aurelius allowed his son Commodus to succeed him. The second century was a glorious period of peace and prosperity when the participation of the provincial aristocracy and of the middle class was at its height. Trajan himself was a Roman from Spain, a man of outstanding personal reputation, a very successful general with a distinguished public career – apparently the reincarnation of the moral, sober, achieving public figure traditionally associated with the Roman Republic.

The philhellenic Hadrian (pl. 40), the bureaucratic Antoninus Pius and the stoical Marcus Aurelius maintained the strength of the Empire, the last doing so in the face of severe barbarian pressure on the German frontier. Germans broke through the frontier defence in the 170s, invading northern Italy, and were beaten back only with great difficulty. This violation of Italian soil shocked the Romans, who began to recognise with increasing anxiety the seriousness of the barbarian threat in the north and on the eastern frontier. The helical reliefs of the Column of Marcus Aurelius in Rome, completed by his son, Commodus, in the 180s, follow the model of Trajan's Column, but the Romans now appear much less confident of victory. The Aurelian reliefs are more schematic, the emperor's presence

40. Portrait of the Emperor Hadrian on a Roman coin, the sestertius, 2nd century AD. British Museum, London.

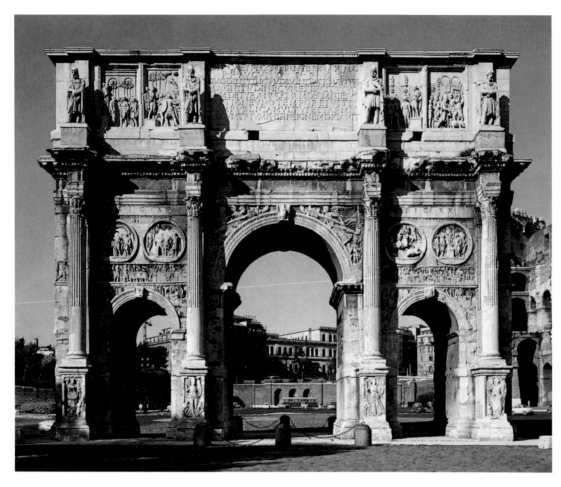

dominates the composition more insistently, and an unprecedented expression of savagery and anxiety manifests itself in violent scenes of battle.

Stress, uncertainty, an awareness of good times passing began to affect the Romans' sense of security. In the second and third centuries, Roman sepulchral art, especially sarcophagi – great marble caskets decorated with relief sculpture – increasingly emphasised the importance of victory over inevitable death, often using Greek mythological heroes as the vehicle of rescue. The coupling of anxiety over the future with a slowly developing alienation from the values of Graeco-Roman society stimulated the expansion of cults, such as Mithraism and Christianity, which promised salvation and a better life, if not here and now, then in the hereafter. In the third century, after the death of Septimus Severus (AD 211), the Roman army intervened more and more in the imperial succession; its generals contended for power in civil wars which wasted the resources of the Empire and neglected the ever more porous frontiers. Barbarians invaded Gaul, crossed the German frontier, drove the Romans out of much of Dacia, invaded Greece, raided deeply into Syria, upset settlements and outlying

farms in Egypt and in North Africa, and made trouble on land and sea. The haggard portrait of the Roman general and emperor Decius (AD 250), clearly expresses this altered state of mind and with it the determination to go on (pl. 32).

In the late third century under the leadership of Diocletian the Empire was reorganised. It became an absolutist state, ruled by all-powerful emperors, regarded as gods and so revered. The separation between the very rich and powerful and everyone else grew greater, and increasingly people were bound permanently to their positions, their vocations and the places in which they lived and worked. Trade and industry declined, as did the pursuit of high culture and art, and the old institutions lost much of their ancient vigour and support, while new institutions such as the Christian church rose into prominence. Rome was no longer the sole capital of the Empire, Constantinople having been created to rule the eastern part of a divided Graeco-Roman world.

But Rome survived and with it the memory of its glory was preserved. Constantine defeated his rival Maxentius in battle just outside the city in AD 312, and three years later he celebrated this

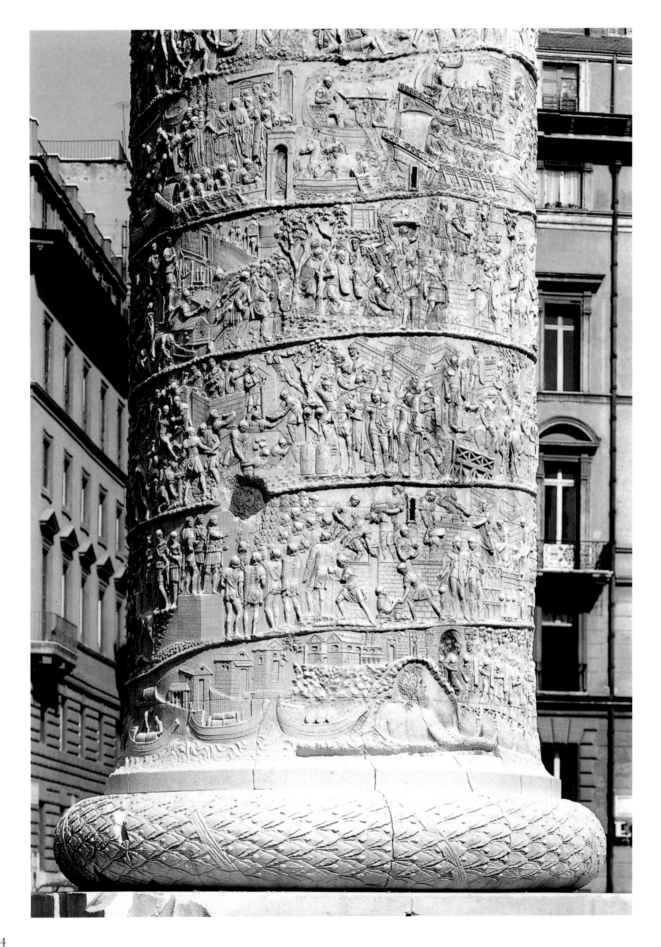

THE COLUMN OF TRAJAN

Consistent with the image of the virtuous emperor, Trajanic art experienced a revival of traditional Republican values, often presenting a modified version of the sober, descriptive 'Roman' mode in some of its most imperial monuments. Such a monument is the Column of Trajan, the capstone of the Forum of Trajan in Rome, erected in AD113 to celebrate the victory over the Dacians in what is now Romania and the addition of their territory to the Empire. The entire complex of the Forum, including the column, which stands exactly on the crossing axes, may have been designed by a great architect, Apollodorus of Damascus, an eastern Greek in the imperial service who created a classic Roman work.

The helical relief (*left*) winds upward around the column shaft, extending about 100 m and containing more than 150 separate scenes and thousands of figures carved in marble. This extraordinary relief sculpture presents the facts of the Dacian campaign, convincing visual evidence for the Roman viewer and for posterity of Trajan's achievement. The continuous narrative is divided into well-defined scenes: the Roman army embarking from the port of Ancona, crossing the Danube, building fortifications and camps, attacking and defeating the Dacians, taking and burning their villages, accepting their surrender and occupying the Dacian land. History has thus been made visible and permanent.

The relief is filled with such specific detail throughout its length that an annotated visual record must have been made in the field to bring back to Rome as the basis of an 'official history' of the triumphant campaign. Evidently this record included drawings of people and places, soldiers and civilians, weapons and tools, cities, villages, bridges and military machines, all of which entered into the cartoon which the artist must have used to compose this great frieze.

The finished monument thus provides a visual narrative of victory and constitutes a powerful sign of triumph. Factual detail, despite its abundance, is everywhere subservient to the historical construction of events, moving smoothly in chronological order along the rising path of the relief; this record is punctuated by set-scenes of greater or lesser complexity which characterise the typical and symbolic actions of the Dacian campaign, culminating in the final defeat and surrender of the barbarians to the Romans and Trajan.

Over and over again the dominant figure of the emperor catches the eye. He appears and reappears as the guiding force for the army, for the viewer's attention and for the Roman state. By this means the artist combined traditional Roman realism and historical narrative, subjecting both to the demands of the imperial ideology with its focus on Trajan.

His gilded statue once stood on top of the column, high in the air, flashing gloriously in the sun; and the emperor's ashes were preserved in the pedestal, itself covered by reliefs representing the weapons surrendered by the Dacians in vast numbers, while personified Victories flank an inscription, dedicated to Trajan, conqueror of the Germans, and the Dacians. Despite the abrasive winds of time, the column still preserves the calculating subtlety of Roman narrative art, a masterpiece of visual composition on the grandest scale.

victory in a civil war with a triumphal arch (pl. 41). The Constantinian arch contains the spoils of earlier imperial monuments: reliefs of the triumphant Trajan on the ends and along the central passageway; roundels from a monument of Hadrian, showing the emperor as a great hunter, on each façade; and at the attic level, panel reliefs from a triumphal arch of Marcus Aurelius, celebrating his German victory. The heads of Trajan, of Hadrian and of Marcus Aurelius were replaced, for the most part, by portraits of Constantine himself, symbolising the new emperor's assimilation of his great second-century predecessors and implying his promise to follow in their footsteps.

A narrow frieze of Constantinian relief runs around the entire arch, recounting his campaign against Maxentius. The frieze culminates on the north side in two formal scenes, one showing the emperor giving aid to deserving citizens, the other addressing the assembled Romans in the Roman Forum (pl. 43). On either side of the centrally placed, large, frontal (but now headless) figure of Constantine are two superimposed rows of stubbily proportioned officials, standing stiffly in attendance upon the emperor; there is no illusion of space, but each figure, each architectural element, is symbolically present. Constantine speaks from the Rostra in the Forum, readily identified by the architectural background; he addresses the Roman audience – ourselves – beyond the limits of the scene, and is the centre of all things, the absolute focus of attention. This new abstract, symbolic mode of composition reflects the new order of the Roman world. It also anticipates the non-illusionistic, dehumanised, symbolic art of the Middle Ages in the West. Above, in the attic of the arch, the words *instinctu divinitatis* ('with divine inspiration') appear in the inscription, making a reference, it is believed, to the god invoked by the Christian soldiers who helped Constantine defeat Maxentius and old Rome at the Battle of the Milvian Bridge.

The late Roman artistic legacy of motifs and compositions lived on in Christian and Byzantine art for centuries, and so too did its architectural heritage. According to the fourth-century Roman historian Ammianus Marcellinus, when the Emperor Constantius II visited Rome for the first time in AD 357 he was amazed by the splendour of its architecture, by the great bath buildings, the Colosseum, the Pantheon, like some 'rounded city-district', and the Forum of Trajan. His amazement, like the admiration of the builders of the Romanesque cathedrals and that of the architects of the Italian Renaissance, was occasioned by the standing evidence of the Romans' ability to produce architecture of unprecedented scale, complexity and space.

Roman architecture depends in part on Greek models for specific building-types, such as rectangular, gabled temples with columns, and for the Doric, Ionic and Corinthian orders of architectural design and ornament. Roman architects often detached the Greek orders from their tectonic function as working parts of architecture and applied them decoratively to organise the surface of buildings or façades or as columnar screens, defining but not isolating space. The gabled columnar front, characteristic of the Greek temple, might be retained, but often only as the façade of a temple, such as that of Antoninus Pius and Faustina in the Roman Forum, or to serve as the porch for another kind of building such as the Pantheon. This Greek front is just that, preceding a building that faces forward and covering an interior space that must be penetrated; it also plays a symbolic role, like the Greek elements in the Prima Porta Augustus, signifying a noble presence and purpose, an idealised, even abstract form of architecture.

Although very important, the Greek component of Roman architecture is only part of its basic conception. Unlike Greek architecture, which depends on cut-stone masonry construction and the rectangular articulation of forms, Roman architecture is built of coarse materials bonded together in a single mass and of the curving flowing shapes and surfaces that the technique of building in concrete makes possible. Roman concrete consists of a mixture of lime, sand and water with small stones or pieces of rock or pottery added; when dry and hard, the mixture coheres into a solid mass, capable of bearing great loads. By the second century BC Roman builders had discovered that with the addition of small amounts of a powdered volcanic stone from Pozzuoli, near Naples, they had created a concrete that was very strong and waterproof, even while setting. This reliable material simplified construction, made it possible to build large structures relatively quickly and inexpensively, and gave Roman architects the opportunity to develop new curviform shapes, once they had learned how to use a timber framework to hold the concrete mass while it hardened. To cover and protect this concrete mass from the weather, Roman builders used a cladding of dressed stone, or brick, or fine marble veneers, or painted and moulded plaster, often in combination. In the process they often produced an elegant, highly decorative surface bearing little or no rela-

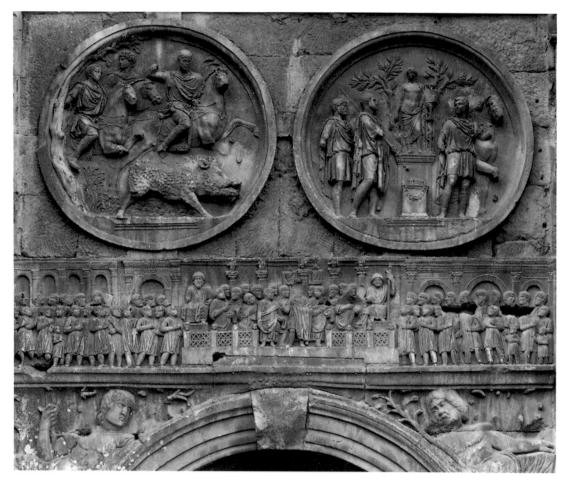

43. *Arch of Constantine (north façade). Relief showing Constantine (now headless) addressing the Romans in the Forum. Early 4th century AD. The roundels above the frieze come from an earlier monument and date from AD 117–138.*

tionship to the structure which it concealed.

The ruins of the ancient towns of Pompeii and Herculaneum, of great Roman villas in the Campanian countryside around Vesuvius, of the city of Ostia at the mouth of the Tiber near Rome, and of other splendid buildings, have preserved many fine examples of Roman decorative wall painting. Beginning with simple patterns, imitating stone and plaster veneers and derived from Hellenistic models of the third and second centuries BC, Roman interior designers soon developed an 'architectural style'. This fashion of interior decoration suggested complex illusions of depth, as if the wall surface itself were transparent and opened out upon attractive prospects of porticoes or landscapes. In the early Empire these architectural designs became more and more fantastic or irrational, with complicated passages of interlocking, richly coloured forms; by the second century AD a preference for surface pattern itself, often of great delicacy, came to the fore, especially in the decoration of Hadrian's Villa at Tivoli and in Roman painted tombs. The pigments were applied to a dry wall, smoothly plastered, and often used tempera as a binding-medium.

By the first century BC such wall-painting compositions might also include (as illusions) 'framed' replicas of Greek panel paintings, otherwise lost (pl. 44) . These replicas were copied by the wall-painters, or by a master brought in for the purpose, because the originals were admired or because in new combinations the house-owner could find new meaning in their contemplation. Hundreds of these 'reproductions' survive, especially in Pompeii. They offer further evidence of the high reputation of Greek painting, of the Romans' desire to possess these masterpieces for themselves, and of the great loss of almost all Greek and Roman panel painting – and with it the work of the greatest painters of antiquity.

Similar reproductions of great paintings can be found in the form of framed panels set in the centre of Roman floor mosaics, often brilliantly composed from bits of coloured stone and glass held together by mortar. Such mosaics were especially popular in the palatial houses and villas of the second to fourth centuries AD in the eastern Mediterranean, at Antioch in Syria and in Roman Cyprus. Some polychrome mosaics covered hundreds of square metres, often preserved in powerful figured compositions such as the *Little*

THIS PAGE 44. *Ixion Room in the House of the Vettii, Pompeii, 1st century AD. Note the illusionistic paintings of windows and vistas as well as the replicas of Greek paintings.*

OPPOSITE 45. *The Sanctuary of Fortuna Primigenia at Palestrina (Praeneste), Italy, c. 80 BC.*

BELOW OPPOSITE 46. *Reconstruction model of the Sanctuary of Fortuna.*

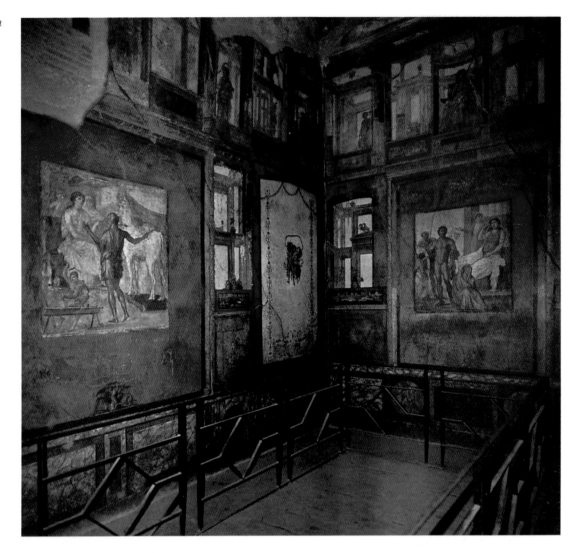

Hunt Mosaic from the fourth-century Imperial Villa at Piazza Armerina in Sicily (pl. 33), which still provides a very good idea of the splendour of such palatial establishments, filled with paintings in stone. However, most Roman mosaics were much simpler in colour and composition; they adopted geometric or carpet patterns in a narrow range of colours and motifs to meet the demands of the floor plan, the movement and direction of traffic, and the designer's need to complement the decoration and surfaces of the ceilings above.

The arch, the arch prolonged into a barrel vault – either straight, or curved, or crossing at right angles – and various kinds of domical vaults articulate the ceilings of Roman concrete buildings and constitute the basic elements of their lofty design. From these elements Roman architects created complex, often vast, buildings in which structure and surface were separately conceived. As early as the late second century BC, the oracular Sanctuary of Fortuna at Palestrina (pls 45, 46) displayed many of the fundamental elements of Roman architecture: rough stone and stucco-faced concrete, which made it possible to construct terracing on a vast scale (over 300 m wide) and thereby reshape the natural landscape; the use of Greek orders, columns, pilasters and entablatures to order the surface of this great complex and to connect one terrace level to another; and a symmetrical, strongly axial design that rationalised the composition, made it comprehensible, and led to its visual and cultic conclusion in the hidden shrine of the oracle at the top.

The Circus Maximus, better known as the Colosseum (pl. 47), held gladiatorial shows and approximately 50,000 spectators. Built by the Flavian emperors, Vespasian and Titus, to benefit and divert the Roman populace, the Colosseum is a classic example of the Roman architect's ability to surround an open space with a penetrable surface. Constructed out of rubble concrete, which combines broken stones and con-

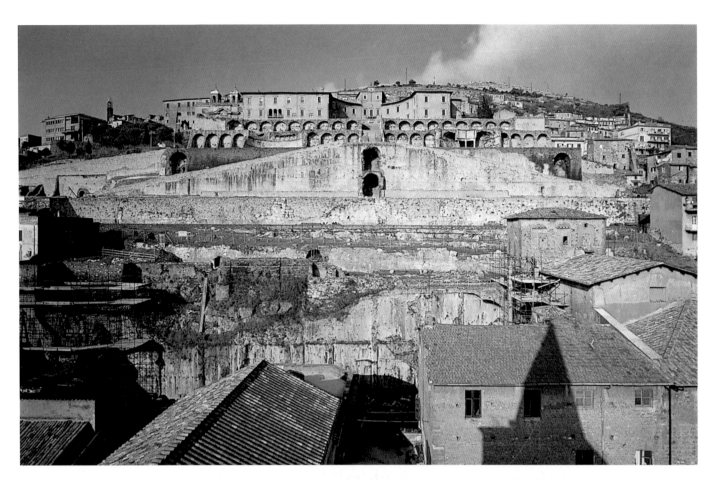

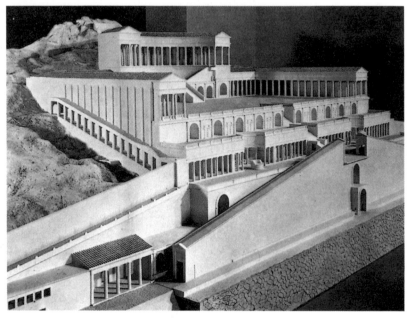

crete into a solid mass, this great oval building is protectively clad with well-drafted masonry on the exterior, all rhythmically organised by the alternation of solid and void, by vertical and horizontal lines which, like some flexible grid, seems to hold the curving façade in place. The vertical sequence of engaged orders from Doric on the bottom to Ionic and then Corinthian pilasters on the top serves to lighten the mass visually, perhaps in preparation for the canvas awning originally stretched over the interior to shelter the crowd from the hot sun. Entrance into the Colosseum could be obtained at many points. The different parts of the building were linked by barrel-vaulted corridors and passageways; the vaults were surfaced with moulded stucco and painted. Then one entered into the great interior, a vast oval space, gradually widening as it rose, ringed by horizontal rows of seats filled with excited people, perhaps even the emperor himself in his imperial box. There was a circular opening in the centre of the canvas awning over the arena for the circulation of air. This hole also allowed enough sunlight to enter to illuminate the scenes of violence staged for the audience's pleasure on the sandy floor of the arena.

The spatial implications of Roman concrete

47. *The Colosseum,
Rome. Begun by
Vespasian in AD 70 and
completed by Domitian in
AD 82. This vast,
elliptical amphitheatre
could hold 50,000
spectators.*

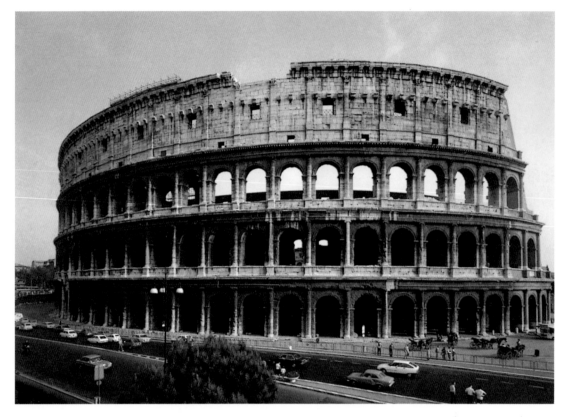

architecture began to be more fully exploited by architects employed by Nero for his Golden House (Domus Aurea) after AD 64, and by Domitian for the imperial palace on the Palatine Hill and other projects in the last two decades of the first century. In the famous octagonal dining-room of the Golden House, the design rises from an octagonal floor plan to a shallow circular dome with a hole (an oculus) in the centre. At the same time the crossing axes of the centralised floor plan terminate in side chambers, opening inward, that enrich the movement of space while permitting the entrance of light, fresh air and flowing water into the once spectacularly decorated interior. Domitian's Palatine palace displayed a great variety of barrel and domical vaults of different dimensions; the complex curving surfaces of the ceilings were richly complemented by floor plans dominated by intersecting convex and concave arcs.

Domitian's palace may have led to the interlocking curvilinear composition of the so-called Maritime Theatre in Hadrian's Villa at Tivoli (pl. 48) in the hill country a few miles east of Rome. This suburban imperial retreat extends for more than a mile and contains public and private buildings of many types: dining-pavilions, libraries, philosophical academies, covered promenades, servants' quarters, bath buildings (pl. 53) and isolated look-outs from which Rome itself was visible in the distance. The whole estate was embellished by rich paintings and mosaics, decorative marbles, and originals or copies of masterpieces from the entire repertory of the ancient art world (pl. 54). In the midst of all this splendour, surrounded by numerous officials and servants, Hadrian could retreat into his own private world, his tranquil island, separated from the rest of the villa by a water-filled moat, traversed by a single, guarded bridge. A vaulted portico surrounds the outside edge of the moat, but on the island, despite the radial symmetry of the design, all is in movement, as space flows from one open segment of arc into another – perhaps a symbol of the emperor's restlessness.

Hadrian took the lessons of the Golden House and later Roman architecture and – possibly with Apollodorus' help – had the Pantheon constructed (AD 118–28; pls 49–52).

Although no greater interior space was ever created in Roman architecture, bath buildings of the second and third centuries were impressive structures, capable of holding thousands of people at one time. Saucer domes, hemispherical domes, half-domes, vaulted apses, barrel vaults by themselves or intersecting others at right angles: all these were widely employed in Roman imperial baths and other large public buildings in order to create lofty, fluid spaces – often contained, however, within regular, even symmetric-

al, ground plans. Despite their disrepair, many of these vaults still seem to float in the air like billowing sails, apparently denying the real weight of their materials (pls. 53, 56). Late Roman buildings emphasised the splendour of their interiors often at the expense of the exterior, as if the experience of a splendid interior were more meaningful, somehow more intense and focused.

Reddish-brown brick might cover the outside, but the late Roman interiors gleamed with figured mosaics on the floor, polished inlays of coloured marble on the walls, and painted, gilded, moulded stucco on the ceilings and vaults; windows might be filled with glass, sometimes painted, or with thin sheets of translucent alabaster, shedding a soft, warm light; statues of gods, of mythic figures and of members of the imperial family, sometimes gilded, could be found in such places, and often there was the sound of water running in elegant fountains. At a reduced scale, late Roman private houses exhibited a similar preference for visual splendour, but hidden away in the interior, as if such an experience would be more precious, more enjoyable, if it were private. Even the Emperor Diocletian concealed his august splendour behind high walls and the barrier of court ritual when he retired in AD 305–6 to his palace at Split on the Dalmatian coast – fortified for safety and planned like a Roman army camp.

When the emperor himself had to take refuge behind fortified walls, it was clear that the centuries-old security provided by the universal *Pax Romana* had broken down. In the late third and fourth centuries barbarian pressure became irresistible, especially on the northern frontier; cities and towns, even Rome, were fortified; industry and commerce declined, and both town and country lost population; the food supply was less reliable, aqueducts fell into disrepair and the currency was debased. A precious few were extremely wealthy, many who had been well-off descended into poverty, and the urban and rural poor sank further into their misery. This decline was especially marked in the Western Empire, where the disruptions were more severe than in the East, the outlying provinces much further from the capital, and the traditions of Classical culture less deeply established.

Everywhere men and women turned away from the growing unpleasantness of life to seek comfort, hope and salvation in religious belief, in cult observance and in religious communities. The cult of the Persian god Mithras, whose powers were believed to span earth and heaven, was especially popular among the military in the second and third centuries, while Christianity spread rapidly among the disenchanted poor and among women, finally reaching deeply into the Western aristocracy in the fourth century. Both

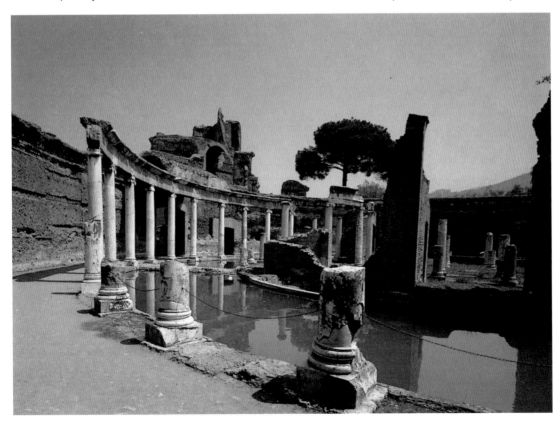

48. *The Maritime Theatre at Hadrian's Villa, Tivoli, AD 118–25.*

THE PANTHEON

The Pantheon, the greatest and best preserved of all Roman buildings to survive from antiquity, was begun in 118 by the Emperor Hadrian and completed in less than ten years.

The word 'Pantheon' in Greek means 'all the gods'. Hadrian, like Agrippa before him, probably intended the Pantheon to serve an abstract religious purpose and symbolise the imperial edifice in its most perfect form.

Hadrian's Pantheon replaced an earlier rectangular temple of the same name, built by Agrippa in the reign of Augustus; he recalled Agrippa's name and probably the form of the gabled front of the earlier structure in the columnar

porch (*opposite left*), but the rest is new. Once set facing a rectangular, colonnaded court, now missing, the Hadrianic Pantheon consists of three distinct parts: a pedimented porch with an eight-column (octostyle) front; a rectangular imtermediate zone behind; and, last, a domed cylinder, made largely of concrete, brick-faced on the exterior and covered with fine stone inlay and stucco on the interior (*opposite right*). The true glory of the building lies in its interior, which combines a cylinder and a hemisphere into a unified space as wide as it is high (about 46 m).

In this conjunction of cylinder and dome a pure sphere is formed (see diagrams), so evident to the eye and to the mind as to suggest that the physical structure is subservient to it, rather than the reverse. Here, then, space seems to rule the forms of architecture, creating such an absolute environment that it constitutes a comprehensible image of the vast cosmos. Looking upward, guided by the calculated recession of the coffer ribs like some globular network, one sees the great oculus (about 9 m wide) suspended overhead. Through it the rain falls in the winter like quicksilver; at other times the sun's rays pass through, moving around the circumference of the dome as the earth turns. Thus, cosmos and the Pantheon's interior space are inter-related.

The Pantheon is more than the greatest extant Roman building; it seems to be an all-inclusive architectural phenomenon in every aspect of its being. The building incorporates the straight lines of the columnar porch and the triangular shape of its gable; the grand, curving network of the coffering of the domed interior, the semicircles of the interior niches, the tall cylinder of its internal body, the hemispherical dome above, the perceived spherical perfection of its interior space, and the transparent oculus

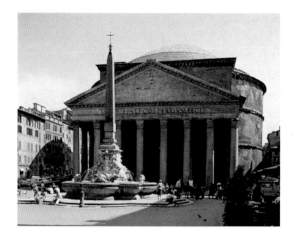

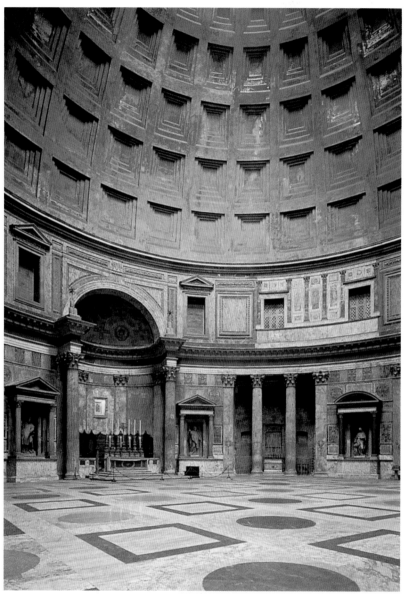

at the top, open to the great bowl of the sky beyond; and everywhere the play of surface, solid and space. Even the present floor, restored in the nineteenth century but preserving its original scheme, offers in miniature the conclusive repertory of circle and square, of dark and light, of concentration and linear extension in its rhythmically patterned design. In contrast with the apparent solidity of the floor, the coffers of the dome, 145 in number and set in five horizontal rows, seem almost flexible, diminishing as they rise so as to emphasise the vertical movement toward an ultimate release through the oculus.

The surfaces of the Pantheon were once elaborately decorated, especially on the inside, and dull sheets of lead now cover the exterior of the dome, replacing gilded tiles removed in 663. It is not only the scale of the building nor its incorporation of the grammar and syntax of the Roman architectural imagination that even now excite our admiration, but the quality of interior light – palpable, coloured, universal, a true illumination – that soon fills our vision and our mind. We are fortunate to be able to walk beneath the shadowy porch, pass between the huge, original bronze doors, and enter the heart of the Pantheon where space and light are one, forever mingled by the moving shaft of sunlight which enters through the oculus and makes the round of the building each day.

According to legend, when the barbarians sacked Rome in the fifth century, they entered the Pantheon ready to vandalise the building and steal its treasures. When they arrived inside, they were so overawed that they left the building whole. It is not difficult to understand why.

ABOVE 53. *The baths at Hadrian's Villa, Tivoli. 2nd century AD.*

OPPOSITE 54. *The Older Tormented Centaur. Dark marble statue from Hadrian's Villa Tivoli. 2nd century AD. Capitoline Museum, Rome.*

Mithraism and Christianity were practised in secret. For the devotees of Mithras secrecy contributed to the power of the mystery and to the sense of fraternity. For the Christians secrecy assured safety because the religion was considered anti-social and proscribed by the authorities until, with the triumph of Constantine, who embraced Christianity in AD 312, it could come out into the open, and with a vengeance. In the fourth century, and especially at the urging of Bishop Ambrose of Milan, Roman temples and shrines were closed, the practice of the traditional state cults was prohibited and the ancient pagan images were destroyed. Churches such as SS John and Paul and St Clement in Rome were built over Mithraic temples, others, such as St Mary, built over a temple of Minerva, publicly triumphed over the old gods, the old ways. Although Christians continued to be buried underground in catacombs all around the periphery of Rome well into the fifth century, martyrial churches began to be built above ground as public places of worship and to mark the presence of the faithful dead.

Medieval tradition had it that Rome would survive as long as the Colosseum did. This mighty edifice has remained as an image of ancient Rome for centuries, but not always passively, as it profoundly influenced the Renaissance architect Bramante in his reuse of the Classical orders of architecture. Neither did ancient Roman art stand still. On 14 January 1506 excavators accidentally uncovered the marble statue of Laocoon and his sons (pl. 55) in the soil of Rome. All the great artists, poets and antiquarian scholars of the time rushed to see it; excited by this chance survival of a work known to them from the account by Pliny the Elder (*Natural History*, XXXVI. 37). The statue represents the Trojan priest Laocoon and his sons being overcome by the serpents sent by Apollo; it was executed by the Rhodian sculptors Hagesandrus, Polydorus and Athenadorus early in the first century AD, possibly for the Emperor Tiberius. A work of great reputation in ancient Rome, the *Laocoon* came to life again in the Renaissance and fired the imagination of other men, especially that prince of artists, Michelangelo.

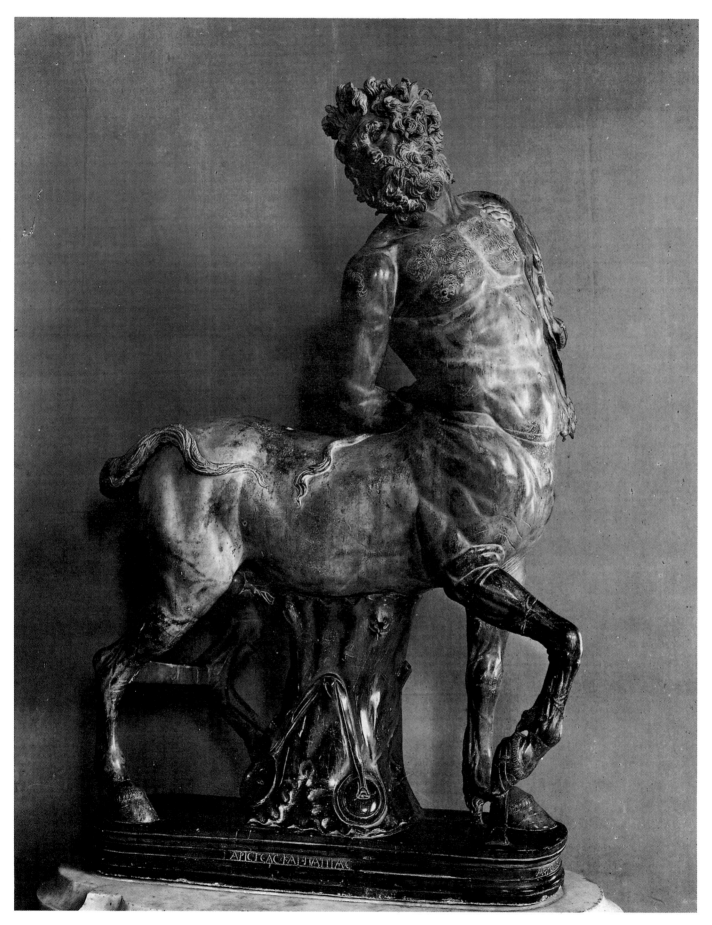

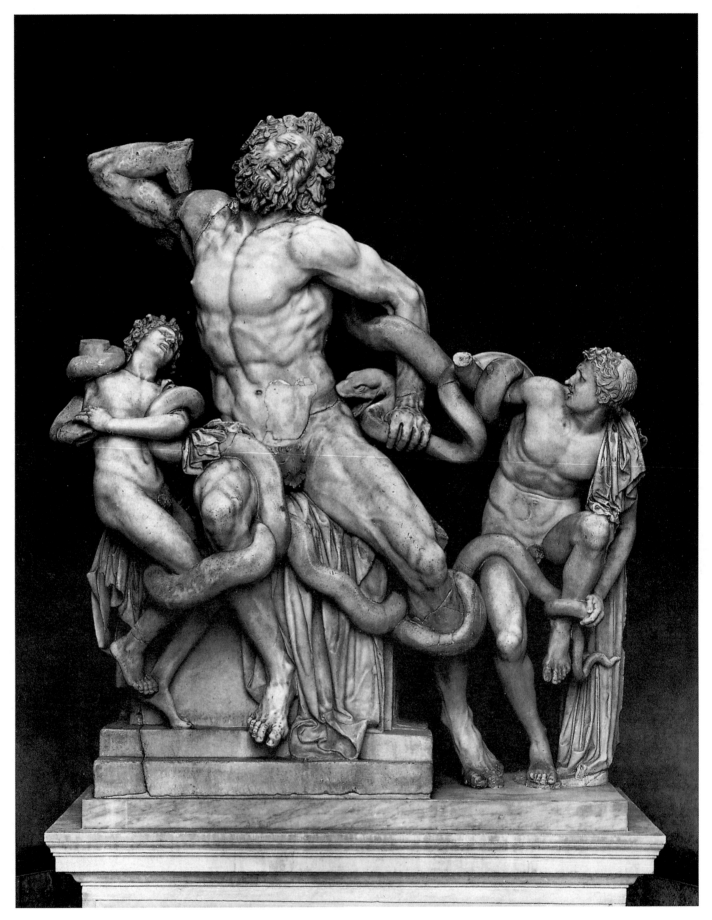

The position of the *Laocoon* in the history of art exemplifies a critical issue in the evaluation and characterisation of Roman art, especially in its admiring use of Greek models. Deference and dependence in the figural arts of painting and sculpture have been viewed negatively by those who measure creativity and artistic worth on the standard of originality, the modernist myth. Roman concrete architecture, specific portraiture and commemorative art have been evaluated positively as important Roman artistic achievements because they seem to be less dependent on Greek models and thus more 'original'. True or not, such a view fails to recognise the importance of tradition and continuity in the visual arts, and the fact that originality, even creativity, can be expressed *within* the boundaries of an accepted artistic tradition. Roman artists and architects worked within a continuous artistic tradition, to which they brought new insights and forms, responding to the novel opportunities of patronage presented by the vast resources and varied subcultures of the Empire. Roman art, therefore, continued the creative impulses of the Graeco-Roman artistic tradition while simultaneously preparing the way for the development of the first art of the European West, itself a precursor of the art of the Middle Ages.

And no one should forget that the very idea of civilisation, of living in towns designed to ameliorate the human condition, is perhaps Rome's greatest legacy to the West, lived out in Florence, Milan, Vienna, Paris and London – all Roman foundations.

OPPOSITE 55. HAGESANDRUS, POLYDORUS and ATHENODORUS: Laocoon and His Two Sons. *Early 1st century AD. Vatican Museums, Rome.*

BELOW 56. *The Baths of Caracalla, Rome, 3rd century AD. View of the frigidarium (cold room).*

57

3

THE EARLY MIDDLE AGES

PAUL CROSSLEY

INSET 57. *Engraving of Centula, abbey church of St Riquier, 790–9, rebuilt in 15th century. Bibliothèque Nationale, Paris. Pétau's engraving of 1612 is based on an 11th-century manuscript illustration.*

OPPOSITE 58. *The Incarnation Initial from the Book of Kells (fol.34). Early 9th century AD. Trinity College Library, Dublin. A masterpiece of Hiberno-Saxon. manuscript illumination. Note the miniature details of squirrels and otters at the base of the huge letter 'X'.*

In AD 312, on the eve of the decisive battle of the Milvian Bridge, the Emperor Constantine saw a vision of Christ's Cross, and welcomed it as an assurance of divine support and victory. Some time between 1145 and 1147 Abbot Suger of St-Denis (outside Paris) set up in his new abbey church – the first fully Gothic building – a colossal cross, standing 6 m high decorated with gems and enamel plaques. It was a commemoration of Constantine's visionary cross; in Suger's own words, 'a banner of the eternal victory of the Saviour'.

The Christian continuity that links these two events is obvious, but the 800 years that separates them saw a succession of upheavals that shattered the Classical world, and laid the foundations of European civilisation. The Roman Empire divided into eastern and western halves; Islam established an empire in the southern Mediterranean stretching from Persia and North Africa to Spain and the Pyrenees; and in northern Europe waves of barbarian invasions destroyed Roman institutions and led to the economic and political disintegration known as the 'Dark Ages'. From these upheavals and confusions a new, united and expansive northern world was created whose attitudes and institutions anticipate those of modern Europe. The centre of gravity of civilisation moved from the Mediterranean to north of the Alps. Two ideals – the concept of an enduring Roman Empire, and the Christian religion – outlived the disintegration of

the Classical world, and, personified by kings and popes, formed the twin powers of early medieval society. The year 1000, universally dreaded as the year of the Last Judgement, marked the beginning of a European recovery. In the eleventh century the barbarian invasions ceased; populations, towns and trade expanded; and a new sense of unity and common purpose animated almost every sphere of life. The First Crusade, called in 1095, assembled a truly European army in what amounted to the first major counterattack of the West against its enemies.

All these forces – the Christianisation of antiquity, the prestige of Rome, the upheavals of barbarian invasion, the growing power of an international and militant Church – shape the history of early medieval art, and underlie its powers of renewal and invention. In the treasury of the church of Ste-Foy at Conques, in central France, is a bejewelled reliquary whose construction constitutes an almost literal deposit of many of the cross-currents and contradictions of early medieval art (pl. 59). It contains the relics of Ste Foy, a virgin martyr of the late third century, who died in Agen in south-west France, and whose body was stolen, in the middle of the ninth century, by monks of Conques eager to boost their abbey as a pilgrimage centre. About a century later her body was placed in the present wooden effigy, which was covered with gold sheet and encrusted with gems and decoration. This little

59. Reliquary statue of Ste Foy at Conques, c.980 incorporating earlier and later treasures. Conques Abbey Treasury. The cult of this virgin martyr was the inspiration for the pilgrimages to Santiago de Compostela.

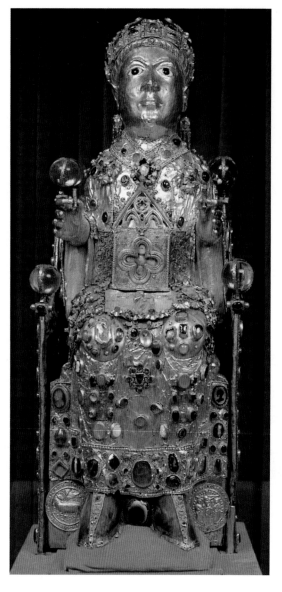

doll-like icon proceeded to become a potent force in the art and architecture of the eleventh and twelfth centuries. Her cult provided funds to build a setting for her in the form of one of the finest Romanesque churches in France (pls 81, 83). The statuesque and 'lifelike' form of her reliquary anticipated the revival, in the late eleventh century, of monumental stone sculpture, at Conques and in other French Romanesque churches. Her cult inspired the pilgrimage to the shrine of St James at Santiago de Compostela and the reconquest of Spain from the Moors. But her reliquary also opens vistas backwards, through the successive accretions of early medieval taste. Some time during the ninth century the Carolingian Emperor Charles the Bald, or his son Pepin II, gave to the shrine an imperial treasure: a purple cloth as a shroud for the saint's head and at least two gemstones, both now

attached to her throne. One, showing an engraved Crucifixion, is Carolingian, and typical of the ninth-century revival of the Classical technique of intaglio. The other intaglio is an original late Classical survival. But it is not the only reused Classical ingredient. The whole head of the reliquary is a Roman parade helmet of the fifth century, in which the enamelled eyes were set, and the crown added, probably around the year 980. Such revivals and reuses of antiquity testify to one of the persistent enthusiasms of early medieval society: to participate in the Christian Classical culture of the Mediterranean. But there is no question here of a Renaissance; the medieval attitude to antiquity was almost entirely pragmatic. In this little statue, and throughout early medieval sculpture, architecture, philosophy and literature, antique culture was treated as plunder to solve the needs of the present. Like their barbaric German ancestors, early medieval artists took the disembodied fragments of antiquity and reassembled them, with supreme confidence, in alien contexts. In reality, the appeal which such antique gemstones as Ste Foy's exercised on the early Middle Ages reveals not only a veneration for the Classical past, but also a precisely opposite tradition: the fascination for gold, precious stones and lavishly wrought jewellery that runs through the art of the Germanic tribes in the north and east of Europe during the Dark Ages. Although pagan and secular, the abstract and symbolic language of barbarian ornament, as well as its fabulous material value, was easily transferred to religious art as a metaphor of the divine. Saints' relics, as precious manifestations of divinity, deserved to be housed in the greatest material splendour. The gleaming, gold-encrusted reliquary of Ste Foy, surrounded by monks and pilgrims, encompassed, on feast days, with the cacophony of horns and bells, gripped and kissed by beggars and farmers, bishops and kings, made the saint it contained a living and tangible reality: she was a feudal patroness in the midst of her *familia*. To focus the supernatural on *things*, on a single holy object, came close to idolatry. Bernard of Angers, who came to Conques in the early eleventh century, was scandalised by such an idol. He felt the thin dividing-line between Christian ritual and the underworld of pagan custom. Ste Foy's hypnotic stare and stiff hieratic pose are distant echoes of such late antique images of authority as the colossal enthroned statue of Constantine in his basilica in the Roman Forum, and her jewelled vestments recall the trappings of barbarian heroes. Early medieval art flourished in the service of the

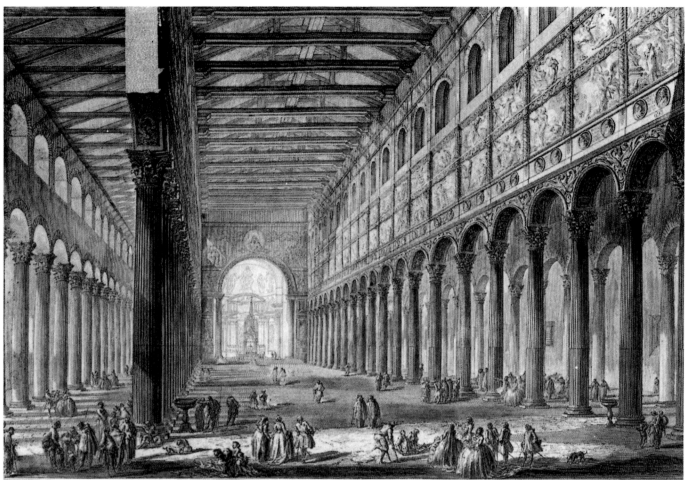

church, but it also catered for secular patrons and interests, and its sacred iconography was frequently disrupted by the openly materialistic.

CHRISTIANITY CIVILISED, ANTIQUITY CHRISTIANISED: EARLY CHRISTIAN AND BYZANTINE ART

The Emperor Constantine's adoption of Christianity in 312, and his recognition of the Christian faith as the official religion of the Empire, transformed, almost overnight, a private community cult into a public, state-controlled religion. The new church required a new architecture, consciously rejecting the model of the pagan temple, but public, spacious and compatible with the dignity of its imperial patron. For regular assemblies of the faithful and celebrations of the Eucharist, the Roman basilica – used previously as a drill hall or court of justice – proved especially successful, aesthetically and liturgically. The rather monotonous Roman prototype, with flat roofs, corridor-like aisles and endless rows of columns, was given a new dignity in the colossal size of the earliest Christian basilicas. The late-fourth-century Old St Paul's (pl. 60) and Constantine's foundation of Old St Peter's (pl. 61),

both in Rome, remained among the largest churches in Christendom until the early twelfth century. Their plans were perfectly adapted to the liturgy of an official and hierarchic Christianity: the large atrium or forecourt and the outer aisles of the nave for the catechumens (postulants not yet baptised); the long nave whose multiple aisles seem to shape and segregate the processions of the baptised faithful bringing their offerings to the sanctuary; and, separated by a transept or a huge arch, the distant and screened-off choir, reserved for the clergy and the celebration of the

ABOVE 60. *The late-4th-century basilica of St Paul's-Outside-the-Walls, Rome, from an 18th-century engraving by Piranesi.*

BELOW 61. *Ground plan of Old St Peter's, Rome. Begun by Constantine possibly in 333.*

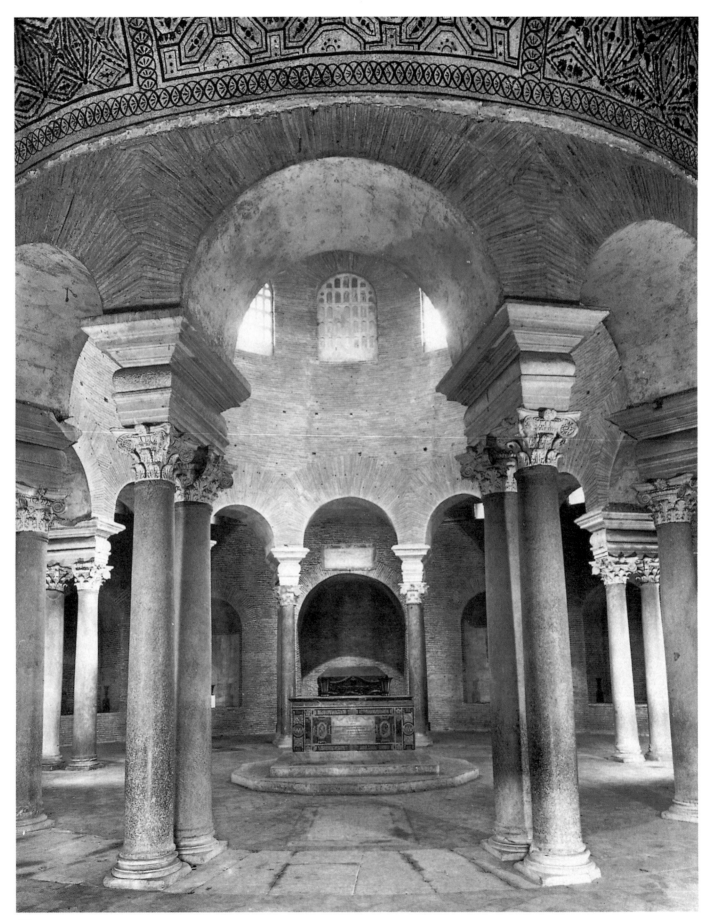

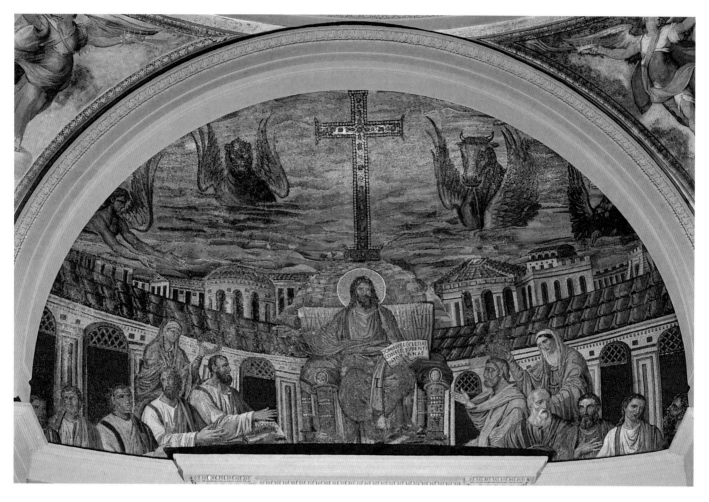

ABOVE 63. *Apse mosaic of S. Pudenziana, Rome, showing Christ in Majesty. Early 5th century.*

Mass. For non-congregational buildings – baptistries, shrines, commemorative structures – the Roman centralised mausoleum offered an equally convenient precedent. The most celebrated of early Christian centralised churches was the Holy Sepulchre church in Jerusalem, a huge rotunda built in the middle of the fourth century over the traditional site of Christ's Resurrection. It is now destroyed, but its general shape is commemorated in early Christian ivories (pl. 65), and is reflected in hundreds of small churches in the eastern and western halves of the Empire, such as the church of S. Costanza in Rome (pl. 62), built about 350 as a mausoleum for Constantine's daughter.

The speedy adaptation of Roman architectural precedent to Christian use should not blind us to the tensions and ambiguities between Christianity and late antiquity in early Christian art. This is especially evident in the figural arts. When Christianity ceased to be an underground religion, it required a new visual language, more lavish and more didactic than the art of the catacombs. The exteriors of early Christian churches are usually simple; all richness was concentrated inside. Hung with silk-embroidered tapestries, lighted by golden chandeliers, divided by silver and gold screens, the walls of early Christian churches shimmered with marbles and mosaics. Theodore of Nyssa, writing in the second half of the fourth century, defended such extravagance on the grounds that beauty was a stimulus to religious devotion. But what is overtly Christian about the mythological figures, the vines and the cupids harvesting grapes, in the mosaics of the ambulatory of S. Constanza, or the porphyry sarcophagus beneath the dome, with its Dionysian masks? Such decor was an inseparable part of the conspicuous consumption of late antique life – the late Roman *dolce vita*. With some justification, Renaissance archaeologists misidentified S. Costanza as a temple of Bacchus. The subject matter of Christian art expanded considerably in the fourth century – to biblical scenes, lives of the saints, images of the Virgin Mary, Christ in Majesty (pl. 63) and a new vocabulary of symbols as tokens of the faith. But these images naturally coalesced with the visual habits and interests of late antique civilisation; indeed, Christianity now saw itself as the guardian of

OPPOSITE 62. *Interior of S. Costanza, Rome, c.350.*

Classical values. The humble Good Shepherd of the catacombs reappears on numerous early Christian sarcophagi as a beardless Roman hero, seated among his well-groomed apostles like a Classical schoolmaster. Even art production in late antiquity responded to the dual pressures of a pagan and Christian market. On the eve of the Sack of Rome by invading barbarians in 410, the same ivory workshop could carve an exquisitely neoclassical diptych of a pagan priestess sacrificing at an altar, and an equally exquisite relief of Christ's Ascension, where the three Marys appear as Roman matrons, and the Holy Sepulchre church as a Roman turret tomb (pl. 65).

Constantine's conversion gave his imperial authority a divine sanction. For the first time the Roman emperors derived their authority not from within their own divinity but from God. On his coins, and in his gigantic enthroned effigy in his basilica in the Roman Forum, Constantine, as God's Vicar on Earth, was shown with his eyes turned upwards, 'yearning', as his biographer Eusebius put it, 'towards God in prayer'. Much of early Christian and Byzantine art is informed by this theocratic conception of authority. Eusebius called the longitudinal axis of the Christian basilica 'the royal path'; and the apse of the basilica, decorated with the awesome figure of Christ in Majesty surrounded by the symbols of the four evangelists, consciously recalls the emperor as the Sun of Justice, enthroned in person or in effigy, in the apses of imperial audience halls. The imperial cult is also celebrated in the small-scale luxury arts. The exquisite silver plate made for the Emperor Theodosius I in Constantinople in 388 (pl. 64) is like a diagram of the late antique state. It represents the emperor enthroned behind a palace façade reminiscent of the imperial throne room of Diocletian's palace at Split. Sustaining the composition (much as the wealth of an urbanised Mediterranean underpinned the Empire) is the submissive and recumbent figure of Abundance. Framing the whole scene (securing, so to speak, its frontiers) are soldiers of the imperial army. An official (a reference perhaps to the ubiquitous imperial bureaucracy?) hands the emperor a document. But Theodosius himself seems to inhabit a different order of reality from that of those around him. His eyes, like Constantine's, are fixed heavenwards. Haloed like a God, he towers over his son Arcadius and the Emperor Valentinian II, who flank him. The almost liturgical formality of the scene, the flat floating figures and the strange dislocations of scale look forward to the hieratic and idealised images of Byzantine art.

Theodosius was the last emperor to rule over the western and eastern halves of the Empire. In 330 Constantine had given the Empire a new capital by enlarging the small town of Byzantium, on the banks of the Bosphorus, into the city of Constantinople (now Istanbul). The Roman Empire vanished from western Europe in 476, but Constantinople and its Eastern Empire remained, with a distinctive Byzantine culture of its own, until overrun by the Turks in 1453.

The emperor responsible for the creation of the first mature Byzantine art was Justinian I (527–65). Byzantines saw their history as Roman and called themselves *Romaioi* (Romans); but from the beginning Byzantine art differed in a number of ways from 'Early Christian'. In the first place, Justinian's colossal programme of art and architecture was more centralised and more extensive than any previous imperial patronage. Having recovered most of the western provinces from the barbarians, he hoped, by reconstructing and embellishing hundreds of buildings, from Spain and the Balkans to Palestine and North Africa, to bring home to every citizen of the Empire his presence and his rule. Secondly, in his two court churches at Constantinople, Hagioi (SS.) Sergios and Bakchos (c. 520) and Hagia Sophia (532–7), he created a new kind of congregational church architecture. Constructed of

64. Silver dish issued to commemorate the tenth anniversary of the accession of Theodosius 1 in 388. Probably made in Constantinople. Academia de la Historia, Madrid. The main figures are Theodosius, his son Arcadius and Valentinian II, the emperor of the Western Empire.

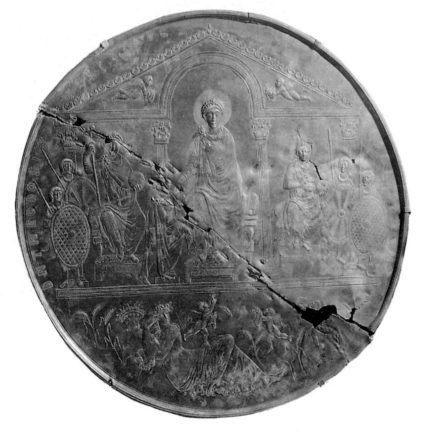

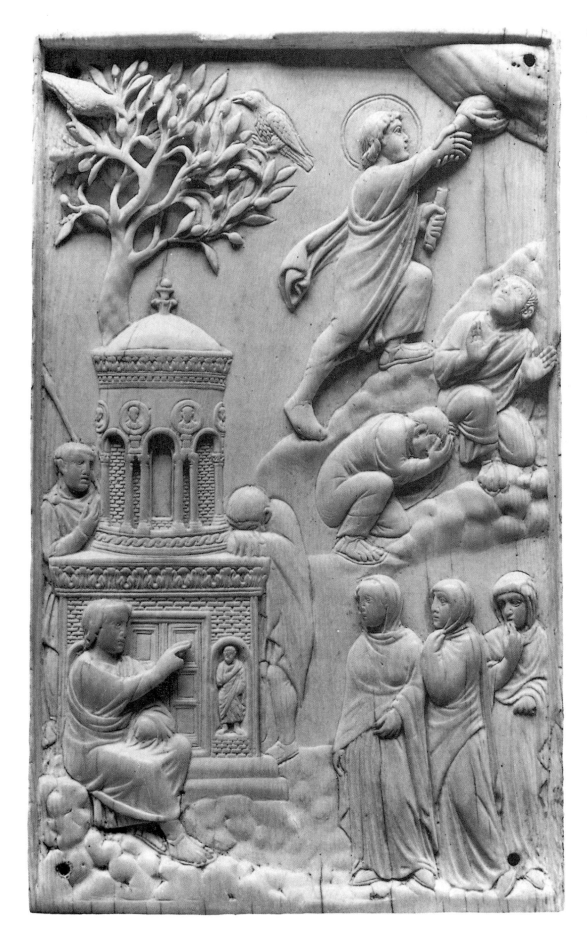

65. *Ivory relief of the three Marys at the Sepulchre, and the Ascension. Late 4th or early 5th century, Rome. Bayerisches Nationalmuseum, Munich.*

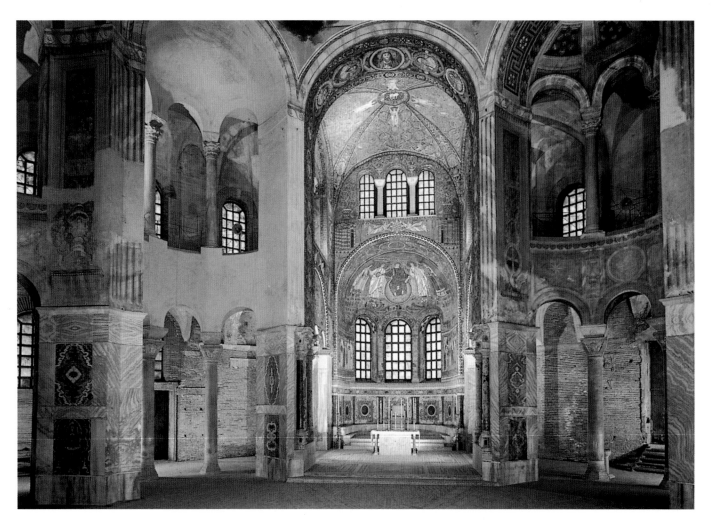

66. *Interior of S. Vitale, Ravenna, c.530–48. View towards the sanctuary.*

light thin bricks, these churches replaced the longitudinal Early Christian basilica with a vaulted centralised structure in which all the interior spaces are composed around a dominant central dome. And, finally, Justinian's artists evolved a theocratic and religious art designed to enhance the sanctity of the church and the majesty of the emperor. It was in Byzantium in the fifth and sixth centuries that the idea of the Christian state was first systematically worked out. Writing in about the year 500, an anonymous Syrian theologian known to the Middle Ages as Dionysius the Areopagite conceived of Heaven as a hierarchy of God and his angels, and saw the clergy, patriarchs and emperor as its earthly reflection. Theologians and mystics gained a greater prominence in Byzantine society, and exercised a greater influence over its beliefs, than in the Western Empire. These mystical, ultimately oriental, ideologies had a profound effect on the formulation of Byzantine art. Byzantium inherited and preserved the naturalism of Graeco-Roman art, but in the depiction of God, the saints and the emperor it felt bound to transform mere human

likeness into the superhuman. Forms were stylised into symbols. Sculpture in the round was replaced by carving in low relief, and the mosaic became the reflection of a transcendental splendour.

Only one building outside Constantinople conveys the quality and subtlety of Justinian's court art: S. Vitale in Ravenna (pl. 66). Constructed largely between 538 and 545, it might be justly called the western sister of Justinian's contemporary court churches in Constantinople. Like Hagia Sophia and Hagioi Sergios and Bakchos, it is a tall domed space opening into the surrounding zones of ambulatory and galleries; like them it conceals and denies all solid masonry behind open screens of columns, floating domes, and thin walls flattened into veneers of marble and mosaic. And, like them, the side spaces present an unresolved and fragmentary series of vistas: the design unfolds only from the centre of the structure. The interior decoration is also comprehensible only from the central space. S. Vitale possesses the most complete and arguably the most beautiful set of mosaics surviving from Justinian's reign. The choir apse with its apoca-

lyptic Christ dressed in the purple of an emperor, the choir walls embellished with Old Testament prefigurations of the Eucharist, the choir vault transformed into a starry dome of heaven: the whole ensemble, shimmering with diffuse light from alabaster windows, and once illuminated by silver and gold lamps, suggests a sacred brilliance emanating not from any 'real' external light, but from within the figures and scenes themselves. Procopius, Justinian's court historian, described the interior of Hagia Sophia in similar terms: 'You might say that the church is not illuminated by the sun from outside, but by the radiance generated within.'

The importance of the central space at S. Vitale may reflect fundamental changes in Byzantine imperial liturgy. In Early Christian basilicas the lay congregation was allowed into the central aisle of the nave. But at S. Vitale and at Justinian's court churches at Constantinople the congregation was relegated to the side aisles and the galleries, while the choir and central domed area became the exclusive stage for the liturgy of the clergy and – in line with his sacred office – for the processions of the emperor and his court. Justinian never visited Ravenna, but his presence is permanently confirmed in two mosaics in the apse of S. Vitale which may possibly commemorate this theocratic liturgy (pls 68, 69). Haloed in purple, his enlarged eyes transfixing the spectator with the hypnotic intensity of late antique portraiture, Justinian and his court seem to inhabit no earthly setting. His floating and elongated body emerges from its gold background like the manifestation of a divinity. Here, in this fragile western outpost of the Eastern Empire, was a model of imperial iconography and architectural splendour that dazzled western Europe for half a millennium.

BARBARIANS AND CHRISTIANS

The most marked feature of the early Middle Ages in the West was the geographical split between the southern Mediterranean – with its centres in Rome and Constantinople – and the underdeveloped countries of the North. From the fifth century to the ninth, waves of barbarian invasion transformed Roman civilisation in northwestern Europe into a warrior society. The only institution to survive this collapse relatively intact was the church. Under Pope Gregory the Great (589–603) – 'the last pope of Christian antiquity, the first pope of the Middle Ages' – much of the maintenance of imperial power in the West came to depend on the papacy. With his encouragement, Benedictine monasteries (com-

munities of monks living according to the rule of St Benedict of Nursia, c. 480–c. 550) proliferated north of the Alps as missionary outposts, self-sufficient economic units and oases of intellectual life. In the Dark Ages the Roman church and the monastic scriptoria copied the works of Classical authors and, in a weak and debased style, maintained the traditions of Classical figural art. North of the Alps, however, these traditions were confronted by a barbarian art diametrically opposed to Classical values, an art of precious small-scale portable objects decorated with abstract ornament of fantastic complexity. The gold, garnet and mosaic-glass purse lid and shoulder clasps recovered from the pagan Anglo-Saxon burial ship at Sutton Hoo, dating to around 625, display the full range of this barbaric style: Celtic spirals, coloured step patterns, and Germanic animals interlace (pl. 67). The magical abstractions of this 'decorative' art, reaching back into a pagan and preliterate world, seem at first quite irreconcilable with the demands of Christian teaching and the character of Classical naturalism; but the confrontation and interaction of these two traditions is one of the fundamental themes of early medieval art.

The first dramatic interaction took place in one of the remotest parts of the Christian world: the north of the British Isles in the seventh and eighth centuries. Gregory the Great had already prepared the way with his direct mission from Rome to southern England in 597. A century later Benet Biscop constructed his Northumbrian monastery churches of Jarrow and Monkwearmouth *iuxta Romanorum morem* ('in the Roman manner'), and brought panel paintings and figu-

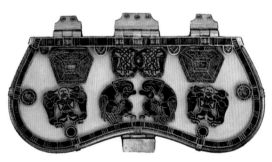

67. Purse lid and shoulder clasps from the Sutton Hoo Ship Burial, c.625. Gold, garnet, mosaic glass. British Museum, London.

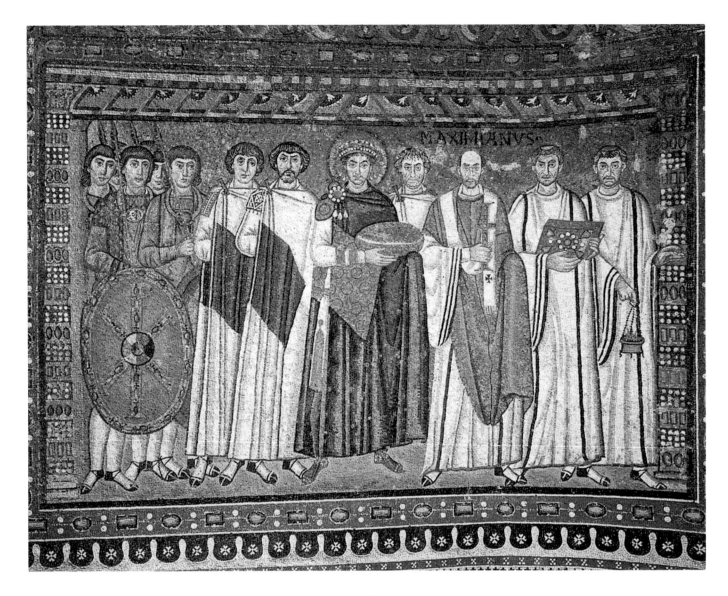

SANCTUARY MOSAICS, S. VITALE, RAVENNA

Sixth-century Ravenna was a western outpost of the Byzantine Empire, recently recaptured from the barbarians. The mosaics (c.AD 547) show the only surviving portraits of Emperor Justinian I and the Empress Theodora. The imperial couple never visited Ravenna, but their images signified their presence and authority by proxy. Both scenes depict a particular ceremony of Early Byzantine liturgy, the so-called First Entrance. Bishop, clergy, large numbers of the lay faithful, and at times the imperial household in full regalia, would assemble in the western porch of the church. The emperor was acclaimed and antiphons sung. Then the faithful would enter the church through side entrances, while the clergy and emperor entered through the main ('royal') door and processed up the central aisle and into the sanctuary. The first mosaic (*above*) shows the bishop of Ravenna, Maximian, leading the procession. He is wearing an episcopal stole and holding a jewelled cross. Two deacons accompany him, one carrying an incense burner, the other a bejewelled Gospel book, which, as a symbol of Christ and the Word of God, will be placed on the altar. Following the bishop, or walking side by side with him (the precedence is, perhaps deliberately,

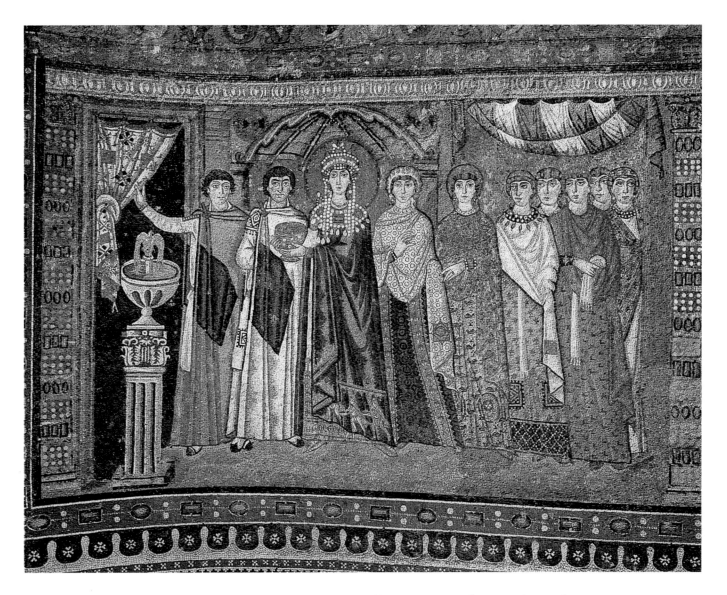

unclear), is Justinian, identified as emperor by his crown, his halo, and his purple chlamys. He holds a golden bowl, a gift he will lay on the high altar. Three court officials stand behind him, sometimes identified as the banker Argentarius on his left (who financed the building of S. Vitale), and the general Belisarius on his right (who recaptured most of the western provinces from the barbarians). Behind them stand a military guard. The opposite panel (*above*) shows the Empress Theodora, a former circus girl of remarkable beauty and courage, distinguished by her diadem, jewelled pendants and necklace. Procopius described her as 'fair of face, and charming as well, but the ex-pression of her eyes was always grim and tense.' She and her retinue enter one of the doors from the churchyard. The chalice she carries, as well as the Three Magi embroidered on her chlamys, suggest an act of offering. The stiff elongation of the sumptuously dressed figures, their proud impassive faces and resplendent setting, convey in abbreviated form the awesome ceremonial of Byzantine court ritual (Theodora travelled with four thousand attendants!). The mosaics also underline the power structure of the Byzantine state: a co-operation – almost amalgamation – between God's two earthly representatives: church and state, patriarch and emperor.

69

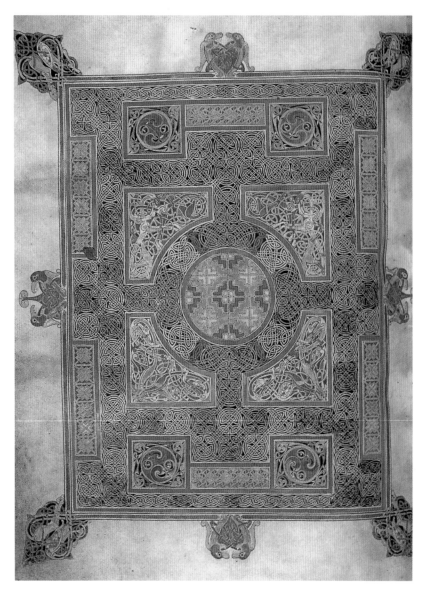

ABOVE 70. *Lindisfarne Gospels. Immediately before 698. Cross-carpet page introducing the Gospel according to St Mark (fol.95). British Library, London.*

OPPOSITE ABOVE 72. *Ivory book cover of the Lorsch Gospels. Early 9th century. Biblioteca Apostolica Vaticana, Rome. Christ treading the beasts. Below: the Magi before Herod and the Adoration of the Magi.*

'carpet pages' placed before each gospel Eadfrith takes the whole repertoire of barbarian ornament, some of it closely resembling the Sutton Hoo treasures, and pours it over the page. There may be some magical meaning in this interlace, its writhing mass suggesting the dark forces of the 'haunted tanglewood', or, in the words of the Anglo-Saxon poem *Beowulf*, 'serpents in the water, strange sea dragons swimming in the lake'. Certainly the discipline required to paint such microscopic patterns was seen by monk illuminators as another way of serving and praising God. In this case the artist also honours St Cuthbert, his predecessor as bishop of Lindisfarne, for an inscription in the manuscript tells us that 'Eadfrith originally wrote this book for God and St Cuthbert'.

The Book of Kells, made perhaps in Iona shortly before the island was sacked by the Vikings in 807, stands with the Lindisfarne Gospels as the masterpiece of Hiberno-Saxon book painting. Its painted miniatures, more numerous and more densely decorated than in any other medieval manuscript, sparkle and glitter like precious metalwork. Their decorative inventiveness is inexhaustible. The opening page to St Matthew's account of the Nativity (pl. 58) is devoted to a huge monogram of Christ, the large 'X' (the first letter of Christ's name in Greek) embracing a mass of scrolls, interlace and knots, inhabited by angels, rabbits, otters, salmon and cats. The humblest of God's creatures cluster around the sacred name of Christ, and are assumed into the dazzling other-worldly intricacies of its design. By His Nativity 'the Word is made Flesh', and the world made holy.

Obviously such books were no ordinary instruments of communication. Like a reliquary or a precious altar vessel, large illuminated gospel books were carried in procession, placed on an altar or read from a lectern. Here, too, the contrast with Classical culture could not be more pointed. To the Classical world the written word was a rational means of communication, the book an everyday object. In the Latin West of the early Middle Ages, where the written word had ceased to be taken for granted, the gospel – the Word of God and the Book of Books – acquired a magical significance. St John's Gospel opens with the proclamation, 'In the beginning was the Word, and the Word was with God, and the Word was God.' Books such as the Lindisfarne Gospels and the Book of Kells took on the sacred qualities of the texts they enshrined. As holy things they were worthy of the most lavish embellishment. Christianity became the religion of the Book.

ral textiles direct from Rome. But in this northern setting his artists must have encountered a very different, but highly accomplished, artistic tradition, flourishing in the Irish monasteries off the west of Scotland and the Northumbrian coast. The manuscripts of these rugged and remote settlements rejected the inspiration of late antique painting and instead made use of a wealth of decorative 'barbarian' patterns drawn from a long prehistoric tradition of Hiberno-Saxon art. The inevitable fusion of 'Classical' and 'barbarian' is magnificently accomplished in the Lindisfarne Gospels (produced shortly before 698), the masterpiece of Northumbrian book painting (pl. 70). The illuminator, Eadfrith, bishop of Lindisfarne from 698, certainly knew the late antique Italian manuscripts imported by Benet Biscop, and copied his schematic portraits of the four evangelists from one of them. But in the so-called

ART AND THEOCRACY: THE REVIVAL OF THE EMPIRE IN THE FRANKISH AND GERMAN KINGDOMS

The confrontation between Classical and barbarian in the so-called Insular art of northern Britain anticipates the first major *rapprochement* with Classical culture in northern Europe, under Charles the Great or 'Charlemagne' (768–814), king of the Franks and – from Christmas Day 800 – 'emperor of the Romans'. The most powerful of the barbarian tribes in Europe in the eighth century, the Franks had stemmed the Moorish advance in southern France and extended Christianity deep into Germany. As God's anointed viceroy and the guardians of Christendom, Charlemagne and his court – a small and largely clerical circle of poets, historians, theologians and philosophers – began a reform of literacy and learning, of script and language, that amounted to a revival of late antique culture. Fundamental to the success of this 'Carolingian Renaissance' was the regeneration of architecture and the revival of a 'naturalistic' art. The monasteries which formed the centre of educational reform needed large stone buildings; and, to standardise the liturgy and to create and multiply authentic scriptural texts, a new range of narrative and pictorial imagery was required. Charlemagne's art advanced under the motto of his seal: *renovatio Romani imperii*, 'the revival of imperial Rome', but a Rome in the widest sense – pagan, Constanti-

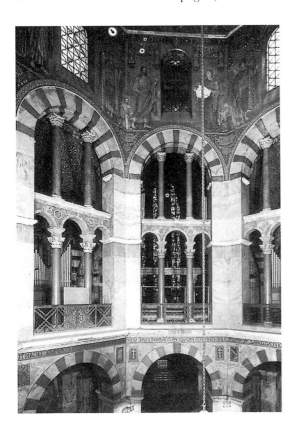

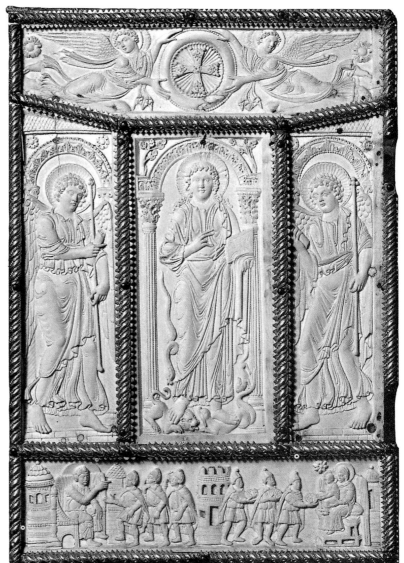

nian, Christian and Byzantine. The great T-shaped transept and even the actual dimensions, of the colossal Benedictine abbey of Fulda in Saxony, begun in 791, were copied, *Romano more* ('in the Roman manner'), from Old St Peter's in Rome (pl. 73). Charlemagne's new palace in his capital at Aachen was called the Lateran, in honour of Constantine's palace in Rome. Its audience hall was modelled on Constantine's at Trier; its chapel (pl. 71), dedicated in 805, with many of its columns and marbles pillaged from Classical ruins in Ravenna and Rome, is a heavy-handed copy of Justinian's S. Vitale. Charlemagne's throne is placed on the first floor of the chapel, framed, as in a Roman imperial audience hall, by the triple arches of the gallery openings. Opposite stood the main altar of Christ the Saviour, and above, in the dome, was a mosaic of the Christ of the Apocalypse surrounded by the

LEFT 71. *Interior of the Palatine chapel, Aachen. Begun in the 790s.*

BELOW 73. *Ground plan of Fulda abbey church, Saxony, 791–819.*

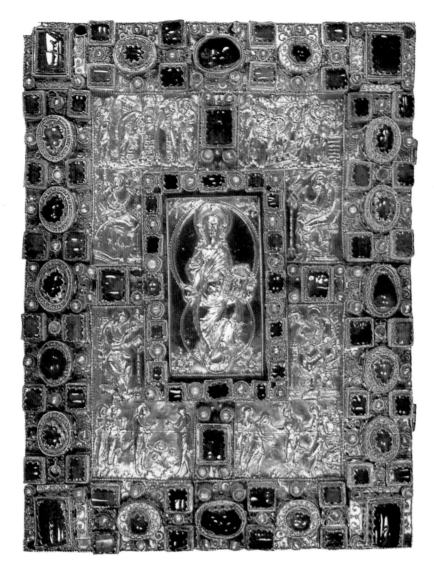

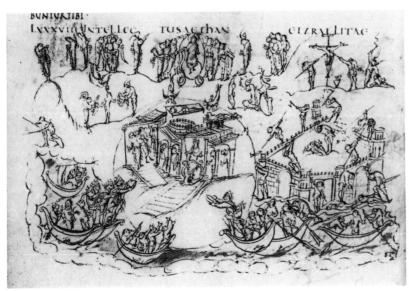

heavenly court of the twenty-four elders. The Constantinian and Byzantine analogy between Christ and emperor here merges with the medieval ideal of sacred kingship.

The use of architecture to endow figures with an imperial and Classical dignity is just as evident in Carolingian court ivories and manuscripts. The ivory cover of the Lorsch Gospels (pl. 72) has a format reminiscent of late antique ivory diptychs, and is similar in style to a number of ivories presented by Justinian to Ravenna. Christ, the youthful emperor, and his angels in the guise of court attendants, stand beneath the triple arches and Classical pillars of imperial reception halls. The same lavish treatment of drapery and surface ornament characterises the full-page painted miniatures of the four evangelists in the Harley Gospels (pl. 76). The elaborate Classical architecture, the sumptuous colours, the overloaded detail and the restrained formality of each figure recall the *gravitas* of an imperial ceremony, and suggest the direct inspiration of late antique art in northern Italy.

Such enthusiastic celebrations of antiquity belong, however, to only one current among the varied and divergent energies of Carolingian culture. Charlemagne's art was bound to be eclectic. In the Byzantine Empire antiquity had never died; in eighth-century northern Europe it had painfully to be reborn and reconstructed, from the fragments of opposing traditions, a process which stimulated compromise, synthesis, experiment and originality. Three examples are instructive. In the Harley Gospels, side by side with the grand Classical depictions of the evangelists, are frontispiece pages decorated with abstract interlace and animal ornament that owe everything to the tradition of the Lindisfarne Gospels. Alcuin of York, Charlemagne's minister of culture, had brought Insular manuscripts to Aachen; and via the Carolingians that style was to remain a conditioning factor in manuscript painting on the continent for many generations. The monastic church of St-Riquier in Centula, in northern France (pl. 57), consecrated in 799 and known to us through seventeenth-century engravings, revitalised the monotonous silhouettes of the early Christian basilica by placing, over its east and west ends, staged towers reminiscent of centralised churches in Asia Minor, or Roman turret tombs. This double-ended structure, with its prominent western block-like façade, formed a blueprint for the westworks and towers of the Romanesque. The famous Utrecht Psalter (pl. 75), made at Reims in about 820 under the guidance of Ebo, archbishop of Reims and formerly

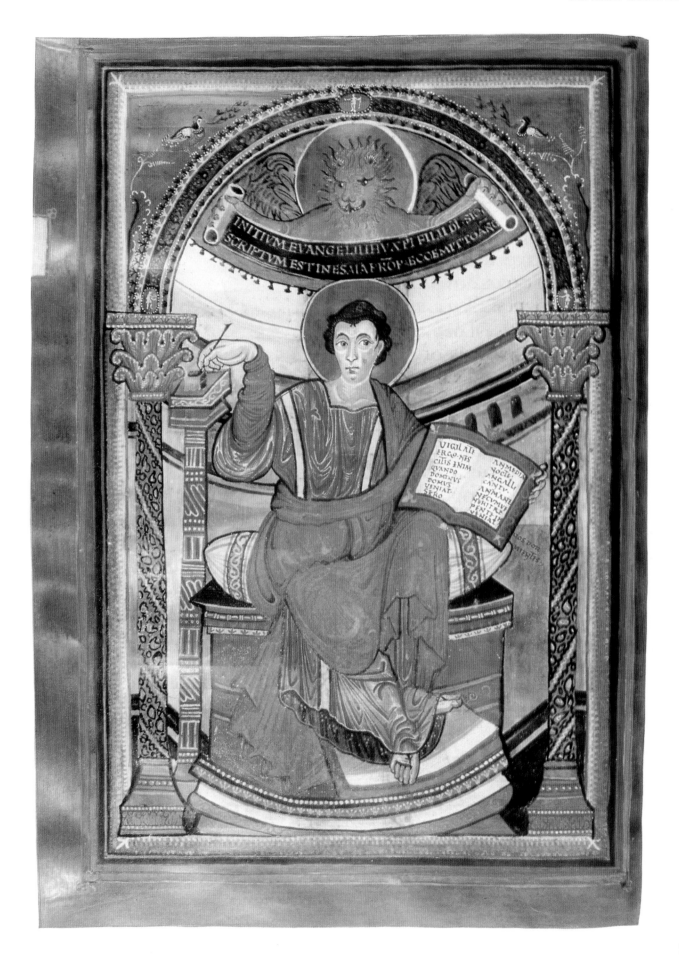

Charlemagne's librarian, shows the toy buildings, feathery trees, undulating hillocks and gesticulating figures typical of the illusionistic style of late antiquity, and, in particular, of Byzantine painting in northern Italy. But the naturalistic traditions of late Roman painting are here, perhaps for the first time, distorted and transformed by a peculiar kind of visual energy which was to inform much of Romanesque art in the West, and which can best be described as 'expressive', 'ecstatic' and 'spiritual'.

If divinity could be expressed through the distortions of the Classical figure, it could be made even more explicit in the material preciousness of works of art. In the year 870 the Emperor Charles the Bald, grandson of Charlemagne, gave a sumptuous Gospel Book, the Codex Aureus, to the monastery of St-Denis outside Paris (pl. 74). The cover depicts figures in gold relief with the

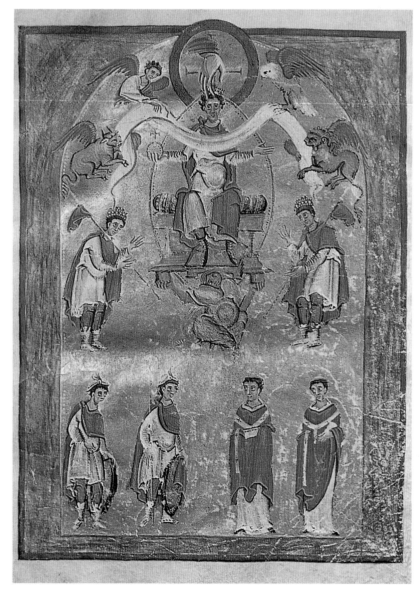

same slender and vivacious bodies as we find in the Utrecht Psalter, but they are now almost smothered in a panoply of gold and precious gems. Such splendours reflect, of course, the book's status as a precious liturgical object; but in this case they may have a more precise symbolism. In 855 Charles the Bald had commissioned John Scotus to translate into Latin Dionysius the Areopagite's treatise on the celestial hierarchies. At the core of the treatise, described by one authority as 'the most imposing mystical construct in the history of Christian thought', is the idea that God is light, and that the whole universe is created and animated by bursts of divine illumination. Every creation, according to its rank in the scale of things, receives and reflects back that original luminosity. The Codex Aureus, displayed on the high altar of the abbey church alongside the equally precious golden retable (also given by Charles), must have conveyed to Charles the Bald and the monks of St-Denis Dionysius' *lux divina* with particular splendour.

Charles the Bald died in 877. By the end of the century the Carolingian Empire had virtually disintegrated, and political and cultural power shifted eastwards to Germany. In 955 Otto I, prince of Saxony, who gave his name to the Ottonian dynasty, defeated the Hungarian invaders at Lechfeld, and, as the new saviour of Christendom, was crowned emperor in Rome in 962. It was natural for the Ottonians to base their art and architecture on Carolingian models, but Germanic artistic patronage was less centralised and less programmatic than Charlemagne's. The cohesion of the new empire depended more than ever on alliances between the state and the powerful landowning bishops and abbots, appointed by the emperor as feudal lords in return for homage and fealty. Artistic patronage naturally diversified among the monastic scriptoria and cathedral schools of these princes of the church. Such limitations did not, however, dampen Ottonian ambitions. The marriage of Otto II to a Byzantine princess extended the dynasty's dreams of dominion over both the western and eastern halves of the Empire, and brought a Greek refinement to an uncouth Saxon court. Otto III, in conscious emulation of Constantine, set up his capital in Rome, and with his friend and tutor Pope Sylvester II (named after Constantine's pope) dreamed of a universal empire restored through the partnership of church and state. Ottonian art stresses the theocratic conception of kingship with an intensity and frequency unprecedented in the West. The Liuthar Gospels (pl. 77), written for Otto III in about 990, prob-

ably in Trier, show the young emperor crowned by the hand of God, and with attributes normally reserved for Christ: his throne framed in an oval mandorla, his arms opening crosswise, his person surrounded by the symbols of the four evangelists. He is supported by a personification of the Earth: two crown princes bow in homage, and below them appear representatives of the lay aristocracy and the all-important ecclesiastical dignitaries of the German state. The stern monumentality of this and other products of Ottonian painting may owe something to the court style of Charlemagne; but the Carolingian love of detail has been suppressed, and, perhaps for the first time in Western book painting, the traditional coloured backgrounds, suggesting depth and recession, are replaced – probably under Byzantine influence – by a flat shining foil of gold leaf, in front of which the isolated figures hover in unearthly space. The exaggerated hands and gestures, the intense glowing eyes and the overall vibrancy of light and texture give to this monumental scene a transcendental intensity quite foreign to Classical and even Carolingian art. In fact, this new style prefigures many of the qualities of Romanesque painting in Europe in the eleventh and twelfth centuries: strong colours, thick contours, flat backgrounds and stylised gestures.

To genuflect before the glories of ancient Rome, only to celebrate its defeat by Christianity, is the explicit theme of a huge column, 4 m high, cast in bronze at Hildesheim in Saxony in about 1020 for Bernward, its bishop (pl. 78). Bernward had been a tutor to the young Otto III, and had made several journeys to Rome, where he must have seen the great Classical columns, including Trajan's (pl. 42), celebrating the triumphs of Roman emperors in spiral reliefs. Bernward's theme at Hildesheim (and the subject was his own choice, for he was a practising artist) is Christ's triumph on Earth, winding its way up the column from his baptism to his entry into Jerusalem. Originally standing in the centre of Bernward's church of St Michael at Hildesheim, and crowned by a monumental cross, the column must have shone out in the dark church like a victory monument.

Manuscripts, wall paintings and furnishings might reflect the triumphs of an imperial Christianity, but only architecture could re-create the physical grandeur and *gravitas* of ancient Rome. Begun around 1030 and completed in 1106, the cathedral of Speyer (pl. 79) was built as the pantheon of the German emperors, and a statement of their universal ambitions. Its clusters of towers at the west and east ends recall St-Riquier; its colossal Roman-style vaults and richly Classical capitals, inserted at the height of the quarrel between emperor and pope over the spiritual and temporal leadership of Christendom, reassert the ancient, Roman authority of the German kings. But in at least two respects Speyer marks a turning point in European architecture. It is a colossal building, exceeding the dimensions of all earlier northern churches, and comparable only to the largest early Christian basilicas. And it is the first major church to break up the unarticulated interior walls of the early Christian and Carolingian basilica into vertical bays. The tall piers of the nave, which rise up over the win-

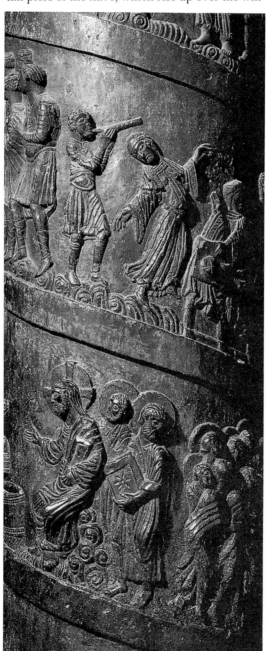

PAGE 73. 76. *The Harley Gospels. Opening page to St Mark's Gospel: the 'Evangelist Page' (fol.71) depicting St Mark in a niche. Court School, Aachen, c.790–800. British Library, London.*

OPPOSITE 77. *The Liuthar Gospels. Otto III receiving the homage of kings and princes. Made c. 990, possibly in Trier. Cathedral Treasury, Aachen.*

LEFT 78. *Bronze column with scnes from the life of Christ. Made in Hildesheim, c. 1020. Hildesheim Cathedral.*

dows, are no doubt quotations from the exterior pilasters of Constantine's fourth-century audience hall at Trier; but they are now conceived as part of a system of shafts (attached to them) and vaults, a system which articulates the wall into a scaffolding of vertical panels and divides the interior into cubic blocks of space. Here, in the accents of imperial Rome, is the rhythmic and spatial language of Romanesque, and even Gothic, architecture.

ROMANESQUE IN WESTERN EUROPE: THE CHURCH MILITANT

Speyer was one of the last genuinely innovative achievements of early medieval architecture in Germany. By the middle of the eleventh century the artistic initiative had moved westwards, to the Low Countries, Spain, England and the territories now occupied by modern France.

The essential differences in the artistic production of France and Germany in the eleventh century stemmed from the relative weakness of the French kings. The break-up of the Carolingian Empire and fresh waves of barbarian invasion in the tenth century left them with effective power over only a small territory around Paris. Elsewhere the kingdom disintegrated into hostile independent principalities. When these upheavals subsided in the eleventh century, and France began to enjoy an economic recovery, artistic initiatives did not come primarily from the French kings. Whereas German Romanesque was stamped with the theocratic ideals of kingship, its

French equivalent bore the imprint of two forces that often opposed royalty and profited from its weakness: a militant church and a vigorous feudal aristocracy.

In the second half of the eleventh century the right to ultimate authority over Christian society came to be contested between kings and the church. Kings could point to their ancient sacral powers as Christ's anointed representatives; but a reformed church, led by a militant papacy, claimed that the conduct of Christian life should be uncontaminated by lay interference. The reforming popes of the eleventh century demanded clerical celibacy, condemned the sale of church benefices, took over royal prerogatives as peacekeepers and leaders of holy wars, and challenged the traditional right of kings to dispense ecclesiastical offices. In the autumn of 1095 Pope Urban II consecrated the altars of the new abbey church of Cluny in Burgundy, and at the Council of Clermont launched the First Crusade. Seven months later, on 20 May 1096, he consecrated the high altar of the pilgrimage church of St-Sernin in Toulouse. Those three events underline papal support for three international forces that shaped the course of Romanesque art in France in the eleventh century: crusade, pilgrimage and monasticism.

The crusade against the Moors (Arabs) in Spain caught the imagination of Christian Europe and inspired some of the greatest art and literature of the Middle Ages. The first counter-offensive, led by the Asturian king Alfonso III (866–911), already sought to dignify territorial conquest under the banner of holy war. The cross which he donated to the cathedral of Oviedo in 908 (pl. 80) is typical of countless gem-encrusted processional and altar crosses that adorned every well-stocked Romanesque church in Europe. Like Suger's great cross at St-Denis, it reminds us not of Christ's real gibbet, but of the glories of his redemption. But the Oviedo cross had a particular message. Like Constantine's visionary cross, it was also seen as a battle standard; and its inscription proclaims confidently that 'By this sign the God-fearing are protected and the enemy vanquished.' Alfonso actually carried it into battle, and many Spanish Beatus manuscripts inserted a prefatory picture of it before the main text. It had become a symbol of the reconquest of Spain from the Arabs. By the mid eleventh century the Papacy had turned Christian expansion in Spain into a crusade. The corpus of Old French poems known as the *Chansons de Geste* – especially the *Song of Roland*, the fictitious account of Charlemagne's crusade against the Moors –

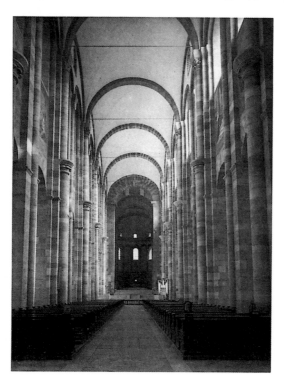

79. *Speyer Cathedral. Begun c. 1030, completed 1106.*

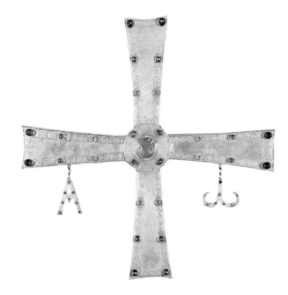

LEFT 80. *Cross of Victory given by Alfonso III to Oviedo Cathedral in 908. Gold, enamels, pearls and gems. Camara Santa, Oviedo.*

overspill; and the whole design culminates in the east end, in the spaces enclosing choir, high altar and the saint's relics. Outside, the bold massing of the apse, ambulatory and radiating chapels (each chapel containing a minor relic) resembles an early Christian circular mausoleum cut in half. But whereas early Christian planners had usually separated the centralised mausoleum from the longitudinal basilica, and early Romanesque had awkwardly incorporated them, at Conques the transept, crowned by its tower, smoothly unites choir and nave. Inside, too, the whole design moves easily from the dark nave to the lighter choir, for, in the absence of a crypt, the whole east end was treated as a setting for the shrine of Ste Foy (pl. 59). The reliquary was elevated behind the high altar and visible, through the apse columns, to the streams of pilgrims circulating around the spacious ambulatory. Their goal was the reliquary itself. Pilgrimages could be acts of penance, or, as Chaucer reminds us, holidays for the sociable; but their real purpose was to bring humanity into physical contact with

encouraged the Christian knights of France and Spain to see themselves as participants in a long heroic saga of holy war. And St James the Apostle, whose tomb had been conveniently rediscovered in the ninth century at Compostela, in the north-west corner of the Iberian peninsula, was transformed into Santiago the *Matamoros* ('Moorslayer'), depicted on church portals, including one in Compostela itself, as a knight mounted on a white charger, leading the Christians to victory.

The cult of Santiago inextricably links the Spanish Crusade with the popularity of pilgrimage in a heroic and expansive Europe. Santiago proved such a magnet for pilgrims that in the second half of the eleventh century, at Compostela, and on each of the four main pilgrimage routes that led through France to the Pyrenees (pl. 82), five large 'pilgrimage' churches were built, all of very similar design, and all marking a high point in the history of French Romanesque architecture. Although the smallest of the group, Ste-Foy at Conques (pls 81, 83) typifies them all in its clarity, functional efficiency and technical mastery. All the characteristics of French High Romanesque architecture are here: instead of the timber roofs of earlier structures Ste-Foy has stone vaults throughout, thus reducing the risk of fire and giving the interior a solemn, noble dignity. The high Roman-style barrel vaults (hence the early-nineteenth-century term 'Romanesque') are ingeniously supported by buttresses hidden in the galleries. And, as at Speyer, tall shafts articulate the whole building into regular bays. This assured language is unobtrusively adapted to the overriding needs of pilgrims: wide aisles, running round the whole church, mark their processional paths; above the aisles the large galleries may have accommodated any

BELOW 81. *Abbey church of Ste-Foy, Conques. Second half of 11th century. Interior looking east.*

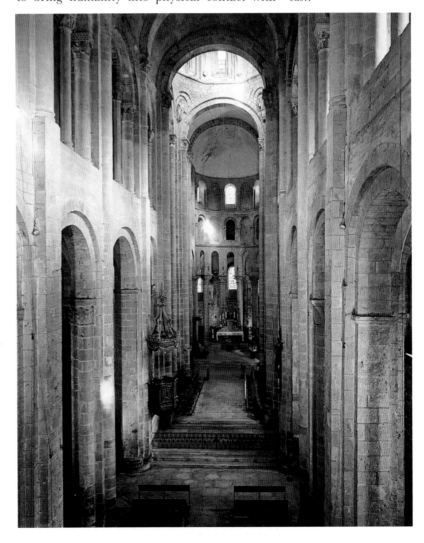

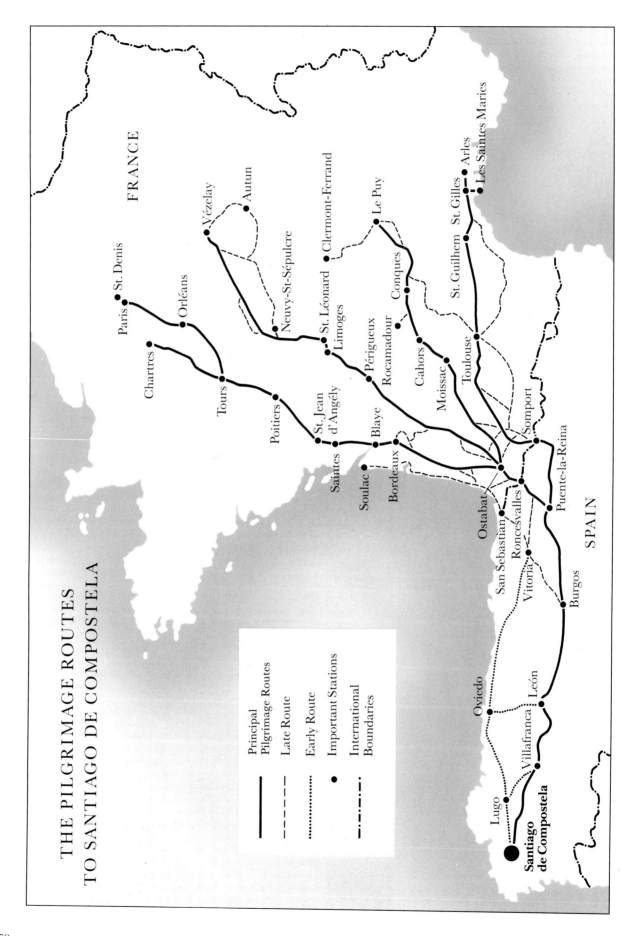

THE PILGRIMAGE ROUTES
TO SANTIAGO DE COMPOSTELA

FRANCE

SPAIN

St. Denis
Paris
Orléans
Chartres
Tours
Poitiers
Vézelay
Autun
Neuvy-St-Sépulcre
St. Léonard
Limoges
Clermont-Ferrand
Le Puy
Périgueux
Rocamadour
Conques
Cahors
Moissac
St. Guilhem St. Gilles
Toulouse
Arles
Les Saintes Maries
St. Jean
d'Angély
Saintes
Blaye
Soulac
Bordeaux
Somport
Puente-la-Reina
Ostabat
Roncesvalles
San Sebastián
Vitoria
Burgos
Oviedo
León
Villafranca
Lugo
Santiago
de Compostela

Principal
Pilgrimage Routes
Late Route
Early Route
Important Stations
International
Boundaries

OPPOSITE 82. *The main routes used by pilgrims to the shrine of St James at Santiago de Compostela. The five main pilgrimage churches are at Tours (St-Martin), Limoges (St-Martial), Conques (Ste-Foy), Toulouse (St-Sernin) and Santiago de Compostela itself.*

LEFT 83. *Conques. Exterior of abbey church and town from the north east.*

holiness. A kind of divine radiation poured out from a saint's remains. If you got close enough to them they could cure an illness, make a marriage fertile, or intercede on your behalf, like a feudal superior, with your Christ-lord. Ste Foy specialised in rescuing Christians from Moorish captivity. On the miracle-working powers of her relics and her jewel-bedecked icon the fame and prosperity of Conques, the very existence of the town and its church, depended.

Conques was a Benedictine monastery. The cult of relics and the Spanish crusade are inseparable from the third, and most powerful, artistic force in eleventh-century France: monasticism. The monasteries had suffered badly in the anarchy of the ninth century. Reform was supported by the German emperors, the papacy and a few outstanding individual abbots, of whom the greatest was Odo of Cluny. The Benedictine monastery of Cluny was founded in Burgundy in

79

ABOVE 84. *Cluny III from a watercolour painted by J.B. Lallemand c.1773. Bibliothéque Nationale, Paris.*

909, and placed under the direct control of the papacy. Under a succession of energetic and saintly abbots Cluny became the spearhead of monastic reform in western Europe. In two major aspects Cluniac life departed from the Rule of St Benedict. Benedictine monasteries had tended to be separate institutions with their own customs; Cluny, by a system of affiliated houses, each one owing direct allegiance to the mother house, created a monastic empire controlled from the top by Cluny itself and numbering, by the

early twelfth century, nearly 1,500 priories, spread across every part of Europe. Under Cluny, Benedictine monasteries ceased to be the receptacles of a fugitive civilisation and became pioneering, colonising institutions. The enormous wealth brought to the mother house by this quasi-feudal organisation is revealed in the scale of the monastery at the apogee of its power under Abbot Hugh (1049–1109). Most of Cluny was tragically destroyed in the aftermath of the French Revolution, but drawings and reconstructions

RIGHT 85. *A reconstruction of the monastery of Cluny c.1150. In the foreground the diagonally slanting infirmary buildings, beyond them the square cloister, and to its west the hospices and stables. The small church in the centre is the remains of the second of the abbey's churches, built under Abbot Mayeul (954–94). The colossal third church to its right was begun in 1088 under Abbot Hugh (1049–1109). Reconstruction drawing after K.J. Conant.*

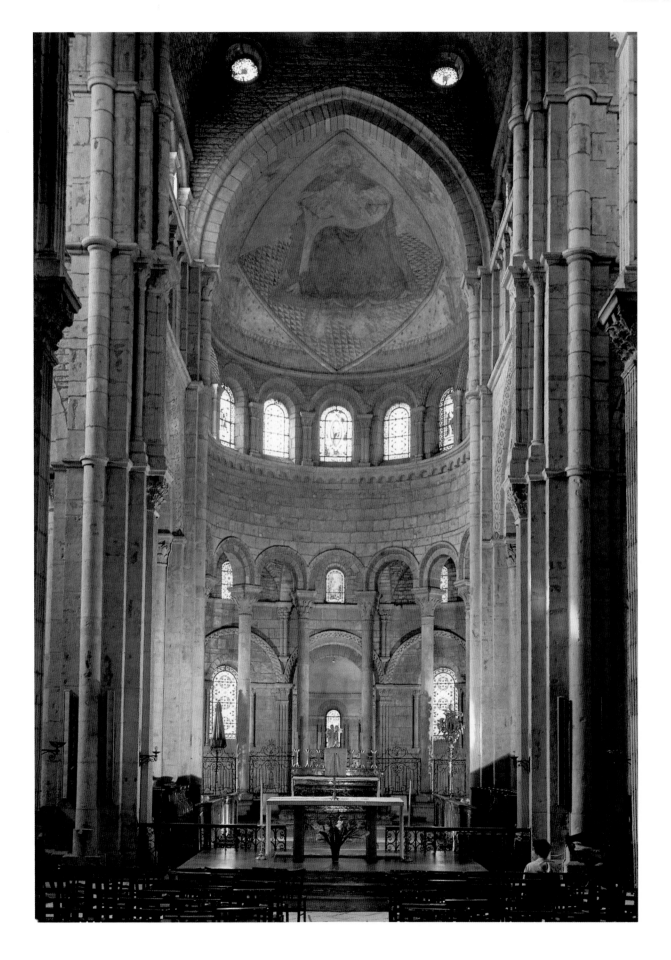

PREVIOUS PAGE 86.
Paray-le-Monial. Cluniac priory church built c.1100. Interior looking east.

OPPOSITE 88. *Decorated Initial from Flavius Josephus', 'Jewish Antiquities'. Christ Church, Canterbury, c.1130. Cambridge University Library.*

BELOW 87. *Capital from the ambulatory of Cluny III representing the Third Tone of the Gregorian Chant.*

evoke its lost splendours (pls 84, 85), and the surviving Cluniac priory church of Paray-le-Monial (pl. 86), built around 1100, offers us an accurate but small-scale copy of Abbot Hugh's great church. The monastery at Cluny adopted the kind of monastic plan standard in the West since Carolingian times, but constructed it on a scale and lavishness unprecedented in western Europe. Dominating the whole complex was the colossal church ('Cluny III'), begun under Abbot Hugh in 1088, consecrated in 1130, a symbol of the abbey's direct links with the papacy, and of Roman power north of the Alps. The church was dedicated to St Peter, and its five-aisled nave copied Old St Peter's in Rome, but its dimensions actually surpassed Constantine's basilica, making Cluny III the largest church of its day in Europe.

The scale of the church also reminds us of Cluny's second radical departure for older Benedictine monasticism. St Benedict's Rule envisaged a balanced regime of manual labour (*opus manuum*), reading (*lectio divina*) and prayer (*opus Dei*). Cluny sacrificed everything to communal prayer and the celebration of the liturgy. The monks gathered in the choir for seven or more hours each day to sing the offices, and clearly the church was designed as their resplendent liturgical setting: ambulatory and aisles for processions, clusters of chapels for the growing numbers of monk priests, and high barrel vaults to resonate the chant. Like Paray-le-Monial, the interior of Cluny III was embellished with a wide repertory of Classical ornament – moulded cornices, Corinthian capitals and fluted pilasters – inserted no doubt to link the monastery with early Christian Rome and the papacy, as well as to give an appropriately Roman dignity to the liturgy. But the symbolism as well as the practice of the liturgy also played a direct part in the design and embellishment of the church. The earthly liturgy was an image of the heavenly. The monks' chants are echoes of the praise offered at the throne of God. 'Here,' wrote Raoul Glaber, a monk of Cluny, 'was so much piety that one would think the monks angels.' It was easy to extend this celestial analogy from the liturgy to its surroundings, and to see the whole church as a foretaste of Paradise. Cluny III was built as an image of the Heavenly Jerusalem, its towers, in the words of the Cluniac Bernard of Morlas, 'the many-towered, golden city of Sion'. Its proportions may even have been derived from the musical ratios (seen as divine harmonies) of the Gregorian chant. But to make that symbolism more immediate it was necessary to people the City of God with images of its saints. Such images had always appeared in church furnishings, but now sculptured altars, crosses and free-standing reliquaries were no longer enough: images of the saints had actually to inhabit the structure. The capitals carved around the apse of Cluny III, probably in the 1090s (some, significantly, commemorating the tones of music), count among the first examples of the revival of monumental stone sculpture in Europe after a demise of nearly six centuries (pl. 87).

The striking feature of these and later Romanesque capitals is the ingenious way in which individual figures, and often whole narrative scenes, are adapted to the awkward shape of the capital, so as to retain its architectural character but also point up the meaning of the scene. This bending and twisting of figures into frames is an essential quality of Romanesque art, and some of its most imaginative inventions are to be found in the decorated initials of manuscript painting, where interlace and foliage are intertwined with human figures and narratives. Such initials were handled with special wit and

ANNOZ TRIGINTA·

·I·

LEXANDRE
REGINE MORTE IN
suprori uolumine
demonstrata: se
quentia refera
mus. nichil
aluid festi
nantes: in
minime
qcquia
de ge
stis
reb;

memorie pruudendo preterir. Nam q
conscribunt hy·storias. & reueteres in

inventiveness in English manuscripts of the twelfth century (pl. 88). Norman artists (by now most of them laymen), working in the great Benedictine scriptoria of St Albans, Bury St Edmunds and especially Christ Church, Canterbury, ingeniously combined human figures and scenes with the older insular motifs of interlace ornament and animal heads introduced to English illumination by the Hiberno-Saxon style of the Lindisfarne Gospels. The meanings of these initials are still debated among specialists in the history of Romanesque art. Some have avoided suggesting meanings for them at all, others have regarded them as recherché manifestations of the all-powerful religious iconography of the medieval church, and a few scholars have interpreted them as fancies and follies, reflections of a new secular and worldly impulse in medieval life. Sometimes the subject matter of the initial illustrates the adjoining text; sometimes their fiercely twisting shapes convey only a general sense of struggle and confrontation akin to the heroic conflicts of the *Chansons de Geste*, or the saint's triumph over the forces of evil. Some initials are purely decorative and do not appear to signify anything. 'Theophilus', author of a famous early-twelfth-century treatise on the arts, *De Diversis Artibus*, and himself a monk and artist (he is usually identified as Roger, a monk of Helmarshausen), recommended such initials both for stained glass and manuscripts as 'embellishment', as a craftsman's labour in honour of God, 'working with his hands the thing which is good'.

The fantasy and humour of these decorative miniatures may be characteristic of a peculiarly English love of caricature and the grotesque that resurfaces in Hogarth, Gilray and Gerald Scarfe. Certainly they provided a perfect foil to the solemn events depicted in the main illustrations of the manuscript, where the quality of the painting is no less impressive. The twelfth century marked a high point in the history of English book production: books for the monk's private reading, books for church services (missals, psalters, gospel books) and – most magnificent of all – the giant illustrated Bibles for reading aloud in church and refectory. The great Bible illuminated by Master Hugo (a lay craftsman) for the abbey of Bury St Edmunds in about 1135 (pl. 89) is typical of the international stylistic language of Romanesque painting. The strong heavy colours, the firm outlines, the expressive gestures and intense gazes, the solemn poses, the lack of any indication of physical space, and the stylised animals and foliage are all characteristics we first noted in Ottonian painting. By the mid twelfth

century they were common to most of western Europe. But Master Hugo showed a particular sensitivity to Byzantine influences. The flowing hair of his figures, their solemn wide-eyed faces and the structure of their bodies revealed behind the rhythmic folds of their drapery betray a new interest in England in the humane and classicising values of Byzantine art. Hugo's 'Byzantine' style counts as one of the finest manifestations of a widespread invasion of Byzantine influence into western Europe during the twelfth century. Similar hieratic figures with 'damp-fold' draperies appear in the magnificent early-twelfth-century wall paintings decorating the Cluniac priory chapel of Berzé-la-Ville, just north of Cluny, a priory favoured by Abbot Hugh as a place of quiet retreat. Its apse and semi-dome are dominated by a Christ in Majesty,

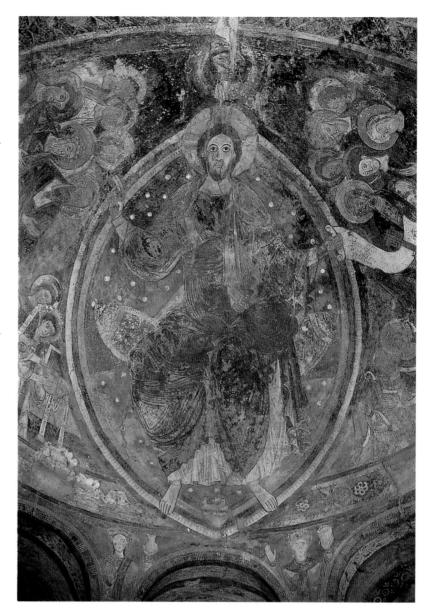

ABOVE 90. *Apse of the chapel of Berzé-la-Ville in Burgundy. Early 12th century. Christ in Majesty flanked by the Apostles. Note St Peter holding the keys and receiving a scroll from Christ's left hand.*

OPPOSITE 89. *Bury Bible. Frontispiece to the Book of Deuteronomy: Moses expounding the law of the unclean beasts. Painted by Master Hugo at Bury St Edmund's abbey, c.1135. Corpus Christi College, Cambridge.*

85

framed in a mandorla and flanked by his Apostles, with special (and typically Cluniac) emphasis given to St Peter (pl. 90). The powerful composition, animated by colours ranging from vibrant browns to olive greens and solemn blues, is probably a small-scale copy of a similar Majesty decorating the apse of Cluny III itself, which survived into the early nineteenth century. Christ in Majesty had been a common theme in apse painting for many centuries, but it was given a new meaning and a new impact at Cluny in the first decade of the twelfth century. The theme not only decorated the apse of Cluny III, but also appeared over its western portal, where, probably for the first time, it was carved in stone.

The rediscovery of monumental stone sculpture in France in the early twelfth century gave medieval art a new public and didactic medium. It was exploited swiftly and effectively in Burgundy and southern France by the five great 'pilgrimage' churches, and by Cluny and its priories. In around 1110 Cluny installed above the western portal of its new church a colossal carved

semi-circular tympanum of Christ in Majesty. Traditionally confined to apses, the theme was now brought down to the laity, in three dimensions, at the threshold of the church. Cluny's portal is lost, but something of its scale and splendour is conveyed by the large western portal of the Cluniac priory and pilgrimage church of Vézelay in Burgundy, carved around the year 1125 by the leading Cluny sculptor (pl. 91). It represents Pentecost, with the fires of the Holy Spirit radiating down to the apostles from the outstretched hands of the Christ of the Ascension. Surrounding them are the pagan nations of the world, waiting for conversion. The symbols of time in the archivolts – the signs of the zodiac and the labours of the month – stress the cosmic meaning of the event, and anchor it in the rhythms of the Cluniac liturgical year. Vézelay annually attracted thousands of pilgrims, for it preserved the supposed relics of St Mary Magdalen and was the starting-point of one of the four main French roads to Santiago de Compostela. On these pilgrims, crowded together in the west-

91. *West portal tympanum of the abbey church of St Mary Magdalen, Vézelay, depicting Pentecost and the Mission to the Apostles*, c. 1125.

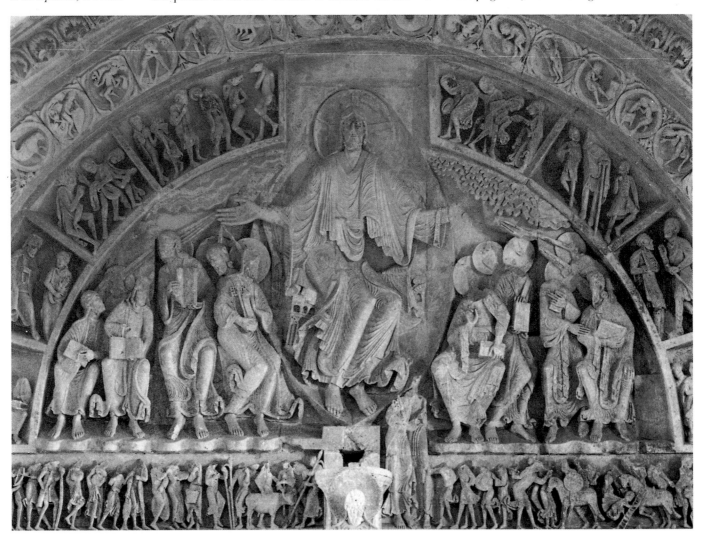

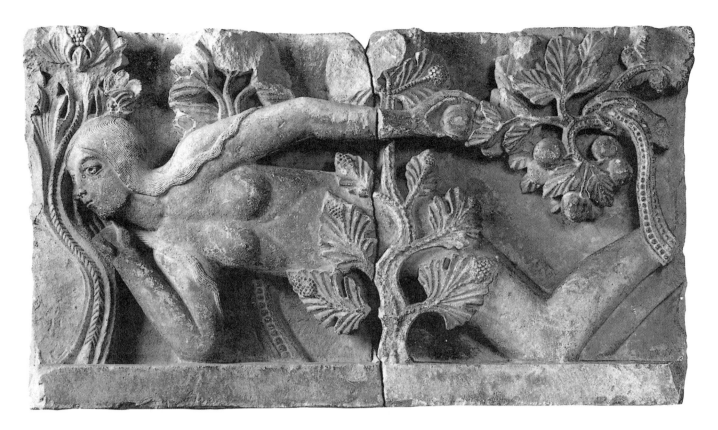

ern porch, the large tympanum, once brightly painted, was calculated to create the maximum impact. It is difficult for us today, in a society cluttered with images and information, to appreciate the pervasive power of the visual in a culture were few images existed, and where few people were literate. But to a twelfth-century audience the scale and imagery of the Vézelay portal – its densely crowded figures, their unreal contrasts of size and gesture, their tunics swirled by·the mighty wind of the Spirit, and the ecstatic figure of Christ – would have had the force of a vision.

An even more dramatic appeal to the fears and hopes of a pilgrim audience was made by the great tympanum over the western portal of the nearby pilgrimage church of St-Lazare at Autun (pl. 93). The portal, carved at about the same time as Vézelay's, faced the cathedral's cemetery, and appropriately shows the Last Judgement. An awesome figure of the enthroned Christ, modelled on that of Cluny III, forms the calm and impassive centre of a world teeming with tiny figures: angels sounding the last trumpet; the souls rising gingerly from their tombs; the saved welcomed by St Peter at the gates of Heaven; the damned pulled into Hell by hideous demons. Beneath the feet of Christ, almost in supplication, the sculptor has carved his own name: 'Gislebertus hoc fecit' ('Gislebertus made

this'). The presence of a signature, a rarity in a period when most artists remain anonymous, tallies with the extremely personal style of all Gislebertus' carving at Autun. He certainly trained at Cluny, probably as an assistant to the Cluny-Vézelay master, but his style is distinctly his own: elongated figures with exaggerated gestures, a sympathetic eye for human detail, a lyrical charm and a dramatic realism without parallel in Romanesque sculpture. The Autun tympanum is memorable for its small incidents of horror and tenderness. But its central message lies in the stark duality of the whole composition, where meaning and visual organisation clearly reinforce each other. The figure of Christ on the dominant vertical axis of the tympanum divides good from evil, the damned on his left (sinister) side, the just on his right. Christ is the final arbiter who segregates opposing moral forces. As such, the theme of the Last Judgement is the ultimate resolution of that epic sense of combat and struggle between sharply defined antagonists which animates so much of early medieval art. Heaven and Earth, history and eternity, angel and man, pagan and infidel, good and evil find their rightful place around the throne of a remote and inscrutable God.

Similar dualities formed the theme of the now-destroyed north portal at Autun, also carved by Gislebertus. The recumbent figure of Eve is the

92. *Figure of Eve once decorating the north portal of St-Lazare, Autun. Carved by Gislebertus, c. 1130. Musée Rolin, Autun.*

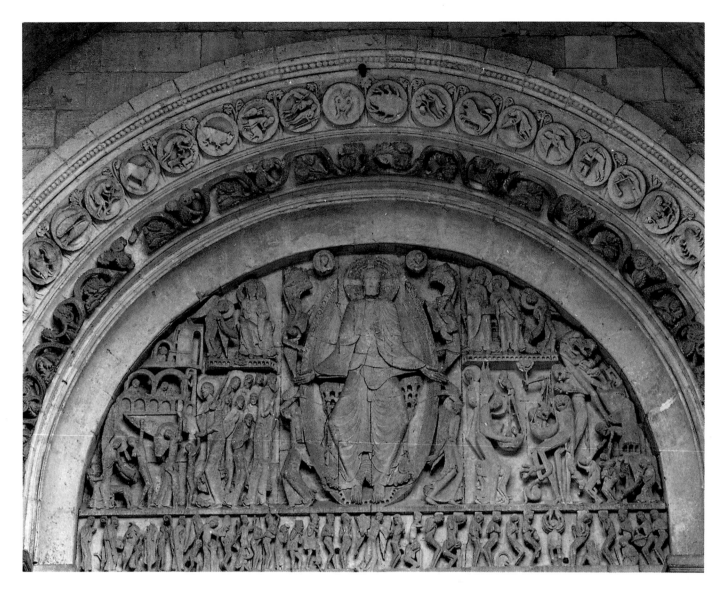

GISLEBERTUS, TYMPANUM OF WEST PORTAL, CATHEDRAL OF ST LAZARUS, AUTUN

The portal above carved by Gislebertus in c.1135 represents the Last Judgement as described in St Matthew's Gospel (25:31–46), when Christ, 'the Son of Man, takes his seat on the Throne of Glory . . . to separate the unjust, who will depart to eternal punishment, and the virtuous to eternal life'. Gislebertus depicts the cataclysm on a scale, and with a dramatic intensity, never attempted before. The impassive figure of Christ the Judge forms the dominant axis around which the drama unfolds. To his right

(our left) are the saved. In the lintel they rise excitedly and fearfully from their tombs, among them two pilgrims (*far right*) with badges on their bags, one showing a cross for Jerusalem, the other a cockle-shell, symbol of St James, and proof of a pilgrimage to Santiago de Compostela. Above the lintel, St Peter with a huge key welcomes the blessed to Paradise, in the form of a small Romanesque building already inhabited by souls, one of them climbing into its portals with the help of an angel. On Christ's left (our right) are the damned. In the lintel directly beneath his feet the angel with the flaming sword drives them from Paradise. All are pitifully naked:

the miser weighed down with his money bags, the adultress with snakes gnawing at her breasts, and the screaming soul gripped by a giant pair of claws appearing from nowhere (*below, middle*). Above them the Archangel Michael, with souls clinging to his coat tails for protection, is weighing a soul (*below left*). A hideous devil opposite him tries to tilt the balance in his favour, and a smaller devil sits in a scale to weigh it down.

These dramatically human incidents (all originally picked out in bright colours) were calculated to overawe an impressionable pilgrim audience. The two figures of the resurrected pilgrims must have recommended pilgrimage as an instrument of redemption, while the three prominent clerics among the saved (a monk and two bishops with croziers) underscored the claims of the church to intercession and salvation. The cathedral at Autun possessed the relics of St Lazarus, who was raised from the dead by Christ and was seen as the essential precedent for the general Resurrection at the end of time. This, and the fact that

the portal faced the cathedral's cemetery, may explain the emphasis on death and resurrection in the tympanum.

Despite its human dramas, the whole composition of the portal, with its strange dislocations of scale, was designed to emphasise the supernatural nature of the Last Judgement. The vast elongated Christ dominates the drama like a vision, and determines the size and posture of all the figures. The damned move away from him, and remain unnaturally small and cowed; the saved look up to him, and convey a sense of gradually rising movement, appearing to grow more vertical and elongated the closer they approach the throne of God. The Last Judgement was too awesome an event to be expressed in the normal language of 'realistic' art. If God can be understood through images, he must be represented by discordant, expressive, and 'dissimilar' forms. In the words of the mystical theologian Denis the Areopagite, 'unlike symbols accord more closely with that which is ineffable'. The holy demanded distortion.

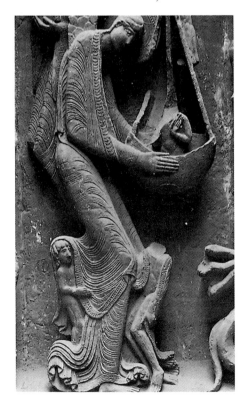 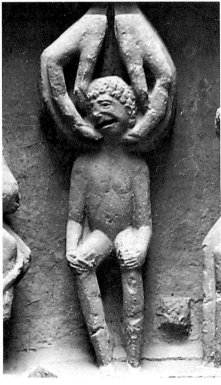 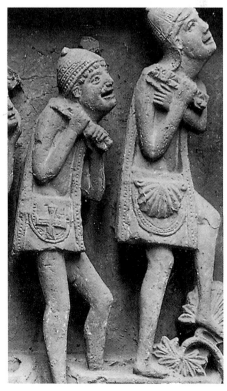

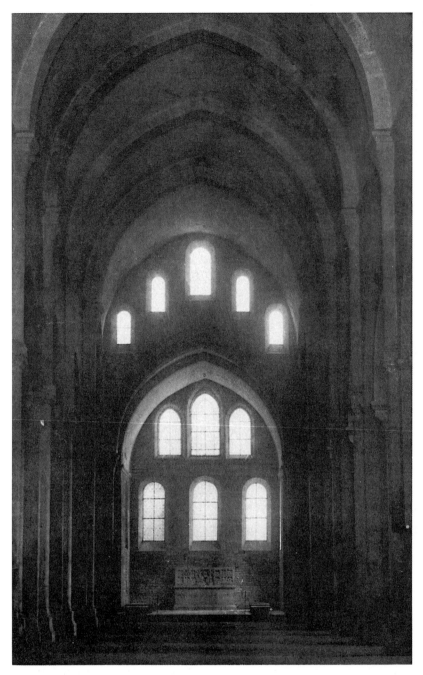

97. Fontenay. Cistercian abbey church, 1139–47. Interior looking east.

finest of its surviving fragments (pl. 92). She is an image of original sin and its punishment, but in the context of a portal which celebrated forgiveness and resurrection. Her sensuality is here suggested (with a frankness unparalleled in Romanesque sculpture) by the turn of her breasts and shoulders, only to be denied by her disjointed hips and thighs and the tree that conceals her sex. Her right hand is raised to her cheek in a gesture of shame, but her left continues to pick the forbidden fruit. Sin – the battle of good and evil – is as manifest in the divided consciousness of mankind as it is in the antagonisms of external events, or in the separation of the saved and the damned on Judgement Day.

Cluniac sculpture of this power and splendour may have been effective on an uneducated lay audience, but was it suitable for the monks? Much Cluniac art was cast in a high theological mould, but many of its images – such as the monstrous pagan races of the Vézelay tympanum, or the anecdotal details of Autun – were at best distracting, and at worst meaningless. Cluniac capitals, or the decorated initials of monastic Bibles, reveal a thriving underworld of semi-meaningless creatures and events that owe little to religious iconography, and much more to the purely aesthetic fancy of the artist. For monks dedicated to a life of contemplation and prayer, was not this art a dangerous distraction? And was not the scale and lavishness of Cluniac art incompatible with monastic poverty? Such doubts and anxieties were persistently raised by the sternest critic of the Cluniacs: the Cistercian order of reformed monks, and especially its eloquent and influential leader, St Bernard of Clairvaux (c. 1090–1153). In a famous letter to William of St-Thierry, Bernard castigated the cloister capitals at Cluny:

'Under the eyes of the brethren, engaged in reading, where is the meaning of that ridiculous monstrosity, that amazing misshapen shapeliness and shapely misshapenness?... those monstrous centaurs? those semi-humans? ... On all sides there appears so rich and amazing a variety of forms that it is more delightful ... to spend the whole day admiring these things than in meditating on the law of God.'

The Cistercians legislated against 'frivolity' and 'superfluousness' in the arts, and excluded from their churches all stained glass, rich furnishings and sculpture. The Cistercian abbey church of Fontenay in Burgundy (pl. 97), under construction in the 1140s – small, towerless, square-ended – epitomises Bernard's taste, and the Cistercian reaction in general. What effect Cistercian criticism of Cluny had on the decline of Romanesque is more difficult to assess. Like Cluny, the Cistercians adopted an international monastic organisation; and they enforced their puritanical views on all their houses. But outside the order they seemed to have made few aesthetic converts; and the new Gothic style, which owed nothing to the Cistercians appeared in northern France in the 1140s, rapidly eclipsed French Romanesque and soon spread to other parts of Europe.

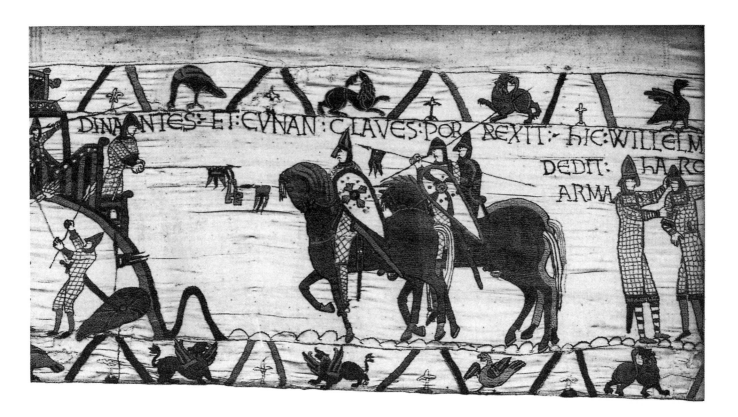

DINANTES·ET·CVNAN·CLAVES·POR REXIT· HIE·WILLELM DEDIT· HARO ARMA

THE USES OF FEUDALISM:
THE ART OF NORMAN ENGLAND

Feudalism – that system of personal obligation in which vassals held the lord's land as fiefs, and in return paid him dues, accepted his judgements and rendered him military service – emerged in western Europe in the tenth and eleventh centuries as a consequence of royal weakness. As a system of government and a military technique no single people used feudalism more effectively than the Normans. With it they carved out for themselves kingdoms or fiefs from Hadrian's Wall to Sicily. Their two essential weapons for conquest and control were mounted and armoured knights – a small but dominant force in battle – and the castle, usually built in the form of a wooden or stone tower ('donjon' or 'keep') placed on a high mound and surrounded by walls. Both instruments of conquest appear prominently in the famous Bayeux Tapestry (pl. 98). The 'tapestry' (it is really a strip of linen, about 70 m long, embroidered in coloured woollen threads) represents episodes from the life of King Harold of England up to his death in the Battle of Hastings in 1066. Where it was made, and for what purposes, is still not entirely clear, but it represents a rare survival of a long tradition of depicting secular narratives in wall paintings or textile hangings. Its nearest literary equivalents are the Nordic prose sagas, or the epics of

the *Chansons de Geste*. Like them, it is a story of betrayal and treachery; like them, it celebrates the virtues of a feudal, warrior society: loyalty, generosity, courage in battle, the rituals of oath-taking and homage. Its format – which consists of strips of continuous narrative – goes back ultimately to the Roman idea of a picture roll, as seen in the helical relief of Trajan's Column, and adapted in Bernward's Hildesheim variant.

All these narratives celebrate triumph, and few victories have been more decisive than William the Conqueror's at Hastings. Almost at once England received a new dynasty, a new language and a new art and architecture. The country was covered with a dense and repressive network of castles – almost all of them distinguished by massive keeps. England's enormous wealth, and the reforming zeal of the Norman higher clergy (men such as Lanfranc and St Anselm), encouraged a prodigious outburst of church building. In the course of just fifty years nearly every cathedral and abbey church in England was rebuilt on a scale unprecedented in England or Normandy. Some of these churches – for example, Winchester Cathedral – count among the largest in Europe since Roman antiquity; others, such as Durham (pl. 101), suggest size by the sheer massiveness of their masonry.

The castle and cathedral of Durham, dominating that famous escarpment above the river

98. *Detail from the Bayeux Tapestry. Made in southern England, c.1082–7. Centre Guillaume le Conquérant, Bayeux.*
William the Conqueror receives the keys of the castle of Dinant, and invests Harold with his arms, thus making him his feudal subordinate (far right). In the text above, 'Haroldo' is placed below 'Willelm'. Note the castle keep (far left) and the prominence given to the mounted knights.

Wear, epitomise the scale and success of the Norman revolution. Their twin accents reflect the unique double authority of the Durham bishops, the only ecclesiastical lords in England with the

99. *Groin vault*

same temporal power as the great magnates. The enormous wealth of the diocese helps to explain the scale and ambitions of the new cathedral. Begun in 1093 and completed by around 1130, Durham Cathedral is of European importance because it represents one of the earliest attempts in medieval architecture to cover a large

100. *Rib vault*

building with rib vaults. The Durham vaults behave in a very similar way to so-called groin vaults (see Speyer's, pl. 79), transferring the pressure principally on to the corners of each bay (pl. 99). But the ribs (pl. 100) do have certain advantages. They reinforce the folds of the vault along their weak edges, and they visually integrate the vault with the two walls supporting it. These merits were at once perceived in Normandy, and rib vaults were made one of the main

OPPOSITE 101. *Durham Cathedral, 1093–c.1130. Interior of nave looking east.*

features of the early Gothic style. But the system was not developed in England until the later twelfth century, and the total impression of Durham is not remotely Gothic. Its sculptural clusters of shafts and piers, and its massive drum columns, mark a high point in that Romanesque, and particularly Norman, emphasis on bulk and richness of surface. Much of the interior, including the prominent geometric patterns incised on the columns, was once brightly painted.

Paradoxically, Durham, so often seen as a high point of Norman architecture, takes us right back to the golden age of Anglo-Saxon monasticism, and the glories of the Northumbrian 'Renaissance'. The church preserves the relics of one of the most popular saints of northern England: St Cuthbert, the seventh-century bishop of Lindisfarne, and hermit of the Farne Islands. The Venerable Bede (673–735), monk of Jarrow, the first English historian and author of two *Lives* of St Cuthbert, is also buried in Durham. St Cuthbert's body first found refuge in Durham in 995. Inside his coffin were a number of treasures, the most recent a set of unique silk vestments, lavishly embroidered with figures of prophets and saints in a monumental style derived from Carolingian and perhaps even Byzantine sources. They were given to the shrine of St Cuthbert in 934 by King Athelstan. The other treasures take us right back to the seventh century, and to Cuthbert himself. One is his simple wooden coffin, made a few years after his death in 687; the rest are his more precious personal effects: his little portable altar and his pectoral cross. The last treasure, the Lindisfarne Gospels, made for him by Eadfrith, came to Durham in the coffin, but is now in the British Museum. All these relics, including the coffin and the body, were rescued from the monastery of Lindisfarne after it was sacked by the Danes in 793. They were taken by the monks to Chester-le-Street, and in 995, after fresh Viking raids, they eventually found a permanent home in Durham. But their long journey to Durham is only the mirror image of a journey backwards which they open up to us. Like Ste-Foy at Conques, St Cuthbert's body and its treasures vividly remind us of the achievements of early medieval art: from the discipline of Norman England to the lavish patronage of an Anglo-Saxon king and his Carolingian connections; and then, across the century of the Viking invasions, to the glories of Insular art and its barbarian roots. There is even a glimpse of distant Byzantium. Norman Durham looks back on many of the revivals and elaborations that make up the novelty and vitality of early medieval art.

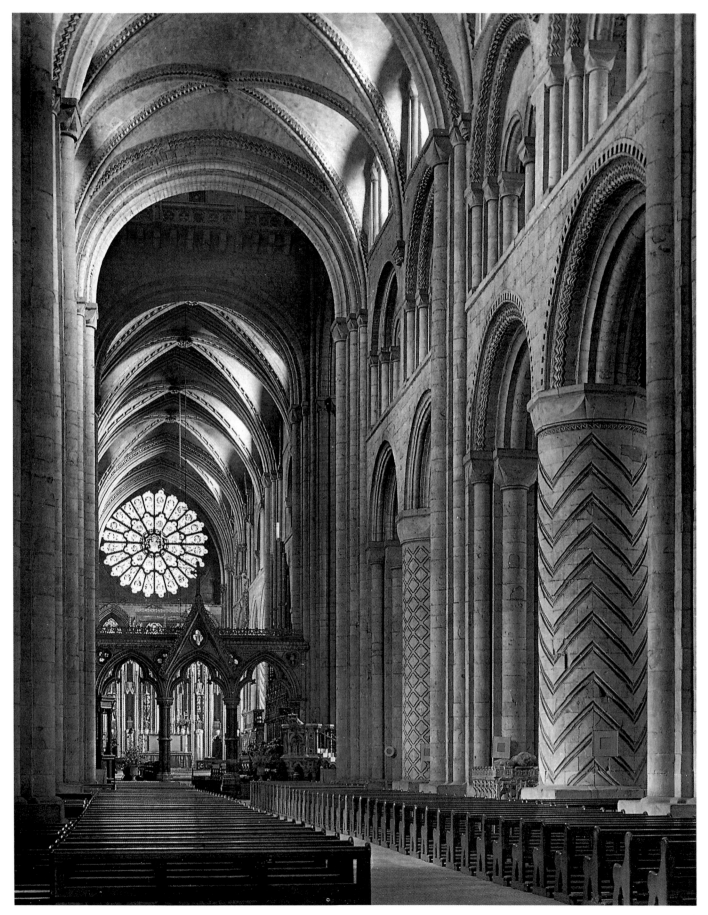

4
GOTHIC

WILLIAM CLARK

INSET 102 *Column figures from Chartres Cathedral, south transept, left portal, 1210–35. From the left: St Theodore (dressed in armour and bearing the arms of a crusading knight), St Stephen and Clement of Rome.*

OPPOSITE 103 *Early-13th-century stained-glass window from the Chartres Cathedral depicting the life of St Chéron. In the bottom panel the sculptors who contributed to the window are shown carving figures for the new portal.*

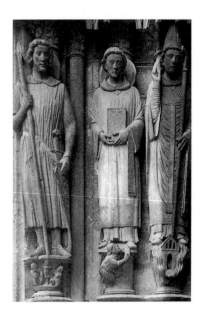

The outpouring of skill, labour, faith and wealth in the age of Gothic cathedrals needs to be understood in the light of the major changes that took place in western Europe between 1100 and 1300. A number of mutually dependent factors appear to have worked together to produce the conditions favourable to the construction boom of those centuries. Among the most important was the dramatic population growth. In those two centuries the number of people in western Europe as a whole increased threefold; in the most prosperous and developed areas the increase was as much as tenfold. Towns and cities grew at an unprecedented rate and hundreds of new ones were founded. The old, rigid social system was changing.

At the same time, everything was still dependent on agriculture. Most of the forest cover of western Europe had already been cleared and turned into farmland. In fact, the ratio of forest to farmland in the twelfth century was almost exactly the same as in the early twentieth century. Earlier developments in farming equipment, such as the plough and the horse collar, and changes in the practice of farming, such as crop rotation, had, together with improvements in the crops themselves, begun to produce an agricultural surplus. That surplus began to change the economy when it was traded in the towns for goods and services, or simply sold outright for money.

The growth of a money economy fuelled trade, particularly in the developing cloth industry. Wool from the enormous herds of sheep belonging to the monasteries of northern England was routinely shipped to Flanders. There it was turned into a variety of different types of cloth and traded southward through the great fairs, such as those in Champagne, to merchants from Italy. They brought luxury items from the Mediterranean world, particularly spices and other valuables, to trade for Flemish cloth. In addition, there was a booming wine trade in northern Europe by the twelfth century, as the warmer climate permitted grapes to be grown even in northern France. Western Europe was no longer a series of isolated centres of population and civilisation, but a rich, cosmopolitan network of towns and cities connected by a system of roads inherited from the Roman past. And those roads were frequented by travellers and pilgrims of all sorts.

All of these mutually dependent and supporting developments benefited from the lengthy periods of relative peace that existed in the twelfth and thirteenth centuries. For example, the French king Louis VI completed the pacification of noble families in the Ile de France and pressed most of them into his service. During his reign he brought relative peace to an increasingly larger area, a policy he inherited from his father, Philip I, and bequeathed to his son, Louis VII. The power and prestige of the Capetian dynasty continued to grow in the twelfth century, reaching what most historians consider its peak

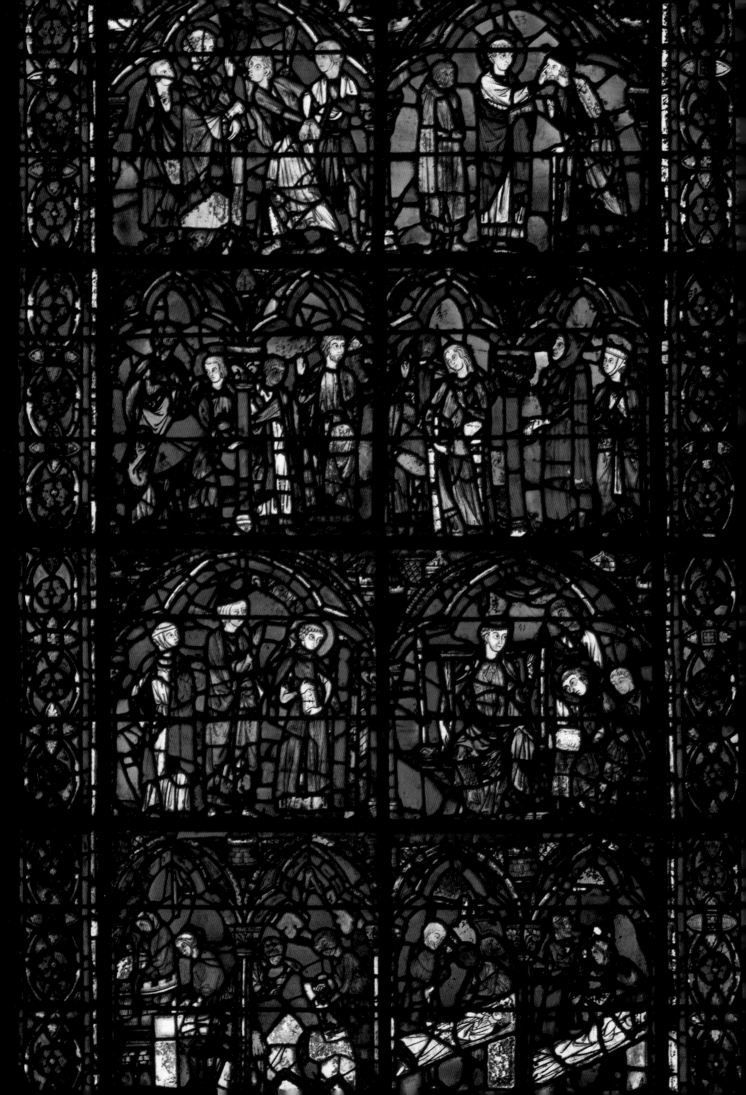

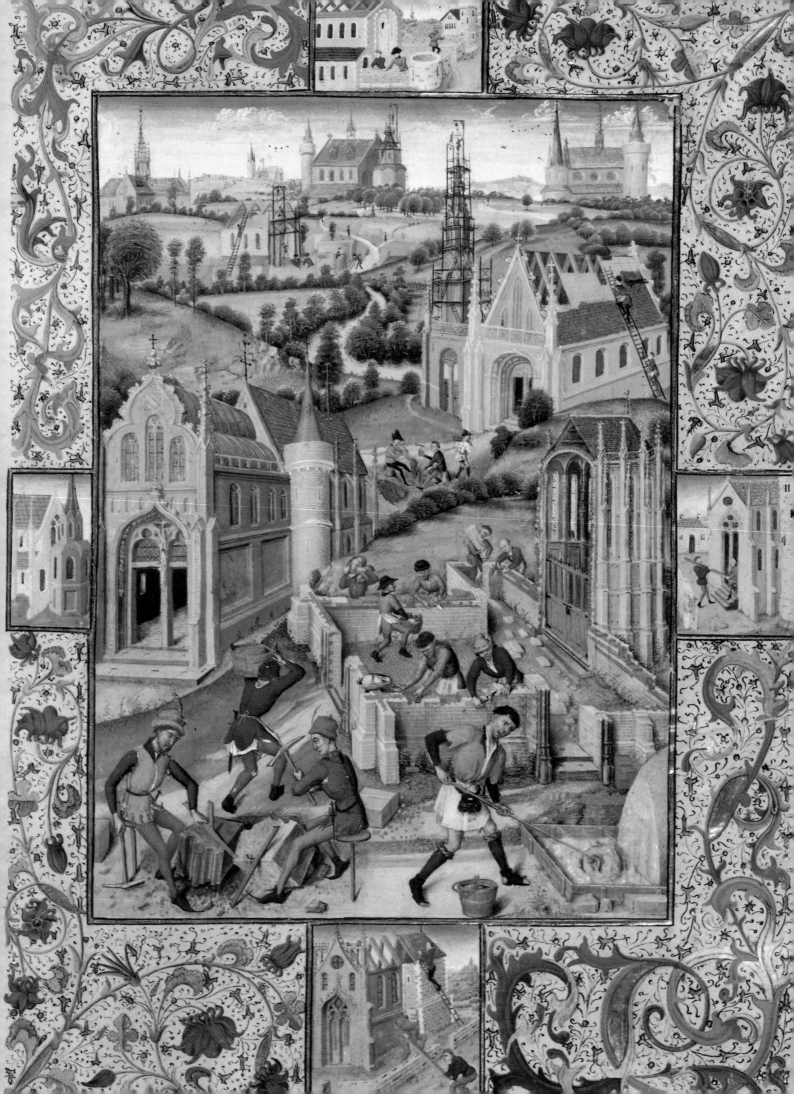

under Philip Augustus, who in 1214 emerged as the most powerful king in Europe with the defeat of all of his major enemies at once in the Battle of Bouvines. Yet it was his grandson, Louis IX, who was recognised, even in his lifetime, as the ideal Christian king, the model for all European kings. When Louis IX was canonised in 1297, French kingship even attained blessed status.

England, too, benefited from long periods of relative peace in the wake of the upheaval that followed the Norman conquest in 1066. In the twelfth century, except for the internecine warfare between rivals for the throne following the death of Henry I, and the squabbles between Henry II and his quarrelsome sons, most of England enjoyed a peace and prosperity comparable to that of the rest of western Europe.

On all fronts it was an exciting, vital period, especially in the intellectual centres springing up around the old cathedral schools. In fact, the cathedral schools themselves were changing. Scholars such as Peter Abelard challenged the existing order by changing the way philosophical questions were posed and argued. Not only were the methods changing, but whole new bodies of knowledge were suddenly available. For example, the major writings of Aristotle now became available in Latin translations from the Arabic and reached western Europe via Spain, as did many of the Arab advances in mathematics and science. It was during the twelfth century, for example, that western Europeans adopted Arabic numerals in place of Roman numerals. The change sounds simple, yet it had a profound impact and made possible an enormous expansion in mathematical knowledge. Adding and subtracting were relatively easy with Roman numerals, but more complex manipulations, such as multiplication and division, were difficult and time-consuming, if they were understood at all. Arabic numerals made them easy and quickly comprehensible, and facilitated all the advances in mathematics that followed.

Abelard and the generations of teachers and scholars that followed him paved the way for a shift not only in the way people argued and reasoned, but, more fundamentally, in the way they thought. Modern scholars are finally beginning to shift their attention from *what* medieval scholars thought to *how* they thought, and are identifying the new intellectual patterns that led to the emergence of the great thinkers of later centuries, from Thomas Aquinas to Francis Bacon.

One example of this shift in thinking can be drawn from law. By the later twelfth century the ordeal, an individual test of guilt or innocence

that bore little relation to the crime in question, had been replaced by a system that recognised classes of crimes and specified standard punishments. No longer did conviction and punishment depend on the arbitrary workings of the ordeal.

By the late twelfth century the greatest centre of intellectual activity was Paris, the largest city in western Europe. Teachers and students flocked there in such numbers that the old cathedral school could no longer accommodate them and they had to move from the Ile de la Cité, the island in the Seine where the cathedral was located, to the sparsely populated left bank. This was the first step toward the establishment of an independent university, which was finally chartered, much after the fact, in 1223. Oxford, Cambridge and other centres soon followed suit.

All of this social and intellectual change is reflected in the great building boom that swept western Europe. It has been estimated that in France alone during the three centuries from (roughly) 1050 to 1350, more stone was quarried for building than in the entire 3,500-year history of ancient Egypt. The sheer number of buildings put up is difficult to imagine, but it is estimated that there was a church for every 150–200 persons and that even modest-sized cities, such as Lincoln and Norwich, had forty to fifty churches each. In major centres such as Paris, the number that existed was enormous, far in excess of the number that survive.

Over the course of the twelfth century architecture also underwent a major shift. In fact, it ceased to be a craft that could be practised by anyone with minimal talent and became a profession that attracted skilled workers, and eventually specialists, in considerable numbers. For this reason, we must view with caution reports such as that of Robert de Torigny, abbot of Mont St-Michel, who speaks of noble men and women helping to haul carts of stone at Chartres in the 1140s. Amateur enthusiasm, however pious the inspiration, is unlikely to have been well received by professional workers. Indeed, the many images of medieval construction, the majority of them illustrations of the building of the biblical tower of Babel, rarely show more than a few workers engaged on the projects. The well-known fifteenth-century image of the construction of twelve churches, from the Girart de Roussillon manuscript now in Vienna (pl. 104), is not only instructive in that sense, but also explicit about tools and techniques used.

From the surviving records of building costs, it is clear that cathedral construction was a major expense and not to be undertaken lightly.

OPPOSITE 104. GIRART DE ROUSSILLON AND HIS WIFE: The Construction of Twelve Churches. *15th-century manuscript illustration. Österreichische Nationalbibliothek, Vienna.*

105. The Bishop of Paris Blessing the Lendit Fair. *14th-century manuscript illustration. Pontifical of Sens. Bibliothèque Nationale, Paris.*

religious life of the town and surrounding communities on important holy days, such as Easter and Christmas, or on the feast days of local saints who might lie buried in the building. Just as the cathedrals are still so often the dominant local landmark, so they played a visible role in the economic and social life of the town. Sometimes the role was not positive, as when oppressive taxation led the populace of Reims to revolt against the archbishop and the clergy in 1233 and to attack the cathedral works as a symbol of that oppression. More often than not, however, relations tended to be good and the cathedral was regarded as an expression of civic pride and wealth, even though there might be problems with the costs.

Monasteries and parish churches often went through the same fund-raising difficulties as cathedrals. Interestingly, one of the first things that Abbot Suger did after his election at St-Denis was to set about reorganising the abbey properties and revenues, which he reported had fallen into disarray. Only then could he turn his attention to rebuilding the abbey church.

A NEW STYLE: ST-DENIS

Rarely in the history of art can we locate with any precision the birth of a new style, and it is rarer still to be able to pinpoint it to a specific time and place; but that is exactly what we can do in the case of the Gothic style. It was created at the abbey of St-Denis, north of Paris, in the new works added to the old, eighth-century church by Abbot Suger, one of the most remarkable men of the twelfth century. Suger was a man of humble background and modest means. Sent to the monks of St-Denis as a child, he was educated in their schools and rose through the ranks to become abbot of St-Denis in 1122. Abbot Suger also served his old schoolmate, now King Louis VI, well. He was godfather to the future Louis VII, and, in what historians regard as one of the triumphs of Capetian diplomacy, arranged his marriage to the wealthiest woman in Europe, the young heiress Eleanor of Aquitaine. When the young Louis and Eleanor went on crusade, Suger served as regent of France. Between running the abbey with its many properties and his diplomatic activities he found the time not only to write a biography – the first since Carolingian times – of Louis VI, but also to record accounts of his building activities and the consecration of the newly enlarged abbey church dedicated to the apostle of Gaul, St Denis.

The costs of construction, like the maintenance, cleaning and day-to-day operations of the cathedral, were the responsibility of the clergy, usually organised into a chapter of canons. They were the actual owners of the building, even though it contained the symbol of the bishop's authority, his chair or *cathedra*. The bishop might assume a role in raising the money for construction, but the actual responsibility rested with the canons. For example, although the bishop of Paris licensed and gained considerable income from the Lendit Fair held just outside the city walls (pl. 105), there was no way in which an uncooperative bishop could be forced to contribute from this income against his will. Usually, however, bishops, most of whom had been canons in one cathedral or another prior to their elevation, did take the lead in organising funds for construction. On the other hand, despite the contributions of bishop and canons, most projects were underfunded and had to depend on other revenue sources, such as donations by the king and nobles, and the offerings of pilgrims and townspeople.

Naturally the cathedral played a central role in urban life and acted as an important symbol of the town where it was located. While it served a parish, usually not much bigger than the other town parishes, the cathedral was central to the

Suger's texts, which present elaborate justifications of the need to enlarge the old church,

98

explain that on important holidays the building got so crowded that people trying to enter on one side forced others out of the opposite doorway, and that on more than one occasion the monks had to escape through the windows with the abbey's relics, the bodies of the saint and his two companions, in order to protect them. To accommodate the faithful and to ensure the protection of the relics, the old nave was lengthened by four bays and closed off at the west end by a new, twin-towered façade, and an expanded and enlarged two-level chevet or liturgical area was constructed to the east.

Though much mutilated in the eighteenth and nineteenth centuries, when the sculpture was attacked and the north tower pulled down, the west façade (pl. 106) still preserves some of its original appearance. Attention focuses on the three elaborately decorated, sculpted portals separated by the massive vertical buttresses that support the towers. Above each doorway are windows flanked by arcading, and above these, forming a third level on both sides, are tall windows. In the centre was the first large-scale circular, or rose, window in Gothic architecture.

What makes the façade, dedicated in 1140, 'Gothic' is not any specific change in the figural sculpture, but a change in the relationship between the sculpture and the architecture itself. There is a new clarity and order in the arrangement of the vertical and horizontal divisions, though they do not form a grid. The portals extend to the buttresses, and each division is clearly marked by foliage bands and mouldings. The windows are not isolated holes, as they had been on earlier façades, but are flanked by arcades and mouldings that visually link them to the dominant vertical buttresses. None of these elements is 'new' at St-Denis: elaborate sculpted portals have a long history in Romanesque art, particularly in Burgundy and Languedoc, while façades heavily decorated with mouldings and sculpture are characteristic of the south-west of France. What is new about the façade of St-Denis is the way in which these elements articulate the design to create a totally unified, coherent expression of the two-towered façade and to suggest the nave and aisles behind it.

But the new style is more evident in the chevet (pls 108, 109), the eastern end of St-Denis. There, the crypt or lower storey, and the ambulatory (pl. 107) and radiating chapels built above it survive, although the upper parts were replaced in the thirteenth century. This new eastern end, which Abbot Suger tells us was built in three years and three months, was dedicated in June 1144 in the

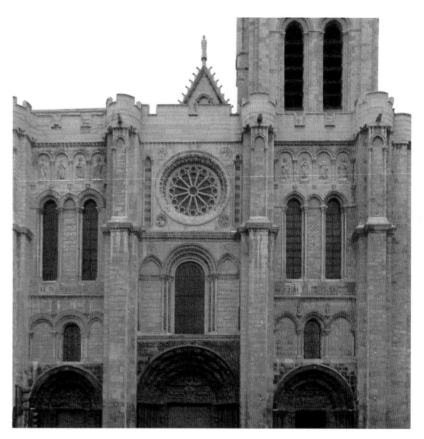

presence of the king and queen, the court and an impressive number of ecclesiastical dignitaries, including several archbishops and abbots and more than a dozen bishops. The new chevet is usually described in terms of the builder's constructional devices: columns, segmental or pointed arches and rib-vaults. As with the façade, none of these elements were new to St-Denis, all had been used earlier elsewhere.

What makes the ambulatory and radiating chapels at St-Denis unique is the new spatial conception, the way in which the constructional elements are, for the first time, combined to create a sense of a total space, a unified interior in which all of the parts are subsumed within the whole. The eye is constantly drawn across and through the space to the windows, the limits of the spatial envelope. Although the central space above the main altar was rebuilt in the thirteenth century and made much taller than in Abbot Suger's time, the feeling of unity and spatial clarity remains.

The key to understanding the ambulatory and radiating chapels at St-Denis lies in the perception that the many minor differences and variations in the handling of the architectural elements are always secondary to the sense of a total, unified space. The builder began by expanding the crypt to create an even floor level

106. *Abbey church of St-Denis, near Paris. West façade, 1140. Abbot Suger's additions to the 8th-century St-Denis mark the emergence of the Gothic style.*

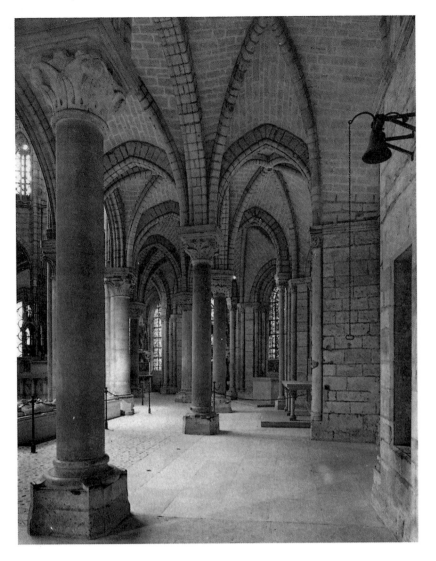

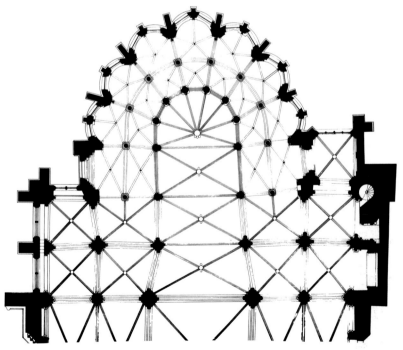

throughout the ambulatory and chapels, then eliminated dividing interior walls to achieve the openness. The columns reduce the interior structure to a series of slender supports for a network of arches and vaults. The use of segmental (or pointed) arches made it possible for the builder to adjust and regularise the height of the vaults, resulting in a nearly even sense of ceiling height throughout, despite the irregular trapezoidal and pentagonal units of the plan. The roundness and slenderness of the columns, whose height and proportions are based on those of the eighth-century nave, contribute to the openness of the space. Their foliage capitals, likewise inspired by those of the earlier church, serve as the gathering-points for the multiple arches that define the units, as well as for the ribs of the vaults. The columns seem to lift the arches and vaults to a common ceiling height and leave the interior space open and unencumbered.

The wall as a limiting surface has practically disappeared in favour of large stained-glass windows, translucent screens that flood the interior with light. Surfaces have been replaced by openings and the multiple mouldings around them. Even the piers between the chapels have columns standing in front of them, and slender colonnettes standing in niches cut into the pier to deny its mass. All of these vertical lines are continued right into the vaults; often the colonnettes and vault ribs even have the same diameter. The result is that the wall, already reduced to a peripheral screen, is further dissolved by linear accents that soar directly into the vaults. Together the arches and ribs create a linear network across this ceiling surface. The size of the ribs and the choice of single round mouldings for their profiles further accentuates the aesthetic of thinness. The builder has created a visual network across the ceiling and down the walls between the windows that leaves the main interior space accented only by the slender columns that lift the linear pattern upwards. The result is a light, open, uninterrupted space that extends from one side to the other, and that is unified by the ring of magnificent stained-glass windows, the first accurately dated, large-scale ensemble of stained glass, of which Abbot Suger was justifiably proud.

While most of the gold and jewelled treasures he bought for the abbey have disappeared, the opulence of the liturgical space itself is suggested by the mid-fifteenth-century painting *The Mass of St Gilles* by an anonymous Flemish artist, now in the National Gallery in London. The painting shows the main service altar of St-Denis set with

gold and jewels. A few of the liturgical objects from Abbot Suger's time, such as the beautiful gold and jewel-encrusted agate chalice (pl. 111), now in the National Gallery in Washington, or the vases and pitchers preserved in the Louvre, still survive to suggest the magnificence of the church intended to house the tombs of the kings of France, a tradition Suger was instrumental in reviving.

The experience of the revolutionary eastern end of St-Denis must have been a surprising, even shocking, revelation to those present at its dedication in 1144. Abbot Suger carefully recorded the names of the ecclesiastics who participated in the consecration ceremonies, although he conspicuously omitted all mention of the bishop of Paris and the abbots of the other important abbeys in or near the city. His list is revealing because in less than fifteen years every one of the cathedrals and abbeys whose dignitaries attended the dedication was being rebuilt in the new style created at St-Denis, the style that we now call Gothic. From Sens to Senlis, from Reims to Laon and Soissons, all across the region north of the Loire river and even as far away as Canterbury, early Gothic buildings still bear wit-

ness to this enormous surge in building activity. Within fifty years the Gothic style had spread all across western Europe and had become the dominant architectural mode, as it would remain for 300–400 years.

This does not mean, however, that its success was instantaneous or that its history is one major achievement after another. The eastern end of St-Denis was such a radical departure from existing practices that it took ten to fifteen years for builders to master the means of achieving that sense of unified interior space, just as it took them time to learn how to exploit the possibilities offered by the constructional devices. Only by the second half of the 1150s were builders capable of surpassing the architectural accomplishment of St-Denis.

NOTRE-DAME, PARIS AND CHARTRES

Larger, broader and above all taller than St-Denis, the cathedral of Notre-Dame in Paris (pl. 110) is the first Gothic structure with an interior over 30 m (100 feet) high. Unlike Suger's church, however, Notre-Dame (begun c. 1155) had no radiating chapels protruding on the exterior. Instead the builder used double ambulatories, one

ABOVE 109. *St-Denis. Chevet interior, 1140–4.*

OPPOSITE ABOVE 107. *St-Denis. Ambulatory. 1140–4.*

OPPOSITE BELOW 108. *St-Denis. Plan of the chevet.*

around the other, to achieve the sense of lateral spaciousness on a colossal scale.

The dramatic increase in height (Notre-Dame was over 25 per cent higher than its contemporaries) caused its builders some difficulties. An important solution to problems of stability and wind pressures at that height was found by the adoption of the flying buttress. The present flying buttresses in Notre-Dame all date from the nineteenth century, but evidence of the first design can still be seen. That first design, by externalising major structural supports for the roof and the vaults, revolutionised Gothic engineering and pointed the way to the spectacularly tall cathedrals of the thirteenth century at Reims, Amiens and Beauvais.

The visual effect on the appearance of the buildings was no less dramatic: the flying buttress is the external hallmark of the French Gothic style, the most immediately recognisable feature at Notre-Dame. Soaring, lacy networks of arches and ornament surround the building,

creating an ambiguous sense of the exterior and concealing the arrangement of the interior spaces behind powerful upreaching verticals.

One of the first large buildings to show an awareness of the potential offered by the flying buttress is the cathedral at Chartres (pl. 112). This most sacred shrine to the Virgin Mary in France was almost totally destroyed by fire in June 1194. Only the crypt, the western towers and the three sculpted portals between them were spared. The canons were still bemoaning the loss of the cathedral's most precious relic, the tunic worn by Mary on the night she gave birth to Christ, when two of their number emerged from the still-smouldering ruins carrying it. They had rescued the tunic and taken refuge in the crypt. With the papal legate visiting the city, needless to say the salvation of the relic was immediately proclaimed a miracle and fund-raising for the new cathedral initiated on the spot. The scale of the undertaking at Chartres was extraordinary, even by medieval standards. Most projects were

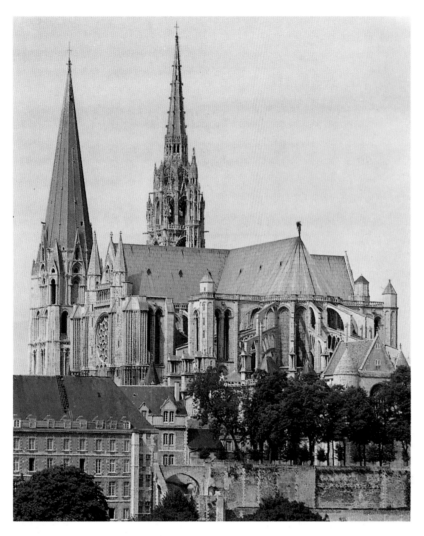

112. *Chartres Cathedral, mainly 1194–1260. View from the south-east.*

One of the major characteristics of Chartres is the sudden enlargement of every component to colossal size (pl. 114). The design is one of repetition and regularity in the units, or bays, from the bases of the piers right through the rectangular rib vaults. In addition, each element has been rethought. The piers, for example, consist of a columnar core flanked by four axially disposed shafts that lend immediate visual emphasis to the vertical lines of the elevation and, on the front face, run uninterrupted from floor to vault-springing. These are not delicate lines, but big, bold architectural elements that are echoed in the upper parts of the building by other strong mouldings. Certainly the reduction to a few strong lines lends a sense of power, just as it also made building easier and quicker. The use of a wall passage at the second level, taken over from earlier buildings but, like the other elements, rethought, permits circulation for cleaning and repair. Because it is a series of identical continuous arcades on the front surface, the wall passage creates a rhythmic contrast to the otherwise overwhelmingly vertical lines.

That this builder understood the potential of the flying buttress and incorporated it in this design from the beginning is indicated by the height and size of the windows. In fact, the buttresses he designed for the nave at Chartres are, according to modern analysis, overbuilt, as though to make certain there would be no problems. Understanding the supporting role of the flying buttress and using a series of deep arches around the openings allowed the builder to maximise window size, perhaps the most revolutionary change at Chartres. The pattern of two tall thin windows, called lancets, beneath a large oculus, or round window, is a direct visual reflection of the desire to utilise all the available space. These enormous windows were planned from the very beginning to hold stained glass, the single most expensive element in cathedral construction and decoration. Their size not only suggests the great wealth of the chapter at Chartres, but may also indicate the builder's awareness that stained glass reduces the amount of light that can penetrate the interior.

begun on a note of caution, with the rebuilding of only a part of the church, but at Chartres, contrary to older arguments, the entire building seems to have been started at the same time.

The builder at Chartres, the man who decided on the scheme and formulated it for the masons, benefited from a half-century of architectural experiments. No doubt under pressure from his patrons, the chapter at Chartres, who wanted the church replaced as quickly as possible and who seem to have had the funds available, the builder worked out a radically simplified design that made construction both easier and quicker. The result is one of the most successful architectural schemes of the Middle Ages (pl. 113). It consists of an elevation of three storeys; tall main arcades fronting tall side aisles, a relatively low wall passage (triforium) that lends horizontal emphasis, and enormous clerestory windows, openings as tall as the main arcade, to contain the glory of Chartres, the stained-glass windows. Finally, the whole elevation is visually united by the regularly repeating rectangular vaults used over each bay.

Coloured glass was apparently used by the Romans for small windows, but the technique of making stained glass was perfected in the Middle Ages. The coloured glass was blown and either spun into a round plate of varying thickness or quickly pressed into a cylindrical mould, then cut and unrolled into a flat piece while still molten. The cooled pieces, which had the colour distributed through them rather than merely on the

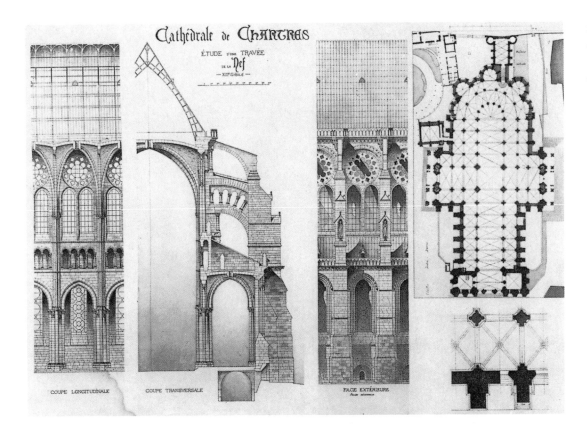

LEFT 113. *Nave sections, elevation and plan of Chartres Cathedral. 19th-century study by A. Goubert.*

BELOW 114. *Chartres. Nave wall. Completed c.1230.*

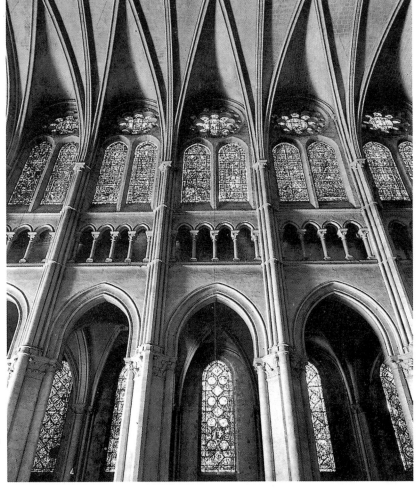

surface, were cut or carefully broken into smaller pieces that fitted the pictorial design, and these pieces were painted with a dark pigment to represent heads, hands, garments or other details. They were then refired to bond the vitreous paint to the surface of the glass. Finally, using lead strips to hold them in place, the elements were fastened together to create panels, and the panels, together with decorative borders, were attached to iron armatures that were set into the stonework. The resulting windows glow with a rich translucent light and fill the interiors with coloured light, predominantly red and blue, but with accents of other colours as well.

Chartres has more of its original stained glass than any other medieval cathedral. Now that the windows are being cleaned and restored to their original glory, we can appreciate the transfixing radiance and jewel-like brilliance of the exceptional Chartres glass. The richness of the light creates a mystical aura on the interior, visual confirmation of the success of the scheme.

The distribution of the windows in the cathedral is visually coherent. Multi-scene windows depicting legends of the saints and stories from the Old and New Testaments are restricted to the windows of the aisles, ambulatory and chapels. Windows with only one or two large figures – of saints, prophets, kings, bishops or others – are limited to the clerestory, where the power of their

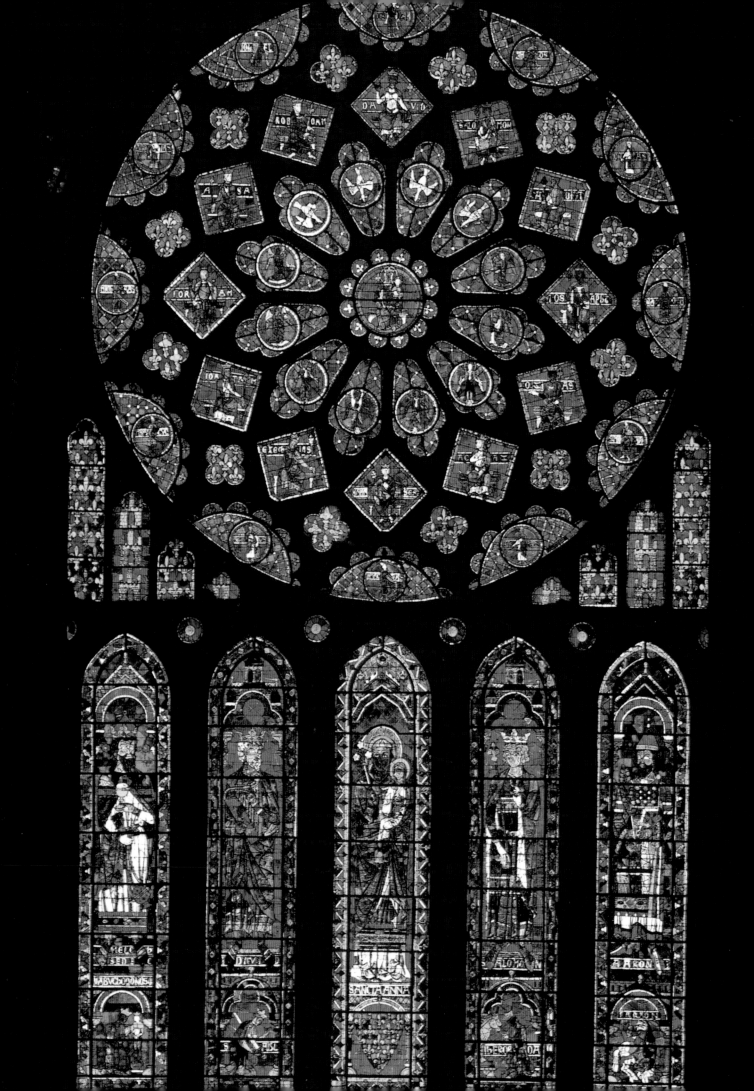

visual imagery can be appreciated from the floor. This sensitivity to the positioning of scenes and figures means that the visitor to Chartres can readily appreciate the more visually complex windows at the lower level and the simpler, more majestic, other-worldly images in the upper windows. However, there does not seem to be any single iconographic programme uniting all the windows. Even those relating to Mary or to Marian themes seem rather randomly placed.

Many of the aisle and ambulatory windows contain donor scenes in the lowest panels, positioned where they are clearly visible to viewers. Recent research suggests, against the conclusions of earlier scholars, that these scenes of daily life in the early thirteenth century may not have been intended to honour donors for their piety in paying for the windows, but show them, rather, paying for the privilege of being allowed to practise their trade or craft within the cathedral precincts, exempt from the control and taxation of the city of Chartres. This theory certainly helps explain the windows depicting the building trades: the sculptors, for example, are shown carving figures for the new portals (pl. 103). Equally certain is the competitive patronage found in the two great rose windows and lower lancets that occupy the façades of the transept. The windows in the south transept façade were donated between 1217 and 1225 by the most important local noble family, the house of Dreux, whose arms appear in the lancets. The rose and lancets in the north transept (pl. 115), in which we can see the Capetian royal insignia, the fleur de lys, were given by the queen, Blanche of Castile, according to the usual interpretation, as a kind of challenge to the authority of the house of Dreux, as well as demonstrating royal magnanimity. Modern viewers are the true beneficiaries of this supposed competition, because no other cathedral possesses a pair of rose-window ensembles that can rival those of Chartres.

The three lancet windows in the west façade also must be counted among the most magnificent creations of the period. They predate the fire of 1194 and form an iconographic group celebrating the Infancy of Christ, the Passion, and the royal genealogy of Christ, in the form of a Tree of Jesse. The Infancy window is the largest surviving stained-glass window of the twelfth century. The Tree of Jesse (pl. 116) provides a link between the Old and New Testaments, always an important theme in the Middle Ages, because it offers visual confirmation of the statement in the gospels that Mary was of the 'house' (or tribe) of David: Jesse, at the foot of the tree, dreams that it is filled with his descendants, beginning with David (his son) and the kings that succeeded him, and continuing upwards to Mary and, at the very top of the tree, Christ.

All of these windows bear eloquent witness to the enormous skill of the glass-maker's art at Chartres. Undoubtedly inspired by illuminated manuscripts and, to a lesser degree, wall painting, but more closely related to metal-working in its thermal technology, stained glass actually replaced wall painting and mosaic as the preferred decoration in Gothic churches. And nowhere else can the effect of these luminous walls of colour and the glowing reflections they cast on the walls be appreciated better than at Chartres.

Chartres is equally famous for its exterior sculpture, particularly the ensemble of three portals in the west entrance that has been known collectively as the royal portal since the thirteenth century. Like the three lancet windows above it, this ensemble (pls 118-121) predates the fire of 1194 and occupies a place of prominence in the history of medieval art. The sculptor responsible for them was one of the most remarkable artists of the early Gothic period. Although he is usually called the 'Headmaster', to indicate the importance of his work here, his name may have been Roger, because 'Rogerus' is prominently inscribed at the top of the centre pier between the central and south (right) portals.

According to the most recent analysis, the royal portal at Chartres is the work of three major artists, each of whom created about the same amount of sculpture. Each artist's work is related to the others' in various ways – not least in its contribution to the overall iconographic programme of salvation through Christ – and this suggests that they worked on the portals concurrently.

In the later sculpture on the north transept the Virgin appears as the central focus in the tympanum of the central portal (pl. 117). Now she is the crowned Queen of Heaven, enthroned and presiding over the celestial court with Christ, the King of Heaven. The figures in the archivolts stress two aspects of her lineage. The Tree of Jesse provides the royal genealogy, while the prophets and sibyls who predicted the Virgin Birth stress her divine role. Her presence in Heaven before the Last Judgement is explained by the pair of scenes on the lintel. To the left we see the death of the Virgin, her bed surrounded by mourning apostles, with Christ in the centre receiving her soul. To the right, in an exactly parallel composition, angels lift her body from

OPPOSITE 115. *Chartres. The north transept rose window, c.1230, given by Queen Blanche of Castile. The rose window comprises twelve semicircles showing the twelve minor prophets and twelve squares containing twelve kings of Judah. In the centre is the Virgin and Child surrounded by doves and angels. The figures in the five lancet windows are Melchizedek and Nebuchadnezzar; David and Saul; St Anne; Solomon and Jeroboam; and Aaron and the Pharaoh, who is falling into the Red Sea.*

116. *Chartres. The Tree of Jesse window from the west façade, c.1150. Jesse reclines at the bottom of the window. From his body springs a tree bearing in its branches four kings of Judah, then Mary, with Christ at the top. Surrounding these are the fourteen Old Testament prophets who foretold that Christ would come from the House of David.*

the tomb for transport to Heaven so that, soul and body reunited, she can preside as queen.

The statue columns reveal most clearly the change that has taken place in the attitude toward the human body in the interval (nearly half a century) between the work of Roger and his contemporaries on the west façade and that of the sculptors who worked on the transept entrances. The Old Testament figures in the central portal of the north transept are much freer and less restrained by the architectural framework. The bodies can be seen beneath the draperies, which are handled in a new way. The figures have a new sense of movement and more animated facial expressions. They are also more easily identifiable because of their actions and attributes. For example, we can recognise Abraham with his son, Isaac, standing in front of him. Abraham has been preparing to follow God's command and sacrifice Isaac, whose chin is held up to expose his throat to the sword. But an angel appears at the last moment and a startled Abraham turns and looks up as the angel commands him to substitute a ram, shown on the console on which father and son stand. Along with the actions and the attributes, a sense of time is conveyed.

The other statue columns, among whom we can recognise Moses, Aaron, David, Isaiah, Simeon, Melchizedek and John the Baptist, all symbolise salvation through sacrifice and thus prefigure the sacrifice of Christ. The doorpost, or trumeau, in this central portal shows St Anne, the mother of the Virgin, holding her infant daughter. St Anne's presence, which is most unusual, is probably related to the gift to Chartres, after the crusader sack of Constantinople in 1204, of the relic of her head.

Two side portals flank the central portal of the north transept, the whole ensemble being prefaced by an elaborately decorated porch filled with statuary. This and the equally elaborate façade of the south transept, also with three portals and a porch, belong to the reconstruction project initiated after the great fire of 1194.

With a large number of sculptors working on the transept portals and their porches at the same time, we naturally find a wide variety of styles. The speed with which the work was carried out is suggested by the fact that the sculpture is mostly of a rather average level of competence. Some of the figures appear relatively old-fashioned, others more abstract, while yet others reflect an increased appreciation of Classical antiquity, strikingly coupled with an awareness of the contemporary world. This coupling of ancient and modern is perhaps best exemplified by the

statue of the warrior saint Theodore on the left portal of the south transept (pl. 102). The artist's awareness of Roman sculpture is shown by the fact that the figure seems to be standing with the weight borne on one foot, as in the Classical contrapposto pose. If we do a systematic analysis of the pose, we see that the sculptor's understanding of it is incomplete: that is, he had no doubt seen such a pose, but has not related it to the workings of the human body. On the other hand,

the figure of St Theodore is one of the first thirteenth-century sculptures in which the subject is shown in contemporary dress: he wears the armour and bears the arms of a crusading knight.

For all of the wealth of stained glass and the profusion of sculpture on the transepts at Chartres, it was the architectural scheme that had the most lasting influence. The impact of this simple yet colossal design, in which the divisions are few but enormous and the sudden enlargement of every element is so startling, was considerable. While the simplification, standardisation and regularity made it possible to proceed rapidly with this giant project, it must have seemed overscaled, even brutal, to other builders. The churches that followed and were influenced by the scheme at Chartres began almost immediately to soften and refine it. The most influential of these later churches was Reims Cathedral, the coronation church of French kings, which reduces the heaviness of the Chartrian scheme and clarifies both design and structure. The introduction of carved-stone window tracery at Reims changed the conception, if not the overall design, of the windows and permitted builders to achieve a new harmony and regularity.

AMIENS

It remained for Robert de Luzarches, master of the nave of Amiens Cathedral (pl. 122), to accomplish the full synthesis. (Work on the nave began in 1220 and was complete by 1236 at the latest.) He took over the structural system of Reims, a much more efficient and lighter system than had been used at Chartres, but he changed the proportions of the elevation and introduced a new complexity in the design. The ratio of height to width at Amiens is 3:1, giving an overpowering sense of tallness. Interestingly, this effect was achieved not by increasing the height of the upper storey, but by narrowing the width and pushing the height of the side aisles to unprecedented levels (the aisles of Amiens are taller than most naves built in the twelfth century). The effect of this is to merge the aisle space with the nave, and reduce the visual sense of the main piers as supports. The lower storey of the nave, up to the one uninterrupted horizontal, the distinctive band of carved foliage at the base of the wall passage, is exactly half the total elevation. Above this, the front screen of the wall passage is a sophisticated attempt to integrate horizontal continuity with the rhythmic grouping of the vertical elements, and the division between the wall passage and clerestory is intentionally blurred by

having the main verticals in the clerestory windows actually begin at the base of the wall passage. The window design follows a pattern of twin lancets surmounted by an oculus as at Chartres, but at Amiens each lancet in the basic scheme is treated as a full window on a smaller scale with two lancets and a small oculus. Thus the whole window becomes a screenwork of delicately carved stone tracery in which each ele-

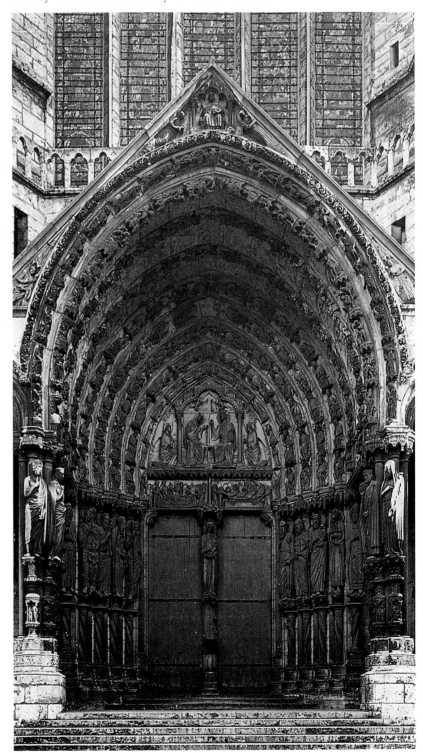

117. Chartres. North transept, central portal, 1205–10. The tympanum shows the Virgin as the crowned Queen of Heaven.

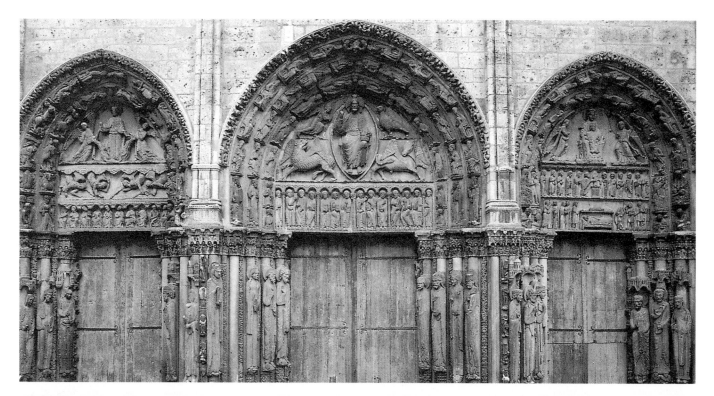

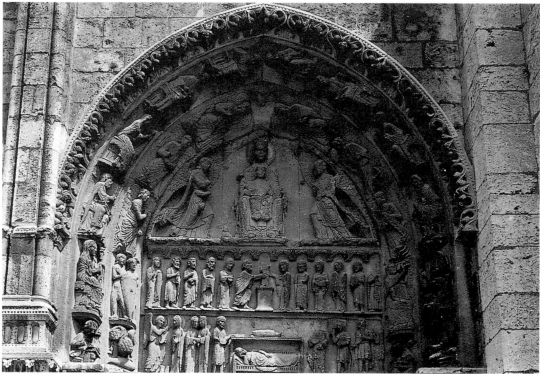

THE ROYAL PORTAL, CHARTRES CATHEDRAL

The sculpted royal portal, the ensemble of three portals in the west entrance of Chartres (*main picture above*), completed close to 1150, occupies an important place in the history of medieval art. The iconographic programme of salvation through Christ links all three portals. The central-portal tympanum, beneath the concentric arches framing the doorway (*above right*), shows Christ enthroned

in Majesty, surrounded by the symbols of the four evangelists, angels and the twenty-four elders of the Apocalypse, holding musical instruments and vials of tears. On the lintel are the apostles.

In contrast to the inner tension and dynamic animation that characterises the Romanesque sculpture of the tympanum at Autun (pl. 93), with its terrifying vision of the threat of damnation to unrepentant sinners at the end of the world, here we see the promise of salvation and of an eternity as ordered, peaceful and harmonious as the composition centred on the supremely confident figure of Christ.

The tympanum in the north portal (*main picture, left*) is traditionally identified as the Ascension of Christ. The scenes of Christ's earthly life in the south-portal tympanum and lintels (*main picture, right*) appropriately emphasise the importance of the Virgin, to whom the cathedral is dedicated. She appears in the scenes of the Annunciation, Visitation and Nativity on the lower lintel and in the Presentation in the Temple on the upper. In the tympanum, enthroned and holding the blessing Christ Child, she personifies the *sedes sapientiae*, the Seat of Wisdom. The labours of the months and the signs of the zodiac, in the archivolts of the lateral portals, lend terrestrial and celestial significance to the whole.

The New Testament scenes in the upper part of the portal are visually supported by the tall, thin figures of Old Testament prophets, kings and queens attached to the architectural columns beneath the upper arches (*opposite, far left*). Here the changed relationship between sculpture and architecture that was initiated at St-Denis is elevated to new heights of expression. These calm, grand figures float serenely in space, yet their slim, vertical proportions are dictated by the architectural framework behind them. An underlying abstract

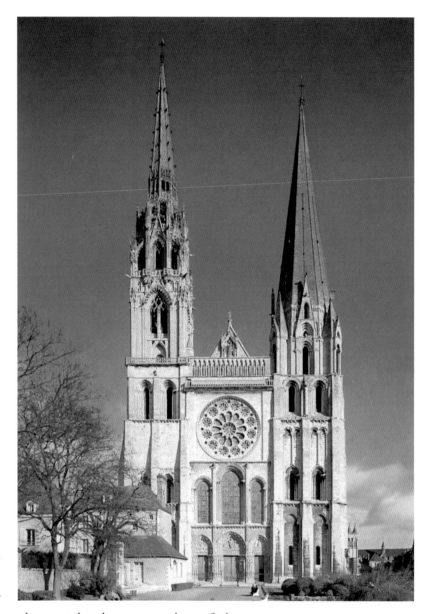

element in the conception of the composition sets all the heads at the same level and determines the positioning of the arms – the right one raised, the left one lowered, despite the differences in the figures' gestures and attributes. The figures are also remarkably free from the tension between architecture and sculpture characteristic of the Romanesque period. They are, above all, animated by an approachable humanity – the very embodiment of the new humanism being taught and studied in the famous cathedral school at Chartres.

BELOW LEFT 122. *Amiens Cathedral. Nave, c.1220–36.*

BELOW RIGHT 123. *Wells Cathedral. Nave section and elevation. Drawings by Cattermole, 1824.*

ment or subdivision of the design is differentiated by separate layers to preserve clarity.

The developments in tracery at Amiens announce an important advance in Gothic architecture: a new emphasis on design, now that structural problems had been solved (for instance, by the flying buttress), and a new style, characterised by lace-like patterns of great geometric precision in window tracery, and later on gables and other features. The new style, Rayonnant, takes its name from the tracery of rose windows. The earliest really sophisticated examples of it are found in and around Paris, in churches that enjoyed royal patronage, such as Louis IX's Sainte-Chapelle, or had longstanding royal associations, such as the abbey of St-Denis. The rebuilding begun there in the 1230s finally joined the two parts of Abbot Suger's church, the façade and chevet, with a nave and transept in the Rayonnant style. It is this version of Gothic, identified with the artistic centre of Europe, Paris, and with the patronage of the ideal Christian ruler, Louis IX, that made the Gothic style popular across Europe, from Scandinavia to Spain and from Bohemia to the British Isles.

ENGLISH GOTHIC

The distinctive spatial approach that characterised the Gothic style in France was introduced in England well before the thirteenth century. The Romanesque choir of Canterbury Cathedral, built in the 1130s, burned to the ground in 1174. According to the chronicle of the rebuilding, composed by the monk Gervaise, the monks at Canterbury interviewed a number of builders before engaging a Frenchman, William of Sens, to design and build the new choir. His work introduces French Gothic spatial integration to England, while preserving many traditionally English structural and decorative details. Gervaise's year-by-year description of the work is the only such account to survive from the Middle Ages. It not only provides valuable information on the process of construction, but also emphasises the importance of the master in directing operations. Gervaise describes how William of Sens fell from the scaffolding and was 'sorely injured'. He completed the building season by directing the work from his bed, but, as his health did not improve, he eventually retired to France and was replaced by a second master, also named Wil-

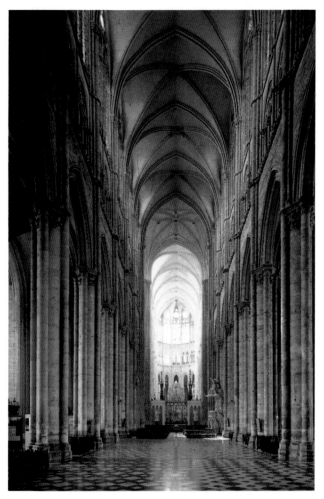
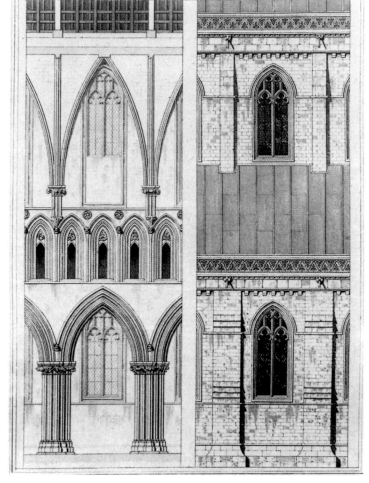

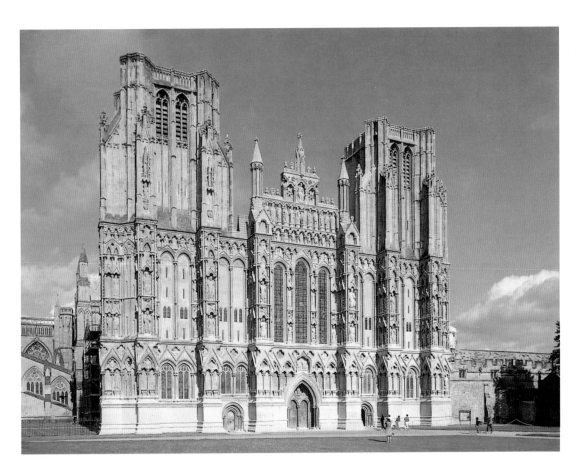

124. *Wells Cathedral.*
Façade, begun c.1175.

liam, and known as 'the Englishman' to differentiate him from his predecessor. It was he who designed and constructed the new shrine for the martyred archbishop Thomas Becket, who had recently been canonised. Interestingly there are far fewer native English decorative details in the design of William the Englishman. His work, dedicated in 1184, exhibits an awareness of the latest French style, as can be seen from the rudimentary flying buttresses on the exterior and the capitals on the interior.

It was the builders of Wells Cathedral, begun around 1175–80, who created the first distinctively English statement of the Gothic style. The cathedral was constructed on a new site, unimpeded by previous buildings, and the work carried out up to the dedication in 1257 displays remarkable regularity. The original plan consisted of a three-bay choir flanked by aisles and square ambulatory, with probably a single chapel opening to the east; a square crossing topped by a lantern tower, with three-bay transepts and a ten-bay nave. The layout and dimensions of the elevation (pl. 123) are based on a square and on the relationship between the sides of the square and its diagonals. These relationships determined the width of the nave and aisles in relation to the height, as well as the square of the

crossing and other important measures.

We encounter the concealing linear effects characteristic of Wells in the broad, expansive screen façade (pl. 124), which is divided into clearly defined horizontal zones by a marked difference of surface ornament. There could hardly be a greater contrast than that between the lower zone with its multiple gables and the upper zone with its stacked niches and tall tracery screens wrapped around the heavy, projecting buttresses and covering the wall planes between them. The smallness of the entrances has been linked to the introduction at Wells by 1218 of the liturgy of Sarum (now Salisbury), specifically the liturgy for Easter, one of the few special occasions in the church year when the west door was open. Choristers were positioned behind openings in the passage just above the door to sing important processional portions of the liturgy. The façade, which was designed by a later builder, perhaps Thomas Norreys, achieves a sense of balance between the horizontals and the verticals, between the sense of surface and the denial of mass and flatness that represent the most original English contributions to the Gothic.

The continuing fascination with spatial illusionism at Wells finds expression in the incredible thinness and lightness of the Lady Chapel

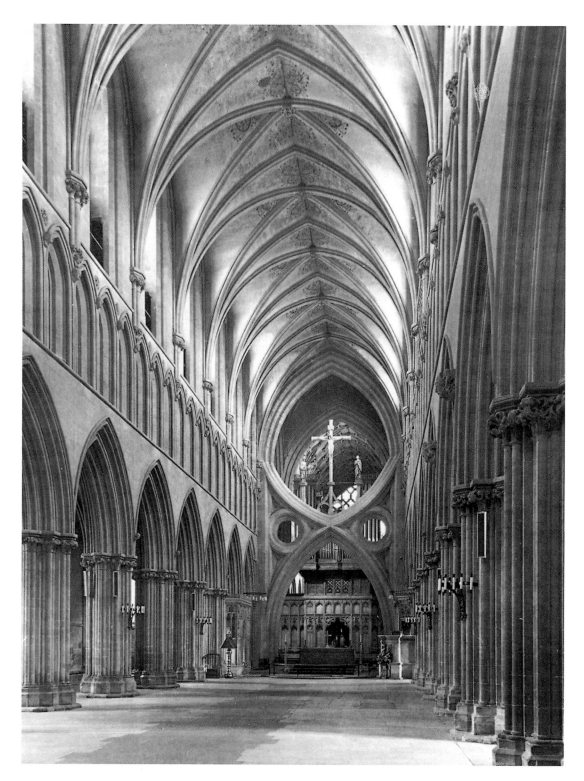

WELLS CATHEDRAL

Wells represents a particularly English interpretation of the Gothic style. Structurally, the basic design follows the three-storey elevation of Anglo-Norman Romanesque, but Wells (begun c.1175–80) is one of the earliest Gothic buildings to employ segmental or pointed arches throughout and to demonstrate the Early English gothic interest in the elaboration of surface patterns; these suggest layers in depth yet by their very profusion distract from the massiveness of the walls they cover (which are over 2 m thick).

English builders developed elaborate illusionistic effects – as in the nave at Wells (*left*) – that create a sense of almost infinitely expanding space. The illusion of length is extended by the repetition of identical bay units and by the uninterrupted horizontal layers which further multiply the number of units.

The illusionistic effect of layers of ornament makes it virtually impossible to identify the limiting surface of the wall. The nave is extended to considerable length but the handling of the surface suggests expansion in depth. These effects are heightened by the fineness and thinness of the multiple shafts and bands of mouldings that envelop the arches and piers, and by the layers of concentric moulding framing the narrow ventilation slots of the second storey. The deep undercutting of groups of shafts and mouldings, like the vigorous carving of the magnificent stiff-leaf foliage in the capitals, creates strong contrasts of light and shade, which focus attention on clusters of shafts and thereby emphasise the linear quality of this ornamentation and detract from the sense of surface planes.

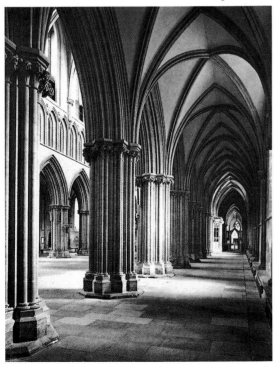

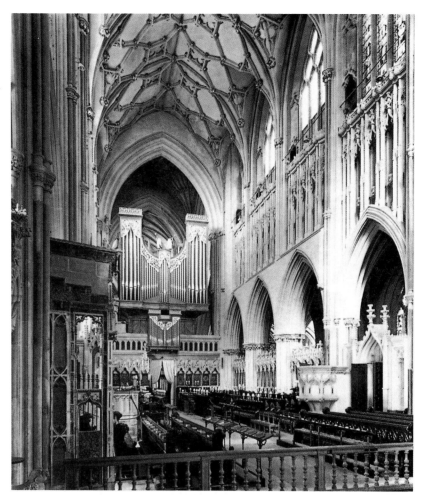

All of these tendencies culminate in the multiple lines of the vault ribs, which create a unifying, protective canopy over the entire length of the nave. The strainer arches added to reinforce the crossing tower only date from the fourteenth century. Thus the spatial flow was not originally restricted to the nave, but included the choir as the appropriate focus.

The illusion of spatial unity is continued in the choir (*above*), where the multiple angled lines of the ribs of the net vault spin out over the surface in a profusion of geometric ornament and pattern. This vault, built by William Joy, ties together the original twelfth-century choir and his extension (dating from the second quarter of the fourteenth century) into a single space. Bay divisions and stylistic differences disappear under the unifying spatial canopy.

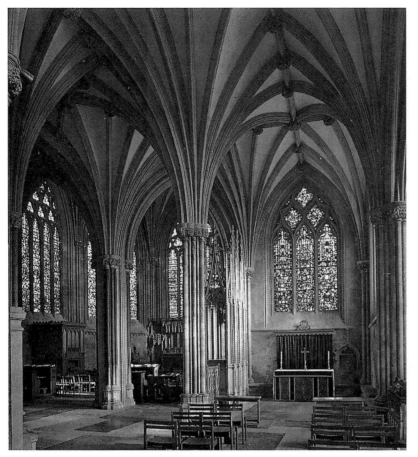

and retrochoir (pl. 128) built in the Decorated style (the English equivalent of the French Rayonnant) by Thomas of Witney in the early fourteenth century. The Lady Chapel was built on an irregular polygonal plan, but all trace of the irregularities disappears under the impact and presence of the magnificent star vault that covers it. The lines of the vault ribs, constructed with a sure sense of solid geometry, create a strong centralising effect comparable to that of a dome. To add to the spatial complexities, the western end of the Lady Chapel penetrates the space of the retrochoir. The angled and diagonal lines create a vivid series of viewing angles, which suggest overlapping, interpenetrating layers of space. The effect of the narrow, attenuated supports and fine mouldings is heightened by the delicate, lacy window tracery and web-like vaults. The multi-directionality of the architectural lines and the interpenetrations of space carry illusionism to extremes of refinement rarely equalled, even in the Perpendicular style so noted for its delicacy.

St Hugh's Choir at Lincoln Cathedral (pl. 129) is the other acknowledged masterwork of the Early English style in the twelfth century. Here, out of the most strikingly varied set of piers, the most unusual coloristic effects in masonry and

the most extraordinary variety of stiff-leaf foliage, one of the most original builders of the period constructed, for a very demanding patron, one of the most original of buildings. The walls of the choir, begun in 1192, are covered with layers of pattern of such exquisite variety that earlier generations of scholars were convinced that they came from different phases of construction. In fact, they come from one immensely fertile imagination determined to erect the most richly varied and extraordinarily illusionistic liturgical space in all Europe.

The final phase of the Gothic style in England is known as the Perpendicular after the overwhelmingly vertical nature of the fine network of ornamental tracery that covers every available surface of wall and vault, as at King's College Chapel, Cambridge (pl. 130). King's College Chapel also has some of the finest surviving fan vaults, themselves a distinguishing characteristic of the Perpendicular. Seen from below, fan vaults appear to be giant half-cones set against the outer walls. They are connected by arches that rise from the floor, but separated by flat panels between the semicircular perimeters and the rectangular shapes of the vault units. Generally, fan vaults are constructed of thin panels carefully shaped to fit into place, but with little regard for following the lacy mouldings that ornament their surfaces. The whole appearance of King's College Chapel, with its slim, narrow proportions, tall thin windows and lofty longitudinal space, is unified by the fan vaults. Innumerable panels of

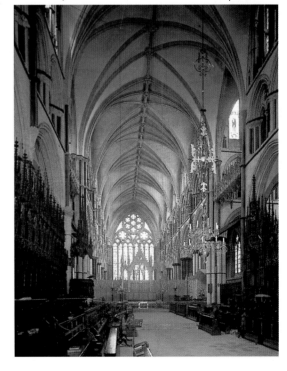

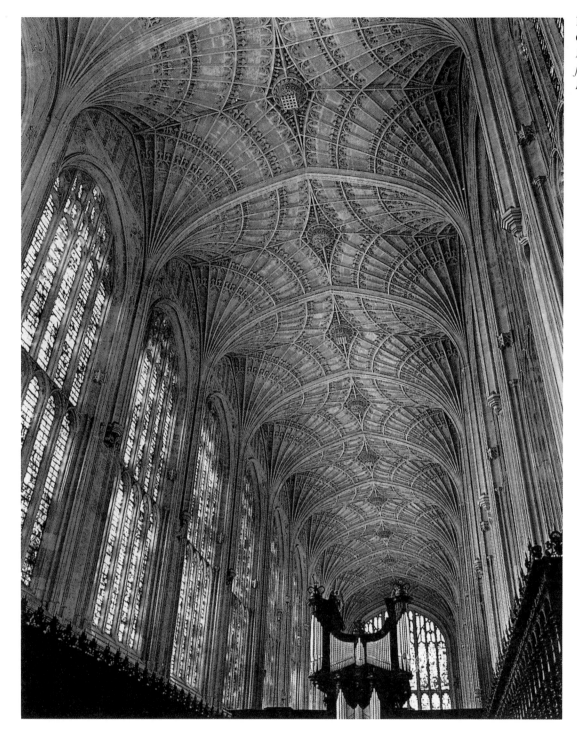

130. *King's College Chapel, Cambridge, 1446–1515. One of the finest examples of the Perpendicular style.*

moulding cover wall and windows as well as vaults, lending a feeling of delicacy to the whole vast structure. The contrast between the smallness of the ornamental units and the largeness of the space continues that very English interest in architectural and spatial illusionism that began with the first English essays in the Gothic style.

The last phase of continental Gothic offers parallels to the English Perpendicular, although there are now many different national variants, from the French Flamboyant to the distinctive hall churches of Germany, the fairy-tale mirages of Bohemia, the vast monospatial giants of Catalonia, and the intensely mystical structures of southern Spain. This late, highly illusionistic phase of Gothic continued right into the sixteenth century in northern Europe, well after the beginnings of the new currents that marked the Renaissance in Italy and in Flanders.

5

THE EARLY RENAISSANCE IN ITALY

JOHN WHITE

INSET 131.
LEONARDO DA
VINCI: Man in His
Ideal Proportions,
c.1487. Gallerie dell'
Accademia, Venice.

OPPOSITE 132. PIERO
DELLA FRANCESCA:
Resurrection, *1463–65.*
Fresco in Pinacoteca
Comunale, Borgo S.
Sepolcro.

There is no better single image of the hopes and aspirations of the rapidly changing medieval world from which the arly Renaissance sprang, and within which it continued to have its being, than the fresco *The Well-Governed Town and Country* (pls 133-6) which Ambrogio Lorenzetti (active 1319–47) painted in the Palazzo Pubblico, the town hall of Siena, in 1338–9 next to his purely medieval *Allegory of Good Government* and opposite the *Allegory and Effects of Tyranny*. The composition radiates in all directions from the centre of the city where the maidens dance in all their silken finery. From this focal point, buildings and figures alike diminish, not only directly into depth, but out to left and right and on into the far reaches of the distant landscape. It is likewise from this centre that the lighting of the composition radiates.

This fresco, like the vast majority of the works of the next century and a half, however beautiful and immediately appealing in and for itself, can only be appreciated to the full when seen within its context. Physically that context has, in this particular case, remained substantially intact and needs no reconstruction. To the right, a window still provides a panoramic, bird's-eye view, over the rooftops far below, towards just such a distant countryside. In front of the Palazzo Pubblico, the city of Siena still climbs steeply up beyond the shell-like Campo, or main square, towards the great cathedral that then was, and

still now is, the centre of the city's religious life. The room itself in which the fresco stands was once the inner sanctum of the Nine, who were, under the stern gaze of the *Madonna and Child Enthroned with Saints and Angels*, which Simone Martini (active 1315–44) had painted in 1315 on the wall of the grand council chamber next door, the supreme, elected rulers of the city.

As the first surviving panoramic land- or cityscape to have been painted anywhere in Europe since antiquity, Ambrogio's fresco is a presage of the new, increasingly secular world of the Renaissance, which still lay over half a century away into an unseen future. The revolutionary naturalism of the scene is such that it is easy not to realise that it is much more than a well-composed, wide-angle snapshot. The centring of the composition in the town accentuates the physical domination over the surrounding countryside for which Siena, like so many towns in Italy, had been fighting for a century or more and which it had now finally achieved. The emphasis on trade and commerce is exactly expressive of the gathering momentum of the move away from a feudal, country-castle dominated world of landed nobility and toiling peasants, largely dependent on the bartering of services and goods, to one in which, in cities such as Florence and Siena, a rich, urban middle class, which had fought its way into control, was by now already having to struggle to retain its power against the

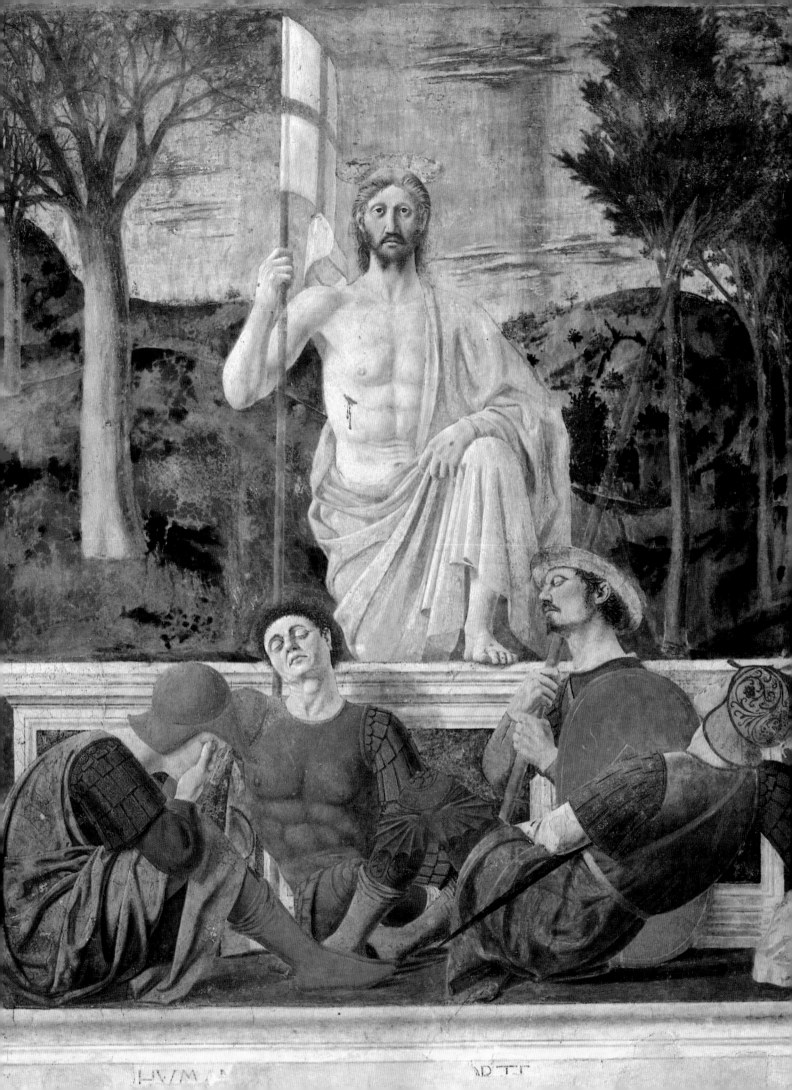

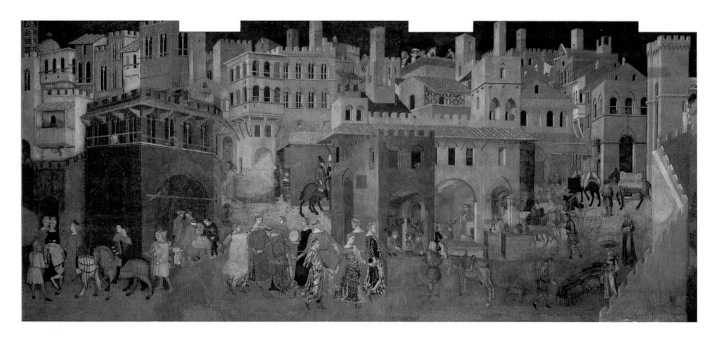

AMBROGIO LORENZETTI, THE WELL-GOVERNED TOWN AND COUNTRY

This fresco (1338–9) in the Sala di Pace of the Palazzo Pubblico, Siena, demonstrates Ambrogio's extraordinary achievement and the speed of early-fourteenth-century artistic development. No earlier pure landscapes have survived except for two tiny panels (27 × 40 cm) which he probably painted himself a decade or so previously. The contrast with their bird's-eye views and doll's-house architecture could hardly be greater.

The dancing maidens at the centre of the city hint at the lost glories of late medieval textiles. Paintings like this are now the only substantial record of the materials themselves and of the cut and composition of the clothing. Real or imagined, there can never have been a more exciting textile than Ambrogio's dragon-fly design, with its enormous insects set in contrast to the plain cloths, tiger stripes and abstract patterns of the other dresses (*detail above*). Indeed, the real and the ideal continually merge. There were strict sumptuary laws in fourteenth-century Siena to control dress, safeguard modesty and restrain public ostentation

and displays of wealth. Moreover, dancing in the streets was not allowed.

The city itself is a mine of information. Stone and brick survive the centuries, but the wooden balconies and overhanging upper storeys, together with their wooden struts, have all but disappeared, as have the outdoor frescoes which adorned innumerable walls and terraces (*detail far right*). Gone also are most of the town towers which once made every medieval town resemble a stone jungle. Today only a few examples, such as nearby S. Gimignano, give us some idea of the excitement of a medieval skyline. The towers were city fortresses, the final rallying point and refuge for the extended families and clan groupings which continually fought for dominance. They were mostly razed by statute, or cut down to the general roof-line of the streets, as each commune sought an end to internecine strife.

The manner of their building is shown by the climbing scaffolding on which the labourers toil (*detail far right*). The height and scale of many civil and religious structures made it quite impractical to build up timber scaffolds from the ground. The buildings rose upon themselves and the

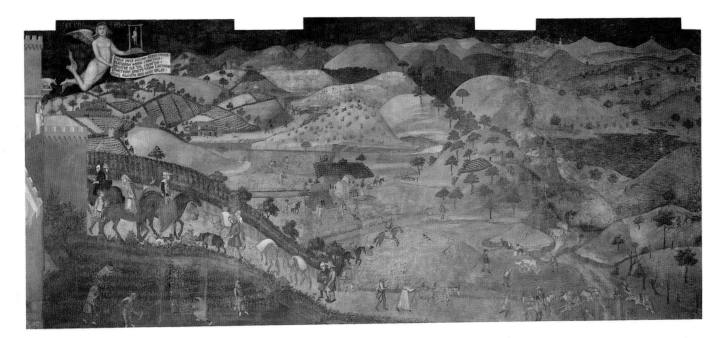

cranes and tackles used to lift large statues or masonry blocks were raised stage by stage to stand on the unfinished walls. For more straightforward and, particularly, brick-built structures, put-log holes were left breast-high in which to thrust supporting timbers for the planking at the following level, to be reached by a short ladder. Then, as the fresco shows, the beams and planking were successively withdrawn, leaving the unfilled holes available for maintenance purposes. A myriad such put-log holes still march across the face and up the soaring bell-tower of the Palazzo Pubblico.

Fresco painting was a continuation of the building process, involving different trades and labourers to make the scaffolding, roughen the walls to take the underplaster or *arriccio*, prepare the slaked lime with which it was mixed, and do the plastering. The master painter would have assistants or *garzoni* for grinding and mixing pigments, and for a major commission might bring in additional apprentices and even established masters to help with the actual painting.

To limit damage, work invariably moved downwards by stages. In true or *buon fresco*, the *arriccio* often carried a boldly sketched-in underdrawing or sinopia. This was then covered over as the final layer of plaster, the *intonaco*, was laid on in successive patches or *giornate*, each sufficient for a day's painting. The earth pigments, again suspended in lime water, were applied when the plaster was still moist. Then, in drying, chemical reactions bonded paints and plaster to create an extremely durable surface. Since alterations were impossible in the moist plaster, accuracy was as vital as speed as each successive stroke was laid on, building and following the form in a stroke pattern strictly similar to that left by the brushes of the miniaturists and the panel painters or by the toothed chisels of contemporary sculptors.

Since colours such as azure blue, vermilion or verdigris could not be mixed in lime water, they were applied *a secco* in an organic glue, often of egg-yolk, as in tempera painting upon panel, after the plaster was dry. This left the pigment as a superimposed layer, which was much more liable to flaking that the chemically bonded *buon fresco*. Ambrogio, probably working with a small team, used this technique in the Palazzo Publico.

137. GIOTTO: The
Trial by Fire,
*c.1315–20. Fresco in
Bardi Chapel, S. Croce,
Florence.*

ambitious lesser merchants and tradesmen rising from below.

In the well-governed town, the lecturer is at his desk, the hosier at his counter and the taverner at his outdoor bar. Outside the walls, the countryside is teeming with activity. There are the tilling and the pruning of the vineyards and the threshing of the wheat. The hunted hare, the huntsmen and hunting dogs are there, as are the peasants coming into town with their grain-laden donkeys and their saddleback pigs. All of the warm months of the year, from March to September, seem to have been represented. Beneath the wings of peace, each individual beauty has its own significance, each anecdote its meaning.

This whole, casual-seeming natural world may well reflect the seven mechanical arts, which, as the counterpart of the seven liberal arts, encompassed – indeed, somewhat uncomfortably compressed – the multifarious activities of the workaday world. The liberal arts themselves covered the intellectual fields of learning and of education in literature and science, through the trivium of grammar, dialectic and rhetoric, and the quadrivium of arithmetic, geometry, astronomy and music, all of which are figured in the series of quatrefoils incorporated in the fresco's

borders. These categories of secular activity were set against, indeed subordinated to, the seven Christian virtues, headed by faith, hope and charity, and focused on the life of every individual and all of them personified in the *Allegory of Good Government*, to which Lorenzetti added, with characteristic originality, such civic 'virtues' as peace and concord, magnanimity and the common good. The town and landscape seem to be the culmination of a revolutionary effort to encapsulate the whole encyclopaedic, medieval system of ideas with its ordered categories of intellectual, spiritual and physical activity.

The entire fresco is a dream of peace and order set within a warring world of feuds and faction fights, of urban insurrection and of rural pillage. Within ten years, only the dream upon the wall remained. Ambrogio was dead and half of Tuscany died with him in the plague of 1348, which was itself only the greatest and most cataclysmic of recurrent waves of pestilence which swept across the face of Europe in the later Middle Ages. Death, and the images of death, were everywhere from Pisa to Palermo. The frescoes of its triumph in the Pisan Campo Santo are a world away from the quiet, analytic exploration of the means of giving visual immediacy to the gospel

stories and the lives of the saints which had occupied such men as Giotto (documented 1302–37) in the first third of the century.

During those three decades sculptors and painters alike had been in the process of creating a new pictorial language which, in clarity, in flexibility and above all in poetic power, was the counterpart of the revolution in the written language which was being brought about by Dante. The sculptured pulpits in Pisa and Pistoia by Giovanni Pisano (doc. 1265–1314), Duccio's altarpiece, the *Maestà*, for the cathedral of Siena, Giotto's frescoes in the Arena chapel in Padua and in the Bardi and Peruzzi chapels in the Franciscan church of S. Croce in his native Florence, all contributed. The latter were the chapels to which men such as Raphael and Michelangelo came two centuries later to make drawings and to learn the fundamentals of their trade.

The new pictorial language is epitomised in Giotto's fresco *The Trial by Fire* (pl. 137), in which St Francis, seeking to convert the sultan and his people, challenged the Muslim religious leaders to a test of faith. The action has been set within a clear but shallow space. The simple weight and volume of the clearly constructed figures, as they stand upon the solid, horizontal platform of the ground, are enlivened by the looping Gothic folds of the draperies held up to shield the Muslims' faces in their shame. As they slink away, despite the urging of their statuesque retainers, the bulky figure of St Francis on the right is on the verge of moving forward to the flames. The sultan at the centre, high upon his throne, is made the fulcrum of the whole design. The eye moves back and forth from left to right and right to left to see which way the scales will tilt. The timeless moment of decision has been caught and held in paint upon a wall.

No single fresco can epitomise, however, the organisation of the narrative cycle as a whole. The fertile visual interactions as the story moves from scene to scene over the surface of the individual wall or across the intervening real space from one side of the chapel to the other; the linkage of the painted framework to the architectural structure of the building itself; the division of the story into visually defined chapters, the creation and co-ordination of narrative and formal climaxes – nothing of this can be experienced to the full except by actually being there, surrounded by the resonating world which architect and painter have collaborated to create.

The Dominicans and Franciscans were the passionate preachers of late medieval Europe. They used their words to captivate the minds and tug at the emotions of the faithful, rich and poor alike. In Italy in general, and in Tuscany in particular, they aimed, above all, at the new, wage-earning masses growing up within, and flocking into, each of the expanding centres. It was for them that painters such as Giotto and Duccio (active 1278–1318), and sculptors such as Giovanni Pisano, sought and found new ways to bring the sacred stories into vivid life, trying to make them feel that they were actually there, participating personally in those great spiritual events.

But it was also for their actual patrons that they worked. In Padua, in the Arena chapel in 1305–13, Giotto had been commissioned by Enrico Scrovegni to decorate a building almost certainly erected, at least in part, in expiation of the sins of usury on which the family fortune had been founded. The Bardi and Peruzzi, who commissioned Giotto's frescoes in S. Croce, were, like many of those behind the building and decoration of the churches for the urban poor, men of enormous riches. It was the danger to their own immortal souls, inherent in their wealth and in the manner of its earning, against which the great Franciscan preachers in S. Croce itself so constantly and powerfully inveighed, which led so many to spectacular attempts at expiation in their wills and in their lifetime gifts to charities and to the church.

EXPANSION AND COMPETITION

A fundamental aspect of the new economic expansion was the jealously guarded purity of the Florentine coinage. The golden florin, first minted in 1252, had been established by the early fourteenth century as the common trading currency of Europe. The Bardi were bankers to the papacy and their financial empire stretched from the Angevin kingdom of Naples in the south to Flanders, France and England in the north. The position of the major Italian trading-centres as the middlemen upon the Mediterranean trade routes to the East, established during the twelfth century, had been reinforced in the fourteenth by the massive expansion of the wool-based European textile trade. In the process, Tuscany became a centre for the associated finishing and cloth-manufacturing industries.

This, together with the fourteenth-century eclipse of its great Tuscan rival, Siena, for lack of adequate supplies of water on its hilltop site, was a major factor in the transformation of Florence from one of innumerable, feuding, local city states into a power in Europe. When, in 1427, the Florentines inaugurated a universal, graduated

OPPOSITE 139.
ARNOLFO DI
CAMBIO: *Nave of S.
Croce, Florence, Founded
1294–5.*

138. BERNARDO
ROSSELLINO: *Tomb of
Leonardo Bruni, c.1445–
50. S. Croce, Florence.*

property tax, some 38 per cent of the heads of working families in the Florentine territories – which, by that time stretched from Pisa and Livorno on the coast to Prato and Pistoia in the north, to Arezzo and Cortona in the south-east, and as far as Montepulciano to the south – were active in the textile industries.

Indeed, the economy of republican Florence, with its merchant-dominated government, was so firmly based in the interlinked, expanding worlds of commerce, industry and banking that none of the mid-fourteenth-century calamities could shake it. Neither the collapse of the Bardi and Peruzzi banks when Edward III of England defaulted on his enormous continental borrowings, secured by liens upon English taxes which were used by the Florentines to finance their purchases of English wool, nor the universal

cataclysm of the Black Death, was enough to bring it down. The immediate halving of the population of Florence, which succeeding waves of pestilence reduced from its early-fourteenth-century peak of over 100,000 to something under 40,000 by the early fifteenth century, only served to concentrate existing wealth and to increase the opportunities for commercial and territorial expansion for the survivors.

Nowhere is this fundamental continuity better embodied than in S. Croce (pl. 139). Its architecture, with its flat wall surfaces, its pointed arches and the crisp, prismatic forms of their supports, is pure late-thirteenth-century Italian Gothic. To walk towards the choir, with its late-fourteenth-century frescoes and stained-glass windows by Agnolo Gaddi (d. 1396), flanked by Giotto's *Stigmatisation of St Francis*, and to watch the chapels gradually opening out to either side, their openings finally creating a kind of architectural altarpiece from which the structural pattern of the actual altarpieces on each altar is derived – this is to see and feel the world as it once was upon the threshold of the Renaissance.

With the tomb of Leonardo Bruni (pl. 138), chancellor of Florence from 1427 to 1444, we can cross that threshold without ever leaving S. Croce. The monument, by Bernardo Rossellino (1409–64), is, in itself, a wordless combination of the Christian and the Classical. Bruni lies upon his bier, supported by the Roman eagles and surrounded by a wealth of Classical detail, his hope of Heaven in the roundel of the Virgin and Child above his head. Here is the Florence of the humanists; of the knowledge and the wisdom of the ancient world. They were the heirs of Petrarch; men who sought to replace the dog Latin of the Middle Ages with pure Ciceronian Latin. But they were not just Latin scholars. They also turned back to the origins of Western thought with the great Greek philosophers. Bruni himself translated Aristotle's *Ethics* and *Politics* and also several of the works of Plato which had hitherto been inaccessible to Latinists. He also wrote a history of the Florentine people running from antiquity to his own day. Although the span is similar and the parallels are many, the contrast with the chronicle in the vernacular which the banker Giovanni Villani had written in the years before he perished in the Black Death could hardly be greater. In its literary elegance and continuity and its critical use of original sources, together with its awareness of cultural development, Bruni's *History* put historical writing on to a wholly new footing.

The sense of history, of the distance and the separateness of the past, and the desire to understand it, to learn lessons from it and to use it as a potent weapon in contemporary politics, were as important as the emphasis on the antique in the formation of the Renaissance. It is clear that the tyranny of the Visconti in Milan and the struggle to contain their inroads into Tuscany lie behind Bruni's arguments, in his *De Militia*, for a citizen army to replace dependence on the roving, mercenary bands of the *condottieri*, but the extent to which they also influenced his new emphasis on liberty and on specifically republican, as opposed to imperial, Roman history is still a matter for debate. The accent on the furtherance of the well-being of society at large is not.

The artistic life of that society at the beginning of the fifteenth century was powered by civic competition. This was no revolution in itself. The cityscape of Florence had, throughout the fourteenth century, increasingly been dominated by the new cathedral rising up inexorably at its heart. For half a century it grew, like an invading organism, round and through the Romanesque cathedral of S. Reparata. The latter was not finally engulfed and then destroyed until after 1357, when walls were still having to be breached without endangering the roof of the original structure, and a jumble of medieval houses was still standing within the area of the present choir. It was only then that the precise dimensions of the nave, which differed radically from those laid out by the original architect, Arnolfo di Cambio (d. 1302–10), were settled by a full commission. At no point was there any thought of slavishly adhering to an overriding master plan. As each new problem, each new phase of building, was encountered, then and only then were matters finalised. As the work continued, competitions, involving not only detailed drawings, but also models in plaster, wood and stone, were held to decide the exact form of such things as the bases and capitals for the main piers of the nave or the shape of the upper windows. Indeed, it was only in 1368, after three separate advisory panels of sculptors, goldsmiths and painters had been called in, followed by a unified commission of twenty-five painters, sculptors, goldsmiths, architects and laymen, that the form of the church as a whole was finally settled on the basis of the present four-bay nave instead of the earlier three-bay design. The final decision – and this is what makes Florence such a special case – was not left merely to the experts. It was only after the citizenry at large had formally been called in to record their opinions that a decision in favour of

the commission's proposals was taken and the destruction of all competing models, some of them in stone, was ordered.

If the passionate involvement of the citizenry as a whole in architectural and artistic affairs was a settled feature of Florentine city life, the actual engine driving the process at the beginning of the fifteenth century was competition between the guilds and competition between the artists commissioned by them. In most of Europe, separate guilds for each and every occupation tended to proliferate in the late Middle Ages. In republican Florence, on the other hand, large groups of specialisms remained under the shelter of a single, overarching organisation in which the mass of craftsmen were politically controlled by the financial leaders of the trade or industry involved. Thus it was that in 1330–1 responsibility for supervising the construction of the cathedral was handed over to the Arte della Lana, the guild of the wool and cloth-manufacturing industry. The latter, along with the Arte del Cambio, the bankers' guild, and the Arte di Calimala, the guild of the finishers and wool and cloth importers and exporters, was the richest of the consolidated corporations, which, in their turn, by means of their seemingly democratic but actually oligarchic structure, ensured patrician control of the city government itself.

It was the Calimala which, in 1401, set in train the most famous, and perhaps most characteristic, of all the great artistic competitions of the period. What was at stake was the commission for a second pair of bronze doors for the Baptistry. The new doors were to feature New Testament scenes, to complement the pair with the Life of the Baptist which Andrea Pisano (doc. 1330–48) had completed in 1336. The fact that we still know so much about the competition is in itself a reflection of the new Renaissance ways of thinking. It is not merely that Vasari, the first, and arguably the greatest, of all art historians, recorded the story in his mid-sixteenth-century *Lives of the Painters, Sculptors and Architects*. Lorenzo Ghiberti (1378–1455), the goldsmith-sculptor who won the competition, also gave his own version of events in a highly contentious and combative autobiography largely directed against Filippo Brunelleschi (1377–1446), his most bitter rival amongst the seven chosen finalists from various parts of Tuscany. It is also typical of new attitudes to art that, instead of being destroyed, as would previously have been the case, the competition reliefs of the Sacrifice of Isaac by Brunelleschi and Ghiberti were preserved.

What would have happened to the history of

THE EARLY RENAISSANCE IN ITALY

early-fifteenth-century sculpture if Brunelleschi had been the winner is one of the more intriguing might-have-beens of the history of Renaissance art. In the event, his defeat was instrumental in converting him from goldsmith-sculptor into the greatest of all the practising architect-builders of the period. In his relief (pl. 140) he uses the ass and the two young men of the biblical story as the base of his design and concentrates on the human and superhuman drama of the action. In this he is the heir of Giotto and the forerunner of Michelangelo, with whom he shares a disdain for all but the very minimum of geographical description. As the flames begin to lick out of the altar furnace, Abraham strides forwards, urgency expressed in every line of flying drapery. He wrenches Isaac's head as if he were some struggling sacrificial animal. His knife is at the boy's throat as the angel rushing through the sky seizes his wrist to stay his hand. The straining Isaac's legs seem to reflect the running pose found in the central roundels of fifth-century BC red-figure cups of the kind which were so often brought to Italy from Greece by the Etruscans. They also

call to mind one of the many memorable images in Giotto's masterpiece, the fresco decoration of the Arena chapel in Padua: the infant in the *Massacre*, for ever fleeing from the sword thrust and for ever held immobile at his mother's breast. Then again, the ram, trying to kick its horn free from the entangling bush, is drawn directly from an ancient prototype, and so, despite his Gothic draperies, is the left-hand figure of a servant squeezing out a thorn.

Ghiberti's version of the scene (pl. 141) betrays an almost totally contrasting attitude. There is none of Brunelleschi's intensification of the inherent drama. The angel, following the biblical narrative more closely, calls to Abraham and does not seize his wrist. Abraham's knife is still held back in preparation for the thrust and not caught in mid-action at the very throat of Isaac. Isaac's pose is static. Both his knees are anchored to the altar. Here, in a figure still more clearly taken from antiquity than anything in Brunelleschi's entry, what is presented is not violence, but an anatomical display of youthful grace, as graceful as the ram, so calmly caught and signally at

BELOW LEFT 140. FILIPPO BRUNELLESCHI: Sacrifice of Isaac. *Competition relief, 1401–2. Bargello, Florence.*

BELOW RIGHT 141. LORENZO GHIBERTI: Sacrifice of Isaac. *Competition relief, 1401–2. Bargello, Florence. It was Ghiberti's relief that won the competition for the Baptistry doors and effected Brunelleschi's change of career from goldsmith-sculptor to architect.*

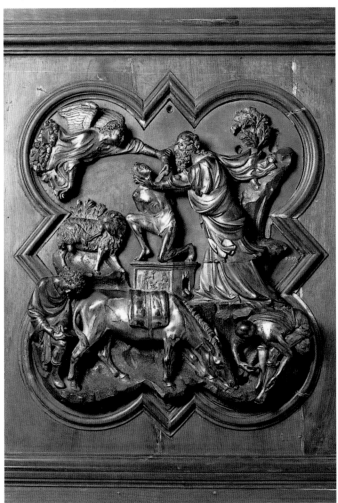

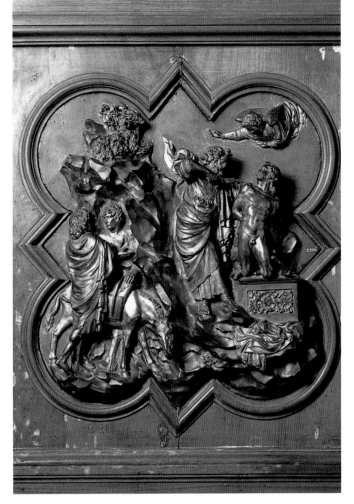

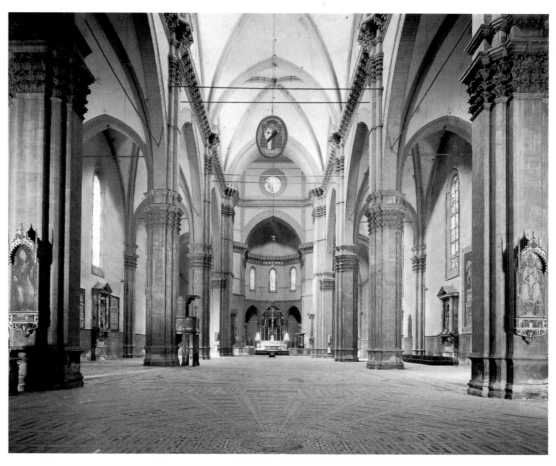

rest. Isaac is poised and posed as carefully as is the swaying line of Abraham's body as it gracefully accentuates the curve of the nude torso. In the process of embodying the physical description of the mountain at the foot of which the Bible says the servants waited, the great diagonal shaft of rock performs a unifying and dynamic function in the compositional economy of the relief. At the same time, its actual forms, such as those of the left-hand figure's looping draperies, are redolent of the decorative, international Gothic style which provides the context for the upsurge of Renaissance art in Florence.

If Brunelleschi was the loser to Ghiberti in this first great fifteenth-century artistic competition, he was eventually victorious over him in the second, no less bitter, conflict which raged back and forth for several years before the commission to build the dome over the crossing in the cathedral was assigned in 1420. The detailing of the existing structure (pl. 142), with its wide, flat surfaces of wall and the crisp, planar forms of the supporting piers – their sharp angles streaming upwards to support the arches of a nave arcading notable, like that in S. Croce, for the absence of a single rounded moulding – was, despite its Gothic flavour, ripe for the Renaissance. As the

massive body of the building gradually assumed its final shape in the first two decades of the century, it must have been a quite extraordinary sight to see the vast gape of the crossing opening up within it. For half a century there had not been an architect in Europe, let alone in Italy, who could have had the foggiest idea of how to solve the structural problems which would be involved in covering it. It is also typical of the period, as it had been of the preceding centuries, that when a man was needed he was found.

The octagonal internal form of the dome, deriving from the nearby Baptistry, was, of course, already dictated by what had previously been built, and the vertically accentuated outer shell and soaring ribs (pl. 143) devised by Brunelleschi provided an awe-inspiring climax for the building. Only in Rome were structures on a comparable scale to be found, and it had been to Rome that Brunelleschi had gone to study and to seek solutions to the problems which he hoped that it might eventually fall to him to solve. His initial problem when he was indeed appointed, and his opening triumph, was to devise a form of scaffolding which could be started, not at the ground, but at the top of the drum, some 56 m overhead. It would have been quite impossible to have filled

so great a space with a forest of timber strong enough to support not only its own weight but also that of the cupola as it was being built. Brunelleschi's second technical achievement was to ensure that the dome was actually self-supporting during its construction. This was done by laying the brickwork in a herring-bone (*spinapesce*) pattern in which the horizontal courses are regularly interrupted by a series of vertically laid bricks which provide a kind of internal skeleton, locking the horizontal rings in place whilst the mortar is setting. The fact that, but for the first few courses, made of stone, brick was used throughout served in itself to minimise the weight of the whole vast construction. But even that was not enough, and Brunelleschi's final master-stroke was to devise a double skin which served immediately to solve the problem of access, both for building and for subsequent maintenance, whilst the massive ribs which bound the inner and the outer shells together ensured its strength and structural stability.

In short, the final form of Brunelleschi's dome arose not so much from the imposition of some external aesthetic as from a brilliantly inventive accommodation to structural imperatives. Indeed, it was only in the Classical forms of the surmounting lantern that his stylistic reaction to the splendours of antiquity were given rein.

What Brunelleschi chose to do when he was freed from the constraints of an existing structure and of massive engineering problems can be seen in the delicate, free-running lightness of the forms in the Ospedale degli Innocenti (Foundling Hospital), on which he had begun work a year earlier, in 1419 (pl. 144). The scale is anything but Roman, and the omnipresent arch-on-column motif, both of the external colonnade and of the internal courtyard likewise owes less to antiqui-

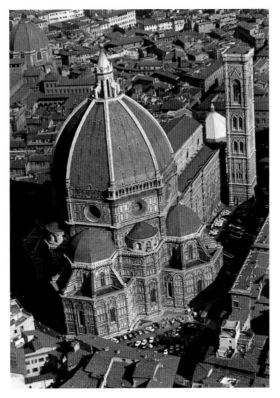

143. *Cathedral of S. Maria del Fiore, Florence, with Brunelleschi's massive dome, 1420–36, and lantern, after 1446.*

ty than to twelfth-century Tuscan Romanesque. The very nature of the building, with its ordered ground plan and its no less carefully planned enrichment, through its airy loggia, of the broad piazza which it flanks, is expressive of the humanist stress on bringing good from evil, social profit out of monetary gain. It is the very essence of the Renaissance that out of riches there should flow the visible enrichment of the very fabric of the city. Here, in its first flowering, is a reminder that in architecture and in art alike the Renaissance, the rebirth of antiquity, is not a matter of the aping of the outward show, the husk of ancient style. It is no mere copy, but a new crea-

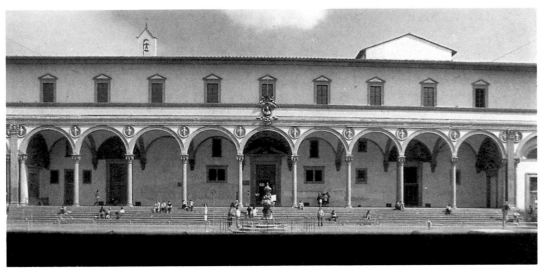

144. FILIPPO BRUNELLESCHI: *Façade of the Ospedale degli Innocenti (Foundling Hospital), Florence. Begun 1419.*

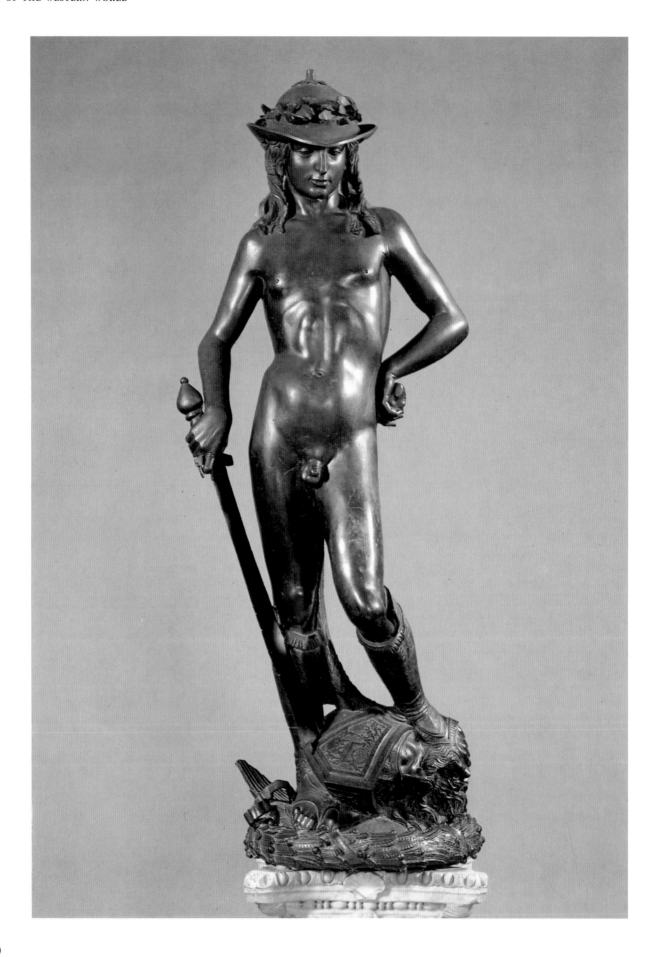

tion based on order and on reason. An understanding of the structural principles underlying outward appearance was the secret that was sought at every turn. Central to this endeavour was the study of the human form, not only for itself, but as a vehicle for the expression of man's spirituality, his individuality and his emotions.

THE NEW SPIRIT IN SCULPTURE AND PAINTING

In sculpture the epitome and the supreme embodiment of this new spirit is the figure of St George (pl. 146) which Donatello (c. 1386–1466) carved for the armourers' guild. It originally occupied a tabernacle on the east side of the church of Orsanmichele, as part of an all-embracing decorative scheme in which each one of fourteen niches was assigned to a different guild and to which all the major sculptors of Florence contributed. The confident, quiet naturalism of the figure and the sense of due proportion are immediately apparent. The whole pose speaks of character and calm determination; of awareness of what must be done. The bare simplicity of the enclosing niche, in contrast to the busy marble encrustation of its fellows, together with the relative smallness of the figure and the space left free above it and to either side, gives visual expression to the silence and to the intense aloneness of the moment that precedes the battle.

The most extraordinary of all of Donatello's linkages of form and fundamental meaning lies, however, in the nudity of his small bronze *David* (pl. 145), which is notable as the first surviving, post-antique attempt to solve the formal problems involved in the creation of a fully free-standing figure. The living, breathing naturalism which Vasari praised, its links with antique statuary and its obvious homosexual connotations have been endlessly discussed. On the other hand, the fact that such a figure of 'St David', king and psalmist, ancestor and antetype of Christ, could not have survived in fifteenth-century Florence unless its startling nudity was justified not merely by an orthodox, but by a primary, Christian meaning, has hardly been addressed. Just such a meaning does exist. It lies in the long tradition, reaching back through St Augustine to St Paul, which treats of the Christian faithful in their confrontation with the force of evil as defenceless but in Christ. In David's nudity Donatello had found the ultimate visual symbol for the central Christian meaning of the struggle with Goliath. It is in this light that the multiplicity of secondary symbolism should be seen. Florence's struggle with the might of the

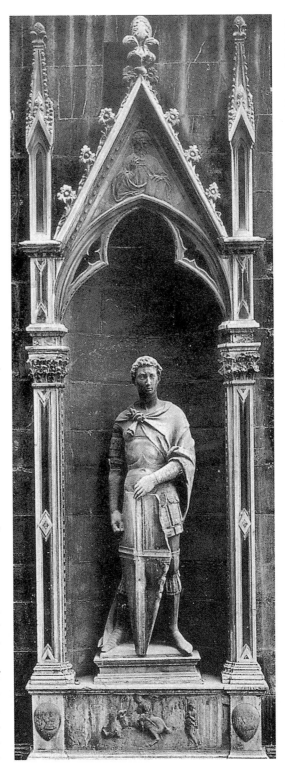

LEFT 146. DONATELLO: St. George and Tabernacle, *c.1416*. *Orsanmichele, (figure now in Bargello), Florence.*

Visconti; the wreath of victory at David's feet; the wing from the dead giant's helmet that caresses David's thigh, expressive of the bonds which link the slayer to the slain – there is layer on layer of meaning to strike home, while the abstract angularities (as they inevitably are to the modern eye) of hand and wrist, arm and elbow, knee and shoulder-blade and back, articulate and control

OPPOSITE 145. DONATELLO: David. *Probably mid-1430s. Bargello, Florence.*

131

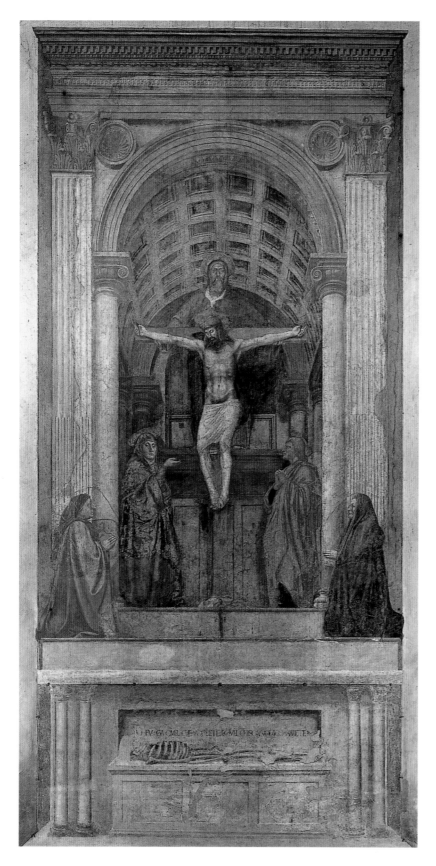

surrounding space and direct the onlooker to quiet contemplation of each aspect of this most attractive of all Donatello's figures, in which the ambiguities and subtleties of arly Renaissance ways of thinking are most memorably embodied.

Alongside Brunelleschi and Donatello, the painter Masaccio (1401–c.1428) is the third of the triumvirate who set Renaissance art in motion and whose names and works epitomise its fundamental unity. The relationship of architect and sculptor is apparent in the very fact that almost every major figure sculpture of the opening quarter of the century was commissioned for the decoration of the cathedral and campanile or of Orsanmichele. The close relationship between painting and sculpture was already clear in ancient Greece, and the primacy of sculpture in the creative reproduction of the human form is still more certain in the late-thirteenth- and early-fourteenth-century prelude to the Renaissance, and again in the first years of the fifteenth century itself. The reason is not far to seek. Where sculptors deal in three-dimensionality as of right, using a solid medium to describe a solid form, painters have to fight at every turn for the appearances of three-dimensionality against the unyielding two-dimensionality of the surfaces on which they work. Nicola and Giovanni Pisano and, above all, Donatello were the men who showed Masaccio the way towards the monumental sculptural solidity which is a primary characteristic of his figure style.

In terms of space, it was Brunelleschi, followed by his fellow architect Alberti (1404–72), who put the all-important representational weapon of a scientific, focused system of perspective in the painter's hand. If all the rules of the new system they created are obeyed, the outcome is an exact reproduction of what would be seen if the surface of the wall or panel were a window looking out upon the real scene. All lines running directly into space recede towards a single vanishing-point exactly opposite the eye of the spectator. Still more importantly, the system is dependent on the creation of a series of precise proportional relationships which link together each and every aspect of the whole design. In spatial terms, the real and the ideal are as indissolubly united as they are in Leonardo's famous image (pl. 131), illustrating a passage from the Roman architect Vitruvius, in which man, shown in his ideal proportions, is set within the perfect geometric forms of the square and of the circle, which, in its turn, is the symbol of the Godhead in whose image man was made. The Neoplatonist philosophers

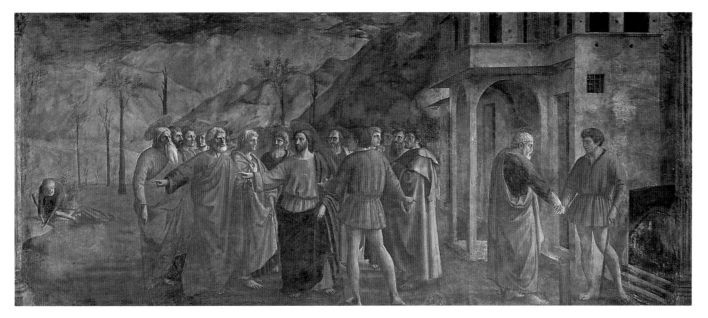

of the Renaissance saw man as unique in the created universe. He was alone in sharing his corporeality with the animals and the material world whilst being, through his soul, united with the immaterial angels and with God himself. In architecture and in art, man was the measure, and proportionality was all.

The power of the new vanishing-point perspective when, for the first time since antiquity, it was combined with all-pervasive, focused, unitary light, directed from a single source, is demonstrated by the fresco of the Trinity (pl. 147) which Masaccio painted in the Gothic church of S. Maria Novella. In it, a skeleton is shown beneath the fictive altar and above it realistic portrait figures of the donors kneel in worship. The monumental figures of the Virgin and St John, and of Christ and God the Father, are set in a no less monumental space in which the relationships of arch and roundel, column and pilaster come, like the perspective system, straight from Brunelleschi. Paradoxically, these architectural forms appear to take on a new grandeur in comparison with their source in the façade of the Ospedale degli Innocenti.

The golden evening sunlight, flooding in through the west-facing window over the altar in the Brancacci chapel in S. Maria del Carmine, seems to provide the single source of light in all frescoes which Masaccio painted on its walls. In the scene of St Peter healing, the saint walks forward, looking neither to the left nor the right. He is oblivious of his healing shadow as it falls on the cripples on the street. For the first time in the history of Western art a miracle can become an inward, spiritual event that needs no physical embodiment, no wide, arm-sweeping gesture, for its consummation. When, as in *The Tribute Money* (pl. 148), the natural light apparently illuminates the monumental circle of apostles centred upon Christ, whose head is made the focus of all the receding lines in the perspective of the buildings on the right, which measure out the space the figures occupy, the outcome is as unforgettable as it is epoch-making.

Yet, for all the transformations that are wrought, much of Masaccio's inspiration lies in work produced fully a century earlier. The figure of St Peter, as he pays the tribute, is no doubt derived from that in Giotto's *Rising of Drusiana* in the Peruzzi chapel in S. Croce. Likewise, it is Giovanni Pisano's famous figure of Prudence at the base of his pulpit in the cathedral at Pisa (pl. 149), itself clearly derived from an antique Venus Pudica, that lies behind the Eve in that most concentrated and most dramatic of all the frescoes in the chapel, *The Expulsion of Adam and Eve from the Garden of Eden* (pl. 150). The glaring light that shines on them in their remorse and misery, the sculptural and anatomical reality of their forms, the softness of their flesh, the space they occupy and their convincing motion are all harnessed to a single purpose, the creation of a deep and moving spiritual and emotional experience in a closer union with the world of the observer than had ever been achieved before.

A different king of grandeur and a different relationship with sculptural and architectural form is to be seen in what is arguably the most magnificent of all the arly Renaissance altarpieces that have come down to us intact in the exact location for which they were designed. The superb carved

ABOVE 148.
MASACCIO: The Tribute Money, *c.1427.*
Fresco in Brancacci Chapel, S. Maria del Carmine, Florence.
Christ, in the company of the apostles, is approached by the tax collector at Capernaum.

OPPOSITE 147.
MASACCIO: The Holy Trinity, *c.1427. Fresco in S. Maria Novella, Florence.*

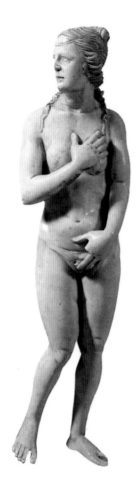

ABOVE 149.
GIOVANNI PISANO:
Prudence, *1302–10.*
Supporting figure from
pulpit, Duomo, Pisa.

RIGHT 150.
MASACCIO: The
Expulsion of Adam
and Eve from the
Garden of Eden,
c.1425–7. Fresco in the
Brancacci Chapel, S.
Maria del Carmine,
Florence.

wooden frame of Andrea Mantegna's *Madonna Enthroned with Saints and Angels* (pl. 151), in S. Zeno in Verona, derived directly, so it seems, from the original architectural forms of Donatello's fully three-dimensional sculptural altarpiece for S. Antonio in Padua, is a reminder that the painted panels of a Renaissance altarpiece, however beautiful in themselves, become no more than a dismembered corpse without the frames which were a major element in their design. Mantegna (active c. 1441–1506) makes the columns of his frame into the three-dimensional forward elements of the painted supports of the deep, architectural space in which the figures have been set. The light falls, as if wholly naturally, from a window which was cut into the previously blank choir wall for the purpose, and the brilliant reds and yellows of St Peter's robes echo the colours in the fourteenth-century frescoes, visible immediately above the altarpiece on the upper wall over the windows of the apse. The low viewpoint of the painted architecture conforms to the position of the onlooker who stands before this massive, and yet beautifully proportioned structure, some 4.80 m wide and 4.50 m high. Standing as it does before the Gothic apse of the rebuilt choir of one of the finest of Italian Romanesque churches, it witnesses to the explosive force of the eruption of Renaissance theory and Renaissance art into the largely medieval world of northern Italy.

CLARITY AND DEFINITION
The clarity of mathematical proportion and of spatial definition, which is central to the arts of the Renaissance, and which was endlessly explored by men such as Filippo Lippi (c. 1406–69), Paolo Uccello (1397–1475) and Andrea del Castagno (c. 1423–57), can be seen in actual architectural terms in Brunelleschi's church of S. Lorenzo (pl. 153). The contrast with the relatively undefined, free-flowing Gothic space of S. Croce is not due simply to his borrowings from the vocabulary of the Roman and the Romanesque. Here, everything is measured out column by column, and by square and rectangle and square, in the large pattern of the floor. Square coffering by square coffering marches down the ceiling. The linear cornices of nave and aisles, and the orthogonals of floor and ceiling, stream towards the altar, focusing attention as inexorably as the vanishing-point to which the great vault of Masaccio's *Trinity* recedes.

The revolution which the new perspective wrought in sculptural terms is to be seen already in the pictorial low relief which forms the base for the entire design of Donatello's tabernacle of St George (pl. 146), providing a dramatic contrast to the pensive figure overhead. It shows more clearly still in such reliefs as the *Jacob and Esau* (pl. 152) of Ghiberti's second pair of Baptistry doors. The clear gradation of relief, the classicism of the architectural forms, the measured unity of space which holds the separate scenes of the continuous narrative together, and the sense of Classical proportion in the figures – everything is redolent of new ideas that leave the triumph of *The Sacrifice of Isaac* far behind. Yet such designs conceal a

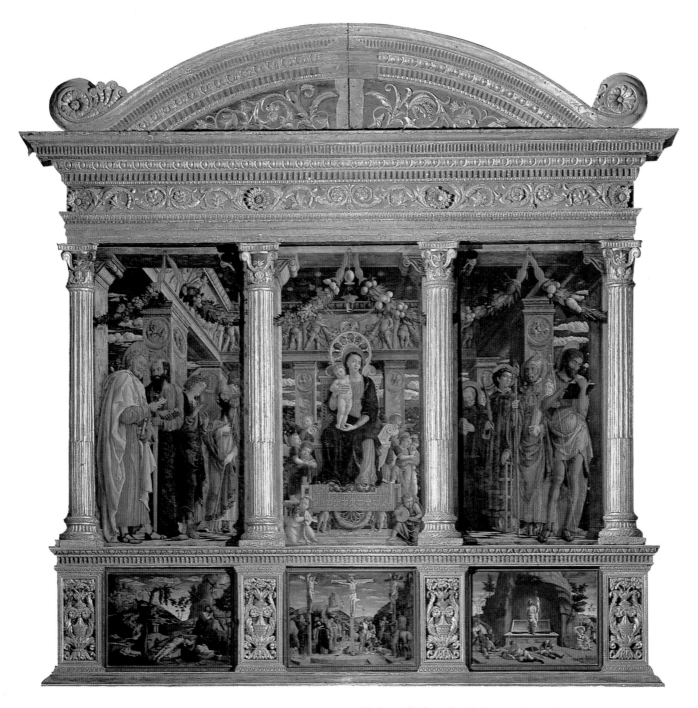

147. ANDREA MANTEGNA: *Madonna Enthroned with Saints and Angels*, 1456–60.
Altarpiece at S. Zeno, Verona.

paradox which serves to draw attention to the continuing controversies which surrounded their genesis. Here, once again, the experts were called in, and it was Leonardo Bruni himself who provided a complete scheme for the subject matter of the doors. This could well be assumed (as it often is by iconographers and art historians who are unduly dominated by the written word) to be a telling proof, despite the evidence for the gradual, often compositionally motivated, evolution of such works as Raphael's *Disputa* in the Stanza della Segnatura (pl. 207) or of Michelangelo's Sistine ceiling (pl. 201), that even the greatest artists simply followed orders handed down to them by humanists and theologians. What is significant in this case is the fact that Bruni, like most verbally oriented individuals, was constrained to remain within the confines of existing visual patterns. Ghiberti, the creative artist, smarting in all probability under the lash of odious comparisons with his old antagonist Brunelleschi, and his new and endlessly inventive rival Donatello, was the man who suddenly, when the framework was already

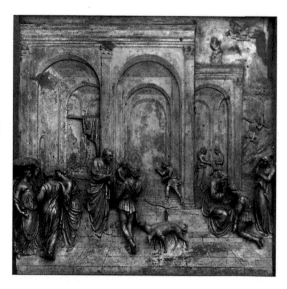

RIGHT 152. LORENZO GHIBERTI: Jacob and Esau *from the 'Gates of Paradise', c.1436. Baptistry, Florence.*

BELOW 153. FILIPPO BRUNELLESCHI: *Interior of S. Lorenzo, Florence, 1421–5, continued 1442–6.*

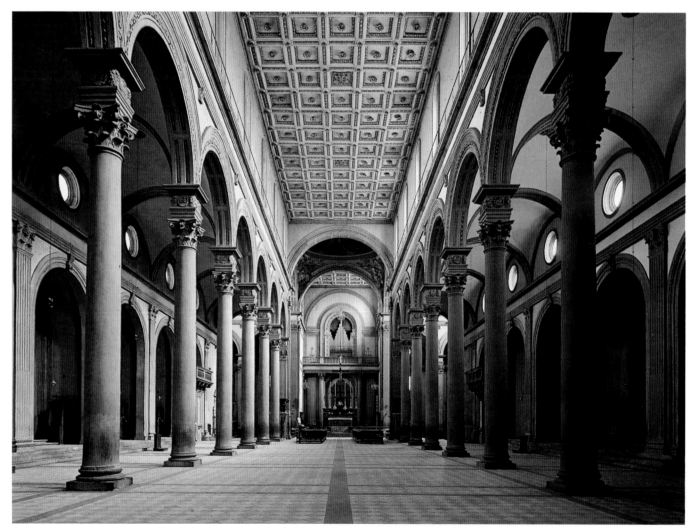

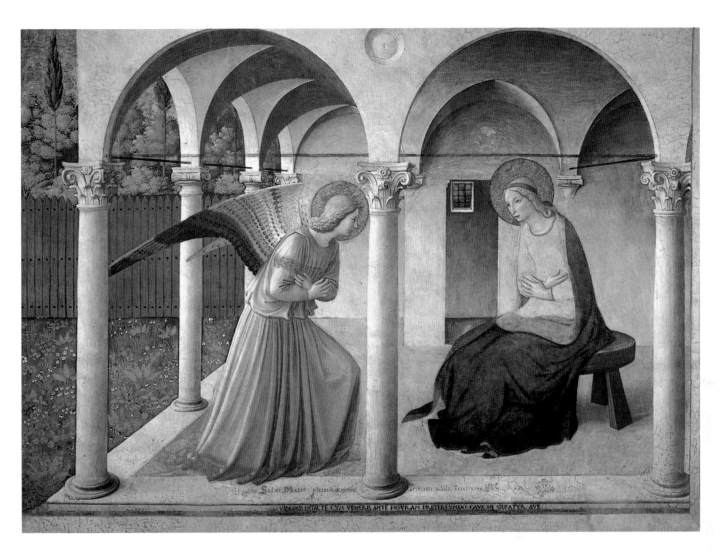

cast along the lines of the preceding pairs of doors, abandoned everything to start again, transforming subject matter and design alike in order to create the work of art (now flood-damaged) that Michelangelo subsequently dubbed the 'Gates of Paradise'.

These same men, who helped to mould a world of civic show and of conspicuous expenditure, also contributed to another, quieter world which saw the cultivation of the Classical, the study of the authors of antiquity, as a dangerous distraction from essential Christian truth. Ghiberti carved the marble framework of the triptych which the saintly Dominican friar Fra Angelico (active c. 1418–55) painted for the guild hall of the linen-weavers in 1433. Cosimo de' Medici, the richest man in Europe, kept a personal retreat in the Observant convent of S. Marco which he had commissioned the architect of his new palace, Michelozzo (1396–1472), to rebuild. The frescoes which Fra Angelico painted in the cells of the refurbished convent, are devoid of outward show. That same simplicity and that same spir-

itual intensity are still present in the more public fresco of the Annunciation (pl. 154) at the head of the main stair. In it, the new pictorial ideas are drawn on to confirm and to invigorate an age-old faith. The restrained forms of Fra Angelico's architectural setting, with its metal tie rods and Ionic capitals, are directly related both to Brunelleschi's Ospedale degli Innocenti and to the arcaded cloisters of S. Marco itself, as well as to the convent's vaulted library, which is Michelozzo's masterpiece. The simple brilliance of the handling of the perspective structure and the subtle placement of the figures, the intensity of interaction, the near-dematerialisation of the Virgin's form, the clarity of contour and the carefully restricted colour harmonies are combined in the creation of an image that lies far beyond the reach of words.

WEALTH AND PATRONAGE

The spiritual destiny of any man, however rich, might be decided in the prayerful solitude of a monastic cell, but for the leading citizens in the

154. FRA ANGELICO: Annunciation, c.1440–5. Fresco in the Convent of S. Marco, Florence.

through suggestion and discretion. This approach to governance was still largely practised, despite the increasingly aristocratic pretensions of the ruling circles, and despite his sobriquet, by his grandson Lorenzo the Magnificent, who was himself a poet and a scholar and a man more interested in diplomacy than in banking. Nevertheless, standing before the massive stone pile of the Medici palace (pl. 155), it takes an effort to remember that Cosimo had turned to Michelozzo as his architect because he thought that Brunelleschi's project was too ostentatious for him. As in this case, most such palaces were built about a spacious internal courtyard, reminiscent of the Roman atrium or the monastic cloister. For all the magnificence of their sequences of vast, high-ceilinged rooms, they were intensely private and familial places, closed against the outside world. Yet, at the same time, the grandeur of the huge, exterior façades was no less carefully calculated both as an enhancement of the public image of the builders and a contribution to the splendour of the city within which they dwelt.

The street face of the palace which Alberti designed for Giovanni Rucellai is a textbook of the new proportional approach, and the imposing block of Michelozzo's Medici palace, although less obviously mathematical and modular in its design, is likewise energised and given grace by subtleties of texture and relationship. The clarity with which the three storeys are defined; the perspectival graduation of the stonework, from the fortress rustication of the bottom storey, through the dressed stone definition of the *piano nobile*, to the smooth, upper surfaces which provide the maximum of contrast to the three-dimensionality of the monumental upper cornice; the sense of scale and the sure spacing of the openings; all contribute to a synthesis of elegance and strength which has captured the imagination of succeeding generations for 500 years and set the pattern for a multitude of banks and palaces throughout the Western world.

The block-like palace which the Strozzi built from 1489 on the same general lines is still more vast, still more palatial. It marks a further stage in the move from sober, bourgeois attitudes towards increasing emphasis on courtly, aristocratic ideals. The change accompanied a shift from oligarchic republicanism to dynastic continuity and finally, in the 1530s, to the centuries-long, hereditary despotism of the Medici dukes and grand dukes of Tuscany. The borrowing of chivalric trappings, jousts and pageants and ephemeral, secular events of every kind, to which

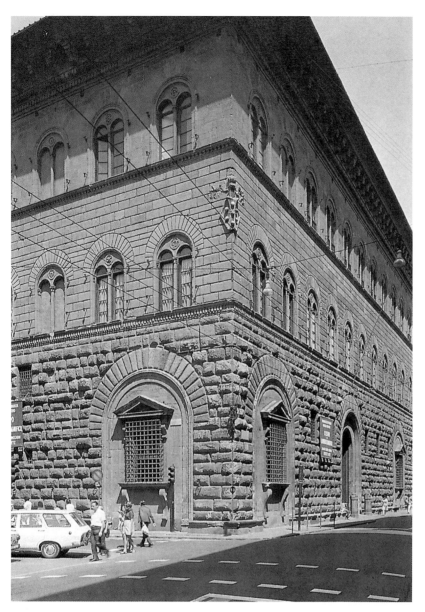

155. MICHELOZZO DI BARTOLOMMEO: *Palazzo Medici-Riccardi, Florence. Begun 1444.*

towns of Renaissance Italy the proof of social worth which justified accumulated wealth, the test of their magnificence and the guarantee of their own and their family's enduring fame, lay in the palaces which they built. Nowhere else in Europe did the town house, rather than the country seat, take on such monumental form or play so dominant a social role so early in the structuring of post-medieval urban life. Where fourteenth-century citizens had tended to be reticent about their wealth in a dangerous, uncertain world, the demonstration of it was the key to fifteenth-century social dominance, and Cosimo de' Medici was the supreme example of a man who straddled these two worlds. He was no more than the *de facto* leader of the city. He ruled by influence and indirection through the interweaving of industrial, commercial and financial networks;

the leading poets, sculptors, architects and painters made extensive contributions, were increasingly the order of the day. The prime example of the transition from the medieval mystery to the secular pageant, and of the invasion of religious life in general by secular concerns, was the spectacular series of *feste* which were organised by the Company of the Magi. These were dominated by the leading families of Florence and became the excuse for ever more ostentatious displays of wealth and patronage.

These new attitudes are encapsulated in the painting of the *Adoration of the Magi* (pl. 156) which first established the enduring fame of Sandro Botticelli (c. 1445–1510). Where earlier Adorations were almost invariably processional in format, Botticelli pioneered the centralised, pyramidal design, which was, in its innumerable variations, to become the compositional hallmark of the High Renaissance. The pyramid is supremely stable both in structural and in visual terms, and it inherently creates a balance between lateral extension and central focus. There is also inbuilt harmony between the three-dimensional form and the triangle which it creates upon the picture surface. It is therefore no surprise to find that Leonardo likewise used it for his own, unfinished *Adoration* (pl. 194), which now hangs upon a neighbouring wall in the Uffizi.

In other respects, however, Botticelli's version is very different. In earlier ages, small-scale donor figures entered timidly upon the scene. Now the Medici are kings. The grey, shaven-headed Cosimo (d. 1464) grasps the Christ Child's foot. His short-lived successor, Piero (d. 1469), is the second of the Magi and the third is probably his other son, Giovanni (d. 1463). Behind the last stands Giuliano, Piero's younger son, while Botticelli himself is possibly the figure

156. SANDRO BOTTICELLI: Adoration of the Magi, *c.1475. Galleria degli Uffizi, Florence.*

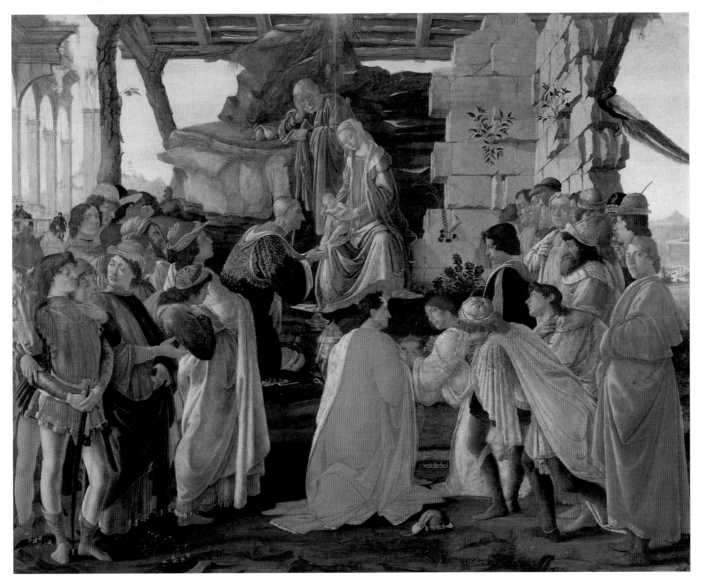

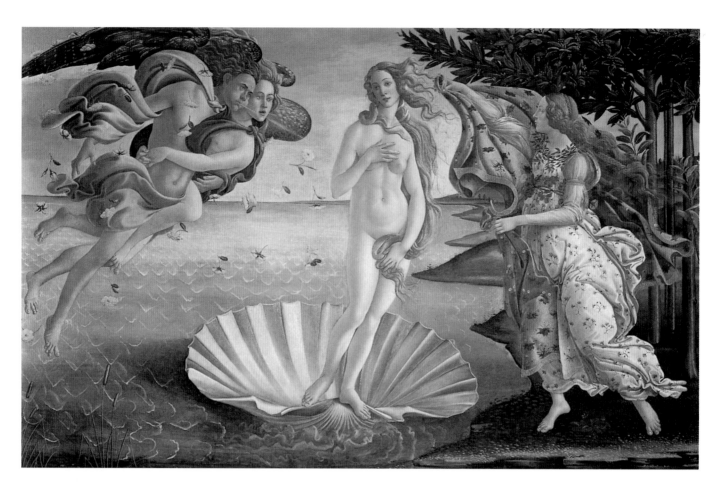

157. SANDRO
BOTTICELLI: Birth of
Venus, *c.1484–6*.
Galleria degli Uffizi,
Florence.

on the extreme right who stares so arrogantly out at the spectator. But which, if any, of the figures on the left – the young buck with the sword who seems to be too youthful and too out of character, or the more stately, white-robed figure next to Cosimo, who does not look much like Lorenzo – is in fact Lorenzo the Magnificent is another question. It is also one which points towards the endless unsolved problems which continue to attend attempts at the interpretation of the subject matter of Renaissance art.

Nowhere are these problems, and the unending series of controversies which surround them, more acute and yet, in some ways, more irrelevant than they are in that most quintessential of all Florentine Renaissance paintings, Botticelli's *Primavera* (pl. 160). It was painted, probably in the late 1470s or the early 1480s, for Lorenzo di Pierfrancesco, the cousin of Lorenzo the Magnificent, under whose wing he was brought up and by whom he was introduced to such distinguished tutors as the court poet Naldo Naldi and the philosopher Giorgio Antonio Vespucci, and to the whole humanist circle, which included the still more famous Neoplatonist Marsilio Ficino and the poet and Greek scholar Poliziano. There are doubtless layers on layers of

hidden meanings and associations to be found within the painting, and doubtless the uncertainties will never end. Nor should it be forgotten that often in the greatest art, as in the greatest literature, essential ambiguity lies at the very heart. Without it, *Hamlet*, Rembrandt's portraits and the *Mona Lisa* would not hold attention, generation after generation, as they do.

The scene of Botticelli's tapestry in paint is the mythological, far western home of the Hesperides, the garden of eternal spring, its golden apples turned to oranges. Venus, richly clothed, is at the centre, in her role as goddess of love and fruitful marriage. Yet, at the same time, she unmistakably calls up associations with innumerable earlier representations of the Madonna. Overhead, a blindfold Cupid aims his blazing arrow at the Graces, Venus' attendants in antique mythology. As Botticelli shows them, there are echoes of the ancient sculptures of them which survived in Tuscany and Rome; echoes of nymphs, of dancing maidens and of Flora, such as we now know them from surviving Roman stuccoes and Pompeian frescoes. There are echoes also of Alberti's recommendations in the *Della Pittura*, his famous and by now increasingly influential treatise on the theory and practice of

painting, in the revealing, fluttering draperies blown by Zephyr, the one wind allowed into the ancient garden. In the painting, he sweeps in from the right, a blue-green aerial spirit who embraces the fleeing Chloris, nymph of the blooms which stream out of her open mouth to turn into embroideries on the dress of Flora, goddess of the flowers. Mercury, the messenger of the gods, stands on the left and holds up his caduceus to keep the chill grey clouds out of the golden garden. Here is poetry in paint and poetry in the purity of singing line that gives grace to the Graces. It was this same sense of line, expressed in terms of pure, unaided penwork, that enabled Botticelli to produce the only illustrations to Dante's *Divine Comedy* which can stand up to William Blake's hallucinatory images in the nineteenth century.

Only a glance at Mercury's naked torso or at the foot and ankle of the central figure of the Graces, or at their wrists and hands and intertwining fingers overhead, is needed to appreciate the depth of understanding with which Botticelli could represent the anatomical essentials of the human form when he so wished. But, as the variable proportions of the figures show, conditioned as they are by compositional needs, the painting was clearly not intended as a demonstration of the knowledge which by this time painters drew directly from attendance at dissections. An anatomical pattern book of the kind which Antonio Pollaiuolo (active c. 1457–98) produced in his almost contemporary *Martyrdom of St Sebastian* or his engraved *Battle of the Nudes* was never in Botticelli's mind. Nor is it simply anatomical fact that has to be subordinated to the needs of art, not out of ignorance, but by intention. In the *Primavera* Chloris's draperies, blown by Zephyr, actually meet the fluttering ends of Flora's flowered robes, blown in the opposite direction by her rapid movement. Such things do not disturb, but actually enhance the dreamlike harmony of the whole.

The same ability not to ignore, but to transcend the facts is no less evident in Botticelli's *Birth of Venus* (pl. 157). Here, once again, there is no slavish following of any text, but transmutation into painted poetry. The ancient texts and the contemporary poem by Poliziano which underlie the subject matter have been radically recomposed. Zephyr and Chloris reappear upon the left, the springtime Hora on the right. In everything, from the clear figure contours to the draperies and trees and to the abstract, brushpoint V-strokes of the waves, there is supreme economy of handling. Venus herself is certainly no antiquarian reflection of an antique statue.

There is at least as much of Gothic line as of Renaissance structural form. Venus remains a vision that transcends the study of proportion and perspective, of anatomy and structure, and the acquisition of the power to represent the real world with an unprecedented faithfulness and clarity which, none the less, are the foundations of Renaissance art.

TRANSFORMATIONS

Transcendent in a very different way is Donatello's *Mary Magdalen* (pl. 162). Yet it is only in the Renaissance, and in the light of the new knowledge, that such an image could have been brought into being. The Magdalen herself was famous for her beauty in her youth. Now all her flesh is eaten up by fasting and remorse and by her love of God and of the Christ who died to wash her free of sin. Her flamelike hands burn with the intensity of her longing and her love. Her matted hair flickers like flames, consuming the emaciated remnants of corporeal being and transmuting body into soul.

Donatello's final works, the two unfinished bronze pulpits for Brunelleschi's church of S. Lorenzo, are no less radical in their attack (pl. 161). Ideals of beauty and the mathematics of perspective space have been left far behind. Here, for the first time in the history of Western art, we find a true late style, a breadth of handling of material that leads on to the work of Titian and of Rembrandt and beyond them to the sculptors of the twentieth century. The way in which the spatula carves into the clay and the chisel cuts the bronze once it is cast is revolutionary. As with none of his contemporaries or precursors, except Giovanni Pisano, the actual handling of the tools becomes a vehicle for emotion. As Christ's heavy figure surges from the tomb, it is no joyous Resurrection, but a battle won against the odds. Below, the soldiers sleep as the old order passes, and a fleeing devil from the Harrowing of Hell in the preceding scene becomes a scorpion on a Roman shield. Above, Christ's careworn face seems burdened with the sins of all mankind as he climbs up from darkness into light.

A very different Christ stares out hypnotically from Piero della Francesca's fresco of the Resurrection (pl. 132). It is as far from the late works of Donatello as it is from Botticelli's mythic dreams, and is a reminder that the greatest works of art are not inevitably to be associated with the breaking of existing bounds. As the history of Renaissance art and architecture amply demonstrates, the exploration and the exploitation of new canons is itself, at times, linked to the highest

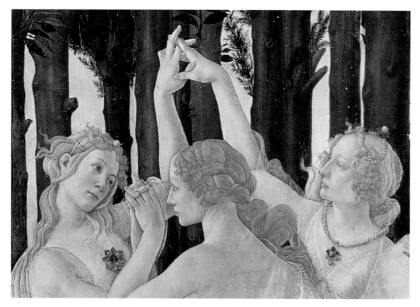

SANDRO BOTTICELLI, PRIMAVERA

In many respects, the *Primavera* (c.1478–83) is a world away from Ambrogio Lorenzetti's fresco of *The Well-Governed Town and Country* (pl. 133). Yet both are dreams, the latter more closely grown out of the world of everyday humanity, the other more mysterious in its messages.

In the Sala di Pace, Ambrogio detailed the ravages of civil strife on the opposite wall. Standing before the *Primavera*, it takes an effort to remember that Botticelli may well have been at work on it in 1478 when the Pazzi conspiracy reached its climax and Giuliano de' Medici, whom Botticelli placed so prominently in his *Adoration of the Magi* (pl. 156), was assassinated at High Mass in the cathedral, Lorenzo the Magnificent barely escaping with his life. Only three months later Botticelli was frescoing the effigies of the main conspirators, including the Archbishop of Pisa, hanging by the neck, hard by the Signoria from the windows of which they had been hanged.

In the 1490s Botticelli's output was to be profoundly affected by the hellfire preaching and apocalyptic visions of Savonarola on whose bonfires of the vanities so many Early Renaissance secular and mythological paintings perished. The very flowers beneath the feet of the central figure, Venus, are redolent of secular delights. The fourteenth-century frescoes of the papal palace at Avignon; the garden frescoes of Pompeii; the mille-fleurs tapestries of northern palaces, mingle with the mental images of the flower-decked lawns that grace fifteenth-century Gothic altarpieces and draw upon the observational accuracy of the new-style herbals. Beneath the Seville orange trees that shade the garden of the *Primavera* bloom the coltsfoot and the lesser periwinkle of late winter and early spring in Italy. The stinking hellebore, geranium, pinks and common iris that come out in March and April; the late spring blossoms of the buttercup, the salad burnet and the water forget-me-not, alongside accurate portrayals of some twenty other species, can be seen together with more stylised forms. Flora herself is decked and garlanded with daisies and wild strawberries, sweet violets, cornflowers and carnations as she strews her roses (*detail below*).

None of Botticelli's studies from nature or preparatory drawings for the

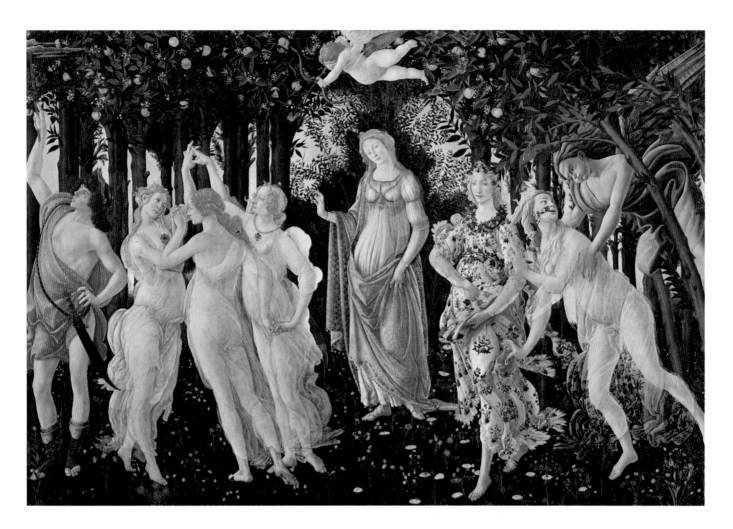

Primavera have survived. Yet the transformation of the role of drawing, following the replacing of parchment by paper, is essential to the art of the Florentine Early Renaissance. The painting of the *Primavera* was almost certainly preceded by a wealth of compositional sketches. By this date the full-scale cartoon, sometimes in outline, sometimes fully modelled, and then incised or pricked along its major outlines for direct transfer to wall or panel, was coming into its own.

This period saw the climax of the art of tempera painting on panel, in which the pigments are mixed with yolk of egg. The *Primavera* is among the latest and greatest of a line of masterpieces reaching back to the thirteenth century and beyond, their technical sophistication soon to be overtaken by the richer, more flexible medium of oil paint.

The *Primavera* is made from seven planks of poplar, covered by several increasingly fine layers of gesso, made of chalk or gypsum mixed with water and bonded with glue or gelatine and smoothed to a bone-hard surface. The tempura painting could then begin and, because this medium was much faster-drying than oil, could be carried forward more or less continuously from the green underpainting for the flesh to the hair-fine touches of the highlights, building up almost to low relief in the opaque darks of the leafage (*detail opposite left*).

The *Primavera* depends not upon new techniques or on a medieval richness of materials, but on the genius of the artist who conceived and executed it. Soon to be superseded, like the season that it represents, it is a haunting record of the springtime of the Renaissance.

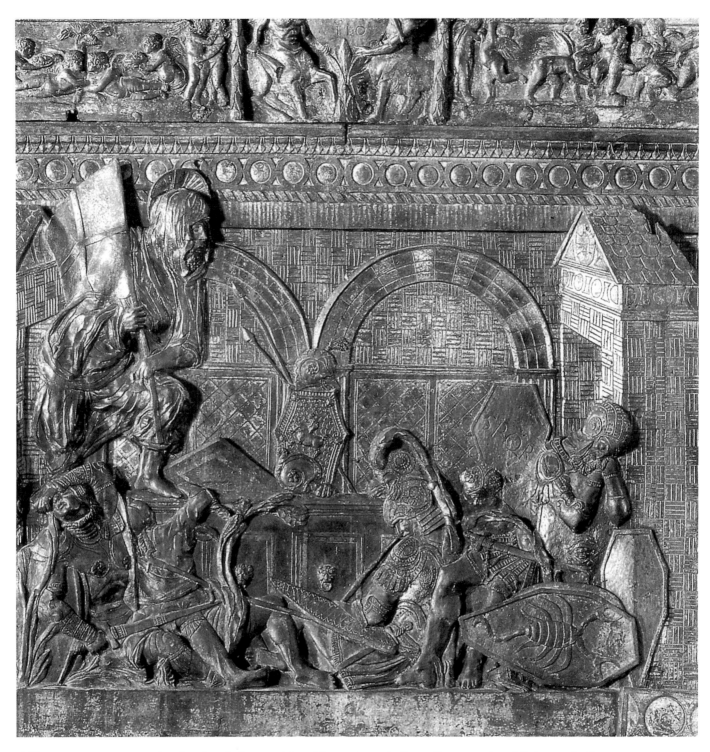

161. DONATELLO:
Resurrection, *1460–6.*
North pulpit, S. Lorenzo,
Florence.

levels of artistic creativity. Here, through Renaissance columns that might have come straight from the architecture of Alberti, is Alberti's window into space, created by a man whose own perspective treatise in its detailed rigour far outstripped Alberti's rapid formulation. This silent, monumental, ramrod figure is Vitruvian man, the source of architectural proportion. It is not only God made man, who stands triumphant in the cool, dawn light, but man as God, his human

form an echo of divine perfection.

Piero (active 1439–78, d. 1492) the artist-theorist trained in Florence, though an Umbrian by birth, is, in his career, as much as Brunelleschi or Alberti or Donatello, or Botticelli, the familiar of the poets and the scholars in the circle of Lorenzo the Magnificent, a prime exemplar of a crucial stage in the slow transition from medieval artisan to modern artist. The continuing exclusion of painting and sculpture from the charmed

circle of the liberal arts was becoming steadily less significant even as the arguments for their inclusion on the part of the painters and sculptors, who hoped thereby to justify their claim to equal status with the humanists and scholars in the courts of princes, grew more clamorous. The weakening of the guild structures as the century wore on and the gradual withering of the restrictive practices with which they were increasingly associated, together with the growing social and financial independence of the leading artists, meant that the academic arguments were largely being overtaken by events. The *Resurrection* is itself an analogue for the transformation that was taking place. The startling pink of Christ's robe comes from a late-fourteenth-century altarpiece that still survives in the museum in Borgo S. Sepolcro, and his pose goes back to Duccio in all probability, but the outcome is a Resurrection that is like no previous and, indeed, no subsequent evocation of the theme. The moment of eternal stillness in the midst of action lingers in the mind. An art in which the style is not imposed upon reality, but arises out of a profound attempt to come to grips with it, and finally to transcend it, is not easily forgotten.

In social terms the Early Renaissance was, in sum, a time which saw new emphasis upon humanity and a new spirit of inquiry, together with a growing belief in change and progress, and an increasing concentration on the organisation of trade and manufacture and the accumulation of capital. It was a period which at its culmination saw the first of the great voyages of exploration which opened up the New World and prepared the onset of an age of empires. In art, there was an emphasis on space and light, perspective and proportion and anatomy, and on the theoretical basis of representation, as the artists struggled to rise out of the stable but restricted world of the mere manual worker. There was a growing sense of history and a desire to understand the past and to assimilate the wisdom and to comprehend the formal basis of the distant world of Classical antiquity in order both to match its artistic achievements and, if possible, to surpass them. It was an age in which men saw an understanding of the past as opening up new pathways to the future. Artists whose art was bedded in the work of earlier generations were eager to experiment, to stretch themselves to breaking and beyond. It was a period full of ideas and enterprise. In many ways it stood upon the threshold of the modern world; and its architecture and its art, so often unsurpassed, lead on to Leonardo, Raphael, Michelangelo and Titian.

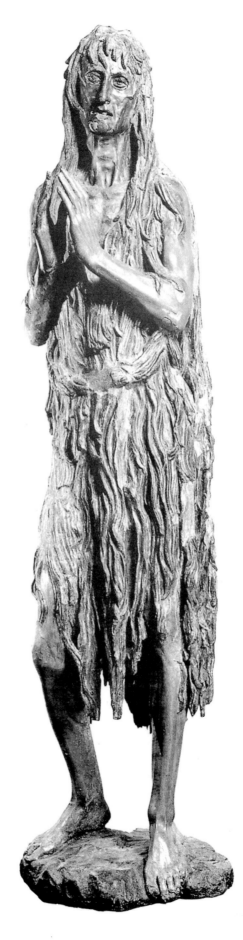

162. DONATELLO: St. Mary Magdalen, *c.1455. Baptistry, Florence.*

145

6

THE EARLY RENAISSANCE IN THE NORTH

CATHERINE REYNOLDS

INSET 163. STEFAN
LOCHNER: Virgin
and Child in a Rose
Garden, *c.1440.*
*Wallraf-Richartz
Museum, Cologne.*

OPPOSITE 164.
ALBRECHT DÜRER:
Self-Portrait, *1498.*
*Museo del Prado,
Madrid.*

The art of the North in the fifteenth century, the period often described as 'Early Renaissance' in Italy, gains any unity not from the rebirth or rediscovery of Classical antiquity but from the growing dominance of the artistic styles of the Low Countries in painting, sculpture, tapestry and metalwork. While in architecture, too, Netherlanders made their contribution to the cross-fertilisation of late Gothic styles in Europe, their role was not the determinant one of the Netherlandish painters in their own field. In painting, it was the Netherlands that set the style, exporting art and artists throughout Europe from the Baltic to the Mediterranean. Painting and sculpture shipped to the comparative stability of Italy, Spain and Scandinavia fared better than the art and, inevitably, the architecture remaining in the Netherlands, exposed to the hazards of war in an area repeatedly used as Europe's battlefield into this century. In the sixteenth and early seventeenth centuries, with the break-up of the hegemony of the Roman Catholic Church, an even greater danger came from the deliberate destruction organised by the Protestant Reformers for whom church art was a breach of the second of the Ten Commandments, against graven images, and an invitation to idolatory. In many areas, not just of the Netherlands but also of Germany, Switzerland, France, England and Scotland, the destruction of the artistic heritage was almost total. What did survive was then imperilled by

the eighteenth century's disdain for an art which had fallen out of fashion and which only began to regain admirers by the beginning of the nineteenth century.

The great altarpiece of *The Adoration of the Lamb*, known as the Ghent Altarpiece (pl. 165), painted by the brothers Hubert (d. 1426) and Jan (d. 1441) van Eyck and completed in 1432 for the Cathedral of St Baaf (Bavo) in Ghent, survived because, already in the sixteenth century, it was revered as the masterpiece of the founders of Netherlandish art. Even though the name of its artist was forgotten, the magnificent altarpiece of *The Last Judgement* (pls 166, 167), made for the hospice at Beaune in Burgundy by Rogier van der Weyden (1399/1400–64) around 1445, survived because it was remote from religious iconoclasm and protected from the political destruction of the French Revolution. Survival of such works was largely a matter of chance, for altarpieces were the images most distrusted by the Reformers and least likely to survive a change in taste. Size is masked in reproduction by the minute precision of early Netherlandish painting technique, achieved by overlapping layers of translucent, oil-based paint with virtually imperceptible brushwork. It requires imaginative effort to restore the Ghent Altarpiece or the Beaune *Last Judgement* to the grandeur of their true dimensions. The general perception of Netherlandish art as small and precious is largely due to the accidents of survival: the small was more likely to be kept or to escape being thrown away. And, for comparison

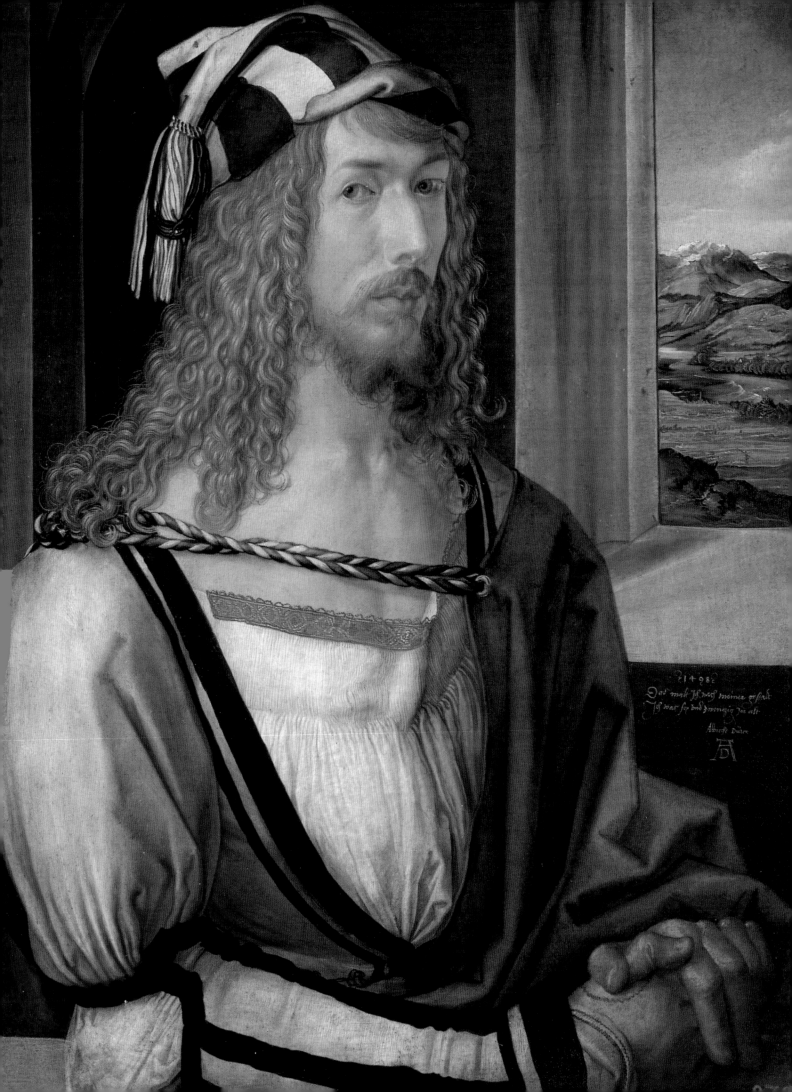

165. HUBERT AND
JAN VAN EYCK: The
Adoration of the
Lamb, *1432. St Bavo's
Cathedral, Ghent.*

with the monumental frescoes of Italy, it is more appropriate to look to Netherlandish tapestry than to surviving panel or mural paintings.

The misguided belief in the inherently small-scale preciosity of Netherlandish art is matched by a common misapprehension of its subject matter as overwhelmingly religious, appealing to the emotions to the detriment of the intellect. Apart from portraits, few secular paintings survive from before the sixteenth century and knowledge of the range of subject matter has to be supplemented from other art forms – tapestries, book illustrations and prints – and from written evidence. Italian admirers recorded that both Jan van Eyck and Rogier van der Weyden painted erotic pictures of nude women bathing, pictures which have fallen victims to prudery or changing canons of physical beauty. Eyes accustomed to Raphael would find Jan van Eyck's Eve (pl. 165) hard to accept as the ideal she represented to contemporaries.

Discussion of Jan van Eyck and Northern art of the Renaissance usually focuses not on idealism but on realism. The careful observation and depiction of visible objects was not, and could never be, the simple repetition or duplication of reality, and yet, from the sixteenth century onwards, a false contrast was drawn between the intellectual Italians, capable of the Classically inspired ideal, and the mindless Northerners, capable only of mechanical imitation. It was also in the sixteenth century, with the beginnings of art history, that it became a commonplace to regard van Eyck as the founder of the Northern school of art and the inventor of oil painting. The invention of oil painting is now seen as an evolution, to which van Eyck may have contributed and whose history becomes clearer as more pictures are scientifically analysed. Similarly, Netherlandish painting did not spring into being with just one artist. Change is not evenly paced and van Eyck's career coincided with and contributed to a period

of rapid change, although his personal evolution is hard to detect in his known works. To find the antecedents of his style in a purely Netherlandish context is difficult: so little survives, and that little can seldom be assigned a definite date or place of origin.

NETHERLANDISH ARTISTS IN FRANCE

The best-documented Netherlandish artists in the decades around 1400 worked in France, at the courts of Charles VI, who reigned from 1380 to 1422, and his relations, especially his uncles, John, duke of Berry (d. 1416), and Philip the Bold, duke of Burgundy (d. 1404). Many were not formally retained by a prince but set up in Paris, the centre of the trade in luxury goods on which the wealth of France was lavished. Precious metalwork studded with gems and labour-intensive tapestries, woven in fine wools and silks and gold and silver thread, seem to have headed the lists of prestige belongings, together with the fantastically expensive clothes worn on special occasions. Painting came lower down the scale and was then treasured more in the form of illuminations, the illustrations of manuscript books, than as independent pictures to hang on the wall. Appropriately, it is in a book that one of these princes appears in all his magnificence: the duke of Berry receiving his guests on New Year's Day illustrates the month of January in the calendar of his book of hours or personal prayer book, distinguished from the others in his collection as the *Très Riches Heures* ('*Very Rich Hours*'; pl. 168).

The illusionistic potential of painting is exploited to depict the art forms with which the duke has surrounded himself, and yet painting itself plays little part, restricted to the heraldic patterning of the ceiling-beams. The walls are hung with tapestries; gold and silver vessels are in use on the table and displayed on the sideboard; gold leaf picks out the sculptural decoration of the fireplace; Berry himself sits under a costly canopy, the richness of his jewellery and robes matched by his courtiers' attire, probably at his expense.

ROGIER VAN DER WEYDEN, LAST JUDGEMENT ALTARPIECE

The *Last Judgement* (c.1445) was painted for the hospital of the Hôtel-Dieu at Beaune in Burgundy, founded in 1443 by Nicholas Rolin, chancellor of the duke of Burgundy since 1422, and his wife, Guigonne de Salins. The polyptych stood on the altar of the chapel which opened directly off the main hall where the sick and dying were tended by nuns. Closed, as it usually was (*see opposite*), the altarpiece provided the sick with votive images of St Sebastian and St Anthony Abbot, both invoked against disease, and of the Annunciation, flanked by kneeling figures of the donors, identified by their coats of arms. Originally the contrast between the monochrome simulated sculptures of the saints and the colour of the humans would have been even more pro-

nounced, when their hangings still had their red and gold brocade patterning and the blue of the prie-dieu cloths had not darkened. Even so, little would have prepared the sick for the blaze of gold and resplendent colouring revealed when the wings of the altarpiece were opened (*above*).

In the centre, Christ the Judge is enthroned between angels bearing the Instruments of the Passion; on his right hand, he welcomes the blessed to heaven with words written below the lily of mercy; on his left hand, the damned are dismissed below the sword of justice. Angels blow the Last Trump on either side of the archangel Michael, who weighs the souls of men in his balance. Sins, on the right – the side of hell – sink, outweighing virtues, which rise on the side of the ascent to heaven, a reversal of the usual formu-

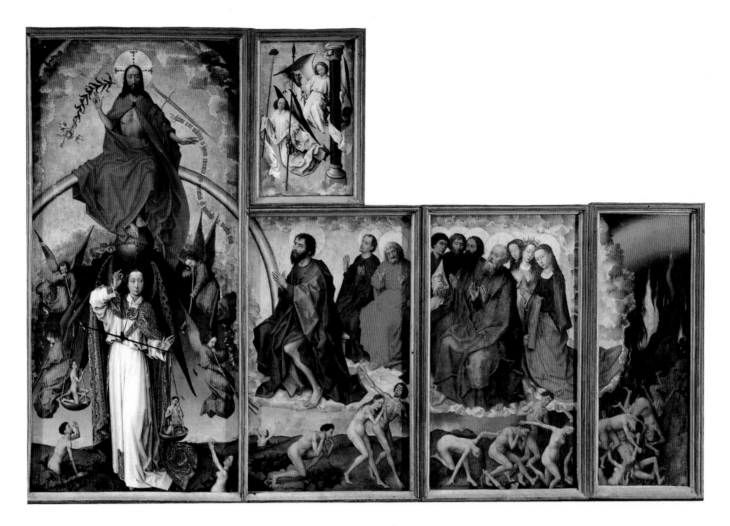

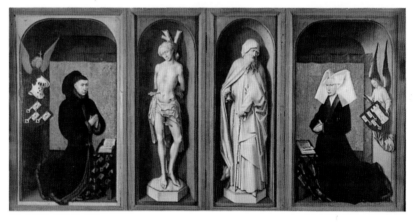

la, followed by van der Weyden in the underdrawing, where virtue falls to outweigh vice. Whether to achieve this visually more appropriate effect or to match the larger number of the damned in his version, van der Weyden changed the design at the painting stage. The pessimism of his Judgement is emphasised by the frames dividing Christ from the interceding figures of the Virgin and John the Baptist, whose appeals seem of little value given the enormity of men's sins. Apostles and other saints complete the court of heaven, while the earth cracks to release the dead who move towards the celestial gate or, terrified, towards hell, not driven by demons but by a knowledge of their own guilt and the eternal Judgement of God. A clearer statement of the need for penitence and a Christian death is hard to imagine.

buildings and landscapes can be related to characteristics of early Netherlandish panel painting, of which very little survives from the first decades of the century. How far the de Limbourgs can be considered Netherlandish artists is debatable, for at least two of them trained with a Parisian goldsmith and their short careers were spent in France, initially with Philip the Bold of Burgundy and then John, duke of Berry. They were highly rewarded by the dukes of Burgundy and Berry and benefited enormously from being removed from the more routine demands of the commercial world of the Parisian book trade. A salaried position with a prince or town formed the only regular remuneration available to an independent artist, an advantage also enjoyed by Jan van Eyck in the service of Philip the Good of Burgundy, grandson of Philip the Bold. His peremptory orders to his exchequer to pay van Eyck's wages in full, for fear of losing his services, demonstrate the standing that artists could achieve with their patrons. The relationship between artist and patron could apparently achieve a relaxed intimacy; Philip the Good employed van Eyck on secret missions, and the de Limbourgs presented the duke of Berry with a mock book as a joke New Year's gift.

One of the greatest of the many Netherlandish artists drawn to the wealth of France was the sculptor Claus Sluter (active 1379–1404, d. 1405/6). None of Sluter's work in his native Haarlem or in Brussels, where he was employed around 1379, survives, so that knowledge of his style comes only from the Charterhouse of Champmol, outside Dijon, founded by Philip the Bold as a burial place for his line of the dukes of Burgundy. The monastery was a magnificent foundation, twice the normal size, furnished with lavish care so that the monks could recite the services with the full panoply of altar vessels and vestments before richly carved and painted altarpieces. In worldly terms, Champmol marked the foundation of a new and powerful dynasty; in spiritual terms, the Carthusian monks provided a powerhouse of prayer, interceding with God for the well-being of the duke, his family and his territories. Although the Carthusians were an austere order in intent, the Charterhouse at Champmol was required to be both an appropriate offering to God and a fitting funerary foundation for the dukes of Burgundy. Monumental stone sculpture was an inevitable part of such a complex, and Sluter found at Champmol the commissions which gave him the chance to demonstrate his genius.

Workshop collaboration and the time required

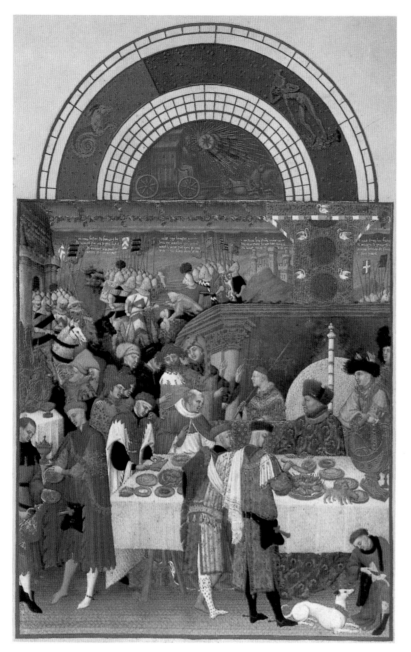

168. DE LIMBOURGS: January, *from the* Très Riches Heures *of the duke of Berry, depicting New Year festivities, (fol.1v), c.1416. Musée Condé, Chantilly.*

By living up to his divinely ordained rank, the duke provided employment for skilled artist and unskilled labourer alike. Shabby and parsimonious princes were more criticised than those who, with reasonable demands in taxes and feudal dues, fulfilled their function in the social and economic order.

The *Très Riches Heures* was illuminated for the duke of Berry by three brothers, Paul, Herman and Jean de Limbourg, from Nijmegen in the northern Netherlands. The last of them had died by 1416, leaving the project incomplete. The de Limbourgs did not employ van Eyck's oil-based medium for book illumination, using instead white of egg and gum, but their technical brilliance in reproducing the appearance of people,

for the execution of large-scale sculpture, despite the employment of assistants, makes it difficult to assess the contributions of Sluter's predecessor and successor to his first undertaking, the church portal, and to his last, the duke's own tomb. Engaged in 1385 as an assistant, Sluter took charge in 1389 on the death of Jean de Marville, a Fleming. On his own death in 1405, he was succeeded by his nephew, Claus de Werve. De Marville may have contributed to the design of the church portal, where the duke and duchess are immortalised, kneeling on either side of the Virgin and Child and protected by their patron saints. Sluter's bulky and deeply cut figures are astonishingly liberated from their architectural setting. They carry no suggestion of the caryatid or column figure, since they are placed in front of the wall, freed from any load-bearing allusion.

In a similar way the tomb chest of Philip the Bold, which carried a magnificently poly-chromed effigy of the duke was used to set off the figures placed around it. These figures echoed the procession of clergy and mourners which would accompany the dead prince to the graveside. The idea of the procession was not new; what was new was its conception as a series of free-standing figures, placed around the tomb, instead of as relief carvings fixed to the sides of the tomb chest with an effect of far less mobility.

Sluter's greatest opportunity for creating sculpture in the round came with the commission for a huge crucifix to stand in the symbolic pool at the centre of the cloister garth. Fragments of the crucified Christ remain; the Virgin, John the Evangelist and the Magdalen, who stood or knelt at the foot of the Cross, are lost. Sluter's *Well of Moses* (pl. 169) was only the base of this group, a hexagonal pedestal with a life-sized prophet placed against each face. Inevitably, the position of Christ gave the ensemble a dominant, frontal viewing-point, opposite Moses, but the placing of the figures around the Cross and the interaction of the prophets around the base would have encouraged the discerning viewer to circle the pool to appreciate the full range of statues and the variety of sightlines. The prophets who foresaw the Passion were linked to the event above by the weeping angels, whose overt emotionalism contrasts with the more dignified bearing of the prophets. The careful individualisation of the latter has often been compared with that achieved later by Donatello in his treatment of the same subjects. The comparison is made easier by the virtual disappearance of the original polychromy, since now, as in fifteenth-century Florence, the material of sculpture is expected to be unadulterated, as were the marbles and bronzes of the antique statues rediscovered by Renaissance collectors. For Sluter and the dukes of Burgundy, sculpture could only be enhanced by the addition of expensive pigments, gold leaf, metal haloes and, for Jeremiah, spectacles.

The dukes of Burgundy had particularly easy access to Netherlandish artists because in 1384 Philip the Bold became count of Flanders by right of his wife. Through further judicious marriages, diplomatic pressures and military force, his grandson, Philip the Good, duke from 1419 to 1467, exerted control over most of the territories of the Low Countries. The wealth of the Netherlandish towns, founded on wool, in particular the processing of raw English fleeces, but extending into all areas of commerce, enabled the Burgun-

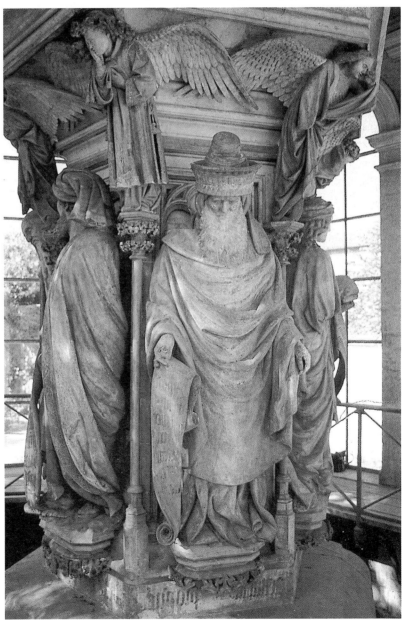

169. CLAUS SLUTER: Well of Moses, *c.1395– 1403. Chartreuse de Champmol, Dijon. The prophets are life-size.*

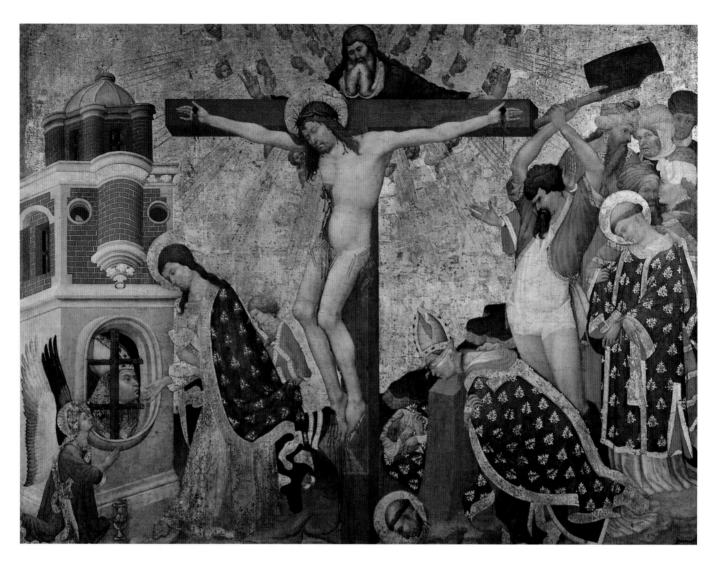

170. HENRI
BELLECHOSE:
Trinity with the
Martyrdom of St
Denis, *1416. Musée du
Louvre, Paris.*

dian dukes to rival and outstrip kings in power
and luxurious living. Wealth did not flow ex-
clusively into the ducal treasury, nor was it
restricted to the two greatest trading and man-
ufacturing centres, Bruges and Ghent. Their
predominance led foreigners to apply the name
Flanders to the whole of the Low Countries, even
though other towns, such as Brussels in Brabant
and, increasingly, Antwerp, could finance a way
of life which allowed nobles and townsmen alike
to spend handsomely on what is now categorised
as art.

Unlike Philip the Bold and John the Fearless,
Philip the Good did not concentrate his financial
resources and political energies on advancing his
position within France, which was more or less
closed to him. Despite the Peace of Arras of 1435,
Philip could never forget that his father had been
murdered by Charles VII of France, while
Charles was embittered by Philip's attempt to
disinherit him in favour of Henry V of England.
The splendid flowering of the arts at the courts of

France around 1400 had withered away in pro-
and anti-Burgundian feuding and in the war with
England, which left Paris in English hands from
1420 to 1436. Although some Netherlandish
artists continued to find work in the new royal
centres in the Loire valley, Paris was no longer
the magnet drawing talented Netherlanders to
work abroad.

JAN VAN EYCK

It cannot simply have been convenient proximity
that led Philip the Good to lavish rewards on Jan
van Eyck, established in Bruges from 1430, while
his painter in Dijon, Henri Bellechose (d. 1440/4)
from Brabant, was neglected to the point of
poverty. If van Eyck had become Philip's pre-
ferred painter, Bellechose's work, as represented
by his *Trinity with the Martyrdom of St Denis* (pl.
170), made for Champmol in 1416, might well
have lost its appeal for him. Though damaged,
the *Trinity* still shows a dramatic combination of
the splendour of the Godhead in a blaze of gold

154

and the pathos of the dead Christ and suffering saints. The limitation of the tonal range, the gentle transition from light to only slightly darker tones, prevents the figures from conflicting with the flatness of the reflecting gold ground. Volume is suggested more by exquisite draughtsmanship than by internal modelling. In *The Adoration of the Lamb* (pl. 165) van Eyck and his brother Hubert achieved three-dimensionality by manipulating the full range of tonal values, so that figures and landscape, over which light plays to reveal or cast into shadow, are described in varying intensities of light and dark shades. The resulting image is as supernatural as Bellechose's but for a different reason: the accumulation of individually credible details into an impossible whole. Van Eyck's realism establishes an unreality, using the physical world to communicate a spiritual vision. People had long been accustomed to look on the physical world as an expression of the divine. Just as the corporeal humanity of Christ provided a way for men to approach the incorporeal Godhead, so the immaterial Creator could be appreciated through the material of his creation. The unreality of van Eyck's paintings encourages a spiritual response to his apparently literal transcriptions of reality.

The illusory character of van Eyck's reproductions of reality is evident even in such paintings from 'real life' as his portrait of Giovanni Arnolfini, one of the many Italians resident in the great European banking centre of Bruges, and his wife, from another Italian family of traders and financiers long settled in the North (pl. 171). While totally plausible, the room in the painting cannot be reconstructed exactly. The couple might have stood together in a room of similar luxury, but van Eyck has not simply transcribed this assumed reality on to his panel. The single candle burning in a room flooded with daylight and the unusual form of the artist's signature have formed the basis of a detailed symbolic interpretation of the picture as a record of the Arnolfinis' marriage. The inscription 'Jan van Eyck was here' above the mirror presumably implies that he is one of the figures reflected entering the room. If it were possible for the picture to be just an extension of our reality, a window frame through which to look, as the fifteenth-century Italian theorist Alberti recommended, we should then see ourselves in the mirror. And, if the picture were a straightforward record of a couple posing in a room to be painted, we should see a reflection of the artist at work, as van Eyck showed himself impossibly mirrored in the armour of St George in the van der Paele altar-

piece of 1436. The success of van Eyck's illusionism has masked his subtle exploitation of painting's potential for mimicking the physical world while rising above its limitations.

None of van Eyck's work as painter to Philip the Good survives, although Philip's chancellor, Nicholas Rolin, can still be seen as van Eyck painted him, kneeling before the Virgin in a Romanesque architectural fantasy opening on to an immaculately detailed landscape (pl. 172). As in *The Adoration of the Lamb*, the combination of plausible details into an impossible whole removes the image from the physical world into the realm of the ideal. It is the concept of Rolin's devotion for which van Eyck finds visual expression, not any actual meeting between human and divine. The background celebrates the world and its Creator without tying the protagonists to its physical confines.

171. JAN VAN EYCK: Giovanni Arnolfini and his Wife, *1434. National Gallery, London.*

ROGIER VAN DER WEYDEN AND ROBERT CAMPIN

When, in 1443, Rolin and his wife founded a hospital at Beaune in their native Burgundy, van Eyck had been dead for two years and the artist they commissioned to paint an altarpiece for the hospital (*The Last Judgement*, pls 166, 167) was Rogier van der Weyden, the other founding figure in the history of Netherlandish art. From his home town, Tournai, van der Weyden had moved to Brussels, where he was town painter in 1435, and attracted commissions from the great of Europe. Compared to van Eyck, he made greater use of the expressive and descriptive potential of line and less of the minute depiction of detail. This made his art more accessible to both painters and sculptors, and accessibility must have played a part in his overwhelming influence, it-self evidence of his widespread appeal.

The resplendent gold background of *The Last Judgement* is typical of one aspect of van der Weyden's work. He could and did paint superb architectural and landscape settings, but the simple backgrounds of gold, textile hangings or minimal indications of architecture did not distract the viewer from the figures and ensured, by their abstract quality, a spiritual response to the physicality of the figures, who retain their credibility despite anatomical distortions for expressive effect.

Van der Weyden's most influential work, his *Deposition* (pl. 173), was commissioned not by a ruler or a courtier, a Philip or a Rolin, but by a guild of archers, a body that combined a practical role in training potential soldiers with a prestigious social framework of competitions, feasts

172. JAN VAN EYCK: Virgin of Chancellor Rolin, *c.1435. Musée du Louvre, Paris.*

173. ROGIER VAN DER WEYDEN: Deposition, *c.1440*. *Museo del Prado, Madrid.*

and meetings. The Great Archers' Guild at Louvain maintained the chapel of Our Lady Without the Walls, for which they commissioned the large altarpiece featuring their emblematic crossbows in the fictive carved tracery at the corners. Within the gilded box, defined by the front tracery and the back cornice, is compressed a group of people, lowering the body of Christ from an impossibly small cross. The setting can be rationalised as a transcription into paint of a carved wooden altarpiece, where scenes were similarly assembled in compartments. This does not, however, explain the spatial relationships of the figures. The emotional intensity of their grief-stricken instability around the descending corpse demands active involvement by the viewer, offered no escape into a flow of narrative detail. He is forced to concentrate not so much on the event of the Deposition as on its significance, both for the protagonists, as the Virgin swoons in a posture echoing that of her son, and for himself, for whom the sacrificial offering of Christ's body and blood affords the only hope of salvation.

'Realistic' is an even less satisfactory term for such an image than for van Eyck's more minutely rendered compilations of detail. The monumentality of van der Weyden's figures has little to do with van Eyck and can be traced to the influence of van der Weyden's master, Robert Campin, documented in Tournai from 1406 until his death in 1444. Campin was almost certainly the author of the works associated with two panels thought to have come from an abbey of Flémalle. Neither the great Flémalle altarpiece nor a large *Deposition*, a fragment of which, showing a crucified thief, is in Frankfurt (Städelsches Kunstinstitut), has survived intact. Fortunately, Campin was widely imitated, although he failed to attract the international reputation of van Eyck and van der Weyden, and many of his works can be re-created from later copies and variants. His development from the effective yet still hesitant *Entombment Triptych* (London, Courtauld Institute Galleries) to the mastery of the *St Veronica* (pl. 175, from the Flémalle altarpiece) is that of an outstanding genius. The eloquent force of Veronica's face and pose, the combination of closely observed detail with a grasp of overall form, the reconciliation of the flat pattern on the actual surface of the panel with the created illusion of space, were all achievements noted by van der Weyden. The decision to show the saint in old age instead of her usual youthful beauty demonstrates an inventiveness shared by van der

157

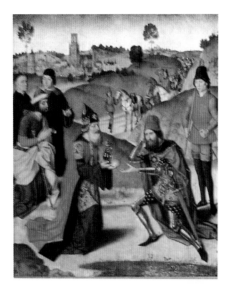

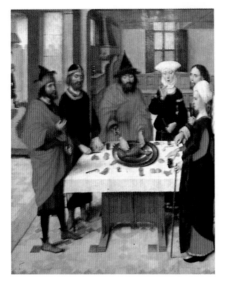

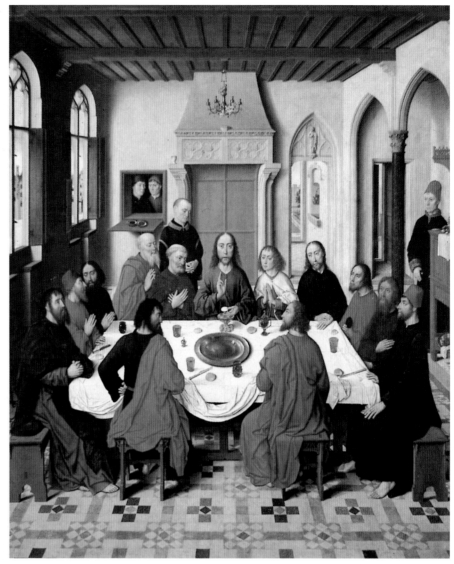

174. DIERIC BOUTS: Sacrament Altarpiece, *1464–8. St Peter's Church, Louvain. To the left of the Last Supper are Abraham and Melchizedek and the Passover; to the right, the Gathering of Manna and Elijah in the Desert.*

Weyden, whose iconographic innovations and new compositional solutions dominated Netherlandish, and so much of European, art into the sixteenth century.

DIERIC BOUTS AND HUGO VAN DER GOES

The loyalty of Netherlandish artists and patrons to the formulations of van der Weyden may have been encouraged by the training and trading structures embodied in the guild system. While details of practice varied from town to town, the predominant aim was to protect the licensed artists by controlling the quality of the town's output and by limiting possible competition from outside the town. Training was by apprenticeship to a registered master, whom the apprentice would learn to imitate. When he was skilled enough, he would be able to help in the painting of the master's panels or to produce pictures entirely on his own which were stamped with the

master's style and could be sold as products of his workshop. Only a master was allowed to display and sell his work, so that a qualified painter without the substantial capital required to pay the guild fees and set up his own workshop had to hire himself out as a journeyman, in which capacity he would, again, probably be expected to imitate the master's style. Greatly reduced guild fees for offspring encouraged sons to follow their fathers' trades; even if they did not have much natural talent, they might well manage to make a living off their father's reputation and patterns. Such a system might seem unlikely to foster originality, but it must be remembered that the great innovators were as much its products as were the uninspired copyists. Patrons seem to have encouraged this conservatism, sometimes asking for earlier pictures to be taken as models or, in the sixteenth century, having the great devotional icons of van Eyck and van der Weyden repeated

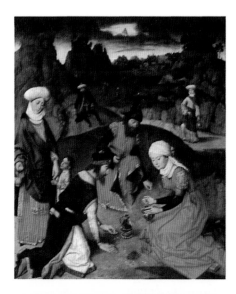

dress in attendance at the Last Supper. The room in the central panel with the Last Supper uses a single vanishing-point construction, while the wings, with Old Testament scenes prefiguring the Eucharist, show a concern to depict landscape and figures as a unified totality, instead of using the landscape simply as a background to the figures (as in van Eyck's *Virgin of Chancellor Rolin*). Bouts's narrative scenes required landscape settings – the wilderness into which the manna falls, for instance – but the developing taste for landscape meant that landscape backgrounds, without the intervening architecture of van Eyck's *Virgin*, were increasingly employed for pictures where the subject matter did not specifically demand that the painter provide an exterior setting.

175. ROBERT CAMPIN, the MASTER OF FLÉMALLE: St Veronica, *c.1440*. *Städelsches Kunstinstitut, Frankfurt.*

with their own portraits.

Dieric Bouts (c. 1415–75) of Haarlem combined van Eyck's interest in spatial construction with van der Weyden's monumentality to form an art that was, in its own turn, much imitated. Bouts settled in Louvain, where he worked until his death. His *Sacrament Altarpiece* of 1464–7 (pl. 174) was commissioned by a confraternity devoted to the Holy Sacrament, for their chapel in the church of St Peter in Louvain. The financing of van der Weyden's *Deposition* is unrecorded; the accounts of the Louvain confraternity show even the humble members making modest contributions to 'our panel'. Corporate patronage gave them the opportunity to be involved in the commissioning of a major work that was far beyond the resources of any one of them on his own. Four members of the brotherhood were empowered to supervise the commission, and they are probably recorded in the four figures in contemporary

159

Bouts's more logical integration of figures and settings was not followed by Hugo van der Goes (c. 1435–82), one of the few other Netherlanders to make even a selective use of geometric perspective in the fifteenth century. Van der Goes enrolled as a master-painter in his native Ghent in 1467; around 1478 he retired to a monastery outside Brussels, where he continued to paint until overcome by melancholic madness shortly before his death. A fellow monk ascribed his dementia to his pride, since in renouncing the world Hugo, the great artist, had attracted even more attention than if he had remained within it. Certainly his work and reputation reached beyond the Netherlands, and much of his greatest work (like that of many others) survives because it was exported: to Scotland for James III, to Spain for unknown fifteenth- or sixteenth-century owners, and to Florence for Tommaso Portinari, the agent of the Medici bank in Bruges. The centre panel of the *Portinari Triptych* (pl. 176) combines accurately constructed space with figures who, by perspectival rules, vary illogically in size. In conjunction with the wings, where the patron

about completing his paintings. Another factor lies in the dramatic political and economic consequences of the death of Charles the Bold, Philip the Good's son and successor, at the Battle of Nancy against the Swiss in 1477. Tommaso Portinari had advanced vast sums to Duke Charles, and he and the Medici bank were almost ruined, but the repercussions spread far beyond Charles's immediate associates. Charles had hoped to carve out a Middle Kingdom uniting the Netherlandish and Burgundian territories. Instead, his heiress, Mary, was disinherited of the duchy of Burgundy because she was a woman and had difficulty resisting the incursions of the French and the rebellious stirrings of the towns, despite her marriage to the future emperor, Maximilian of Habsburg. Her early death in 1482 and the union of their heir, Philip the Fair, with the heiress of Spain and the New World meant that the Netherlands were treated as a province of the wider empire, instead of the principal economic and political power base they had been under the earlier dukes. Maximilian was an active patron of the arts, who visited van der Goes in his

176. HUGO VAN DER GOES: Portinari Triptych, *1475. Galleria degli Uffizi, Florence. The Adoration of the Shepherds with, to the left, Tommaso Portinari and his sons with St Thomas and St Anthony; to the right, Maria Portinari and their daughter with St Margaret and St Mary Magdalen.*

saints tower over the kneeling donors, the discrepancies in scale become dramatically apparent. Van der Goes took *accuracy* as far as he wanted: rigorous consistency would have replicated the experience of the visible world more closely but would not have produced a devotional image of such power and intensity.

The *Portinari Triptych*, begun in the mid 1470s, was not delivered to the church of S. Egidio in Florence (the meeting-place of the Florentine painters' confraternity) until 1483. The delay can be explained by van der Goes's working-methods, for, we are told, one of the stresses contributing to his mental collapse was his anxiety

monastery, but he could not provide the Low Countries with the cultural centre afforded by the courts of his wife's father and grandfather.

HIERONYMUS BOSCH

While the Netherlands ceased to be the political centre of their rulers, their economic prosperity increased, stimulated by the new trade with America and the new sea routes to the East. Artists continued to thrive thanks to the prospering home market and the booming export trade. The shift away from seasonal production geared to the great trading-fairs made it easier for artists to try out ideas on the open market. They did not

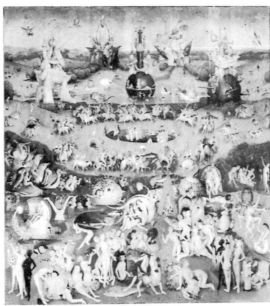

177. HIERONYMUS BOSCH: The Garden of Earthly Delights, *before 1516. Museo del Prado, Madrid.*

have to settle in the great centres such as Bruges and, increasingly, Antwerp: the surname of Hieronymus Bosch (c. 1455–1516) shows that he could use the name of his home town ('s Hertogenbosch) as a distinguishing signature in reaching a wider market. His popularity continued throughout the sixteenth century, when forgers were already putting their imitation Bosch paintings up chimneys to be artificially aged by the darkening effects of smoke. Bosch drew on traditional subject matter and technique but redeployed both to achieve new ends of distinctive individuality. His triptych known as *The Garden of Earthly Delights* (pl. 177) shows his more fluid application of thinner layers of oil paint, a significant loosening of the meticulous methods of earlier painters. The Creation, on the left wing, and Hell, on the right, are both treated with unusual inventiveness but are not revolutionary as subjects. Yet the subject of the centre panel, and hence the meaning of the whole triptych, has never been satisfactorily explained by either literary texts or paintings of similar subjects. The presentation of Eve to Adam, the prelude to the Fall and the introduction of sin and lust, is followed by a complex fantasy of naked men and women frankly making love or in highly charged erotic juxtapositions with animals, giant birds and outsized fruits. The progression to the torments of the damned in the left wing surely indicates that this is sinful lust and not some meritorious age of innocence. Bosch's mastery of colour and design is evident in the instant legibility of the intricate compositions, which then invite a closer examination of their countless details.

The triptych was owned by Philip II of Spain,

an ardent collector of Bosch's works, which would never have been allowed inside Philip's palace-monastery of the Escorial if their doctrine was unsound. God presides over all the follies and disasters of men in Bosch's panoramic visions. God, after all, creates Eve and gives her to Adam. In the *Haywain* triptych, where the pursuit of worldly riches and success is symbolised by the greed for hay, a Christ of the Last Judgement appears above the central scene of human covetousness. As judge, he will condemn men to the Hell on the right wing, and yet, as judge, he displays the wounds in his hands and side, the symbols of his death of atonement by which man can be saved to attain the bliss of Heaven.

THE INFLUENCE OF NETHERLANDISH ART

Europe's receptivity to Netherlandish art means that the influence of Bosch and his predecessors can be traced in most countries. The gradual replacement of egg by oil as the chief medium for paint was directly due to Netherlandish example. It is not only in their changing technique that the debt of artists such as Piero della Francesca to the Netherlands is evident, but also in their adoption of Netherlandish motifs and compositions and in their new awareness of light and texture. Piero's chief patron, Federigo da Montefeltro, duke of Urbino, employed a friend of Hugo van der Goes to decorate his new palaces, and earlier the duke and duchess of Milan had sent their court painter to Brussels to train with van der Weyden.

Netherlandish artists or those with a deep knowledge of Netherlandish art were found at work across Europe. The anonymous *Pietà* from

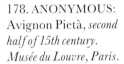

OPPOSITE 179.
MARTIN
SCHONGAUER:
Virgin and Child in a
Rose Garden, *1473.*
Church of St Martin,
Colmar. Exhibited in the
Dominican Church,
Colmar.

Villeneuve-lès-Avignon in the south of France, perhaps of around 1465 (pl. 178), has much in common with van der Weyden's monumentality, linearity and emotional intensity, although the Avignon artist created drama by a more evident distortion of form and simplification of contour.

In parts of Germany – for instance, the area around Cologne – the legacy of pre-Reformation art fared better than in France and it is easier to see an indigenous tradition responding to the outside influence of the Netherlands. The soft, painterly prettiness of earlier Cologne painters was continued by Stefan Lochner, active in the first half of the fifteenth century. His exquisite *Virgin and Child in a Rose Garden* (pl. 163) should not blind us to the fact that, like the Netherlanders, he could also work on a large scale: his authenticated altarpiece for Cologne Cathedral is a triptych some 5 m across when open. A larger-scale treatment of the theme of the Virgin of the Rose Garden, from Colmar in Alsace, further up the Rhine, shows how a younger painter, Martin Schongauer (1435–91), had fallen under the spell of van der Weyden (pl. 179).

Schongauer's Virgin reflects van der Weyden's ideal type in appearance and van der Weyden's style, in contrast to Lochner's, in the strong linearity, which emphasises the essentially flat geometry of the design on the panel while inter-

nal modelling maintains the volume and substance of the figures. Sensitivity to line is even more evident in Schongauer's graphic work, where he carried the new art of print-making to technical and expressive achievements which inspired the young Albrecht Dürer (1471–1528).

ALBRECHT DÜRER

Dürer's admiration for Schongauer is proved by his disappointment on arriving in Colmar to find that the master had died. This was during his *Wanderjahre*, the years of travel after his formal apprenticeship, which began in 1489 when he left his native Nuremberg at the age of eighteen. Not all his route is known, but he seems to have visited the Netherlands, as his goldsmith father had done in his youth, and he certainly worked in Basel designing woodcuts for illustrated books. He returned to Nuremberg in 1493 and set up as a painter and print-maker, attracting the patronage of Frederick the Wise, elector of Saxony, and later of the Emperor Maximilian, as well as of the patrician merchants of Nuremberg.

In his *Self-Portrait* of 1498 (pl. 164), Dürer proclaimed his success in terms of wealth and status. Enjoying his personal beauty and his luxurious costume, which, with its gloves, deliberately distances him from the manual worker, he directs attention to his skill as an artist only in the com-

178. ANONYMOUS:
Avignon Pietà, *second*
half of 15th century.
Musée du Louvre, Paris.

180. ALBRECHT DÜRER: The Knight, Death and the Devil, *engraving, 1513. British Museum, London.*

paratively small inscription announcing his name, authorship and age. The format and detailed technique reveal his thorough grounding in the Netherlandish and Northern traditions. He was also anxious to learn from Italian prints, particularly from Andrea Mantegna, whose sharp-edged linearity of style was well conveyed through engraving. In his desire to comprehend the Italian's achievement, Dürer made minute copies of his works.

When Dürer went to Venice in 1505, he found that his own prints were being copied and that through them he was already famous in Italy. By this date his European reputation was firmly based on his successful single prints of religious and secular subjects and on the first of his great series, the fifteen woodcut illustrations to the Apocalypse or Book of Revelation, for which he acted as his own publisher in 1498. His woodcut designs forced his cutters to the limits of the medium; his engravings and etchings give a

direct experience of his extraordinary technical skill. The later (1513) engraving *The Knight, Death and the Devil* (pl. 180) demonstrates his ability to control a complicated design by distinguishing the textures of overlapping forms, and to convey volume and movement by contrasting the direction and density of the lines incised on the metal plate to hold the printing-ink.

Dürer was not satisfied with his fame as a graphic artist and he was given the opportunity to establish himself in Venice as a painter and colourist when a confraternity of German residents commissioned the large altarpiece of *The Virgin of the Rose-Garlands* (pl. 181). In it are open borrowings from the work of Giovanni Bellini – 'old', according to Dürer, 'but still the best in painting' – whose achievements in old age easily compete with the works of the youthful Titian and Giorgione, who were heavily indebted to his example. The raised position of Dürer's Virgin and the music-making angel below are clearly derived from Bellini altarpieces such as that of S. Giobbe (pl. 226), and the colour and looser oil technique owe much to Venetian art. Bellini, in turn, admired Dürer's prowess in paint, wrongly believing the secret of his skill to lie in exceptionally fine brushes.

Dürer was anxious to learn from the Italians, particularly those aspects of art which could be systematised. In Germany he had resented the refusal of an emigrant Italian to divulge his system of ideal human proportions, and from Venice he dashed off to Bologna because he had heard of someone there who could advance his knowledge of perspective. The intimate friend of humanist scholars, Dürer recognised that the visual arts needed a theoretical base in science and mathematics to be accepted as liberal and not mechanical arts, and he planned to publish a series of books to instruct young artists in draughtsmanship, perspective and proportion. Yet he was well aware that over-systematisation could lead to a lifeless accuracy of representation which had little to do with art, and himself recommended his rules as ways of training the eye and hand, not as laws perpetually to be obeyed.

Dürer died in 1528, his great educational project incomplete. The complexity of his intentions and achievements emerges from his substantial body of completed paintings and prints, his annotated drawings and meticulously observed watercolours, his books, notebooks and letters, and the observations and reminiscences of his friends and admirers. Among them were many of the great scholars and leaders of the Reformation, as well as princes, statesmen and merchants.

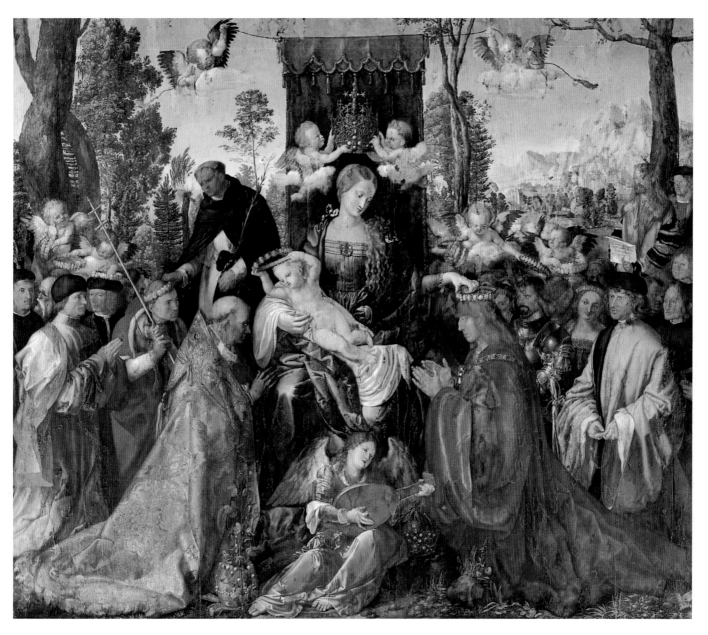

CROSS-CURRENTS

In seeking a theoretical basis for his art and, of necessity, turning to Italy, where there was already a tradition of writing about the visual arts, Dürer appears to have been unique in the North. He was not alone, however, in adopting Italian fashions for the revived language of Classical antiquity. Back in 1447, the French painter Jean Fouquet (1420–81) had visited Rome and returned with a developed interest in geometric perspective and the vocabulary of Classical architecture and figure types. His Italianate style, seen in the book of hours he illuminated for Etienne Chevalier, treasurer of France, around 1455 (pl. 183), seems to owe most to Fra Angelico, with overtones of Donatello's decorative freedom in the wreath-bearing putti. Some classicising motifs were introduced into the French repertoire by Fouquet, but, on the whole, Northern artists ignored Italian developments in the fifteenth century. Although Rogier van der Weyden travelled to Italy in 1450, probably as a pilgrim for the Holy Year, no such journey could be deduced from his work, which shows little Italian influence. Van der Weyden's lack of reaction was a far more typical response than Fouquet's receptivity.

Northern awareness of Italian art changed dramatically around 1500, the development of reproductive prints offering an effective means of artistic interchange. When Jan Gossaert (c. 1478–1533) went to Rome in 1508 in the train of one of the bastard sons of Philip the Good, he made drawings from antique sculpture and

181. ALBRECHT DÜRER: The Virgin of the Rose-Garlands, *1506. Národní Galerie, Prague.*

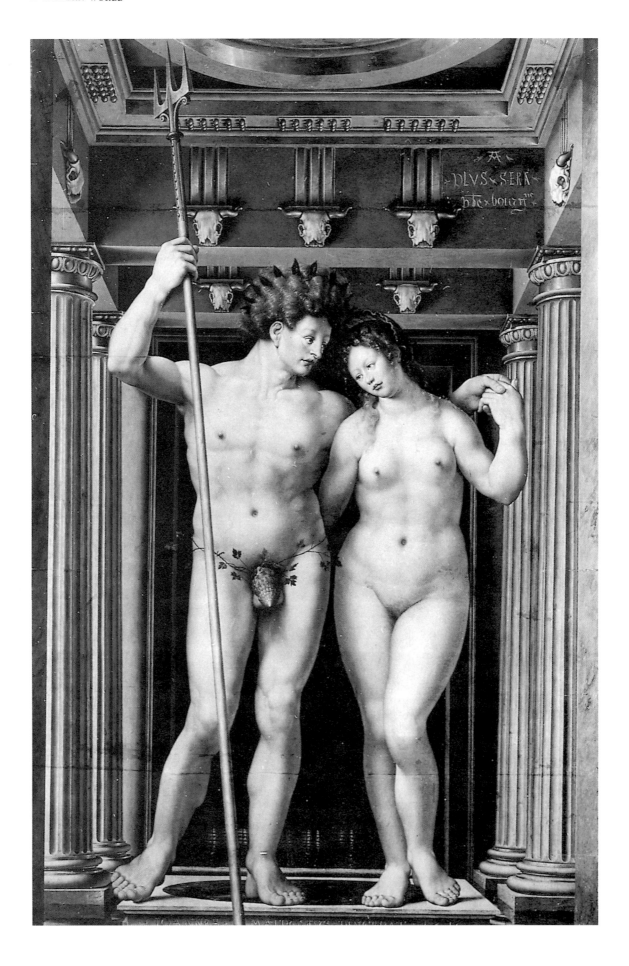

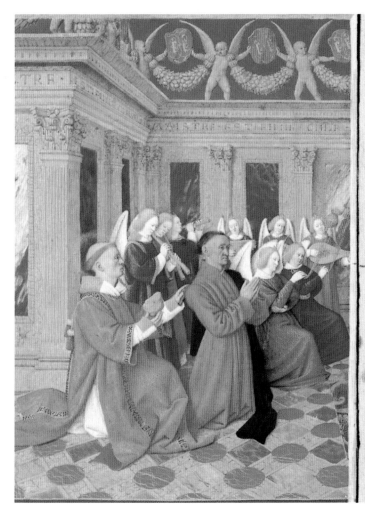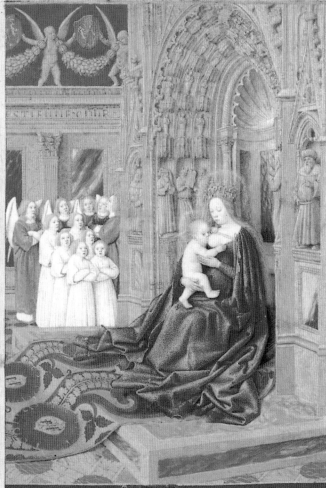

architecture, perhaps partly at his humanist patron's behest, and, on his return to the Netherlands, produced paintings of mythological subjects, long popular in contemporary garb, in appropriate undress (pl. 182). Gossaert seems to have relied for his figures more on prints than on his direct experience of Italy, but he was labelled in the evolution of Netherlandish art as the painter who brought back from Italy the true way of depicting nudes. The notion that Italy was the source of the true, the ideal, the ultimate in art became a commonplace advanced not just by the Italians but by the Northerners themselves.

Gossaert still maintained a traditionally minute painting technique, and artists were inevitably selective in their Italian borrowings. In Germany, Lukas Cranach (1472–1553) exploited the new respectability given the nude in his erotic Venuses and Lucretias, whose proportions have little in common with either Classical sculpture or Raphael. As court painter to the electors of Saxony, the protectors of Martin Luther, Cranach became almost the official artist of the Lutheran Reformation. His large work-

shop turned out numerous painted and printed portraits of the Reformer (see pl. 184); his altarpieces gave expression to the new doctrinal ideas; he designed the illustrations for Luther's biblical translations and writings, some of which he even published. Luther was opposed to immorality (as he saw it) in art, yet his friend Cranach continued to paint his classicising nudes with their distinctively Germanic accoutrements. Many German artists similarly translated subjects drawn from antiquity into their own idiom. Albrecht Altdorfer, active in Regensburg from 1505 until his death in 1538, is chiefly remembered as a landscapist and yet responded magnificently to a commission for a painting of one of the famed battles of antiquity, the defeat of Darius by Alexander the Great (pl. 185). As in other of his works, classicising props make an appearance (for instance, Darius' chariot), but overall the picture derives little from Italian or Classical art for its panoramic integration of the destructive power of human warfare with the turbulence of the natural world.

German artists, therefore, could treat the

ABOVE 183. JEAN FOUQUET: *Two leaves from the* Chevalier Hours, *c.1455. Musée Condé, Chantilly. St Stephen presents Etienne Chevalier to the Virgin and Child.*

OPPOSITE 182. JAN GOSSAERT, called 'MABUSE': Neptune and Amphitrite, *1516. Bode Museum, Berlin.*

OPPOSITE 185.
ALBRECHT
ALTDORFER:
Alexander's Victory
over Darius, *1529. Alte
Pinakothek, Munich.*

BELOW 184. LUKAS
CRANACH THE
ELDER: Martin
Luther in his Youth,
*c.1524. Germanisches
Nationalmuseum,
Nuremberg.*

themes of antiquity as successfully in their own idiom as they could the religious subjects with which they are perhaps more associated. The painted wings of the Isenheim altarpiece (pls 182, 183) show the artist known as Grünewald (c. 1475–1528) making a few superficial borrowings from the Italianate and then transforming them, as in the pedestals and columns of St Sebastian and St Anthony and perhaps the exaggerated musculature of Sebastian. The same imaginative freedom is applied to human proportions and 'laws' of perspective and scale. Opening from the horror of the Crucifixion on to the joy of the Annunciation, Incarnation and Resurrection, giving way to the tribulations of human life in the scenes of St Anthony, the altarpiece presents the central mysteries of the faith, mysteries which demand an emotional as well as an intellectual response. Grünewald aimed not at an abstract

notion of ideal beauty or at rigorously ordered space but at the forceful expression of religious truths. The spirituality of the painting is signalled by its refusal to accept the limitations of replicating the material world.

With a painting it is not difficult to distinguish between the physical reality of the panel or canvas covered with paint and the illusory reality created by the image painted on it. The sculpted image immediately has a material physicality which the painted image largely escapes. Waxwork-like reproductions of the human figure seldom constitute art; like painters, sculptors had to achieve credibility while avoiding the limitations of replicating the real world too exactly, a replication which would be even more apparent in three dimensions than in two. The achievements of Northern sculptors after Sluter, particularly the wood sculptors of southern Germany, cannot be summarised in a paragraph: one work will have to demonstrate the freedom and inventiveness with which they treated their material, creating images with an impact as profound and immediate as the more obviously intellectual contrivances of painting.

Veit Stoss (c. 1450–1533) literally defied mass and gravity by suspending his *Annunciation of the Rosary* (pl. 188) from the ceiling of the church of St Lawrence in Nuremberg. Although the tensile strength of wood is fully exploited for maximum freedom of draperies and gestures, the open lightness of the ensemble depends on metal struts. Both the 'reality' and the 'spirituality' of the central figures are heightened by gold and brilliant colours, which also serve to increase the legibility of the surrounding medallions.

Stoss's *Annunciation* was begun in 1517, the year that Martin Luther posted his Ninety-Five Theses on the church door at Wittenberg. This action is now taken to mark the beginning of the process that led to the setting up of churches independent of the pope in Rome and the dissolution of the unity of Western Christendom. The word 'Reformation' applied to this process is an appropriate indicator of Luther's original aims, but he and others, such as Zwingli and Calvin, found reform impossible within the existing institutions and were forced into a position of total opposition. Church and state could not be separated, so that the resulting conflict inevitably framed the political history of Europe. Many artists, among them Dürer, were profoundly affected by the new ideas. For Dürer, Luther was the man who had helped him out of great spiritual distress, and he filled pages of his diary with an impassioned outburst when a rumour of

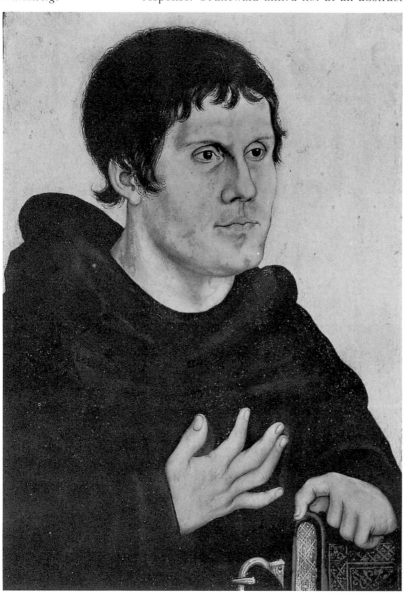

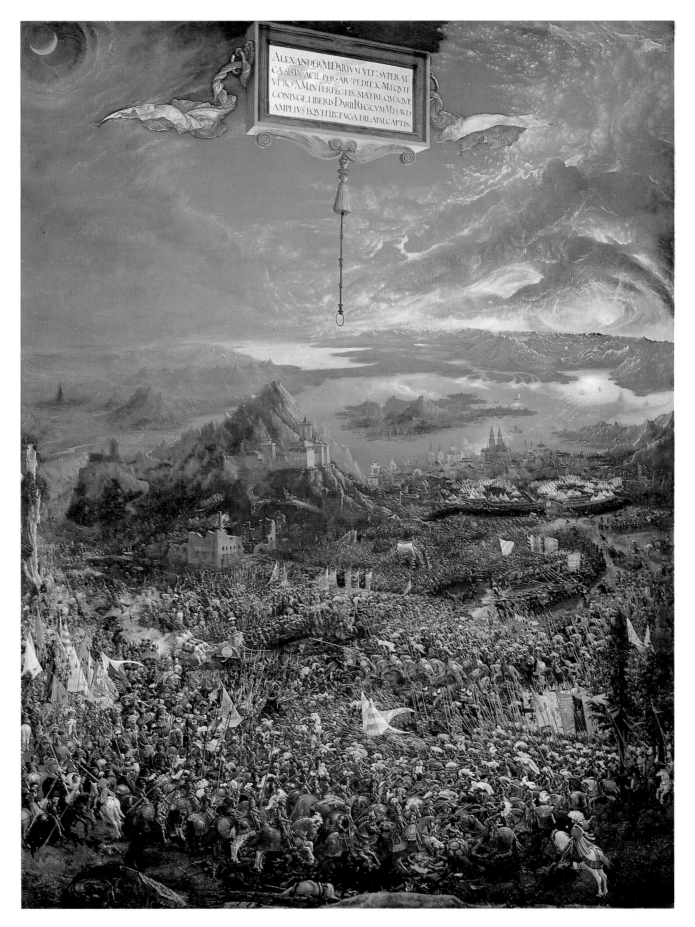

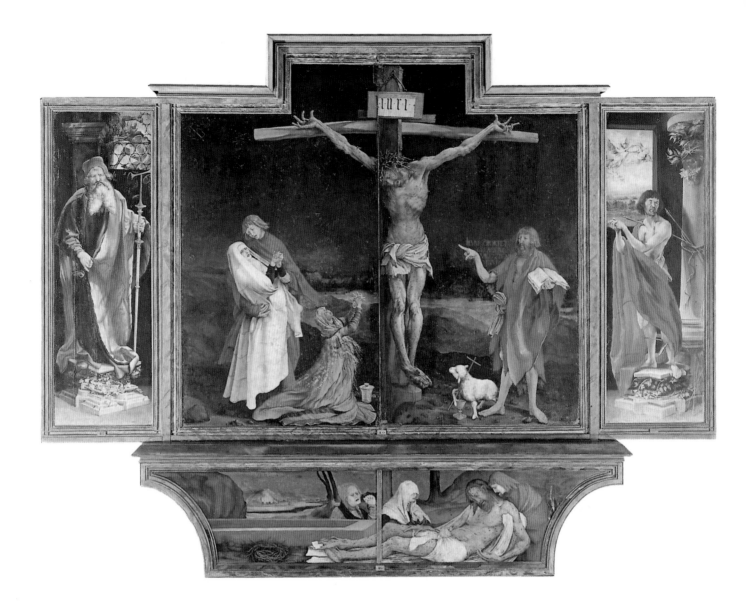

MATTHIAS GRÜNEWALD, ISENHEIM ALTARPIECE

The Isenheim altarpiece (c.1510–15) was made for the monastery at Isenheim in Alsace, where members of the Order of St Anthony tended the sick, particularly those afflicted with St Anthony's Fire, or ergotism, a disease causing horrific lesions and eruptions of the skin. A new patient was brought first to the chapel before the altarpiece in the hope of a cure through direct divine intervention. He would have seen initially the closed altarpiece: the panels with the semi-nude St Sebastian and St Anthony Abbot are fixed, while Christ and the Cross are placed off-centre so that the Crucifixion panels could open to reveal further paintings of the Annunciation, the Virgin and Child and the Resurrection. The centre panels with the Virgin and Child again opened to show sculpted figures of St Anthony between Sts Augustine and Jerome, all of them lavishly gilded and polychromed. The reverses of the second shutters were also painted so that the wooden statues were flanked by pictures of St Anthony meeting St Paul the Hermit in the desert and St Anthony tormented by demons. For this final stage, the Lamentation below the Crucifixion opened on to a carved predella with half-length figures of Christ and the Apostles.

The paintings were famed even in the

sixteenth century as the work of Matthias Gothardt or Nithardt, now known as Grünewald. The sculptures are attributed to Nicholas Hagenauer (c.1445–1526). The coat of arms of Guido Guersi (d. 1515), preceptor or head of the monastery, is on the panel of St Anthony meeting St Paul, and the date of 1515 is inscribed on the Magdalen's ointment pot at the foot of the Cross. The monastery was supressed at the French Revolution and the altar-piece dismantled. It is now displayed separated into its three stages, although there is still some uncertainty about the details of its original form.

It seems more likely that St Anthony was at the right hand of Christ so that the viewer would have made the natural left to right progression from St Anthony assailed by the demon, through the redemptive sacrifice of Christ, affording salvation from the devil, to St Sebastian, achiever of the joys of heaven and the martyr's crown. The diseased may have found it easier to relate to the agonised contortions of Christ's broken body than to the serenity of St Sebastian's victory over the flesh, which no longer senses the transfixing arrows. The Son of God is most unmistakably Man in sharing his fate of death. In addition to the wounds of nails, spear and crown of thorns, his flesh has been torn by the whips and birches of the flagellation which have left splinters embedded in the body. His sufferings could be compared very directly to those of the patients afflicted with St Anthony's Fire and are made even more apparent by the mental anguish of those who have watched his agony. The Virgin swoons into the arms of St John the Evangelist; the Magdalen curves backwards in the anguish of her helpless grief. On the other side, John the Baptist can stand more solidly: prophet of the Messiah, he was martyred before the Crucifixion, which he therefore did not witness as such. He points at Christ, a gesture symbolising the words 'Behold the Lamb of God', with which he first recognised him. The sacrificial nature of the Lamb is made clear in the symbolic animal bleeding into a chalice at his feet. The actual words above the Baptist's arm are 'He must increase but I must diminish.' If not granted a cure through the intercession of Sts Anthony and Sebastian, the diseased could sink their torments in the greater agonies of Christ and hope to share in the redemption he had so dearly bought.

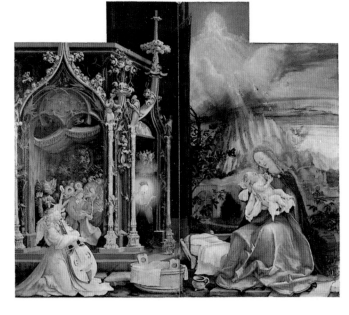
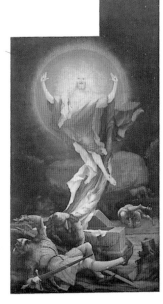

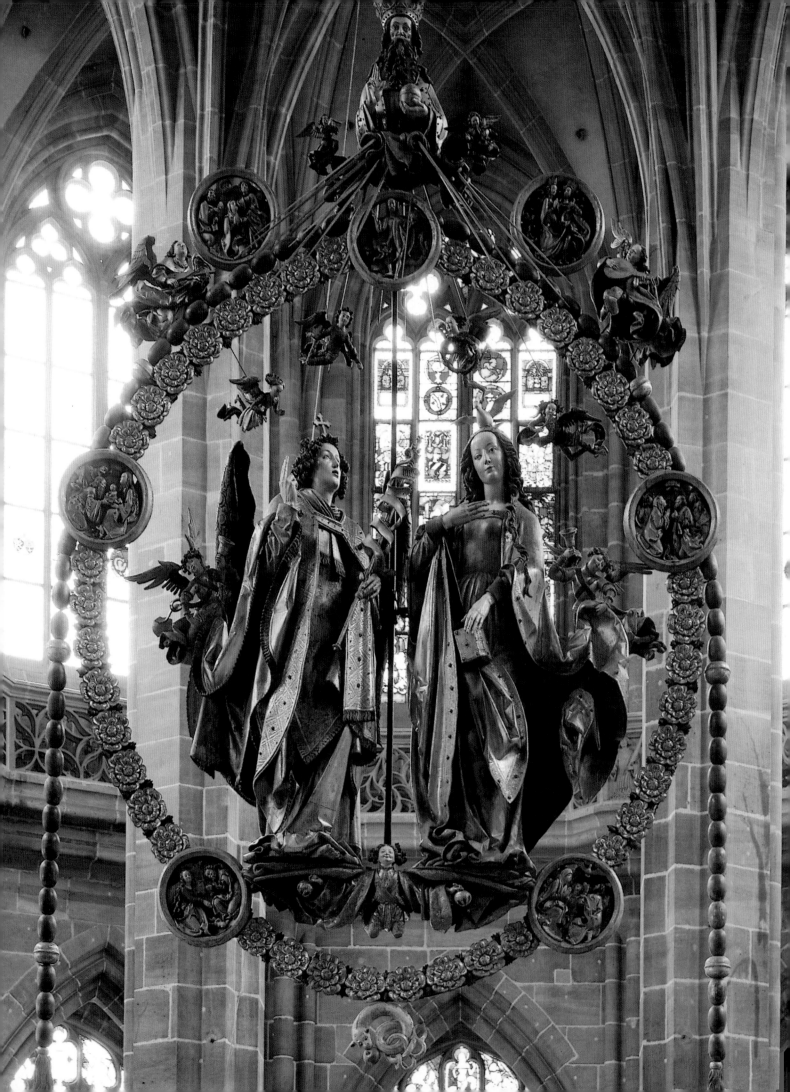

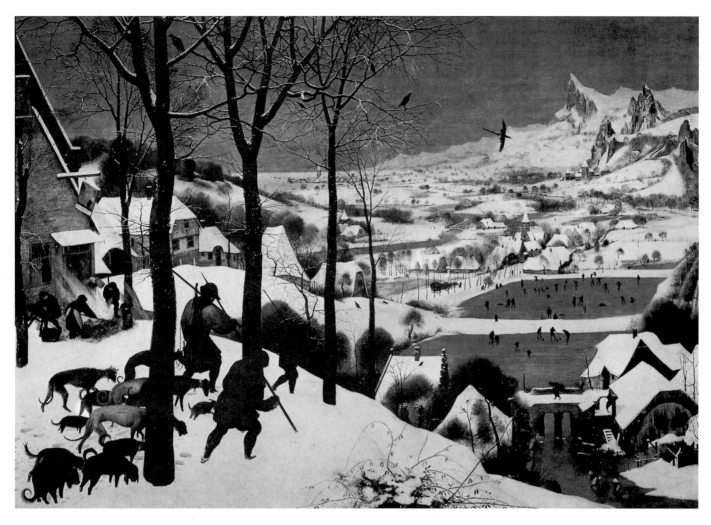

Luther's arrest reached him in the Netherlands. Other artists were caught up in events willy-nilly, and so, of course, was the art they had made. When Nuremberg was reformed, under the comparatively moderate influence of Luther, Stoss's *Annunciation* had to be covered but did remain in the church. These grand images were, at best, irrelevant to the reformed faith, and many artists suffered great hardship in newly reformed areas. The sculptors were hardest hit, for statues were especially vulnerable to association with idolatry and they had fewer openings in the non-ecclesiastical market. Painters, such as Hans Holbein (1497/8–1543), who left the rigours of reformed Basel for the court of Henry VIII of England, could always turn to secular decorative schemes, portraiture and book illustration.

The Reformation did not in itself lead to the rise of secular art – much of the demand for landscapes, for instance, continued to come from Catholic Italy and Spain – but it did force artists in Protestant countries to concentrate on non-contentious subject matter or on religious art with a suitably didactic, narrative element. Por-

traits, landscapes and the developing fields of still-life and genre scenes of everyday life were already being seen as Northern specialisations before the full effects of the Reformation had been codified in the Netherlands. In the context of contemporary, Italian-based art theory, landscape and portrait were especially suited to the Northerners' capacity for realism. Northerners could only imitate nature, while Italians could translate the grand idea into art; it was actually a Northerner who said that Netherlanders can only paint with their hands while Italians paint with their heads. Many Northern artists tried to emulate the history painting of the Italians, with varying degrees of success; others accepted their stereotyping as landscape, portrait, still-life or genre painters and achieved fame and fortune. Yet in the world of the High Renaissance, when all accepted the pre-eminence of Italy, the ineffable art of Pieter Bruegel the Elder (c. 1525/30–69; pl. 189) was as far from mere imitation of nature as had been the art of Jan van Eyck in the early Renaissance, when Italy, and all Europe, looked to the Netherlands for the best in art.

ABOVE 189. PIETER BRUEGEL: Hunters in the Snow, *1565. Kunsthistorisches Museum, Vienna.*

OPPOSITE 188. VEIT STOSS: Annunciation of the Rosary, *1517–18. Church of St Lorenz, Nuremberg.*

173

7

THE HIGH RENAISSANCE IN ROME

A. RICHARD TURNER

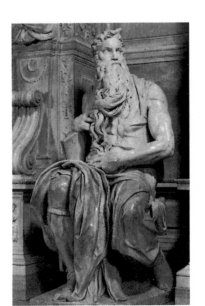

The period of Italian art that we have come to call the High Renaissance belongs to the beginning of the sixteenth century (approximately 1500–20). In his *Lives of the Artists* the artist-historian Giorgio Vasari (1511-74) charted the revival of the arts in Italy in terms of a three-phase development. Tentative beginnings were made in the later thirteenth and the fourteenth centuries. The second stage was the fifteenth century, when a parade of advances in the rendering of the nude, perspectival construction of space and depiction of motion made possible an art ever more faithful to the appearances of nature. But only in the third phase, beginning about 1500, with Leonardo da Vinci (1452–1519) as the pioneer, were fluid draughtsmanship, proportion, measure and grace raised to a new height in which nature was surpassed and the excellence of the ancient artists challenged. The culmination was reached in Michelangelo, whose genius was seen as nothing less than a gift from God.

If this art was a fusion of beauties distilled both from nature and from the best of ancient art, it was no less a moral statement. It was to celebrate its virtue that Vasari wrote his *Lives of the Artists*. The antiquarian and art historian Johann Winckelmann echoed Vasari's judgement in the mid-eighteenth century, seeing the sixteenth century as a rebirth of the glories of antiquity achieved through a renewed understanding of the Greeks. And Winckelmann's spiritual son, Goethe, saw in the culture of ancient Greece the perfection of humankind itself. Not all critics, however, read the past in that way. A number of voices in the nineteenth century, of which John Ruskin's is surely the most memorable, saw the time around 1500 as an ominous watershed between an authentic Christian art, on the one hand, and on the other an arrogant secular art that had lost its soul.

By the end of the nineteenth century whatever vigour this polemic possessed was spent. A series of scholars, including the Swiss Jacob Burckhardt and the Frenchman Eugène Müntz, had sketched panoramic views of a secular society whose greatest brilliance was in its cultural manifestations, a society that for a brief time attained a golden age. It remained for Burckhardt's pupil Heinrich Wölfflin to define closely the visual characteristics of art around 1500, a task completed in *Classic Art*, published in 1899. In a radical turn away from the habits of the day, Wölfflin all but gave up any treatment of the historical setting or biographical data. His is an art history in which the objects themselves and their family resemblances are the subject of study. While periods in the history of art may be predicated on any number of foundations – great men, political dynasties, underlying cultural assumptions, geography, and so on – Wölfflin's work and its following have assured that the term 'High Renaissance' rests first and foremost on criteria of visual form and style. This chapter attempts to

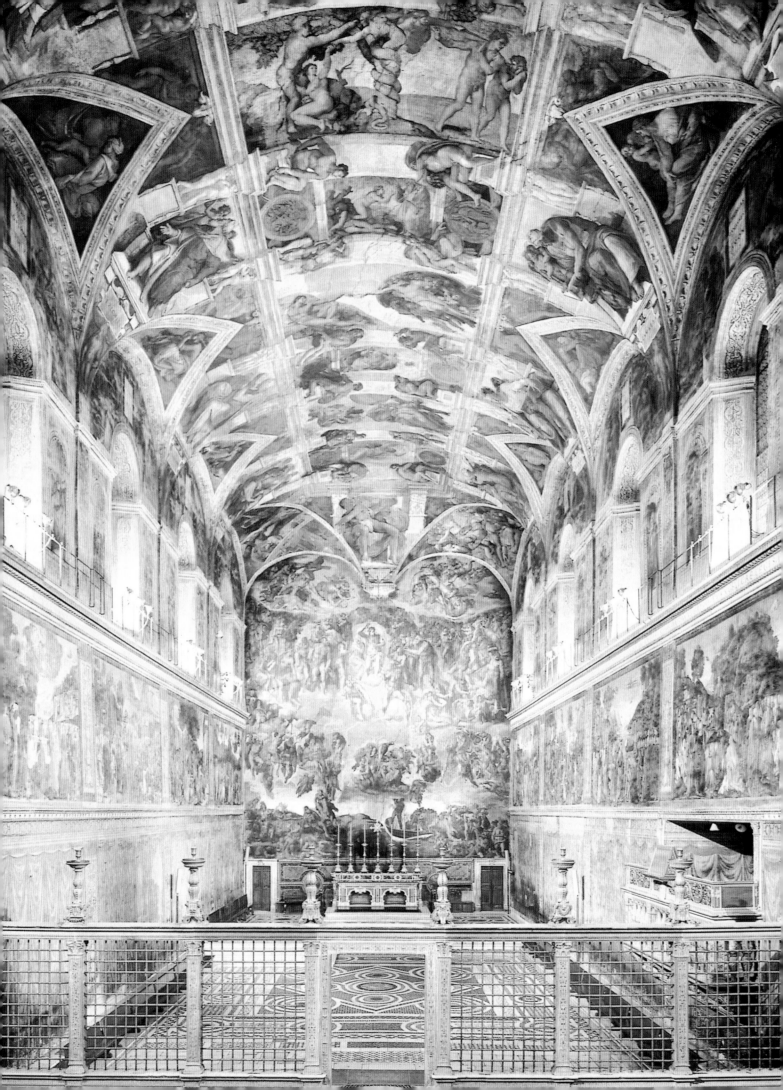

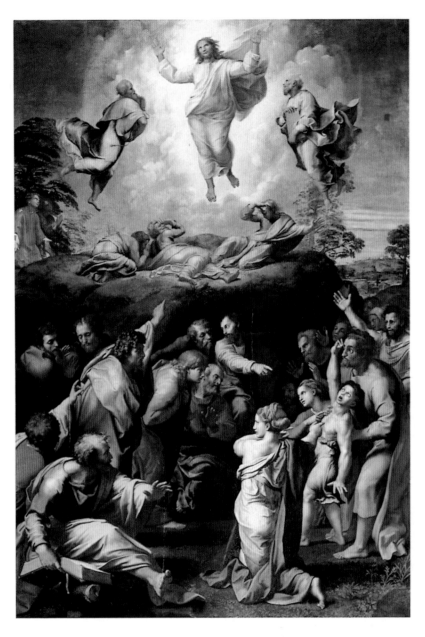

192. RAPHAEL:
The Transfiguration,
*1517–20. Vatican
Museums, Rome.*

consciously poised, ideal. From Michelangelo's seers on the Sistine ceiling to the Madonnas of the mature Raphael, an affirmation of spiritual strength housed in beautiful flesh is the artistic hallmark of the age.

The creators of this art had a new sense of their position in society, and a new self-consciousness about their art. For centuries the making of art had been a modest vocation, akin to making shoes or furniture. Already in the fourteenth century there are hints in writers such as Dante and Boccaccio that the artist deserves more. The humanist Leon Battista Alberti in his *De Pictura* (*On Painting*) of 1435 makes the claim specific: the successful artist must not only possess technical mastery, but also be well-lettered. Towards the end of the fifteenth century the sculptor Antonio del Pollaiuolo (c. 1432–98) added a new liberal art to the canonical set on a papal tomb: it was Perspective, the patroness, if you will, of painters. By the early sixteenth century the change in the artist's professional and social situation had become clear. Leonardo and Michelangelo could pick and choose their patrons and were capable of abandoning commissions that proved uncongenial. In place of the old-fashioned contract, a patron would settle for a work, any work, from the hand of a great man. Michelangelo could dare to spar with a pontiff, and Raphael is described as having an entourage like that of a prince of the church. Giulio Romano (prob. 1499–1546) ended his days in one of the grandest houses of Mantua, designed by himself.

While the evidence is less complete, it seems that an increased self-consciousness about the creative process accompanied this new sense of intellectual and social position. Vasari and others before him comment upon Leonardo's habit of leaving works of art unfinished, suggesting a dissonance between the vistas of the mind and the reach of the hand. Leonardo's own notes on painting make abundantly clear that it is a science worthy of comparison with other complex intellectual activities. The artist now thinks about the premises of what he is doing, and shares his thoughts with his friends, the men and women of letters. In many ways he had become in less than a century the sort of person we think of today when the word 'artist' is spoken – a creator, an intellect.

A GOLDEN AGE

Now imagine, if you will, an elderly Roman seated before the church of S. Pietro in Montorio in the autumn of 1523. The view from the Janiculum, one of the seven hills of Rome, is of old Rome, the Rome that in his childhood was but a

define that style, and also to consider issues of patronage and iconographical significance that have interested scholars in recent years.

The decades on either side of 1500 were among the most tumultuous in the history of the West. These are the years when Africa was rounded and America discovered, in which the great powers of Europe contended to partition the states of the Italian peninsula, when Christian Europe became a house divided between Catholic and Protestant, and when the first flowering of publishing-houses spurred an unprecedented explosion of knowledge. Whatever one's assumptions concerning the connections between art and a wider spectrum of historical events, there is no denying that an age marked by turmoil and uncertainty produced an art that is heroic, self-

town. Its topography was layered with the debris of the ages, laced through with winding, unpaved roads. The culture was provincial and the economy poor, dependent on a papacy only recently returned from exile.

By 1523 all that had changed. Beginning around 1450, a series of popes sought to revive Rome. They fortified her walls, for political viability in the contest of Italian city states was a precondition of spiritual pre-eminence. They restored and beautified her ancient Capitol, churches, streets and bridges, so that pilgrims to the holy city might find physical amenity, and have their spirits uplifted by the refurbished monuments. Restoration and renewal were the hallmark of these years, a revival in which the glory that was ancient Rome and the supremacy of the church of Peter were married. Rome was the Eternal City, the city of Caesar and Peter, and her destiny was to serve as the temporal and spiritual centre of the world until the fullness of time.

Yet for our old man on the Janiculum in 1523 there must have been a sense of closure that went well beyond the autumn of his own life. Raphael, the central painter of his age, had died in 1520, and was enshrined in the Pantheon across the river. His primary patron, Pope Leo X, had died only a year later, to be succeeded by a lugubrious and unsympathetic foreign pontiff. Something indeed seemed to be at an end. It was what contemporaries called a golden age, and what our century has described as the High Renaissance. There, at the church of S. Pietro in Montorio in 1523, an altarpiece and an unusual little building bore witness to what had been accomplished in the past quarter century. We may with profit look at what they eloquently summarise before examining how it all begun.

THE TRANSFIGURATION AND THE TEMPIETTO

The Transfiguration (pl. 192) was Raphael's last major painting and, as a recent cleaning has revealed, almost wholly by his hand. At first displayed as the valedictory of the deceased artist, it had been transferred to S. Pietro in Montorio in 1523. The upper part of the altarpiece shows the transfigured Christ and those who attend him, suave floating forms bathed in an aura of cool, pellucid light. This assured realm of Grace contrasts with the animated and confused human condition below. The wild-eyed boy to the right is possessed, and the viewer is invited to contemplate the miracle of exorcism that the Light of the World will perform.

It is a monumental and powerful artistic vision. Figures are sculptural in their modelling and assured outline, their three-dimensionality enhanced by a strong play of light and dark. The flow of forces within individual figures and between them is fluid and vital. The narrative message conveyed by these means is a heroic conception of mankind. These are graven figures, their facial expressions and above all their poses and gestures testimony to their physical and spiritual strength.

If *The Transfiguration* embodies a heroic visual rhetoric and the masterly achievement of *disegno* (design founded on sculptural drawing), the Tempietto – little temple (pl. 193) – in the courtyard adjoining S. Pietro in Montorio speaks eloquently of the ideology of religious and cultural renewal that involved both pagan and Christian conceptions. The building was designed by the Lombard Donato Bramante (1444–1510), probably in 1502. Minimal and severe in form, the

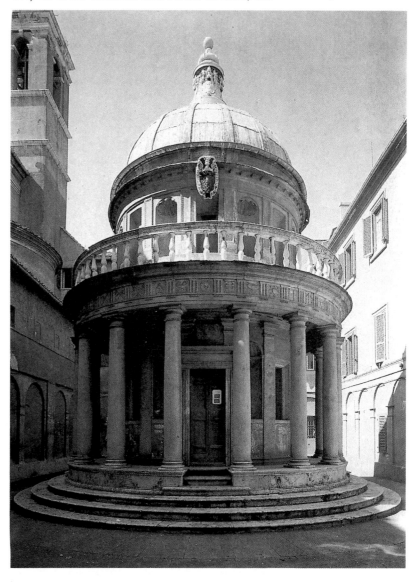

193. DONATO BRAMANTE: *The Tempietto, 1502. S. Pietro in Montorio, Rome.*

Tempietto recalls Roman Republican round temples of the type that still stand by the Tiber and at Tivoli. Yet it is in no way slavishly archaeological, for its small dome sets it apart from any similar Roman model. If the forms of the Tempietto evoke pagan Rome, its content seeks to celebrate the Rome of Peter, to whom Christ entrusted his church. A lively contemporary debate concluded in a consensus that the Golden Hill (Montorio) was where Peter died a martyr's death by being crucified head downward. While the form of Bramante's building is ostensibly that of a Republican temple, the Renaissance also knew that a round edifice, a martyrium, was the appropriate memorial to a Christian martyr. Should there be any doubts about the Christian significance of Bramante's building, one need only contemplate the liturgical instruments that adorn its frieze.

THE BIRTH OF A NEW VISUAL LANGUAGE

As we have seen, Vasari understood the progress-ive artistic development of his age as occurring in three steps, the last of which began around 1500 and culminated in the divine Michelangelo. The pioneer of this third phase, called by Vasari the 'modern', was the Tuscan Leonardo da Vinci.

Leonardo first made his public mark in Florence in the later 1470s, but, for reasons that are not wholly clear, he moved to Milan in 1482, leaving behind him an unfinished painting of the Adoration of the Magi (pl. 194). This underpainting (a monochrome drawing in paint preparatory to the application of colour) contains the principles of a new art.

Leonardo takes a subject that earlier had been presented as a festive pageant, and imposes upon it a new intellectual rigour. The Virgin and Child are placed as a stable triangular configuration that includes the kings in the centre of the composition. This triangle is backed by a shallow hemicycle of attendant figures before a brow of land from which rise two trees. The landscape beyond is a separate realm, marked by a ruin,

194. LEONARDO DA VINCI: Adoration of the Magi. *Begun 1481. Galleria degli Uffizi, Florence.*

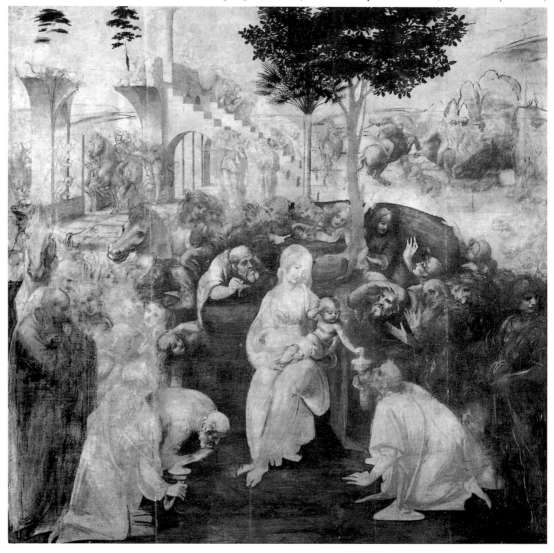

running figures, animals and battling horsemen. The looseness of the background contrasts with the tight organisation of the foreground, and a symbolic polarity is probable: the disorder and unreason of the pagan world versus the harmonious dispensation under Grace.

Variety within unity is a cardinal principle of Leonardo's art. As he would prescribe later in his notebooks, figures are drawn as if from the bones outward. Nothing was left to chance: the few surviving preparatory drawings testify to careful study of groupings and perspective. Here indeed was painting conceived as a science. A significant historical subject, rendered in sculptural drawing in light and shadow to which colour is only added secondarily, rigorous perspectival construction of space, variety of figure types differentiated by expression and gesture, appropriateness of pose to the figure depicted – here were gathered together for the first time what were to be the fundamental tenets of Western art for centuries to come. And here, for the first of many times, we see a mental conception which the hand is unable to bring to full fruition.

The *Adoration of the Magi* reveals an intellectual control of complexity that was to mark Leonardo's entire career. Anatomist, applied scientist, architect, hydraulics expert, fortification engineer – these and many other occupations filled Leonardo's eighteen years at the Milanese court. He could make exquisite drawings of the human skull, and, as if in the same train of thought, as architect sketch the masses and volumes of central-plan churches (pl. 195), thumbnail-size harbingers of Bramante's plan for the new St Peter's.

The culmination of the Milanese years was the *Last Supper* (1495–7; pl. 196), a mural on the end wall of the refectory of S. Maria delle Grazie. Painted in an experimental medium that proved a technical failure, the mural was described by Vasari as already a ruined splotch on a wall. Today, after centuries of well-intended but damaging restoration, the painting is being returned to what remains of the original in a painstaking work of conservation.

The late Lord Clark wrote that the *Last Supper* is the most literary of pictures. Indeed, whatever the disputed theological subtleties of the image, the basic subject is the emotional turmoil that ensues as Jesus announces to his apostles that one of them shall betray him. If Raphael's *Transfiguration* is the fulfilment of the idea of visual rhetoric at the service of a heroic humanity, the *Last Supper* is where the idea is first fully formulated. It is fair to say that it is one of the handful of great visual archetypes in the history of Western art.

195. LEONARDO DA VINCI: Project for a Church, *c.1490.* *Manuscript B. Institut de France, Paris.*

With the fall of his patron and of Milan to the French in 1499, Leonardo began years of wandering that would last until his death in France in 1519. He spent much of the earlier part of the first decade of the new century in Florence. It was there that he met Michelangelo (1475–1564). The younger man had returned recently from Rome, where he had made his name with sculptures of *Bacchus* and the *Pietà.* For a brief few years there ensured what amounted to a competition between two artists, with little love lost.

In 1501 Michelangelo took up a large rectangular block of marble that had languished in the workshop of the cathedral for decades. From it he carved a colossus more than 3 m high whose subject was the biblical David (pl. 197). The work had been planned for a buttress of the cathedral, but it was realised quickly that the symbolic im-

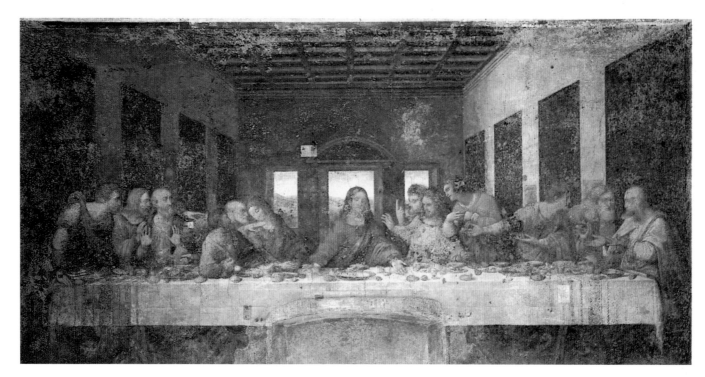

LEONARDO DA VINCI, LAST SUPPER

One can hardly stress sufficiently Leonardo's innovative approach to the *Last Supper* (1495–7). He followed custom only by painting the scene as an illusionistic extension of the actual space of the refectory of S. Maria delle Grazie, Milan. Thus Jesus and his apostles appear to be seated at the high table of the religious community below.

Jesus is isolated at the mid-point of the table just after announcing his impending betrayal. A calm centre amidst rolling waves of human emotion, Jesus's upper body is a stable triangle silhouetted against the sky, the window functioning as a natural halo. The red and blue primary colours of his garment draw us to him, as do the perspective lines of the wall hangings which converge in his downcast face.

The twelve apostles are arranged in four tightly-knit groups. They consist of a limited number of head types, ranging from the grizzled old man to the beautiful youth. There is an alternating rhythm to these groups. That furthest to the right is contained within itself, the two outer apostles anchoring our attention on the end of the table. The next group leans towards Jesus through gesture and gaze. The third group, on Jesus's right hand, palpably draws away from him, its swarthy outermost member being the traitor, Judas. The last group anchors the other end of the table, all eyes directed towards Jesus. A mute dialogue of hands enriches the complex relationship between these four groups.

No small part of the emotional power of the scene lies in the dense packing of figures about the table. Leonardo impresses the figures upon us by 'pinching' the space of the room: the side walls seem to splay outward as they come forward, and the back wall with its three openings seems to push towards the forward plane in which the figures are situated.

The space of the *Last Supper* is in fact an ideal space whose perspectival viewing point is located some 4.5 metres above the floor of the refectory. As recent scholarship has shown, the dimensions of this space are based upon the ratios of musical harmonies.

port and miraculous aesthetic achievement of the piece warranted a· more conspicuous location. That chosen was by the entrance to the palace of government, the Palazzo della Signoria. (A copy is there today, the original having been brought to the Galleria dell'Accademia in 1873.)

The significance of *David* is powerful and unequivocal. He was the symbol of constant vigilance and strength to the citizens of a free republic surrounded by hostile city states, many under autocratic control. David was a popular Florentine subject: one need only recall Donatello's (pl. 145) and Andrea del Verocchio's (1435–88) bronze sculptures of the youthful conqueror with the severed head of Goliath at his feet. Michelangelo chose a radically different moment, that just prior to the encounter. The strap of the sling pulled across his back and the stone in his raised hand, David looks intently to his left into a space that we must understand as containing the approaching giant. His right side is flexed and closed, his left relaxed and ready for the engagement. By changing the moment from that chosen by his predecessors, Michelangelo drove home the symbol of eternal vigilance.

The sculpture as realised is a wonderful paradox, portraying an adolescent as a marble colossus. The anatomy speaks of the lessons Michelangelo had learned from ancient statuary, but the statue resembles no ancient sculpture. The powerful body retains some of the awkwardness of a youth, with its large head and gangly right hand. Not for a moment are we allowed to forget the physical improbability of a spiritual victory over his adversary.

Another major sculpture, the *St Matthew* (pl. 198), was left unfinished when Michelangelo was called to Rome. Only roughed out, the figure half emerges from the rectangular stone, its surfaces scored by the chisel like the ink strokes on one of the master's drawings. The left leg raised upon a block, the knee bends inward toward the supporting right leg, thrusting the body into a dynamic *contrapposto* (uneven distribution of weight between the two sides of the body) in which the pelvis and shoulders are steeply tilted. The eyes gaze upward, the twist of the head almost painfully emphasised by the downward pull of the pendulous right arm. Michelangelo attacked the marble block straight on, his focus upon the power of the torso rather than on definition of the limbs. Compact, closed in outline, energetic in torsion, the *St Matthew's* physical force is readily translatable into an exalted state of spiritual energy, in contrast to the restrained power of the *David*.

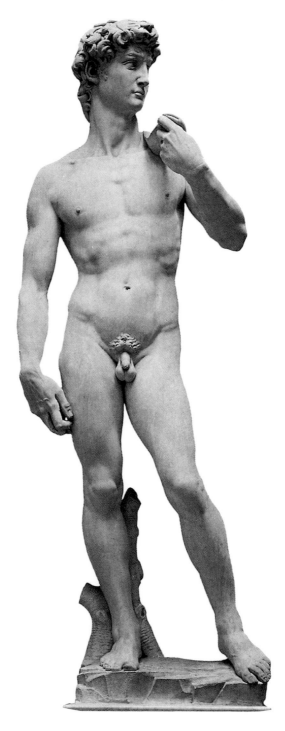

197.
MICHELANGELO:
David, *1501–4. Galleria dell'Accademia, Florence.*

The *St Matthew* was but the first of twelve apostles projected for the cathedral. If one thinks of it, a project of such scope is audacious, and would have consumed a good part of the sculptor's working life. But Michelangelo was a man capable of envisioning the barely possible. As fate would have it, the man who ascended the throne of Peter in 1503 shared those sorts of dreams. This was Julius II, and it was to be in Rome that a great artist and a great patron each met his match.

JULIUS CAESAR PONTIFEX MAXIMUS

Julius was a soldier of Christ who dedicated himself to securing the temporal power of the Papal States, and to asserting the authority of the papacy against dissident clerical movements. His propagandistic programme aimed to bring to a climax the fused pagan-Christian renewal of the Eternal City. 'Julius Caesar Pont[ifex] II' was inscribed on a coin issued on the return from one of

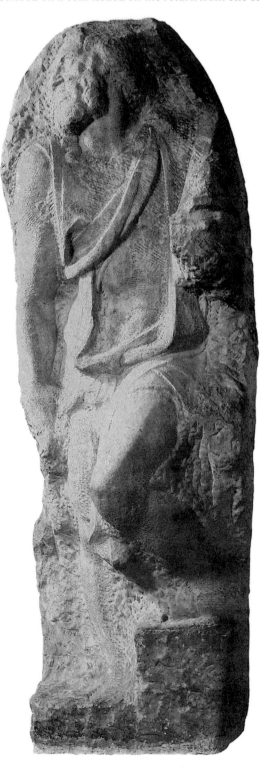

198.
MICHELANGELO:
St Matthew. *Begun 1505. Unfinished. Galleria dell'Accademia, Florence.*

the pope's military campaigns. The pontiff was represented in his papal cope, and on the coin's obverse was the inscription 'Blessed is he who comes in the name of the Lord!' This little artefact speaks volumes about the man, and about an age in which poetry and panegyric reiterated the notion of a pontiff in the lineage of both Caesar and Peter.

On becoming pope, this boldly overreaching pontiff began a grandiose, indeed megalomaniac, programme to evoke a Rome reborn: he planned a tomb for himself worthy of Hellenistic princes; envisioned a new St Peter's of unprecedented size; and commissioned a façade for his palace that mirrored the ruins of the imperial palaces of the Palatine Hill, and a huge terraced court reminiscent of giant antique architectural complexes. His was to be an architecture of grandeur, rivalling in scale and size the ruins of ancient Rome. To realise his all but impossible dream he chose the sculptor Michelangelo and the architect Bramante.

Julius, Michelangelo and Bramante are bound together in the new century in two great projects: the pope's tomb and the rebuilding of St Peter's. Tradition would have it that the two projects were sequential, but common sense suggests that undertakings of such magnitude and complexity must have been born of a piece.

The tomb (pl. 199), as pope and sculptor conceived it, was to be free-standing, about 6 m by 9 m, with an oval chamber inside. Its base was to be girdled by bound slaves and victory figures of marble, accompanied by bronze reliefs. On top of this base, stepped inward at the four corners, were to be four large sculptures: Moses, Paul and the Active and Contemplative Life. In the centre of this second level would rise another as a base for the throne, or catafalque, of the pope, borne by two angels. The early biographers offer conflicting accounts of what all this signified, and modern interpretation has spawned an extensive bibliography. In general it is sound to postulate a vertical ascent from earthly bondage towards salvation through the two approved Christian routes, the active and contemplative lives. At the apex was Pope Julius, beyond the vicissitudes of time in Paradise.

The form and placement of the tomb were meant to echo ancient monuments, and royal pretension. The combination of architecture and sculpture would have recalled monuments such as the Arch of Constantine (pl. 41). The pyramidal disposition of the tomb evoked what was believed to be the form of one of the wonders of the ancient world, the Mausoleum of Halicarnas-

sus (pl. 31). This new wonder was to be placed in St Peter's, apparently in the choir arm – the privileged place chosen earlier for rulers' tombs in Pavia and in the abbey of St-Denis, near Paris. Such multiplication of associations is a characteristic strategy of Julian propaganda.

The tomb was completed in 1542 in drastically reduced form as a wall monument in S. Pietro in Vincoli. Through six disputed contracts and unspeakable frustrations, Michelangelo lived out what one of his early biographers called the Tragedy of the Tomb. Only three major sculptures came from Michelangelo's hand, all done in the 'teens of the century: the two *Bound Slaves*, now in the Louvre, and the statue of *Moses* (pl. 190), which forms the centrepiece of the finished tomb.

Moses combines the controlled energy of *David* with the manifest power of the *St Matthew*. The patriarch is seated with the tablets of the Law pressed against his side, looking intently to his left. The strength of his right side is conveyed by a weighty arch of drapery over a pile-driver-like leg, while his left leg is drawn back, giving the left side a more relaxed look. His glance is ferocious, his pent-up emotions intimated by fingers that pleat the long, flowing beard. Here, surely, is an image of *terribilità*, that awesomeness of character that Vasari praised in Michelangelo and that later ages of a Classical persuasion have found his most troubling characteristic.

Moses is over life-size, and is but one of roughly forty sculptures projected for the tomb. No man could possibly have achieved this in a lifetime, and even under the best of circumstances the Tragedy of the Tomb seemed foreordained. The artist, and no less his patron Julius, were possessed of a grandiose vision that passed the bounds of reality. Whatever the true relation of events, it is clear that Julius's attention quickly turned from the tomb to the rebuilding of St Peter's, whose cornerstone was laid on 18 April 1506, the day after Michelangelo fled Rome in disgust and fear after being rejected by the pontiff. The design delivered by Bramante, architect of the Tempietto, was for a church of a size unprecedented in Christendom.

By the middle of the fifteenth century the old fourth-century basilica (pl. 61) was in perilous condition, its nave walls dangerously inclined. Repairs and modernisation of the choir were begun, but the work languished. With Julius's reign a vision of unprecedented audacity was born. The venerable church under which lay the tomb of Peter was not repaired, but razed and built anew. Bramante's surviving drawings reveal

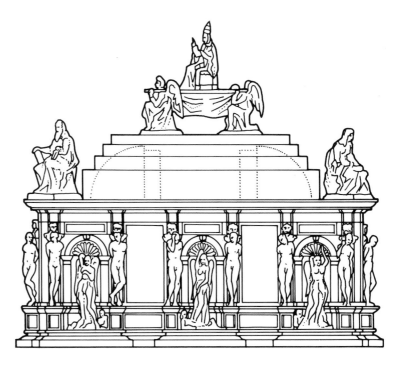

some doubt about whether the new church should have a traditional basilican plan or be a centrally planned 'temple', the word and form advocated by the humanist-architect Alberti in the mid fifteenth century. A surviving presentation drawing on parchment showing half of a centrally planned church, and the foundation medal by Caradosso (pl. 200) leave no doubt that Alberti's radical proposal prevailed.

The church was to be over 150 m across, a honeycomb of curved walls and piers rising to support a semicircular dome based upon that of the Pantheon (pl. 51). Each of the four equal arms was to terminate in an apse, and there were to be four subsidiary domes just outside the intersection of the cross axes. At each corner there would be a tower. In sheer size, spatial complexity and engineering boldness, nothing like this had been

ABOVE 199.
Reconstruction of Michelangelo's 1505 design for the tomb of Pope Julius II (after C. L. Frommel).

LEFT 200.
CARADOSSO:
Foundation medal for the new St Peter's, 1505, British Museum, London.

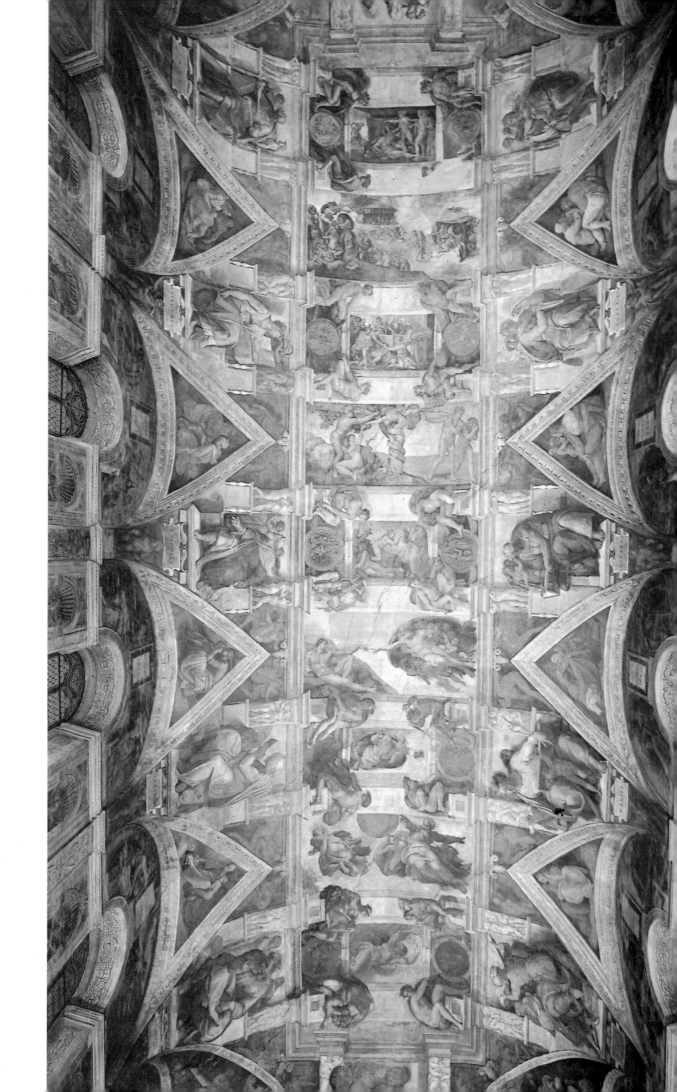

MICHELANGELO, THE SISTINE CEILING

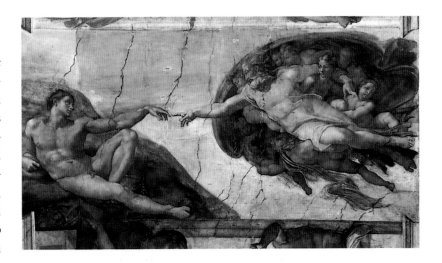

Scholarly interpretations of the Sistine ceiling (1508–12) – some complementary, but most conflicting with each other – fill a small library. This much may be said with reasonable assurance. First, since this is the pope's chapel in the centre of Christendom, the significance(s) can only be orthodox. Second, the persons who frequented the chapel were learned princes of the church, so there may be layers of meaning beneath the obvious. Last, any theological programme, presumably prepared by an intellectual middleman, would have experienced free and highly imaginative translation at the hands of a great artist.

Here only the probable core Christian significance of the ceiling can be sketched. The Genesis narrative in nine panels, not always in exact chronological order because of the exigencies of alternating small and large pictorial fields, stresses the paradox of a humanity that is heroic, yet fallen from Grace. The first three panels show Yahweh as he moves across the heavens in the appointed rounds of creation. The middle three panels are devoted to the creation of humankind, and to the expulsion from the Garden. In *The Creation of Adam (above right)*, the first man lies languorously upon a barren rock, his body perfected, but as yet unendowed with a soul. The energy-charged figure of God approaches with his celestial retinue, and in but a second the fingers will touch, and the circuit of love in the universe be completed. *The Temptation* echoes the principle of free choice elaborated by the humanist Pico and others. A sensuous Eve reaches for the fruit, wholly unmindful of her act. Adam, by contrast, rises to rebuke the serpent. Therein is intimated Pico's doctrine that man by his own free will may aspire to God, or sink to a beastly condition.

The final three panels concern the story of Noah. The last shows a drunken Noah, in a pose that obviously echoes that of Adam in *The Creation of Adam*. Man is once again a body bereft of a spirit: the gift that we see Adam about to receive has been voluntarily relinquished by his descendant. Thus the sub-narrative of the Genesis panels is the notion that humankind in the image of God is not once but twice fallen, and in perpetual need of salvation.

Yet God is father of his children, and many times intervened to save them. The four large corner spandrels (curved triangular fields) narrate four miraculous interventions on behalf of the chosen people: the Brazen Serpent, Haman and Esther, David and Goliath, Judith and Holofernes. God's children are in need of salvation, and in one culminating act God will provide it, in the form of his only begotten Son. This is the triumphant message of the seers who foresee the advent of the Messiah. The largest of these figures, Jonah, is directly above the altar. The three days he spent in the belly of a great fish before being regurgitated prefigure the three days that Christ spent in the tomb before his Resurrection. Gazing ecstatically upon God in the first act of creation, Jonah also presides over the Host upon the altar, through whose efficacy a worshipper may sit at the right hand of the Father.

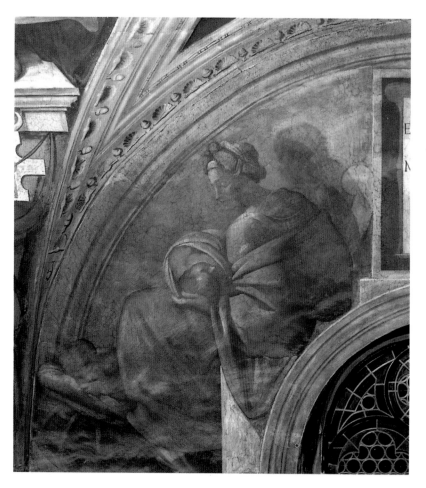

203.
MICHELANGELO:
Sistine Chapel ceiling.
Lunette figures before
restoration. Vatican,
Rome.

of Christ. Beyond the straightforward biblical narrative, the two series present the era under the Law as a prefiguration of the era under Grace, with a sub-theme of glorification of the pope as teacher, lawgiver and priest. Just what Julius and his artist first had in mind for the ceiling is not wholly clear. The few surviving drawings suggest that at first the twelve apostles were to ring the ceiling, with most of the pictorial field laid out in a pattern of geometric compartments, a convention popular in later fifteenth-century art. For whatever possible combined reasons of content and formal challenges presented by the shape of the vault, a radically different solution was adopted (pl. 201).

Taken at face value, the subject matter is the era before the Law, a choice that complements the earlier series. Reading from altar to door, nine panels recount scenes from the book of Genesis, from the separation of the light and darkness to the drunkenness of Noah. Adjacent to these panels are huge seated seers, the prophets of the Hebrews and the female sibyls of the Gentiles, whose common power of clairvoyance bore witness to the coming of a Messiah.

Working from door towards altar, with ever-loosening brush and increasing fullness of form, Michelangelo frescoed the ceiling between 1508 and 1512. He worked largely alone, spending little more than two years on the project in working days. An architectural framework is populated by 343 figures. There is little else – no landscape to speak of, few decorative embellishments. It is tempting to believe that the ceiling was Michelangelo's way of coping with the thwarted dream of real sculpture on real architecture, the Julius tomb.

The vault is a flattened barrel vault, complicated by the necessary cross-angle curvature above each window. On each side, a set of thrones is provided for the seers, with a cornice running above. The two sides are connected by bands, between which are set the narrative panels. There is no 'correct' perspectival viewing-point, and the ceiling's system is optically somewhat ambiguous.

The heroic men and women on the ceiling are based on a vision of a physically perfect masculinity, exalted to an ideal that goes beyond gender. Michelangelo found particular inspiration in late Hellenistic sculpture of a muscular, athletic sort, the most spectacular example of which – the *Laocoon* group (pl. 55) – had been uncovered in 1506. It is, however, not primarily the physicality of Michelangelo's figures that moves us, but the fact that they are invested with a

attempted since the Gothic cathedrals. But the scheme was not born of Bramante's mind alone. As in so much else, Leonardo was the forerunner; and Bramante must have been familiar with the architectural sketches that Leonardo made when they were both resident in Milan.

Again, the immensity of the project as originally conceived militated against its fulfilment. After Bramante's death in 1514 a series of architects, beginning with Raphael, returned to a basilican plan, though the dome was retained because placement of the four piers to support it had already begun. Bramante died with his dream intact, but the church as completed, a century later, was much altered from his conception.

Though Michelangelo had fled with the ascendancy of his rival, the separation of artist and pope was brief. As early as 1506, apparently, Julius had another project in mind for Michelangelo, a frescoed ceiling for the papal chapel next to St Peter's that had been built by Julius's uncle Sixtus IV in the 1470s (pl. 191).

In the early 1480s the leading Tuscan and Umbrian artists had painted facing bands of narrative panels on the walls, those on the left depicting the life of Moses, those on the right the life

radiant spiritual life, prefigured in the *David* and *St Matthew*. The artist runs the full gamut of emotion, from the ecstasy of Jonah to the profound inward contemplation of Jeremiah.

Our idea of this heroic race is in the process of re-evaluation because of the cleaning of the ceiling. There are now two ceilings to be seen. The first is the familiar one towards the altar – large sculptural figures rendered in subdued colours, lightly veiled in atmosphere, playing against a softly defined architecture. All this is given a warm aura through tungsten illumination. On the other side of the suspended scaffold where Vatican conservators are removing centuries of accumulated grime, the ceiling has reappeared much as it looked when Michelangelo laid down his brushes in 1512. The restored ceiling is seen in natural light. The architecture is crisper in linear definition and cooler in tonality. The relation of figures to one another and to the architecture seems more lucid, their sculptural definition more emphatic. Most remarkable of all, the once-muted colours turn out to be vivid hues – lemon yellows, lime greens, brilliant blues (pls 203 and 204) – all easily readable from the floor 20 m below. Michelangelo is revealed as a great colourist, but colour wed to a disciplined design.

One of the first artists to be moved by the ceiling was Raphael Sanzio, who was born in Urbino in 1483. Trained initially by his father and then by Pietro Perugino (c. 1445/50–1523), the precocious Raphael had by his late 'teens already executed important work in several Umbrian towns and in Siena. Raphael was in Florence by the early 1500s. He rapidly assimilated the complex figure-groupings of Leonardo, and joined them to the pacific landscape vision of his master Perugino. The 1505 *Madonna of the Meadow* (pl. 205) is one of several pictures that explore a similar compositional theme. The theme picks up a motif already worked out in sketches by Leonardo in the late 1470s, presenting it in mellifluously rounded forms. The group is placed in a serene Peruginesque landscape setting that knows no specificity of season or time of day. It is by virtue of such paintings that Raphael became typed as the painter of beautiful Madonnas, whose debased descendants grace church offering-envelopes even today.

Raphael immediately responded to the pictorial essays in action, power and expression that Leonardo and Michelangelo were working out in Florence during these same years. His efforts did not go unnoticed, and by 1509 Raphael was in Rome, called by Pope Julius perhaps at the

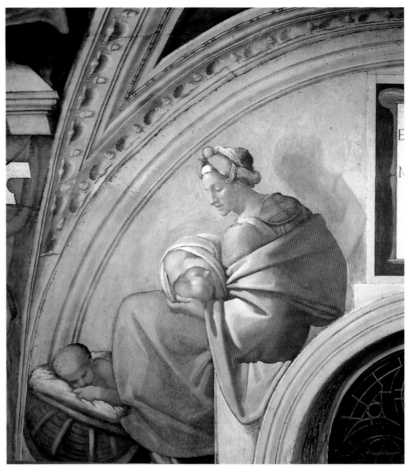

urging of Bramante. Julius's project was the decoration of a suite of four rooms in the papal palace. They had already been begun by a team of lesser painters, who were replaced by Raphael. Over more than a decade the rooms were frescoed by Raphael, and, after his death, by his pupils, largely according to his designs.

The first of these rooms was the so-called Stanza della Segnatura (pl. 208), Julius's personal library. The decoration celebrates the major divisions of knowledge as then conceived. The theme is set in the ceiling in four roundels depicting allegorical figures of Theology, Poetry, Philosophy and Justice. Below each on the wall are lunette frescoes which illustrate the division of knowledge personified above. Under these frescoes in turn were the bookcases housing the library.

The *Disputa* (Conversation on the Blessed Sacrament; pl. 207) is under the personification of Theology, and was the first section to be frescoed. Echoing the curved format, Raphael painted figuratively an apse whose building-blocks are human figures. The Trinity is on the central axis: at the top is God the Father, giving blessing; below, the Son, flanked by Mary and John, is seen against a large gold disc; while against a smaller

204.
MICHELANGELO:
Sistine Chapel ceiling.
Lunette figures after
restoration. Vatican,
Rome.

gold disc beneath the Son the Holy Spirit appears in the form of a dove. Figures alternately from the Old and New Testaments are seated on the clouds on either side. This is the Church Triumphant, serene in eternal truth and outside place and time. On the lower, terrestrial level, all perspective lines lead to the Eucharistic chalice silhouetted against the sky. The spiritual warriors of the Church Militant – the fathers of the church, popes, saints and poets – debate the mystery of the Eucharist in that muted rhetoric of gesture and expression first enunciated by Leonardo.

The *Disputa* harmoniously resolves the potential tension, common to all pictures, between the idea of a flat surface and the illusion of depth. Again, the resolution is attributable to Leonardo's example in the *Last Supper*.

The School of Athens (pl. 208) is below the allegorical figure of Philosophy. If the *Disputa* is figuratively an apse, the architecture of *The School of Athens* is like an extended nave, punctuated by domes at crossings. While this architecture refers to no building known or projected, it evokes both the grand massiveness of Roman ruins, and the planned huge size and scale of the new St Peter's. If the two frescoes are related in form, by both echoing the semicircular format of the field and harmonising the relation of surface and depth, on the level of content they testify to the age's yearning for a reconciliation of pagan and Christian wisdom. The protagonists in *The School of Athens* are all ancient philosophers, disposed in two

semicircular arms that curve from the men silhouetted against the sky down several steps to the foreground groups on either side. The two central figures are Plato to the left, holding his *Timaeus* and pointing to the realm of ideas, and Aristotle on the right holding his *Ethics*, making a gesture that moderates between ideas and terrestrial particularities. The cynic philosopher Diogenes sprawls on the steps, holding his bowl, the last of his earthly possessions, soon to be abandoned when he sees a peasant drink from cupped hands. To the left Pythagoras writes, attended by his followers, and to the right Euclid makes a geometrical demonstration.

Thus the truths of philosophy and theology rest easily together, their central essence at the perspectival vanishing-points of the two frescoes. It is hard to remember in this room that we gaze upon idea painting rather than story-telling painting, for such is the fluid grace of Raphael's manner that all hint of didacticism disappears. Contemporary portraits are found in these frescoes (including that of Raphael himself), leaving no doubt that a chain of wisdom extends unbroken from antiquity to the present.

If one opens the shutters between the two frescoes, the long prospect of the Vatican Museum lies before us. In Bramante's original conception a three-tiered open courtyard (pl. 206) flanked by passageways would have extended nearly 300 m to the fifteenth-century Villa Belvedere. Immediately below there would have been a courtyard for the mounting of spectacles, then stairs to

OPPOSITE 205.
RAPHAEL: Madonna of the Meadow, *1505. Kunsthistorisches Museum, Vienna.*

206. DONATO BRAMANTE: *Belvedere courtyard in an engraving by Cartaro. Begun 1505. Vatican, Rome.*

OPPOSITE 208.
RAPHAEL: *Stanza della Segnatura looking towards* The School of Athens, *1510–11. Vatican, Rome*

BELOW 207. RAPHAEL: Disputa *or* Conversation on the Blessed Sacrament, *1509. Stanza della Segnatura, Vatican, Rome.*

a garden parterre, and more stairs to a third level that included a secret garden where Julius had established a museum of ancient sculpture.

The project fairly reeked of antiquity, drawing upon the multi-level temple complex at Palestrina (pl. 45), memories of the Roman circus, and the remains and literary descriptions of ancient villas. Thus it was that the successor to Peter and Caesar could stand in one spot, viewing from his window a Rome re-created, and on the walls to either side ideal realms – if you will, a communion of saints both pagan and Christian inhabiting a Rome triumphant in the fullness of time.

THE POPE'S BANKER

Julius II died in 1513, to be succeeded by the Medici Leo X. If Julius was the new Caesar, Leo was the new Augustus, a man of less grandiose tastes who collected manuscripts and fine objects and commissioned tapestries and smaller-scale

decorations. The patronage of the pope's banker and close friend, Agostino Chigi, gives a good idea of this Leonine taste. Chigi was the son of a Sienese banker, and had made his fortune in the alum mines of Tolfa. Owner of a fleet of a hundred ships at the height of his power, he had acted as banker to each pope since Alexander VI. His wealth served him as a splendid patron of the arts, in particular as champion of the revival and dissemination of Greek letters.

Between 1505 and 1510 Chigi had his compatriot Baldassare Peruzzi (1481–1536) design a suburban villa by the bank of the Tiber, the Villa Farnesina. This was a true pleasure dome, its façades decorated with monochrome frescoes in the antique style, while on the ground floor a pair of loggie opened on to the surrounding gardens. The interior was decorated by several artists, their subjects complementary to the owner's personal life. In the entrance loggia Raphael's pupils

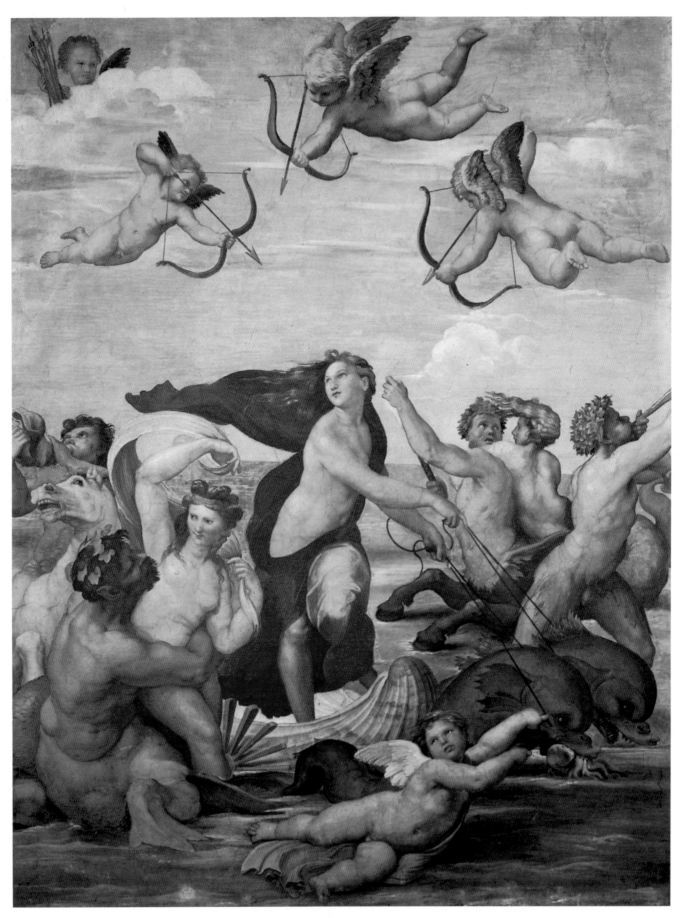

executed from his designs stories of Psyche, rendered on illusionistic tapestries, and a pergola echoing the real vegetation outside. In the adjoining garden loggia a decorative scheme was planned illustrative of the four elements, but this was only partially executed. Probably in 1513 Raphael frescoed the water nymph Galatea (pl. 209), shown drawn across the sea in her nautical chariot, attended by a court of Nereids and Tritons. Circularity on the surface and in depth is joyously reiterated, the lithe twist of Galatea's body constituting the gyrating axis of this centrifugal composition. Physicality is celebrated, but one gentler than Michelangelo's, one that celebrates the difference between male and female. Galatea seems a sister of a Raphael Madonna, and no wonder: Raphael wrote to Baldassare Castiglione that in conceiving the fresco he relied not on nature but on 'a certain idea in the mind'.

Castiglione, friend of Chigi and Leo, is most famous as the author of *The Courtier*. It is in Raphael's portrait of him (pl. 210), based upon the example of Leonardo's *Mona Lisa*, that we sense the qualities of Leonine culture – elegant, self-possessed, sensuously open.

THE OLDER MICHELANGELO

Modern scholarship until recently has tended to see a break in Italian art around 1520. The date is seen as roughly the end of the High Renaissance, and the beginning of Mannerism. Vasari at the time perceived no such break, and recent thinking has been more inclined to agree with him. According to this argument, much of what happens after 1520 is but an attenuation of currents of artifice and stylisation inherent in the art of the 'teens.

Be that as it may, the course of art throughout Italy was fundamentally changed by a catastrophic event, the Sack of Rome at the hands of imperial troops in the spring of 1527. German soldiers put the pope to flight, and days of pillage, rape and conflagration followed. One of the outcomes was the dispersal of artists and the Roman style to all parts of Italy.

In the decades that followed, the work of one man stands alone. While still in his later forties Michelangelo had begun to refer to himself as old, not knowing he had yet some forty years to live. Once celebrator of the artist as creative surrogate for the Creator, Michelangelo came increasingly to doubt the Christian legitimacy of image-making. Non-figural arts – architecture and poetry – took more and more of his time, and his drawings of Christian subjects seem an act of private confession.

In 1535 there was still painting to be done, the great *Last Judgement* (pl. 212) for the altar wall of the Sistine Chapel. While this grim subject is often referred to the Roman state of mind after the Sack, there is no reason to accept the connection. The prior decoration of the chapel, we recall, represented the eras before the Law, under the Law, and under Grace, to which Raphael had added the mission of the apostles in the form of a series of tapestries narrating the works of Peter and Paul. To complete the Christian story, the end wall called for either the Resurrection or the Last Judgement.

The Last Judgement was selected, and represented as a floating oval of nude bodies (most of the draperies were added later). Most have no attributes, and their expressionless faces are those of Everyman. Christ is a muscle-bound athlete who gestures menacingly towards the damned below. Mary, the traditional intercessor for humankind, cowers helplessly at his right side. There is a ferocious physicality about this

ABOVE 210. RAPHAEL: Baldassare Castiglione, *c.1515*. *Musée du Louvre, Paris*.

OPPOSITE 209. RAPHAEL: Galatea, *c.1513. Villa Farnesina, Rome*.

vision, heavy bodies floating in a space devoid of perspectival structure and of atmosphere. Here a figure is pulled towards the maw of Hell in hopeless despair; there a saved man is hoisted by a rosary, as if it were a lifeline. The grim business of salvation and damnation is coloured by apocalyptic passages from Matthew, Isaiah and Revelation, and the physical fact of the resurrection of the flesh seems insisted upon.

This *Last Judgement* is sombre, indeed pessimistic, and a poignant clue to the artist's own state of mind is presented by the bearded man below and to the left of Christ. This man, holding a knife and a limp human skin, is St Bartholomew, who is said to have been skinned alive. The saint's features are those of Pietro Aretino, who had acerbically criticised Michelangelo for his interpretation of the subject. The flayed skin unmistakably bears the features of Michelangelo himself. So was put in place one of the most unusual and forlorn of artistic signatures.

The *Last Judgement* was completed in 1541. Already Michelangelo's activity had moved towards architecture, for in the late 1530s he turned to the task of refurbishing the ancient Roman

Capitol above the Forum. His project, only completed in the seventeenth century, is revealed in a contemporary engraving (pl. 211). The bronze equestrian statue of Marcus Aurelius, long believed to represent the first Christian emperor, Constantine, was moved from the Lateran Palace to become the centrepiece of an open piazza adorned with an oval pavement pattern. Michelangelo planned façades on three sides, the highest for the Palace of the Senators, the lower ones on either side articulated by giant orders with a loggia below and a balustrade as crowning feature. The Capitol, centre of ancient Rome, was fraught with symbolic weight. Sixtus IV had already begun to assemble an art collection there to stress this symbolism, and over the years inscriptions and added sculptures reinforced the message of renewal.

At the death of Antonio da Sangallo (1485–1546) Michelangelo became head architect of St Peter's. Not only did he reject the dark and intricate neo-Gothic proclivities of his predecessor, but he boldly proposed to return to a central-plan church, reducing Bramante's plan to a simple cross-in-square. On the exterior (pl. 213) he used

213.
MICHELANGELO:
St Peter's from the west.
Michelangelo's work
begun 1546. Vatican,
Rome.

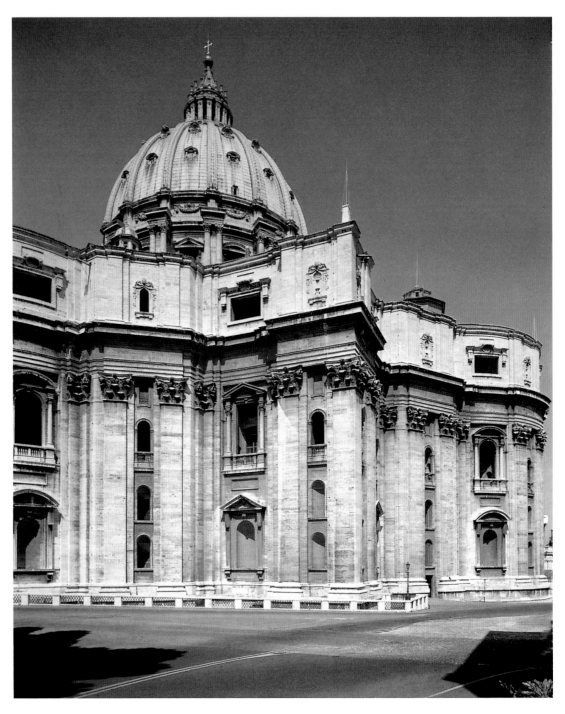

the giant order once again, topped by an attic to mask the vaults, and projected a dome that would have risen more prominently than Bramante's. (The present dome is roughly to his intentions, the giant order of his design, and the present basilican plan represents a final rejection of the central plan.)

First and last, Michelangelo was a sculptor. In the late 1540s he sketched designs for groups of the *Pietà*. These were to be physically robust figures, descendants of the nudes of the *Last Judgement*. One marble group, intended for his own tomb, is unfinished. A pitifully broken body of Christ is sustained by Mary, Mary Magdalen and Joseph of Arimathea, a self-portrait of the old sculptor. For whatever combined reasons of dissatisfaction with his work and religious anguish, Michelangelo attacked the piece with a hammer. Its survival and, in part, its present form are due to his pupils.

Only six days before his death in February 1564 the old man was at work on another group, the so-called *Rondanini Pietà* (pl. 214). The fragment of a right arm suggests the substantial

forms originally intended. But what was realised is a wraith-like bowed bonding of mother and son, reduced from flesh to an almost dematerialised essence, cut away to a point of no return. What have we here? A resurgence of Gothic spiritualism? The incapacity of aged hands to realise the image in the mind? A ritual of artistic suicide? Perhaps it is a little of each, but what we witness here most of all is probably the indomitable will of great artists to work until the end.

In their clarity of thought and lucid language, Michelangelo's last poems suggest that he had found a peace of sorts, his deep spirituality but an intense expression of a faith shared by most men and women of his age, whatever their love affair with the memories of ancient Rome, whatever their celebrations of the beauties of the flesh.

My course of life already has attained,
Through stormy seas, and in a flimsy vessel,
The common port, at which we all land to tell
All conduct's cause and warrant, good or bad,

So that the passionate fantasy, which made
Of art a monarch for me and an idol,
Was laden down with sin, now I know well,
Like what all men against their will desired.

What will become, now, of my amorous
 thoughts,
Once gay and vain, as towards two deaths I
 move,
One known for sure, the other ominous?

There's no painting or sculpture now that
 quiets
The soul that's pointed toward that holy Love
That on the cross opened its arms to take us.

(Translation by Creighton Gilbert, repro-
 duced by kind permission.)

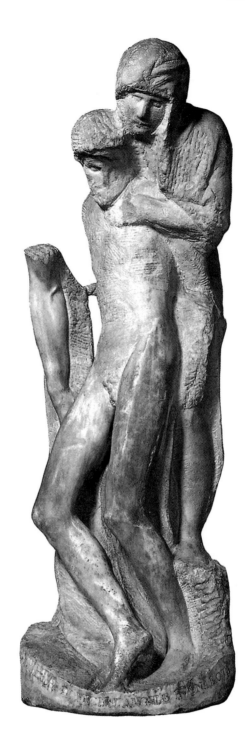

214.
MICHELANGELO:
Rondanini Pietà,
*1554–64, Castello
Sforzesco, Milan.*

8

THE HIGH RENAISSANCE IN VENICE

DAVID ROSAND

INSET 215. JACOPO SANSOVINO: *Statue of Apollo from the Loggetta, Venice. 1545.*

OPPOSITE 216. TITIAN: Assumption of the Virgin, *1516–18. S. Maria Gloriosa dei Frari, Venice.*

Founded upon the waters, Venice was always a spectacular city, the Queen of the Adriatic. At the crossroads between East and West, it was uniquely cosmopolitan. Its commercial fleet dominated trade between Europe and the Levant for centuries, and its streets and squares were coloured by the exotic costumes of the world. Venice was luxurious, an important centre for the production of textiles and, especially, glass, in which it was unrivalled. It was also powerful. By the middle of the fifteenth century the maritime republic ruled an empire that extended from the coasts of the Adriatic and the Aegean in the east deep into the Italian mainland in the west, including the cities of Verona, Brescia and Bergamo. And yet Venice also represented, to itself and to many others, the ideal state, a republic ruled by constitutionally established law, apparently undisturbed by internal strife. Impregnable within the watery protection of its lagoon, it remained unconquered by foreign forces until it fell to Napoleon in 1797. Venice was justified in claiming for itself the epithet of *la Serenissima*, the Most Serene Republic.

Visitors to Venice and the Venetians themselves recognised in the city a unique combination of power and pleasure. And the art that developed in Venice reflected both. It gave full visual expression to the authority of the state even as it created styles of exceptional richness and sensuous appeal.

THE SPECTACLE OF THE STATE

The opening decade of the sixteenth century witnessed the greatest threat to the survival of Venice. In 1508, the League of Cambrai, an alliance of European and Italian powers including the papacy, the Holy Roman Empire and France, joined to counter the imperial ambitions of the Republic. To the weight of their combined military might was added the spiritual blow of excommunication, as Pope Julius II thundered against Venetian territorial expansion and the claims of Venice to ecclesiastical prerogatives. By the summer of the following year Venice had lost nearly all its mainland dominion, including, briefly, the nearby university city of Padua. And yet Venice survived. Less through military prowess than through clever diplomacy, less through aggression than through patience, it regained most of its territory on the mainland as the alliance unravelled. Chastened by military defeat, Venice none the less declared itself triumphant. And that tone informs the public and monumental art of the Republic.

The natural gateway to Venice is from the water: the Bacino, the basin, just before the entrance to the Grand Canal, opens on to the Piazzetta, which is marked by two great columns, spoils from Constantinople taken during the Fourth Crusade in the early thirteenth century (pl. 217). Serving as a kind of antechamber to the great space of Piazza San Marco, which fronts the church that is the spiritual and political heart

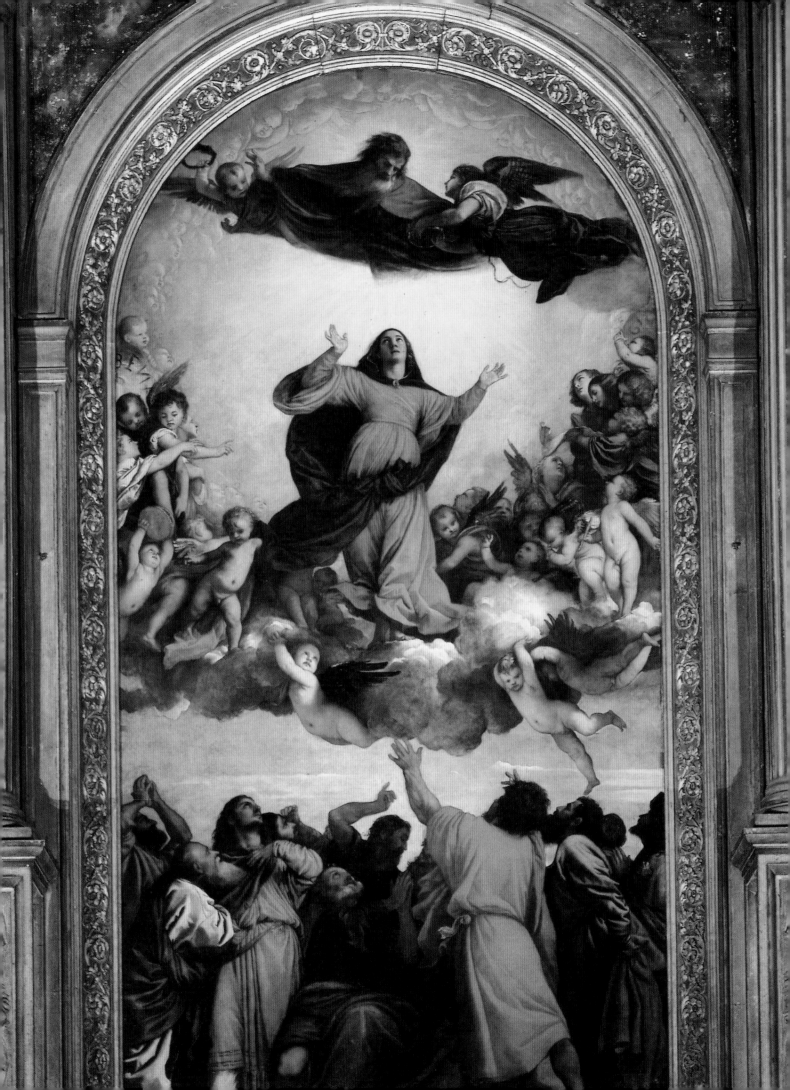

217. *The Piazzetta, Venice. On the left: the 14th-century Doge's Palace. On the right: Sansovino's Library of St Mark's, 1537–54. Beyond the two great columns is the Bacino, the gateway to Venice.*

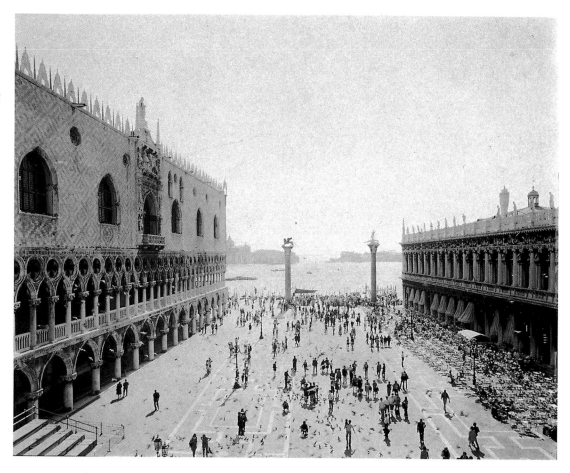

of Venice, the Piazzetta is flanked by the Doge's Palace on one side and by the Library of St Mark's on the other. These two buildings represent the old and the new Venice: the colourful Gothic of the Doge's Palace is of the fourteenth century; the Library, begun in 1537, speaks a classicising architectural language inspired by Rome, modern as well as ancient. The architect of the Renaissance Library was Jacopo Sansovino (1486–1570), a Florentine by birth who had come to Venice following the Sack of Rome in 1527 and who was responsible for modernising the urban fabric of the city.

Venice became a refuge for many who fled the despoiling of Rome by unruly imperial troops. An ambitious doge, Andrea Gritti (ruled 1523–38), realised the opportunity offered by the presence of Sansovino in the city and saw to his appointment as architect to the procurators of St Mark's, the body of distinguished nobles who served as trustees of the state church. That position gave him control over the public buildings and spaces around the Piazza and elsewhere in Venice. Sansovino, in turn, recognised the possibilities of the situation. He transformed those spaces, displacing the ramshackle market stalls that had clustered around the public buildings

and the great columns, straightening the perimeters, and establishing a sense of order worthy of the ambitions of the Republic. The architectural style he brought from Rome conferred a Classical monumentality upon those spaces; its patterns of columns and arches, of richly sculpted spandrels and entablatures, recall the magnificence of the ancient capital. His style brought new weight and gravity to the lighter, polychrome forms of earlier Renaissance architecture in Venice. Sansovino gave permanent form to the rhetorical claims of the Republic to be a new Rome, a true imperial centre. Through his architecture those claims acquired visible conviction.

By realigning one side of the Piazza, Sansovino liberated the Campanile, the great bell tower of St Mark's, isolating it as a free-standing monument. At its base he designed a new Loggetta, essentially a small pavilion that served as an informal gathering place for Venetian nobles (pl. 219). Like an ancient Roman triumphal monument, its façade is formed of a triple arcade articulated by columns and sculpture, supporting a richly figured attic. And yet, for all its Romanising monumentality, Sansovino's Loggetta remains responsive to its Venetian setting, espe-

cially in the rich sculptural decoration of its surfaces and in its material polychromy. Accentuated by strips of green and variegated marble in the columns, its basic marmoreal palette of pink and white reflects the coloristic patterns of the Doge's Palace. The Loggetta faces the main entrance to the Doge's Palace, and Sansovino clearly designed it to complement that centre of Venetian government. Through such spatial orchestration, a kind of urbanistic polyphony, he realised the spectacular possibilities inherent in the very fabric of the city.

With its Olympian deities (pl. 215) and crowning representation of Venice personified as Justice, the sculptural programme of the Loggetta figures forth the basic tenets of the myth of the Republic as the perfect state. As in architecture, so too in sculpture did Sansovino give new monumentality to a classicising visual language, now of figural rhetoric. Just such rhetoric proved essential to the self-presentation of Venice following the crisis of the League of Cambrai. Even as its actual power was diminished in the face of larger European forces, the Republic sought new ways of asserting its stature as a worthy successor to ancient Rome. Across from the Loggetta, viewed through the doorway to the Doge's Palace and the archway of the Arco Foscari, the fifteenth-century monument that dominates the palace's interior court, is the great outdoor staircase that served as a stage for public ceremonies, especially ducal coronations. Sansovino realised the natural scenographic effect of this complex when he created the two giant statues that now crown the staircase – giving it its name, the Scala dei Giganti (pl. 218). These figures of Mars and Neptune, Michelangelesque in their proportions, stand as symbols of the power of Venice on land and at sea, reassertions of its imperial ambition.

PAINTING AND PLEASURE

It was in painting that Renaissance Venice made its most original and significant contribution to the visual arts. In a technical sense, this involved the development of oil painting on canvas, the medium and support that would continue to dominate European painting to our own day. Because the constant humidity of the Venetian climate prevented plaster from setting properly, thereby undermining the stability of fresco decoration, the Venetians adapted canvas for mural painting. Working on that woven, textured surface, they transformed the application of the oil medium. The artist responsible for that transformation was Giorgione (c. 1478–1510).

As first developed in the fifteenth century in the Netherlands and then in Italy, and especially in Venice, the oil medium was used particularly on a wood-panel support prepared with a smooth ground of gesso. Pigmented layers of oil were applied as glazes directly to the light surface and then, as they dried, over one another; each successive layer modified the hue and tone of the previous one. The entire procedure depended upon the transparency of the medium; light penetrated to the underlying white ground of the support and, there reflected, seemed to emanate from the very depths of the picture. The great master of this technique in Venice was Giovanni Bellini (c. 1433–1516), the first pictorial genius of the Venetian Renaissance.

Giorgione's technical revolution involved a greater density of pigment in the binding-medium, creating a more opaque paint, especial-

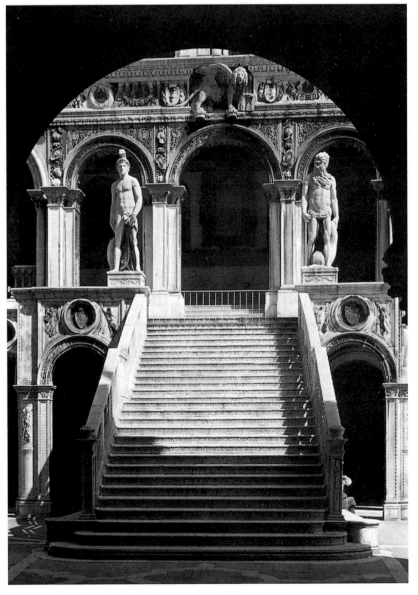

218. JACOPO SANSOVINO: *Statues of Mars and Neptune atop the Scala dei Giganti, Doge's Palace, Venice, 1550.*

JACOPO SANSOVINO, THE LOGGETTA

The sculpture that fills the niches and the attic of Jacopo Sansovino's Loggetta (begun 1537) declares the values that constitute the myth of Venice as the most perfect state. The precise significance of these figures is recorded by the sculptor's son Francesco in his monumental guide to Venice, *Venetia citta nobilissima et singolare* (1581): 'Since for the ancients Minerva represented Wisdom, I intended (he said) this figure to be Minerva in armour, lively and ready to act, for the Wisdom of the Fathers of the Venetian State is singular and without peer in matters of governance. . . . And because all things prudently thought through and acted upon must be expressed with eloquence, for things said with richness have much more impact on the souls of listeners than those expressed without eloquence; and in this Republic eloquence has always enjoyed a special place, and men of eloquence, who have been great in number, have enjoyed the highest reputation: thus have I represented Mercury, signifying letters and eloquence. This other is Apollo (pl. 215): as Apollo signifies the Sun, and the Sun is truly one, unique. . . . Thus this Republic by virtue of the constitution of its laws, its unity, and its uncorrupted liberty, is unique in the world, ruled with Justice and with Wisdom. In addition, it is known that this nation takes natural delight in music, and therefore Apollo is represented to signify music. And since from the union of its Magistrates joined together with inexpressible temperament issued extraordinary harmony, which perpetuates this admirable government, Apollo was therefore depicted. The last statue is Peace, that peace so loved by this Republic and by which it has grown to such greatness, and which has rendered it the Metropolis of all Italy, for its commerce by land and by sea.

That peace it is which the Lord gave to the Protector of Venice, Saint Mark, saying to him *Pax tibi Marce Evangelista meus*. In that manner did Venice originate, from religion, from justice, and from the observance of law – from which emanates the consent of a unanimous harmony.'

In the reliefs above, flanking the central figure of Venice personified as Justice, are images of Venus and Jupiter. Together they declare Venice's just dominion over sea and land.

During the dogate of Andrea Gritti and following the diplomatic triumph of the Peace of Bologna (1530), which left its *terrafirma* empire virtually intact, Venice created a new and expanded image of itself. Calling upon the resonance of the pagan gods of antiquity, it appropriated their powers and virtues to represent its own. Sansovino's sculpture and architecture proved essential to this programme of self-presentation, for its form as well as its iconography made that very message visibly manifest. As Francesco Sansovino's text suggests, the aesthetic, civilising aspect of this imagery was an integral part of its content; its very style attested to historical heritage and destiny. Through this monumental architecture and through the classicism of these figures, the Christian republic of Saint Mark affirmed its position as legitimate successor to ancient Rome. The great mission of this most privileged state, in whose harmonic order the higher heavenly harmony is felt on earth – is to bring peace to the world. Political propaganda had found its ideal figural language.

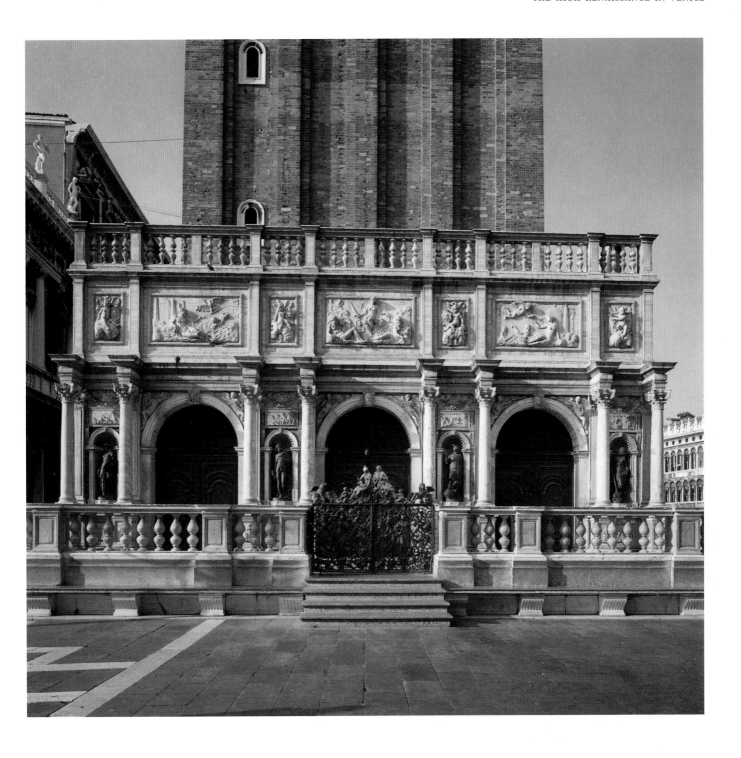

ly white. His practice was to build from a darker ground toward light, so that the brightest parts of his painting are executed with a relatively thick impasto, solid white. No longer dependent upon the delicate transparency of glazes, Giorgione's method permitted a new freedom. Corrections could be made directly on the painting in the course of execution: if still wet, areas of paint could be scraped off; if already dry, they could be painted over, completely covered by a new layer of opaque colour. The process of painting became an open one. No longer did the design have to be carefully prepared and fixed in preliminary drawings.

The possibilities of this technique are best seen in the enigmatic little canvas known as *The Tempest* (pl. 220). X-rays reveal that Giorgione radically modified the composition in the course of execution, for originally there was another female nude where the soldier now stands.

The sixteenth-century Tuscan critic Giorgio Vasari criticised Giorgione for having abandoned the sure path of drawing in favour of painting directly on the canvas. None the less, Vasari acknowledged that the Venetian painter had established something new and important, an art

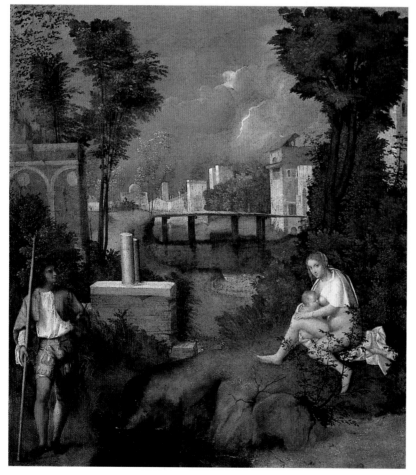

220. GIORGIONE: The Tempest, *1503/4 (?).* *Gallerie dell'Accademia, Venice.*

that created its illusion primarily through the use of tonal values. In this, the critic recognised, Giorgione joined the Florentine Leonardo da Vinci in initiating the modern style. By keeping painting open and responsive, Giorgione created an art that managed to capture the shifting qualities of reality; forms are softened, sharp outlines disappear in the passage of shadow, and a tonal ambience binds object and space in a continuum of tangible atmosphere. Furthermore, like Leonardo's, Giorgione's conception of artistic creativity as an open process found its ready analogue in nature's own continuing self-creation.

For modern observers, as for Vasari, this openness complicates the problem of interpreting Giorgione's pictures; their subjects are often difficult to determine with absolute certainty. *The Tempest*, for example, was described in one sixteenth-century listing simply as 'the little landscape on canvas with the tempest and with a soldier and a gipsy', and the picture continues to defy definitive interpretation. It has been read as a mythological representation (the birth of Bacchus, among others), as a biblical image (Adam and Eve after the expulsion from Paradise), as a political statement (an allusion to the plight of Padua during the war of the League of Cambrai), as an allegory (of Fortitude [the soldier] and Charity [the nursing mother] subject to Fortune [the storm]), and even as a picture with no exact subject other than the forces of nature in motion (a theme quite appropriate to the painter's own creative process). Just as the shadowed spaces of Giorgione's imagery invite the participation of the beholder's imagination, so the images themselves seem to invite active interpretation.

Like his art, the artist himself remains an enigma. We know relatively little about his life – other than that he was of large build and enjoyed a reputation as a lover and musician – and connoisseurs disagree constantly about his work: fewer than a dozen pictures are attributed to him with any degree of unanimity.

One of the most challenging and controversial of the problem pictures is *Concert champêtre* (*Pastoral Concert*, pl. 221). Although traditionally ascribed to Giorgione, the painting has also been attributed to his great follower, Titian (c. 1488–1576). None the less, *Concert champêtre* represents the fullest manifestation of the aesthetic values associated with Giorgione. Evoking the situations of ancient pastoral poetry, shepherds and nymphs making music together in a pleasant grove, the picture establishes the basis for a fully secular appreciation of landscape. Into this ver-

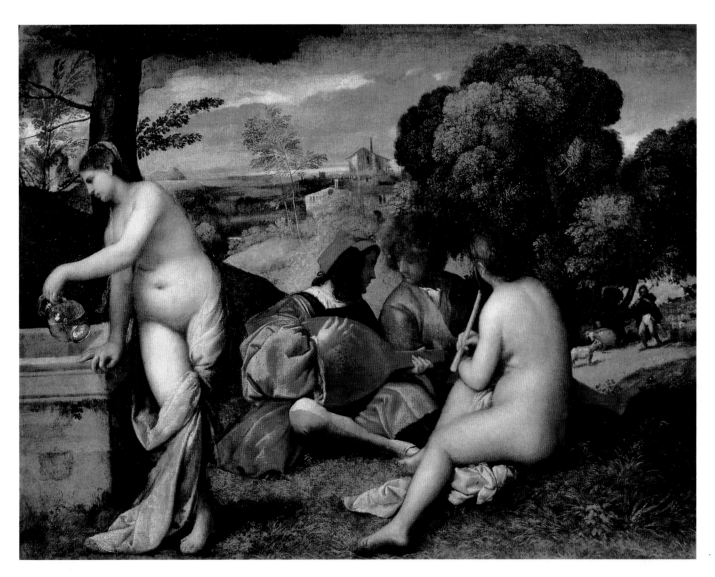

221. GIORGIONE: Concert champêtre, c. 1508. Musée du Louvre, Paris.

dant realm – where gods and mortals mix, where urban poets escape to join their rustic counterparts – the viewer is invited to participate in its soft sensuality and to enjoy the still-sounding notes of its music. The shadowed eyes of the young musicians frustrate precise physiognomic expression, leaving the imagination free to endow form with feeling.

This is the kind of picture that Giorgione's contemporaries would call a *poesia*, a pictorial invention that explicitly opened itself to interpretation and, perhaps more importantly, to projection on the part of the viewer. Generally small pictures, such painted poems were intended for private delectation; they appealed to a new kind of connoisseur and collector, literate and sensitive to the values of a literary culture inspired by the examples of antiquity. But, above all, a picture such as *Concert champêtre* appealed to the senses.

If Michelangelo's marble statue of David can stand as the symbol of Florence and its art, then the corresponding representative of Venetian painting would be the reclining female nude. The motif was established by Giorgione in his most influential pictorial invention, the *Sleeping Venus* (pl. 222). Conceived to celebrate a marriage, the painting was evidently left unfinished at Giorgione's premature death and was brought to completion by the young Titian. Recognising in the motif of the reclining female nude the opportunity to explore and display oil painting's natural sensuousness, Titian appropriated it for his own art, as in the *Venus of Urbino* (pl. 223).

Titian's variations on the theme included the introduction of other figures: a Cupid, who either caresses or crowns his divine mother, and a musician, a courtier serenading his divine lady (*Venus and the Lute-Player* pl. 224). The juxtaposition of an admiring male figure in contemporary dress and a female nude recalls one of the more striking aspects of Giorgione's *Concert champêtre*, as does, of course, the role of music as expressive medium.

In creating a scene of intimate courtship, Titian exploited the full range of painting's sensual appeal: the beauty of Venus caters to our sense of sight as it so clearly does to the eyes of her young lover; our ears strain to hear the sound of their music; and our sense of touch is stimulated by the dimpled texture of her painted flesh.

This array of the senses can be articulated in the language of Renaissance Platonism in its concern with the perception of beauty. The eye, window to the soul, represented the highest sensory organ, followed by the ear: sight and sound were sufficient for the perception of the earthly reflection of the divine good. The sense of touch was relegated to the lowest order of the hierarchy: its object was not love but mere lust. In its fullness, Titian's painting celebrates the higher perception of beauty without, however, ignoring our baser instincts. Responding to the invitation of this picture, the viewer (implicitly male) may enjoy a moral predicament. The dilemma he confronts is epitomised in the final lines of sonnet 71 from Sir Philip Sidney's *Astrophel and Stella*:

So while thy beauty draws the heart to love,
As fast thy virtue bends that love to good.
But ah, Desire still cries: 'Give me some food!'

No matter how anxious we might be to accept a purely moralising interpretation of Titian's painting, desire refuses to abandon its claims.

Titian not only realised the potential of Giorgione's poetic imagery, including its musicality, but also explored the fuller implications of his technical lessons. Expanding the scope of Giorgione's methods, painting larger and more boldly still, Titian found in the physical substance of the paint itself an equivalent to the material being represented. Visitors to his studio reported his using brushes as big as a broom, and at least one account has him applying paint directly with his fingers: 'Wishing to imitate the operation of the Supreme Creator, [Titian] used to observe that he too, in forming this human body, created it out of earth with his hands.' Reversing an old medieval trope – in which God was likened to an artist – the Renaissance master made bolder claims through such a comparison.

As his contemporaries fully recognised, in Titian's art paint became flesh. In his late style, Vasari himself observed, the broad strokes of the brush, the broken touches, the rough fields of colour seem illegible from close up. From a distance, however, they miraculously create a new nature. Here, too, the viewer's active participation is

222. GIORGIONE: Sleeping Venus, 1507–8. Gemäldegalerie, Dresden.

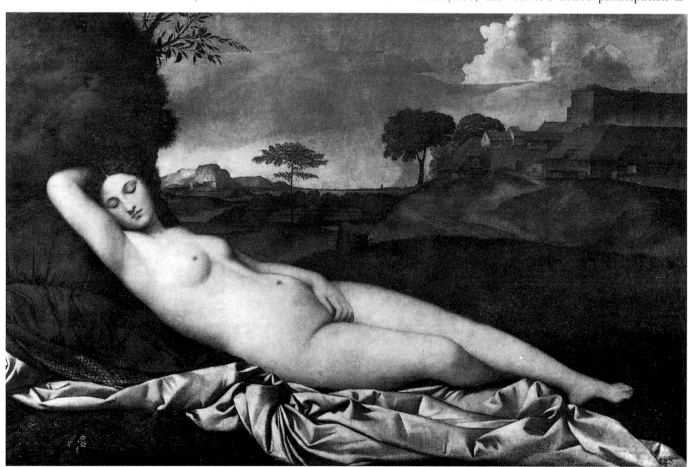

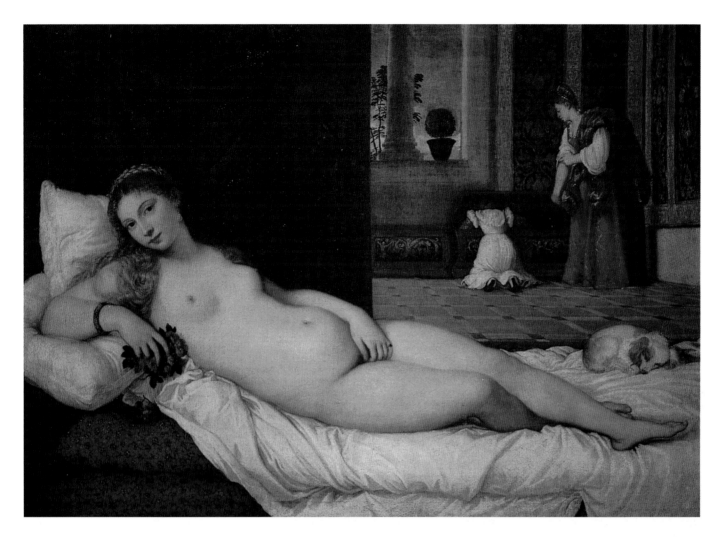

TITIAN,
VENUS OF URBINO

Early in his career Titian had brought to completion Giorgione's *Sleeping Venus* (pl. 222). In the *Venus of Urbino* (1538) Giorgione's Venus has been awakened and brought indoors; aware of her audience, she displays her charms in a public proclamation of love. Nudity, in the context of the interior setting and her jewelled adornment, is evidently not her natural state; she is, rather, naked, awaiting the garments that will clothe her.

Titian's painting, like Giorgione's, was intended as a marriage picture, its imagery evoking the blessings of the goddess of love. In her hand Venus holds a bunch of roses, and on the window ledge in the background a myrtle plant, in perpetual bloom, is pointedly silhouetted against the glowing sky. These floral symbols, traditionally associated with Venus, suggest the permanent bond of marital affection. The little dog curled up at her feet in contented slumber overtly symbolises that ideal fidelity. Adding a naturalistic anecdotal dimension to the sensuous symbolism of the central motif, the background scene of maids at an open *cassone*, or marriage chest, confirms the social significance of the image.

Neoplatonic traditions acknowledged the full range of human experience, from carnal passion, which was base lust, to the highest vision of pure beauty, which was divine love. The *Venus of Urbino* could be enjoyed on the lowest level of its basically sensual appeal, but the interpretive impulse would have been to elevate it to a higher plane of perception.

RIGHT 224. TITIAN:
Venus and the Lute-
Player, *c. 1560.*
*Fitzwilliam Museum,
Cambridge.*

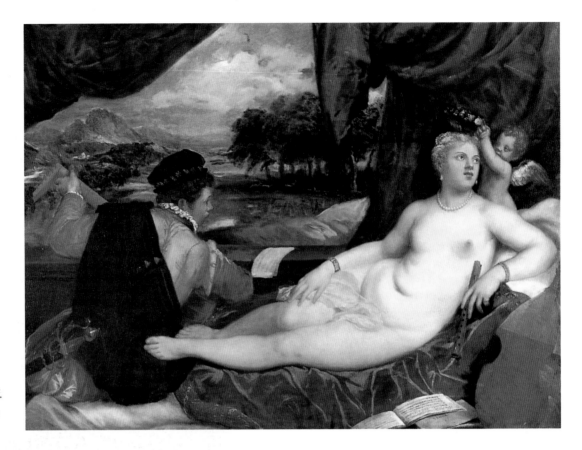

BELOW 225. TITIAN:
Pietà. *Unfinished in 1576.
Gallerie dell'Accademia,
Venice.*

necessary to bring the image into full being, and it is just that participation that guarantees it life, in and through the imagination. In things of the flesh in particular, Titian's painting was a second nature, and it is hardly surprising that the master who was so celebrated for his female nudes enjoyed an even higher reputation as a painter of portraits. A portrait by Titian, declared his friend Pietro Aretino, is a living thing; an effigy from his brush challenges the claims of death over mortals. Such rhetoric was standard fare in Renaissance praise of portraits, but no artist more than Titian, the most sought-after portraitist in all Europe, elicited it with such conviction.

PIETY, PATRONAGE AND POLITICS

Painterly sensuality, however, could serve other ends as well, giving pictorial substance to the flesh of Christ. In the *Pietà* that he intended for his own tomb (pl. 225), Titian's brush – and, we may suppose, fingers – moulded the body of his redeemer; and that deeply personal, indeed professional, piety is confirmed by the artist's own appearance in the guise of St Jerome approaching and touching that body. As Michelangelo had in the *Pietà* he carved for his tomb, Titian assured his own perpetual contact with the body of Christ. In each case, the artist's own medium bonds him to the Saviour.

In the valedictory of the *Pietà* Titian paid tribute not only to his publicly acknowledged rival, Michelangelo, a Florentine and a sculptor, but also to his own great Venetian predecessor and master, Giovanni Bellini. Bellini's S. Giobbe altarpiece (pl. 226), painted nearly a century earlier, established the basic terms of Titian's own compositional structure: above all, the golden mosaic niche that marks the sacred space, evoking the glowing domes of St Mark's. What Bellini had achieved through a meticulous technique of translucent painting in oil, that light from within, Titian created out of the fattier substance of opaque paint, subsequently modified, however, by final glazes to yield a similar profundity of illumination.

Titian designed his *Pietà* for a side altar in S. Maria Gloriosa dei Frari, the major Franciscan church in Venice. The canvas remained, awaiting its finishing touches, in his studio at his death. It would have been his third altarpiece for the Frari and would have completed his claim upon the space of that Gothic basilica. He first impressed his art upon the Frari in 1518, with the dedication on the high altar of his monumental *Assumption of the Virgin* (pl. 216). With this great panel, rising over 7 m in height, Titian established a classical High Renaissance art in Venice, an art of grand gesture and breadth of form, with a geometric structure of symbolic clarity. His composition takes into account the vast spaces of the Frari itself; it is conceived to be seen initially from a distance, down the nave of the church, through the aperture of the fifteenth-century choir screen. Its bold geometry and distribution of colour are calculated to be legible from afar. By siting his altarpiece through the choir screen, matching the details of its frame in that of his own panel, Titian realised the scenographic potential of the site with unprecedented imagination.

Essentially a circle over a rectangle, the monumental geometry of the composition declares the fundamental terms of its thesis: the circle above, the cumulus choir of angels completing the curve of the frame, contains the golden realm of Heaven, against which the full body of the Virgin Mary is silhouetted; below, on earth, the densely impacted bodies of the disciples form a solid base. The circle, with neither beginning nor end, is the perfect symbol of the divinity; the square or rectangle, with its quadripartite equivalence to the four elements and temperaments, is symbolic of this world. This traditional geometric symbolism is translated into convincing reality by Titian. Heaven is made palpable: we sense the weight of the body assumed, acknowledge the

functional responsibility of sustaining clouds and angels, feel the wind filling the Virgin's garments, willingly hear the music of celestial jubilation. And, below, we are persuaded by the very musculature of bodies planted on the ground, of powerful arms straining upward in celebration of the miracle, of body as well as soul transported to Heaven.

Following the clamorous success of the *Assumption*, Titian was commissioned to paint another altarpiece in the Frari, for a side altar belonging to the Pesaro family (pl. 228). Here too, the painter took into account the spatial experience of the site, for his composition, in its asymmetry,

226. GIOVANNI BELLINI: S. Giobbe Altarpiece, *c. 1480. Gallerie dell'Accademia, Venice.*

227. JACOPO
TINTORETTO:
Crucifixion, *1565. Sala
dell'Albergo, Scuola di
S. Rocco, Venice.*

acknowledges the initial oblique vision of the viewer coming down the nave of the church. Boldly displacing the Virgin and Child from their traditional central position in the altarpiece, Titian transformed the genre itself. By constructing an asymmetrical composition, he set the once stable situation of the *sacra conversazione*, the heavenly conversation between holy figures and mortals, into more dynamic motion. From the veiled apex of Mary and Jesus a divine grace falls, through the mediation of St Peter, St Francis and St Anthony of Padua, down to the worshipping members of the Pesaro family. Indeed, as we stand, or kneel, before the Pesaro altar, our access to the holy figures is only through the Pesaro themselves – beginning, most notably, with the youngest of the clan, whose gaze meets ours.

Jacopo Pesaro, on the left, leads the several generations of his family before the enthroned Virgin and Child. A bishop and victorious commander of the papal fleet against the Turks, he is acknowledged by St Peter, the first bishop of Rome. The gathering of this clan in perpetual prayer demonstrates in the most public way the piety of Venetian patricians, as well as their service to the Christian cause. So, too, Jacopo Pesaro's commissioning of an altarpiece for the Frari was an act of personal piety as well as a public contribution to the adornment of the church.

In celebrating themselves, the Pesaro family were also celebrating Venice, for in a fundamental way its ruling noble families were identical with the Republic. Patrician pride and piety reflected that of Venice itself. The government of Venice was an oligarchy from which were ex-

cluded all non-patrician elements of the population. Yet *la Serenissima* had earned its title by maintaining internal equilibrium and concord as well as independence from foreign domination, and this required offering compensations to the disenfranchised segments of society. Institutions such as guilds and confraternities (known as *scuole*) afforded the means by which the average Venetian citizen found his place within the structure of the state. These institutions offered, in effect, a plebeian microcosm of the larger order of the patrician state. Participating in the governing of their confraternities, in their acts of piety and distribution of charity, as well as in their contribution to the pageantry of state ceremony, the brothers of the *scuole grande* could legitimately consider their magnificent chapter halls as not immodest equivalents to the noble Sala del Maggior Consiglio, the great council hall of the Doge's Palace itself (pl. 237).

Collectively, the brothers of these confraternities contributed to the greater glory of Venice through the adornment of their halls, and, in the sixteenth century, pre-eminently through the transformation of the Scuola Grande di S. Rocco into a monument to one great artist, Jacopo Tintoretto (1518–94). Over fifty canvases by Tintoretto decorate the three major rooms of the Scuola, constituting a vast cycle representing the life and Passion of Christ. In the panoramic *Crucifixion* that dominates the Sala dell'Albergo, the vast crowds witnessing the sacrifice on the Cross include portraits of the officers of the confraternity (pl. 227). As for the patrician class, so here, too, patronage is itself an act of piety, and

228. TITIAN:
Madonna of the
Pesaro Family,
1519–26.
S. Maria Gloriosa dei
Frari, Venice.

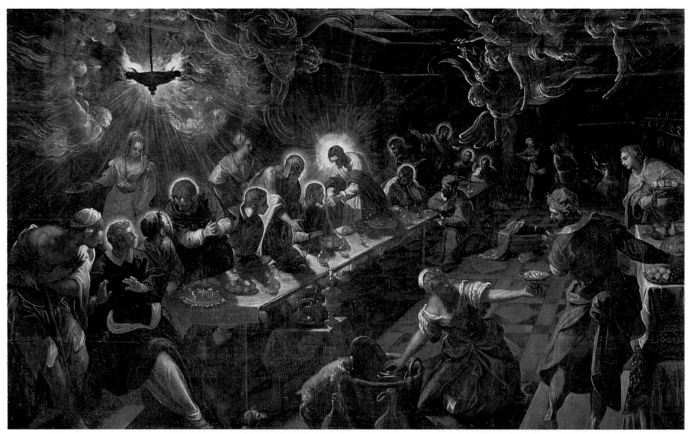

229. JACOPO
TINTORETTO: Last
Supper, *1592–4.*
S. Giorgio Maggiore,
Venice.

its rewards implicitly extend beyond this world.

Tintoretto developed the dramatic possibilities of tonal structure in painting on a monumental scale. Activating the forces of light and shadow, he created a dynamic relationship between Heaven and Earth that gave new force to religious imagery. The theme of the Last Supper, for example, gained a particular resonance from the energies of his brush (pl. 229). Heaven and Earth are distinguished by the very mode of Tintoretto's brushwork, as he gives pictorial form to the basic tenets of the liturgy for the feast of Corpus Christi: the gossamer presence of the angels declares the holiness of the Eucharistic fare, the bread of angels ('Ecce panis angelorum'), whereas below we are reminded that this is not to be wasted on dogs ('non mittendus canibus'). Pictorial style and painterly technique are very much in the service of religion.

The oddly elongated, asymmetrical perspective of Tintoretto's *Last Supper* – too often seen as a merely wilful indulgence on the painter's part, a deliberately radical formal gesture – responds directly to the conditions of its site. Conceived for a wall of the presbytery of the Benedictine church of S. Giorgio Maggiore (where it faces a representation of the gathering of manna by the Israelites), the canvas can only be viewed obliquely – like Titian's *Madonna of the Pesaro*

Family. Seen from that angle, before the high altar, from the nave of the church, the composition automatically corrects itself.

The church of S. Giorgio Maggiore (pl. 230) was designed by Andrea Palladio (1508–80); construction began in 1565. Located on an island in the Bacino, it faces the Piazzetta across the water, and the architect took full advantage of the potential of this relationship. His church is crowned by a dome that answers the domes of St Mark's; his bell tower, too, responds in form and material to that of St Mark's. Extending the lessons of Sansovino, Palladio knit the fabric of the city into a still larger unity.

Facing the giant columns that frame the official entrance to Venice, S. Giorgio presents a monumental façade of Classical purity. Palladio's design results from an intersection of two antique temple fronts, two intersecting orders – the larger of half-columns, the smaller of flat pilasters. These announce basic relationships of the interior. Here (pl. 231), progress down the length of the nave is paced by the sequence of half-columns and arches, and that rhythm of alternating motifs is measured against the continuity of the unbroken cornice above. In its detailed articulation as well as in its overall impression, the great vaulted space, illuminated by large antique thermal windows, claims the nobility and grandeur of

ancient Roman architecture for new Christian purpose. The pure whiteness of Palladio's surfaces sustains a brightness of illumination that finds its natural focus in the central dome, declaring the particular value of light in this aesthetic: 'Of all the colours,' Palladio himself wrote in his *Four Books of Architecture* (1570), 'none is more proper for churches than white, since the purity of the colour, as of life itself, is particularly satisfying to God.'

Beyond the high altar, past a screen of double columns, the windows in the monk's choir glow in the farthest recess of the church. Continuities of luminous space that transcend physical barriers invite the eye to enter places forbidden to the lay body. Palladio was especially sensitive to such scenographic possibilities in architecture.

CULTIVATION ON THE LAND

Palladio was just as aware of such prospects in the siting of the villas he built for noble clients on the mainland. One of the most beautifully situated of these is that of the brothers Daniele and Marcantonio Barbaro at Maser (pl. 232). Inspired by the descriptions of ancient Roman villas, the villas of the Venetian patricians were both country retreats and working farms, places

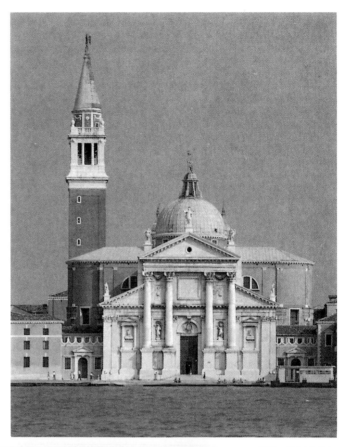

ABOVE 230. ANDREA PALLADIO: *Church of S. Giorgio Maggiore, Venice. Begun 1565.*

LEFT 231. *Church of S. Giorgio Maggiore. View down the nave towards the high altar.*

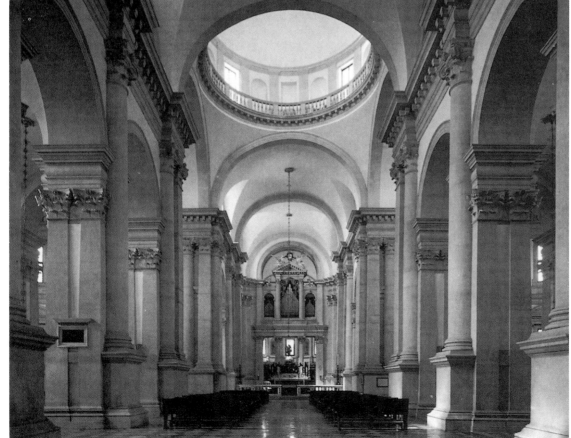

213

of leisure and of labour. Indeed, many of those patricians now preferred economic investment in the land to the seafaring commerce of their forebears. This was specially so following the treaties (1516, 1529) that finally resolved the hostilities with the League of Cambrai and effectively returned most of its mainland empire to Venice. The Venetian government moved to consolidate its position on the mainland. It actively encouraged land reclamation and, in 1556, established an office to supervise and even subsidise such projects; the policy was to put Venetian nobles on the mainland, realise increased taxes, and, perhaps most importantly, guarantee grain supplies to the capital.

Among the results of this cultivation of the land are the many Palladian villas that punctuate the hills and plain of the Veneto. None of these is culturally more resonant than the Villa Barbaro, built about 1560, which represents a particularly close collaboration between patron and architect.

Palladio's own career depended very much upon his relationship with such noble patrons. Apprenticed as a stone-carver in Padua, Andrea di Pietro della Gondola would have continued as an artisan had it not been for patrician intervention. From such patrons the mason received a new education in the architecture and culture of Classical antiquity. His talent was recognised

and he was given a new, classicising name, derived from Pallas Athena, goddess of wisdom. Although Palladio's story may represent the triumph of talent, it also reminds us of the enabling role of patronage in the recognition and reward of such virtue.

Palladio had already collaborated with Daniele Barbaro on the patrician's translation of and commentary on the ancient architectural treatise of Vitruvius (published in 1556), serving as a sort of technical adviser and draughtsman. And we must assume that patron and architect continued to work closely on the design of the villa at Maser. In Palladio's own published plan (pl. 233) each room is inscribed with a number: these relate to one another harmonically – that is, their ratios are musically consonant, as divisions of the octave. Although the adoption of musical proportions in architecture was central to the Renaissance tradition, Palladio realised its potential with remarkable thoroughness. In this way, we might say, his building is literally in tune with the universe, a microcosmic echo of the larger harmonic order.

Set against a hill, the villa looks out over the cultivated farmland of the plain. Form and function declare both the cultural aspirations of the building and its practical needs: 'The front of the master's house has four columns, of the Ionic order,' Palladio explains. 'To either side there are

232. ANDREA PALLADIO: *Villa Barbaro, c.1560. Maser.*

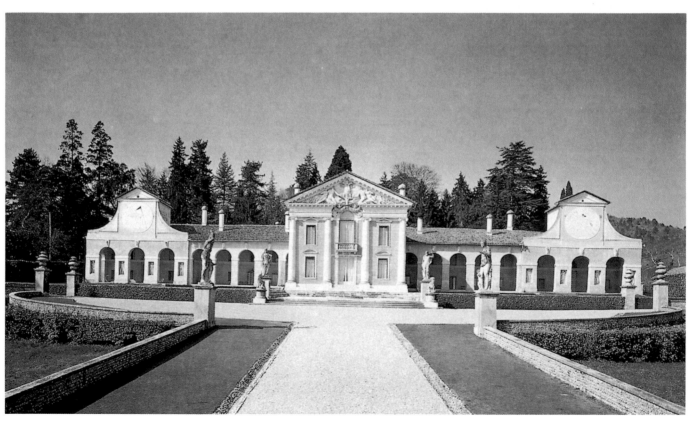

loggie, which, in their extremities, have two dovecotes; and below these are places to make wines, the stables, and other places for the use of the villa.'

The third collaborator in the creation of this villa *all'antica*, in the ancient mode, was the painter Paolo Veronese (1528–88). Veronese's frescoes transformed the central rooms of the Villa Barbaro into a pictorial world of many dimensions. The vaults he populated with Olympian deities, uniting the Zodiac, the elements, and the seasons under the eternal rule of divine harmony or love (pl. 234). In effect, Veronese placed the entire house under divine aegis. Just below this heavenly realm he painted members of the Barbaro family; their portraits link that higher imagined realm with the reality of our lower world. Finally, the painter opened the walls to landscape vistas of a comparable allusive range. Following the precepts of ancient writers such as Vitruvius – who recommended for the decoration of villas the representation of 'harbours, promontories, seashores, rivers, fountains, straits, fanes, groves, mountains, flocks, shepherds . . .' – Veronese created visions that evoked both the landscape of antiquity (into which he inserted a 'portrait' of the Villa Barbaro) and the fluid technique of ancient Roman mural painting. Other views, however, those toward the front of the house, overlooking the cultivated Barbaro farmlands, correspond to the reality of the sixteenth-century Veneto. With their horizons set at the same level as that seen through the central window, these painted landscapes achieve a further harmony of the ideal and the real, the basic theme of the Villa Barbaro.

VENICE TRIUMPHANT

Together, Veronese and Tintoretto came to dominate Venetian painting in the latter part of the sixteenth century. Their styles were fundamentally different: Veronese's more splendidly chromatic and grander of gesture; Tintoretto's more deeply tonal and more dynamic in action. And, to some extent, those differences were reflected in the patronage they enjoyed: Veronese's clients tended to be more aristocratic, often from the Veneto, and with more luxurious tastes; Tintoretto was the painter of the Venetian citizenry, of the confraternities, and of a more popular piety. Both, however, were employed by the state, and together they achieved the fullest pictorial representation of Venice.

Veronese established his reputation as a painter of magnificence with a series of great feasts commissioned for the refectories of wealthy

monasteries. The most celebrated of these was completed in 1573 for the Dominicans of SS. Giovanni e Paolo (pl. 235). Originally conceived as a representation of the Last Supper – in fact, to replace one by Titian that had been destroyed by fire two years before – its title was changed to the *Feast in the House of Levi* following a hearing before the Inquisition. Veronese was challenged by the Holy Tribunal for having introduced improprieties, including 'buffoons, drunkards, Germans, dwarfs and other such scurrilities', at the Last Supper. His defence was essentially poetic licence: 'We painters assume the same licence as do poets and madmen. . . .' Such a vast canvas, he argued, left much room for invention after the requirements of the subject were satisfied. Moreover, the figures to which the Inquisitors objected were not actually in the same space as Christ: 'I intended to cause no confusion, especially since those figures of buffoons are outside of the place where Our Lord is depicted,' he volunteered, offering a perceptive visual analysis of his own composition. Rejecting this defence, the Inquisitors ordered the painter to make

233. *Plan and elevation of the Villa Barbaro at Maser from Book 2 of Palladio's 'Four Books of Architecture', 1570.*

215

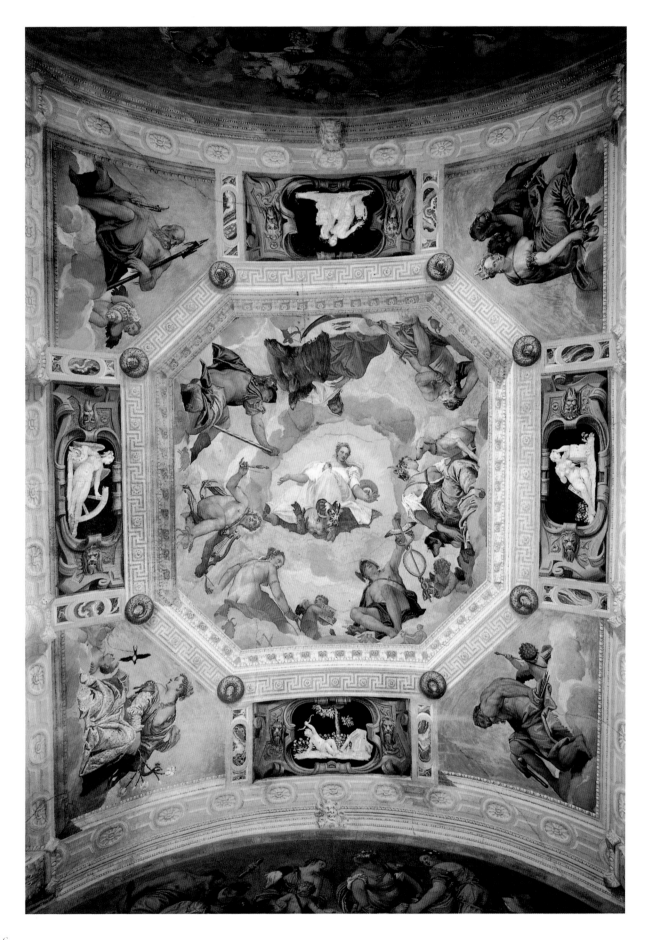

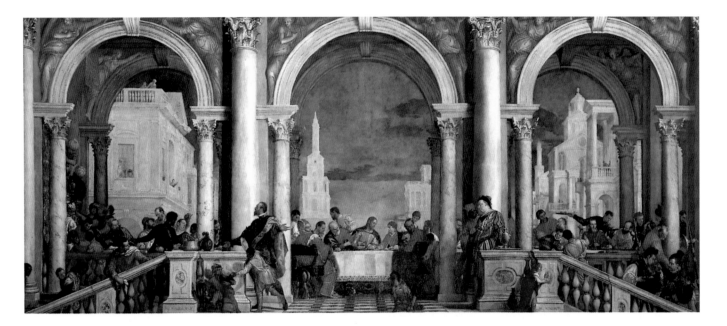

appropriate corrections to his canvas. All that Veronese did, however, was to change the title: the feast in the house of Levi explicitly called for the presence of 'publicans and sinners' (Luke 5:30) and presumably could accommodate 'other such scurrilities'.

In being called before the Inquisition, Veronese found himself something of a pawn in the religious politics between papal Rome and Venice. Following the Council of Trent (1545–63), concern with decorum in religious painting had become a major issue, part of Rome's larger effort to protect the church against Protestant heresy. Venice, considering itself the most Christian Republic, none the less resisted such outside interference in its own domain. Rome, on the other hand, viewed Venice with deep suspicion; it saw its vaunted political liberty serving as a haven for Protestant heretics. The conflict would lead, in 1606, to the second excommunication of the Republic.

Toward the close of the sixteenth century Venice witnessed the continuing erosion of what was left of its maritime empire in the east. Not even the jubilation over the Christian naval victory at Lepanto in 1571 could mask the seriousness of the loss of Cyprus to the Turks the previous year. Yet, even as her actual power diminished, Venice continued to exploit her rhetorical arts in self-celebration. Renewed opportunity for such pictorial celebration came, unfortunately, as the result of two disastrous fires in the Doge's Palace in 1574 and 1577. The latter necessitated the reconstruction and redecoration of the great council hall (pl. 237).

On the wall over the ducal throne, Tintoretto replaced the original fourteenth-century fresco with an enormous canvas representing the celestial Paradise. At the apex of the composition is the Coronation of the Virgin, the focal action toward which the assembled saints and angels turn in praise. Radiating from that centre, concentric banks of clouds and figures create the heavenly setting that sanctifies the hall in which the Venetian nobility congregated in state deliberation. That pictorial structure of expanding spheres gives visual form to the great celestial harmony, in which, by clear implication, the harmonious state of Venice participates. More pointedly, the golden light emanating from Christ himself descends to shed its grace upon the enthroned doge below. Tintoretto's mural proclaims the divine ordination of the Republic of St Mark.

Venice claimed to have been founded on 25 March 421: the date is that of the Feast of the Annunciation, the day of the Incarnation; the year is that after the invasion of the Veneto by Alaric and his Goths, who had sacked Rome in 410. Without pagan Roman origins, Venice was born, as the Venetians said, in Christian liberty, the first state of the new era. Such legends were part of the myth of Venice; they provided the basis for the Republic's sense of itself and of its position in history, and the context for appreciating the fuller resonance of its official imagery.

On the ceiling immediately above Tintoretto's *Paradise* is an image in a very different mode, Veronese's *Apotheosis of Venice* (pl. 236). The very opulence of the painter's style – its chromatic clarity and material sumptuousness – reflects the glory of the Republic. The standard personification of Venice had come to assume the form of a

ABOVE 235. PAOLO VERONESE: Feast in the House of Levi, *1573. Gallerie dell'Accademia, Venice.*

OPPOSITE 234. PAOLO VERONESE: *Frescoes in the dome of the Sala dell'Olimpo, 1560–1. Villa Barbaro, Maser.*

217

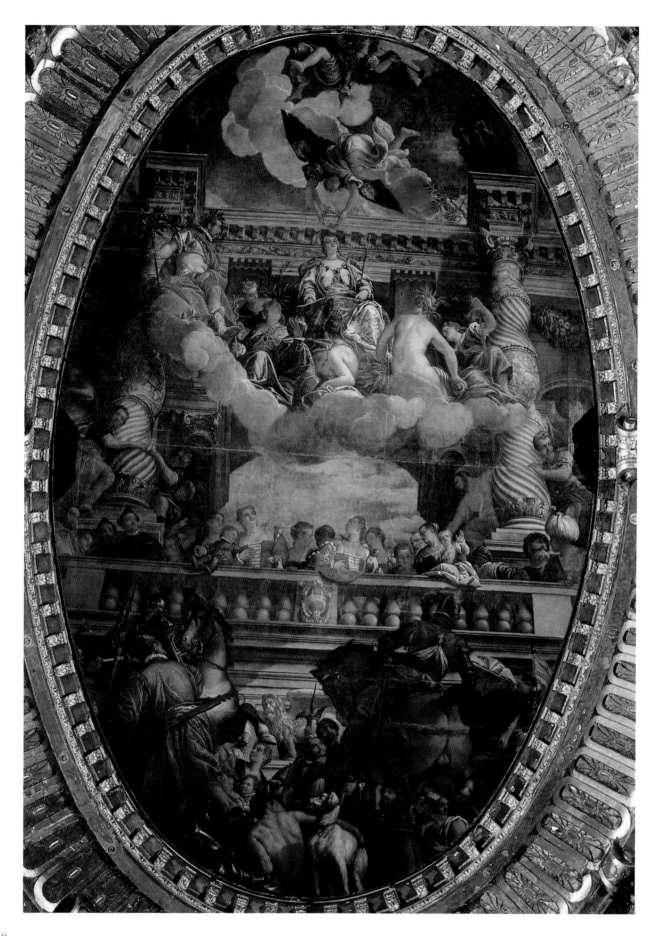

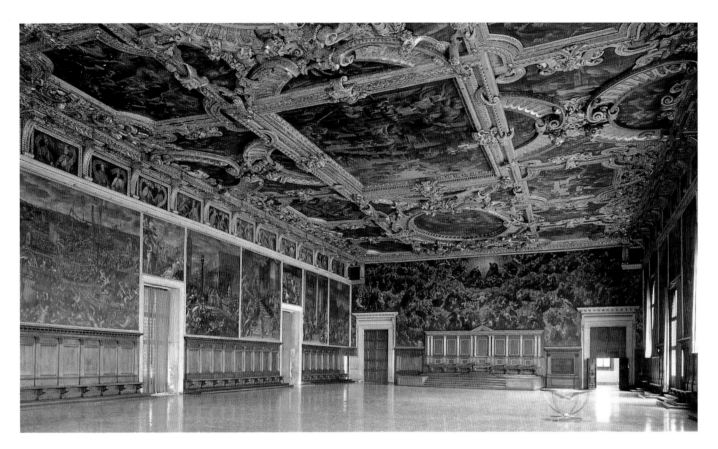

figure of Justice, a regal woman with sword and scales, upon a lion throne – as on Sansovino's Loggetta. In the course of the sixteenth century, this traditional image was further elaborated with reference to the ancient depiction of the goddess Roma, but also by allusion to beautiful Venus (also born of the sea) and, as we have seen, to the Virgin Mary herself (Venice, too, never violated, remained virgin). This development culminates in the enclouded imperial figure of Veronese's ceiling painting: crowned by Victory, her renown trumpeted by Fame, she is surrounded by a court of Olympian deities whose several virtues she embodies – strength, peace, wisdom, bounty, liberty; her citizens sing her praises and her conquered provinces willingly accept the beneficent rule of this great queen.

More than any other political entity of the early modern period, the Republic of Venice shaped the visual imagination of European political thought. The example she offered was of a constitutional state, a state founded in and ruled by law, in which the highest public virtue was justice. And on that foundation depended too the economic well-being of this commercial city – as attested by Shakespeare's Merchant of Venice:

The duke cannot deny the course of law;
For the commodity that strangers have

With us in Venice, if it be denied,
Will much impeach the justice of the state;
Since that the trade and profit of the city
Consisteth of all nations.

As she instructed Europe and, ultimately, America in the idea of statehood, so Venice taught how to give that idea eloquent pictorial form. In the figure of Venice personified an abstraction acquired substance, the very idea of the state became visibly perceptible. The effectiveness of this imagery depended upon both the idea and the embodiment: it was the power of the painter's brush that gave it reality.

This has been a fundamental truth of Venetian art, its commitment to reality through the materiality of its own medium, and especially in painting. What Giorgione first discovered, Titian fully exploited: namely, that the very substance of oil paint could do more than merely imitate reality; it could, through its own physical presence and organic operations, substitute for it. Tintoretto and Veronese would extend this lesson in different ways, discovering in their own brushwork ways of making palpable things of the spirit as well as of the flesh. The reality of painting is fundamentally Venice's great legacy to European art.

ABOVE 237. *Sala del Maggior Consiglio, Doge's Palace, Venice. Behind the throne is* TINTORETTO'S *Paradise, 1588–92.*

OPPOSITE 236. PAOLO VERONESE: Apotheosis of Venice, *c. 1585. Ceiling of the Sala del Maggior Consiglio, Doge's Palace, Venice.*

9
ITALY, FRANCE AND AUSTRIA IN THE 17TH CENTURY

JEREMY WOOD

In the closing days of November 1680, Gianlorenzo Bernini (1598–1680), the great sculptor and architect who had dominated the artistic life of Rome for sixty years, entered his last illness and got ready for death. In many ways this seems to have been a work of art in itself, an event for which the artist had prepared throughout his life by attending the Jesuit service known as 'The Devotion of the Good Death', and the piety of his closing days excited the admiration of all Rome. One work by him is particularly associated with this exemplary event: a Christ on the Cross where the blood of the Redeemer gushes from his wounds and is gathered by the Virgin in order to be offered, on behalf of the sins of mankind, to God the Father (pl. 238). Bernini had this image placed at the foot of his bed and gazed at it as the end approached. Art, life and religion are inextricable in this disturbing image of the Cross hovering above a sea of blood that stretches to infinity.

Not all of Bernini's contemporaries would have said that he was entirely without human faults. One commentator described him as 'a dragon' who 'made sure that no one else should snatch the golden apples of papal favour', who 'spat poison everywhere, and was always planting ferocious thorns of slander along the path that led to rich rewards'. Great opportunities were created for artists, and particularly for Bernini, by a series of popes. The fountains which he designed throughout the city were a public

demonstration of the new aqueducts constructed, at the beginning of the century, in order to bring water to previously undeveloped areas of Rome. New roads were built to connect the seven great pilgrimage churches which drew visitors to the city from throughout the Christian world. Old churches were renovated and new ones were constructed for the recently founded religious orders such as the Jesuits, with whom Bernini was closely associated, and the Oratorians. Not least, enormous sums of money were spent by the popes on St Peter's itself. Although Bernini was not involved in the completion of the nave at the beginning of the century, the interior was decorated largely under his supervision (pl. 240). He designed the baldacchino, a bronze canopy supported by four columns over the tomb of St Peter, and the Cathedra Petri, a monument containing St Peter's chair in the apse of the basilica, as well as the great piazza with its colonnades.

One of the people who felt Bernini's ruthlessness most acutely was the architect Francesco Borromini(1599–1667). At one brief moment when it seemed that Bernini was out of favour and Borromini's career might prosper, Innocent X arranged a competition for the design of a new fountain with an obelisk in the Piazza Navona. In one account it was said that Bernini arranged to have his model placed in a room where the pope would see it by accident, and naturally be captivated. In another it was said that Bernini had his

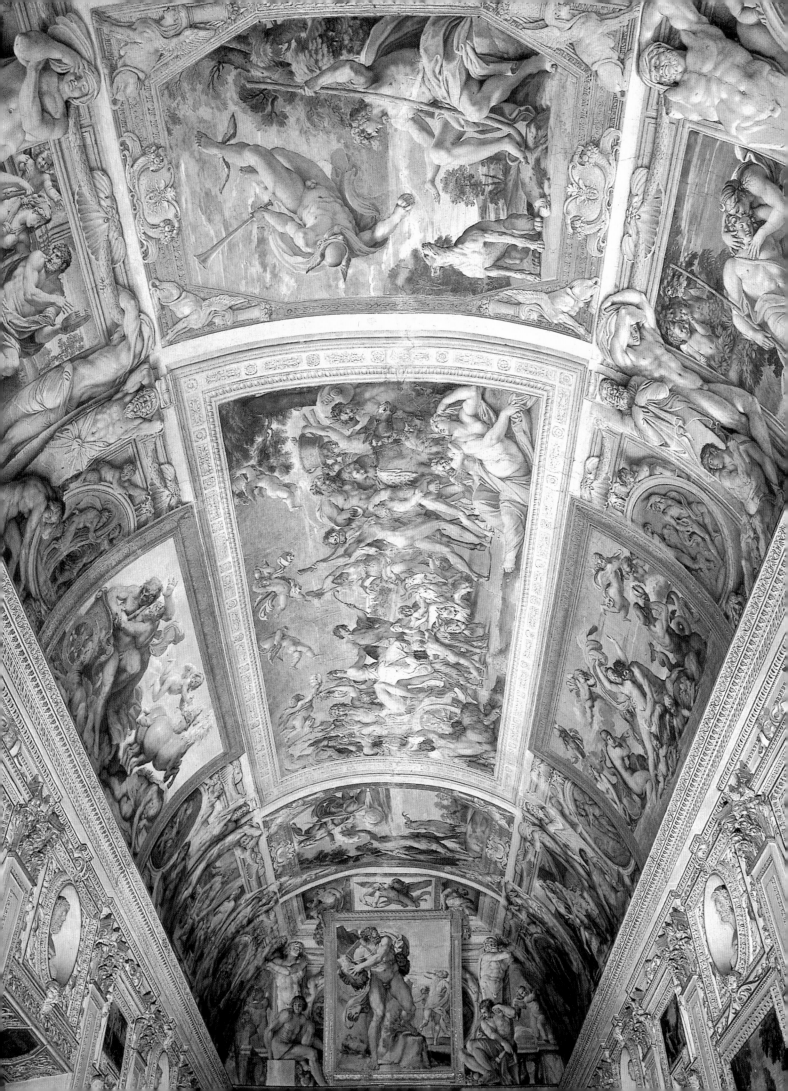

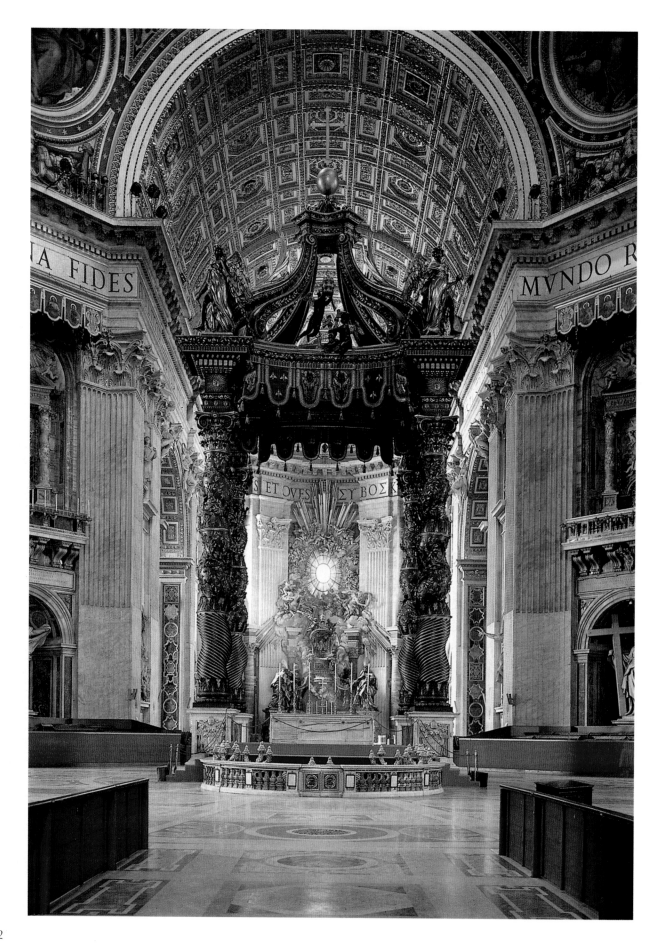

model cast in silver and that he presented it to the pope's sister-in-law, a lady with little charm and great forcefulness, who was nicknamed *la Dominante* by the Romans. However it happened, against all the odds Bernini seized the commission for the Four Rivers fountain (pl. 241) and it became one of the most celebrated in Rome, despite the fact that its expense was much resented and provoked a popular saying to the effect that people could not eat obelisks and fountains. While Borromini lost the commission for the Piazza Navona he did obtain some other important ones, though the most prestigious were, in the main, denied to him. His biographers record the increasing paranoia and resentment that he felt towards Bernini at the end of his life, and Borromini's death could hardly have been more different from that of his rival. He chose to commit suicide (and hence risk eternal damnation) by falling on his sword like an ancient Roman, but made such a botched job of it and died so excruciatingly slowly that he was able to dictate an account of his decision to kill himself which is among the most chilling documents of artistic life in seventeenth-century Rome.

Bernini did not make enemies only in Rome. In 1665, at the height of his career, he travelled to Paris and managed to antagonise nearly everybody he met. That the reluctant artist should have had to make the long and arduous journey at the age of sixty-seven, in order to satisfy the young French king's ambitions for the enlargement of the Louvre (pl. 242), says much about the changing balance of power between Louis XIV and the pope at that time, Alexander VII – a balance which was soon to shift artistically as well as politically in France's favour. Indeed, the development of French art in the seventeenth century cannot be easily separated from that of Italy.

Bernini planned the Louvre as an immense and magnificent Roman *palazzo* to go in the centre of Paris, but his conception of architecture as something which should look splendid from the outside came into sharp conflict with the French concern for the efficient housing of the court, its protocol, and such niceties as the placing of privies. As the young architect Charles Perrault wrote, 'The Cavaliere [Bernini] would have none of this, taking the attitude that it was beneath the dignity of a great architect like himself to have to bother about such details.' Although never realised, these plans did have great influence on the vast palaces built throughout Europe in the late seventeenth and early eighteenth centuries. While he was in Rome in the 1670s, the Austrian architect Johann Bernhard Fischer von Erlach

(1656–1723) had access to Bernini's studio and studied the projects for the Louvre; their impact can be felt on the designs he produced for palaces and country pleasure houses around Vienna in the 1690s. In turn, these influenced the work of Fischer von Erlach's rival Johann Lukas von Hildebrandt (1668–1745), and echoes of Bernini's ideas can be found in the Belvedere Palace built for Prince Eugene of Savoy in Vienna between 1714 and 1722 (pl. 243).

THE BAROQUE AND THE CLASSICAL

During his stay in Paris, Bernini was generally tactless about all things French, but he was overwhelmed, in so far as that was ever possible, by the paintings which Nicolas Poussin (1594–1665) had sent from Rome to collectors in France

OPPOSITE 240. GIANLORENZO BERNINI: *The Baldacchino and the Cathedra Petri, 1624–33.* St Peter's, Vatican, Rome.

BELOW 241. GIANLORENZO BERNINI: *Fountain of the Four Rivers, 1648–51.* Piazza Navona, Rome.

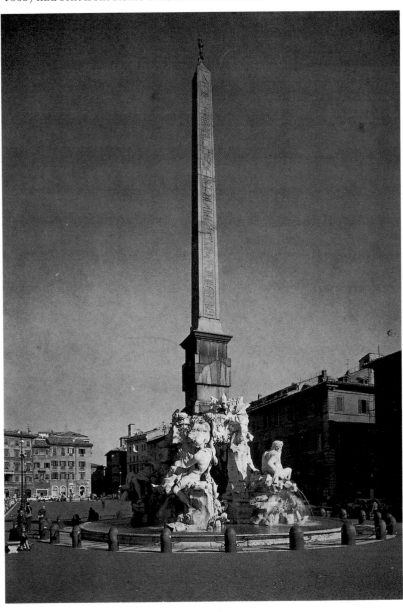

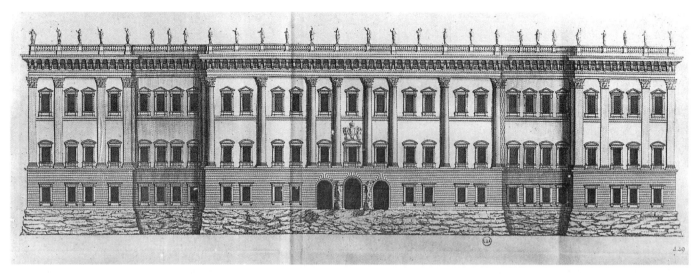

ABOVE 242.
GIANLORENZO
BERNINI: First
Project for the East
Façade of the Louvre,
*1664. Cabinet des
Dessins, Musée du
Louvre, Paris.*

BELOW 243. J. LUKAS
VON HILDEBRANDT:
*Upper Belvedere, Vienna.
1714–22.*

during the previous thirty years, and which Bernini had clearly not had the opportunity to see in Italy. Bernini and Poussin are often discussed as completely opposed artists, the former standing for the 'Baroque' and the latter for 'Classicism' (or even a hybrid 'Baroque Classicism') in seventeenth-century art, but this distinction is too crude and it ignores the views that they held in common. When Bernini saw Poussin's work in Paris he thought it not only 'extremely beautiful' but said that it was 'painted in Raphael's style'. For Bernini, as for most of Poussin's other early critics, his achievement could be ranked with Raphael and those Italian artists, notably Annibale Carracci and his pupil Domenichino, who were thought to have reformed Italian painting in the opening years of the seventeenth century. At the time this reform was defined by Monsig-

nor G. B. Agucchi, secretary to a powerful cardinal and friend of the Carracci, in terms of 'following the style of the antique statues' and 'mastering the design of the Roman School', in particular the work of Raphael. Italian art of the later sixteenth century, which is often categorised as 'Mannerist', was felt by Agucchi to have become corrupt: 'New and diverse styles came into being, far from the real and lifelike, supported more by appearance than by substance.' Bernini also entirely agreed with Poussin that the example of ancient Roman sculpture provided the finest model for any artist to imitate. Although the two artists may have put these opinions into very different practice, and Poussin does not seem to have returned Bernini's admiration quite so generously, this should not obscure the fact that a fundamental respect for the antique and for Raphael bound them together.

In some ways the style label 'Baroque' seems to fit architecture best, although the three main Roman architects – Bernini, Borromini and Pietro da Cortona (1596–1669) – had surprisingly little in common. Bernini said in a conversation about Borromini's work that 'it was better to be a bad Catholic than a good heretic', and the great biographer and critic Giovanni Pietro Bellori wrote that Borromini was 'an ignorant Goth who had corrupted architecture'. For Bernini, Borromini's heresy lay in breaking the 'rules' of Classical architecture, abandoning a system of proportions based on the human body, in pursuit of the 'chimeras' of geometrical shapes. Borromini's church of S. Ivo della Sapienza (pl. 244), built between 1644 and 1655, is often said to represent the Baroque at its most ingenious and original, but at the time these qualities were seen as faults, and Borromini would have answered the charge by citing the example of Michelangelo's unortho-

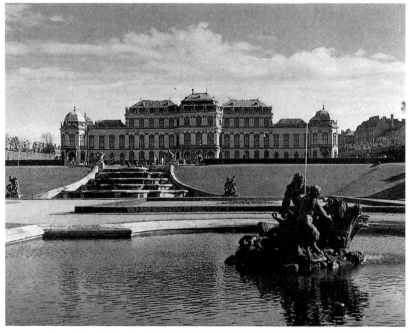

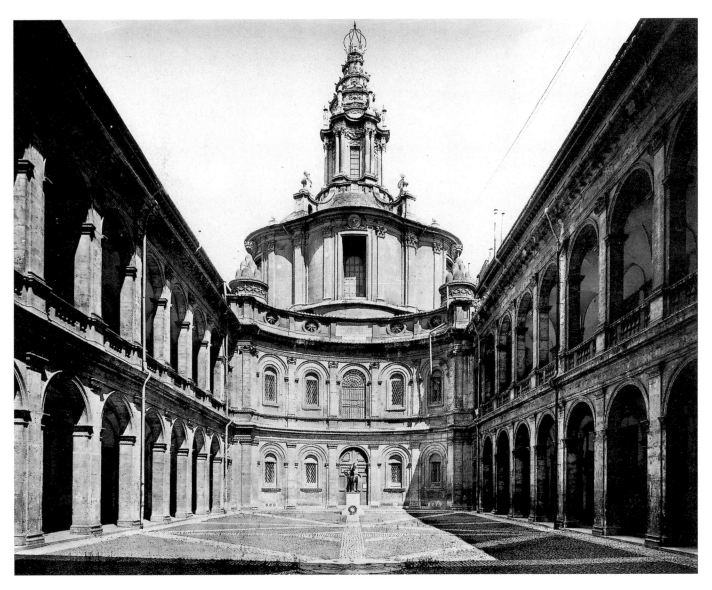

dox architecture. When Alexander VII visited S. Ivo, he said that 'the style of Cavaliere Borromini was Gothic', and that this was not surprising 'since he was born in Milan where the Cathedral is Gothic'; modern historians have related his work to the use of geometry by masons in a tradition going back to the medieval period. Borromini, who came from a family of stonemasons, conceived architecture in very different terms from Bernini, who thought of himself as faithfully following the example of the ancient Romans.

In relation to this question of the nature of the Baroque, it is worth considering how far the style of architecture in Rome can be linked to that in south Germany and Austria during the late seventeenth and early eighteenth centuries. The role of Borromini in this has certainly been much exaggerated, and the intricate geometrical shapes of S. Ivo are very different from the monumentality of Fischer von Erlach's Karls-

kirche in Vienna (pl. 246), which was built between 1716 and 1738. Although the church was dedicated to one of the new reforming saints, Charles Borromeo, in thanks for Vienna's delivery from the plague, it is as much a memorial to the Habsburg dynasty, who had dominated the history of central Europe during the previous centuries, and the architectural conception of the building derives from its dual function. The façade is dominated by two extraordinary columns which refer back to the one built by Trajan in Rome, the reliefs on them depicting the life of Charles Borromeo. Their function, however, is to allude on a gigantic scale to the personal device, or *impresa*, of the Holy Roman emperors, which contained the columns of Hercules through which Charles V's fleets were said to have sailed. The façade derives part of its effect from what Italians would call a *concetto*, a brilliant and original idea, of the kind at which Bernini excelled.

244. FRANCESCO BORROMINI: *S. Ivo della Sapienza, Rome. 1644–55.*

225

RELIGIOUS ART DURING THE COUNTER-REFORMATION

It is not always clear how far the meaning of some religious commissions was determined by the patron or the artist, and in particular whether, during the Counter-Reformation, the ideas of the reformers had any relationship to the artistic 're-form' which was said to have happened in the early seventeenth century. The Counter-Reformation set out to purge abuses from the church in the face of Protestant dissent, and there is no doubt that a great revival of Catholicism occurred at this time. Bernini's celebrated chapel dedicated to St Teresa in the Roman church of S. Maria della Vittoria (pl. 247), completed in 1651–2, is often discussed as an example of this new piety. It is not known, however, who devised the iconography of the chapel, although it is likely that Bernini talked to Father Alessio Maria della Passione, a member of the Discalced Carmelite order founded by St Teresa and an expert on her life (he published a book about her in 1655). In the absence of any evidence to the contrary, it has to be assumed that Bernini was responsible not only for the design but also for the iconography of the chapel. Bernini was well known for his expertise in religious matters, and his son recorded that the Jesuit General, Father Oliva, said that discussing religious matters with the artist was 'a professional challenge, like a disputation on a thesis'. The Jesuits started out with little interest in the visual arts, preferring austerity in their churches, but Oliva seems to have grasped – perhaps through his friendship with Bernini – what enormous potential art offered for reinforcing faith. From this point of view it appears that Bernini influenced the church as much as the church influenced him.

The Counter-Reformation was characterised by a new emphasis on the lives of the saints, and on the Eucharist, defending the Catholic belief that Christ's body and blood become present in the Sacrament of the Mass and can provide salvation for mankind, an idea encapsulated in Bernini's *Blood of Christ* (pl. 238). During this period there was also an avoidance of obscure or apocryphal subjects in religious art, and many church leaders felt that ordinary people should be able to understand the stories in religious pictures. In the sixteenth century there had been criticisms of indecency (as well as obscurity) in religious art, and Vasari remarks how an altarpiece by Fra Bartolommeo (*c.* 1474–prob. 1517) of St Sebastian had such 'charm and melting beauty' that women 'had sinned at the sight of it'. As a result the picture had to be removed and en-

ded up in the gallery of the French king, where presumably it could do little further harm. In 1582 the Florentine sculptor Bartolommeo Ammanati (1511–92) publicly repudiated all the nude figures that he had carved, and urged his fellow artists to depict only clothed ones. The most famous case of a furore over decorum in art is probably the reaction to Michelangelo's *Last Judgement* in the Sistine Chapel (pl. 212), which the writer and collector Pietro Aretino attacked for including such things as 'men dragged down by their genitals, things in front of which brothels would shut their eyes'. By the seventeenth century, however, the need for strict religious decorum was beyond controversy, and neither Bernini nor Poussin, for example, could ever be accused of impropriety of this kind.

The paintings which Federico Barocci (*c.* 1535–1612) was commissioned to send to Rome at the end of his career provide a good example of the kind of religious art that was liked by the leaders of the Counter-Reformation. In 1582 Francesco Pozzomiglio, a private patron, obtained rights to a chapel in the church newly founded by St Philip Neri and often simply known as the Chiesa Nuova. The saint had instituted a new kind of devotion in the middle years of the sixteenth century, the 'oratory': this was an afternoon meeting in which a reading from a holy text was followed by a sermon and a discussion, and it proved so accessible and popular that Philip Neri's followers became known as the Oratorians. Interestingly, the altarpiece for Pozzomiglio's chapel was not commissioned from a local artist in Rome, but from Barocci, a very distinguished painter who had worked all his life in Urbino. When the picture, which depicts the

ABOVE 246. J.B. FISCHER VON ERLACH: *The Karlskirche, Vienna. 1716–38.*

OPPOSITE 245. FEDERICO BAROCCI: The Visitation, *c.1583–6. Pozzomiglio Chapel, S. Maria in Vallicella (Chiesa Nuova), Rome.*

GIANLORENZO BERNINI, THE ECSTASY OF ST TERESA

According to his son, Bernini said of the Cornaro Chapel, S. Maria della Vittoria, Rome, that it was 'the least bad work' he had ever made. Although the chapel was given relatively little attention by his early biographers, who probably found it overshadowed by the great projects in St Peter's (pl. 240), it now seems the embodiment of Bernini's ability to unify sculpture with painting and architecture.

The chapel was commissioned by Federico Cornaro, a Venetian cardinal, in order to commemorate his family. It is dedicated to St Teresa, the founder of the order of Discalced (Barefoot) Carmelites, whose written accounts of her visions became extremely popular during the Counter-Reformation. The saint is shown above the altar at the moment known as her 'transverberation'. Bernini visualised her in a pose of complete passivity, as if beyond physical sensation, shown at the moment when (according to her own account), the angel who appeared to her in a vision had plunged a golden spear with a tip of fire into her heart and entrails: 'As he drew it out . . . he left me completely afire with a great love of God.' These details were mentioned at her beatification in 1614 as well as in the bull of canonisation of 1622, and it is interesting that Teresa was depicted at this moment in the decorations of the ceremony, held in St Peter's, which marked the end of the lengthy process by which she became a saint. Although Teresa was also revered for her exemplary death, there is little doubt that the transverberation was the most popular, and sensational, event from her life.

Despite the effectiveness of the group of saint and angel, one of the puzzles of the chapel is quite what the members of the Cornaro family, who are depicted in the reliefs on the side walls, are doing. They are in animated discussion but presumably cannot see (or take no notice of) the vision above the altar. They have been described as 'witnesses' of Teresa's sanctity, but one of the first accounts of the chapel, published almost immediately after its completion in 1652, could only weakly call them 'admirers of Teresa glorified'. This unsatisfying ambiguity was eliminated by Bernini in later projects, such as the chapel dedicated to Gabriele Fonseca, doctor to Innocent X, in S. Lorenzo in Lucina, where the extraordinarily vivid bust of Fonseca is gazing intently from one of the side walls at the painting of the Annunciation above the altar.

Bernini was said by one of his biographers to have aimed at unifying architecture with sculpture and painting, so as to make 'a beautiful whole'. In the Cornaro Chapel he linked the architecture of the church to that of the chapel by retaining its colossal pilasters and entablature. A pedimented tabernacle above the altar creates the frame for a three-dimensional picture, formed by the colourless marble figures of the saint and the angel who are set in front of gilded wooden rays, the whole thing being lit from an oculus above. It seems that Bernini originally intended less light to fall on the group than at present and that the figures should appear as a shimmering but indistinct apparition, framed by the rich but dark polychromy of the surrounding coloured marble.

Visitation (pl. 245), arrived in Rome, the duke of Urbino's agent commented that it 'pleases everyone very much', and that 'for three days there was a queue to see it'. This painting, one of the most delicate and tender of all Barocci's works, was particularly liked by St Philip Neri, who often sat before it in a devout ecstasy. Some of his female penitents used to spy on him while he was in these trances, and on one occasion his ecstasy was so deep that it took a violent shaking to arouse him, much to the saint's vexation. Later in the century Bellori (whose life of Barocci appeared in his collection of artists' biographies) wrote that 'Barocci had a special genius for painting sacred pictures', and he commented on 'how rare it is to find paintings in churches which have the decorum and sanctity necessary to arouse devotion'.

Although a private individual paid for *The Visitation*, it seems that it was the Oratorians themselves who were particularly keen to obtain a work by Barocci. Conversely, in the case of the commission for their high altar, the man who paid the bill appears to have put pressure on them to accept Rubens, his choice of painter. Clearly it is not always easy to know who selected the artist for a particular commission, but what was required in terms of subject matter is often well documented, and the newly founded confraternities could sometimes make very specific demands which may have encouraged artists to work in new ways. Barocci's *Madonna del Popolo* (pl. 248) was painted for the chapel of a lay confraternity in Arezzo devoted to caring for the sick and the poor. The artist was first asked for a Madonna of Mercy, an image which had precedents in Piero della Francesca's *Madonna della Misericordia* – to be seen not far away from Arezzo, at Borgo S. Sepolcro – in which diminutive figures are depicted sheltering under the Virgin's robe. Barocci, not surprisingly, was unenthusiastic about this idea and presumably wanted to avoid any unnatural difference in scale between the figures; he suggested that an Annunciation, Assumption or Visitation of the Virgin (all of which are interesting subjects dramatically) would do much better. When the contract was drawn up for the new altarpiece in 1575, he was asked to provide something rather different:

> Let the subject of this picture be of the most glorious ever-Virgin Mary, Mother of God, interceding and praying to the Lord Jesus Christ her blessed son for the people, who are there likewise painted and represented in the said picture with decorum, charm and grace, taking account of the condition and quality of

the persons to be painted there, by referring each thing to each corresponding element in a fitting manner.

This document was rediscovered only a few years ago, and its significance has hardly begun to be assessed, but it does seem clear that the contract was based on discussions with the painter, and that Barocci contributed as much as his patron to this new formulation, which puts a lot of emphasis on including ordinary people in the altarpiece. In an early drawing for the composition (pl. 249) Barocci shows a member of the confraternity giving alms to a beggar, but he removed this detail in the painting, where one can hardly make out that the gipsy mother on the right is in fact being given money; allusion to the Acts of Mercy is otherwise discreetly limited to some small figures in the

OPPOSITE 248. FEDERICO BAROCCI: Madonna del Popolo, *1575–9. Galleria degli Uffizi, Florence.*

BELOW 249. FEDERICO BAROCCI: *Compositional Study for the* Madonna del Popolo, *c.1575. Formerly in the Chatsworth Collection.*

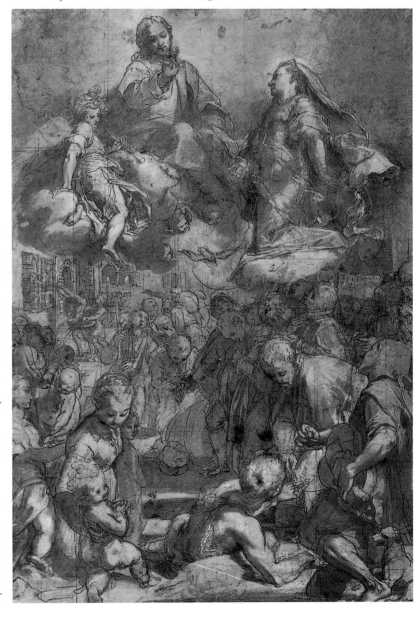

OPPOSITE 250.
CARAVAGGIO: The
Seven Acts of Mercy,
1606. Pio Monte della
Misericordia, Naples.

background who are visiting the imprisoned and bringing them clothing and food. The result is that the group of a mother with her two children on the left, which relates to the conventional way of depicting Charity but has the figures in modern dress, and the blind hurdy-gurdy player on the right with his disabled companion are presented in a somewhat abstracted way, and do not look towards the spectator but turn inwards towards the eight members of the confraternity (whom Barocci includes in the background) or look upwards at the miraculous apparition in the heavens. As one might expect from the wording of the contract, the figures are very carefully distinguished by their dress between those who are privileged witnesses of the Virgin's intercession and those who are the objects of charity. In the heavens above, the Virgin appeals to Christ on behalf of mankind. This intercession is the theological point of the altarpiece, and it is here that Barocci links the heavenly and earthly zones of the picture in a naturalistic and convincing manner.

The success of Barocci's altarpiece lies in its brilliant and shimmering effects of light and colour, and the skill with which the subject is visualised in a specific time and place but also idealised. Bellori said that Barocci's discoveries languished for a long time in Urbino (where he worked in relative isolation) until a younger generation of painters came 'to restore and give aid to art'. While he was certainly right, there could hardly be a greater contrast between the *Madonna del Popolo* and one of the pictures produced by a younger painter of a comparable subject, *The Seven Acts of Mercy* (pl. 250) by Michelangelo Merisi da Caravaggio (1571–1610), made for a similar charitable confraternity in Naples in 1606 and paid for in 1607. It was originally intended by the patrons that the seven altars in their church should each have an altarpiece depicting one of the Acts of Mercy, but eventually (and rather surprisingly) they decided to combine all of them into one image for the high altar. The result is a picture which is visually exciting but not very easy to read in terms of the subject matter.

At first sight the altarpiece seems to be interpreted in terms of contemporary life (something which is often said about Caravaggio's treatment of religious subjects) and almost looks as if the events it portrays are taking place on the streets of Naples, but this is not really true. It is in fact Barocci who depicts religious scenes as if we could open the door of a house in Urbino and find the Holy Family inside, or look out through a window and see the Three Crosses on the neighbouring hillside. Caravaggio's picture is divorced from any recognisable setting and actually contains an odd mixture of figures. From the Old Testament there is, for example, Samson refreshing himself by drinking from the jawbone of an ass. There are two saints – St Martin, who clothes a naked man by dividing his cloak, and St Roch, who is given shelter by an innkeeper. Perhaps the most surprising allusion is to the Roman Charity, a scene of filial piety from ancient history, in which Pero visits her starving father Cimon in prison and feeds him from her breast – an image which combines visiting the imprisoned with feeding the hungry. Nor are these figures visualised in terms of modern life: they wear either very simple robes or picturesque sixteenth-century costume, which was not at all the dress of Caravaggio's own time. However, the picture does have a very strong and tangible sense of reality, which may result from working directly on to the canvas from posed models in the studio; unlike his contemporaries Caravaggio seems never to have made preparatory drawings. He convinces the spectator that this is a realistic image even though the lighting which falls on to a confusion of limbs is harsh and arbitrary, and the relationship between the figures is deliberately unclear. The same mixture of very tangible figures and very unnatural lighting can be seen in *The Flagellation of Christ* (pl. 251), painted at almost exactly the same time, where light is used to pinpoint details that are either inconsequential, such as the patch of sunburn on Christ's chest (as if observed from a model), or highly significant, as in the way that the cords bite into Christ's arm and his skin is just beginning to bruise, emphasising his suffering in a very physical way.

In the upper zone of *The Seven Acts of Mercy* the Virgin and Child can just be made out, lost in a jumble of flying angels who embrace each other rather intimately. X-rays of this group show that the Virgin was added very late in the execution of the work, probably on the instructions of the confraternity, who refer in church documents to the picture as 'Our Lady of Mercy'. Although she is such an indistinct part of the picture, the Virgin is clearly central to the iconography of the Acts of Mercy, as can be seen by looking back to Barocci's altarpiece, and if Caravaggio had actually excluded her he would have painted an even more unorthodox work than the one that was finally accepted.

Some of Caravaggio's religious paintings were refused, or rapidly replaced, by the people who had commissioned them, but the reasons for this

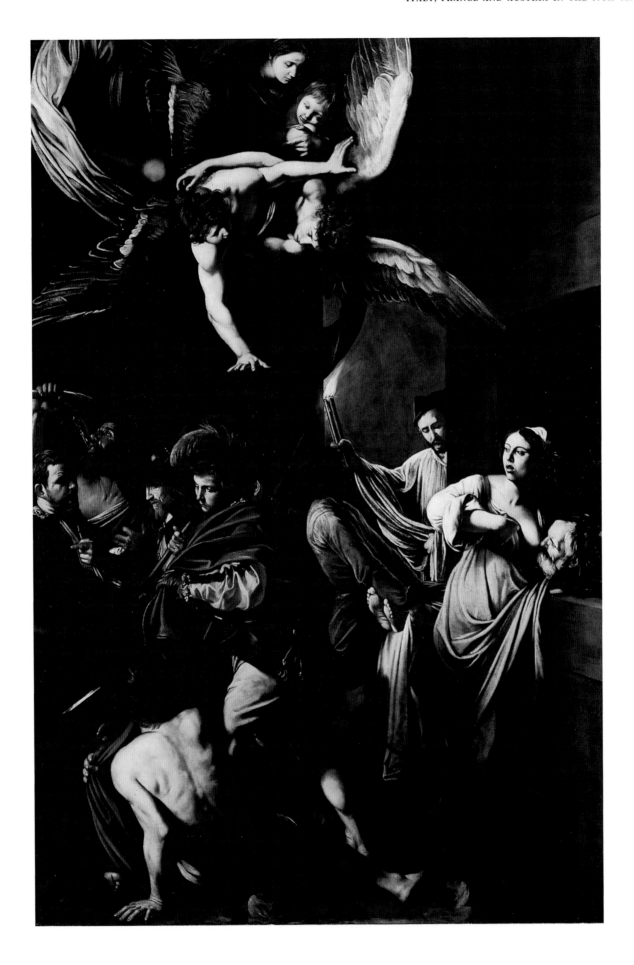

are often unclear, and there were a number of keen collectors who were prepared to make offers that could not be refused for his work. In fact, the confraternity that owned *The Seven Acts of Mercy* resisted pressure from a greedy collector to part with it. Caravaggio had moved to Rome in 1592, but at first he had to struggle for work and was sometimes exploited, in one case by a papal official whom he nicknamed 'Monsignor Insalata'

because he gave the painter nothing but vegetables to eat. After 1599, however, Caravaggio's career gained in momentum and success following his first major commission for a Roman church. Among the works of this time is the *Madonna di Loreto* (pl. 252) where, in contrast to Barocci's *Madonna del Popolo*, the poor and the sick are allowed to see an apparition of the Virgin. Such pictures sometimes provoked criticism,

251.
CARAVAGGIO: The Flagellation of Christ, *1607 or 1610. Museo Nazionale di Capodimonte, Naples.*

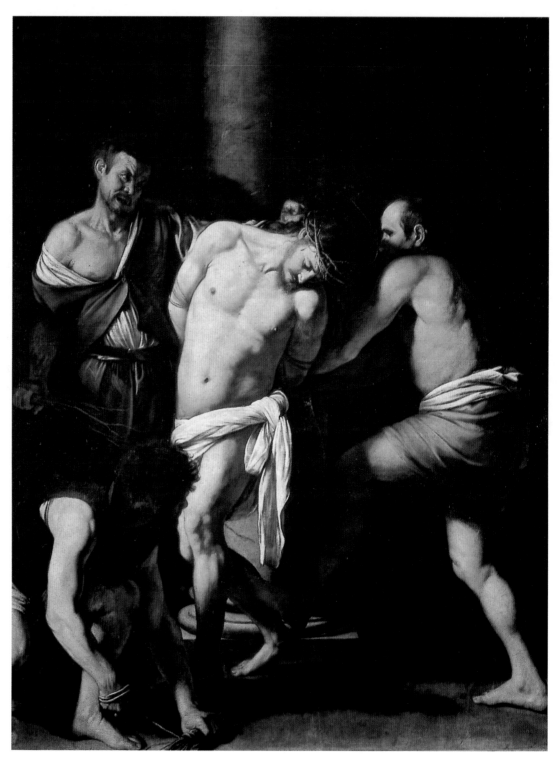

but it is not always easy to tell whether people disliked *how* they were painted, or *what* was painted. In Counter-Reformation Rome there were often problems over religious iconography.

Bellori wrote later that, although Caravaggio 'advanced the art of painting', he 'considered the highest achievement not to be bound by art', and this idea of painting without style is one of the most powerful, and misleading, notions to have become attached to his work. It is misleading because Caravaggio's work is clearly highly artificial, but it is interesting that in order to paint an angel he found it useful to have a pair of wings among his studio props. There has been no real agreement about Caravaggio's importance for seventeenth-century painting, and, while it has been claimed that his use of brilliantly lit figures against a dark background influenced artists throughout Europe (even when they had little opportunity to see his work), it has also been said that, because he had no pupils and discouraged imitators, his influence was short-lived in Italy and did not last much beyond 1620. This can be understood because of the brevity of his career in Rome (he was forced to flee the city after committing a murder), and his early death on a beach at Port' Ercole. 'Caravaggism' became associated with scenes of low life that he had seldom painted, and with the use of an internal light source, which was also rare in his work (the torch in *The Seven Acts of Mercy* is one of the few exceptions). His near-contemporary Annibale Carracci (1560–1609) is reported to have said that Caravaggio 'used a confused light falling from above, while I used a full light falling from the front. The difficulties of art came from these shadows of night, while I, in the clear light of midday, could pursue the most profitable studies.'

ALLUSION AND ILLUSION
Annibale Carracci's ceiling in the Galleria Farnese (pl. 239), painted between 1597 and 1601, and so exactly contemporary with Caravaggio's first altarpieces in Rome, proved to be momentous in quite a different way. The Galleria is a room in the palace of one of the great Roman families, painted for a leading cleric but devoted to celebrating the power of sensual love over the gods and heroes of mythology, who are in fact shown as reduced to a state of near imbecility through its influence. From early on people seem to have been surprised by the frankness and humour of the ceiling, and Bellori misleadingly puts a moral gloss on it as the triumph of heavenly over earthly love. More recently it has often been stated that the ceiling was painted as a celebration of the

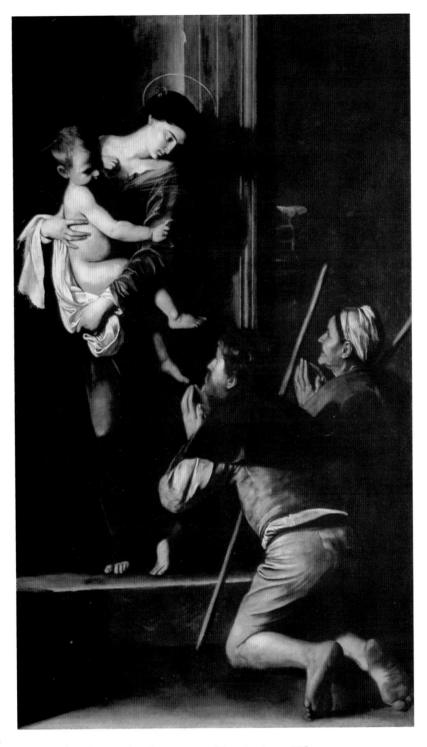

wedding of Ranuccio Farnese to Margherita Aldobrandini, despite the inappropriateness of some of what is going on in the ceiling. In fact, the project appears to have been begun before the marriage was announced in 1598; it was unveiled in 1601 after the event had taken place; and Ranuccio does not seem to have spent much time at the Palazzo Farnese anyway. This modern interpretation is really just another attempt to make the ceiling respectable, and what is impor-

252.
CARAVAGGIO:
Madonna di Loreto,
*1603–05. Cavalletti
Chapel, S. Agostino,
Rome.*

235

ant is that it is a private not a public commission; after all, Aretino's criticism (mentioned above) of Michelangelo's *Last Judgement* was based on where it was to be seen.

The ceiling is also full of references to past art, taking many hints from the original function of the room to display antique sculptures, and in particular from Raphael's even more frankly erotic decorations in the Villa Farnesina, not very far away. Bellori points out, for example, that the figure of Mercury in one of the scenes on the ceiling was adapted by Annibale from Raphael's Mercury in the Farnesina, but Annibale also made many preparatory drawings, and one which survives shows that he did not just imitate Raphael's figure but studied the subject afresh from life, posing the model with a bunch of paintbrushes in his hand rather than Mercury's trumpet (pl. 253). Vincenzo Giustiniani, one of the

253. ANNIBALE CARRACCI: *Study of a male nude for the figure of Mercury in the Galleria Farnese, c.1597. Musée des Beaux-Arts, Besançon.*

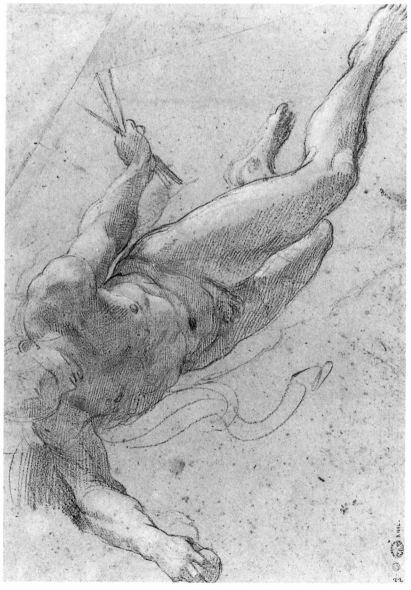

most eager private collectors of Caravaggio's work, said that both Caravaggio and Annibale Carracci combined 'style' (*maniera*) with study from nature, unlike some painters who could manage one but not the other. The idea that Annibale restored Italian painting in this way was a commonplace of the period, and Carlo Maratta (1625–1713) demonstrated it rather handsomely in an allegory of the artist raising up Painting and leading her to a temple where Minerva will wrap him in her mantle, and Apollo crown him with a handy laurel wreath (pl. 257).

Annibale encouraged his pupils to revere Raphael, and when he was ill and depressed two of his students dedicated a set of etchings to him after Raphael's biblical frescoes in the Vatican Loggie, in the hope that it would cheer him up. The fact that Annibale promoted Raphael through his teaching was clearly crucial for the 'reform' of painting. When one of Annibale's most able pupils, Domenichino (1581–1641), painted a chapel in S. Luigi dei Francesi between 1612 and 1615 with scenes from the life of St Cecilia, the fresco on the right-hand wall of *St Cecilia Distributing Alms to the Poor* (pl. 254) not only looked back to an earlier painting by Annibale, but developed ideas from one of Raphael's most famous frescoes, *The Fire in the Borgo* (pl. 255). Domenichino's return to Raphael was understood and appreciated by his contemporaries: apparently the painter Andrea Sacchi (1599–1661) met a fellow artist, Carlo Maratta, in front of the St Cecilia frescoes and said, 'Well, Carlo, what do you think of these paintings? If they were in the Stanze of Raphael, wouldn't they have a beautiful conversation? Some people say they're too studied, but for me that study always seems more and more worthy of praise.'

Raphael's importance for the Carracci School, and particularly Domenichino, is often remarked but is seldom analysed carefully. In the case of the two frescoes just mentioned, the relationship is not an obvious one in terms of the composition, but Domenichino has adapted many of the figures or groups of figures from Raphael's fresco (which tells a quite different story) without actually quoting them in an obvious way. If one compares the two pictures it is apparent that Raphael's woman handing down a child to save it from the fire is turned by Domenichino into the saint giving clothes away to the poor, while the boys climbing the wall below echo Raphael's acrobatic male nude, and the groups of a young man carrying his aged father and a mother scolding her badly behaved children occur in both works. Even the pattern on the pavement in *The*

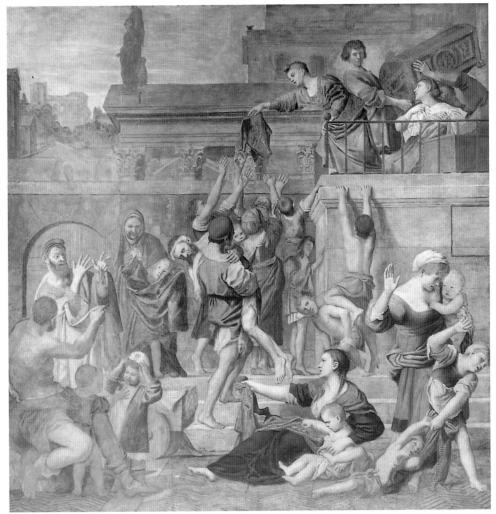

LEFT 254. DOMENICHINO: St Cecilia Distributing Alms to the Poor, *1613–14. Polet Chapel, S. Luigi dei Francesi, Rome.*

BELOW 255. RAPHAEL: The Fire in the Borgo, *c.1515. Stanza dell'Incendio, Vatican, Rome.*

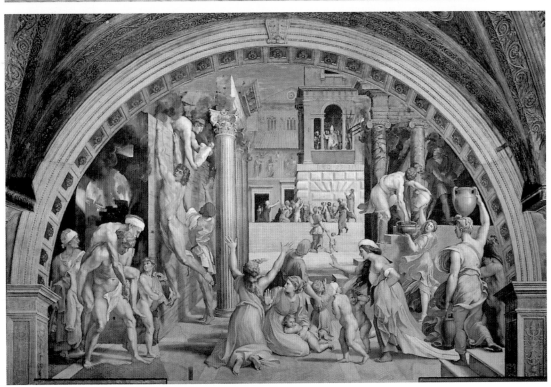

256. GIANLORENZO
BERNINI: Apollo and
Daphne, *1622–5.*
Galleria Borghese, Rome.

Fire in the Borgo is imitated by Domenichino, as a means of creating recession in his picture. The result is that Domenichino imitates the way Raphael tells a story through a variety of figures whose actions and emotions are effectively conveyed to the spectator. In seventeenth-century Italy this concern with emotion was referred to as depicting the *affetti*, and it was for his ability to tell a story through gesture that Domenichino was praised greatly by his biographers and critics. Sometimes when the figures are not self-explanatory these writers help to explain what is going on, and Bellori says that the seated mother with a child in the foreground (another echo from *The Fire in the Borgo*) is offering one of the garments for sale to the rather puzzling man on the left, who has an open purse in his hand, and is holding up his fingers to tell her that he is offering eight denarii for it. One famous anecdote relates how Annibale Carracci went to visit the young Domenichino while he was working on a fresco, and was amazed to find him shouting and gesticulating in front of the picture. Domenichino was in fact putting into literal practice Horace's well-known dictum that to express emotion the artist has first of all to feel it, and Annibale embraced the younger artist, saying, 'Domenico, today I learn from you.'

Domenichino's frescoes in S. Luigi dei Francesi did not go unnoticed among artists in Rome, and when the young Pietro da Cortona set to work on one of his first major commissions there (some scenes from the life of St Bibiana painted in the mid-1620s) he clearly looked at Domenichino's work, but produced frescoes which completely lack Domenichino's ability to suggest that momentous events are unfolding before our eyes. Between 1632 and 1637 Cortona painted the ceiling in the Salone of the Palazzo Barberini (pl. 258), a work which is immensely pleasurable and humane, and extends the brilliant illusionism of Annibale Carracci's ceiling in the Palazzo Farnese, which must have been at the back of Cortona's mind when he began work. Up to this time the Galleria Farnese had had surprisingly little impact on ceiling painting in Rome, and even Annibale's pupils seem to have avoided competing with it, preferring to adopt simpler, more conventional, decorative schemes. Cortona's fresco was painted for a family that had been elevated to great power and wealth following the election of Maffeo Barberini as Urban VIII in 1623, and it is designed as a eulogy to the pontiff. Although, like the Farnese ceiling, it was executed in a private palace, Domenichino (who did not like it at all) commented sarcastically that it seemed more

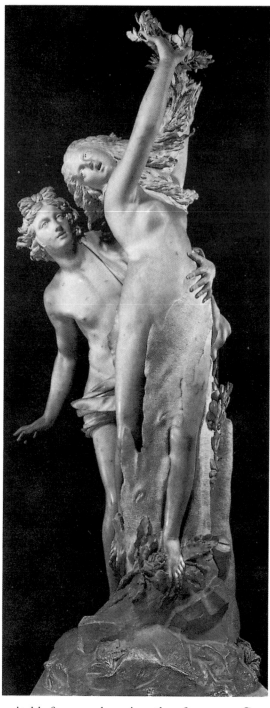

suitable for a secular prince than for a pope. Cortona's illusionism and use of foreshortened figures in this ceiling was also not at all to the taste of Poussin, who said in conversation with an English visitor to Rome in 1650 that it was 'licentious and improper, because we are not accustomed to seeing people in the air'.

There are two sources of information about what the ceiling may mean: a straightforward account by Rosichino of 1640, and a more elaborate one in Girolamo Teti's *Aedes Barberinæ* of 1642, which finds many allusions to the Barberini

family in the fresco. Unfortunately the original programme, which was devised not by Cortona himself but by the grossly eulogistic Francesco Bracciolini, is lost. The fact that he had to follow someone else's ideas does not seem to have been a problem for Cortona, who was an extremely biddable artist with little inclination to do anything he was not told to do. In this he was probably rather exceptional. For example, when he went to Florence to paint a series of rooms in the Palazzo Pitti, he seems to have followed a programme written by the Medici duke's librarian, Francesco Rondinelli, although a programme by him had been rejected as inept a few years earlier by the painter Giovanni da San Giovanni, who had insisted on writing his own.

Eulogistic works such as the Barberini ceiling can be seen as 'open symbols': in this period works of art were often used as a starting-point for an interpretation which might be straightforward or wildly implausible, and could end up being very remote from what the artist or his patron had really intended. At the same time, when the interpretation originated in the lifetime of the artist, and was widely known, it is hard to dissociate it completely from the meaning of the work. Bernini describes how when he was carving the *Apollo and Daphne* (pl. 256) for Cardinal Scipione Borghese, the patron and several other clerics came to see it. One of the visitors suggested that he would have scruples about having such a beautiful young woman in his home. The cardinal replied that he could solve the problem with some verses, and composed an epigram in Latin to the effect that anyone who pursues the delights of love will end up (like Apollo) with only withered leaves in his hands. Bernini added the lines to the grotesque cartouche on the pedestal, but it was not part of his original conception nor was it a common moral for the story.

GATHERING THE MANNA

Earlier we saw that the paintings of Poussin provided one of the links between French and Italian art in this period. There are few instances before Poussin of an artist keeping so much control over both what he painted and how he chose to paint it. Not much is known about Poussin's religious beliefs, although he certainly became fascinated with re-creating the world of the Bible and the history of the early church. He seems to have found religious subjects taxing, and in a typically sharp and laconic letter to a patron who had requested a pendant to a Crucifixion that he had already painted, he wrote, 'The Crucifixion has made me ill, I have taken great pains with it, but

the Carrying of the Cross would end in killing me'. In 1650 he completed *The Ecstasy of St Paul* (pl. 259) for one of his French patrons, Paul Scarron. The work makes no concessions at all to the taste of a man whom Poussin despised, but who was prepared to be both patient and persistent in obtaining work from him. The painting formed the subject of two lectures given to the Académie Royale de Peinture in 1670–1, and one might expect these to provide a reliable guide to its meaning, but they are completely different. In December 1670 the painter Nocret gave a straightforward account of Poussin's treatment of light and colour in the work, without any suggestion that the subject was treated unconventionally, while in January 1671 another artist, Charles Le Brun, offered a most extraordinary interpretation based on the notion that the angels are dressed in symbolic colours and therefore stand for three theological levels of Grace. Le Brun also said that the sword in the foreground could not refer to the saint's martyrdom, because he still has his head on; instead it represents his writings, which smite heretics. The point is logical enough, but ignores the conventions followed by artists in depicting the saint. Le Brun's audience was sceptical, probably recognising that he was following a standard way of interpreting religious images which was widely known through the teaching of the Jesuits. Poussin's picture is in fact conventional in its iconography if not in its form, and it may be this that, perversely, encouraged Le Brun to give it an elaborate exegesis.

This does not mean that Poussin's paintings are either so simple as not to need interpretation, or so obscure as to be beyond sensible analysis. Quite a lot is known about how he thought

257. CARLO MARATTA: An Allegory of Annibale Carracci Raising up Painting, *second half of 17th century. Cabinet des Dessins, Musée du Louvre, Paris.*

PIETRO BERRETTINI DA CORTONA, GLORIFICATION OF THE REIGN OF URBAN VIII

During the 1630s Pietro da Cortona painted this eulogy of the reigning pope, Urban VIII, for the ceiling of a room in his family palace, the Palazzo Barberini, in Rome. It is conceived as an architectural structure made up of an entablature supported by four massive piers, and it breaks from the tradition represented by Annibale Carracci's Galleria Farnese (pl. 239) in not covering the vault with a number of separately framed pictures. Many of the figures on Cortona's ceiling spill out over the framework, and there seems to be a more or less continuous space open behind them. On one level the painting can be admired for the brilliance of its illusionism, but on another level the spectator is clearly meant to understand the meaning of the allegory. The main figures are either well-known characters from mythology or they represent abstract qualities identified by their attributes.

The central section could be compared to an *impresa*. This is a personal device which combines a motto with an image, and learned sixteenth- and seventeenth-century Italians took pleasure in inventing them; it was also usual for a patron's *impresa* or coat-of-arms (*stemma*) to be included in fresco decorations that he had commissioned. The Barberini coat-of-arms is formed by three enormous bees flying in formation and surrounded by a wreath of laurel supported by female personifications of Faith, Hope and Charity, identified by the symbolic colours that they wear. This device is surmounted by the crossed papal keys (originally given to St Peter) which are held by a figure representing Religion, while the female figure of Rome holds the papal tiara aloft. The pope was proud of the verses that he wrote, and a little *putto* leans over the frame holding a laurel wreath to

acclaim him as a poet. The prominent figure below, whose gesture seems a fulcrum for the entire ceiling, represents Divine Providence who directs Immortality to crown the Barberini arms with a luminous diadem of stars, while further down are the figures of Time and the Three Fates. From these details we know that Divine Providence rules both the present and the future. This section of the ceiling alludes to the virtues of Urban VIII through the use of personification, and Cortona is careful not to include any of the gods of mythology who take part in the scenes on the lower part of the vault.

In the four lower scenes created by the architectural frame Cortona combines Classical figures, some of whom are taken from mythology, with personifications, in a way that looks as though a story is being told but is in fact much closer to allegory. For example, one of these scenes is dominated by a central figure of Peace, holding her attribute, the caduceus, which had originally been used by Mercury to part two fighting snakes. She takes advice from Prudence who holds up her own attribute, the mirror, while on the left is the mythological scene of the Forge of Vulcan where the god is hard at work making weapons, assisted by the one-eyed giants, the Cyclops. This clearly refers to the forces of war that the pope should restrain, and when Cortona painted this scene Urban VIII had not yet become embroiled in the disastrous War of Castro (1641–4) with the Farnese duke of Parma. In his book on the ceiling, published in 1642, Girolamo Teti tried to have it both ways, and claimed that the Forge of Vulcan related to Urban's rearming of the papal forces, who were in fact about to scatter, leaving Rome extremely vulnerable. This reading of the picture is typical of the way in which allegories could be astutely adapted by courtiers to changing circumstances.

241

pictures should be 'read' (his own term), and Bellori acknowledged that his method of discussing paintings was based on Poussin's advice that he should provide 'the conception and motivation of each and every figure and the actions which accompany the emotions [*affetti*]'. In two of the artist's letters discussing another picture which was sent to France, *The Israelites Gathering the Manna* (pl. 260), he suggested that it should be looked at in terms of how the figures are fitted to the subject. Some of the Israelites suffer from exhaustion and hunger, while others realise that a miracle is taking place which will save them, and their actions are varied accordingly. The painting formed the basis of an earlier lecture by Le Brun in November 1667, and this not only proved crucial for the definition of the rules of art in the newly founded French Academy, but also is more convincing as an account of the work in question than Le Brun's discussion of *The Ecstasy of St Paul*. Le Brun had known Poussin quite well

in the period shortly after he had painted the *Manna*, and so in this case was probably better informed about the artist's intentions and less inclined to demonstrate his cleverness. He analysed the way in which the bleak setting of the scene enhances the lassitude of the Israelites, and he argued that the figures have to be interpreted as a series of groups, each one of which is thought out in terms of the relationships of the different people to each other and to their predicament. One example is the young woman who compassionately feeds her mother from her breast (in a variation of the Roman Charity) while having to deny this nourishment to her child, and weeps at the dual pressures of duty and piety; the group is completed by a man who steps back in amazement at this scene and helps to focus attention on it.

Despite the authority and thoroughness of Le Brun's account of the picture, members of the audience complained that Poussin had not followed the Bible literally enough: the manna had fallen at night and not during the day, and the Israelites had not been in such extreme distress as Poussin shows. Le Brun's answer to this was that the painter had to be like a historian, but as he could not show the events that preceded the one depicted, he might have to adjust some details in order to suggest the cause of the event. Otherwise it would be as if the historian, instead of relating the whole story, were just to tell its end.

Neither of these two religious works by Poussin, *The Ecstasy of St Paul* and *The Israelites Gathering the Manna*, was commissioned by an ecclesiastic or intended for a church, and in fact Poussin's patrons were of a different kind from those of most of the artists who have been discussed in this chapter: for example, Caravaggio and Barocci were mainly painters of altarpieces, Bernini's career was dominated by large sculptural and architectural projects for the papacy, and Pietro da Cortona, who was an architect as well as a painter, specialised in frescoes for a wide range of patrons. Rome also provided a market for smaller pictures for private collectors all over Europe. The variety of opportunities that was open to artists meant that many different skills were needed, from the devising of Counter-Reformation iconography to the creation of eulogies for princes, or small-scale pictures to be appreciated by intelligent and informed connoisseurs.

The competitive nature of the Italian art world can hardly be overestimated, and its rewards could be worth fighting for. When the rivals Domenichino and Giovanni Lanfranco (1582–

259. NICOLAS POUSSIN: The Ecstasy of St Paul, *1649–50. Musée du Louvre, Paris.*

1647) were both painting frescoes in the Roman church of S. Andrea della Valle in the mid-1620s, Domenichino sawed through the scaffolding in the hope that Lanfranco would fall and break his neck. In turn, when Domenichino went to Naples in the 1630s he found himself up against a vicious cabal of local artists who threatened his life, and mixed ashes in his plaster so that the frescoes he was painting would soon crumble. Not every artist of talent could hope to do well in this active but ruthless market, and Pier Francesco Mola (1612–66) left a wry caricature of himself as an impoverished artist who has dumped his palette and brushes on the ground and, sprouting wings, has ascended on clouds to escape an importunate wine-seller; he turns back only to lift up his coat and suggest his opinion of the whole business, while the irate wine-seller is unaware of a thunderbolt about to strike him from behind (pl. 261). Mola was an artist who had a glimpse of the 'golden apples of papal favour' encountered at the beginning of this chapter, but who never tasted their 'rich rewards'.

ABOVE 260. NICOLAS POUSSIN: The Israelites Gathering the Manna, c.1637–39. Musée du Louvre, Paris.

LEFT 261. PIER FRANCESCO MOLA: The Impoverished Artist, before 1666. The Pierpoint Morgan Library, New York.

10
SPAIN AND THE NETHERLANDS IN THE 17TH CENTURY

IVAN GASKELL

INSET 262. DIEGO DE VELÁZQUEZ: Equestrian Portrait of Baltasar Carlos, c.1635. Museo del Prado, Madrid.

OPPOSITE 263. PETER PAUL RUBENS: Marie de' Medici as the Victor of Jülich, 1622–5. Musée du Louvre, Paris.

On 15 May 1648 the thread of fate into which the fortunes of two nations at the opposite poles of Europe had been spun for over 140 years was finally cut. Representatives of the republic of the United Provinces of the Netherlands and of the Spanish crown swore oaths of ratification of the treaty which brought to an end eighty years of warfare. Spain renounced all claims of sovereignty over the northern Netherlandish provinces, which had fought so long for independence from successive Spanish monarchs. The southern provinces of the Netherlands, though, remained firmly under Spanish control. The treaty merely confirmed the different political and cultural courses already taken by the two halves of the divided Netherlands: the northern Protestant republic and the southern Catholic Spanish dominion. The difference between Spain and its southern Netherlandish provinces, on the one hand, and the United Provinces, on the other, is often presented as being that of haughty royal absolutism and intolerant militant Roman Catholicism versus republican freedom and tolerant Protestantism. There were indeed great differences between these societies and some of these differences are reflected in the art produced within each. However, one is entitled to wonder if it made that much difference to an ordinary working man or woman whether the right to rule and ultimately to dispose of an individual's fate was claimed by a Spanish king or by a clique of wealthy Dutch burghers.

The Dutch painter Gerard ter Borch (1617–81) was present at the ceremony concluding the war between the United Provinces and Spain. It took place in the town hall of Münster and he depicted the scene in a painting on copper (pl. 265). The setting, details of furnishing, decoration and dress in ter Borch's picture all accord with written descriptions. All the leading figures who were present can be identified in the painting. Yet this work also tells us something of Dutch painterly conventions in the portrayal of reality – the quality for which Dutch painters of the seventeenth century are most celebrated – for ter Borch has taken several liberties in his depiction of the scene. In the first place, the participants are arrayed not in their actual positions during the ceremony, but for the convenience of the viewer of the picture, so that the features of the most important might be readily legible. The work, therefore, is an adaptation of one of the most characteristic and artificially contrived of Dutch painting-types, the group portrait. Secondly, ter Borch has conflated events so that the Spanish and the Dutch delegations take the oath together instead of (as they actually did) separately. The politically significant moment is artificially constructed in pictorial terms. When we know this we become aware that even the most realistic picture in seventeenth-century art – whether Dutch, Flemish or Spanish – is an invention, a made object in which convention and the artist's choice play all-important roles.

THE UNITED PROVINCES
1648

GRONINGEN

Emden

Stedum

NORTH SEA

Franeker ● ● Leeuwarden ● Groningen

Midwolde ●

FRIESLAND

● Assen

DRENTE

● Enkhuizen

Alkmaar ● ● Hoorn

Kampen ●

Zwolle ●

Edam ● ZUIDER ZEE

HOLLAND

OVERIJSSEL

Haarlem ● ● Amsterdam

IJsel

Deventer ●

● Weesp

Enschede ●

Katwijk ● Warmond ● Het Loo ●

Scheveningen ● Woubrugge

● Soestdijk

Leiden ● Oudshoorn ●

Zutphen ●

Lochem ●

Huis ten Bosch

Woerden ● UTRECHT

The Hague ● Rijswijk ● Utrecht ● Zeist ●

Renswoude ● GELDERLAND

Honselersdijk ● ● Delft Ijsselstein ●

Gouda ● Amerongen ● Arnhem ● Middachten ●

Lek

Schiedam ● ● Rotterdam Rhenen ● Rhine

Gorinchem ● Nijmegen ●

Dordrecht ● Zaltbommel ●

Waal

Willemstadt ● Klundert ● L. OF S.G.

's-Hertgenbosch Rhine

ZEELAND (Bois le Duc) Maas

Breda ●

Middelburg ● LANDS OF THE

Bergen op Zoom ● STATES GENERAL

Flushing (Vlissingen) ● Eindhoven ●

Antwerp ●

Ghent ● Schelde

Maas

Malines ● (Mechelen)

Cologne ●

Maastricht L. OF S.G.

Brussels ● Louvain ● ●

(Leuven)

Aachen ●

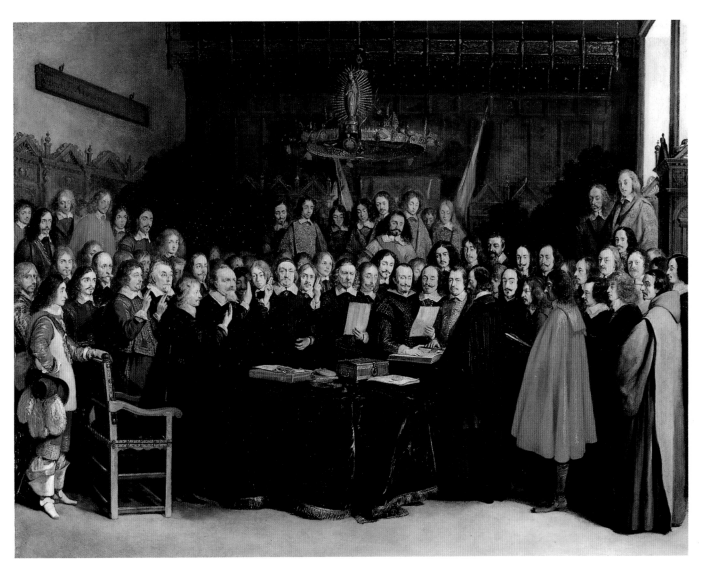

Representatives of the Dutch and Spanish sides had arrived in the Westphalian city of Münster in 1646 to undertake the final negotiations. Ter Borch, too, went to Münster, to paint portraits of the important diplomats gathering in the city. With the aid of a landscape specialist, he painted a sizeable canvas depicting the arrival of Adriaen Pauw (pl. 266). The Dutch delegate is shown with his wife and daughter approaching the city in an elaborate carriage drawn by six horses and accompanied by liveried attendants. This is a record of a display calculated to denote that the senior representative of the States of Holland, although an Amsterdam burgher, travels like a nobleman and so should be accorded a noble's dignity.

One of the great problems for the upper echelons of a new mercantile republic in a continent of monarchies and principalities was the acquisition of international social respectability. One response was to be true to a Calvinist-inspired national mythology of puritanical restraint as the outward sign of the moral superiority conferred by election to the ranks of the saved. According to this view, sobriety and simplicity were the guarantors of national independence and success, whilst the adoption of sumptuous foreign habits, especially in food and dress, was the road to ruin. When strict Calvinist factions gained the ascendancy, sumptuary laws were enacted to limit displays of wealth. In 1656, the year after this occurred in Amsterdam, a large canvas by Govert Flinck (1615–60), *Marcus Curius Dentatus Refusing the Gifts of the Samnite Ambassadors* (pl. 267), was installed in the burgomasters' council chamber in the city's grand new town hall. The consul Dentatus refuses Samnite bribes to betray Rome, preferring constancy and a diet of turnips. Verses by the poet, Joost van den Vondel, engraved beneath the painting, express the sentiment that Dentatus's preference for turnips rather than gold exemplifies the belief that the city was built on temperance and loyalty.

ABOVE 265. GERARD TER BORCH: The Swearing of the Oath of Ratification of the Treaty of Münster, *1648. National Gallery, London.*

OPPOSITE 264. *The United Provinces, 1648.*

247

266. GERARD TER
BORCH and GERRIT
VAN DER HORST (?):
*The Arrival of Adriaen
Pauw at Münster,
c.1646. Westfälisches
Landesmuseum, Münster.*

PRETENSION AND DECORUM

Carefully selected republican Roman consuls were rather more remote role models for Amsterdam's ruling élite than were the indigenous Dutch nobility – the most prominent being the Orange-Nassau family, whose successive heads held high offices of state – and the visiting nobility of Europe, whom they entertained continually. The consequence was a scramble for such appurtenances of nobility as were available. Sovereignty being vested in individual town and provincial assemblies, no authority existed by means of which the longed-for titles of nobility could be created or conferred. Although relatively remote from the real centres of political power, the nobility set an example in the patronage of the arts, establishing fashions which the wealthy commercial oligarchs hastened to emulate, especially the acquisition of country estates and the building of country houses. Other than through a rare grant by a foreign prince, the acquisition of property carrying with it a title of lordship was the only means by which a burgher might gain the titular distinction of nobility.

A fine example of an Amsterdam capitalist emulating the form of grandiose self-presentation associated with the high nobility and royalty of Europe is provided by the large *Equestrian Portrait of Frederik Rihel* (pl. 269) by Rembrandt van Rijn (1606–69). Rihel was a wealthy Alsatian businessman with leading interests in several major Amsterdam-based international trading-ventures, including arms dealing. During the ceremonial welcome of Princess Mary Stuart and her young son William III, prince of Orange, into Amsterdam on 15 June 1660 – soon after her brother Charles had assumed the English throne – Rihel on horseback led one of the militia companies which greeted the distinguished visitors outside the city. He commissioned the portrait to commemorate his role on this occasion, and Rembrandt completed it in 1663, by far the grandest portrait of an individual he ever painted. Rihel executes a *levade*, a dressage exercise designed to display the rider's poise and control and his mount's perfect obedience.

The *levade* was regularly employed as a visual metaphor of the triumph of the royal will in affairs of governance, the most celebrated example having been Titian's *Portrait of Charles V on Horseback* (1548) in the royal collection in Madrid. Philip IV of Spain's leading court painter, Diego de Velázquez (1590–1660), used the device a number of times in royal portraits for Madrid palaces. The principal state room of the new Buen Retiro palace, the Salón Grande or Hall of Realms, was decorated between 1633 and 1635 with a didactic pictorial scheme for which Velázquez provided five large equestrian portraits for the end walls. At one end were the king's parents, Philip III and Margarita of Austria, while at the other a portrait of his son and heir-apparent, Baltasar Carlos (pl. 262), was hung between portraits of Isabella of Bourbon and the king himself. In adopting this form of royal portraiture, dictated by precedent and decorum, Velázquez

could not help but evoke comparison between his treatments and those of both his predecessor of the previous century, Titian, and his most famous older contemporary, the Antwerp artist Peter Paul Rubens (1577–1640). Only about five years previously Velázquez had seen his own earlier *Equestrian Portrait of Philip IV* replaced in the new gallery of the Alcázar palace by Rubens's version of the same subject, painted during his visit to Madrid during the autumn and winter of 1628–9 and known today only from a later copy. The humanist scholar Rubens used Classically derived allegorical figures to elaborate his portrait. The Spaniard met the challenge by eschewing such devices, choosing a pure naturalism in which an ostensible actuality stands alone as a metaphorical representation of princely power and control. Rembrandt took the same course in his portrait of Rihel, though with one significant difference. The royal and princely subjects of Titian's, Rubens's and Velázquez's portraits execute their *levades* with one hand only on the reins, the other holding a lance or baton of military command. Rihel's pretentiousness – and that of Rembrandt on his behalf – did not reach quite such an extreme. There was evidently a limit beyond which they were not prepared to push the boundaries of decorum.

Decorum also dictated that the depiction of men and women in equestrian portraits should be distinct. While a man could properly be shown causing his horse to rear, no woman might. In the portraits of Margarita of Austria and Isabella of Bourbon, Velázquez and his workshop assistants depicted the ladies seated side-saddle, their stationary mounts raising their left forelegs, crooking the foot from the fetlock. In Rubens's painting in his grand series glorifying Marie de' Medici, sometime queen regent of France, she is depicted as the military victor over the Austrians at Jülich (pl. 263). The queen carries a baton and wears the sphinx-crested helmet of Minerva in her role of warrior protectress. She is attended by the Classically derived personifications of Victory, Fame and the defeated Austria offering jewels. Yet, in spite of the deployment of an extensive visual repertory of military glorification – usually a male preserve – her mount performs the exercise associated with female equestrian portraiture rather than the masculine *levade*.

Rubens's series of twenty-one paintings to which *Marie de' Medici as the Victor of Jülich* belongs was, like the scheme incorporating Velázquez's royal equestrian portraits, an exercise in princely glorification. Commissioned in 1622, completed three years later and installed in Marie de' Medi-

ci's palace of the Luxembourg in Paris, the series employs a wide range of Classically derived allegorical imagery to exalt its heroine, the widow of Henry IV. Her subsequent quarrels with her son, Louis XIII, led her to occupy an equivocal political position during the 1620s. This decorative scheme, provided by the most celebrated artist in Europe was an important propoganda exercise – not only in its original form, as a series of paintings, but also as a set of engravings after them. Engravings were also a significant source of income for the artist, and Rubens was consistently concerned to control the reproduction of his works. The contract of 1622 specified that Rubens was to paint with his own hand twenty-four pictures portraying the queen's heroic achievements. Rubens himself produced the painted sketches – small works on panel – but the finished works were produced mainly by his assistants.

267. GOVERT FLINCK: Marcus Curius Dentatus Refusing the Gifts of the Samnite Ambassadors, *1656. Koninklijk Paleis, Amsterdam.*

His position as court painter to the regent-governors of the Spanish Netherlands meant that Rubens was not constrained by the Antwerp guild regulations limiting the number of apprentices and journeymen a master-painter might employ. This enabled him to build up a large, quasi-industrial workshop and to take on an enormous amount of work. Some idea of the volume of work being undertaken at any one time is given by the fact that the queen's commission was not limited to the one gallery to contain twenty-four paintings glorifying her, but provided also for a second gallery, to be devoted in a similar manner to her assassinated husband, Henry IV. For political rather than artistic reasons, this was not completed, though the artist made eleven oil sketches for this second series before work on the project stopped. In the same year Rubens also undertook to produce twelve tapestry designs for a series on the history of the Roman emperor Constantine the Great for the Paris tapestry workshop patronised by the king, Louis XIII. By the following year all the oil sketches had been delivered. In 1625 seven of the

panels had been woven for the king and these were given in that year as a diplomatic gift to the visiting papal legate, Cardinal Francesco Barberini (see pl. 268). Woven in thread of gold and silk, such tapestry remained the most expensive form of interior decoration in the seventeenth century. Many still thought of painted canvases, such as Marie de' Medici commissioned from Rubens, as a cheap substitute.

The intellectual justification for Rubens's procedure was that the artist's invention – the expression of an idea in visual terms – was the work of true value, while the manual execution was essentially a secondary consideration. Painting, according to this new view fostered in Italy during the previous century, was a liberal art rather than an artisanal craft, and as such the equal of poetry. The continuing conflict between these two views of art is a constant theme underlying the theory and practice of painting in Spain and the Netherlands, north and south, during the seventeenth century. This had social ramifications concerning the status of the artist. For Rubens the invention was paramount, whereas

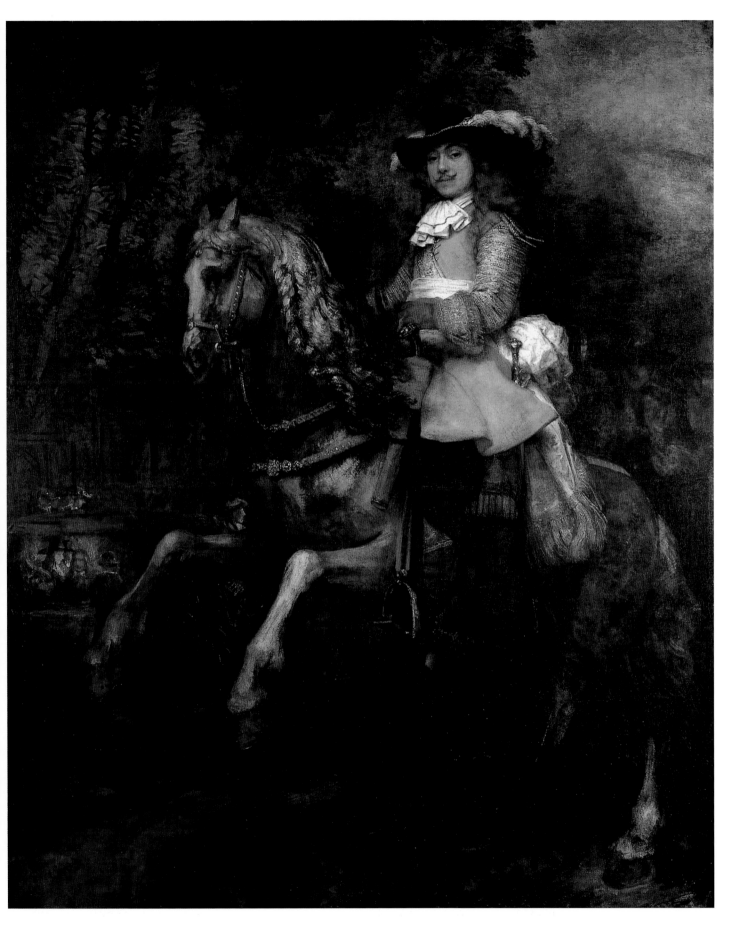

for Marie de' Medici it was vital that the finished works should be 'from his own hand', as specified in the contract. After their delivery and installation in the Luxembourg Palace, Rubens spent nearly four months retouching the paintings, and this must undoubtedly have given the queen and her advisers the impression that he was the sole author. He performed this considerable task between February and May, 1625. However, he did not entirely succeed in avoiding political controversy in the execution of this sensitive commission. When he arrived in February 1625 bringing the last canvases, the painting depicting *The Flight of Marie de' Medici from Paris* when threatened by her son's supporters, was rejected. Rubens was obliged to produce a replacement, and in doing this demonstrated his ability to exploit his considerable Classical learning while working at great speed. He substituted *The Felicity of the Regency*, an elaborate allegorical work in which Marie de' Medici sits enthroned with the attributes of Justice, presiding over a return of the Golden Age to France.

270. SALOMON SAVERY after SIMON DE VLIEGER: Waterborne Entertainments for the Reception of Marie de' Medici in Amsterdam, 1638. *Engraving from C. Barlaeus: 'Midicea Hospes sive Descriptio Publica Gratulationis', Amsterdam, 1638.*

MUNICIPAL PRIDE AND PUBLIC CEREMONIAL

The political differences of Marie de' Medici and Louis XIII were far from over and in 1631 she left France. Seven years later she visited Amsterdam and was accorded a spectacular triumphal reception which included banquets, fireworks, and allegorical *tableaux vivants* and masques performed on floating stages on the Rokin canal. Allegorically conceived civic receptions based on the Classical Roman practice of the triumphal entry of a ruler into a city were common large-scale courtesies all over seventeenth-century Europe, one of several forms of ephemeral project in which artists played a leading role. The various media employed – verse declamation, drama, temporary architecture in the form of decorated triumphal arches – could be combined to express a coherent didactic message. In the case of Marie de' Medici's reception at Amsterdam there were two complementary messages: first, the city, now the richest in Europe, was the equal of any prince; and, secondly, as a

Florentine Medici, the mother of the French king was a member of a dynasty of mercantile capitalists rather than feudal overlords. The event received considerable attention throughout Europe by means of the publication of a lavish book containing the official addresses and illustrative prints etched and engraved by Salomon Savery (c. 1594–1665) after designs by Jan Martsen the Younger (c. 1609–after 1647) and Simon de Vlieger (1600–53; pl. 270).

The visual forms used in Amsterdam for the reception of Marie de' Medici conformed to the same Classical humanist conventions used elsewhere in Europe. For instance, just three years previously, in 1635, Rubens had designed a similar reception for the new governor of the southern Netherlands, Philip IV's younger brother Ferdinand, the cardinal *infante*. Rubens was commissioned by the city government of Antwerp to design the decorated temporary arches, stages and triumphal cars past which the cardinal *infante* and his entourage would process when he arrived in the city. Rubens designed the arches and stages on behalf of the sponsors of the individual displays. These included not only the municipality itself, but also bodies such as the community of Portuguese businessmen and the Antwerp branch of the banking firm of Fugger. The vast task of making the displays was far too great even for Rubens's sizeable establishment, so other master-painters – including Jacob Jordaens (1593–1678) – and their staffs contributed,

with Rubens overseeing the whole project. He executed his sketches in oil on small panels as usual, other painters producing the finished works. The construction of the huge pieces in collaboration with carpenters and sculptors took place in the galleries of the Bourse and the refectory of the Carmelite convent, which the municipality made available. Rubens himself worked on two of the finished pieces: the two wings of the huge triptych 22 m high which formed the centrepiece of the elaborate 'Stage of Welcome', the first of the lavish constructions to be seen by the cardinal *infante* on his route through the city.

This vast scheme was not simply an elaborate form of flattery and display of municipal pride; Rubens gave the whole undertaking a didactic unity. His theme was the decline of the trade and prosperity of the city of Antwerp, which had lost its commercial primacy in the Netherlands to its northern rival, Amsterdam. Rubens's scheme was a plea to the new governor to take steps to revive the city. The eloquence of the design was apparent not only during the occasion itself, but, most importantly, in the lavish publication commissioned by the municipality the following year and published in 1641, in which the entire undertaking was described and illustrated by engravings after Rubens's designs by Theodoor van Thulden (pl. 271). This represented a bid for favourable political attention within the vast Spanish dominions and an enhancement of prestige on the larger international stage. The lan-

271. Arrival of Cardinal Infante Ferdinand at city gate of Antwerp. *Extra engraving included in some copies of C. Gevartius: 'Pompa Introitus . . . Ferdinandi', 1641.*

guage of the event itself and of the publication – Latin – stood for an erudite Classical learning. We may well wonder to what extent the citizens of Antwerp witnessing the event appreciated what they saw, beyond registering the excitement of a grand royal and civic spectacle. The comprehension of the intended meaning of such schemes was the preserve of an educated urban and court élite. As spectacle, however, such events were an effective means of social manipulation.

Seventeenth-century governments attempted to regulate the social patterns of cities in more permanent ways by means of town planning. The imposition of urban discipline, to the advantage of the wealthy commercial bourgeoisie, upon a growing late medieval city can be seen in the building history of Amsterdam. In the fifty-year period before 1640 the population of Amsterdam more than quadrupled, to reach approximately 139,000. In the course of a century, from 1575 to 1675, the area of the city increased sixfold. The expansion of the population may have been haphazard, but that of the city was not. The municipality controlled the form it took, planning the construction of the new concentric ring canals (which give the city centre its present distinctive form) and, of even greater importance, the surrounding fortifications. The opportunities for private gain at public expense were enormous. Powerful patrician families made fortunes through land speculation, buying property pri-

vately which they resold for inflated sums to the city through municipal bodies which they controlled. Poor-quality housing was constructed in the new western areas of the city, landlords charging high rents to desperate families occupying basement rooms which flooded regularly because insufficient wooden piles had been used in preparing the marshy ground.

At the geographical centre of the city was the medieval market square of the Dam. The municipal weigh-house stood within it (pl. 272). On the western side was the old town hall, by the late 1630s a somewhat ramshackle building which the proliferating offices of city government had outgrown. During the decade following 1648 the appearance of the Dam was radically altered (pl. 273). A new town hall was built in an opulently severe Classical style – the grandest public building yet seen in Europe – and the square was considerably enlarged by the demolition of a block of houses on the north-west side to reveal the imposing Nieuwe Kerk (New Church), previously approachable only by alleys. Through the work of the architect Jacob van Campen (1595–1657) and the sculptor Artus Quellien (1609–68) the regents (the governing élite) created not only a monumental edifice proclaiming their own greatness (and that of the city they ruled), but a huge new public arena, flanked by State, Church and Commerce, for the enactment of the rites of civic discipline. From

272. BALTHASAR FLORISZ: *Map of Amsterdam, 1625. Detail of the Dam. Gemeentearchief, Amsterdam.*

the summit of the town hall pediment Quellien's imposing statue *Peace and Public Happiness* surveys the site of public executions and intimidatory military processions below. In Romeyn de Hooghe's (1645–1708) print (pl. 276) the militia companies parade before the town hall in perfect discipline while the ordinary populace look on from the edges of the square. The front of the crowd is patrolled by municipal officials armed with cudgels with which they threaten the onlookers.

The twenty companies of civic guards and the regents in the town hall were the two mutually supportive elements of the city's government. The families who ruled throughout the seventeenth century and beyond had acquired power in 1578 when the Catholic regents were expelled by the civic guard which they had dominated. These citizen militia companies were the guarantors of the regents' dominant political position against the potential threat of the population, and membership was an important step on the ladder of political power. Captaincies and lieutenancies were generally held by rising young members of regent families. The arms practice ranges of the companies included buildings used for meetings and banquets. The new hall of the Musketeers' Civic Guard was decorated during the first half of the 1640s. The hall was hung with seven large group portraits of the governors of the guard and the members of each of six companies of the guard. The most celebrated since the

nineteenth century has been Rembrandt's contribution to the scheme: *Members of the Musketeers' Militia Company of the Second Precinct, Amsterdam* (1642), better known as *The Night Watch* (pl. 274). Though not typical of the genre to which it belongs, subordinating the clear representation of individual members to the conventions of history painting, the work certainly evokes the pride, the concern with rank, hierarchy and prestige, of the privileged citizens who maintained and influenced by implicit threat of force the self-perpetuating, plutocratic oligarchy of the city, which in turn was the most consistently influential power in the United Provinces.

The urban sites for public spectacle and power display in Spain were usually the *plazas mayores*, the major town squares. One of the most important types was the medieval square modified in the sixteenth or seventeenth century by the construction of galleries and balconies to serve as theatres for great secular and devotional events. Similar structures were built by governmental or ecclesiastical authorities in an imposing Classical style for the same purpose. From the point of view of royal status and propaganda, one of the most impressive of these was the Plaza Mayor in Madrid. It was rebuilt by Juan Gómez de Mora (1580–1648) for Philip III between 1617 and 1621 in a severe Classical style. The project included not only the balconied and arcaded buildings enclosing the square itself, but also

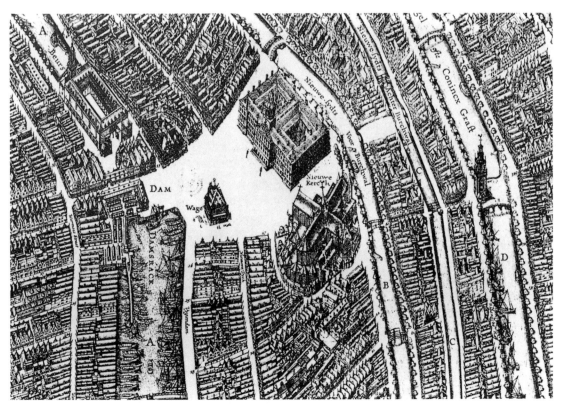

273. BALTHASAR FLORISZ: *Map of Amsterdam, 1658. Detail of the Dam. Gemeentearchief, Amsterdam.*

255

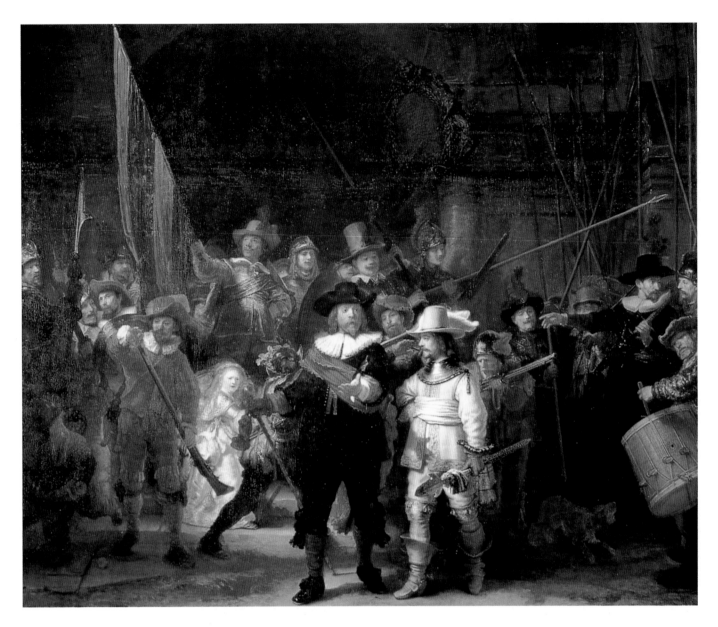

REMBRANDT VAN RIJN, MEMBERS OF THE MUSKETEERS' MILITIA COMPANY OF THE SECOND PRECINCT, AMSTERDAM

The Night Watch (1642) is regarded as the zenith of Rembrandt's achievement as a public painter (*above*). The canvas was originally one of seven works by various painters commissioned in or shortly after 1638 to decorate the assembly hall of the newly built wing of the headquarters of the city's six musketeer militia companies. The officers and those of the 200 or so men in each of the six companies who could afford to contribute were depicted in company group portraits, the seventh painting being of the four governors.

As a direct consequence of each participant having to pay for his own features to appear, all were expected to be equally legible. There was nothing 'democratic' about this, for composition was expected to reflect hierarchy, and once this consideration had been accommodated, a higher sum could secure an individual greater prominence. Although his overall solution appears novel, Rembrandt adhered to a structure defined by social hierarchy and financial means. The most prominent of the sixteen members of the com-

pany are the captain, Frans Banning Cocq (in black in the centre foreground), and his lieutenant, Willem van Ruytenburgh, on his left. The ensign stands at the rear holding the company's banner, while the two sergeants are the main figures on the left and right edges of the composition. We can be sure that the prominent musketeer in red, charging his weapon on the left, paid more for his portrait than did his fellow militiamen whose heads alone appear behind him.

Membership of one of the city's twenty militia companies brought social prestige and a place in Amsterdam's exclusive and rigidly oligarchic power structure. Cocq's advancement was due to his marriage with the daughter and heiress of a former burgomaster and governor of the musketeers' headquarters, the ship owner, Volckert Overlander. On his death in 1630 Cocq acquired the feudal title of 'lord' adhering to a manor Overlander had bought eighteen years previously. In 1632 he was co-opted on to

the council for life. Three years later he became a lieutenant in the militia and before the end of 1640 had advanced to the captaincy commemorated in the present painting. By 1646 he was one of the city's two colonels and in 1650 became one of the four burgomasters – the ultimate authority in the city.

If the Rembrandt is the most prestigious unit of Dutch cultural currency, *The Night Watch* is its highest denomination. That it was cut down in or before 1715, so as to fit between two doors in the town hall where it was transferred in that year, has not significantly devalued it. A reduced copy (*below*), probably by Gerrit Lundens and most likely painted for Cocq only a short time after the original, shows the full composition. The most noticeable loss is on the left where two portrait figures have been cut away. Nonetheless, during the nineteenth century the painting became the focus of national pride. It still serves as a national icon representing the essence of 'Dutchness'.

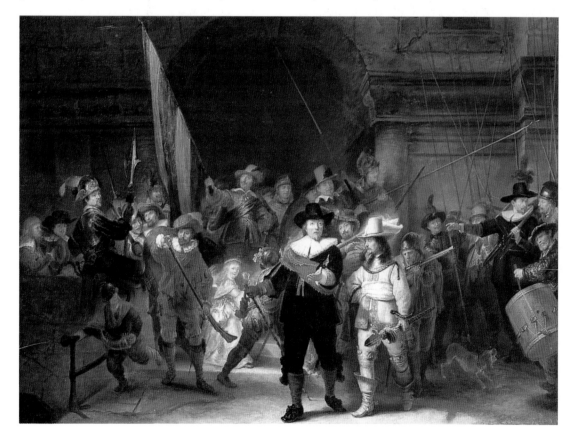

those on some of the streets leading to it. Its form suggested a private space to which the entrances could be easily closed, rather than the open medieval square. The upper storeys of the surrounding buildings were divided into apartments let to tenants, though rights were retained by the court and the municipality to the use of the balconies during spectacles in the square below. The balconies were let or sold separately, or used to entertain official visitors. The king and the royal family occupied the balconies of the central building on the northern side flanked by two spired turrets, the Casa Panadería.

The sights which drew spectators to this grand theatrical urban space were essentially a continuation of a late medieval pattern of spectacle, notably bull fights and tournaments (pl. 277) – a conservative repertory of events. Conservatism was not confined to the nature of the performances; it shaped the pattern of general usage. Unlike the similar and contemporaneous Place Royale in Paris (now the Place des Vosges), the Plaza Mayor in Madrid was regularly used as a market place. This constituted a breach of decorum in the eyes of seventeenth-century French visitors. However, in spite of the failure – as the French would have it – to segregate commerce from aristocracy in the allocation of urban space, the design of the Plaza Mayor ensured that, whatever might

occur in the square, the king when present was the discreetly unrivalled focus of attention. Spanish ceremonial, art and architecture set the person of the king apart from everyone, whether noble or not, rather than differentiating primarily between a monarch and the high nobility on the one hand and the commonalty on the other, as in France prior to the reign of Louis XIV.

Madrid's Plaza Mayor was not only used for secular purposes. Amongst the religious spectacles held there – though infrequently after 1630 – were *autos-da-fé* ('works of faith'): ceremonies of humiliation during which those judged by the Holy Office (the Inquisition) to be recalcitrant heretics were sentenced and handed over to the civil power for execution. The last and biggest *auto-da-fé* to be held in Madrid took place in the Plaza Mayor in 1680 at the behest of Charles II, the last of Spain's Habsburg monarchs. Its royal and religious pageantry was commemorated by one of the king's painters at court, Francisco Rizi (1608–85). The ceremony lasted fourteen hours and claimed 120 victims.

THE INFLUENCE OF THE COUNTER-REFORMATION

The Inquisition, though in decline, was only one aspect of a clerical power in Spain closely sustained by royal and noble patronage. The continuing position of the Roman Catholic Church

276. ROMEYN DE HOOGHE: The Amsterdam Kermis, *1686. Atlas van Stolk, Rotterdam.*

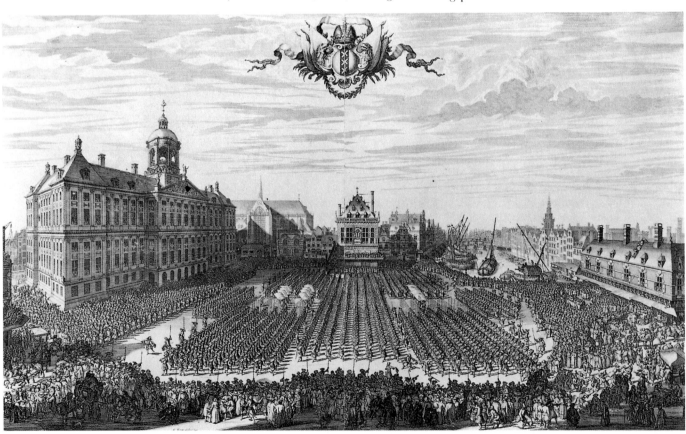

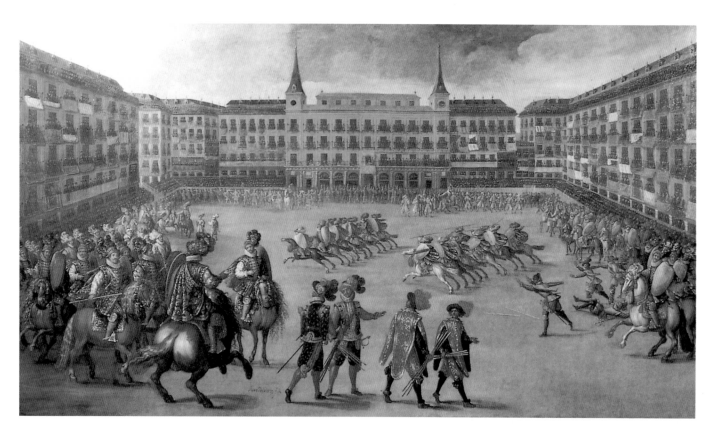

277. JUAN DE LA CORTE: Equestrian Tournament in the Plaza Mayor, Madrid, *1623. Museo Municipal, Madrid.*

in Spain had overwhelming consequences for the practice of the visual arts, not only in Spain itself but also in its dominions, from southern Italy to Central and South America and the Philippines. Churches, monasteries and convents continued to be built and decorated in all these lands throughout the seventeenth century. Ecclesiastical institutions and those who commissioned gifts for them provided by far the greatest amount of work for painters in Spain during this period.

To generalise about Spanish religious sensibility, doctrinal emphasis and their associated visual forms would be misleading, though visitors to Spanish churches built or decorated during these years usually note a taste for elaborate and dramatic ornament often coupled with startling attempts at realism in the depiction of the Passion, the visions and sufferings of the saints. Strong contrasts of light and shade in paintings helped to produce an illusion of reality in darkened interiors selectively lighted by banks of candles. Similarly, life-size polychrome wooden sculptures imitated an imagined reality in order to evoke an intensely anguished piety in worshippers by means of an apparent immediacy. The greatest master of this form of art which appears to create its own sacred reality was the Sevillian sculptor Juan Martínez Montañés (1568–1649). His life-size *Jesus of the Passion* of 1619 (pl. 278) was designed to be carried in procession by the Con-

fraternity of the Passion in the monastery of La Merced, Seville. The visible parts of the figure are carved and coloured in a manner suggesting a heightened emotional realism, while the torso and arms remain rough-hewn. This was because the figure was designed to wear real garments in order to increase the illusion of verisimilitude.

Painters in the service of the church also responded to the new meditational devotion of the later sixteenth century. This was sponsored most notably by the Jesuits, whose founder, Ignatius Loyola, instituted the Spiritual Exercises, a strong feature of Counter-Reformation Spanish religious practice. One consequence was the elaboration of the traditional iconography of the Passion, with new subjects introduced from books of religious meditation. The aim of these works, both textual and visual, was to induce an intensely vivid appreciation of Christ's suffering, elaborating upon the biblical accounts and dwelling on plausible imagined details. This aspect of Spanish art is exemplified by a work painted in 1645 by Antonio Arias (1614–84) for the religious house of the Carboneras in Madrid: *Christ after the Flagellation Recovering His Garments.* This bloody scene of degradation might seem to infringe the boundaries of decorum adhered to in most of Europe, both Catholic and Protestant, in the depiction of God Incarnate; yet it faithfully translates into visual terms a passage from the

Meditaciones of the Toledan mystic Alvarez de Paz.

The Jesuits were foremost amongst those encouraging detailed devotional meditation, but they also co-operated with the Franciscans in promoting the cult of the Immaculate Conception. The notion that the Virgin Mary had been conceived without sin had long been advanced and disputed within the Western Christian tradition and had been opposed consistently by the Dominicans as undermining Christ's role as redeemer of all mankind. So bitter were the public quarrels between the orders that successive popes in 1616 and 1622 forbade discussion of the issue from the pulpit. In Spain, however, its proponents acquired the aid of a number of painters, most notably Francisco Pacheco (1564–1638), Velázquez's teacher and father-in-law.

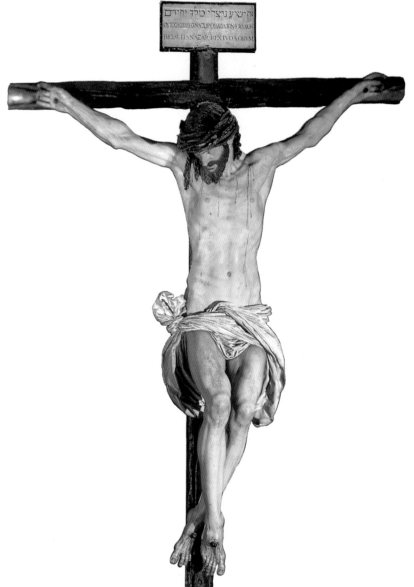

278. JUAN MARTÍNEZ MONTAÑÉS: Jesus of the Passion, *1619. Church of San Salvador, Seville.*

Pacheco not only painted the subject a number of times, but also authoritatively prescribed its complex iconography in his posthumously published treatise *The Art of Painting* (1649), giving a lead to subsequent Spanish painters. Amongst those who excelled in the depiction of this subject, which was further encouraged by a pontifical brief declaring in favour of the devotion in 1661, was Bartolomé Esteban Murillo (1617–82). One of Murillo's most celebrated versions of this subject was painted for the ornate new church of S. María la Blanca in Seville, inaugurated in 1665 (pl. 279). Its companion piece was the same artist's *Triumph of the Eucharist*, in which the Roman doctrine of the Real Presence (another militant Counter-Reformatory subject) is asserted.

The Jesuits were also at the forefront of the Counter-Reformatory movement in the Spanish Netherlands. Their community in Antwerp was re-established in 1585 following the capture of the city from Protestant forces. Their new church was designed to be the most splendid ecclesiastical edifice in the southern Netherlands, a bulwark against the Calvinist heretics a few miles to the north. Building began in 1615 and took six years. Between 1619 and 1620 Rubens and his workshop produced two huge canvases for the high altar: *The Miracles of St Ignatius Loyola* (pl. 280) and *The Miracles of St Francis Xavier* (pl. 281). They were to be exposed alternately: an unusual and extravagant arrangement indicative of the elaboration and expense involved in the project as a whole. The central figures were the sixteenth-century founder and the leading missionary of the young order, and when these huge altarpieces (each 5.6 m high) were commissioned they had not yet been canonised. The programme represents an extraordinarily ambitious and self-assured promotion of their cult by the Antwerp Jesuits. The church, which was gutted by fire in 1718, may have been the largest single ecclesiastical building and furbishment project of its time, yet it was simply symptomatic of a vast campaign of rebuilding and redecoration undertaken in order to repair the damage inflicted by late-sixteenth-century Protestant iconoclasts and to reassert the strength of the Roman Church near its principal war zone with Protestant Europe, represented by the United Provinces. In this task the Rubens workshop was pre-eminent between about 1610 and 1640, the year of the artist's death, but many other southern Netherlandish painters received ecclesiastical commissions, including Anthony van Dyck (1599–1641) and Jacob Jordaens.

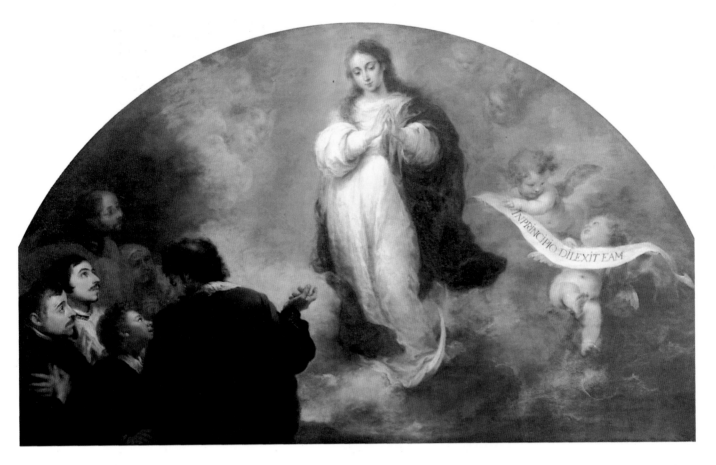

RELIGIOUS AND SECULAR ART IN THE UNITED PROVINCES

North of the border the position regarding religious art was quite different. New churches were built in the United Provinces largely to cope with urban expansion in cities such as Amsterdam, where Hendrick de Keyser (1565–1621) designed the Zuiderkerk (1606–14) and the Westerkerk (begun 1620). The latter was built in a modified late Gothic style using Classical elements. No choir was necessary for the Calvinist services of the Dutch Reformed Church: the pulpit, with its great sounding-board overhead, was the centre of attention in the newly built and re-modelled old churches. The interiors of the older churches were purged of images and altarpieces; altars were removed and walls whitewashed. The Reformation had extremely far-reaching consequences for the practice of the visual arts in the United Provinces. Previously painters, stained-glass makers and sculptures had been largely dependent on the patronage of ecclesiastical institutions; but in the later sixteenth century this major source of employment effectively disappeared and only the painters showed the adaptability to adjust to new social and economic circumstances. Some continued to produce religious works for private use and for charitable institutions, yet increasingly painters turned to secular subjects. In a ruthlessly mercantile capitalist society, they opened up a new market among the commercially successful burghers, exploiting their readiness to spend on domestic decorations which might in turn prove to be sound investments. Portable easel paintings depicting subjects not specifically associated with a particular patron or owner were attractive in themselves as displays of craft skill and could be readily exchanged through the specialist dealers who began to emerge, or sold at auction – another institution which saw its origins in this context. Landscape, townscape, flower arrangements, still-lifes, scenes of domestic labour and relaxation all took on their own dynamic as the growth of a guild-regulated speculative market fostered increasing individual specialisation. Jacob van Ruisdael (1628/9–82) painted virtually nothing but landscapes, Jan Davidsz de Heem (1605/6–83/4) elaborate flower pieces and Emanuel de Witte (1616/18–92) church interiors.

A considerable quantity of Dutch art illustrates moralising proverbs or contains allusions to ethical dilemmas while appearing simply to transcribe daily existence. These meanings might be more or less obvious to contemporary observers, depending on the artist's

279. BARTOLOMÉ ESTEBAN MURILLO: The Immaculate Conception of S. Maria la Blanca, Seville, *1665. Musée du Louvre, Paris.*

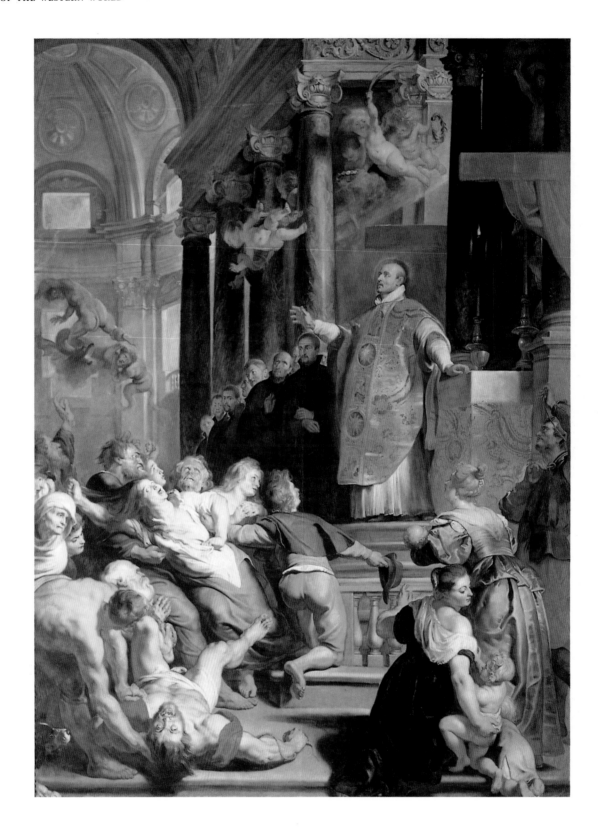

280. PETER PAUL RUBENS: The Miracles of Ignatius Loyola, *1619–20.*
Kunsthistorisches Museum, Vienna.

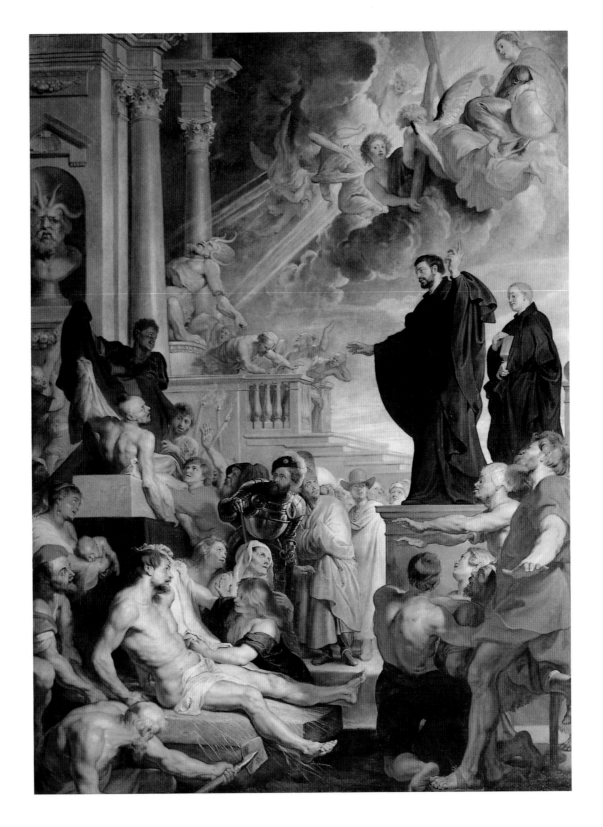

281. PETER PAUL RUBENS: The Miracles of Francis Xavier, *1619–20.*
Kunsthistorisches Museum, Vienna.

RIGHT 282. JAN
VERMEER: Woman
with a Balance,
*c.1662–5. National
Gallery of Art,
Washington DC.*

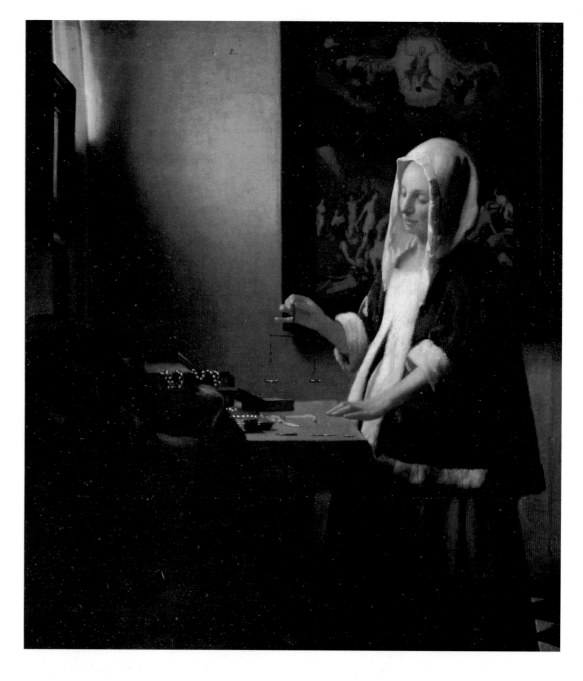

OPPOSITE 283. PIETER
DE HOOCH:
Courtyard of a House
in Delft, *1658. National
Gallery, London.*

chosen mode of representation and the viewer's familiarity with ever-developing visual conventions. For instance, *Woman with a Balance* (pl. 282) by Jan Vermeer (1632–75), has been variously interpreted with reference to contemporary literature and visual material as a reminder of the soul's peril before the temptation of worldly vanities, as an illustration of female virtue or grace, and as an allegory of the divine truth of revealed religion. Allegory might be either thinly disguised, or recondite, or ambiguous; but such scenes were nearly always naturalistically plausible so that delight might be taken in the painter's accurate depiction of observed reality, which was seen as a worthy end in itself.

Pictorial contrivance was not limited to allegorical allusion. Works which appear to be transcriptions of reality often turn out to be inventions, comprising constituents observed by the artist but combined in fanciful compositions. This is how Pieter de Hooch (1629–84) appears to have produced his domestic interiors and courtyard scenes in Delft during the late 1650s. The tablet set above the arch in his *Courtyard of a House in Delft* (1658; pl. 283) is extant, though in a quite different place. It came from the Hieronymusdale Cloister of Delft, and de Hooch also used it in another, differently composed, courtyard scene on loan to the Fitzwilliam Museum, Cambridge. Such paintings are naturalistically

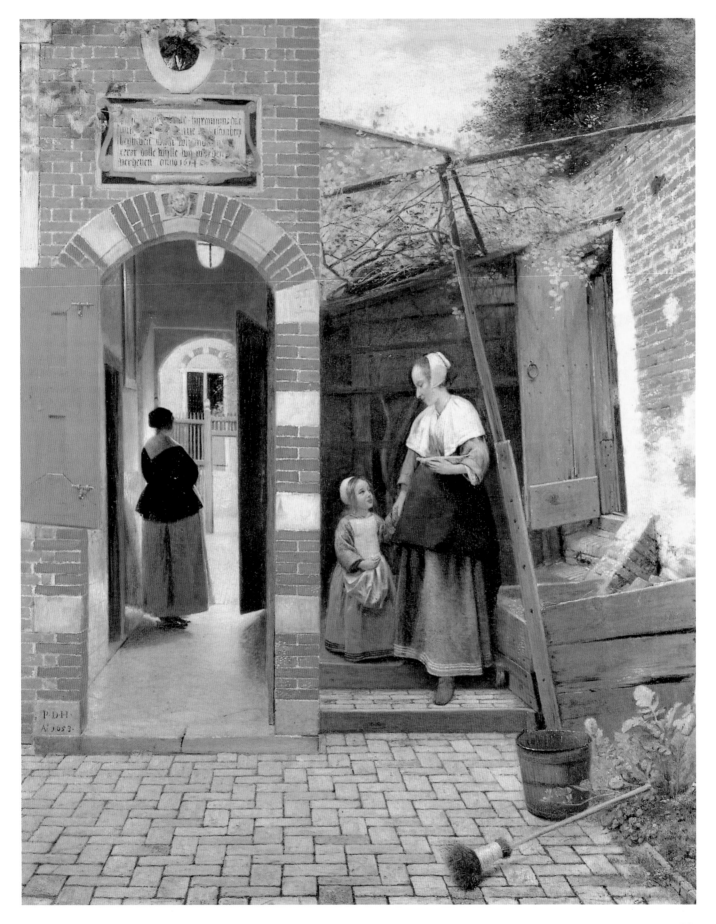

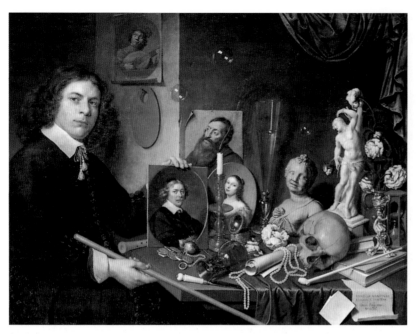

284. DAVID BAILLY: Vanitas with a Young Painter, *1651. Stedelijk Museum de Lakenhal, Leiden.*

IN SEARCH OF STATUS

The struggle for the recognition of the visual arts – that of painting in particular – as fine arts of intellectual invention rather than as manual crafts also transcended national and religious boundaries. Painters in the Netherlands, north and south, and in Spain worked for the most part in late medieval conditions as members of craft guilds, so the social position of a painter was that of a skilled artisan. Some painters reacted against this, appealing to Classical notions of the art of painting and the emergence of the artist painter in Italy. In Seville, for instance, Pacheco was a member of a humanist circle and wrote a treatise on art theory. Subsequently some artists attempted to escape from craft guild associations by forming academies of painters. Murillo and Francisco Herrera the Younger (1612–85) were co-founders of the Seville Academy in 1660.

In the United Provinces artists progressively tried to distance themselves from craftsmen by forming new brotherhoods as alternatives to the guilds. However, existing notions were pervasive for much of the century. When the municipality approved the regulations of a new painters' guild in Leiden in 1642, no distinction was made between fine-art painters and house painters. Upward social mobility for painters as a profession was probably rather more difficult in Spain than it was in the Netherlands. The continuing dominance of the church in the employment of painters helped to preserve existing institutions and attitudes, including a disdain for openly commercial and manual activities on the part of the social élite. In the United Provinces, where the social élite *was* openly commercial, painters might progress up the closely defined social ladder. Often, as in the case of Rembrandt and his pupil Ferdinand Bol (1616–80), social advancement was obtained by means of advantageous marriages. For those painters who succeeded in the ruthless competition for patrons and market share in the United Provinces the rewards in terms of both reputation and wealth might be acceptable, even to the most ambitious. Gerrit Dou (1613–75), for instance, achieved fame, realised high prices internationally for his extremely detailed small panels, invested in property in his home town of Leiden and was said to have turned down the offer of a court appointment by Charles II of England.

Painters who secured a court appointment not only gained in income and prestige, but might also, through undertaking other court business, be able to achieve higher social status than their art alone could win for them. Rubens enjoyed

plausible rather than representationally accurate and are demonstrations of the artist's compositional skills.

The balance between naturalism and symbolism, illustration and allusion was not peculiar to Dutch art. Although still dominated by ecclesiastical patronage and producing a limited amount of domestic secular work, much painting in Spain was constituted in an essentially similar manner. Certain basic themes, or modes of perception, transcended national and even religious frontiers in seventeenth-century Europe. Amongst these was the notion of the transience of human existence and the vanity of worldly endeavours in relation to the life of the soul. For example, the *Vanitas with a Young Painter* (pl. 284) by the Dutchman David Bailly (1584–1657) and the *Allegory of Vanity* (pl. 285), by his younger Spanish contemporary Juan de Valdés Leal (1622–90) share a pictorial language. In spite of the similarity of means, however, the difference of meaning is profound. While the work of Valdés Leal remains firmly rooted in a religious concern for the salvation of the soul, that of Bailly is largely secularised. Indeed, his allegory is as much Classical humanist in inspiration as it is religious in some of its imagery, for it appears to proclaim the triumph of art over life. Bailly appeals to Hippocrates' aphorism 'Life is short but art is long', which was taken by seventeenth-century proponents of the view that painting was a fine art rather than an artisanal craft as a vindication of the lasting power of art and hence of its nobility.

a career as a diplomat, first for Vincenzo Gonza
ga, duke of Mantua (to whom he was court pain
ter from 1600 until 1608), and subsequently fo
the Infanta Isabella, regent-governor of th(
Spanish Netherlands. This came to an end whei
the duke of Aerschot questioned Rubens's socia
suitability for such employment. The fact of his
being a painter – even the acknowledged greatest
painter in Europe, knighted by Charles I of Eng-
land and Philip IV of Spain disqualified him
from further social advancement.

In Spain, Diego de Velázquez sought to ad-
vance himself at the court and in the household of
Philip IV. He became responsible for arranging
royal ceremonial occasions and provisioning the
king's quarters. Most importantly, he acted as
curator of the huge royal painting-collections and
decorator of the royal palaces. Like Rubens, he
craved the status of a knight. Rubens's knight-
hood conferred by Charles I was a diplomatic
gift. Both the active support of Philip IV's aunt,
Rubens's employer the Infanta Isabella, and a
petition from the painter himself in which he
pointed out that Charles V had made Titian a
member of the Order of St James were required
before the title of knight (but not membership of
this prestigious military order) was curtly
granted by the king. Velázquez had to struggle
even harder. During a visit to Italy in 1650 to buy
works of art for the king, he tried to gain the sup-
port of the papal secretary of state for his admis-
sion to one of the Spanish military orders. The
royal nomination was not made until eight years
later. 148 witnesses gave evidence during the
winter of 1658–9 that Velázquez was of noble
origin and had never taken money for his paint-
ings – which, of course, he had. The investigating
council turned down the application and in-
tervention by the king to secure a papal dispensa-
tion was necessary not once, but twice, before
Velázquez was admitted to the Order of St James
in November 1659, just seven months before his
death. The insignia of the order – a red cross
worn on the breast – was added to Velázquez's
self-portrait in *Las Meninas (The Maids of Honour*:
pl. 287). either by his own or by a later hand.

As an examination of *Las Meninas* demon-
strates, painting was the art most amenable to
the expression of reflections on the nature of art
and human perception. This observation could
be applied equally well to many paintings pro-
duced in the United Provinces. However, it was
the character of easel paintings as readily ex-
changeable commodities – as first recognised and
exploited by Dutch artists during the seventeenth
century – which helped promote the cabinet pic-

ture to the point where it became the commer-
cially predominant art form in eighteenth- and
nineteenth-century Europe. Secular and reli-
gious subjects became interchangeable: a matter
of the customer's preference rather than a ques-
tion of faith or dogma. The painters of the United
Provinces effectively spawned an enormous prog-
eny across continental Europe, Britain and
North America, while those of Spain had to await
'rediscovery' by the French in the mid-nineteenth
century. However, the real significance of the
proliferation and dissemination of styles derived
from Dutch prototypes at the beginning of
Europe's age of colonial expansion lies in the
light it casts on the subsequent triumph of the im-
agery of middle-class Protestant secularisation.
This in turn helped create the pictorial world of
apparent realism and extreme contrivance
which, through the commercial channels of
advertising and the mass media, dominates our
visual experience today.

285. JUAN DE
VALDÉS LEAL:
Allegory of Vanity,
*1660. Wadsworth
Atheneum, Hartford,
Connecticut. The Ella
Gallup Sumner and Mary
Catlin Sumner Collection.*

DIEGO DE VELÁZQUEZ, THE INFANTA MARGARITA WITH MEMBERS OF THE ROYAL HOUSEHOLD, INCLUDING THE ARTIST

For generations this painting, (*opposite*) probably finished in 1656, has been known as *Las Meninas*. This title, however, refers to only two of the eleven figures in the painting: the maids of honour (*las meninas*) who attentively flank the central figure. The blonde girl in the silvery dress is the daughter of King Philip IV and Queen Mariana, the Infanta Margarita, who was born in July 1651, and so is about five years old in Velázquez's painting. In spite of her centrality and her near-formal portrait pose, the painting is evidently far from being simply a portrait, either of the infanta or of the group in which she stands.

The room in *Las Meninas* can be precisely identified. It is the gallery of what until his death in 1646 had been the apartment of the Infante Baltasar Carlos in the Alcázar in Madrid, which had been converted for the use of the court painter. According to an inventory, its principal decoration was a series of copies by Velázquez's son-in-law, Juan del Mazo, of some of Rubens's paintings for the king's hunting box, the Torre de la Parada. These are the large works to be seen on the walls in Velázquez's painting.

Velázquez was both painter and courtier. As early as 1629 he was appointed an usher of the privy chamber, a position within the royal household. In the year that he took the oath as *ayuda de cámera* (assistant in the privy chamber) – 1643 – his son-in-law was named painter to the infante, so the copies after Rubens in *Las Meninas* should remind us of Velázquez's place within the structures of power and patronage at court. Nine years later he was appointed *aposentador mayor de palacio*, a senior position in the royal household giving him direct access to the king.

One of the principal themes of *Las Meninas* is the hierarchy of court life and Velázquez's place within it. Easily overlooked is that aspect of the painting which emphasises Velázquez's relationship with members of the royal family, notably his enviable access to the person of the king which is alluded to by means of the much-discussed device of the mirror on the far wall reflecting the likenesses of Philip and Mariana (*detail above*). The irregular perspective structure of the work prevents a geometrical analysis from revealing whether or not the reflection is of the canvas on which the painter works, or the space before the picture plane which we occupy. However, this ambiguity need not impede a resolution of the problem. The painting was inventoried within ten years of its probable completion as being in a room in the Alcázar for the personal use of the king. It was not a public painting; rather an intimate – if large – picture primarily for the king's own use. The conjunction of king and queen in the mirror beneath a curtain of honour further suggests an arranged occasion, such as a portrait sitting (they normally led separate lives in

different parts of the palace). By means of this painting the connoisseur king, Philip IV, could contemplate both the 'theology of painting' (as the Neapolitan painter Luca Giordano described the work to Philip's son, King Charles II) and his formal and informal relations with his wife, his daughter and her immediate retinue, and – most importantly from the artist's point of view – with his *aposentador mayor* and leading court painter, Diego de Velázquez.

Las Meninas can therefore be seen as an intricately constructed piece of subtle pictorial flattery and pretension by an ambitious and proud courtier, who hoped to enhance his prestige yet further by depicting an association between himself and Philip, defined through the medium of art, with the creation of art for the king as his subject.

11
THE AGE OF REASON

ROBIN MIDDLETON

The term Neoclassicism, commonly used to describe the art of the eighteenth century, is misleading. It suggests that the age was characterised by a slavish imitation of Classical art, which was not the case. The art of ancient Rome had served as a basic source of inspiration for artists in Europe from the Renaissance onwards, and in the late eighteenth century the art of Greece was added to this resource. The architecture, sculpture and painting of the eighteenth century, however, were far wider and more complex in range. They were based on a vision of an orderly world, encompassing and absorbing all knowledge. It seemed for a short time that the universe might be fully understood by man, that all phenomena might be explained. Human activity could be precisely calculated and pursued to clearly defined ends, and eventually pure order and certainty would prevail.

The foundations of the scientific revolution had been firmly laid in the seventeenth century. The French philosopher René Descartes (1596–1650) had already formulated the concept of nature as a highly complex machine. He had sought to explain even the existence of God in terms of whole numbers. In England, Isaac Newton (1642–1727) following his example, had formulated the fundamental laws of mechanics which led to the law of gravitation. In 1687 he had published the *Principia Mathematica*, still regarded as one of the most significant works in the history of science.

The whole cosmos could be explained in rational terms. In fact, the period is perhaps more appropriately characterised as the age of reason.

This sense of confidence and firm belief in man's ability to control the world was especially prevalent in France, where the power and spectacular success of Louis XIV had imposed its image on seventeenth-century Europe. His great palace at Versailles (pl. 290) set the tone and style for all popular notions of refined culture and civilised behaviour. Yet the royal palace in Paris held greater portents for the future of architecture than anything at Versailles. The east wing of the Louvre was conceived in the mid-century to contain the king's new apartment, and the façade (pl. 292) was a model for architects for the next century and a half. Comparison with the more established seventeenth-century ideal – the façade, for instance, of François Mansart's (1598–1667) Château de Maisons, just outside Paris – clearly reveals the process of change. The Château de Maisons (pl. 291) is composed of three pavilions, a dominant central one and two outlying ones, arranged in roughly pyramidal form, the surfaces beautifully modelled with columns, pilasters, cornices and other mouldings. At the east front of the Louvre the three pavilions are still there – just – and although the central one still dominates with its low pediment, its emphasis is very much played down. The outline of the building is nearly rectangular, the façade almost flat. The

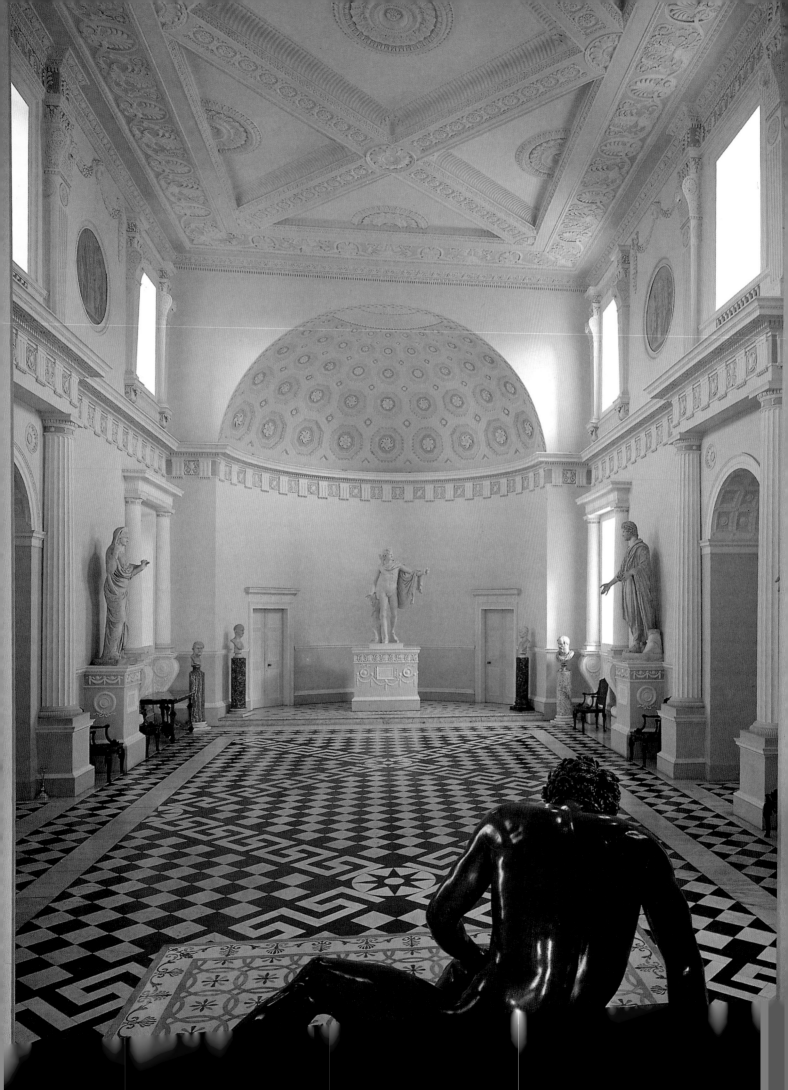

geometry has become far more clear-cut and regular; and, unusually, the focus of the architecture appears to be concentrated not on the pavilions, but on the elements linking them together: the colonnades. Indeed, the façade, which became known as the Colonnade of the Louvre, seems to be made up of free-standing columns – just as in a Greek or Roman temple.

The designer of the façade, generally thought to be Claude Perrault (1613–88) – a doctor and scientist rather than an architect – was reacting against the manner in which columns and related elements of Classical architecture were currently employed (at Maisons and, in particular, on the façades of the courtyard just behind his new wing) virtually as decorative features applied to a surface. In order to purify architecture of such excrescences, Perrault sought the origins of what he considered to be the true style, the architecture of Greece and Rome. The column and the lintel it supported should become the prime elements,

structural rather than decorative.

Perrault achieved this in the Louvre colonnade – where he was using far smaller stones than were available to the Greeks and Romans – by threading a whole armature of iron reinforcement through his columns and lintels (the forerunner of modern reinforced concrete techniques). Thus the advance was both stylistic and technical. As a scientist and a firm believer in progress – even if he referred to the past for authority – he took it for granted that he could improve on the work of his predecessors. Yet in formulating his design, surprisingly, he reverted not only to the Classical past, but also to the national past – the architecture of Gothic France. The coupled columns of the Louvre colonnade hinted, he said, at the clustered columns in the nave of a Gothic cathedral, which, like the Classical temple, embodied an architecture consisting almost entirely of constructional elements reduced, as it were, to a structural scaffold. For Perrault, it was

290. LOUIS LE VAU and JULES HARDOUIN-MANSART: *Palace of Versailles, 1669–85. Aerial view.*

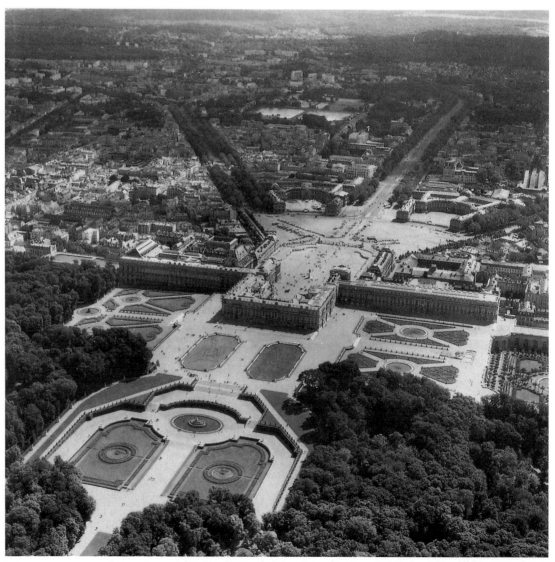

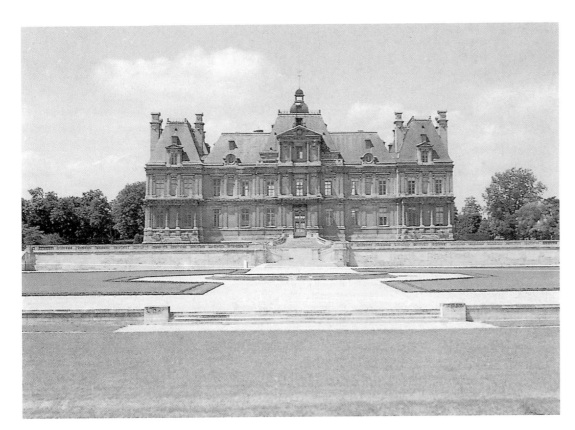

291. FRANÇOIS
MANSART: *Château
de Maisons, near Paris,
1642–6.*

the lucid expression of structure, with none of that uneasy surface modelling, that gave form to architecture.

Perrault's ideas and example were encapsulated almost a hundred years later in a diagram of a primitive hut that served as the frontispiece to the most persuasive of all eighteenth-century architectural treatises, the *Essay on Architecture* (pl. 288), by the Abbé Laugier (1713–69) – once again an amateur, not an architect. Laugier traced back the origins of architectural excellence beyond French Gothic, beyond even the Romans and Greeks, to nature itself. Jean-Jacques Rousseau (1712–78) had already begun to publish his diatribes against the sophistication and degeneration of society, preaching a return to ordinary commonsensical values, to naturalism. Laugier's primitive hut, he said, represented the prime form of architecture, made up of four tree trunks (columns), four logs (lintels) and branches arranged to form a pitched roof (providing a pediment). These were the primary and essential elements in architecture. Everything else, even walls, must be considered as secondary, almost superfluous. Once again, a structural scaffold was offered.

The climax to this pattern of architectural thinking was the building, in the second half of the eighteenth century, of the church of Ste-Geneviève, now known as the Panthéon, in Paris (pl. 293). This was the greatest church to be erected in Europe at the time, the result of a vow made in Metz by Louis XIV's successor, Louis XV, that he would dedicate a church to the patron saint of Paris if he recovered from his present illness. The architect was Jacques-Germain Soufflot (1713–80), who is reported to have said that he wished to erect a Gothic building in the Classical style. The outcome was a kind of inverted temple, with the free-standing columns inside rather than outside (designed suitably for a northern climate). The concern for clear-cut geometry conditions the whole. Soufflot's conception of a simple Greek cross, with rows of columns inside supporting four flat domes over each of the arms, and a grand projecting dome at the crossing, had to be modified in application. Like Perrault's colonnade, the interior architecture seems to consist almost entirely of free-standing columns, with lintels and vaults above, all unnecessary masonry, as far as possible, being cut away. Before the windows in the walls were blocked up at the end of the eighteenth century to make the exterior more bland and bold, shafts of light must have cut through the internal colonnades, creating the lively and dramatic lighting effects of a Gothic cathedral. The Gothic reminiscences are even more obvious outside, where Soufflot introduced flying buttresses to support his vaults.

292. CLAUDE
PERRAULT, LOUIS
LE VAU and
CHARLES LEBRUN:
*East façade of the Louvre,
Paris, 1667–70.*

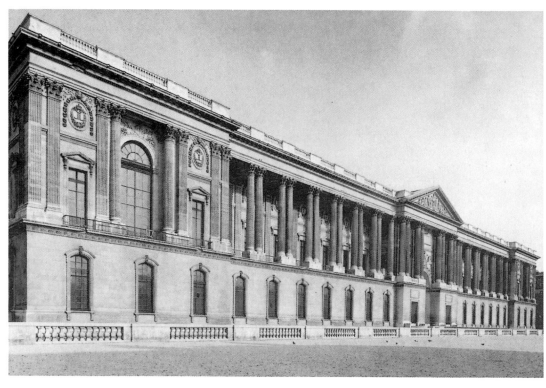

THE REDISCOVERY OF GREECE

The structural elegance that Perrault and Soufflot had sought to combine with a more formal geometry mattered less to the architects of the succeeding generation. For them, weight and mass in architecture were preferable to lightness of form. One reason for this change was the discovery, in the second half of the century, of the architecture of Greece. For it is important to realise that although Perrault and his followers had referred repeatedly to the authority of Greek architecture, virtually nothing was known about it. No architect had sketched or even visited a Greek temple until Soufflot travelled south of Naples in 1750, to Paestum, to draw the three Greek Doric temples there. He was somewhat taken aback by the boldness of the forms, as was Goethe (1749–1832), a few years later. The columns seemed coarse and primitive. The results of Soufflot's inspection were published only in 1764. By then another Frenchman, Julien-David Leroy (1724–1803), had visited Athens and other sites in Greece, and in 1758 had published a great folio volume with seductive views and measured drawings of the architectural remains. Four years later, the Englishmen, James Stuart (1713–88) and Nicholas Revett (1720–1804), who had first conceived of the idea of an expedition to Greece, produced the first volume of their more famous, and also more accurate, *Antiquities of Athens* – a work that was to serve as the basis for the Doric Revival in England at the turn of the century. But whereas this entailed a scrupulous imitation of Greek forms and details, the French were more interested in seeking the spirit of antiquity.

Previous to both these scholarly works, the celebrated Johann Joachim Winckelmann (1717–68) had begun to propagate his ideals of the noble simplicity and calm grandeur of Greek art with the publication in 1755 of his *Reflections on the Painting and Sculpture of the Greeks.* Yet the man who was probably most instrumental in opening European eyes to the spirit of Greek architecture was the perfervid and tempestuous engraver, Giambattista Piranesi (1720–78). Piranesi spent much of his life fiercely opposing all interest in Greek art – he had invested his wife's dowry in the vast copper plates for his views of Rome and had no wish to see tourists travelling instead to Athens. But just before he died, he travelled south to Paestum and prepared a sheaf of eighteen engravings of views of the temples there (pl. 294). The solemn splendour and grandeur of these plates were a revelation to contemporary architects, who thereafter hailed the Doric column as a wondrous sculptural form – its structural role becoming almost irrelevant.

Although the new emphasis was on mass rather than elegance, French architecture of the late eighteenth century abounded in columnar designs. A plan for a royal palace in 1752 won Charles de Wailly (1730–98) the Prix de Rome. The designs of his future associate, Marie-Joseph Peyre (1730–85), another winner of the Grand

Prix, for a group of academies and a cathedral layout done in Rome in the early 1750s, were published only in 1765 in his extraordinarily influential *Works of Architecture*. This included a design of a colonnaded screen for the forecourt of the Prince de Condé's Hôtel (pl. 295). Although it was not built, the arrangement was immediately taken up by Ange-Jacques Gabriel (1698–1782) for the palace at Compiègne, as also by Jacques Gondoin (1737–1818) for the Ecole de Chirurgie, erected in Paris between 1769 and 1775. Moreover, a direct imitation of the Prince de Condé's screen was built by Pierre Rousseau (1751–1829) at the Hôtel de Salm in 1782. Now the Palais de la Légion d'Honneur, alongside the Musée d'Orsay, this was Thomas Jefferson's favourite Parisian building, and its design doubtless accounts for the serried rows of columns of his University of Virginia at Charlottesville.

The relationship of architecture to the landscape was another issue vital to the eighteenth-century theorists and designers. Investigation of this theme may again be initiated at the Louvre. Inside this world-famous museum there is an early copy of a painting by Nicolas Poussin (1593/4–1665) – *The Funeral of Phocian*. The original (pl. 296) was painted in Rome even before Perrault built his colonnade, and it depicts a vision of Athens and the Attic landscape. Neither Poussin nor any of his contemporaries, apart from a few merchants and adventurers, had ever been there.

ABOVE 293. JACQUES-GERMAIN SOUFFLOT: *Ste-Geneviève (now known as the Panthéon), Paris, 1755–92.*

LEFT 294. GIAMBATTISTA PIRANESI: *The Temple of Neptune at Paestum, 1778.*

275

ABOVE 295. MARIE-JOSEPH PEYRE: *Design for entrance screen, Hôtel de Condé, Paris, 1763. Published in his 'Works of Architecture', 1765.*

RIGHT 296. NICOLAS POUSSIN: The Funeral of Phocian, *c. 1648. National Museum of Wales, Cardiff.*

in firm geometrical lines which extended outward from the forms of the architecture to the landscape beyond – evidence of his control of the natural world that extended almost to the horizon. But in the years of his decline, in the early eighteenth century, gardens like Versailles became overgrown, no longer so regularly and viciously trimmed to geometrical formality. This less rigid notion of garden design in France is reflected in the feathery landscapes of Antoine Watteau (1684–1721), greatly influenced by the landscape painters of Holland and Flanders, and in those sketches and watercolours that Jean-Baptiste Oudry (1686–1755) and his friends drew in the overgrown park of the Prince de Guise, at Arceuil, on the edge of Paris.

ALL NATURE IS A GARDEN

It was in England, however, rather than France, that the idea of the picturesque landscape (meaning, literally, a landscape that looks like a picture) was given convincing form and related properly to the geometries of architecture. In this latter sphere, there was already a great model to hand – the work of the sixteenth-century Venetian architect Andrea Palladio.

In England, there was, of course, a court; but it did not dominate society, as in France. The houses of the aristocracy, commanding huge estates which asserted their owners' authority and wealth, were of a number and splendour unparalleled elsewhere in Europe. These estates

But images of this sort seemed so convincing to seventeenth- and eighteenth-century eyes that they were at once accepted as the Classical ideal. Claude Lorrain (1600–82) had conjured up a similar world of Classical calm, bathed in an even more rapturous and glowing light (pl. 298). The Roman *campagna* was no doubt uppermost in both artists' minds, but reality was scarcely a prime concern; they were concerned with a vision of the Classical past which immediately found favour and continued to exert a profound effect.

Louis XIV owned a number of such paintings, and admired them greatly, but never considered taking them as a model for his parks and gardens. His power was to be blazoned forth at Versailles

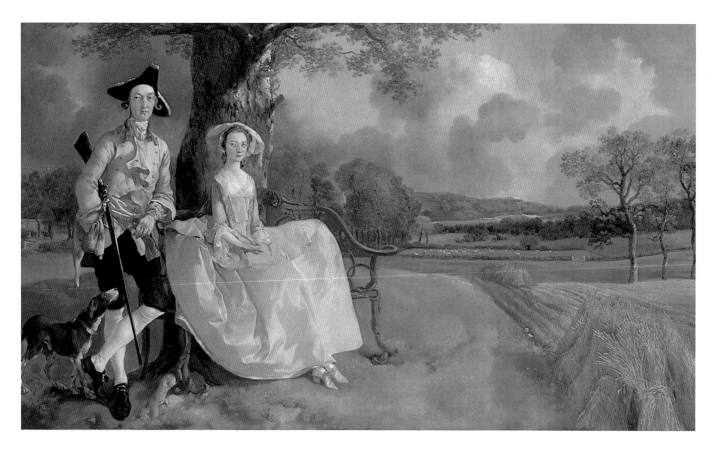

were steadily enlarged by the enclosure of common lands and their productivity was strikingly enhanced by new methods of agriculture and husbandry, generating vast wealth. The focus on country life as a centre of power and privilege was faithfully reflected in the art of eighteenth-century England, not only in the new architecture, but in painting and sculpture as well. It is particularly evident in the landscapes of Thomas Gainsborough (1727–88), which, as the critic John Berger first showed, can be read as images of power and self-esteem (pl. 297); and also in the lucid elegance of George Stubbs's (1724–1806) depictions of countrymen and their pursuits (pl. 299). There is no equivalent in European art to Stubbs's keen, professional understanding of horses and dogs, and this insight was shared intimately by his patrons. Similarly, one may cite the harsh elegance of Arthur Devis's (1711–87) interiors of country houses and their inhabitants (pl. 300) – although these interiors seem a little too spare to be true. The more richly caparisoned conversation pieces of Johann Zoffany (1734/5–1810) are probably a more faithful reflection of the life of the English country house.

The houses that Palladio had designed for the Venetian aristocracy on their estates on the mainland were appropriate models for English country house architecture. These were adopted first by the architect Colen Campbell (1676–1729), who built a variation of Palladio's Villa Rotunda at Mereworth in Kent. But it was Richard Boyle, third Earl of Burlington (1695-1753) who led the new wave of design. He travelled to Italy more than once, and returned with a stack of Palladio's drawings. It was there, too, that he encountered William Kent (1685–1748), struggling to become a painter. Burlington brought him back and transformed him into a successful architect and a great landscape gardener. Kent recognised, as the critic and connoisseur Horace Walpole (1717–97) so concisely remarked, that all nature was a garden. The probable inspiration for Kent in matters of landscape design was the *Liber Veritatis*, a record book made by Claude of his paintings, then in the possession of Burlington's wife's family, a few doors away from his London house. Another rarity that must have influenced Kent's landscape style was a sheaf of engravings, done by a Jesuit missionary, Father Ripa, of the gardens of the emperor of China. These were bought by Burlington himself from Ripa when that intrepid adventurer came to London.

Like Perrault before them, Burlington and Kent were determined to purify architecture, to reduce it to clear-cut geometries, without uneasy

297. THOMAS GAINSBOROUGH: Mr and Mrs Robert Andrews, *c.1749. National Gallery, London.*

OVER 298. CLAUDE LORRAIN: View of Delos with Aeneas, *1672. National Gallery, London.*

277

modelling and messy embellishments. They were unconcerned, however, with any return to origins, whether of a formal antique kind or of a structural nature. They had their model in Palladio – and in his seventeenth-century English follower, Inigo Jones (1573–1652) – and they did not hesitate to adapt or even directly imitate his style, embodying it in the small villa they built for Burlington in 1725 at Chiswick, near London (pl. 305). This was crisp and neat – slightly too neat and none too easily scaled – but with just that degree of variety to provide a series of related rooms of different shape and size, all based on an ancient precedent, that was nonetheless quite coherent in form. At Holkham Hall, dating from the early 1730s, they attempted the whole thing on a much grander scale and with far more success. Lord Leicester's entrance hall (pl. 306), which is both a recollection of one of Palladio's churches and a reconstruction of an antique basilica at Fano, in Italy, is one of the most astonishing rooms of the period in Europe. The sculpture gallery at Holkham, made up of three related spaces, is another *tour de force*. But it is important to add that both externally and internally their method of composition is of the staccato kind – the elements are linked, but remain independent and static.

Kent's attempts at landscaping, however innovative, have much the same quality. In 1738 he laid out a picturesque garden at Rousham, near Oxford, that is made up of a series of small scenes or views – pools, temples or other set pieces – all linked yet each quite separate. There is no sweep of composition to connect them. But in 1741, the

architect Henry Flitcroft (1697–1769), another of Burlington's protégés, and his client, the banker Henry Hoare, combined to create a garden at Stourhead in Wiltshire, in the image of an ideal Classical landscape (pl. 308). Hoare, incidentally, collected the works of Claude, or copies of them; and the garden is as elegiac and dream-like as any of Claude's inventions. The theme is Virgilian, Aeneas's journey through the underworld. But although it is composed of isolated elements – grottoes, temples and statues – there are views back and forth across the lake that form the centrepiece, which serve to unite the composition and to make it an indissoluble whole. The house itself, which had been built in 1722 by Colen Campbell, was kept quite separate from this enchanted realm. When such houses were to be integrated into the landscape, their strong and sharp forms were set in contrast to the flowing landscapes and parks surrounding them, yet they were composed into the overall design much in the manner of Poussin's and Claude's paintings. Later in the century, however, attempts were made to design houses in a picturesque manner too, in some medieval or other exotic style. The outcome of this was the Gothic Revival.

THE GENIUS OF ADAM

As the idea of the picturesque came gradually to dominate English architecture, it took on an even more intriguing turn. The most brilliant architect of the period, Robert Adam (1728–92), describing the way in which he had overturned and replaced the earlier Classicism of Burlington and Kent, wrote:

299. GEORGE STUBBS: Mares and Foals, *1762. Collection of Earl Fitzwilliam, Wentworth Woodhouse.*

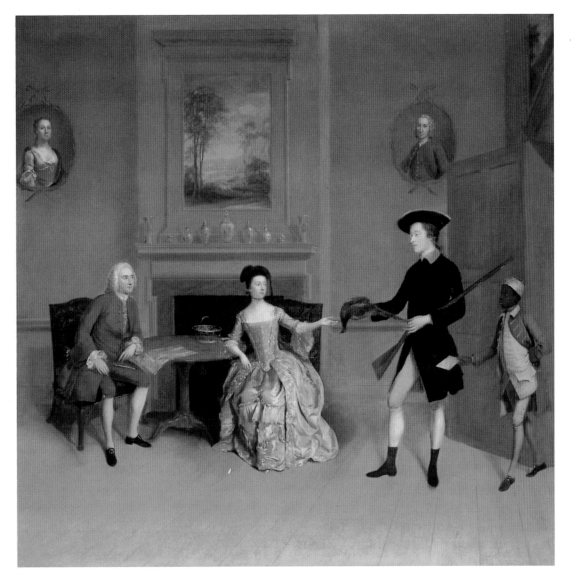

The massive entablature, the ponderous compartment ceiling, the heavy frames ... are now universally exploded.

In their place he had introduced what he called 'movement' in architecture. Here is how he defined it:

Movement is meant to express, the rise and fall, the advance and recess, with other diversity of form, in the different parts of a building, so as to add greatly to the picturesque of the composition. For the rising and falling, advancing and receding, with the convexity and concavity, and other forms of the great parts, have the same effect in architecture, that hill and dale, fore-ground and distance, swelling and sinking have in landscape: that is, they serve to produce an agreeable and diversified contour, that groups and contrasts like a picture, and creates a variety of light and shade, which gives great spirit, beauty and effect to the composition. . . .

The elements of landscape and architecture were now to be composed in one and the same way. But Adam went further, for he was interested in movement through and within architecture. He is often considered as no more than an extremely able decorator – his work, Horace Walpole said, was all filigrane and fanpainting – but he learned to use the decorative devices he deployed so skilfully to articulate both individual and related spaces. He employed such devices to define each area and to lead the observer through from one space to the next, as for example in one of his earliest buildings, Syon House, outside London (pls 289 and 301–304).

This manner of designing interior spaces and

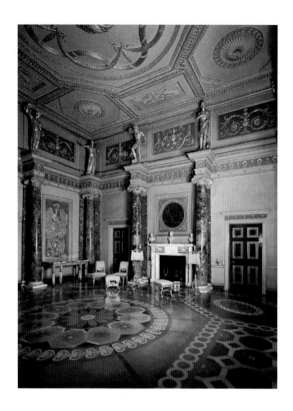

ROBERT ADAM,
SYON HOUSE

Syon House, like so many of Adam's commissions, involved the remodelling of an existing structure rather than the design of a new one. It was a house of some circumstance, the seat of the duke of Northumberland. The building was square, arranged around an open courtyard, with a central entrance in one of the sides. Adam accordingly envisaged two suites of rooms leading off the entrance hall (pl. 289): to the left the private, family apartments, to the right the state apartments for formal receptions and entertainment. The two would be united at the far side of the building by the existing long gallery, where the women strolled in winter and the children played. Adam's first design for the floor of the entrance hall shows a conventional chequerboard of black and white tiles with a border around it. But when work started in 1762 he began to model the space. The level of the entrance floor was lowered and niches were formed at either end. The left-hand niche, which led to the private

rooms, was fully rounded and softened in shape; the one on the right, leading to the state rooms, was geometrically stronger and of far greater architectural elaboration and pretension. It was approached by two small flights of steps, giving an appropriate elevation to the grander rooms. The floor tiles were now boldly and unusually patterned with two giant crosses combining to act as pointers to the left and to the right, indicating the main directions of movement from the hall. This pattern is reflected, even more dynamically, in the mouldings of the ceiling, further reinforcing the directional options. Adam was so proud of his achievement here that he induced his friend Piranesi to engrave the design for his *Works in Architecture*.

The private apartments were never completed, but we can follow the progression that Adam devised through the state apartments, starting with the vestibule (*left*) at the top of those two small flights of steps. This is quite dazzling; a riot of gold and harsh colour, altogether proper for the principal anteroom of one

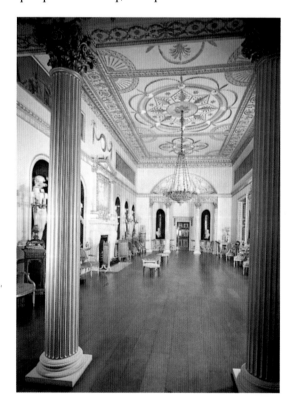

of the first peers of the realm. The columns, said to have been brought from the bed of the Tiber in Rome, are not mere elements of ostentation, but also have a dual architectural role. They regularise the space, making it appear almost a neat cube; and they serve to indicate the direction to be taken as we proceed through the state rooms, setting the line of the new axis which leads into the state dining-room (*left*) – although it is today no longer arranged as such. We encounter first a niche, screened with columns, a space that creates a hiatus, a pause before entering the main central space, thrust forward, as it were, by the mouldings on the dome of the niche. And so on to the drawing-room (*below*), where the materials covering the walls and ceiling are ever richer, yet more closely modelled so that they create a taut network of lines containing and forming this more intimate space. Finally, into the gallery (*right*) – a most unclassical space – where the decoration is applied as a delicate surface pattern, designed not to obtrude, but to give some

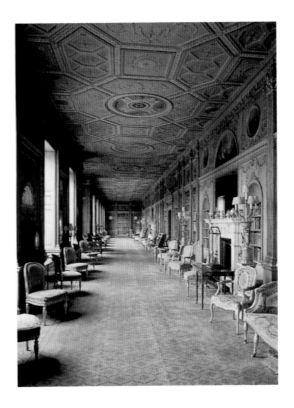

sence of geometrical order to the odd and disparate elements of the old architecture. It all looks perfectly balanced and regular; but that is part of Adam's contrivance. The patterns on the inner wall and the ceiling line up; but those on the window wall only appear to be aligned, for the irregular spacing of the windows that existed before Adam took over make this impossible to achieve. At the end of the gallery is a small circular retreat, a point of rest.

The progressive flattening of the mouldings from the entrance hall through to this last space serves to effect the transition from public display to private intimacy; and this, one assumes, would have been the mood of the private apartments to which the gallery was to have been linked.

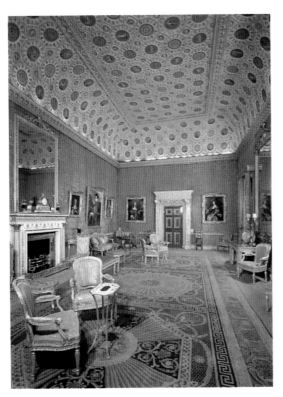

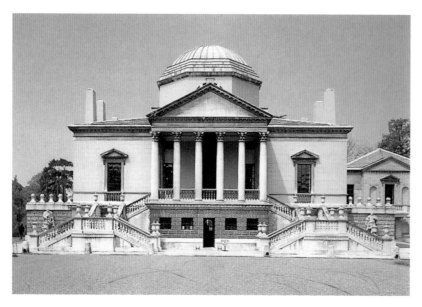

RIGHT 306. WILLIAM
KENT: *Holkham Hall,
Norfolk, 1734. The
entrance hall.*

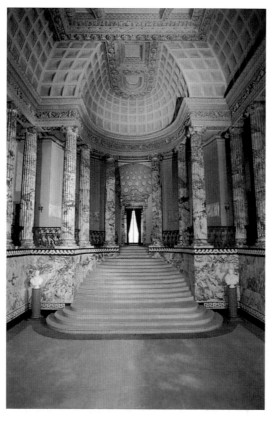

moving one to controlled ends through them can be seen again and again in Adam's work – most conspicuously, for example, in the mouldings and coloured banding of the rooms that make up the sculpture gallery at Newby Hall, dating from 1769–72. In his later works Adam's decorations become ever more flat and filigree, a cat's cradle of lines forming a mesh, a net that appears to contain the space of his rooms. The engraving he offered of the drawing room of Derby House, 26 Grosvenor Square, London (1773) makes his

aims and his means altogether evident (pl. 307). He was an extraordinary architect.

FRIVOLITY AND GEOMETRY

In France, too, the picturesque entered into the realm of architecture, but with different results. The French, although they preferred to think that their ideas of the picturesque emerged from the overgrown gardens of the Regency or directly from the Chinese, in effect borrowed most of their ideas from the English. The so-called *jardin anglais* became fashionable in France, especially in the wake of Rousseau's novel *La Nouvelle Héloïse* (1761) where nature, in its wild form, is used as a symbol of uncontrolled passion and, in its more cultivated, picturesque form, as the proper setting for all fine feeling, especially that of the moral and uplifting kind. In truth, however, the French never really grasped the art of picturesque composition. They preferred a geometrical ordering device. Furthermore, grass was very hard to grow in the French climate.

The picturesque garden served initially in France – and more especially in England – as a field for disposing of the unassimilable. The vast increase in knowledge of the world outside Europe that resulted from extended travel and the opening up of the East and the Americas, proved deeply disturbing. For the evidence indicated that although many societies might be in a savage state (and these were the ones particularly admired by Rousseau) others were highly civilised. The Jesuits in China proved conclusively that Confucianism was older than Christianity, and had a morality, moreover, that could not be faulted. A non-believer might thus be a man of virtue. This was an intolerable conclusion, to Protestant and Catholic alike.

The artefacts of such societies could, at first, be safely contained and even displayed in cabinets of curiosities. But as the coherence of these societies became increasingly evident and obvious – and more of a threat to European notions of morality and civility – they had to be shrugged off as outlandish exotica and trivialised. They became the subject of garden buildings, safely segregated from all serious art and architecture. L. C. de Carmontelle (1717–1806), who designed the pleasure garden of the Duc de Chartres, portions of which survive in the Parc Monceau in Paris, wrote quite candidly of his intent to downgrade the fragments and exotic art forms with which he decorated the garden. It was a realm of illusions, not to be taken seriously.

The delightful Chinese pavilion at Cassan, on the edge of l'Isle-Adam, served likewise to dis-

sipate the threat of Chinese supremacy. Any style, whether the Egyptian or even the Greek itself, when first revealed, could similarly be trivialised. Soufflot's pupil, Ennemond Petitot (1727–1801), designed the costumes for a so-called 'Mascarade à la grecque' for the court of Parma in 1771 that derided all such stylistic alternatives.

One of the only picturesque gardens in France that could claim to equal its English models was that of the Marquis de Girardin, at Ermenonville, north of Paris. He started by composing views from the existing château in the manner of various painters such as Claude, as one might expect, Ruisdael and Hobbema, but he soon added walks and all manner of garden buildings, although none in an exotic style. The chief ornament of the garden was a temple to modern philosophy, a rather coarse imitation of the ruined Roman temple of Sibyl at Tivoli, set overlooking a lake. The temple comprised six standing columns, each one dedicated to one of his heroes – Newton, Descartes, Voltaire, William Penn, Montesquieu and Rousseau. The whole was dedicated to Montaigne, for having said everything. An additional column was left to be dedicated to some new hero; others lay on the ground nearby, awaiting future philosophers. For although the temple might appear to be a ruin and thus an evocation of some past glory, it was not intended to arouse nostalgia, but to be re-

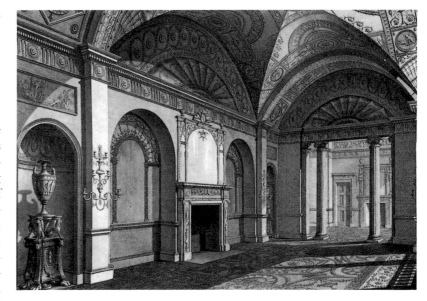

garded as unfinished, a monument to the future. Girardin was a tough-minded progressive.

The hermit in this park was to be none other than Jean-Jacques Rousseau, who did in fact live in a pavilion on the estate for the final six weeks of his life. He was buried in a tomb on the island that had been prepared for him – although his remains were moved to Paris after the Revolution, eventually finding rest in the crypt of the Panthéon, in a tomb designed by the architect Tho-

ABOVE 307. ROBERT ADAM: *View of the third drawing room, Derby House, 26 Grosvenor Square, London, 1773–4. From the 'Works in Architecture of Robert and James Adam', v. 3, 1822.*

LEFT 308. HENRY FLITCROFT: *Stourhead Gardens, Wiltshire. View towards the Pantheon. Completed 1756.*

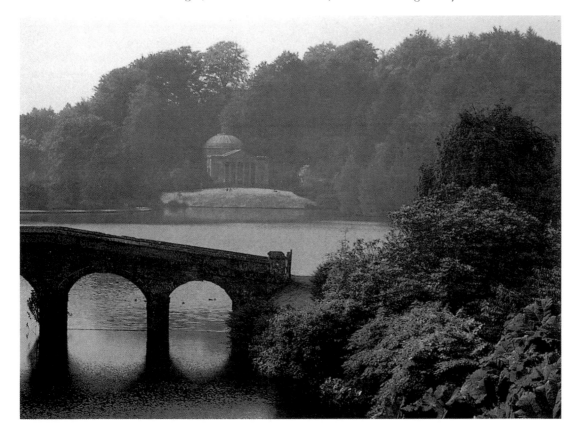

mas Thibault (1757–1826) to look very much like Laugier's primitive hut.

Facing Rousseau's tomb in the Panthéon was that of the wit and satirist Voltaire (1694–1778), another hero of the revolutionaries. Both men, though very different in temperament, had fought for human dignity and freedom. Voltaire had summed up his ideals as early as 1734, in his *Philosophical Letters*, in which he concluded that the purpose of life was not to reach heaven, rather to ensure the happiness of mankind on earth. Rousseau's great contribution to Enlightenment thought, *A Treatise on the Social Contract, or the Principles of Political Law*, appeared first in 1762. He sought to establish the conditions under which men and women might gather together to form societies, yet retain their free will. Freedom remained inherent, he believed, in freely accepted law. The people alone must be sovereign and must exercise their sovereignty through a government which at any time they might dismiss.

The Marquis de Girardin's landscape architect, Jean-Marie Morel (1728–1810), who had also worked at Cassan, quarrelled furiously with his employer and left. In his view there were too many frivolous garden buildings at Ermenonville; such structures should be useful, not decorative or associational. Landscape gardening had become a deeply serious form of art, with elements of nature – still or fast-flowing water, earth, grass, shrubs and trees – as its sole components. Moreover, the effect of the four seasons, of changing light and colour, had to be calculated.

Architects, too, were considering the possibility of abandoning the entire panoply of elements that had made up the various styles of architecture, including even the hallowed Classical examples of Greece and Rome. Julien-David Leroy wrote a small pamphlet six years after the publication of his famous book on the buildings of ancient Greece, in which he suggested that the effect of moving through a great Classical portico or alongside a line of columns might be achieved equally well with groves of trees. He was concerned only with the sensations aroused by the forms, not with any pedantic notions of architectural purity or archaeological exactitude.

Such ideas may seem extraordinary in an age that is so often categorised as Neoclassical. But there is increasing evidence that towards the end of the century architects were abandoning their old loyalties and preoccupations. They were no longer greatly interested in archaeological correctitude nor in the insistent rationalism that had characterised so much architectural thought from the late seventeenth century onwards. They

felt that architecture, in the process of being analysed, had lost something of its mystery, and they wanted to recover it. The theorist Lecamus de Mézières (1721–89), taking his cue from picturesque gardeners, was concerned to find the means of evoking moods in architecture through the control of light to arouse calculated sensations. One of the greatest architects of the period, Etienne-Louis Boullée (1728–99), modelled his theories directly on the ideas of Morel; he composed his forms with a mind to their effect during the different seasons and different times of the day, in varying conditions of light and shade, in sunlight and in moonlight, and even in relation to the spectator's moods. Unlike Morel, however, Boullée despised irregularity in all things. His ideal was symmetry. He built up his designs with spheres, cylinders, cubes, rectangles and pyramids, all regularly arranged. The sphere, in particular, represented the very image of order; yet it was also suggestive of infinite variety. With a bright light projected against one side of a sphere, the other side in complete darkness, one was presented with an unlimited variety of shades, from white to black. Boullée thus subverted completely the language of the picturesque theorists – to them variety meant something very different. It is hard, without reading his surviving notes, to relate his great composition for museums, palaces of justice, libraries and even a tomb to Newton (pl. 309), to the ideals of Morel and other such enthusiasts of landscape design. Yet Boullée's stark geometrical compositions would seem to belong to the picturesque.

Boullée built very little. Aiming at the sublime, he preferred the drawing board to the building site. Yet his contemporary, Claude-Nicolas Ledoux (1736–1806), broke through the barriers of Classical correctitude with equal force and created a whole series of outlandish, altogether original and compelling compositions – first in the salt-works that he designed at Arc et Senans, in the Franche-Comté, to be surrounded, in his imagination, by an ideal city, and a few years later, just before the Revolution, in the string of customs' houses or *barrières* that he erected around Paris. A handful of these extraordinary works survive, as do Ledoux's designs for his visionary utopia: grandiose architecture for everyone, whether workers or kings. It is debatable, however, whether it was any deep sense of humanity that conditioned Ledoux's architectural concerns and flights of fancy, or merely a self-centred desire to build at all costs. In any event, together with Boullée, he has been labelled a revolutionary architect.

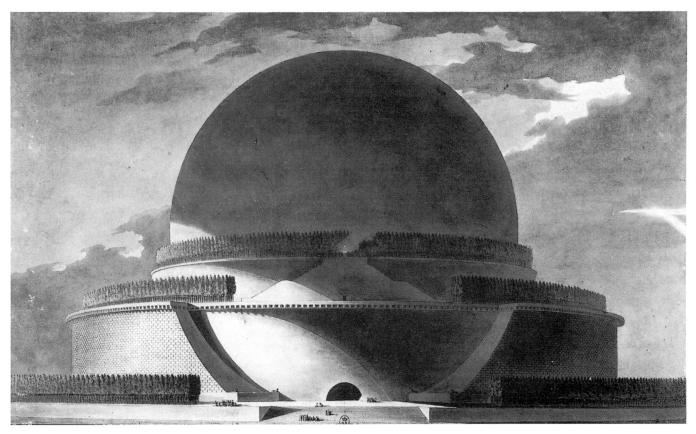

THE NEW MORALITY

In the field of painting, too, the revolutionary note was struck some years before the Revolution itself and was not necessarily a reflection of the ideals, social or otherwise, that are associated with that cataclysmic event. Indeed, the *Oath of the Horatii* (pl. 312), painted by Jacques-Louis David (1748–1825) in Rome in 1784, and exhibited at the Salon in Paris in 1785 – regarded then and to this day as the most daring and uncompromising expression of the new moral fervour – was commissioned for the crown by the Comte d'Angiviller, Surintendant des Bâtiments du Roi. When D'Angiviller came to power in 1774, at the beginning of Louis XVI's reign, he determined to promote the genre of history painting, and David's great masterpiece, which proclaimed patriotism above the entanglements of family feeling and emotion, was no more than one aspect of that programme – a programme which had been furthered consistently from the seventeenth century onwards, but never before in so firm and forthright a manner. D'Angiviller raised the price of history paintings, which had long been the most richly recompensed, to a new peak. Many painters with other talents complained vigorously, but to no avail. History painting was the most favoured genre throughout the century, although today the works of masters such as Carle van Loo (1705-65) or Nicolas Brenet (1728-1792) command little attention.

Our vision of eighteenth-century France is coloured still by that artful compilation, *The Art of the Eighteenth Century*, a collection of articles written over a period of twenty years by the brothers Edmond and Jules de Goncourt, first published in 1875 and since reissued many times. Almost half the artists to whom they directed attention were engravers and illustrators. The painters they especially commended were Watteau, Boucher and Fragonard – names we associate today with the sophisticated, insouciant art of the Rococo – an art of twists and turns and counterturns, a style of the waning Baroque, that was confined for the most part to interiors.

The image of the eighteenth century that the Goncourts contrived was one of easy, light-hearted dalliance and pleasure, an era untroubled by the realities of life, by moral concerns or doubts. The art of Antoine Watteau was, in fact, rooted in the rough and tumble of the fairground and the bawdy humour of travelling players, themes that he toyed with to add a certain piquancy to the lives of his wealthy pleasure-seeking patrons, who were usually depicted in sylvan settings re-enacting the romances and love-play of the theatre (pl. 314). There was hardly a hint of real life in the works of Jean-

309. ETIENNE-LOUIS BOULLÉE: Design for Monument to Isaac Newton, *1784. Bibliothèque Nationale, Paris.*

JACQUES-LOUIS DAVID, OATH OF THE HORATII

David's *Oath of the Horatii* of 1784 (*opposite, main picture and sketch*), proclaiming patriotism above the entanglements of human feeling, is the most uncompromising expression of the new moral fervour in eighteenth-century art.

The story of the Horatii concerns three brothers who are chosen to fight as the representatives of Rome against three Curiatii, from the city of Alba. One of the Horatii is married to a sister of the Curiatii, and the Horatii's only sister is betrothed to one of the Curiatii. All but one of the Horatii are killed in the battle and when he returns home to find his sister grieving her betrothed, he kills her in patriotic fervour.

The story is recounted by Livy, by Dionysus of Halicarnassus and in a French translation of an English edition of Plutarch's *Lives* published in 1778. It was also the subject of a ballet by Noverre, first performed in Paris in 1777, and of a play, *Horace*, by Corneille. But in none of these sources does the incident depicted by David of the three Horatii swearing an oath to their father occur.

David decided first that he would illustrate the incident when Horatius was defended by his father for killing his sister, Camilla, and acquitted by the people. He

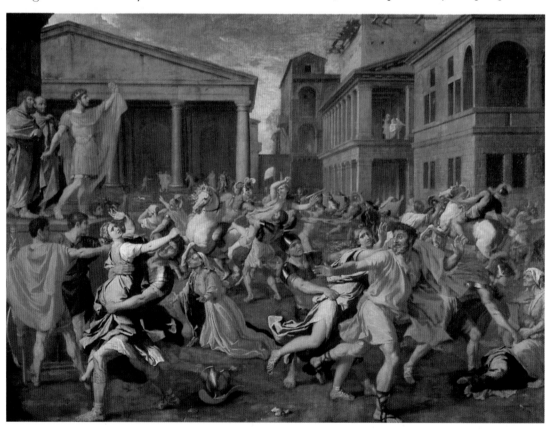

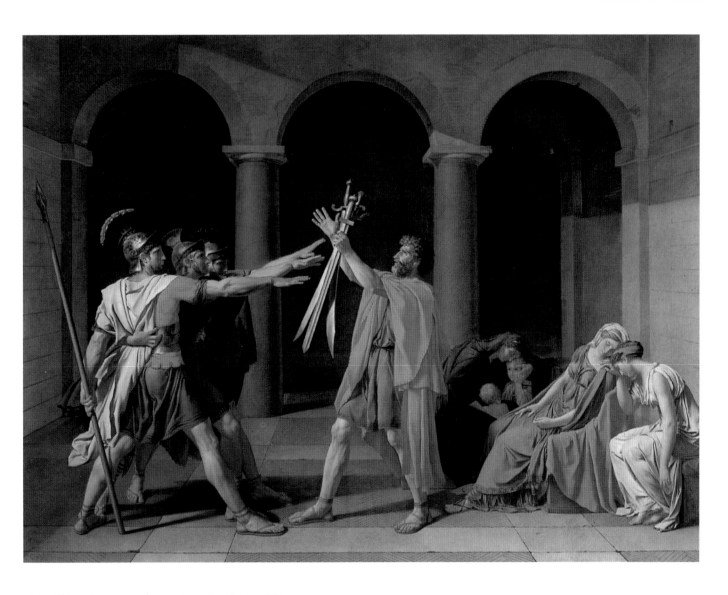

also did a drawing (*opposite, above*) in 1781 of Horatius posing, sword in the air, above the dead body of Camilla. This was an essentially theatrical interpretation. When he saw Corneille's play in 1782 he was greatly moved and thought to represent an incident in the last act, but his friends warned him that whereas tragedy depended on words, not so painting. David then determined on the swearing of the oath. Soon afterwards he viewed Poussin's *Rape of the Sabine Women* (*left*), and was so struck by the posture of the lictor on the extreme left that the whole composition of his future painting started at once to take on its final form and he created one of the most striking icons of eighteenth-century Classicism.

289

Honoré Fragonard (1732–1806), and still less in those of François Boucher (1703–70), who epitomise the popular vision of eighteenth-century artificiality. That vision is, of course, entirely partial and it played little part in the evolution of art in the second half of the century, which was much more serious and thoughtful. This was recognised even by the Goncourts, who discussed, too, the work of Jean-Baptiste-Siméon Chardin (1699–1779). He was responsible mainly for simple still-lifes and interior scenes with no more than one or two figures, all somewhat laboriously painted, but of an intensity and a surprising concern for the surface texture of the paint itself that makes him one of the most memorable artists of the century. They were alert also to the talents of Jean-Baptiste Greuze (1725–1805), the most acclaimed painter of down-to-earth, petit-bourgeois, if somewhat sentimentalised scenes.

The new moral note was struck, appropriately, in 1750, by Jean-Jacques Rousseau, in his prize-winning essay for the Académie at Dijon: *On Whether the Renewal of the Sciences and the Arts has Helped to Improve Morals*. Rousseau was in no doubt that civilisation had served to corrupt and degenerate the natural instincts and modes of conduct of man. Artistic expression was largely concerned with trivialities and hedonistic display. Greuze, an irascible, difficult character, of lowly provincial birth and irregular training, provided a response to Rousseau's critique. His

works, inspired in part by Dutch genre painting, illustrated incidents and events in the lives of the less favoured classes of society (though they were usually sufficiently well-off to have servants), people who are shown to be caring and honest, with a nobility of their own. Greuze's triumph came in 1761 with *The Village Bride* (pl. 315) – a painting that was commissioned by Madame de Pompadour's brother, the Marquis de Marigny, D'Angiviller's predecessor as Surintendant des Bâtiments du Roi. This was followed in 1763 by the equally celebrated *Filial Piety*. But Greuze's acclaim, which was both critical and genuinely popular, did not survive long. There was a degree of sentiment in his depictions that seemed slightly dishonest, however appealing, and there was also a rather old-fashioned quality. This was hinted at by the philosopher Denis Diderot (1713–84), a fervent supporter of Greuze, writing in his Salon review of 1761 of *The Village Bride*:

Its composition seemed to me extremely fine: this is the event just as it must have happened. There are twelve figures; each one is in its place and does what it should. How they are all inter-related! What a flow and what a pyramid they make! I usually make fun of such devices; but when they appear by chance in a painting without the painter having contrived to introduce them, without having sacrificed anything to them, then they please me.

314. ANTOINE WATTEAU: Pilgrimage on the Island of Cythera, *1717. Musée du Louvre, Paris.*

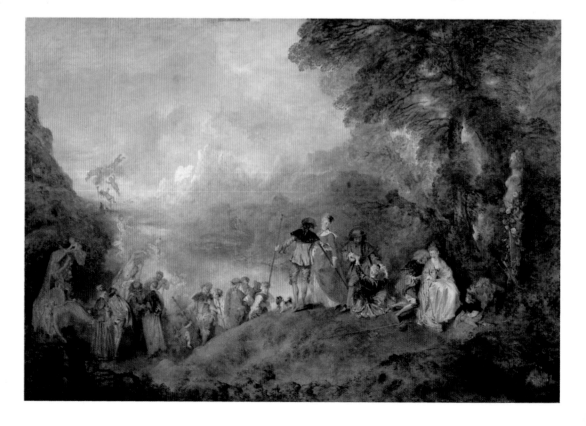

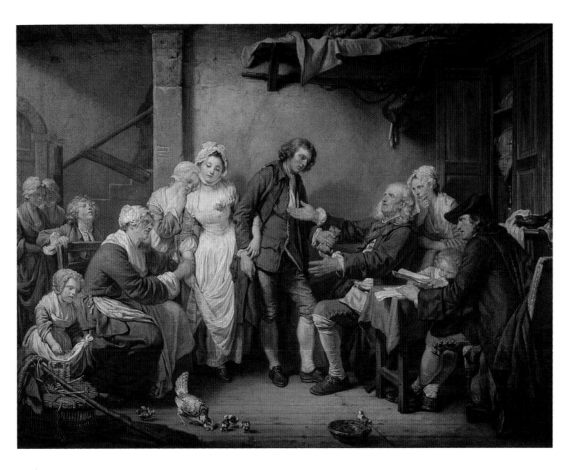

315. JEAN-BAPTISTE
GREUZE: The Village
Bride, *1761. Musée du
Louvre, Paris.*

There was a fatal element of compromise in the work of Greuze. The new hard-liners were to give force to moral concerns of a more exalted, civic kind, with a more fittingly elevated style based on Classical concepts of nobility and ardour. The classicising theme was first introduced by Joseph-Marie Vien (1716–1809) in the Salon of 1763, when he exhibited two paintings, a *Greek Woman at her Bath* and *The Seller of Cupids*, which have some of the eroticism and sexual suggestiveness of Watteau's *fêtes galantes*, but are interpreted in a chastened and somewhat effete Classical form, in direct imitation of the mural painting of Pompeii. Innovations of a similar kind had been made a few years earlier, in 1761, in Rome, by a German painter, Anton Raphael Mengs (1728–79), a close friend of Winckelmann, who was responsible for the ceiling of the main salon of the Villa Albani, depicting Parnassus. The Scots painter Gavin Hamilton (1723–98) also took up a range of Homeric and Roman subjects such as *The Oath of Brutus to Avenge the Death of Lucretia*, of 1763 and 1764, that were profoundly to influence the future of painting. Hamilton's works were engraved a few years later by Cunego (1727–94), imparting to them a sombre, heavyweight air that introduced a new grandeur into art. It was Hamilton who opened up the wonder and the strength of antiquity to the young Venetian sculptor Antonio Canova (1757–1822) when he reached Rome in 1779. Within less than a decade Canova had been commissioned to design the tomb of the pope, Clement XIV (pl. 316), and, a few years later, that of Clement XIII. He was to work for Maria Christina in Vienna and Napoleon in Paris, the most admired sculptor in all Europe – though his somewhat icy yet over-sweet Classicism is today difficult to approach. Vien's mild Classicism, in comparison, might be shrugged off and ignored were it not for the fact that he was the master of David, and believed that he was the vital initiator of his style.

David was from the start wilful and ambitious; he never forgave the members of the Académie for the fact that he had to compete three times before winning the Grand Prix in 1774. In Rome Vien had just been appointed director of the Académie Française and he secured for David his first independent commission, *St Roch Imploring the Intercession of the Virgin for Victims of the Plague*, for the Chapelle du Lazaret in Marseille. This was exhibited at the Salon of 1781. David's composition was bold enough, and it is evident that he had been looking at the work of Caravaggio, but it was still a conventional assemblage.

So too, although far more monumental, was his next great painting, *Belisarius Recognised by a Soldier Who Had Served under Him at the Moment that a Woman Gives Him Alms*, rushed through in time to be exhibited at the same Salon. David's Classical vision developed quickly, spurred in part by his bitter rivalry with Jean-François-Pierre Peyron (1744–1814), who had won the Grand Prix in 1773, the year before him, and seemed for a time to be leading in the development of a noble style based on stirring Classical themes (Peyron had already painted *Belisarius Receiving Hospitality from a Peasant Who Had Served Under Him* in 1779). Their great public confrontation occurred in the Salon of 1787, when both artists showed a *Death of Socrates*. David's sharp and stately picture, composed like a Classical frieze, demonstrated at a glance that he could effortlessly surpass Peyron in imagination of the ancient world. But by then the demonstration was, in any case, redundant. The vast and astonishing *Oath of the Horatii* had been exhibited in Paris two years before. This was succeeded in 1789 by *The Lictors Returning to Brutus the Bodies of His Sons*.

The story of Brutus is even more horrific than that of the *Oath of the Horatii*. After a complexity of killings and the rape of Lucretia, wife of Brutus's friend Collatinus, by Sextus, son of the king Tar-

quinius Superbus, the Tarquins are expelled from Rome by Brutus and Collatinus, who are elected magistrates of the new Republic by the people. Brutus's two sons, however, become entangled in a plot to restore the monarchy and he is obliged to order their death and witness their execution. Although this story would seem to have clear political connotations in 1789, the subject was actually selected two years earlier and was a thrust at official depravity and scandal rather than a call for the overthrow of the monarchy. Even so, David was angrily opposed to all established order – even down to matters of formal composition. Here is the scoffing testimony of J. B. M. Pierre (1713–89), newly appointed permanent director of the Académie, on his visit to David's studio in 1789 to inspect *Brutus*:

> Go on sir, keep it up. You have in your *Horatii* given us three persons set in the same plane, something never seen before! Here you put the principal actor in the shade! . . . Moreover, you're right; the public finds it all lovely; there is nothing more to be said. But where, for a start, have you found that a proper composition can be made without using a pyramidal outline?

The conventions were finally abandoned. At the most formal level, the pyramidal method of composition which had been the seventeenth-century ideal, had been forsaken – in architecture rejection of established conventions was more profound. He was soon thrust directly into the political arena. By July 1789 the Revolution had begun; the Bastille was stormed on the 14th of that month, but whatever the anger of the hungry rioters, the overthrow of the monarchy was not their initial aim. David first took up a political stance to break the power of the Académie – he wanted, in fact, to be appointed director of the Académie Française in Rome; but soon, in close consort with Robespierre, he was designing the major public festivals of the revolution and painting the great icons that charted its history. The finest of these depicts the death of Marat who was one of the foremost figures of the years of the Terror. On 13 July 1793, a young girl from Caen, Marie-Anne-Charlotte Corday, inspired by the works of Plutarch, entered his apartment in Paris and stabbed him in his bath. David was called upon next day in the Convention by Citizen Guirault, of the Section du Contrat Social, to record this death. To which David replied, 'Aussi le ferai je' – 'I will.' He then painted the greatest – almost – of *Pietàs*, appropriately a secular one (pl. 317). In it, the simple stark figure is all.

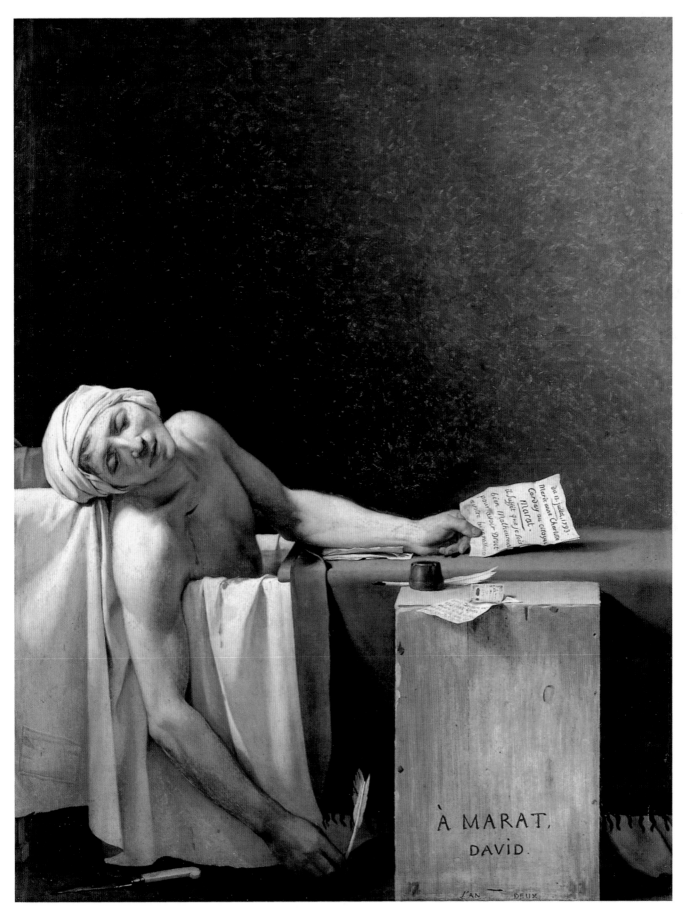

12
THE AGE OF PASSION

ROBIN MIDDLETON

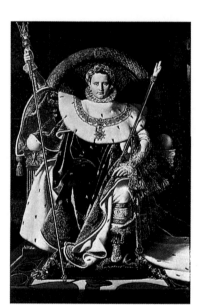

Every definition of the Romantic movement can be revealed as false. Each characteristic, each aspect, whether the belief in a changing system of values, an emphasis on the validity of personal experience and understanding, on originality and genius, or attitudes to the phenomena of nature – the Alps, volcanoes, forest landscapes, rushing torrents and storms – or even to those of the inanimate sort, such as Gothic architecture, all can be identified in the eighteenth century and even earlier. Moreover, the attitudes to these characteristics that are sometimes identified as Romantic were by no means uniformly held by all those thinkers and artists of the early nineteenth century who are regarded as innovators and interpreters of the new. They were often violently opposed one to another; their ideas and their works were often of a highly divergent nature. The paintings of Caspar David Friedrich (1774–1840) are precise in their delineation and smooth in their handling of paint; those of John Constable (1776–1837) are increasingly rough and impressionistic. Their objectives, too, were divergent: Friedrich aimed at a mystic sublime (pl. 319), Constable at an ever more real experience of nature (pl. 325). Yet there was from the last decades of the eighteenth century onwards a profound change in European attitudes to life and to art, a new belief in the importance of the individual, whether in his inward nature or in his role as a shaper of events, often of the momentous kind, and this new sensibility is, broadly speaking, encompassed in the term 'Romantic'.

The events of the French Revolution were crucial in the evolution of the Romantic movement, though it has been argued that the Bastille was virtually empty when it was stormed on 14 July 1789, that feudalism had already come to an end by the time it was abolished soon afterwards, and that the newly found liberties of man were abrogated in the interlude of the Terror five years later – when far more commoners than aristocrats were guillotined. The Revolution effectively destroyed the eighteenth-century system of order. Moreover it released an energy, passionate and almost indiscriminate, that was gradually given focus in the formulation of new ideals and the building of a new order – or rather new orders. The French had demonstrated that ordinary men and women, with enough passion, could determine the future of a society, of a nation. And this lesson was taken up throughout Europe. The notion of a world sustained by common sense and an ideal, rational system of organisation, towards which the eighteenth-century philosophers had aimed, seemed henceforth of little relevance. Fixity and certainty were no longer valued. All values became relative.

History itself was revealed in a new light, for the upheavals of the Revolution showed that it was possible for individuals and whole societies to experience the most profound changes. The

ABOVE 320. JACQUES-LOUIS DAVID: Napoleon at St Bernard, *1800. Musée National du Château de Malmaison.*

RIGHT 321. FRANÇOIS RUDE: The Departure of the Volunteers of 1792, *1833–6. Arc de Triomphe de l'Etoile, Paris.*

world as it existed before the Revolution differed from that which followed it, and from that of the Terror and its aftermath. History was lived and felt in those years as never before, and the understanding of it that emerged was new – although eighteenth-century precursors such as the Neapolitan jurist Giambattista Vico had already outlined and analysed the new conception. Values were to be judged in accord with particular circumstances, at specific times and specific places. There was no universal rule of good and bad. Styles and fashions were seen to have a coherence of their own and each, given a proper understanding of the circumstances that had given rise to it, could be judged as acceptable. Almost nothing was sacrosanct other than the authenticity of personal feelings, the integrity of the self.

IN PRAISE OF NAPOLEON

Although the Revolution was French, so great was its impact on Europe that the events of the succeeding decades can all be judged to be a direct result of that cataclysm or a reaction to it. Napoleon emerged, in time, as the most vital catalyst; and the artistic production of France, even of the most radical nature, was stimulated to an extraordinary degree by the world he created. He conquered most of Europe, and reorganised

the administration and institutions of France, from law to banking. Much of his achievement survives intact to this day.

The greatest paintings of the period are the propaganda pieces commemorating his exploits and the events of his reign, starting with Jacques-Louis David's *Napoleon at St Bernard* of 1800 (pl. 320), followed by Anne-Louis Girodet-Trioson's (1767–1824) *Ossian Receiving the Napoleonic Officers,* exhibited at the Salon of 1802 and Antoine-Jean Gros's (1771–1835) *Napoleon in the Plague-house at Jaffa* of 1804. The celebratory output culminated in two tremendous ceremonial works, David's *Coronation of Napoleon.* of 1805–1807, and Jean-Auguste-Dominique Ingres's (1780–1867) *Napoleon on His Imperial Throne* (pl. 318), of 1806. Indeed, heroic, nationalist fervour continued to sustain artistic enterprise of the finest sort long after the fall of Napoleon. François Rude (1784–1855) created one of the most dynamic of sculptural groups, *The Departure of the Volunteers of 1792* (known more popularly as *The Marseillaise;* pl. 321) for the most celebratory of Napoleon's monuments, the Arc de Triomphe, between 1833 and 1836; and another sculptor, Antoine Etex (1808–88), a fervent follower of the philosophy of the utopian socialist, the Comte de Saint-Simon (1760–1825), provided two somewhat less vibrant but no less histrionic groups, *The Resistance of the French People in 1814,* and *The Peace of 1815,* both completed in 1836.

PROTEST AND CHALLENGE

The reaction against Napoleon and the world he had created was equally forceful and artistically productive, typified by Théodore Géricault's (1791–1824) lithographs (1818) of exhausted, wounded soldiers retreating from Russia and his great *Raft of the Medusa* (pl. 323), exhibited at the Salon of 1819. These dramatic and altogether effective critiques of official incompetence and cowardice challenged not only the bravado and heroics fostered by Napoleon but also subsequent pretensions to overweening power, for they were actually directed against the monarchy that had been restored in 1814, following Napoleon's defeat at the Battle of Waterloo. Géricault himself, coming from a family of lawyers and property owners, understood well the ambition and greed of the new middle classes, but he soon became disillusioned by such power.

Even in Spain the greatest art of the period emerged as a result of the Revolutionary upheaval and its aftermath, specifically Napoleon's conquest of the peninsula. *The Third of May, 1808*, (pl. 322) which Francisco de Goya y Lucientes (1746–1828) painted in 1814 (after the restoration of the monarchy) to commemorate the beginning of the Spanish war of liberation, when the insurgents rose against the French army, might seem to depict a particular incident, but it was clearly concerned rather with the general condition of mankind in those years of upheaval and shifting power. Its composition, too, relates to that of David's *Oath of the Horatii* (pl. 312), but the soldiers who are given the stance of David's heroes are here represented as murderers.

If so vital and independent an artist as Goya could still be in thrall to academic routine, it is hardly surprising that artists in Paris, even those of rebellious temperament, should feel compelled to uphold it. Géricault died in 1824, not yet thirty-three years old. His role was taken over by Eugène Delacroix (1798–1863), who made his debut at the Salon of 1822 with *The Barque of Dante*, a painting whose images of horror and morbidity are clearly inspired by those of *The Raft of the Medusa*. Delacroix's forms are more rounded and turbulent, owing much to Rubens, but the composition of the whole is nonetheless of the formal kind, and the figures all cast in the Classical mould. Two years later, however, when Delacroix exhibited his *Scenes from the Massacres at Chios* (pl. 324) – the record of yet another revolution – it was clear that he was not only challenging the linear clarity of composition so relentlessly and

322. FRANCISCO DE GOYA: The Third of May 1808, *1814. Museo del Prado, Madrid.*

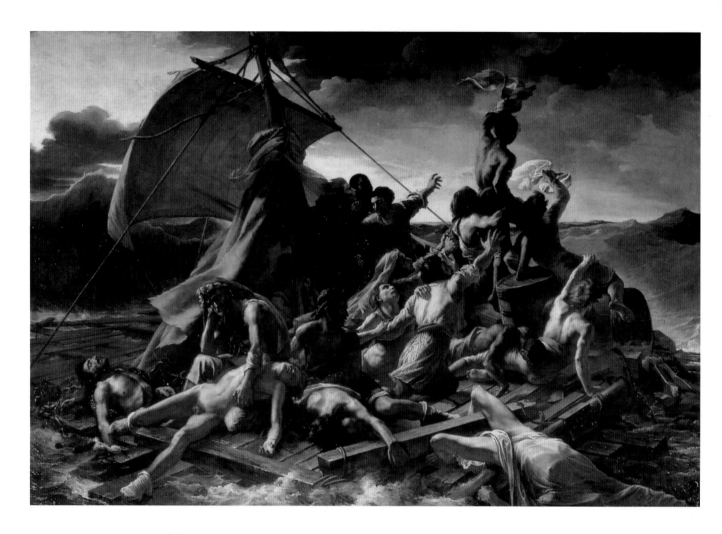

THÉODORE GÉRICAULT, RAFT OF THE MEDUSA

The story of the *Medusa*, a government frigate that was carrying soldiers and settlers to Senegal, was a particularly scandalous instance of the abuse of power. The captain, a former royalist *émigré*, had been appointed by way of a favour. On 2 July 1816, he ran aground and was forced to abandon ship. The officers and most of the soldiers crowded into the six available lifeboats; the crew and the settlers, 150 people in all, were herded on to a hastily constructed raft, which was at once cut adrift. After thirteen horrendous days of storms, mutiny, madness, murder and cannibalism, when only fifteen people remained alive, the *Argus*, another ship from the convoy, rescued them. Only five survived the ordeal.

Géricault made a whole range of sketches, eventually settling on the moment when the last survivors first sighted the *Argus*. He composed them in a great sweep from the bottom left of the canvas, where all is death and despair, to the top right, where hope has gradually aroused them from their torpor; at the apex a black man excitedly waves to the ship.

Although the incident depicted was harshly realistic, the painting was composed in the great academic tradition and the figures were fashioned in the antique manner. Géricault might have aimed at authenticity, but he wished to transpose the real into high art.

When the painting was revealed at the Salon in August 1819 its strength made a stunning impact. The historian Jules Michelet saw it as an allegory of the condition of France. All Frenchmen, he said, must feel that they were on that raft.

rigidly upheld by painters such as Ingres, but was freeing the arrangement of the groups and figures so that there was only a distant and imprecise field of battle and destruction. Yet for all this new realism of reportage, for all the accuracy with which Delacroix depicted the scenes of the massacre, there was a degree of theatricality and indulgence in the exotic costumes that sapped the force of his statement and rendered it histrionic.

ENGLAND: THE OBSERVATION OF NATURE

In England, observation of reality was more dispassionate. John Constable, although he had trained at the Royal Academy Schools in London and, like Delacroix, had been inspired to much liberating effect by the works of Rubens, rejected from the first all attempts at heroic composition or high-flown fantasy. He spent much of his life in the Stour valley, on the borders of Essex and Suffolk, carefully and methodically scrutinising nature and the surrounding farmlands. His most celebrated canvases, such as *The Haywain* (pl. 325), appear at first as no more than pastoral idylls, remote in time. But they are records of working landscapes with the operation of man and beast deliberately observed, the changing patterns of the seasons equally faithfully captured. Although he might appear to be concerned with the humdrum details of rural activities, Constable was interested even more in the world of essential, time-honoured values and truths, and his paintings can be experienced, unhesitatingly, as metaphors for them. His curious cloud studies – swiftly sketched records of the condition of the skies at particular times, each noted carefully in his diaries – are much more than meteorological observations; they are poetic metaphors for such Romantic obsessions as transience, adventure and liberty – all the more forceful for being so literally interpreted. This dogged pursuit of truthfulness, this determination to see things for himself anew, involved changes in the very technique of painting. Constable succeeded in conjuring up the luminosity and dappled effects of nature with flecks of colours and highlights of white, all loosely applied, in a way hitherto unattempted. He revolutionised painting. When Géricault saw *The Haywain* in London in 1821 he was amazed, and informed Delacroix of his astonishment on his return to Paris. Delacroix saw the painting himself three years later, together with *The View on the Stour near Dedham* and a scene of Hampstead, when they were on temporary exhibition, prior to the Salon of 1824. He too was astounded and was inspired at once to

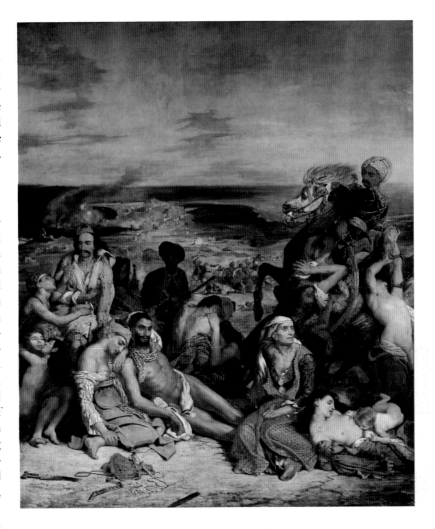

add touches of pure resonant colour and flecks of white to the *Scenes from the Massacres at Chios*, just before it was finally hung. In the following year he travelled to England to pay personal homage to Constable.

Another and perhaps even more celebrated English contemporary, Joseph Mallord William Turner (1775–1851), made an even greater impact on painting in France, although this was not to be as immediate. His marvellously radiant canvases were an inspiration to Claude Monet and Camille Pissarro, delighted Gustave Moreau and his Symbolist followers, and were imitated even by Henri Matisse. Turner's aim to dematerialise the forms of nature and to render them entirely in terms of light – an aim that had been stirred in the first instance by his own encounter with the rapturous studies of landscapes in light by the seventeenth-century painter Claude Lorrain – was first spectacularly realised in his *Snowstorm: Hannibal and His Army Crossing the Alps* (pl. 326) of 1812, which is not only a wholly original and devastating image of the powers of nature overriding human forces, but also a com-

324. EUGÈNE DELACROIX: Scenes from the Massacres at Chios, *1824. Musée du Louvre, Paris.*

BELOW 325. JOHN CONSTABLE: The Haywain, *1821. National Gallery, London.*

ABOVE OPPOSITE 326. JOSEPH MALLORD WILLIAM TURNER: Snowstorm: Hannibal and His Army Crossing the Alps, *1812. Tate Gallery, London.*

BELOW OPPOSITE 327. PIERRE VIGNON: *The Madeleine, Paris, 1807.*

ment on man's degeneracy. The subject, as one might expect, made overt reference to Napoleon. Turner had seen David's *Napoleon at St Bernard* (pl. 320) in Paris in 1802, but though he admired many of Napoleon's achievements (notably the roads he had built throughout Europe) he distrusted flamboyant gestures and arbitrary authority. The distant glimpse of the sun in his own painting betokens the lure of the warm south and the indulgence in pleasure that will lead to the final undoing of the mighty Carthaginian army.

Turner himself claimed that the sublime spectacle of nature he had conjured up in the painting was based on a particular snowstorm that he had witnessed, but the balance between reality and imaginative reconstruction in his paintings was always precarious. He thrilled to rough seas, storms and blizzards, eager to experience natural phenomena at first hand. He would gaze at clouds lying in the bottom of a boat, but rather than paint them directly, like Constable, preferred to paint from memory the changing image of their lighting effects. He did of course paint out of doors, sometimes in the rain. Yet those awesome paintings in which matter is dissolved

in whorls of energy and light were, in fact, works of consummate artifice. He claimed his famous late masterpiece, *Snowstorm: Steamboat off a Harbour's Mouth*, was based on direct experience, after being lashed for four hours to the mast of the *Ariel* off the harbour of Harwich. It is doubtful, however, if he was ever on the *Ariel*, indeed that the *Ariel* ever existed. The name was probably an oblique reference to Shakespeare's *Tempest*. Nevertheless, the poetic image of a distressed ship tossed in the vortex of a storm provided a potent and unforgettable symbol of human destiny, and it was acclaimed as such. The observation of nature had served in England to destroy the formalism of academic doctrine and had provided richer metaphors for the representation of human destiny.

ECLECTICISM IN ARCHITECTURE

In the field of architecture, activity was likewise dominated at first by Napoleon's grandiloquent Classical gestures, although the subsequent reaction against them was prompt and decisive.

The Place Louis XV, renamed the Place de la Concorde, had been the setting for public guillo-

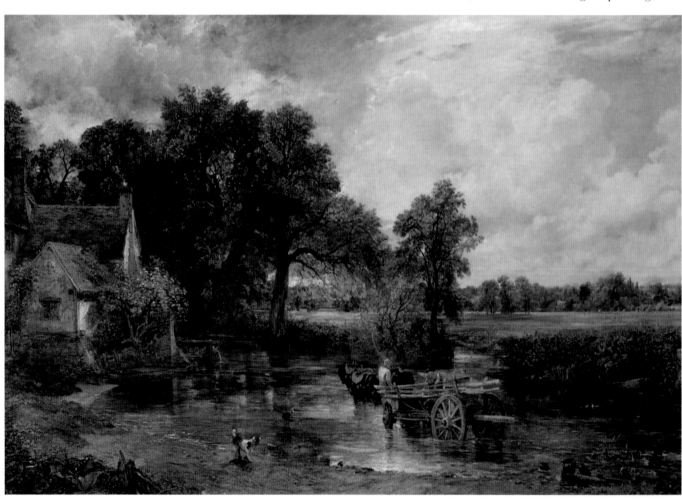

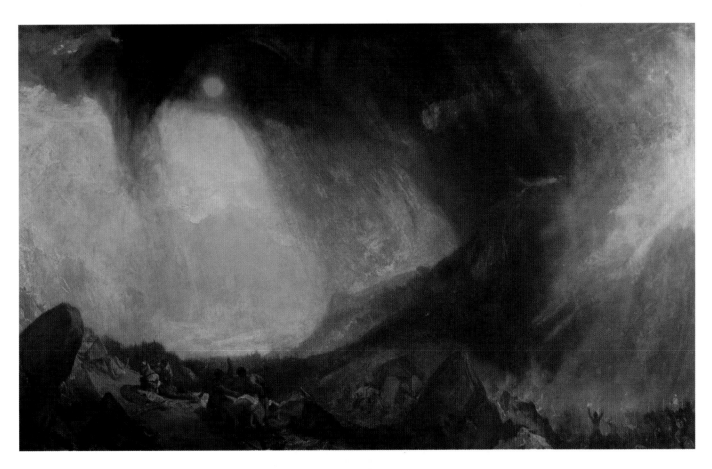

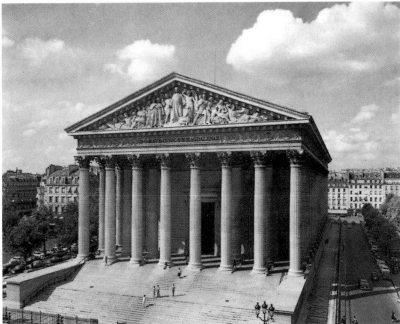

tining during the Terror. It became the centre-piece of Napoleon's rebuilding of Paris. To the north, the church begun in the middle years of the eighteenth century by the architect Pierre Contant d'Ivry (1698–1777) was refashioned in 1807 by Pierre Vignon (1763–1828), who transformed it into a great Roman temple as a monument to Napoleon's army. Today, reconsecrated, it serves as a church, the Madeleine (pl. 327).

To the south is the Chamber of Deputies, begun at about the same time by Bernard Poyet (1742–1824). This is all façade and sham – a scenic composition designed to screen the muddle of older buildings behind the new centre of legislation. Napoleon admired size and consistency in architecture, but it was apparent even to him that Poyet's façade lacked all sense of solid Classical dignity.

Much the same can be said of another of Napoleon's grand gestures, the Bourse, or Stock Exchange, begun in these same years by Alexandre Théodore Brongniart (1739–1813). This too was a lifeless paraphrase of the Roman temple form. These three buildings soon came to be regarded by radical critics as dismal failures. They were mere stereotypes, appearing to represent a fixed Classical ideal, and the truly vital architecture of the period was conceived in reaction against

301

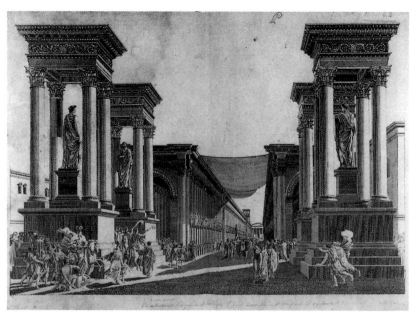

328. LOUIS
FRANÇOIS CASSAS:
*Reconstruction of the
Gallery at Palmyra,
c.1796. Archives of the
History of Art, Getty
Center for the History of
Art and the Humanities,
Los Angeles.*

329. HUBERT
ROBERT: Imaginary
View of the Grande
Galerie in Ruins, 1796.
Musée du Louvre, Paris.

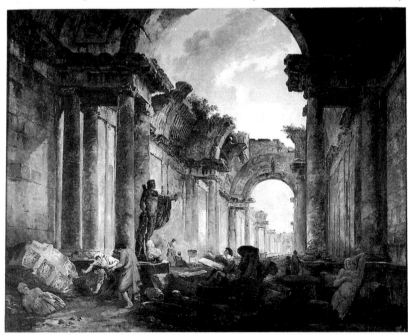

them. Yet whatever the view of more enlightened
minds of the day, or indeed our own judgement,
as to the merit of this architecture, it has to be
noted that it set a standard and a form for official
building that survived unchanged to the middle
years of the twentieth century, serving as the
appropriate outward expression of authority in
capitals as far apart, geographically and ideo-
logically, as Washington and Moscow. The
Madeleine is a symbol still of Paris.

Napoleon's chief architects were Charles Per-
cier (1764–1838) and Pierre François Léonard
Fontaine (1762–1853). They are remembered for
such work as the Rue de Rivoli, leading off the
Place de la Concorde, the related arcaded streets,
and the Arc du Carrousel, an exquisitely detailed
composition, but one that with the destruction of
the Tuileries palace in 1870, to which it acted as
an entrance, appears too small and too precise.
Percier and Fontaine were unable to handle sheer
size or boldness in architecture. They began their
careers as modish decorators and worked first for
the Empress Josephine at Malmaison before they
were employed by Napoleon – introduced to both
by David. At Malmaison they made their one
architectural invention which they were to em-
ploy repeatedly, to most satisfying effect. This
was the device of a screen consisting of a cluster of
four free-standing columns, supporting an arch,
used to divide and punctuate an over-long space.
The way in which they combined Classical prece-
dent and practical novelty here is fascinating and
symptomatic.

The theme of four clustered columns as a sup-
port was brought to French attention – in par-
ticular as a device for dividing a gallery – by the
reconstructions of the ruins of Palmyra, in Asia
Minor, which were prepared in the early 1790s
by the artist Louis François Cassas (1756–1827).
He began in 1794 to make models of this and
other reconstructions of ancient buildings, all of
which were to be exhibited together in 1806, to
provide the first museum of architecture. The
special attraction here was the model of the
street, the 'Grande Galerie', as he called it, at
Palmyra (pl. 328), which was made to appear
more extensive by being prolonged in a mirror,
and more magical in being lit with candles. There
seems little doubt that this image was familiar to
Hubert Robert (1735–1808), the painter, who
was also one of the first curators of the collection
of royal paintings assembled in these years to
form a museum in the Grande Galerie of the
Louvre. Robert had made proposals of his own,
as early as 1789, for dividing up the interminable
length of the Louvre gallery with groups of col-
umns, but it was only in 1796, after the modelling
of Cassas's Roman reconstructions, that he con-
ceived his definitive and most successful variant,
with clusters of four free-standing columns
sheltering a seated statue, each group set at inter-
vals opposite one another and linked by an arch,
to act as a dividing screen (pl. 329).

Percier and Fontaine took up the theme to
charming effect for the study they devised for
Napoleon at Malmaison in 1800 (pl. 330), where
it not only divided the space but masked an
obtrusive chimney flue. Between 1805 and 1810,
just in time for Napoleon's second wedding re-
ception, they introduced this columnar arrange-
ment into the gallery of the Louvre, dividing it

330. CHARLES
PERCIER and PIERRE
FONTAINE: *Napoleon's
study at Malmaison,
1800.*

into nine spaces; many years later, they used it yet again for the Galerie des Batailles, at Versailles.

There are curious parallels with Percier and Fontaine's English counterpart, Sir John Soane (1753–1837). His architecture, too, can be reduced to the development of a single device, conceived in 1792 for the Stock Office of the Bank of England (pl. 333). This is made up of a square central space, topped by a saucer-domed lantern light supported on pendentives, making a canopy, as it were, opening on to two shallow rectangular spaces, each covered with segmented cross vaults, the whole completed by four lower barrel-vaulted spaces to form the rectangle. The variation of levels of these vaults, providing innumerable opportunities for top-lighting and side-lighting, and the diversity of archways opening up one space to another, account for all the richness and oddity of space and light in Soane's architecture. But although Soane indulged a great deal in variations on this motif, particularly in his subsequent rooms at the Bank of England (now, sadly, all gone) his architecture always remained surprising. He brought an added tension to his buildings by emphasising their planar qualities, reducing his ornamentation to incised lines and odd frets, rejecting almost entirely the system of Classical ornamentation. This wonderful fusion of stark geometry and picturesque effects is an achievement that appears again and again at this period. It can be noted in the architecture of the German Karl Friedrich Schinkel (1781–1841), who was equally adept at

manipulating the Classical and Gothic styles to grand scenic effect, or, on an even larger scale, in such cities as Edinburgh, where the hard and clear-cut geometry of the Greek Revival architecture is merged with the rough landscape to produce a picturesque ensemble that partakes of the sublime.

Soane himself resolved such historical excursions on a smaller scale, almost obsessively, in the house he designed for himself and left eventually as a museum, that survives intact to this day. It became a confection of architectural experiments, with an extraordinarily diverse collection of artefacts displayed everywhere – some were no more than personal mementoes and many were architectural reminders in the form of plaster casts of mouldings and ornaments, but there were also great treasures, the Belzoni sarcophagus, two series of paintings by William Hogarth, *A Rake's Progress* and *A Harlot's Progress*, and fifteen vibrant drawings by Giambattista Piranesi for his etchings of the temples of Paestum.

THE GOTHIC REVIVAL

Percier, Fontaine and Soane, however much they were diverted and intrigued by the full range of styles that historical interests and archaeological exploration made available in the early years of the nineteenth century, were ultimately concerned most with the Classical tradition. But some architects, most notably in England, were attracted by the variety and exoticism of historical

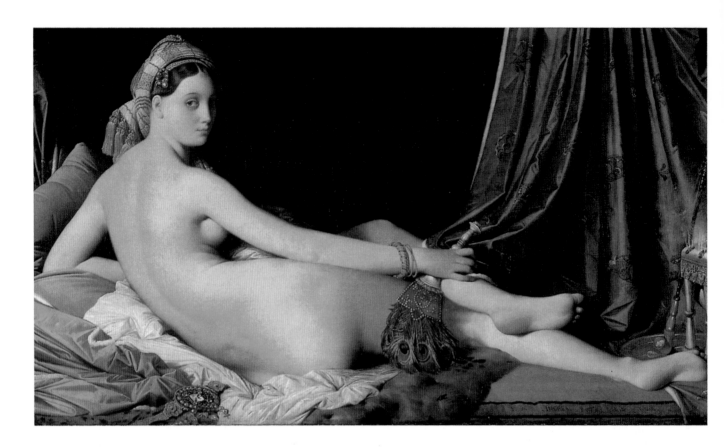

JEAN-AUGUSTE-DOMINIQUE INGRES, GRANDE ODALISQUE

Ingres's *Grande Odalisque*, exhibited at the Paris Salon in 1819, shows the meticulous technique and highly finished surface characteristic of the pupils of Jacques-Louis David. But, in place of David's heroic and moralising subjects from antiquity, Ingres catered to a market for more anecdotal themes and for images of languorous pleasure; he also rejected David's austere style in favour of an elegant exaggeration of line and form.

From its first appearance the *Grande Odalisque* was criticised for its anatomical impossibility – the figure's lack of structure, and the extreme elongation of the back: one critic said that it had three too many vertebrae. The treatment of the figure was clearly intended to complement the exotic subject – a European fantasy of oriental woman; Ingres never visited the Muslim world, and based his vision on written descriptions and engravings.

The *Grande Odalisque* belongs to a long tradition of male constructions of female passivity and sensuality, which can be traced back to Titian's Venuses and forward to Gauguin's Tahitian women. Later in the nineteenth century painters increasingly visited oriental countries to seek inspiration; Delacroix was even able to make studies for his *Women of Algiers* (*right*) in a Muslim house in Algiers. But for Delacroix, as for Gauguin after him, observation only lent a superficial authenticity to pre-existing stereotypes: their visions of the exotic, like those of Ingres, belong firmly within the world of European male fantasy.

The *Grande Odalisque* was shown at the same Salon as Géricault's *Raft of the Medusa* (pl. 323). For the next thirty years Ingres's stillness and sleek finish were seen as the polar opposite to the vigorous brushwork and dramatic action introduced by Géricault and later developed, with an increasing richness of colour, by Delacroix.

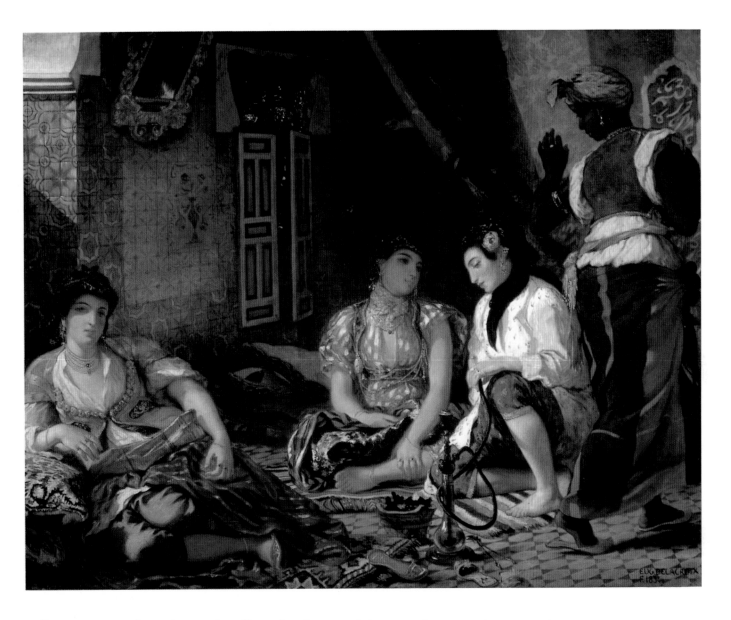

Ingres was elected to the French Académie at the age of 43, and became director of its school in Rome; he was viewed as the leading representative of the Classical tradition in French painting. Delacroix won many major commissions from the French state, but was systematically excluded from the Académie until shortly before his death; his dynamic art was considered the paradigm of Romanticism – a threat to the values for which the Académie stood. Yet Delacroix, dissatisfied with the label 'Romantic', described himself as a 'pure Classic', and his big history paintings, grounded in the art of the Venetians and Rubens, are in many ways closer to the great tradition of European figure painting than Ingres's refined, polished images.

John House

305

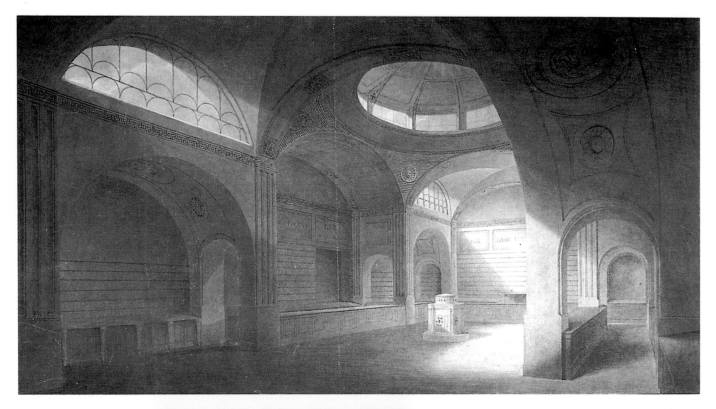

ABOVE 333. SIR JOHN
SOANE: *The Stock Office
of the Bank of England,
1792. The Sir John Soane
Museum, London.*

RIGHT 334.
AUGUSTUS WELBY
NORTHMORE
PUGIN: *St. Augustine's,
Ramsgate, 1843–50.*

newal for contemporary architecture.

The social ferment that was felt throughout Europe in the years following the Revolution was allayed by all manner of personal explorations into esoteric and mystical cults – a desperate search for individual salvation – but it also found an outlet in the revival and reinvigoration of established religion. Napoleon deemed it politic to recognise the Catholic church, which had been outlawed and dissolved after the Revolution, and to use it as a means to contain ardent spiritual energies – in 1802 he signed a Concordat with the pope. In England the government voted £1,000,000 in 1815 for the building of new churches in the expanding areas of towns and cities where no sense of community was as yet maintained and where some focus of aspiration and belief was needed. The churches that were built as a result of this measure – the Commissioner's churches, as they were called – were on the whole mean, pared down and of no great architectural worth. Even their social success may be doubted. Yet they were important elements in re-establishing social ideals that had been called into question by the ferment in France.

The one notable architect who emerged from this renewed religious enthusiasm was Augustus Welby Northmore Pugin (1812–52) – although he was anything but an establishment figure. In fact he repudiated the Church of England, becoming a Catholic convert in 1835, perhaps

styles to indulge in all manner of eclectic revivals, while others sought to find order in a reversion to a particular style that might have special associations of a religious or national kind. Gothic architecture was thought by Germans, by Frenchman and by Englishmen to be a national heritage. But it was only in England that the style served as a moral re-

because his father was a French *emigré*. His architectural ideals, too, were of French extraction, yet he gave to them an individual twist, bringing a new and compelling moral dimension to architectural thinking. He believed that the new architecture should revert to that moment in European history when the Catholic faith was superseded by the Protestant Reformation, to be characterised initially by a revival of late Gothic styles. Yet this was not made explicit when, in 1841, he laid down the principles for the production of good architecture in the most famous of his books, *The True Principles of Pointed or Christian Architecture*. There were two guiding rules, firstly 'that there should be no features about a building which are not necessary for convention, construction or propriety'; secondly 'that all ornament should consist of enrichment of the essential construction of the building'. He thus struck the moral note that conditioned all radical architectural theory of the nineteenth century and survived even into the twentieth century in the functionalist ideals of the Modern Movement. Beauty in architecture, he made clear, was the outcome of structural honesty. He was likewise convinced that only good and honest men could produce good architecture.

Pugin's interpretation of those ideals, however, was all in the Gothic vein, with a succession of great houses, schools, convents and churches – often of the most spectacular, highly wrought and colourful kind, such as St Giles, Cheadle (1834–44) or the decoration, both inside and out, of the Houses of Parliament (1844–52). In the most satisfying and carefully thought out of all his works, his own house, the Grange (1841–3), and the related church of St Augustine at Ramsgate (1843–50; pl. 334), both of which he paid for himself, he gave coherent form to the notion that passionate faith and rectitude were needed to produce an architecture of integrity. His interior spaces are bold yet intimate and mysterious. Pugin's manner was followed and adopted by many men of religious inclination in nineteenth-century England, although they did not necessarily accept his ethical arguments. The Gothic style had many other associations, often of a purely literary kind, for along with the revival of medieval religious fervour there was a romantic yearning for the ideals of the troubadours and the age of chivalry. It even went beyond this, for in England, France and Germany the revived Gothic style was regarded as an assertion of national identity. This fervour was emulated abroad by emigrants and colonists seeking to establish a continuity with their past – most not-

ably, and most surprisingly, in the United States of America.

THE PAST AND THE FUTURE
Nevertheless, it was in France that the most determined and consistent campaign was waged to reinvigorate architecture with new ideals. This was an inevitable outcome of revolutionary propaganda. The movement had begun even before the Revolution with the pleas of social reformers such as Cesare Beccaria in Italy, John Howard in England and Jacques Tenon in France. New prisons and new hospitals were built in the early years of the century, but although many of these buildings were beautifully composed and detailed, they were of limited practical success for it was difficult to translate the ideals of reformers into precise and definite programmes, and even more difficult to give them convincing architectural form. The first harsh expressions of this determinist architecture were in the US – Sing-Sing prison, for instance – where the humanitarian notion that prisoners be given separate cells, of a fixed and minimal size, so that they might repent

335. THÉODORE GÉRICAULT: *Kleptomaniac, c.1822– 3. Musée des Beaux-Arts, Ghent.*

of their misdeeds in silence, led many to madness and suicide. Géricault's penetrating portraits of madmen, one might note, are a direct result of this reformist movement (pl. 335). Later in the century the architect Emile Gilbert (1793–1874) succeeded in giving more clear and ordered form to the ideals of the humanitarians.

Another more obviously superficial attempt to reassess the Classical tradition in architecture – coinciding with so much in Romantic sensibilities – was to add colour to the surfaces. Jacques Ignace Hittorff (1792–1867) was convinced that the notion of a blanched Classical purity was entirely false. All Greek temples, he argued, had been covered, outside and in, with strident colours. Contemporary buildings should be equally colourful. His most notable experiment in this vein was the application of great slabs of enamelled stone to the façade of the church of St Vincent de Paul, built in the 1830s. The paintings, representing scenes from the Old and New Testaments, were all by Jules Jolivet (1803–71), a pupil of Gros. The blaze of colour that spread over the Place Lafayette shocked the

336. JULES JOLLIVET: Adam and Eve, *1860. Panels from the façade of St Vincent-de-Paul, Paris. Now in the Dépot des oeuvres d'art de la Ville de Paris, Ivry sur Seine.*

parishioners. They complained to the Baron Haussmann, all-powerful Prefect of the Seine, and no friend to Hittorff. The archbishop of Paris also protested, scandalised that Adam and Eve (pl. 336) should appear in the nude on a church front. The panels were all taken down.

More successful than these earlier experiments, though not unconnected with them, was the attempt to reassess the whole range of history, to distill it, and to embody this enlarged understanding in building. The reinforced sense of the continuity of the present with the past would thus

give a richness of tradition to architecture. This was, of course, one way of dealing with the stylistic eclecticism of the period but it did not entail an imitation of past styles. It was, in essence, an intellectual exercise.

This episode begins at the Couvent des Petits Augustins, on the left bank in Paris, where Alexandre Lenoir (1761–1839) set up the Musée des Monuments Français in 1795 – a museum in which Soane found much delight. This comprised a vast collection of architectural fragments, statues (including Michelangelo's *Slaves*), stained-glass windows and all kinds of bric-a-brac that Lenoir had gathered together to rescue from revolutionary destruction and theft. He arranged these objects in the rooms of the convent and in the garden outside, so that they made up an historical sequence assembled to aesthetic effect rather than historical accuracy, and with much artifice. The vaults of the thirteenth-century room (pl. 337) were painted bright blue and scattered with stars of gold. It reminded Napoleon of Syria – supporting Lenoir's belief that Gothic architecture might be of Arab, not French origin. In the garden, helped by Fontaine, Lenoir constructed a fictional tomb for Heloïse and Abelard. He thus produced a pageant of French history that was profoundly moving and greatly admired. It seemed to give form, for the first time, to the continuity of the French past. With the return of the monarchy in 1815, however, it was closed down and dismantled, and most of the objects were returned to their original locations. But some pieces remained, notably the architectural features – a part of the Château d'Anet, some arches from the Château de Gaillon, and more. Soon afterwards the site was chosen as that of the new Ecole des Beaux-Arts. The intention was that the debris be cleared and a neat Classical, or rather Italianate, building set in its place. The architect, however, who was to be largely responsible for the reconstruction, Félix Duban (1797–1870), was a member of a young group of radicals (though all had been sufficiently conformist to win the Grand Prix and to go to Rome) who wanted no stereotypes of architecture. They were not interested in the notion of a Classical ideal, considering that architecture should be appropriate to the particular society and locality for which it was designed. Duban made the bold decision not only to retain all the historical fragments but to keep them, as far as possible, just where they were. The Arc de Gaillon (now removed) formed a screen in front of the main façade of his new Palais des Etudes (pl. 338). He planned his fore-

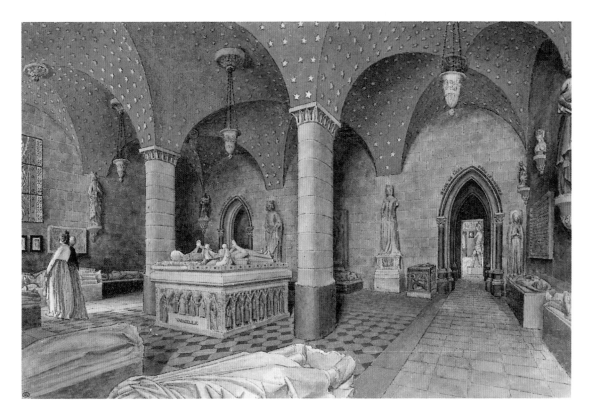

court with its scattered fragments of monuments as a parade through French history, beyond which – and through the Arc de Gaillon – could be glimpsed the antique past in the form of the façade of his great new building. He raised the height of this so that the attic storey could be seen clear above the Arc de Gaillon. His façade was designed to be viewed, unusually, from the top down. The top section commemorated the beginnings of Italian Classicism, the art of the Etruscans. The next floor down, the *piano nobile*, was intended to recall the architecture of Republican Rome, specifically the Colosseum. The base was derived from a Renaissance palace, the Cancellaria. This presented another historical progression, but it was not to be revealed all at once. Although there was a direct axis from the entrance gates of the forecourt right through to the Salle des Prix, the room of ceremonies, which formed the centrepiece and climax to the whole at the rear of the building, it was not an axis that could be followed, but merely a guide-line. In practice, the visitor first took in the fragments of the French past that lined the walls of the forecourt, and then circled the Arc de Gaillon, the gates of which were closed. The main façade was thus approached obliquely and only then was it revealed in its entirety.

Inside Duban planned a great court, for which he later designed an iron and glass covering that would shelter plaster copies of fragments of Clas-

sical architecture and sculpture (these were removed after the student riots of 1968). Beyond is the Salle des Prix – a beautifully conceived and detailed room, a ceremonial and yet most intimate space enveloped by Paul Delaroche's (1797–1856) mural honouring the admired artists of the past.

A scenic encounter with history was Duban's means of dealing with the new feeling for the past. His companion, Henri Labrouste (1801–75), who had worked under Duban in the building of the Ecole des Beaux-Arts, achieved a subtler distillation of history in his great masterpiece, the Bibliothèque Ste-Geneviève, flanking Soufflot's great church. One of the first libraries in Paris to be opened to the public at night, it was used by a wide range of people, and Labrouste sought to give it the stamp of a new social monument. The entrance was marked, appropriately, by lamps of learning, and the visitor then embarked on a quick passage through time. The entrance hall, with its indication of a pergola and treetops, conjured up the groves of Academe, of Classical Greece, but French overtones were provided by busts of St Bernard, Racine, La Fontaine and Voltaire. The stair hall, dominated by a copy of Raphael's *School of Athens* (pl. 208) and four roundels depicting (as in the Vatican) the four traditional divisions of a library – Poetry, Philosophy, Theology and Jurisprudence – was dedicated to the Renaissance.

337. JULES L. VAUZELLE: The Thirteenth-Century Room, Musée des Monuments Français, *c.1815. Cabinet des Dessins, Musée du Louvre, Paris.*

ABOVE 338. FÉLIX JACQUES DUBAN: *Ecole des Beaux-Arts, Paris, 1832–58.*

BELOW 339. PIERRE FRANÇOIS-HENRI LABROUSTE: *Bibliothèque Ste-Geneviève, Paris, 1844–50. Interior of the library.*

The special feature of interest here, which until recently stood at the bottom of the stairs, was a bust of Ulrich Gehring, who first brought the printing press to Paris, to the Sorbonne near by, and who, it was thought, had been buried almost on this site. The stair hall led directly into the library proper (pl. 339), where there were two additional roundels on the wall, History and Science, marking this as a modern library. This was a great long room, divided by a spine of cast-iron columns. The columns supported lattice ribs, also of iron, clearly exposed. This was the first occasion that iron had been used thus demonstratively, unconcealed, in a building of

monumental intent. It was an obvious challenge to accepted ideas. Iron was, of course, a new industrialised material, and that was part of Labrouste's intended statement; but it is likely that he had far more in mind.

The social utopian theorists, who had adopted the ideas of the philosopher Henri de Saint-Simon, extended these in a series of lectures and in some pamphlets published in 1830, to include the arts. They held that only a society whose social aims and religious beliefs were both moral and integral to their way of life could produce great art. This applied particularly to architecture (the highest form of the arts, as being the most social). The only two periods, in their opinion, that could be recognised as whole and coherent, or, in their terminology, 'organic', were the pre-Periclean Greek and Gothic, so that the only architectural forms worthy of admiration were the Greek temple and the Gothic cathedral. 'Organic' periods were followed by 'critical' epochs. It was their devout hope that the 'critical' phase that had followed on the Middle Ages was about to end and that a new society, and thus a new architecture, would shortly emerge. Victor Hugo (1802–85) responded quickly enough to this proposal. In 1832 he added two chapters dealing with matters of architecture to the second printing of his great novel *Notre-Dame de Paris*, the hero of which was widely recognised to be the Gothic cathedral itself. Hugo adored Gothic, but claimed that architecture was dead, and could never again become the prime form of expression of society. The beliefs and aspirations of the men of the Middle Ages were embodied in the forms of the stones of Notre-Dame and were written all over it in its statues, carvings and gargoyles. But this was an unrepeatable phenomenon. For with the invention of the printing press, social and religious ideals would henceforth be voiced and communicated in books. The book had overtaken architecture as the social form. The novel – not surprisingly – was to be the new social art form. Victor Hugo himself was, of course, the great new novelist.

Labrouste was closely involved with Hugo's theories, and seemed to be responding to him in the building of Ste-Geneviève – hence the importance of the statue to Ulrich Gehring. Labrouste was determined to prove that architecture was not dead, indeed that in his temple to nineteenth-century learning, which enshrined the book as the new means of popular communication, he could give expression to new social beliefs and could create a new 'organic' architecture. His spine of cast-iron columns run-

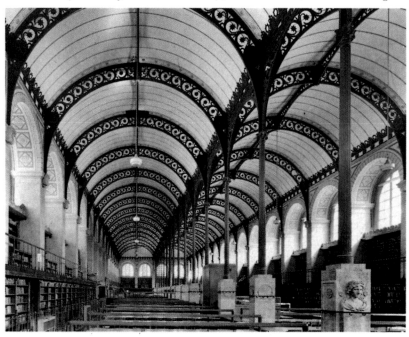

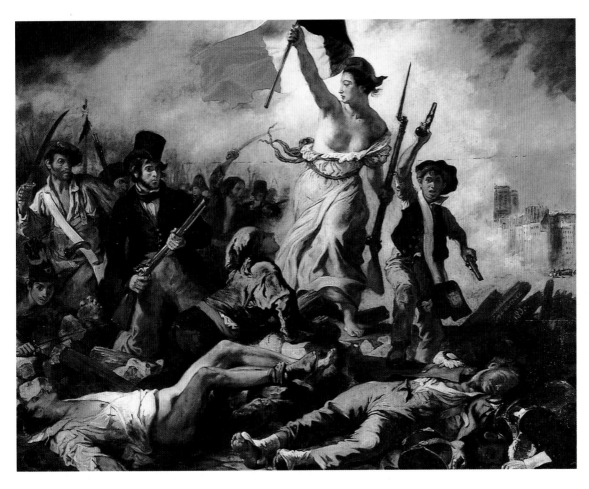

ning the length of the library, with which he might well have dispensed, commemorate the two earlier 'organic' periods of Saint-Simonist acclaim, and represent the third. Greek art was referred to in the so-called basilical temple at Paestum (pl. 23), in southern Italy, which Labrouste had studied as a Grand Prix winner. It had a hipped roof and a spine of columns running down its central axis. Labrouste argued that it was not a temple but a basilica where citizens – no longer so dependent on a religious faith, but confident rather in their own abilities – could meet. This was the Greek 'secular' model for the Bibliothèque Ste-Geneviève. The Gothic 'secular' model was the refectory of St-Martin des Champs in Paris, with a spine of columns down the middle of its length. His friend, Léon Vaudoyer (1803–72), was about to turn this into the library of the Ecole des Arts et Métiers, another populist enterprise of the period. Labrouste's library was a triumphal assertion that a new society and a new architecture appropriate to the nineteenth century had arrived.

The July Revolution of 1848 finally overthrew the monarchy in France. Revolution was the watchword of the early nineteenth-century, cele-brated by Delacroix in his *The 28th July: Liberty Leading the People* (pl. 340) of 1830, depicted in all its hideous aftermath by Ernest Meissonier's (1815–91) *Memory of Civil War* of 1849. Upheaval had succeeded upheaval, one administration another, and throughout men had sought to find a new sense of order. Perhaps the most potent influence in this vital quest was the new understanding of history. Not only individuals but whole societies endeavoured as never before to find strength in a comprehension of their past, their traditions, and in this way to achieve a fresh sense of identity. They were willing to learn also from the past of others. History, for the first time, was recognised as an evolutionary process. This enhanced knowledge led, inevitably, to eclecticism in the arts. An unequalled array of styles, each of which could be regarded as a proper expression of a society in a particular stage of development, became available for emulation. The more thoughtful practitioners, however, as we have seen, preferred not to copy past styles, but to interpret them afresh and to integrate them into a newly constructed history and organisation, one which might replace that shattered by the French Revolution.

340. EUGÈNE DELACROIX: The 28th July: Liberty Leading the People, *1830. Musée du Louvre, Paris.*

13
REALISM AND IMPRESSIONISM

JOHN HOUSE

INSET 341. JEAN-
BAPTISTE
CARPEAUX: The
Dance, *1869. Musée
d'Orsay, Paris.*

OPPOSITE 342. PIERRE-
AUGUSTE RENOIR,
La Loge, *1874.*
*Courtauld Institute
Galleries, London.*
Courtauld Collection.

In debates about art in nineteenth-century France, one issue was particularly controversial: the relationship between art and everyday reality. Should the world which the artist created express the experience of living in contemporary society and, if so, how? Or should art be an escape from mundane realities, and present idealised visions of far-off places and times? Most controversial among the images of the modern world were Courbet's down-to-earth depictions of French rural society, Manet's evocations of the moral uncertainties of Parisian life, and the Impressionists' rapid notations of light and weather effects.

Yet in the twentieth century these same paintings have come to be regarded as the fountainhead of a modern tradition, and the work of the Impressionists, in particular, has gained a vast international popularity. Most viewers today find it easy to accept Impressionist paintings as entirely 'natural' depictions of reality; the pictures have come to seem like a window on to the untroubled pleasures of a past era. However, to most nineteenth-century viewers the way in which the Impressionists treated their subjects, in loose touches of varied colour, seemed a travesty of the art of painting, and their subjects themselves, often showing the most controversial aspects of the modern scene, were considered quite unsuitable as material for fine art. In the past twenty years these pictures have become the focus of fierce critical debate and reassessment

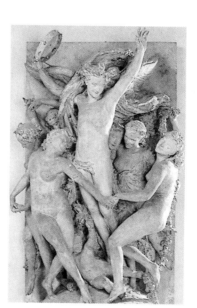

among art historians, who have begun to ask why they were made, and what they meant in their original contexts; what was the significance of this challenge to accepted artistic values?

COURBET AND REALISM

Until late in the nineteenth century, the main outlet for contemporary art in Parjs was the state-organised Salon (pl. 343). Works were selected by jury for this vast exhibition, where thousands of pictures were hung cheek by jowl in large, tall halls. Religious paintings and scenes of heroic deeds from history and mythology were considered to have the highest status, and therefore deserved to be treated on the largest scale and in an elevated manner sanctioned by the Old Masters, while genre scenes of everyday life had a very low status and deserved to be treated only on a small scale. The only potential buyers for the huge history paintings were the state and the provincial museums, which made their purchases directly from the Salon; such paintings were far too large for domestic interiors.

To many commentators, history painting, with its emphasis on heroic action and public values, seemed to be quite irrelevant to the everyday experience of the people. By the 1840s smaller scenes of rural life had acheived a wide popularity. These generally showed the peasants of the French provinces, Italy or Spain, or else figures in historical costume – scenes remote from the viewers of the paintings; only rarely was

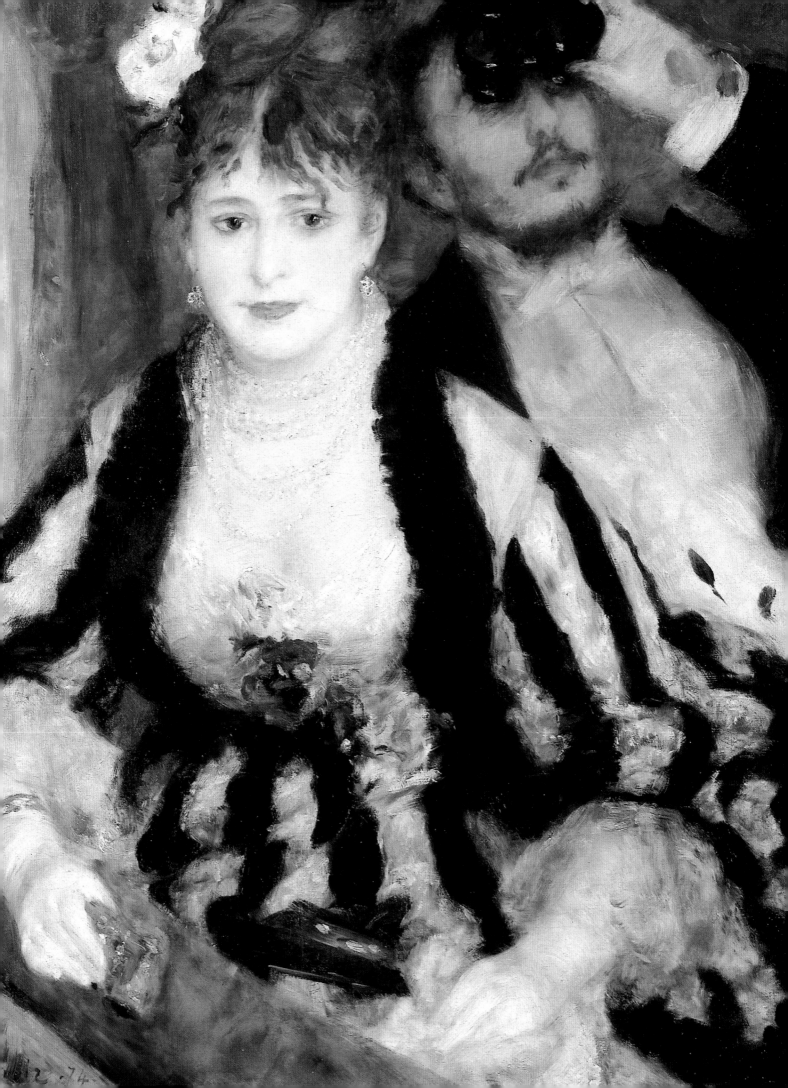

contemporary bourgeois and urban life depicted. However, ambitious history paintings continued to attract the greatest attention, and at the Salon of 1847 it was *The Romans of the Decadence* (pl. 346) by Thomas Couture (1815–79) which was widely seen as proof of the continuing vigour of French art: a gigantic architectural setting, reminiscent of Renaissance art, and of the Venetian painter Veronese in particular; a paint surface which combined the controlled linearity of Neoclassicism with the more fluently brushed, coloured handling associated with the Romantics; and a subject which juxtaposed the spectacular indulgence of the late Roman Empire with the austere, moral past of the Roman Republic.

After the Revolution of 1848, which overthrew the monarchy of Louis-Philippe, there were stronger demands for an art which related to contemporary life. Under the Second Republic, the state bought works from painters such as the landscapist Théodore Rousseau (1812–67), who had been excluded from the Salon under Louis-Philippe, and in 1849 Gustave Courbet (1819–77) won a second-class medal at the Salon for a large scene of contemporary provincial life, *After Dinner at Ornans*, which shows the artist, his father and friends relaxing in a simple interior.

Courbet's father was a prosperous farmer in the Franche-Comté, in the uplands of eastern France, and Courbet found many of his subjects in the everyday life of his home region. He emphasised that he was an outsider in fashionable urban circles; he presented himself as a force of nature, a man of titanic appetites who ignored social niceties.

At the Salon of winter 1850–1, Courbet exhibited three more large scenes of rural life. Most notable of these was *A Burial at Ornans* (pl. 344), which aroused much debate and criticism, and firmly established Courbet as the most controversial painter of the day. In it, he upgraded the customs of his own region to the status of history painting on a vast scale, and in so doing claimed that modern rural society and the landscape of the Franche-Comté were subjects just as worthy of the highest form of painting as heroes and gods.

The picture was particularly shocking to its Parisian audience in the political climate of 1850. In the election of December 1848, Louis Napoleon, nephew of Napoleon I, had been elected president by a huge majority, but in subsequent elections in May 1849 and March 1850 around one third of the rural electorate voted for left-wing republican candidates, seeing Louis Napoleon as the champion of the urban bourgeoisie. So, when the *Burial* was exhibited in Paris late in 1850, the image of a rural society appeared far more threatening than it had when *After Dinner at Ornans* had won a medal in spring 1849.

In the twentieth century, Courbet's art has come to be seen as almost synonymous with

343. *The installation of the 1861 Salon, Paris.*

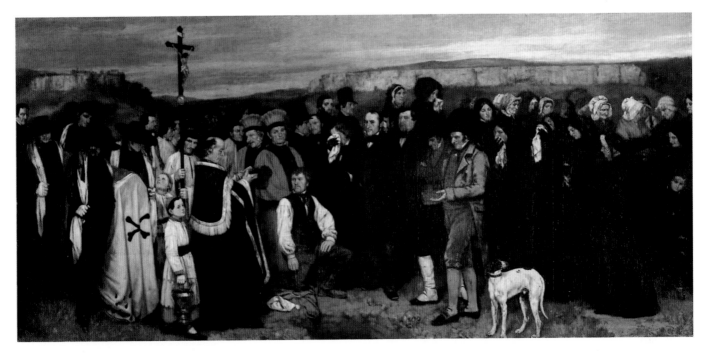

GUSTAVE COURBET,
A BURIAL AT ORNANS

The vast scale of *A Burial at Ornans*, together with its subject and the way in which it was treated by Courbet made the picture a central talking point when it was exhibited in Paris at the Salon of 1850–1.

Images of rural types had been popular in the 1840s, but they presented their figures as members of an unchanging peasantry, tied to the soil. By contrast, several commentators identified the community shown in Courbet's picture as a rural bourgeoisie; this evidence of social mobility increased the threat which the painting's vision of the countryside presented to its bourgeois viewers in Paris in the unstable political situation of 1850–1.

The treatment of the subject added to their disquiet. Traditional pictures of religious observance in the countryside had shown the peasantry humbly acknowledging the authority of the church. In *A Burial at Ornans* the cortège carrying the coffin is only part of the scene, and the figures on the right pay little attention to it; the centre foreground is occupied by the empty hole in the ground – a secular reminder of death – without any hint of faith and afterlife. Nor are the figures the picturesque types which normally characterised the countryside; instead, their faces are vividly individualised, and some treated in a markedly unflattering way. The paint layers are broadly and in places crudely applied, in contrast to the sleek, highly finished surfaces which made conventional images of peasants acceptable to their Parisian viewers.

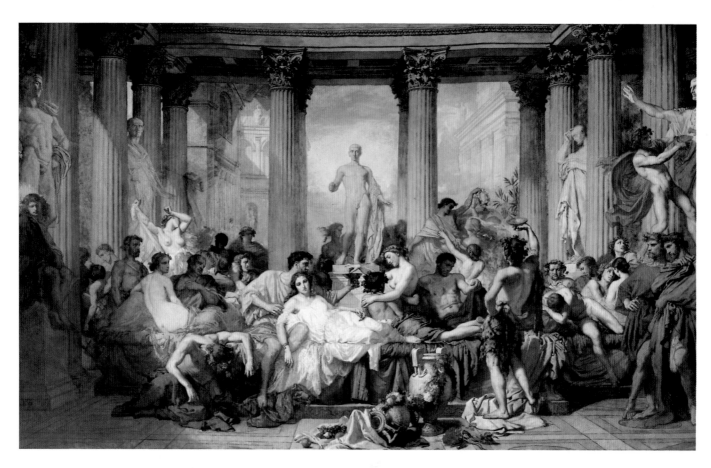

346. THOMAS COUTURE: The Romans of the Decadence, *1847. Musée d'Orsay, Paris.*

Realism; but this term was used in many different ways by artists and critics in the mid-nineteenth century, and acted as a focus of critical debates. Courbet boldly claimed the term for himself in 1855, when he published a manifesto of his ideas about art with the simple title 'Realism'. In it he wrote, 'I have sought simply to derive from an entire awareness of artistic tradition a reasoned and independent sense of my own individuality. . . . My aim is to translate the customs, the ideas and the appearance of my own epoch, as I see them.' For him, Realism was a process of self-liberation, which allowed him to see the world for himself, as it really was; the eye is the artist's true guide, and can free him from the empty conventions of academic art.

However, Courbet's own paintings show that he was acutely aware of the issues under debate in artistic circles at the time. Realism is often regarded as the rejection of the artifices of art, but paintings such as Courbet's were designed to be viewed in the context of other paintings – namely, the other works exhibited at the Salon. So his pictures would inevitably be compared with stock artistic solutions, and very often the devices he used were expressly intended to comment on, and apply a corrective to, those stock solutions. This appears most vividly in *The Bathers* (pl. 348),

which he exhibited at the 1853 Salon. Here, what may seem an everyday subject of country folk is presented in a way which makes no sense without direct reference to the conventions of contemporary painting. The theatrical gestures of the two women echo the rhetorical poses habitually taken up by woodland nymphs in the paintings of the Classical tradition, but in Courbet's picture there is no obvious narrative explanation for these gestures; their massive, unidealised figures, too, are a travesty of the elegant forms conventionally associated with the female nude.

Courbet's 1855 manifesto gained its point from the context in which it was made. Louis Napoleon had seized absolute power in a *coup d'état* in December 1851, and had declared himself Emperor Napoleon III in December 1852. England had staged the Great Exhibition in 1851, though without a fine art section, and Napoleon III wanted to establish France's cultural and industrial superiority by mounting a Universal Exhibition in Paris in 1855. In the event, the Exhibition also served to distract attention from France's involvement in the Crimean War by presenting the nation's supremacy in the arts of peace. The government, in the person of the Minister of Fine Arts, the Comte de Nieuwerkerke, tried to persuade the country's leading art-

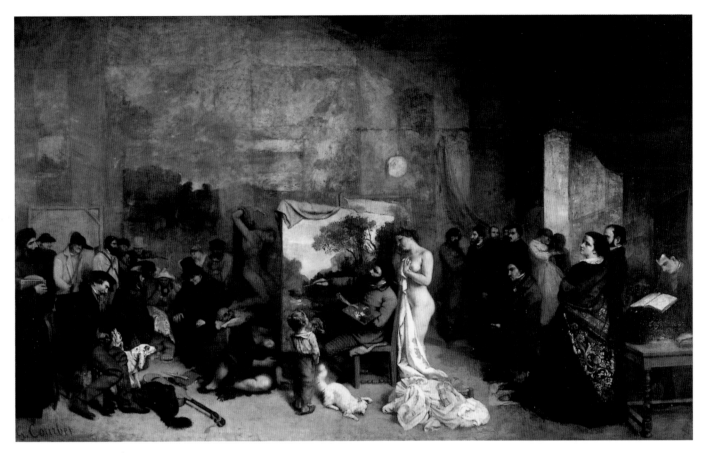

ists to send works to the Exhibition, and he made overtures to Courbet to abandon the more controversial aspects of his art and paint an important canvas for it. Courbet described his indignant response in a letter to his patron Alfred Bruyas:

> I replied that I didn't understand a word he had just said, since he was a government and I didn't consider myself in any way included in that government, that I too was a government, and that I challenged his to do anything whatever for mine that I could accept. I said that for me his government was just like any other private citizen, and that, if my pictures pleased it, it was free to buy them from me.

In the event, Courbet submitted a number of paintings to the jury for the 1855 Exhibition, but the most important of them were rejected, and Courbet mounted his own private display in a temporary building just outside the gates of the Exhibition; his 'Realism' manifesto was published as the preface to the catalogue of this display. Among the rejected pictures, which became the centrepieces of his own exhibition, were the *Burial* and a newly painted picture, of much the same size, *The Artist's Studio* (pl. 347). Courbet described the *Studio* as a 'real allegory' of

his artistic career: on the right are his patrons, friends and supporters, including (on the extreme right) the poet Charles Baudelaire, and the anarchist philosopher Pierre-Joseph Proudhon. Courbet was particularly influenced by the ideas of Proudhon, who rejected centralised government and capitalist ownership, and advocated an egalitarian society based on the freedom and autonomy of the individual. On the left of Courbet's canvas we see a collection of the types who formed the subject matter of his art – country workers, itinerants and outcasts. In the centre Courbet himself is painting a landscape, watched by an unidealised naked woman who, according to one contemporary, was meant to stand for the 'Muse of Truth'. All of these people would never have been present in his studio at the same time, but together they sum up the two groups who made his art possible – the independent-minded supporters and buyers, and the types who were the raw material of his realism. Courbet's own presence at the centre of his world is his militant statement of his own individualism and of his independence of the imperial régime – a deliberately provocative response to Nieuwerkerke's overtures.

Three distinct themes are of central importance in Courbet's major paintings: the assertion

347. GUSTAVE COURBET: The Artist's Studio, *1855. Musée d'Orsay, Paris.*

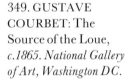

348. GUSTAVE COURBET: The Bathers, *1853. Musée Fabre, Montpellier.*

of the significance of the ordinary people of the countryside, in the *Burial*; the rejection of artistic idealisation, in the *Bathers*; and the declaration of the painter's individuality and autonomy, in the *Studio*. All three were of crucial importance in Courbet's Realism, and taken together they represented a comprehensive attack on the values of academic art, and a challenge which had wider

political implications in the 1850s.

Throughout his career, Courbet painted landscapes of his home region (pl. 349). They generally focus on single natural elements – a rocky crag, a waterfall – presented frontally as if to emphasise the primacy of the eye. Courbet wrote in 1861, 'I believe that painting is an essentially concrete art and can only consist in the representation of *real and existing* things.' His technique, with loose brushwork and broad sweeps of the palette knife producing simple, solid surfaces of oil paint, stands as an expression of his direct engagement with the physical stuff of the world.

Courbet's supporters championed his art under the banner of Realism; opponents condemned it for neglecting what they felt to be essential to true art – a belief in ideals of beauty and the creative imagination. But at the same time other writers adopted the term to describe a more idealised vision of the natural world, in contrast to what they saw as Courbet's crude materialism.

At the 1855 Universal Exhibition, many pictures were shown which critics characterised as Realist; these included Jean-François Millet's (1814–75) images of a simple peasant life (pl. 350), as well as Jules Breton's (1827–1906) sleeker, more beautified visions of rural labour, and Ernest Hébert's (1817–1908) melancholy scenes of the peasantry of the Italian Campagna. In

349. GUSTAVE COURBET: The Source of the Loue, *c.1865. National Gallery of Art, Washington DC.*

landscape painting, Charles-François Daubigny's (1817–78) views of the rivers of France were shown, as well as Théodore Rousseau's forest interiors and Constant Troyon's (1810–65) large pictures of cattle in meadows. In the British section of the Exhibition, French viewers had their first chance to see the work of the English Pre-Raphaelite painters, whose minute detail and brilliant colour led some critics to see them as the ultimate Realists.

Official taste under Napoleon III encompassed many different types of painting. The main awards at the 1855 Exhibition went to two history painters, Ingres and Delacroix (prime representatives of the Neoclassical and Romantic traditions), but also included two painters of scenes of everyday life: Ernest Meissonier, who painted small scenes in historical dress, and Alexandre Decamps (1803–60), who specialised in oriental subjects. At the next Universal Exhibition, in 1867, the balance swung further towards genre painting, and in the 1860s the state even bought a painting from Courbet – a landscape of the Ornans region.

The state also sponsored lavishly decorated public buildings, designed to parade France's cultural supremacy. Most notable of these was Charles Garnier's (1825–98) Paris Opéra (pl. 351), erected in the 1860s at enormous financial and human cost: over thirty-five million francs, with at least ten men killed during its construction, and around 500 houses in the centre of the city demolished to make way for it. The structure of the building is an elaborate fusion of Classical

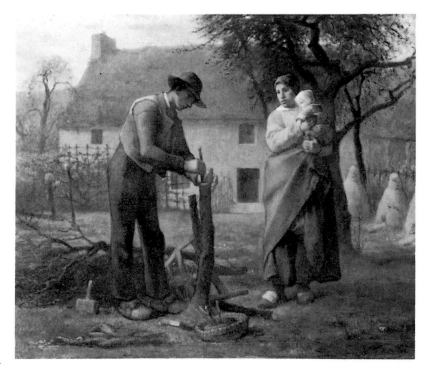

and Baroque styles; it is decorated with allegorical sculpture and painting, deeply indebted to the art of the past. Only Jean-Baptiste Carpeaux's (1827–75) *The Dance*, one of the sculptural groups on the principal façade (pl. 341), infused fresh life into traditional artistic formulae; it aroused great controversy when it was unveiled in 1869, because of the lifelikeness and dynamic energy of its naked figures, in marked contrast to the static Neoclassical groups by other artists elsewhere on the façade.

ABOVE 350. JEAN-FRANÇOIS MILLET: Peasant Grafting a Tree, *1855. Neue Pinakothek, Munich.*

BELOW 351. CHARLES GARNIER: *Opéra, Paris, 1861–74.*

352. EDOUARD
MANET: Le déjeuner
sur l'herbe, *1863. Musée
d'Orsay, Paris*

During the 1860s, though, the most controversial images dealt with modern Paris life. It was not only the modernity of these subjects which caused disquiet, but also the way in which they were treated. In Paris in these years there was the most concerted opposition to the imperial régime, though strict press censorship meant that this could not be expressed openly; paintings which showed the more problematic aspects of city life raised searching political questions about the official image of Paris as the metropolis of civilisation and prosperity. One painter, Edouard Manet (1832–83), was the focus of these debates about the artistic depiction of the city and its diverse inhabitants.

EDOUARD MANET

In marked contrast to Courbet, Manet was born and bred an upper-middle-class Parisian; throughout his career, his subject matter dealt with the city and its suburbs, with their fashionable life and their more or less respectable social rituals and entertainments. There was nothing unusual about his own position as a fashionable man in Parisian society and its bohemian circles, but this world was not regarded as suitable raw material for fine art, and particularly not as Manet depicted it. Subjects from the life of the boulevards or the city's theatres and cafés were common in the journalistic illustration of the day, generally presented as a light-hearted and clearly legible satire on etiquette and social behaviour. In Salon painting, by contrast, there were few subjects of modern urban life – occasional views of the topography of the city, and small scenes of middle-class domestic life.

The first scandal of Manet's career was *Le Déjeuner sur l'herbe (Luncheon on the Grass*, pl. 352), rejected by the Salon jury in 1863, and exhibited at the Salon des Refusés which the emperor set up

that year to display the great numbers of rejected pictures. The composition of the *Déjeuner* was based on a design by Raphael, and the combination of naked women with clothed men was sanctioned by Giorgione's celebrated *Concert champêtre* (pl. 221) in the Louvre – a reference which Manet intended: 'I'm going to redo Giorgione's picture, in the transparency of the atmosphere, with figures like those you see over there, by the river.' The painting also includes echoes of the French eighteenth-century tradition of the *fête champêtre*, and particularly of the work of Watteau; this tradition was still current in the 1860s, especially in prints of a semi-erotic type. But Manet's picture is a travesty of all these traditions. It was presented as fine art, on a very large scale, and intended for exhibition at the Salon; but it showed blatantly unidealised, contemporary figures; reviewers said the man on the right in his smoking cap looked like a student, and protested at the ugliness of the naked woman. Nor could they determine the relationship between the figures. The man on the right appears to be talking, or at least gesturing, but the man beyond stares blankly beyond him, and the naked women ignores them and looks directly out at us, the viewers of the painting; this is a most unusual device in paintings of modern life, which implicates the viewer with uncomfortable directness in the questionable morality of the scene – the woman shows no sign of surprise or embarrassment.

The female nude was very common in Salon painting; indeed, in 1863, the year that the *Déjeuner* was rejected, the gold medal was won by Alexandre Cabanel (1823–89) with *The Birth of Venus* (pl. 353). Here, the frivolous eroticism is distanced from the viewer by its pseudo-Classical subject, by its inexplicit, timeless setting and by the coy twisting of the figure's sinuous pose. The contemporary nude could only be shown if it were located in a remote oriental setting, and presented as a belly dancer or a slave girl, as in the works of Jean-Léon Gérôme (1824–1904).

Manet was not deterred by the rejection of the *Déjeuner*, and executed a reclining nude which was in a sense a modern life riposte to Cabanel's *Birth of Venus*: this was *Olympia*, (pl. 354), accepted for the 1865 Salon but greeted by a storm of criticism. The naked woman, with her discarded modern dress and her black servant, would have been clearly recognisable as a prostitute, and her direct gaze invades the viewer's world, confronting us with her nakedness and forcing us to return her stare. In a way, by involving the viewer with the naked figure in this way, Manet was challenging the unspoken conventions which lay behind Cabanel's *Venus*, by which a naked female figure could be presented in public provided it re-

353. ALEXANDRE CABANEL: The Birth of Venus, *1863. Musée d'Orsay, Paris.*

mained remote and passive. Manet was not alone in rejecting the artifices of paintings such as Cabanel's; the next year Millet wrote, 'I've never seen anything that seemed to me such a real and direct appeal to the passions of bankers and stockbrokers. They appeared to me so gross a provocation that I was astonished that women dared to halt in front of them. Yet these pictures have been accepted with enthusiasm by distinguished men, and considered as the expression of supreme grace.'

Olympia was harshly criticised both for its immoral subject and for the stark simplicity and directness of its execution, so unlike the beguiling finesse of Cabanel's handling. Technique, subject and composition alike seemed to present the viewer with a set of challenges. Manet's technique was seemingly artless, simple and direct; it emphatically rejected the minute skill valued in the academic tradition, and presented the vividly brushed paint surface as the expression of the artist's hand and personality. Courbet, too, sought to give the impression of being a spontaneous, natural painter, and used on occasion to paint whole pictures rapidly in front of admiring spectators. Manet's methods were more de-

ceptive, since he used to erase his work time and again until he produced a version which appeared to be immediate and unmediated, his personal response to his optical experience.

The notion of optical truth, of the innocent eye, was of central importance in attempts to justify paintings such as those of Courbet and Manet. Yet in an essential sense the idea is an illusion. The art of painting itself involves a range of skills in the manipulation of materials which prevents the execution of any painting from being immediate; and any representation also involves many choices, about what is to be shown and how it is to be treated. The Realist enterprises of the mid-nineteenth century gained their effect by rejecting the academic modes of representation, which treated the human figure as the central focus of attention and exalted the hero above the ordinary person in the street. Instead, Courbet painted rocks with as much attention as figures, and Manet was accused by the critic Théophile Thoré of 'pantheism' because he treated the clothing and backgrounds of his figures with as much attention as their faces. This apparent neutrality of vision itself involved deliberate choices, since the human eye, habituated to seek

354. EDOUARD MANET: Olympia, *1863. Musée d'Orsay, Paris.*

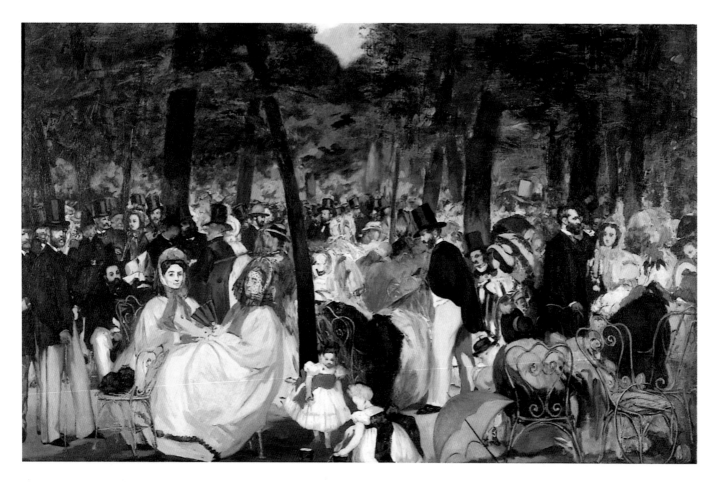

355. EDOUARD MANET: Music in the Tuileries Gardens, *1862. National Gallery, London.*

and recognise forms in what it sees, does not view the world as a set of equally weighted patches of colour; in the context of the 1860s, though, this way of painting carried significant associations: through its rejection of the hierarchies of academic art, it created a vision that was in the broadest sense egalitarian – and hence politically radical in its implications.

This pantheistic vision of the modern world is seen vividly in Manet's *Music in the Tuileries Gardens* (pl. 355), in which the crowd is conveyed by a string of equally weighted touches of coloured paint across the canvas. The picture includes many celebrated contemporaries from the art world, among them Charles Baudelaire, a friend of Manet's as he had been of Courbet's, who is seen in profile in front of the thick tree trunk to the left of the picture. Baudelaire had made a pioneering appeal in 1845 for artists to 'snatch its epic quality from the life of today and make us see and understand how great and poetic we are in our cravats and our patent-leather boots'. He had recently written his essay *The Painter of Modern Life*, which advocated an aesthetic of urban modernity very like Manet's; Baudelaire defined the relationship of the observer to the crowd around him:

For the perfect *flâneur*, for the passionate spectator, it is an immense joy to set up house in the heart of the multitude, amid the ebb and flow of movement ... to see the world, to be at the centre of the world, and yet to remain hidden from the world – such are a few of the slightest pleasures of those independent, passionate, impartial natures. . . . The spectator is a prince who everywhere rejoices in his incognito.

Music in the Tuileries Gardens is one of a number of smaller, more informal images of the modern world which Manet did not submit to the Salon; it was shown in 1863 in a private gallery run by Louis Martinet, whose display spaces were regarded by many artists at the time as far more suitable for smaller pictures than the big halls and packed walls of the Salon; as François Bonvin (1817–87), a painter of scenes of everyday life, wrote to Martinet in 1861, 'Intimate painting needs a space like yours.' Art dealing emerged as a profession in these years. Exhibitions such as Martinet's were important precursors of the group exhibitions mounted by the Impressionist painters, when they, in turn, were seeking a public outlet for smaller pictures in-

tended for purchase by enlightened private collectors. Manet, though, never joined in these group exhibitions, since he continued to believe that the painter should concentrate on producing a few major works each year for the Salon; there they would be seen alongside the 'pictures of the year' and would attract the attention of a vast public, not just that of the few who attended the group exhibitions.

THE IMPRESSIONISTS

The first Impressionist group exhibition was held in 1874. The participants included Claude Monet (1840–1926), Pierre-Auguste Renoir (1841–1919), Camille Pissarro (1831–1903), Edgar Degas (1834–1917), Alfred Sisley (1839–99), Berthe Morisot (1841–95) and Paul Cézanne (1839–1906). The exhibition was an explicit rejection of the Salon and its system of selection; it had no jury (all subscribers had the right to show), and by the standards of the time the pictures were spaciously hung, in two rows, large above small (our present-day notions of spacious hanging have no parallel in the nineteenth century). The exhibition was warmly welcomed by almost all of the critics who discussed it, as an attempt to bypass the Salon, but many of them,

even if they supported the enterprise, were critical of the lack of 'finish' of the paintings. By academic standards, most pictures by the Impressionists appeared unfinished, owing to their visible brushwork and their imprecise definition of form.

However, the artists themselves distinguished between their more elaborate, tidily executed canvases, which they generally sought to sell through dealers, and their sketches – rapid notations of natural effects; it was one of these, Monet's *Impression, Sunrise* (pl. 357), shown with that title in the first exhibition, that suggested the name 'Impressionists' for the group. Most of the painters included both sketches and more finished works in the group exhibitions, so as to show to the public both the immediacy of their artistic vision and their ability to work up their ideas into a more solid and lasting form. In the 1874 show, for instance, Cézanne exhibited his ebullient, freely brushed *A Modern Olympia*, a reworking or parody of Manet's *Olympia*, alongside his densely painted village scene *The Hanged Man's House* (pl. 356), whose taut structure and controlled handling anticipate the qualities of Cézanne's later work, which was to have such an impact on the painting of the early twentieth cen-

356. PAUL CÉZANNE: The Hanged Man's House, *1872–3. Musée d'Orsay, Paris.*

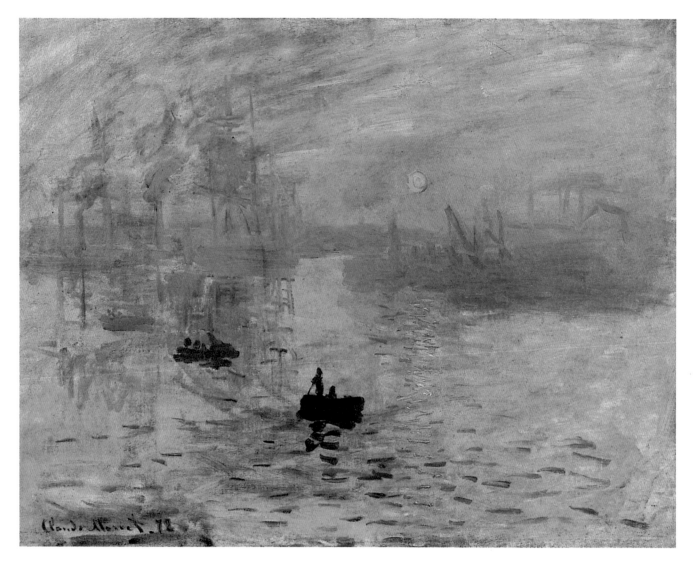

CLAUDE MONET, IMPRESSION, SUNRISE

In titling his picture *Impression, Sunrise*, Monet was adopting a current use of the term 'impression' to describe rapid notations of weather effects. He later said that he had called it this 'because it could not pass as a view of Le Havre'; it lacks the topographical detail which would have qualified it as a view of the seaport.

Although Monet and his colleagues included other, more highly finished views in the exhibition they organised in 1874, several critics singled out Monet's picture as the keynote of the show, and named the group 'Impressionists'.

With its broad sweeps of liquid colour, punctuatedd by the vivid accent of the sun, *Impression, Sunrise* met none of the contemporary requirements of a finished painting; but fellow artists and enlightened art lovers of the period admired such pictures for their virtuosity as a display of the painter's ability to capture in paint the most fleeting effects.

Monet's canvas also went against current conventions by showing a busy modern commercial seaport; by the 1870s Le Havre was France's largest port. However, the coastal scenes in the art exhibitions of the time generally showed neither commerce nor the tourism which was increasingly invading the beaches of the Channel coast in summer, but presented the seaside as the preserve of local peasants and fisherfolk.

tury. Renoir's *La Loge (The Theatre Box,* pl. 342) was another of the more finished works exhibited, and was quickly sold for a good price to a dealer.

Many of the subjects chosen by the Impressionist group in the 1870s were conspicuously modern, and thus quite unlike the landscapes generally shown at the Salon, which presented nature and the countryside as an unspoilt haven, remote from the city and from technological progress. It was a period of dramatic change in France: the industrial revolution – which began far later than in Britain – was at its height from the 1850s to the 1870s; and at the same time the centre of Paris was being transformed by Baron Haussmann, working under the instructions of Napoleon III, who sought to change the old city into a great modern metropolis by cutting axial boulevards through the old *quartiers.* These changes continued after Napoleon III's fall and the Franco-Prussian War of 1870–1. Courbet, who was always associated with the radical political opposition to Napoleon's reign, became a member of the short-lived Paris Commune of 1871; after its bloody suppression he was held responsible and imprisoned for the demolition of the

Vendôme column, a symbol of French imperial power. He died in exile in Switzerland in 1877.

The paintings of Manet and the Impressionists reflected the social changes of the time in their choice of subjects – the contrasts between old and new Paris, the rise of new social classes, public pleasures, the spread of industry and the growth of the suburbs. Until recently, historians have tended to treat the subjects they chose as unimportant – as merely the raw material for their experiments in technique. But recent research has emphasised the links between subjects and technique, suggesting how the emphatic, broken brushwork and the pantheistic touch which treats all elements in a scene alike can be understood as summing up the essence of the experience of the modern world. This was seen by some contemporaries, too. Frédéric Chevalier wrote in 1877:

The disturbing ensemble of contradictory qualities ... which distinguish the Impressionists ... the crude application of paint, the down to earth subjects, the appearance of spontaneity, ... the conscious incoherence, the bold col-

358. CLAUDE MONET: The Promenade at Argenteuil, *c.1872. National Gallery of Art, Washington DC. Ailsa Mellon Bruce Collection.*

ours, the contempt for form, the childish naïveté that they mix heedlessly with exquisite refinements ... all of this is not without analogy to the chaos of contradictory forces that trouble our era.

In the 1870s, both Manet and the Impressionists focused their attention on the outer fringes of Paris and on the city's entertainments. They worked in particular in the areas on the river Seine to the west and north-west of Paris, around Bougival, Chatou and Argenteuil, which were at the time a meeting-point of three different worlds: that of the old rural, agricultural villages of the Ile-de-France, and, invading it, the world of bourgeois pleasure-seekers from Paris and that of developing industrialisation. Sometimes different aspects appear together, as in Monet's *The Promenade at Argenteuil* (pl. 358), but many pictures focus on a single facet of the place depicted – either on the nondescript old village, as in Pissarro's *View of Louveciennes* (pl. 359), or on the world of leisure and pleasure, as in Renoir's *Luncheon of the Boating Party* (pl. 360), painted at nearby Chatou. The purpose of the paintings was not to provide a social anatomy of a changing world, but rather to create landscapes of different

types which might appeal to their Parisian viewers and potential buyers; in depicting modern scenes, they were creating new types of landscape, but this was part of their overall purpose – to create markets for distinctively modern types of painting.

Manet continued to explore the most problematic aspects of the modern scene. He focused particularly on places of recreation and entertainment, suggesting by the way he grouped his figures that human relationships in such places were ambiguous or illegible. This appears most vividly in *A Bar at the Folies-Bergère* (pl. 361), which evokes the ambivalence of women's status in such places of entertainment. There is a deliberate distortion of literal truthfulness in the inconsistency between the remoteness of the figure who faces the viewer and the image seen in the mirror reflection behind, in which the barmaid seems to be chatting with her customer.

The Impressionists' paintings of urban entertainments ranged from the ballet and the smart theatre to places of popular amusement. They were mainly interested in rehearsals, audiences and unusual angles of view, so that even a formal performance is seen in an unusual light. In Degas's *Ballet Rehearsal on the Stage* (pl. 362), for

ABOVE 359. CAMILLE PISSARRO: View of Louveciennes, *1870. National Gallery, London.*

OVER 360. PIERRE-AUGUSTE RENOIR: Luncheon of the Boating Party, *1881. The Phillips Collection, Washington DC.*

327

361. EDOUARD
MANET: A Bar at the
Folies-Bergère, *1881*.
*Courtauld Institute
Galleries, London.
Courtauld Collection.*

instance, the stage itself is seen from high up and to the side, and the dancers in the foreground, resting, stretching and scratching, come between us and the group which is performing. In the ways in which they arranged their pictures, the artists looked to Japanese colour prints, newly fashionable in the West since the reopening of trade routes with Japan in the 1850s. The customary cut-off compositions and oblique angles of vision in Japanese prints seemed to them a particularly modern way of viewing the world around them. This is most marked in the work of Degas, whose interest in odd angles of vision was later to be taken up by photography; until the 1880s, photographs were taken by large cameras on tripods, and photographers generally adopted far more orthodox viewpoints.

One of the Impressionists' central concerns was with the act of seeing itself. This appears in their art in a number of ways: in their compositions, with their unexpected angles of vision; in their brushwork, with its equally weighted, pantheistic touches; in their working methods – the landscapists in the group sought to complete as much as possible of their paintings in front of their actual subjects; and at times in their subjects themselves. Renoir's *La Loge* (pl. 342) plays on this: the woman holds her opera glasses in her

hand, and looks vacantly out in front of her, while her male companion looks through his glasses – upwards, not at the stage, but at another box and implicitly at another woman. This gendered stereotype of a man seeing and a woman being seen was wittily reversed by the American Mary Cassatt (1844–1926), who was closely associated with the group, in *Woman in Black at the Opera*, where the woman looks firmly out through her glasses at another box – but is herself the object of the gaze of a man in the background.

In many ways the example of both Courbet and Manet was very important for the Impressionists. Courbet's defiance of the Salon and his privately organised exhibitions were a rallying-point for them, and they shared his insistence that the artist should paint only what he could see. Manet's example was paramount, both in his handling of paint and in his exploration of problematic contemporary subjects. However, during the 1870s the landscape painters of the group, particularly Monet, Pissarro and Sisley, began to concentrate more on the play of light and atmosphere on their subjects, rather than on the distinct objects within the scene; and by around 1880 most of the group had abandoned explicitly modern subjects. Various factors probably contributed to this major change of direction in their

art. The Impressionist group exhibitions of the 1870s had not won them secure commercial success or critical reputation, and they began to seek other outlets for their paintings; in 1881 the dealer Paul Durand-Ruel began to buy much of the work of Monet, Renoir, Pissarro and Sisley. This change in markets may have led them to abandon their more controversial types of subject matter; and at the same time they began to finish their paintings more fully, again at the encouragement of Durand-Ruel. Their increasing preoccupation with effects of light, too, deflected attention away from the subjects they painted towards the ways in which they were treated; modernity increasingly lay in the manner of painting, not in subject matter. This is part of a broader shift towards what has come to be known as modernism, an attitude towards art which sees the frank exploitation of the physical properties of the medium being used as the defining characteristic of the true work of art. Modernist readings of the earlier paintings of Courbet and Manet have focused on their pictorial qualities at the expense of their polemical content, but recent research has sought to redress this balance, by focusing on their original contexts. Yet in the later work of the Impressionists the elaboration of technique, the unification of the whole picture surface into an integrated harmony of brushwork and colour, is no longer a means of evoking the disjointed experience of the modern world. Pissarro, a committed anarchist in the tradition of Proudhon, presented rich, harmonious images of rural work as a vision of a world of peaceful, co-operative coexistence, as in *Apple-Picking at Eragny* (pl. 364).

In the 1880s, Monet became preoccupied with raw nature, particularly emphasising the opposing forces of land and sea. He prided himself on his physical heroics as an outdoor painter. As Courbet had before him, he painted at Etretat on the Normandy coast; but, whereas Courbet had focused on the physical mass and texture of the spectacular cliffs and rock arches, Monet was more concerned with the play of light and weather across them. Observers watched him painting on the beach on November mornings 'with water streaming down under his cape . . . while the salt water spattered him', and the novelist Guy de Maupassant saw him 'grasp in his hands a shower beating on the sea, and fling it on his canvas'. His battle with the elements nearly proved his undoing at Etretat, when a misreading of the tide tables led him to be swept away by a wave when he was painting the Manneporte, a huge rock

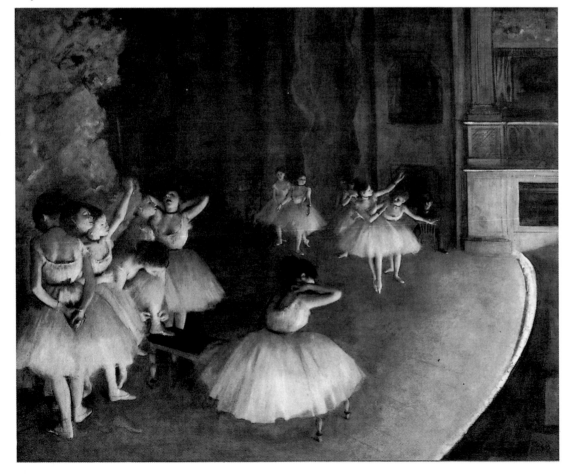

362. EDGAR DEGAS: Ballet Rehearsal on the Stage, *1874. Musée d'Orsay, Paris.*

ABOVE 363. CLAUDE MONET: The Manneporte, Etretat, (I) *1883. Metropolitan Museum of Art, Boston.*

RIGHT 364. CAMILLE PISSARRO: Apple-Picking at Eragny, *1888. Dallas Museum of Fine Art, Texas.*

lems, particularly on the Channel coast: the weather is rarely the same for two days in a row, and the changing times of the tides make it impossible to find again the same combination of lighting and water level. Moreover, on Durand–Ruel's encouragement, he was seeking to finish his pictures more fully. Paintings begun outdoors needed extensive reworking in his studio.

By the 1890s Monet was less concerned with dramatic effects than with the atmospheric *enveloppe* of the scene before him. Effects of light and atmosphere had fascinated him from early on, but now the objects in his scenes were subordinated to the ever-changing veils of coloured air which surrounded them and brought them to life. Notionally he was seeking to capture 'instantaneity', but his dissatisfaction with the rapid sketch meant that the elaborate final surfaces of his pictures emerged in the studio. His subjects were varied – trees, riverbanks, stacks of grain (pl. 365), Rouen Cathedral – but their treatment increasingly displaced attention from the associations of the subjects themselves.

In his final works, he tried to resolve the paradox of his desire to capture the instant in elaborate, highly worked paintings. He began around 1900 to focus on the water garden which he had

arch, from the beach.

In pictures such as his views of the Manneporte (pl. 363), his vigorous dabs and swirls of colour seek to evoke the immediacy of the natural scene, but outdoor painting posed practical prob-

built himself at his home at Giverny in the Seine valley (pl. 366). Here he could work out of doors summer after summer when the weather was right, but he could also work close by in his studio, where his memory would be at its freshest, in order to bring his pictures to the degree of finish he sought. There is a paradox, too, in the fact that the ideal 'natural' subject for his studies of the play of light across water was a totally artificial man-made subject, his own water garden, tended in his last years by six full-time gardeners. Nature itself is made into art, before being translated into art. In contrast to his early works, nature only supplies the raw materials, for the artist to transform.

Monet presented his final works, his Water Lily Decorations, to the French state, which installed them to his specifications in the Orangerie in Paris. This brought his career in a full circle from his beginnings in the 1860s, when, along with Manet's, his modern subjects were unacceptable to the state-organised Salon. During these years, the essential features of the modern art world came into existence. The Salon, with its hierarchies and honours, played a de-

creasing role, and the art market was dominated by independent art-dealers, primarily selling domestic-scaled pictures to private collectors. Increasingly, the art world and its institutions could accommodate the experiments of the *avant-garde*; modernism, with its emphasis upon technical experiment, could readily accept the new.

However, at the beginnings of this process, the challenges which Courbet, Manet and the young Impressionists launched against the Salon and its conventions were more radical in their implications. In the subjects they chose and in the ways they treated them, they presented to the public images of contemporary life which questioned accepted social and artistic hierarchies. These paintings now seem uncontroversial; indeed, the Impressionist image of nature has become one of the yardsticks by which late-twentieth-century Western culture defines the natural. But the history of the period shows that this was not always so, and that this vision of modernity and the open air was conceived in overt opposition to the official art of the period, and to the official values for which it stood.

365. CLAUDE MONET: Haystack at Sunset near Giverny, *1891. Museum of Fine Arts, Boston. Juliana Cheney Edwards Collection.*

366. CLAUDE MONET:
Water Lilies (I), *1905–8.*
Museum of Fine Arts,
Boston.

14
POST-IMPRESSIONISM

GRISELDA POLLOCK

The critic Walter Benjamin called Paris 'the capital of the nineteenth century'. By this he meant that the cultural developments in that city from the mid-nineteenth century on were representative of the changes in society and culture out of which 'modernism' emerged as an international phenomenon. He also meant that there was an intimate link between the culture of modernism and the character of modern life in the metropolis. For a variety of historical reasons, Paris was the first city to experience the configuration of economic, social, cultural and ideological forces which made it the capital of modernity. It was there, too, that the phenomenon of the *avant-garde* first clearly emerged: artists from all over Europe and from further afield came to Paris to work, or looked to what was happening there; and in no art was the city's leadership more marked than in painting.

Some art histories have tried to match what happened in architecture and sculpture to developments in painting. Medardo Rosso's (1858–1928) dreamy sculptures are dubbed Impressionist and Auguste Rodin (1840–1917) is hailed as the father of modern sculpture. Sculpture, however, remained a predominantly public art form, tied to official commissions from the Beaux-Arts administration and public exhibitions such as the Salon. Rodin made portrait busts and small-scale works, but, like most of his fellow sculptors, notably Camille Claudel

(1864–1943), he was chiefly concerned to secure public commissions and produce monuments (pl. 367). The aesthetic ideologies which were upheld by sculptors and critics as well as public officials until the early twentieth century were based upon traditional theories of sculpture, which used the human body to express important ideas and major themes of human existence (love, death, destiny, fate, courage, and so forth). Some of the key shifts in sculpture which led to the emergence of a modernist aesthetic can be found in the sculptures made by artists who were predominantly painters, such as Degas or Renoir, and, later Picasso. The real break in sculpture does not come about until the early years of the twentieth century, when the effects of the artistic, institutional and ideological changes which are associated with *avant-garde* painting in Paris in the 1880s and 1890s extended to other art forms.

In 1891 the Belgian critic Emile Verhaeren wrote in *L'Art Moderne*,

> There is no longer any single school, there are scarcely any groups, and those few are constantly splitting. All these tendencies make me think of moving and kaleidoscopic geometric patterns, which clash at one moment, only to reunite at another, which now fuse and then separate and fly apart a little later, but which all nevertheless revolve within the same circle, that of the new art.

The umbrella term used in art history for what Verhaeren called 'the new art' is Post-Impressionism. It is not a very helpful term and was never used by the artists to whose work it was originally applied. The British critics Roger Fry and Desmond McCarthy invented it for two exhibitions of recent (mainly French) painting that they organised in London in 1910 and 1912. Isolating five major artists, Cézanne, Seurat, Gauguin, Van Gogh (a Dutchman) and, surprisingly, Manet, Fry and McCarthy defined the artistic changes after Impressionism in purely formal terms, emphasising questions of design, form and technique. Paintings were analysed as satisfying arrangements of lines and colours which solved formal problems. This interpretation of the meaning of modern art was extended by an influential American critic, Clement Greenberg. He claimed that modern art began once painting had liberated itself from its dependence on literature for subject matter and from its desire to produce illusion. Painting defined for itself new priorities, which involved acknowledging the flatness of the two-dimensional surface of a rectilinear canvas. Modernist art is consciously concerned with the character of the materials and medium of each art form. Thus, for Greenberg, writing in 1940, this line of development had reached its fulfilment with the emergence of abstract painting.

The formalist view of the origins and meaning of modern art has become standard in the museums, which display modern art as a gradual progression towards abstraction, starting with the Impressionists and Post-Impressionists. In this 'story of art' modern art is presented as a break with all previous art; we are told by A. H. Barr, a former director of the Museum of Modern Art in New York, that artists had grown bored with painting facts and imitating nature. Impressionism was the first move towards abstraction, but its forms were too boneless and its manner too casual. Four major artists heralded a revolution. Georges Seurat (1859–91) introduced systematised brushwork, applying colour in small regular dots (pointillism). He used a scientific theory of colour, known as Divisionism, and organised his paintings through strict and formal designs. Paul Gauguin (1848–1908) replaced the agitated surface of Impressionist painting with broad simple tones of colour, black contours, and quotations from archaic, Egyptian, oriental and peasant art forms. He opposed the scientific rigour of Seurat with an intuitive, conceptual or Symbolist attitude. Vincent van Gogh (1853–90) founded an Expressionist tradition, offering intense and arbitrary colour and a decorative treatment of line. Paul Cézanne (1839–1906), seen as the most complex and subtle painter of this period, pointed toward Cubism through his 'perception of the geometrical forms underlying the confusion of nature' and through his abandonment of perspective and deep space to create a whole through the 'angular, active curtain of colour' (Barr, *Cubism and Abstract Art*, 1936).

The formalist interpretation of early modernism is not wrong, it is only partial. There can be no doubt that in the 1880s and 1890s artists and critics became more concerned than ever before with formal, technical and stylistic issues. Yet formalism does not explain why this radical shift of priorities occurred. Furthermore, it simply ignores the fact that artists were still deeply concerned with *what* they were painting. We need to understand the necessity for novel styles of painting to deal with the subjects ambitious *avant-garde* artists felt were modern.

There was a crisis in the *avant-garde* in the 1880s. Artists lost faith in the Impressionist project. But it was not through boredom with painting facts. It was as a reaction to the compelling social and historical circumstances with which artists were confronted in their attempt to make a new art in response to the challenges of modern life. The world was changing rapidly, and it was difficult to know how art could or should engage with it. What should be pictured – the leisure and pleasure of a remade bourgeois city, with its weekend retreats and garden suburbs, or the desolation of the industrialised suburbs, or yet again the permanent values attributed to a traditional countryside seen as the opposite of the city ruled by money and commodities? Should they celebrate or condemn modernity or could painting only survive by withdrawing into a realm of its own?

A variety of solutions were offered in rapid succession and equally quickly they were challenged or abandoned. But underlying many painters' practices was an impulse to make their pictures more structured. It has been argued that the reintroduction of rigorous painting methods or tightly organised composition is evidence of a longing for the order which artists could no longer find in the social world around them. This longing led in two directions: on the one hand, towards a utopian dream of social harmony, and, on the other, towards a Symbolist fantasy of aesthetic harmony – a left- and a right-wing response to modern life. Either way, the artist distanced himself to some degree from the world in

which he lived and painted. Indeed Félix Fénéon, the apologist for Seurat and the Neo-Impressionists, wrote of Gauguin in 1889, 'M. Gauguin works towards an analogous end but by different means. For him reality is but a pretext for distanced creations.'

THE IMPACT OF SEURAT

In 1881 the Impressionist painter Renoir could still produce a picture such as the *Luncheon of the Boating Party* (pl. 360), a sun-filled, genial image of casual sociability. The informal composition makes the viewer imagine him or herself a part of the scene. Most of the people collected on the veranda of the Restaurant Fournaise on the island of Chatou in the Seine can be recognised as friends, lovers or models from the artist's milieu. The representation of leisure and pleasure and the artist's explicit evocation of places and faces familiar to him were defining characteristics of the painting of the 1870s.

In 1886 Seurat challenged this conception of modern life by exhibiting *Sunday Afternoon on the Island of La Grande Jatte* (pl. 372) at the eighth and last Impressionist exhibition (it was also seen again in September 1886 at the second Salon of the newly formed Indépendants). The Grande Jatte is another island in the Seine where people went to display themselves and enjoy the fresh air on a Sunday outing. We can identify nannies, soldiers and oarsmen, as well as a well-to-do bourgeois with his mistress. But the systematic pointillist application of paint by means of regular dots, and the rational organisation of colour and composition force a radically different experience of such places of leisure and recreation. Immediately we confront a style of painting which distances us from the scene and inhibits empathy or identification with the stiff figures, some verging on the caricature, others disinterested and aloof. Renoir's painting satisfies the fantasies we have about such outings; Seurat's stresses the constraints involved in social rituals. The figures are defined by a kind of hard-edged legibility which allows no fantasies. In the effort to describe Seurat's effects, critics were driven to write of mechanical dolls and Egyptian hieroglyphics, expressing the distance at which we, the viewers, are kept. *Sunday Afternoon on the Island of La Grande Jatte* was a watershed in *avant-garde* painting of the 1880s. No ambitious artist could paint again without acknowledging what Seurat had done to the typical Impressionist subject matter.

Seurat's rigorous procedures attracted many followers known as Neo-Impressionists. They in-

cluded Paul Signac (1863–1935) and the former Impressionist painter Camille Pissarro, who radically altered his methods and adopted pointillism. Seurat's impact can also be traced in the work of Emile Bernard (1886–1941) and Henri de Toulouse-Lautrec (1864–1901), who used caricature or more direct irony to emphasise the unregulated sexuality that pervaded the places of leisure and entertainment which continued to interest them, as in Toulouse Lautrec's *At the Moulin Rouge* (pl. 369). Seurat's *Le Chahut* (pl. 370) shows him following them in finding matter for his art in such places.

Seurat's earlier canvas *Bathers at Asnières* (1883–4) also pointed in new directions. This painting, set on the other, proletarian side of the Seine, in full view of the industrial suburbs, shows workers taking a break from factory labour. The industrial suburbs, barely veiled in *La Grande Jatte*, became a major new area of exploration for *avant-garde* artists, but, in trying both to acknowledge and overtake Seurat, painters began to play self-consciously with style. In works such as Bernard's *Bridge at Asnières* (pl. 371) and *La Place Clichy* (pl. 373) by Louis Anquetin (1861–1932) style has become idiosyncratic, a form of self-advertisement in a competitive sub-culture.

Despite the visible diversity, there was still agreement that key aspects of modern Paris remained the important subjects for advanced and ambitious painting. Seurat, Signac, Anquetin

369. HENRI DE TOULOUSE-LAUTREC: At the Moulin Rouge, *1892. Art Institute of Chicago. Helen Birch Bartlett Memorial Collection.*

OVER ABOVE 370. GEORGES SEURAT: Le Chahut, *1889–90. Rijksmuseum Kröller-Müller, Otterlo.*

OVER BELOW 371. EMILE BERNARD: Bridge at Asnières, *1887. Museum of Modern Art, New York.*

and Vincent van Gogh lived and worked in an area of Paris north of the fashionable streets around the Place de l'Europe favoured by their Impressionist elders. In the streets around the Avenue, Place and Boulevard de Clichy, they had their homes and studios, using the restaurants in which they ate to hold informal exhibitions of their work. In practice they oriented themselves away from the grand boulevards towards the industrial zones north of Paris, around the fortifications. Van Gogh had come to Paris from the Netherlands in March 1886. His *Boulevard de Clichy* shows him painting this part of Paris soon after his arrival.

For the Neo-Impressionists, painting the industrialised and proletarian quarters of the city was a political act. Signac and his colleagues were involved with the anarchist movement, and in the anarchist journal *La Révolte* Signac wrote that the Neo-Impressionists were bringing their witness to the great social struggle taking place between workers and capital. Their interest in formally organised and harmoniously composed pictures was a way of signalling through aesthetic harmony the social harmony that anarchism would bring about. But it was not only the Neo-Impressionists who, as in Signac's *Gas Tanks at Clichy* (pl. 375), were attracted to the wastelands on the margins of Paris. Artists of all political persuasions felt that this marginal territory was where the modern could almost be grasped. Nowhere was the radical instability that typified an era of rapid and uncontrolled social change more strikingly evident than here.

Consider Signac's 1883 painting *The Road to Gennevilliers* (pl. 374). A major road has been laid out linking the bridge at Clichy with the village of Gennevilliers, itself still quite agricultural, but in sight of the industrialised suburb of Asnières, locale for Seurat's *Bathers* the next year. The urbane Impressionist painter Gustave Caillebotte (1848–94) had his country house at Gennevilliers. What is remarkable here is that the viewer is made to look *back* towards Paris across the empty spaces of land in the process of change. Marked out with streets and lamp posts, awaiting builders and factories, this area is no longer countryside. The sheer expanse of empty land is disturbing, and the scene as a whole is the antithesis of earlier landscape painting. The distance between the viewpoint from which the painter worked and any other signs of human activity forces a fundamental question. Why should anyone paint this scene, so devoid of incident and obvious meaning?

Although still on the margins of the *avant-garde*,

GEORGES SEURAT, SUNDAY AFTERNOON ON THE ISLAND OF LA GRANDE JATTE

Every element in the title of Georges Seurat's *Sunday Afternoon on the Island of La Grande Jatte*, painted between 1884 and 1886, helped to secure a specific set of references for the painting. The fact of Sunday indicates that it depicts popular and not élite leisure since the typical working week was six days. Yet working class people often refused to take Sunday off for it was costly to have special clothes and participate in imitation bourgeois rituals. Critics recognised the precision of the social mix in Seurat's painting when they invoked the political phrase 'new social strata', coined by the republican president Léon Gambetta to herald the republican revolution. The island of La Grande Jatte lay between fully industrialised and proletarian zones of Paris and still predominantly middle and petit bourgeois townships, a tiny lick of in-between land with nothing to develop, allowing space for the odd dance hall, some grass to sit on, and moorings for boating enthusiasts.

Most critics tried to define the specific effect of Seurat's methodical manner of composing and painting, combined with the calculated choice of a venue with so particular a social character. The very 'science' of his colours, the precision of his outlines, the fixity of each figure within its own boundaries and hence social space, provided a pictorial language which viewers recognised. It articulated the modernness of the scene in a way that was not anecdotal nor humorously ironic, but insistently formal – like modern life itself was turning out to be.

341

373. LOUIS ANQUETIN: La Place Clichy, *1887. Wadsworth Atheneum, Hartford, Connecticut. The Ella Gallup Sumner and Mary Catlin Sumner Collection.*

LEFT 374. PAUL SIGNAC: The Road to Gennevilliers, *1883. Musée d'Orsay, Paris*

BELOW 375. PAUL SIGNAC: Gas Tanks at Clichy, *1886. National Gallery of Victoria, Melbourne , 1948 .*

376. VINCENT VAN
GOGH: Paris with
Horse-Tram (View
Outside the
Fortifications), *1887.*
Rijksmuseum Vincent van
Gogh, Amsterdam.

377. GUSTAVE
CAILLEBOTTE: Paris,
A Rainy Day, *1876–7.*
Art Institute of Chicago.
Charles H. and Mary F.S.
Worcester Collection.

Van Gogh also tried to represent these ragged
edges of the city. He made a series of watercol-
ours of the *zone* around the fortifications of Paris,
at the Clichy gate. Here working people stepped
down from the horse-drawn trams to take a walk
and breathe the 'fresh air' in a place that was
neither city, nor country, nor actually a suburb.
To the north were the industrial townships of St-

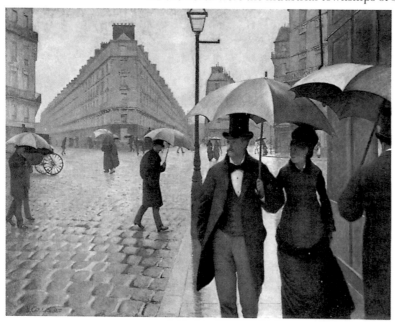

Denis, St-Ouen and Clichy itself. But just by the
fortifications was an area in the process of becom-
ing urban while still available to offer a parody of
the pleasure grounds of the middle classes. In
Van Gogh's watercolours such as *View Outside the
Fortifications* (pl. 376), the ungainly figures are in
marked contrast to the elegant silhouettes in
Seurat's *Grande Jatte* or the comfortable bourgeois
in Caillebotte's *Paris, A Rainy Day,* (pl. 377). Cail-
lebotte lived in the area of Paris he depicts, and
the viewer is invited to feel part of the urbane
street life. In Van Gogh's watercolours both the
artist and the viewer are kept at a distance by the
vast empty foregrounds. But the telling peculia-
rity of the Van Gogh watercolours comes from the
unedited literalness with which the scene by the
fortifications is drawn – women with parasols
strolling on a dirt track, tramps in the ditches, the
skyline unevenly pierced by piecemeal develop-
ment: a factory here, a block of apartments there.

The problems that such scenes posed for the
artists who tackled them are evident from the
pictures themselves. Again and again these
paintings suggest that their subject defeated the
painters, kept them at distance, forced them to
give up the attempt to make sense of what they
were seeing and substitute for the evasive social
order a purely formal and pictorial order. In

378. GEORGES
SEURAT: La Luzerne,
*1885–6. National
Gallery of Scotland,
Edinburgh.*

Seurat's *La Luzerne* (pl. 378) we gaze over a culti-
vated field to the factory town of St-Denis. The
foreground, vast and empty, extends more than
halfway up the canvas. There is very little on
show except a lot of brushwork.

The order, design and internal arrangement of
the picture replaces the attempt to elicit the
meaning of what is being represented. Félix Fé-
néon wrote about Seurat and Gauguin in terms of
an art of premeditation and synthesis. It is ex-
traordinary that an *avant-garde* critic should in
fact be reintroducing ideas from traditional
theories of art with which the Impressionists of
the 1870s had summarily dispensed. In French,
synthèse (synthesis) is another word for composi-
tion, which was central to the academic theories
of art. The Impressionists had wilfully aban-
doned all formulas for composition in the attempt
to make perception the sole basis of painting.

In the *avant-garde* circles of the 1880s, there
could be no simple return to academic theories –
but there was a definite sense that the Impres-
sionist concern with visual phenomena alone
could not sustain painting. Premeditation and
synthesis were brought back in the name of a
more scientific approach, or, more often, as part
of a concern for the absolute necessities of art it-
self. This is when artists first started bandying

around such words as 'abstraction'. In so doing,
they did not announce an intention to abandon
subject matter, but signalled the priority they
attached to formal concerns.

Modernism was produced out of this crisis.
How could painting engage with the vivid and
significant experiences and social upheavals of
the modern world? The subjects and areas which
were agreed to be the critical sites of modern life
presented the artists with considerable difficul-
ties: what is it about the underlying processes of
capitalism that can be captured – let alone ex-
plained – by a picture of its physical con-
sequences? Those paintings of the industrial
frontiers of Paris suggest the answer: very little.

The decisive shift towards twentieth-century
art, which so often abandons the attempt to en-
gage with the social forces of modern life, was
only intimated in the 1880s and 1890s. Eventual-
ly there emerged a full ideology of modernism in
which art was presented as a surrogate realm,
different from the world, concerned with nature,
the spirit, the unconscious, the ineffable, the sub-
lime, the primal – art movements of this century
can be matched to any of these referents. The
painting of the 1880s and 1890s witnesses the
struggle between an agenda inherited from the
Impressionists which demanded some negotia-

379. PAUL GAUGUIN:
Among the Mangoes:
Martinique, *1887*.
Rijksmuseum Vincent van
Gogh, Amsterdam.

tion with modern life in its most vivid form – the city – and a gradual withdrawal into personality, style, art. The intermediate stage was the exploration of the country as a site for *avant-garde* art.

AVANT-GARDE COLONIES IN BRITTANY AND PROVENCE

Under Seurat's tutelage and the influence of anarchist politics the *avant-garde* had tried to colonise the industrial suburbs. Starting with Gauguin, many leading artists abandoned the city, moving into regions and cultures to which they were strangers.

Gauguin had become involved with the Impressionist group in 1879 and exhibited at their shows. Introduced to their techniques by Pissarro, he regularly spent his summer holidays (he worked in a bank) painting with the older man. In 1886 he first went to Brittany to paint, and then in 1887, having been forced out of his job, he went to dig canals in Panama and visited Martinique. *Among the Mangoes: Martinique* (pl. 379) dates from this period.

As a result of European colonisation in the nineteenth century, many Europeans came to know the rest of the world as part of their leisure activities. They travelled to foreign places where the people's rituals, lifestyles, culture and espe-

cially their labour were appropriated for the tourist's enjoyment. Even in regions nearer home, the local people and their ways of life were not appreciated for themselves but seen in terms of their otherness. Whether we are looking at paintings of Breton peasants harvesting or worshipping, or, as after 1891, at Tahitian people gathering fruit or fishing, Gauguin painted such scenes as a tourist. We, the viewers, are both kept at a distance and entertained through lavish colour, archaic forms, simplified faces, exotic and unfamiliar customs. We know that many of Gauguin's stories about Tahitian life and religion were partially invented. A need to believe in otherness and to sustain the notion of the world of untouched primitives is part of tourist mythology – and necessary precisely because tourism means that the society in question has been invaded, colonised and threatened with extinction. This contradiction is central to the artifice of Gauguin's work and to the way it was assimilated into European culture in the 1890s as Symbolism. Literary Symbolism had been announced by a manifesto in 1886 and critics began to apply it to painting in the 1890s. It was a form of secular religiosity, claiming that the phenomenal world was a mere casing for real, universal meanings. Symbolist art was therefore not concerned with describing the

visible world; Symbolists were vehemently anti-Realist, anti-Impressionist. The formal properties of art were to be used to discern and reveal the true, underlying forces and meanings of the world – what had previously been called God but now came clothed as the Idea. Gauguin's decorative and stylised images of a fictional Tahitian society and its religion could be accommodated to this aesthetic, in which accuracy or truth to the concrete social world was irrelevant.

In responding to the opacity of modern life, the *avant-garde* had resorted either to political analysis (as in the case of the anarchist Neo-Impressionists) or to a kind of evasiveness and retreat. They turned to a world that seemed to offer some surety of meaning, something that could be beautifully painted. Bernard and Gauguin left Paris in 1888 and set up an *avant-garde* colony in the village of Pont-Aven in Brittany, already much frequented by artists of all schools and nationalities. Brittany was well developed as a tourist area, with decent hotels and good communications. The southern coast of Brittany was prosperous and fertile with a rich peasantry who donned recently invented and elaborate costumes on Sundays and feast days, offering the exotic spectacle of apparent otherness to the in-creasing hordes of tourists attracted to the area by the revival of interest in Celtic mythology, customs and antiquity. Images of Breton people at religious festivals were very popular at the Salon.

In August 1888 Bernard painted *Breton Women in a Meadow* (pl. 380). It clearly refers to the tourist or Salon visions of Brittany, but more importantly, it is a reworking of Seurat's *Grande Jatte*. The Breton people pictured here are different from the crowds who thronged to the island in the Seine, but they are doing the same thing. It is a Sunday outing. The theme is display and leisure. The people's costume is not modern bourgeois dress but it signals their wealth. Bernard has, however, introduced three figures in modern dress – perhaps to make the connection with Seurat. When Van Gogh saw the painting, he made a copy. He noted the women with their parasols and called it 'a very modern thing'. He even named his work *Sunday Afternoon in the Meadow* – directly referring to Seurat's title.

While ensuring that his picture would recall Seurat's, Bernard also took pains to differentiate it through his style. Indeed, the painting shows Bernard developing a new kind of stylisation, using a range of new resources – notably medieval art and Japanese prints. It is a tissue of

380. EMILE BERNARD: Breton Women in a Meadow, *1888. Private Collection.*

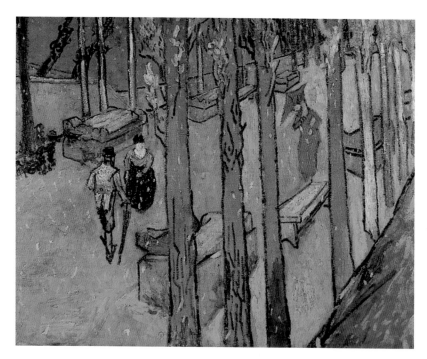

RIGHT 382. VINCENT
VAN GOGH: The Crau
with Peach Trees in
Bloom, *1889. Courtauld
Institute Galleries, London.
Courtauld Collection.*

quotations in which styles become elements of a new vocabulary through which the *avant-garde* artist advertises his or her speciality. The picture must conform to the 'rules of the game' in order to be recognised as part of the *avant-garde*. Bernard's painting shares its subject with Salon art, but is distinguished from it by its prominent use of artistic devices. The painting is not one which gives us access to or empathy with Breton people on holiday. It invites us to scrutinise the surface, to judge how successfully the painter has managed to avoid traditional forms of composition and pictorial construction and none the less hold the visual field together by the manipulation of painted marks and colours.

It also involves us in a new relationship to the people represented in the painting. We are being asked to accept the right of the *avant-garde* artist to manipulate the appearance of people in accord with the dictates of style. What does it mean to medievalise a Breton peasant, or to transform Brittany (or Provence) into Japan? It means a loss of specificity for the world being painted and a shift in the status of the person as subject. People thus painted are not the subjects of representation. They have been manipulated as resources in a stylistic game. It is a telling fact about the forms of power involved that it is more

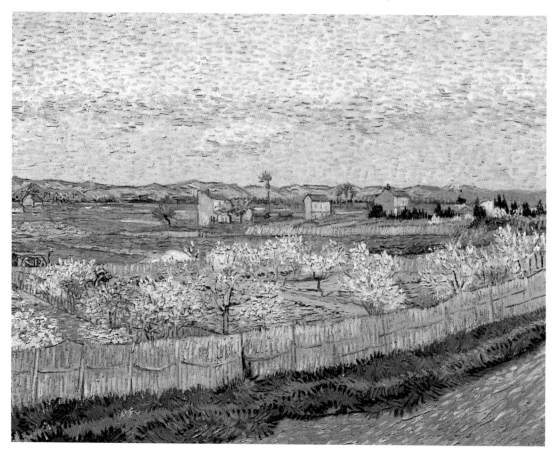

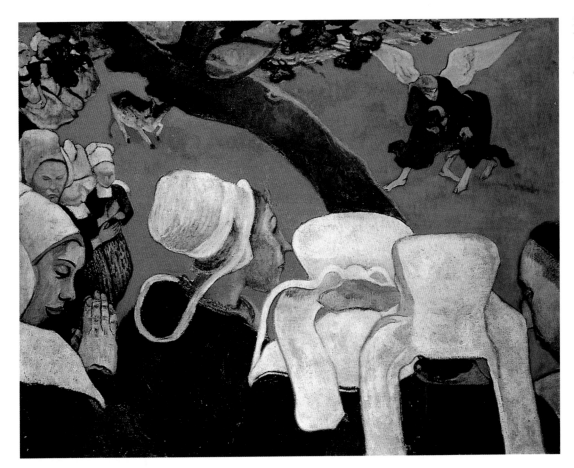

383. PAUL GAUGUIN:
Vision After the Sermon,
*1888. National Gallery of
Scotland, Edinburgh.*

often the *women* of other classes and races who are subjected to such treatment.

Within a few weeks of the completion of Bernard's painting, Gauguin produced his bid for leadership of the *avant-garde*. *Vision After the Sermon* (pl. 383) offers us a field in which pious Breton women leaving church vividly imagine the scene described to them in the sermon they have just heard. Such a description makes the picture quite anecdotal, almost a traditional narrative. It might be seen as religious painting, or at least a painting about religious experience. What place would such a picture have in *avant-garde* circles and concerns? The painting was a bit of a gamble, but by 1890, when the critic Albert Aurier had begun to apply Symbolist ideas to works by Gauguin, the picture was seen in right-wing Catholic revival circles as an endorsement of peasant traditions and the visionary qualities of the 'simple people'. In 1888, however, it was a one-off painting, an attempt to use religious themes to break with the realist programme of Impressionism. Fénéon's phrase for Gauguin's work was 'distanced creations', and this stresses both the imaginative invention of the subject and the distance put between the spectator and the peasant women. Gauguin relies on the stereotype

of the gullible and priest-ridden religiosity of women and the Parisian's view of the peasantry as simple and superstitious. The painting's narrative clearly indicates the distance of the metropolitan tourist from the people amongst whom he painted.

In February 1888, after just two years in Paris, Van Gogh went to the town of Arles, in Provence. He had been brought up in the Dutch countryside, but rural France was not familiar to him. He hardly saw it for what it was. He made its agriculture, architecture and peoples a prop for imaginary landscapes derived from Japanese prints and memories of paintings of seventeenth-century Holland (pl. 382). Like a typical Northerner, he imagined the sunbleached South as a place of vibrant and exotic colour. Furthermore, he remade Arles in the image of the Paris of the *avant-garde*. Thus he painted cafés in the town centre and compared the scene to the Champs Elysées and novels by Maupassant. He also constantly thought about Seurat, and painted public gardens and promenades (pl. 381), scenes at the dance halls – Arlesian versions of *La Grande Jatte* and *Le Chahut*.

Van Gogh was intensely interested in what the Pont-Aven group was doing – and intensely com-

349

petitive. His response to Bernard and Gauguin developed in the period when Gauguin visited him in Arles (October–December 1888). He saw drawings and paintings by the Pont-Aven group and learnt of their theories about the freedom of artists to invent their subjects, to stylise. He was, however, suspicious of Catholic imagery, and tried to make religious art modern through evocative use of colour and a typically Protestant nature symbolism – using suns, stars, trees striving upwards, and rural churches and villages. He looked back to the French Realist genre painter Jean François Millet but through the eyes of 1880s biographers, who presented Millet as a devout believer and religious painter.

In June 1889 Van Gogh painted *The Starry Night* (pl. 384). Set beneath the weird shapes of the Alpilles, the rocky outcrops near St-Rémy, where he was undergoing medical treatment, and incorporating a cypress tree so characteristic of Provence, the picture none the less seems to represent a Dutch village featuring a church which is a composite of the many Dutch churches Van Gogh had known in Holland, and a sky that recalls an etching by Rembrandt, *The Annunciation to the Shepherds*. Rembrandt was viewed in the nineteenth century as *the* humanitarian religious

painter. In his presentation of gospel themes using everyday scenes and a very human Christ, he was seen as a Protestant alternative to the stylised and intellectual iconographies of Catholic art. Unfortunately for Van Gogh, neither Bernard nor Gauguin recognised *The Starry Night* as a reply to their work. To them it was simply a picture of a village in moonlight. But Theo van Gogh, the artist's brother, aptly commented, 'I think the search for style is prejudicial to the true sentiment of things.'

CÉZANNE AND REPRESENTATION

Cézanne also worked in Provence. After a brief but decisive contact with the Impressionists, mainly Camille Pissarro, in the 1870s, he returned to the family estate in Aix-en-Provence, where he had grown up. From there he set out daily to paint the surrounding countryside, which was rich in associations from his boyhood. He was therefore neither a tourist nor a coloniser. His work is quite different from that of the artists discussed so far, although they all watched his work closely and wanted to learn from him.

Cézanne alone remained faithful to the Impressionist quest for a new art founded on direct observation and spontaneity. Day after day, over

384. VINCENT VAN GOGH: The Starry Night, *1889. Museum of Modern Art, New York.*

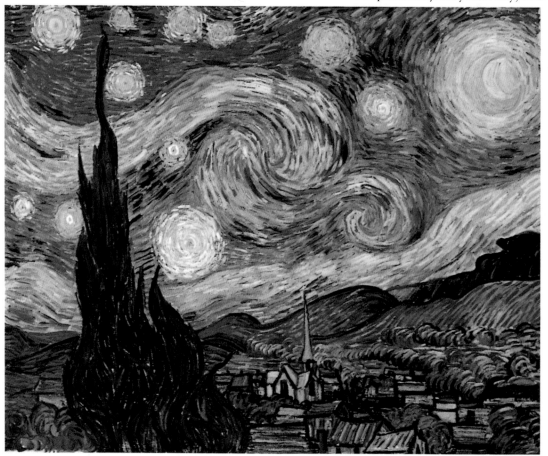

385. PAUL CÉZANNE:
Mont Ste-Victoire,
1902–6. Private Collection.

thirty years, he probed for an answer to the question: could a new art be made by refusing all inherited conventions and academic clichés, all easy recipes for painting, by being faithful to what he called his *petite sensation* – what he saw and what he felt? (*Sensation* in French means both perception and sentiment.) He patiently studied nature and abjured style, but was forced to acknowledge the limitations of art in capturing the richness of colour or the substance of form in nature. He wrote:

I wished to copy nature but I could not. But I was satisfied when I discovered that the sun could not be reproduced but that it must be represented by something else – colour.

Through this honesty in recognising that art could only represent and not replicate, Cézanne's work became extremely influential in the formation of Cubism, whose practitioners believed that the only way to define anything about reality was by self-conscious artifice in painting.

Although Cézanne's paintings are conscientiously composed and intensely coloured, they are the result of a total dedication to the study of the visible world. But the landscape Cézanne painted is never the abstraction 'nature'; it is always something worked, remade by human intervention or humanised, because even in its unworked state it is perceived and made meaningful by a human consciousness. 'The landscape thinks itself in me and I am its consciousness.' Even though there are no people working the fields, the way Cézanne paints the ordered sequences of fields and houses and sets these against the monumental permanence of Mont Ste-Victoire inscribes both the human activity that has shaped the landscape and the human sensibility that engages with it via painting (pls. 385 and 386).

When Cézanne painted the working people of the region he produced monumental portraits of people who can be neither sentimentalised nor patronised. Like Courbet before him, he maintains a respectful distance from his subjects (as in *Woman with Coffee Pot*, pl. 368). He cannot presume to know them; he does not dare to refashion them for his own, purely aesthetic purposes. Instead he submits them to the same discipline as the mountain – the patient analysis of the field of coloured light for which his paint brush and palette must find a sign, so that, taken as a whole, the network of tiny brush marks of colour will gradually build up the solid forms of people and objects in space.

OVER 386. PAUL CÉZANNE: Mont Ste-Victoire, *1885–7. Courtauld Institute Galleries, London. Courtauld Collection.*

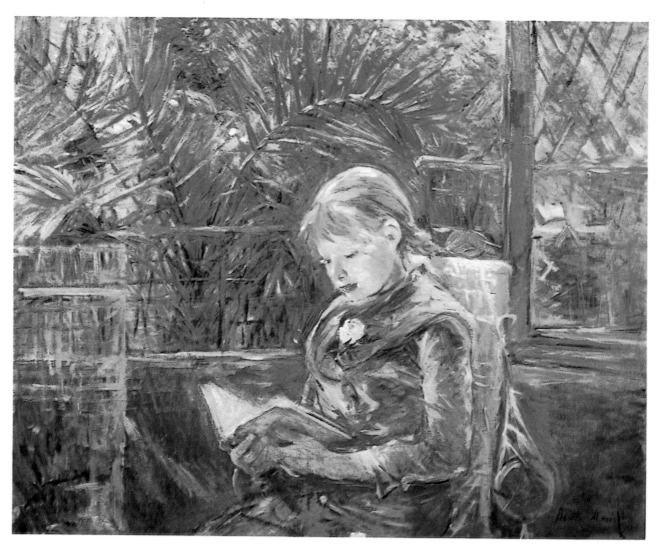

387. BERTHE MORISOT: Little Girl Reading, *1888. Museum of Fine Arts, St Petersburg, Florida.*

WOMEN ARTISTS AND WOMEN IN ART

So far we have looked at the problems of emerging modernism only through men's eyes. The *avant-garde* also included a number of women: Marie Bracquemond (1841–1916), Mary Cassatt, Eva Gonzales (1849–83) and Berthe Morisot. But, as middle-class women, there were limits to where they could go in the city. They had to be chaperoned at the theatre, in the park, in the department stores. This restricted what they could paint. Women artists had almost no access to the streets, bars, music halls, circuses or brothels which featured in the works of their male colleagues as the very declarations of their modernism.

But *avant-garde* women's art presents us with other, equally vivid aspects of modern life – the rituals and disciplines of middle-class femininity. Painting their friends, family and domestic employees, women depicted a known world of intimate social interactions. As a result their human subjects are never reduced to a mere pretext for aesthetic ingenuity. They retain their dignity and the paintings are based upon an acknowledged personal or social relationship between painter and subject (pl. 387). These paintings balance the tension between self-conscious *avant-garde* exploration of medium and form and the treatment of subjects from a world to which the artist belongs and is committed. Like Cézanne, Mary Cassatt painted working people – for instance, women who cared for the family's children. She also followed the example of Japanese art, but unlike Bernard, she used her interest in non-European art forms to achieve density and monumentality. In *The Bath* (pl. 388) the tilted perspective, the play of patterns – carpet, wallpaper, chest of drawers, dress – testify to her innovative use of the example of the Japanese graphics exhibited at a huge show at the Ecole des Beaux-Arts in 1891. But the effect is to concentrate attention on the solidly placed woman and child. The mundane act of bathing is for the woman part of her working day. It is also, like all

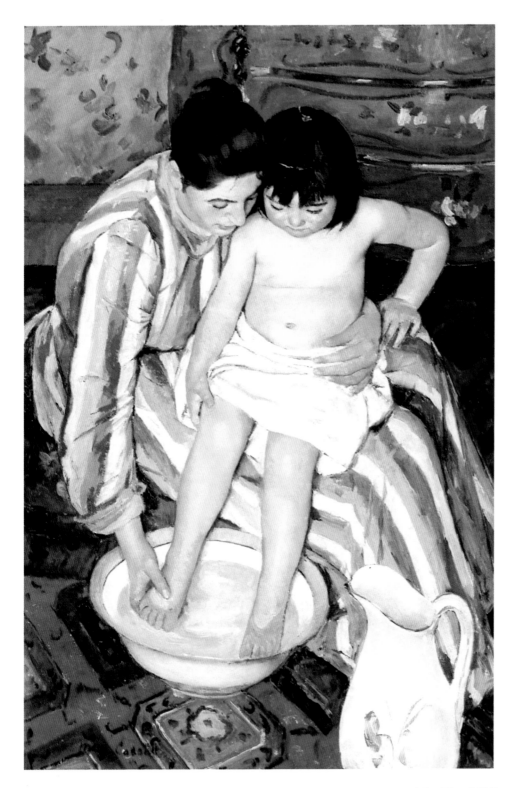

388. MARY CASSATT:
The Bath, *1891–2. Art
Institute of Chicago.*

actions in child care, a form of communication, and the painting manages to suggest the psychological interaction of the subjects.

Suzanne Valadon (1865–1938) came from the working class. One-time milliner and circus performer, she became associated with the *avant-garde* as an artist's model, and was painted in the nude by Renoir in *The Bathers* (1887). She also be-

came a painter in her own right. Her *Self-Portrait* (pl. 389) of 1883 belies Renoir's prettification of her gaunt features and intense presence. She is not presenting herself for the male gaze.

In the 1880s and 1890s that gaze expressed a kind of sexual tourism which was a persistent factor in modernist painting. The possibility or threat of commercial sexuality figures repeatedly

389. SUZANNE VALADON: Self-Portrait, *1883. Musée National d'Art Moderne, Paris.*

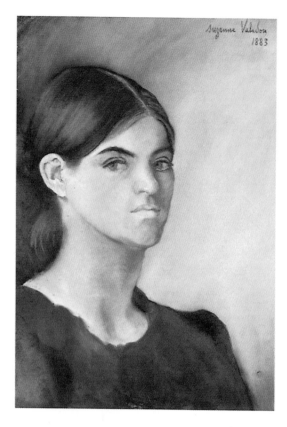

in works by Manet and the Impressionists – from *Olympia* through to *A Bar at the Folies Bergère*. It remains a theme in the art of the 1880s – notably in the work of Toulouse-Lautrec, Bernard and Anquetin. The invention of a simpler and more wholesome countryside may have banished the venality but not the sexuality. Transposed through the power of colonialism, it structured the later work of Gauguin in the South Pacific.

On arrival in the capital of Tahiti, Papeete, Gauguin was horrified at the Europeanisation of the place, and represented this by painting prostitutes. They wear a version of European dress to signal their removal from Gauguin's fantasised state of unsullied nature (often expressed by nakedness), but he uses his licence as artist and Frenchman to refashion them by painting them like figures from an Egyptian frieze. They too have their echoes of Seurat's foreground figure in *La Grande Jatte* – the mistress on the arm of a well-to-do bourgeois. But it is Manet's *Olympia* which is invoked in Gauguin's *Manau Tupapau: The Spirit of the Dead Watches* (pl. 390).

In European thought the primitive is invented as a category through which Europeans can in fantasy or fact escape the sexual etiquette of their own culture. As a European man in a French colony, Gauguin gained access to the sexual services of young Tahitian women – both personal and artistic. He wrote about *Manau Tupapau* in terms

redolent of the coloniser's distance and domination.

> I painted a nude of a young girl. In that position, a trifle can make it indecent. And yet I wanted her that way; the lines and the action interested me. A European girl would be embarrassed to be found in that position; the women here not at all. I gave her face a somewhat frightened expression. This fright must be pretended, if not explained, and this is in the character of the person – a Tahitian. These people by tradition are very much afraid of the spirits of the dead.

Gauguin uses colour, patterns and simplified form to create an image of the exotic far removed from European forms, colours and scenes. Yet echoes of Manet's *Olympia* (which Gauguin copied in Paris in 1891) – the white bed, the displayed body and the watching figure – all tie the image back into European concerns. The difference between the European and the Tahitian is written into the picture on the basis of a power relationship – of the man over the woman, the coloniser over the colonised. Gauguin appropriates and refashions Tahitian culture and *mores*, and enjoys the freedom to make them materials for the kinds of images *he* likes (see his letter above). The artist/tourist reduces the woman's specificity as a social being to a fantasy of difference, exoticism, primitivism, superstitiousness, and he makes her body and her culture a pretext for decorative patterns of lines and colours – 'distanced creations'.

The contrast between the images produced by women and the predominant representations of women in works by men alerts us to the sexual politics in the formation of modernism. The recurring themes and subjects of modern art are about sexual exchanges between middle-class men and working-class or peasant women. How often did they paint women in the brothel, outside the café, at the bar at the Folies-Bergère? From Manet to Picasso, *avant-garde* artists threw down their gauntlets as ambitious modernists on the sexually exploited bodies of working-class women and women of colour. The key paintings of modernism are surprisingly often paintings of prostitutes. The class and gender power enjoyed by artists who are men made these bodies available for artistic colonisation and experimentation. On the bodies of women the implications of 'distanced creation', which came to structure European art of the early modern period, were writ large.

356

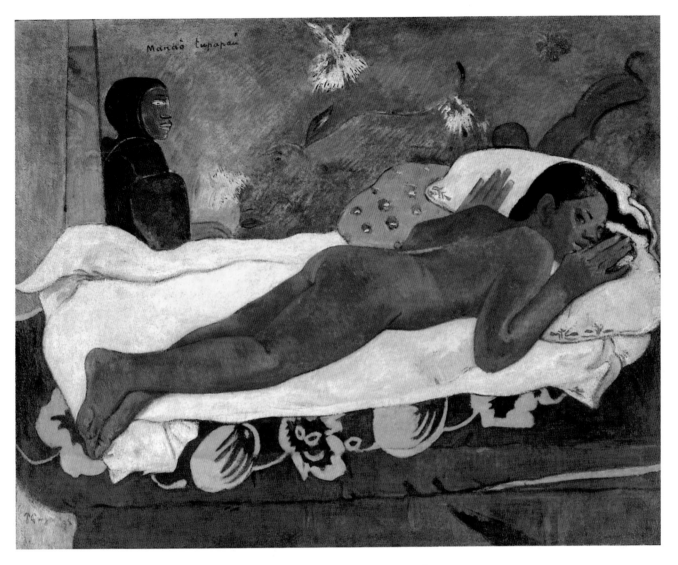

PAUL GAUGUIN,
MANAU TUPAPAU: THE SPIRIT OF THE
DEAD WATCHING

Gauguin invested considerable signifi-
cance in this work to judge by the atten-
tion he gave it in letters to his wife and in
a notebook he prepared for his daughter
Aline. It was painted, in 1892; from a
thirteen-year-old woman, Teha Hama-
na, whom Gauguin married on a journey
across the island of Tahiti. On returning
home from a shopping trip to town, Gau-
guin reported that he found his house in
gloom and Teha Hamana stretched out
in terror on the bed, afraid of the dark-
ness which shielded spirits of the dead.
Gauguin invented much of the mytholo-
gy and deities which appear in his paint-
ings. This work is the Tahitian version of
Vision after the Sermon (1888; pl. 383),
which attributed superstitious suscepti-
bilities to Breton peasant women for the
purposes of his own *avant-garde* gambit
aimed at a Parisian audience. When
Manau Tupapau was exhibited in Copen-
hagen and Paris in 1892 several critics
recognised its intended debt to and re-
working of Manet's famous *avant-garde*
picture *Olympia* (1863; pl. 354) by writing
of a 'brown Olympia' or the 'Olympia of
Tahiti'. This connection reveals how a
woman who in her own society was a
legitimate wife was perceived because of
her colour and the way the painter had
posed her as, inevitably, a sexualised
body, a bought body, a prostitute.

15
ALIENATION
AND INNOVATON
1900–1918

CHRISTOPHER GREEN

INSET 391. VICTOR HORTA: *The Tassel House, 1893. Brussels. View of the staircase.*

OPPOSITE 392. GUSTAV KLIMT: The Beethoven Frieze, *detail from The Hostile Powers – the giant Typhon with the figures of Impurity, Desire and Excess, 1902. Österreichische Galerie, Vienna.*

In the first decades of this century there was an acceleration of innovative change among artists who wanted to be modern. The acceleration was so remarkable that some have talked of advances in visual knowledge comparable with the advances that took place at the same time in science. This was a period when scientists brought into question the very nature of reality. In the visual arts the very nature of art, if not reality, was brought into question too.

There is no simple explanation for the speed and scope of these developments, nor were they confined to one place. Paris was no longer the only centre for change. By 1900 Vienna, or, to be more specific, the Haus der Secession (pl. 395), a building designed in 1898 by Josef Maria Olbrich (1867–1908) for international exhibitions, was one of several European centres of what was dubbed 'Art Nouveau' (New Art) or 'Jugendstil' (Youth Style). This was a phenomenon embracing more than one style; it was a self-consciously modern cluster of styles in architecture and design to be found everywhere from Vienna to Glasgow to Barcelona; and, it is often argued, it spread outwards not from Paris but from Brussels, with Victor Horta's house for a professor of geometry, the Tassel House (pl. 391), its starting-point.

In terms of international Art Nouveau or Jugendstil, it is easy enough to understand what modernism is: it is simply the pursuit across international boundaries of an ideal of progress involving the invention of new decorative styles

and a commitment to new modes of construction using iron and glass. It entails a rejection of models from the past which goes with a desire for independence from official art academies and Salons. The Viennese Secession, housed in Olbrich's building, was founded in 1897 as an alternative to Vienna's Akademie der Bildenden Kunst (Academy of Fine Arts) and the Kunstlerhaus, previously the only exhibiting venue in the city. The first Secession exhibition was opened with full imperial support, and the Viennese bourgeoisie were quick to buy from the exhibitions and to commission the architects of the Secession, but it remained an essentially anti-academic organisation.

If one can characterise the history of early-twentieth-century modernism in progressive anti-academic terms, one cannot extract from it a single, simple line of development. It is a history of conflicting aspirations given expression in cultural activity of widely varying kinds. And perhaps the central focus for conflict was the question of art itself: what was its status, role and meaning in modern developed societies? For some who wanted to be modern, art was an end in its own right, as it had been for the nineteenth-century Symbolists; something whose value was eternal and therefore set apart from the real changes of social and political life. For others, art only acquired value when it was engaged with society. For most, the artist was a leader, a hero, even a 'higher being', struggling against the past.

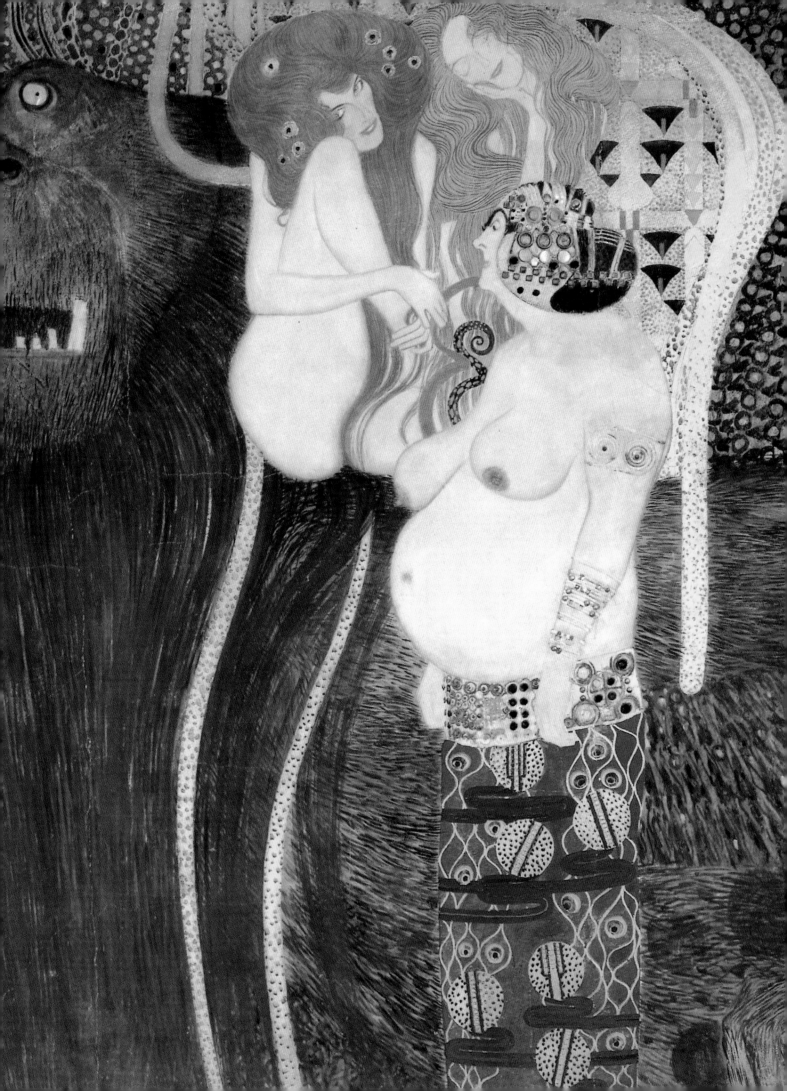

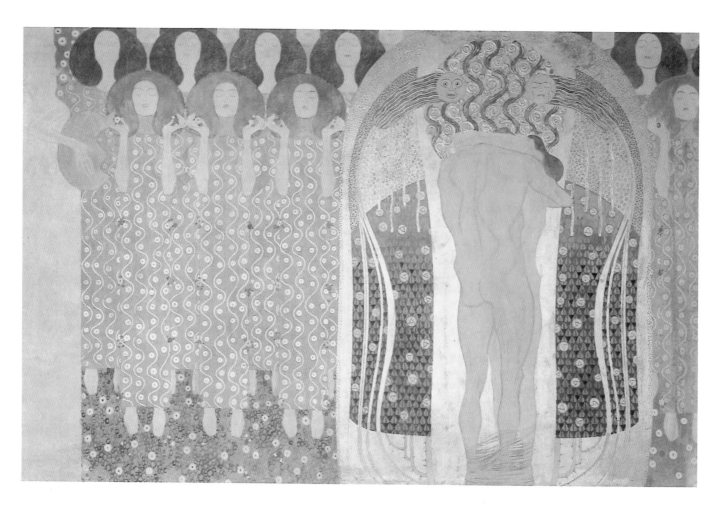

393. GUSTAV KLIMT:
The Beethoven Frieze,
*detail of the Choir of
Heavenly Angels and The
Kiss for the Whole World,
1902. Österreichische
Galerie, Vienna.*

In 1902, at the fourteenth Secessionist exhibition, Gustav Klimt (1862–1918), the leading Secessionist painter, showed a huge decorative painted frieze as part of a modernist homage to a major figure of the nineteenth century, Beethoven. This work, *The Beethoven Frieze*, is dedicated to the ideal of art: its theme is the conflict between the will to happiness and such evils as sickness, excess, death, impurity and desire (pl. 392). It culminates with the achievement of 'pure joy' in art and beauty represented by man and woman fused in a final embrace, a 'kiss for the whole world', surrounded by a thoroughly po-faced choir of angels (pl. 393). In a still Symbolist way, Klimt celebrates art as transcendent, a power the equal of religion.

There was novelty in the ornamental extravagance of Klimt's work, but it had something else which made it seem modern: the capacity to shock; and this came of a factor that might seem rather at odds with the pursuit of artistic purity – its sexual explicitness. Klimt, like many Austrian and German modernists at the time, saw sexual ecstasy and artistic joy as virtually one and the same; hence the fusion of the sexual and the religious in the culminating section of *The Beethoven*

Frieze. This was not, however, a view shared generally by the Viennese who came to see it; hence the shock caused by such a figure as 'Impurity' (pl. 392).

Klimt's use of allegory and his essentially harmonious ideal of beauty (in whatever form) make him, as we have seen, still a nineteenth-century Symbolist. It was in the painting of Klimt's juniors after 1908 that a more distinctively twentieth-century modernism emerged in Vienna, in the work especially of Oskar Kokoschka (1886–1980) and Egon Schiele (1890–1918). Schiele too believed that there was a spiritual dimension to sexual ecstasy; but both he and Kokoschka had a brutally direct approach to sex, an approach that can hardly be aligned with a harmonious ideal of beauty, as is clear in his huddled, spread or sprawling nudes, often bony adolescents (pl. 394). He attacked public propriety in ways which were meant both to excite and to offend. Freud was at work in Vienna at this time, and was also the subject of scandal. His *Interpretation of Dreams* first appeared in 1900, and in 1905 he published *Three Essays on the Theory of Sexuality*, outlining the development of sexuality from infancy to maturity. One reason for the

striking modernness of Schiele's nudes is that they now seem so deeply post-Freudian. They are ruthless explorations of personality, which place at the centre desire and the fear of desire, and which expose, always implicitly to the male gaze, the sexuality of individuals not far beyond infancy. For Kokoschka, sexual relations, far from being beautiful, were violent and destructive. He considered the two sexes to be virtually two different species condemned to continual warfare. This is the theme of his play *Murderer, Hope of Women*, which was performed in Vienna in 1909. He could celebrate love, as he does in *The Tempest* of 1914 (pl. 396), which elevates his love for Alma Mahler to the ideal plane of Wagner's *Tristan and Isolde*, but he could never celebrate it as the source of unalloyed happiness. This is a painting concerned with love *and* turmoil.

What, then, is so specifically twentieth-century about these pictorial responses to sex and love? Recently it has been argued that it is not merely their uncompromising sexual directness, but their discordant tension, their acceptance of the contradictory as a fact of modern existence: love *and* violence, desire *and* death, pleasure *and* pain. Such an acceptance of discord is characteristic of a multi-faceted tendency in the arts that by 1914 was found in Germany as well as in Austro-Hungary; it was known as Expressionism.

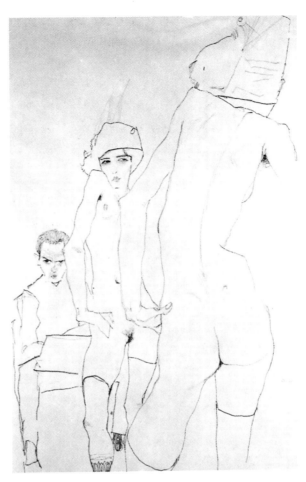

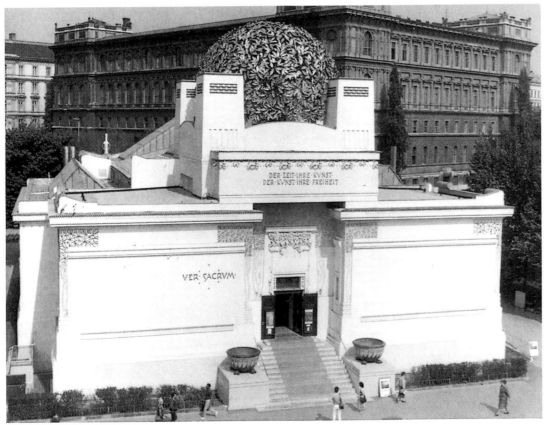

ABOVE 394. EGON SCHIELE: The Artist Drawing a Nude in front of a Mirror, *1910. Graphische Sammlung Albertina, Vienna.*

LEFT 395. JOSEF MARIA OLBRICH: *Haus der Secession, 1898, Vienna.*

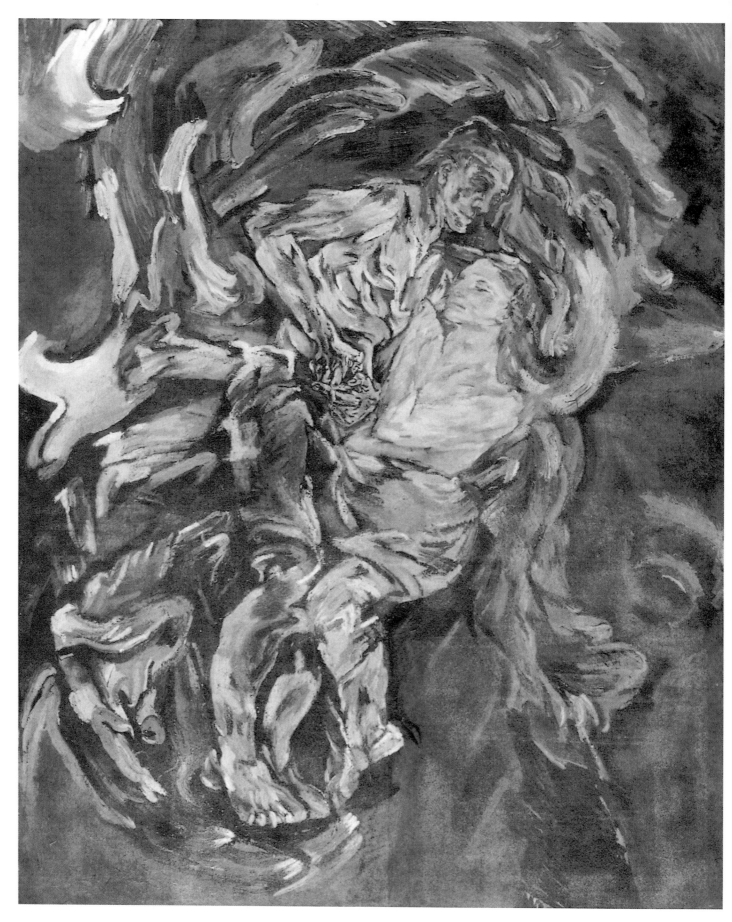

The Viennese Secession was as dedicated to architecture and the crafts as to painting. In architecture Art Nouveau and Jugendstil were, as we have seen, international, and the Secession exhibitions around 1900 promoted this internationalism, showing influential figures such as Charles Rennie Mackintosh (1868–1928) from Scotland as well as the Belgian Henri van der Velde (1863–1957). Vienna, like Glasgow, Paris or Brussels, was growing fast, profiting from rapid industrialisation. Both the imperial state and the wealthy bourgeoisie provided the support for an immense growth in public and private building, which continued into the twentieth century in every imaginable form, from suburban villas to the stations of a brand new underground railway. The chief architect of the Vienna underground, the Stadtbahn, was Otto Wagner (1841–1918), who, like Klimt, was a leading light in the Secession. Olbrich, the architect of the Haus der Secession, was Wagner's pupil and protégé; so was Josef Hoffmann (1870–1956). As in Klimt's painting, one finds in the designs of Wagner, Olbrich and Hoffmann a convergence of nineteenth- and twentieth-century themes. In Wagner's and Hoffmann's case the massing of their buildings is often Classical, to set off the free novelty of their ornament, and, though they insisted that form followed function, for them architecture and the crafts were above all art: art dedicated to the ideal of joy through beauty.

Hoffmann's Purkersdorf Sanatorium (1904–5; pl. 397) is, in its simplicity of form, its interior expression of its reinforced concrete frame and its use of easily cleaned tiling, a building which speaks of quiet efficiency; but everything is calculated for harmonic effect too – every detail, every light-fitting, every piece of furniture. The well-to-do patients who were to sit in these chairs and walk these corridors were considered to be in need not only of medical care, but of art too. This was, in fact, the first building designed and fitted out by Hoffmann in collaboration with the Wiener Werkstätte, a craft workshop which he had set up whose commitment to the ideal of the beautiful, however expensive, was to become proverbial.

As in early-twentieth-century Expressionist painting, it was by challenging the harmonious ideal of Symbolist beauty that early-twentieth-century architects distanced themselves from the nineteenth century. In Vienna, as elsewhere, the modern antidote to harmony in architecture was a cold-eyed brand of functionalism, and the architect who most effectively pitted the functional imperative against the beautiful was Adolf Loos (1870–1933). His Villa Steiner of 1910 is built to an ideal of stripped-down simplicity; he ruthlessly attacked the Secessionists of the Wiener Werkstätte for their obsession with the decorative. Loos was to become the hero of Le Corbusier and the Modern Movement architects of the 1920s, praised for the vehemence of his hatred of ornament and for such rhetorical overstatements as 'We receive our culture from the engineers.'

Across Europe and the West the architectural Modern Movement was to follow a line closely parallel with Loos's, but modernism in painting and sculpture was to be altogether more various in the early twentieth century. Indeed, even if we take just Expressionism, we find that in Germany it was given forms essentially different from those it had in Vienna. In particular, the German Expressionists, unlike the Viennese, gave central importance to the analogy between the modern artist and the so-called 'primitive'. Especially representative of this tendency was a group of young artists in Dresden who, around 1906,

398. ERNST LUDWIG
KIRCHNER: Four
Bathers, *1909. Von der
Heydt Museum,
Wuppertal.*

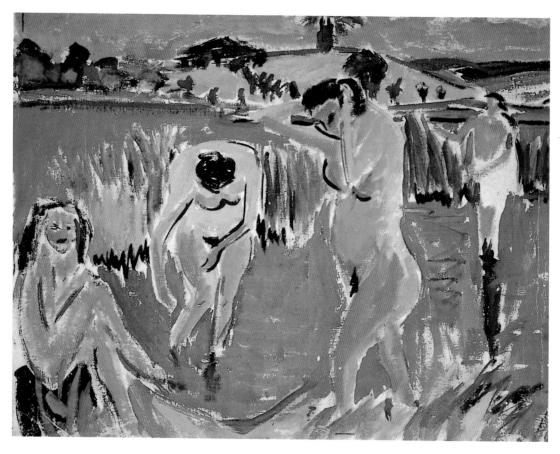

dubbed themselves 'Die Brücke' (The Bridge). The group included the painters Ernst Ludwig Kirchner (1880–1938), Erich Heckel (1883–1970) and Karl Schmidt-Rottluff (1887–1976). For these artists, both in Dresden and in Berlin, to which most of them moved around 1911, the discovery of expressive immediacy and sexual liberation went with a rediscovery of the primitive.

Newly unified, Germany, like Austria, was engaged in a process of rapid industrialisation whose beginnings lay in the nineteenth century. The tight group around Kirchner in Dresden, hardly more than students, rejected this new Germany for an alternative lifestyle as well as an alternative art: the myth of the innocent savage held special attractions. For them, primitive art, the art of tribal societies above all, was not a highly conventionalised art of ritual (as we see it now), but the spontaneous creation of peoples freed from bourgeois constraints, attuned to magic and the irrational. Schiele's and Kokoschka's painting was intensely self-expressive, as was that of Kirchner and his friends, but for the Brücke artists the aspiration to self-expression went with a desire to return to a state of primitive innocence. They actually tried to achieve this in studios redecorated as if centres of a new savage society, and in nudist bacchanals on the shores of the Moritzburger Lakes – when the weather allowed (pl. 398). For the Brücke artists, it seemed briefly possible to live and paint a primitive idyll, and thus to confront modern Germany – industrialised and militaristic – with an alternative. Their enemy was the materialism of their society; they opposed it with the masks and gestures of a Westernised savagery, made possible, ironically, by the growing colonial power of the Kaiser in Africa and the Pacific.

The desire for the pre-industrial was another twentieth-century development of a nineteenth-century theme, in this case one whose most notorious nineteenth-century exponent had been Paul Gauguin. We can see it, too, though without the self-consciously primitive aspect, in the painting of several loosely aligned French artists, the so-called Fauves, whose bright, confident canvases caught the eye of the Brücke group when they were exhibited in Germany. The Fauves it was, indeed, who showed the Brücke painters how to harness strong colour and varied brushwork to expressive ends. And it was, in fact, the best known of the Fauves, Henri Matisse (1869–1954), who instigated the first use of the term 'Expressionism' in Germany; the way that he used the word 'expression' to characterise his own painting in his *Notes of a Painter* (1908) was

picked up by German commentators and applied to the new German art. Matisse's Fauve style matured in the period 1904–6. In those years he began to use a repertoire of coloured patches and marks, brilliantly adapted from Gauguin, Van Gogh and Signac, to produce his own pre-industrial idylls such as *Luxe, Calme et Volupté* (pl. 400), in which the coves and beaches of the Côte d'Azur became the sites of a new golden age. Matisse may have avoided primitive stylisation and may have been too proper and settled in his ways to live like the Brücke painters, but his interest in tribal art was deep, and by 1906 he was an avid collector, along with two other leading Fauves, André Derain (1880–1954) and Maurice Vlaminck (1876–1958).

'Fauve' (a critic's tag) means wild beast, and it was the seeming wildness of Fauve painting that contemporaries felt made it more modern than its sources. But, however expressive their handling of colour, it is obvious that in the Fauve painting of Vlaminck and Derain (pl. 399), as well as Matisse, there is none of the discordant tension that follows from, for example, Schiele's or Kirchner's subject matter. The Fauves were actually much more calculating in their use of colour than they seem. They knew the Neo-Impressionist theories

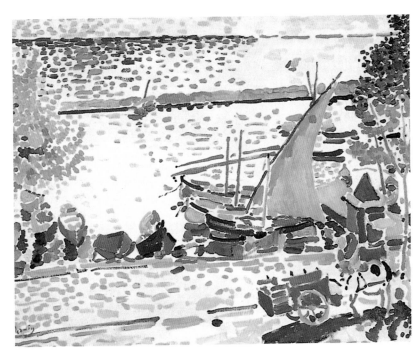

ABOVE 399. ANDRÉ DERAIN: The Harbour at Collioure, *1905. Musée d'Art Moderne de Troyes.*

LEFT 400. HENRI MATISSE: Luxe, Calme et Volupté, *1904–5. Musée d'Orsay, Paris.*

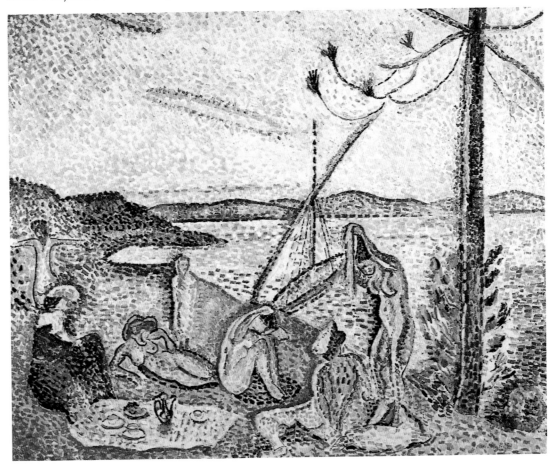

365

of Seurat and Signac: how to use the white ground to set off their dabs of unmixed colour; what a blue and a red would do together. But they used the look of wildness in their painting to thrill the eye. They offered paintings of a new tourists' world, bright with sunshine, far away from the city; paintings which in their look of spontaneity seemed utterly fresh.

LES DEMOISELLES D'AVIGNON AND CUBISM

Early in the century modernism may have been many-faceted and many-centred, but it cannot be denied that still, for most, the centre remained Paris. Paris was the magnet for a motley bohemian army of artists from everywhere. Americans, Russians, Germans, Romanians, Britons all converged on the city; it had become a sort of bohemian finishing-school for the aspiring modern artist. And, despite Schiele and Kokoschka, Kirchner and Matisse, many still feel that *the* modern artist of the twentieth century, right through into its middle years, is a Spanish artist who was based for most of that time in Paris: Pablo Picasso (1881–1973). It is Picasso, above all, who has been elevated by critics and historians to the status of the modern artist-as-hero. His is perhaps the grandest of all late-twentieth-century museums founded to honour a twentieth-century artist. The Musée Picasso in Paris, opened in 1985, is a supreme monument, made possible by the cultural establishment of the French state, to an artist whose reputation was built on the subversion of establishments. In keeping with its grand purpose, it is housed in a massive, opulently ornamented mansion of the seventeenth century, one of the classics of its time, the Hôtel Salé.

In 1907 Picasso painted the single most famous modern picture, *Les Demoiselles d'Avignon* (pl. 401). This is a picture which has not one but many reputations: it has what might be called an 'expressionist' reputation (it is, after all, a work full of tension, brutally sexual in its subject matter); and it is taken, at the same time, as the work that opened the way to another major modern development, one very specifically of the twentieth century: Cubism.

As early as 1912, Picasso's friend, the critic André Salmon, presented *Les Demoiselles* as the painting that made Cubism possible. More recently art historians have tended to play down its role in relation to Cubism, but at least until the early 1970s it was predominantly interpreted in this light. It may be a work that savagely exposes Picasso's obsession with the 'danger' of sexual

engagement (he is thought to have had powerful sadistic inclinations and, at this time, to have been terrified of the possible contraction of venereal disease); but it remains still on one level a work that can be seen to have opened Picasso's way to those discoveries that later (from the period 1908–11) would be called Cubist. And the importance of Cubism is unquestioned; it was certainly the most influential of all twentieth-century art movements, more influential than Viennese or German Expressionism, far more so than Fauvism or international Art Nouveau.

Perhaps surprisingly, *Les Demoiselles* is a picture that invokes a past as well as a future. It alludes, indeed, to a veritable lineage of paintings which extends from the sixteenth to the twentieth century, from sixteenth-century Venetian treatments of the theme of Diana and her attendants, through El Greco's apocalyptic *Vision of St John* and Ingres's *Turkish Bath* to Cézanne's *Bathers* of the 1880s and later. But it does so in order to challenge that past. This combination of respectful invocation and disruptive challenge was a typical tactic of much *avant-garde* art of the twentieth century and especially of Picasso.

The challenge to the past is obvious enough on the level of artistic means, and it is in its technical innovations that the picture opened the way to Cubism, since Cubism's importance lies precisely in the manner in which it renewed the means, the language, of painting and sculpture, and could indeed seem to have reinvented them. The treatment of figures, and, to a lesser extent, space, have usually been picked out as the essential proto-Cubist factors in this painting. The space is shallow, but for the suggestion of an opening behind the nude who enters from the right; it is a Picassian elaboration of the fluid, flattened spaces of El Greco and later Cézanne, the whole pulled together by scything curves that rock and swing right across the surface. The figures are stylised, but this is not all. Those on the right, especially the crouching nude, seem literally to have been dislocated, pulled apart; one feature is wrenched out of alignment with another. This is the result of an attempt by Picasso to fuse views from varying angles, as if he, the artist, or they, the figures, were in movement. The flattening of space and the dislocations of multiple viewpoints were to be characteristic of Cubist painting in all its forms. And so, increasingly, was another feature of *Les Demoiselles*, its openly heterogeneous rather than homogeneous manner: the way that it combines such different modes of styling and depicting the figure and leaves us to see the differences without resolving them. The myth that art can be the

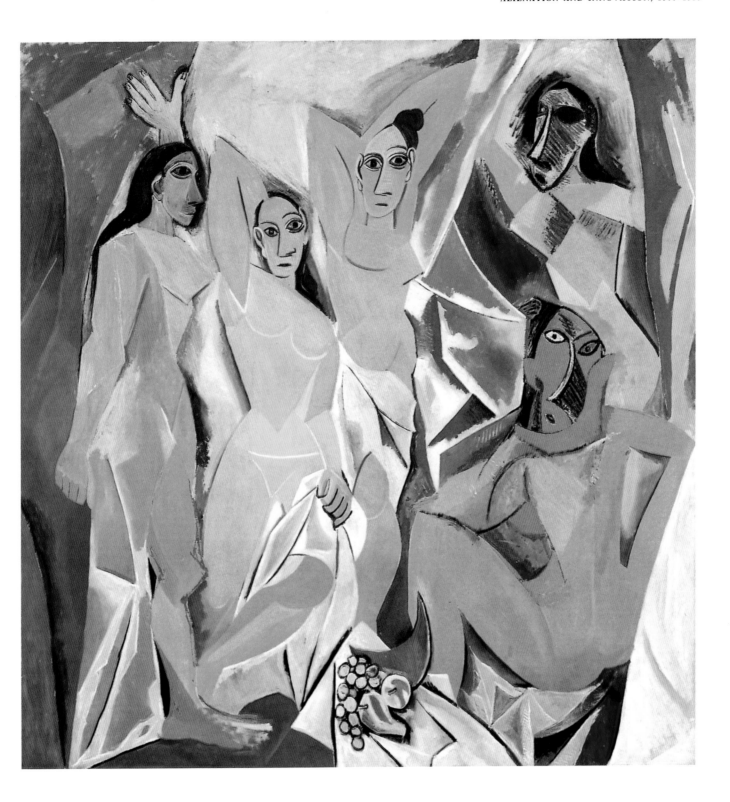

401. PABLO PICASSO: Les Demoiselles d'Avignon, *1907. Museum of Modern Art, New York.*

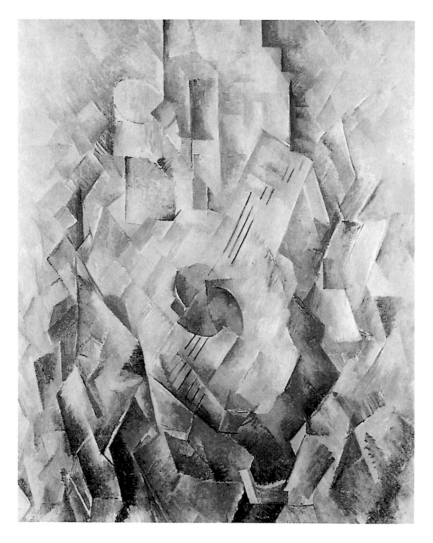

402. GEORGES BRAQUE: The Mandolin, *1910. Tate Gallery, London.*

mirror of the world meets a challenge still more powerful than that offered by the stylisation and unnaturalistic colour of late-nineteenth- and early-twentieth-century modernists such as Gauguin. Painting is laid bare as a set of different pictorial means by which things can be represented, rather than a kind of illusionism which is more or less accurate. It becomes possible to see that it can develop different languages of communication (different ways of depicting light and form in space), which can distort or enhance appearances as the painter wishes.

Picasso had a close ally in the development of Cubism after *Les Demoiselles*, Georges Braque (1882–1963), and it is the role of Braque that has led to a questioning of the importance of *Les Demoiselles* to Cubism. After all, the earliest pictures that are thought of as fully Cubist are very different, all buffs and greys, angular in their faceting rather than curvilinear, and concerned above all with such undramatic subjects as the posed model, landscape and still-life. It was Braque who was the earliest to adapt what he learned from the

dislocations of Picasso's multiple perspective and from the shallow space of Cézanne to the making of paintings which are in this easily recognisable way Cubist.

The Mandolin of 1910 (pl. 402) is an especially subtle work of Braque's; it teases in a way typical of both his and Picasso's Cubism at this stage. Later commentators have tended to focus above all on the flatness of Cubist painting: the way that everything is treated in terms of flat planes spread out across the picture surface, so that the fact that the picture surface is flat is not concealed. Cézanne's use of hatched brushstrokes and of a mosaic of flat colour patches or planes in his later work supplied the means by which to achieve this effect of flattening without losing the sense of depth and substance. In the case of *The Mandolin*, Braque's attempt to integrate objects and their surroundings by an overlay of flat planes, as if faceting the surface of everything, has led to the partial (but only partial) obscuring of the subject, which itself is gently pulled apart by shifts of viewpoint. One is confronted by a complicated structure, obviously imposed, which yet divulges a mandolin and a water jug in a shadowy interior. Picasso, too, at this time (1910–11) allowed the faceting of surfaces to lead to an obscuring of the subject. Indeed, some who saw pictures of this kind – the British critic Roger Fry, for instance – thought of them as totally abstract: they saw only the imposed angular faceting. And certainly it can seem in a figure painting such as Picasso's *Seated Nude* (pl. 403) of 1910 that the geometric planes are antagonistic to any normal perception of the subject and that eventually they must replace it.

There can be no doubt that such works were part of a widespread and profound reaction against the naturalist styles of the nineteenth century, and in this respect Picasso and Braque followed a course comparable to that of stylising modernists such as Gauguin or Klimt, who also reacted against naturalism; but their reaction was very different. The Symbolists sought to replace naturalism with an ideal beauty (they idealised the world); the Cubists sought a wholly new way of representing the world, and, surprisingly, because they remained concerned with things as they saw them, Cubism was almost immediately recognised as a modern *realism*, not as an abstract or ornamental style. What it offered in its early form (between 1909 and 1912) was not an aesthetic ideal of harmony, but a new way of looking and then transferring what was seen on to the canvas: a part-by-part, all-round attempt to grasp things, as if the very act of looking and dis-

covering could be captured in paint, not merely the momentary thrill of light giving form for the pleasure of the eye.

Les Demoiselles d'Avignon was, then, a testing-ground for a whole range of representational techniques later exploited in Cubist paintings. What of its other reputation, its reputation as a highly expressive work concerned with sexuality? There can be no doubt that those innovative techniques of stylisation and dislocation were indeed used to give force to a sexual theme. The subject is, after all, a group of prostitutes on sale to us, the spectator. The poet André Breton, author of the first Surrealist Manifesto in 1924, was to see *Les Demoiselles* in the light not merely of Cubism but of Surrealism too, which, as his manifesto makes clear, was a post-Freudian movement, one of whose central concerns was to break free of the sexual taboos which were held to block entry to the unconscious. Breton and the Surrealists of the 1920s were fascinated by the sheer intensity given to the erotic and the fearsome in these naked women (the objects of desire) by Picasso's extraordinary distortions.

The hundreds of sketches and studies that lie behind *Les Demoiselles* show plainly how Picasso worked in this instance towards an increasingly brutal treatment of the women, and a more immediate confrontation between us, the spectators, and them. In the end, larger than life, they engage us directly, eye to eye. And they have become not so much the objects of desire as the objects of mystery, terrifying and menacing. This brothel is a place of disease and death, not of pleasure; these women are no less disturbing than the women of Klimt and Schiele, and it is worth recalling that, just as Kokoschka presented the relationship between the sexes as mortal combat, so Picasso's close friend, the poet Guillaume Apollinaire, was at this time writing of man and woman as eternal strangers incapable ever of satisfying each other's desires.

Finally, it is clear that the brutality of Picasso's treatment of his nudes has a self-consciously primitivising aspect. But for the two nudes in the centre, these figures (especially their heads) are, like those of Kirchner in Germany a little later, transpositions from certain types of African tribal art. Picasso was aware of the collections of African carvings begun by friends such as Matisse and Derain, and himself took the time to visit the displays of tribal art at the Trocadéro museum, either just before or just after the completion of *Les Demoiselles*. Once again, modern art and a whole range of so-called primitive arts right outside the post-Renaissance European traditions of painting are brought together disruptively. Picasso confronts his own society with a savage alternative made available by colonialism, but, where the ethnologists of his time retained a largely Darwinian evolutionary view of tribal art as primitive or childlike in relation to the 'higher' art of European civilisation, Picasso implied no such value judgement. He saw the magical power of African carvings, then usually called 'fetishes' in France, in a strongly positive light, as the response to profound human needs. It could be said that he took primitive art over for his own distinctly European ends (as an artist he was always a coloniser), but the effect, startlingly, was to bring the modern and the primitive together without prejudice.

CUBISM IN THE MODERN WORLD

Picasso did not set up an idealised version of primitive societies as an alternative to modern industrialised society; he was concerned with primitive *art*. But he did take up a bohemian way

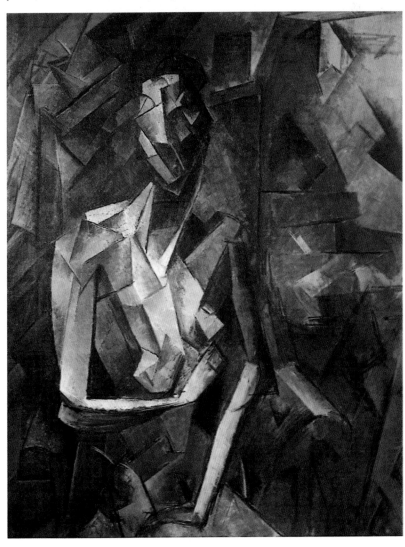

403. PABLO PICASSO: Seated Nude, *1910. Tate Gallery, London.*

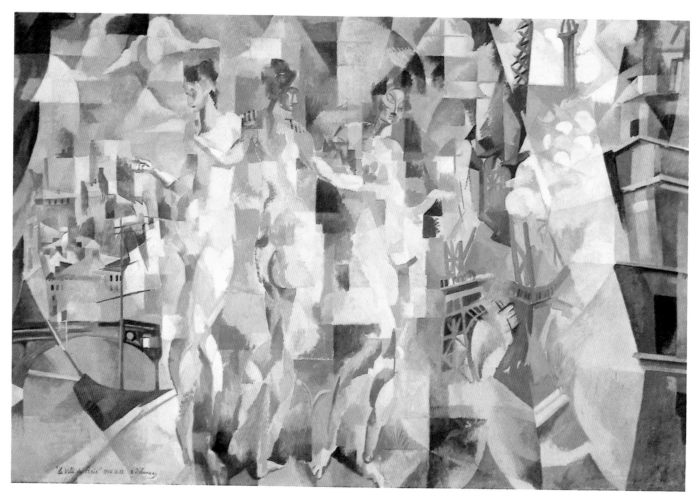

404. ROBERT DELAUNAY: The City of Paris, *1912. Musée National d'Art Moderne, Paris.*

of life, sexually liberated and consciously anti-bourgeois. He shared the need to shock that was endemic among *avant-garde* artists across Europe. Yet, it has to be recognised that, for all its anti-bourgeois commitment, *avant-garde* art everywhere, in order to survive and develop outside the academies, needed the bourgeoisie of Europe. When Klimt responded to the storm of criticism that met his officially commissioned paintings for Vienna University by withdrawing altogether in 1905, he could only do so with the financial support of a wealthy banker, August Lederer, who paid back all the considerable fees that he had already received. Indeed, it is clear that modernist art could not have developed as it did either in the late nineteenth or the early twentieth century except as the other side of a coin minted by a buoyant middle class. Its engine was the fast-expanding system of art-dealing. Bohemians such as Picasso and Braque, living the lives of artists on the Butte de Montmartre, could only do so with the agile support offered by that system. The individualistic, anti-traditional, anti-bourgeois modern art of the *avant-garde* was, ironically, the well-matched partner of the free-wheeling capitalist dealer system.

In Paris, Matisse's work was quickly bought by American collectors, most importantly the Steins, and he was rapidly under contract to the formidable right bank dealer Bernheim-Jeune. Daniel-Henry Kahnweiler, the son of a German banking family, snapped up the work of Vlaminck and Derain. Kahnweiler was also the dealer of Picasso and Braque, and indeed the financial security he supplied allowed Picasso in 1911 to move into a spacious new apartment, down the hill from Montmartre on the Boulevard de Clichy, and hire a maid. He was a new kind of dealer, perfectly suited to the new kind of artist he represented; only Ambroise Vollard at the end of the nineteenth century anticipated what he brought to the dealer system. Kahnweiler was intensely interested in the art of his protégés, especially Cubism; yet he placed no emphasis on publicity, preferring to wait until the international influence of his artists would be such that his judgement was proved right and profits followed. He was more creatively involved with Cubism than Vollard had been with Cézanne; and at the same time he was more uncomprom-

isingly loyal to his artists, however tough a businessman he could be.

Kahnweiler provided good faith and a living so that his artists could forget the need to please a wider public and could dedicate themselves to experimentation almost for its own sake. Picasso and Braque did not need to show in the huge public exhibitions of the pre-1914 years, the Salon des Indépendants and the Salon d'Automne; they had their regular income from their dealer, who took all their work, holding on to most of it, but selling just now and again to a small circle of banker and stockbroker friends.

Between 1912 and 1914 the experiments pursued by Picasso and Braque in this very special situation led to the development of a whole new range of Cubist techniques which opened up a different kind of Cubism: both less obscure and even less straightforwardly illusionist. They introduced words into their compositions (yet another means of communication). They began to stick pieces of material on to their pictures (collage) and pieces of cut-out paper (papier collé), combining these obviously flat elements with a much simpler kind of drawing, which, though far from naturalistic, was often easy to read in terms of figures or still-life objects (almost as easy to read as words). The pieces of paper or material could be used as simple compositional elements (abstract shapes) and to bring into the picture aspects of the subject: the grain of wood, or, as in Picasso's *The Bottle of Suze* (pl. 406), the label of a bottle and the columns of a newspaper. What is more, by making one cut-out shape overlap another, the effect was given of building out into the space in front of the picture surface, not merely of flatness, and Picasso even set about renewing sculpture by *actually* building outwards, using pliable metal, wood and cardboard to make Cubist relief sculptures, later known as 'constructions'. All this, however, Picasso and Braque did at the centre of a small circle of initiates, working in an atmosphere of experiment that was as intense as it was private.

Yet, if this later Cubism can seem to be an art about art, and thus to keep its distance from the wider social sphere, Picasso and Braque continued to avoid abstraction. Their Cubist art was still a creative meditation upon the infinite ways of painting and drawing figures, objects and places. It was just that the world they represented was the narrow world of their circle, of studio and especially bohemian café life. Sometimes Picasso's practice of gluing newspaper cuttings on to his compositions allows a glimpse of a wider world; one finds, as in *The Bottle of Suze*, fragments

of articles on peace demonstrations and the Balkan Wars (a prelude to the Great War of 1914–18, and the cause of considerable alarm in 1912–13). But it all seems a long way off, a distant murmuring in the background. The fragmentary character of Cubist *collages* and *papiers collés* is certainly an echo of the dislocated character of urban experience; the bits and pieces speedily put together call to mind the snatches of conversation and glimpses of life offered in the confusion of big cities. But neither Picasso nor Braque was politically active at this time, and their work did not take in the imagery of the city environment outside the studio or café at all comprehensively. Their Cubism of 1912–14 is more a retreat from the realities of the city than an attempt to embrace its energy and scale. Kirchner and the Brücke artists resisted the urban realities of industrialised Europe by offering a sort of savagery; Matisse and the Fauves by offering the myth of the golden age; Picasso and Braque did so by finding inexhaustible artistic potential in the studio model and in such objects as glasses, bottles, toothpicks and matchboxes on café tables.

There were, however, many modernists right across Europe who could not and would not ignore the cacophony of the city; most modernists, it should be remembered, lived in cities or at least sold their work in urban markets. And, in fact, the modes of representation developed by the Cubists (multiple viewpoints, fragmentation, flattened or condensed spaces) proved to be especially adaptable to the painting of modern subjects. There were Cubists in France who, having learned from Picasso and Braque, made a point of looking up from the café table to take in the city around them in all its multiplicity. These artists showed in the great Salons ignored by Picasso and Braque, and they painted on a scale and with an appeal designed to win converts from the wider public.

Robert Delaunay (1885–1941) was one of them. He painted huge compositions on spectacular contemporary themes using prismatic colour and popular modern imagery. His giant urban subject pictures, such as *The City of Paris* (pl. 404), are the very opposite of the private experimental *papiers collés* produced in 1912–14 by Picasso and Braque. In *The City of Paris* Delaunay uses rhythmic colour transitions as a kind of metaphor for the movement yet unity of the city. The roofs and *quais* of Paris, the Eiffel Tower and the Three Graces (lifted out of a Classical past) are made to flow together: images separated by space and time seem to add up to a unity.

371

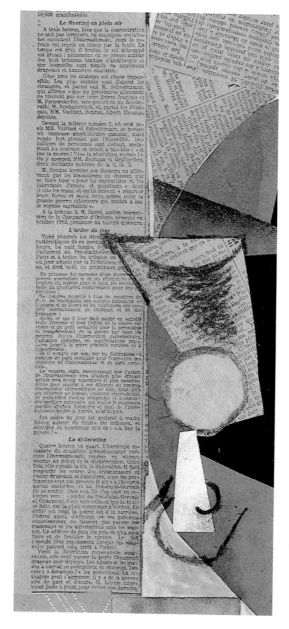

PABLO PICASSO,
THE BOTTLE OF SUZE

This work of autumn 1912 is without a trace of oil paint. Picasso combines pieces of coloured or white paper, a label from a bottle and newspaper cuttings, charcoal drawing and gouache. Yet, like the bulk of Picasso's and Braque's Cubist collages and *papiers collés*, it was given the status of oil painting once bought and sold by their dealer Kahnweiler.

The objects depicted are easily recognised: a bottle and glass on a table. The subject is conventional (still-life) with a touch of the personal (the attributes of a café meeting place of the kind Picasso and his friends used routinely). This apparent conventionality and this clarity of depiction is lent more than a touch of irony by the unconventionality of the work in every other respect, especially technical. There is a contradiction between what can seem a scruffy lack of finesse in the drawing and in the cutting of the paper, and what further consideration reveals to be a highly subtle and skilled exploitation of illusionism. Drawn elements and cut-out paper shapes are placed in overlapping relationships of such a kind as to suggest that some are situated literally in the space in front of the picture surface and some on it or even behind, in pictorial depth. When the bottle and glass are considered as whole items, they appear both behind *and* in front of the shapes that surround them and establish their setting. No element or item holds a clear, unambiguous position in an illusion of depth, and yet possible positions in possible spaces are suggested everywhere. An apparently casual technique is adapted to a highly sophisticated manipulation of line and shape for spatial effect. By never allowing a consistent depiction of things in space, Picasso invites the spectator to see how the techniques for the representation of depth on a flat surface work.

Yet *The Bottle of Suze* raises more than simply technical questions. The fragmentary character of the work as a whole simulates a café experience, and the day's newspaper, open to be read with the glass of Suze aperitif, is part of that experience. Words fill the pictorial space. The events described are highly topical – a report on the war in the Balkans, dated 16 November 1912, and another, to the left of the glass (*detail above left*), of a peace demonstration organised by the international socialist movement in Paris. Something of the agitation of the

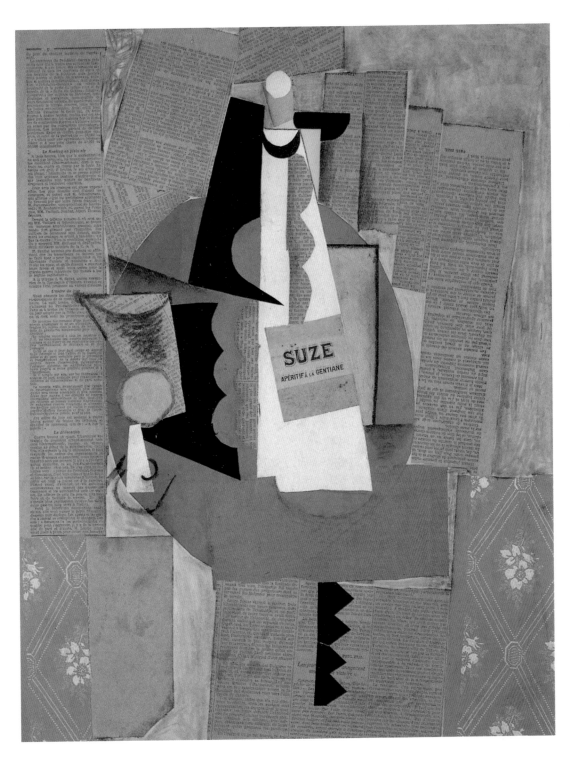

period 1911–14, as Europe prepared for the Great War, is preserved. And, just as the use of roughly cut-out pieces of paper disappoints the expectations conventionally associated with oil painting, so the élite pretentions of fine art are challenged by the presence of newspaper columns in all their popular matter-of-factness.

The question of which should be the centre of attention, the still-life in its ambiguous spatial environment or the words that fill that environment, is left in the air. In such a Cubist work as this, the 'background' is often, simultaneously, in the 'foreground' too.

407. UMBERTO BOCCIONI: Unique Forms of Continuity in Space, *1913. Tate Gallery, London.*

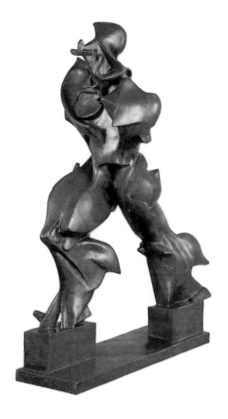

Other Cubists, such as Fernand Léger (1881–1955) and Albert Gleizes (1881–1953), responded positively and excitingly to the spectacle of the city, but certainly the loudest and most noticed of all European *avant-garde* groups to use Cubist techniques to say something about the city and the machine were the Futurists, a group of Italians based mostly in Milan but with strong Parisian connections. They were financed and led by the larger-than-life poet, Filippo Tomaso

408. CARLO CARRÀ: Funeral of the Anarchist Galli, *1910–11. Museum of Modern Art, New York.*

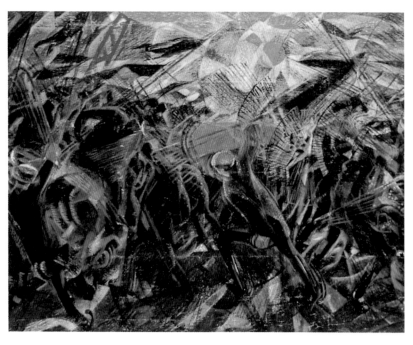

Marinetti. What distinguished the artists allied to Marinetti – among them Umberto Boccioni (1882–1916), Carlo Carrà (1881–1966), Giacomo Balla (1871–1958) and Gino Severini (1883–1966) – was the sheer intensity and exclusivity of their focus on the modern. They formed almost a caricature modern movement. They were not merely new or young (*nouveau* or *jugend*) – they were *future*-ist. Like Delaunay, however, what they wanted to capture in their work was not modern phenomena as such (cars, aeroplanes, factories), but the sheer mobility of the experience offered to all the senses by life at its most modern: the bewildering simultaneity of sounds and sights generated by Milan (a city industrialising late, at speed) and Paris – by people, traffic, construction, sport, violence. Multiple viewpoints and the fragmentation of space were perfectly suited to their purposes. In sculpture the Futurist fascination with dynamism found expression in Boccioni's *Unique Forms of Continuity in Space* (pl. 407); the male human figure streamlined by speed. Boccioni claimed to embody here 'pure plastic rhythm. Not the construction of the body, but the construction of the action of the body.' By 1913–14, artists such as Balla and Severini had become so interested in representing the essence of speed by vibrant colour and 'force lines' that their painting had neared abstraction, but the fact remains that, for them, their art was always about their experience of the modern world; it was never an abstract, self-sufficient activity.

Futurist-like movements proliferated in Europe just before the Great War: they emerged in Russia and, with striking panache, in England with Wyndham Lewis (1882–1957) and the Vorticists; but none of them could match the sheer singlemindedness of the Futurist commitment, not merely to modernity in art, but to direct action by artists in society. The Futurists were the model for the socially and politically engaged modernist, though very much on the authoritarian right rather than the Marxist left. The movement was avowedly political. It stood for what it claimed were the cleansing virtues of violence. The Futurists revelled in the kind of violent political action captured in Carrà's *Funeral of the Anarchist Galli* (pl. 408), the record of a riot, and ranted for war as 'the sole hygiene of the world'. Indeed, they were in the forefront of the anti-neutrality demonstrations that were intended to hasten Italy's entry into the Great War after August 1914. Futurism can now seem deeply unappealing, with its uncritical hymning of the technological and its ideal of mechanised inter-

national thuggery (the relationship with Italian Fascism, which would emerge in the 1920s, is not incidental); but it produced paintings of unquestionable power.

So, though Cubism in the hands of Picasso and Braque tended to become a brilliantly resourceful exploration of the languages of visual art as representation, Cubism, the larger movement, fed into other art movements inside and outside France which did not flinch from the dynamism of the urban world. But the Cubist movement was also connected with tendencies which were far from positive in their response to the urban world. Around 1911, certain of the Brücke artists, Kirchner especially, decided not merely to present a savage alternative to the new Germany, but to confront the reality of its urban environment directly. Cubist stylisation was, for Kirchner, highly compatible with his own liking for primitive stylisation, but he also found the condensed space of Cubist painting extremely effective in presenting an intensified claustrophobic vision of the city. He used all this, as well as a feeling for the force of dissonant colour contrasts, to make of the city a place of menace; and he populated it in his paintings with prostitutes (pl. 409), popular entertainers and bohemian eccentrics like himself. His alienated response to the modern world is explicitly linked to his vision of the depravity of Berlin. Out of Kirchner's Berlin Expressionism of the immediately pre-war years and the urban apocalypses of his German contemporary Ludwig Meidner (1884–1966), came an Expressionist style for the city which reached a climax in the years of crisis that followed German defeat in 1918.

TOWARDS ABSTRACTION: THE SPIRITUAL IN ART

Cubism also had lessons for artists across Europe whose response to alienation in the new urban societies was closer to the idealism and quasi-religious mysticism of Gustav Klimt, artists who believed that the most effective antidote to all that was mean and spiritually destructive about modern life was joy in art. So ideal, for these artists, was art, both in its essential character and in its spiritual role, that they were ready to take it as far as abstraction. Klimt himself, in the role of decorative designer of mosaics, had neared the abstract.

The technical innovations of the Cubists were helpful to early abstract artists such as Piet Mondrian (1872–1944) and Kasemir Malevich (1878–1935), especially the use of flat coloured planes either in stable relationships or overlap-

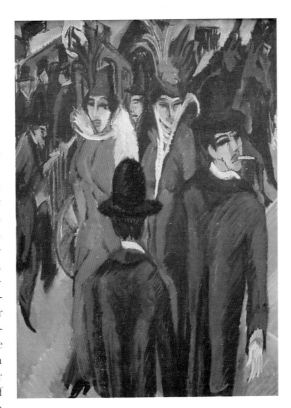

409. ERNST LUDWIG KIRCHNER: Berlin Street Scene, *1913*. *Brücke Museum, Berlin.*

ping one another as if hovering in space. But the driving force behind abstraction early in the century was that same nineteenth-century philosophical tradition of Hegel and Schopenhauer so crucial to the Symbolist movement of the 1890s. Central was the belief that art was the means by which the opposition between matter and spirit could be resolved, by which a metaphysical Ideal could be reached. For artists such as Mondrian and Malevich, art became a spiritual mission, an escape route from a world seemingly dedicated to material progress alone.

Mondrian's beginnings were in Holland, where by 1910–11 he had developed his own special kind of late Symbolist painting, epitomised by his altarpiece-like *Evolution Triptych* (pl. 410). Here he opposes the scientists' Darwinian view of evolution by giving us a mystic's view of spiritual evolution. He presses the geometricisation of Cézanne and Cubism into the task of illustrating a progression from blind materialism (note the closed eyes of the flanking figures) to wide-eyed revelation. All over Europe the reaction against positivism and materialism had taken the form of a spate of popular mystical movements, one of the most influential of which was Theosophy, launched in the later nineteenth century by the American mystical writer H. P. Blavatsky and led in Europe by the German Rudolf Steiner. Mondrian's painting literally illustrates the Theosophical ideal of evolution; in 1909 he had

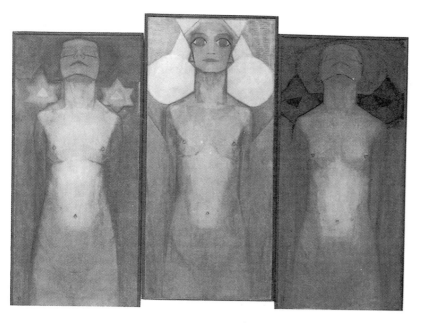

ABOVE 410. PIET MONDRIAN: Evolution Triptych, *1910–11. Haags Gemeentemuseum, The Hague.*

BELOW 411. PIET MONDRIAN: Oval Composition ('Kub'), *1914. Haags Gemeentemuseum, The Hague.*

ABOVE OPPOSITE 412. FRANZ MARC: Fates of Animals, *1913. Öffentliche Kunstsammlung, Kunstmuseum, Basel.*

BELOW OPPOSITE 413. HERMANN OBRIST: *Tomb for the Oertel family, 1905.*

himself joined the Theosophical Society.

Mondrian settled in Paris for the years 1912–14, and there Cubist art taught him that it was possible to find in virtually any subject a structure of intersecting lines and hovering coloured planes which could offer its own aesthetic pleasures to the eye (pl. 411). He came to believe that this aesthetic joy in the balancing of line and plane had a spiritual dimension; it was an intimation of the Ideal. Cubism, therefore, helped him to reject the illustration of spiritual beliefs found in the *Evolution Triptych*, and to replace it with an

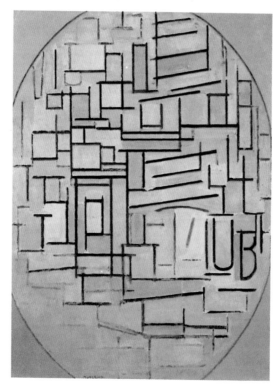

attempt to embody the spiritual in the balanced relations of line and colour alone. At first his compositions were based on the study of things seen, as were the compositions of Picasso and Braque: of trees, church façades, even city scenes. The spiritual essence was something to be extracted from the material world. It was only later, in Holland during the Great War, that he found himself able to compose with straight lines and colour planes alone, and to do without the external world in his paintings.

The way that Mondrian came to his abstract conclusions by working slowly out of Cubism is paralleled in the cases of many others, though few owed so much, so directly, to the Theosophical movement. There were his friends in Holland who later formed the group 'De Stijl' (The Style) with him, Theo van Doesburg (1883–1931) most prominently, and there was, perhaps even more influentially, the Russian Kasemir Malevich, whose so-called Suprematist painting, with its very similar metaphysical ambitions, was to have enormous impact in the West during the 1920s. Yet, if early-twentieth-century abstraction invariably had its spiritual aspect, it was not always technically beholden to the expansion of the Cubist movement. Munich was one European centre where abstract painting was developed with hardly a glance at Cubist painting. Here, in the work above all of Wassily Kandinsky (1866–1944), a kind of abstract painting emerged between 1911 and 1914 which is best understood as pictorial Art Nouveau or Jugendstil carried to an extreme within the context of modern primitivism, the proliferation of mystical sects, and German Expressionism.

Kandinsky in particular learned a great deal from the Jugendstil architects based in Munich, August Endell (1871–1925) and Hermann Obrist (1863–1927). Both these designers developed elaborate theories to support their belief in the expressive potential of colour and line alone, and both produced wonderfully fulsome ornamental designs which are entirely abstract (pl. 413). A Russian in Bavaria, Kandinsky did not forget what he thought of as the spontaneity and directness of Russian folk art, and developed a deep interest in the local craft of glass painting as well as in all forms of primitive art; he was more interested in the Brücke artists and the French Fauves than in Cubism. He too became deeply committed to the legacy of Hegel's and Schopenhauer's philosophy, and to mysticism (Theosophy especially). The result was an extraordinary series of abstract or near-abstract paintings (pl. 414) which were often stimulated

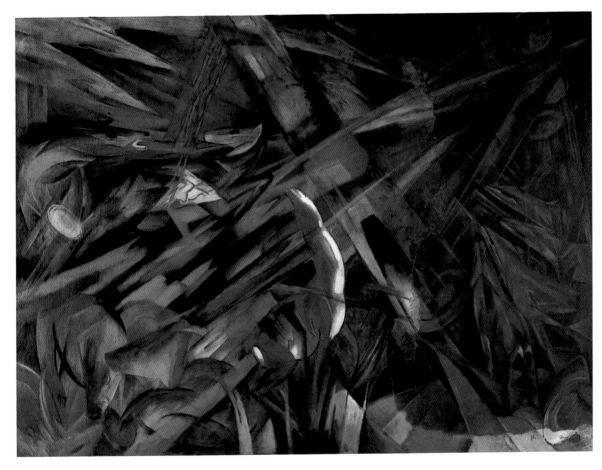

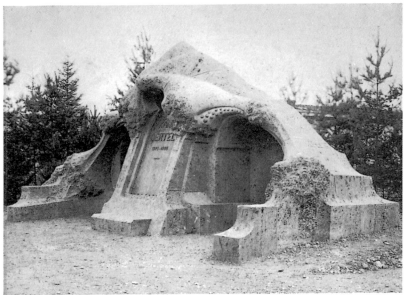

by a single theme: that of catastrophe or apocalypse out of which might come spiritual renewal, a new epoch. He painted them as the self-styled leader of a new exhibiting society 'Der Blaue Reiter, (The Blue Rider), among whose other prominent figures were the German painters Franz Marc (1880–1916) and August Macke (1887–1914).

Following the German philosopher Friedrich Nietzsche, Kandinksy and his friends in the Blaue Reiter were drawn to the belief that the prelude to an age of revelation would be a period of wars and revolutions fought out on a huge scale, when the values and institutions of the nineteenth century would finally burst apart. Such was the explicit meaning, though conveyed through the metaphor of a great animal disaster, of Franz Marc's apocalyptic *Fates of Animals*, painted in 1913 (pl. 412). Predictably, this painting has often been treated as a prophecy of the Great War, which was to lead to the 1917 Revolution in Russia. Marc himself was to die as a soldier.

With upheavals on this scale, modernism from Munich to Vienna, from Paris to Berlin to Moscow, was bound to change too. But the mystics who put their faith in abstraction were not to throw themselves into the apocalpyse of 1914–

18; they were to turn to art. It was against the backdrop of world war that Mondrian and Malevich made their crucial steps into abstract painting, returning, as Malevich put it, to zero.

In Kandinsky's words, 'When religion, science, and morality are shaken ... when the external supports threaten to collapse, man's gaze turns away from the external world toward himself.'

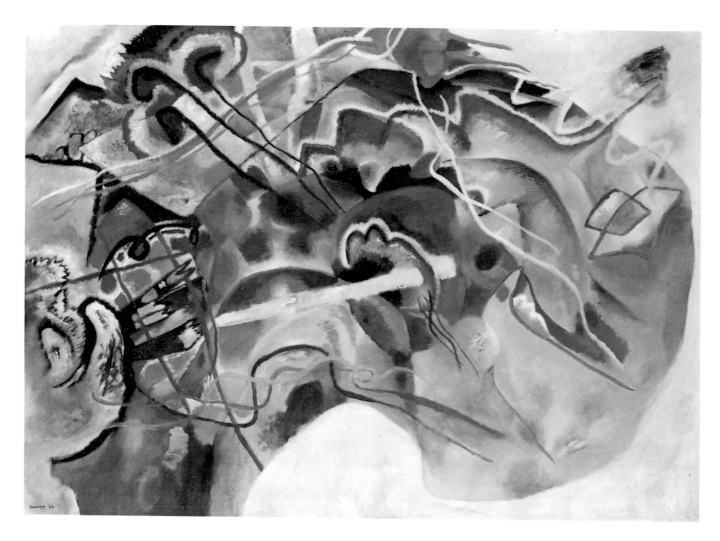

WASSILY KANDINSKY, PAINTING WITH WHITE BORDER

Painting with White Border (*above*) was, for Kandinsky, a major work. It was the outcome of a long series of sketches and studies (*opposite*), and the subject of an important essay by the painter published in 1913, the year of its completion.

Initially, like most of Kandinsky's works of 1913–14, it can give the impression of total abstraction; and Kandinsky's account of the work is kept entirely on the level of the abstract, but for a mention of the fact that the three wavering parallel lines, upper left, derive from a Russian three-horse carriage. Kandinsky analyses the work in terms of two centres joined by the thick white horizontal that crosses the middle of the canvas, one centre dominated by red and blue, the other by thick curving forms with white edges; he also stresses the fact that the amorphous white border on the right was an idea that only came to him at the very end of the process of composition, a point borne out by the existing studies. The title draws attention to this late, peripheral addition, and further underlines the insistence on the abstract.

For Kandinsky, the attainment of abstraction in painting was crucial. It was only thus that material considerations could be supplanted by the spiritual, or, in his terminology, by the 'inner sound'. But he acknowledged the possible role of subject matter, and all his apparently abstract works, including this one, began with subject matter, traces of which remained. Besides the carriage, the studies and the painting itself reveal the pres-

ence of 'motifs' which are found in many other Kandinskys. The central 'motif' is St George killing the dragon. The hunched back of St George is at the core of the right-hand centre, a white-edged, curved form; his lance is the thick white horizontal that crosses the canvas. The dragon occupies the left-hand centre, its claw-like appendages raised against the lance. Also still visible is the long, near-triangular shape of a trumpet, which enters the work top centre and crosses towards the left.

These 'motifs', Kandinsky maintained, triggered an emotion ('inner sound') to be brought out by a process of veiling, of obscuring their presence. Yet they were highly significant within the context of the Blaue Reiter group. St George appears on the cover of the major Blaue Reiter publication, the *Blaue Reiter Almanach* (also of 1913). The saint was a central figure in both Russian folk art and popular Bavarian glass painting, reproductions of which appeared in the pages of the *Almanach*. His symbolic role in popular Christian imagery as a force for spiritual virtue pitched against heretical ignorance was obviously relevant to Kandinsky's vision of himself and the Blaue Reiter group as the leaders of a spiritual campaign against materialism. The 'motif' of the trumpet appears in a whole series of Kandinskys inspired by the Day of Judgement.

However abstract, *Painting with White Border* sets in play an imagery expressive, for Kandinsky, of his own spiritual role in a world on the edge of apocalyptic revelation or disaster.

16
BETWEEN
UTOPIA AND CRISIS
1918–1939

CHRISTOPHER GREEN

INSET 417. HENRY MOORE: Head, *1937. Private Collection.*

OPPOSITE 418. MAX ERNST: Celebes, *1921. The Tate Gallery, London.*

1918 is a highly significant date in the history of the visual arts. It is not simply that the years after the Armistice saw the consolidation of innovations made by artists and architects across Europe, but also that they witnessed both a serious questioning of the attitudes that had instigated those changes, and an increasingly explicit association between *avant-gardism* in the arts and revolutionary aspirations in society. What the pre-war *avant-gardes* had achieved was now open to criticism not merely from the academics but also from the new *avant-gardes*; and with progressive modernism there developed hugely ambitious utopian programmes which met opposition either with contempt or with invulnerable optimism.

1918 was also a date of major importance in the political and social histories of the nations released that year from the First World War, and what happened in the arts is inseparable from those histories. Modernism in culture (literature as well as art) has habitually been discussed, until recently, as if it were quite distinct from political and social developments. For the period between the two world wars such a view is revealed as especially partial and flawed. Over these years modernists themselves can be seen to respond particularly directly to change or the promise of change in the world around them. Indeed, the questioning of *avant-garde* attitudes and values that took place after the First World War centred precisely on the problems that followed from

what seemed to many an over-exclusive dedication to art as such. Dadaists, Surrealists, Constructivists and Socialist Realists all worked above all for a reintegration of cultural and social life, of art and society. And even the mystical idealism of the early abstract artists, apparently so extreme a withdrawal from the material world before 1918, became associated with revolutionary aspirations, with attitudes that gave the highest priority to action in society.

The inter-war period began with hopes and fears: fear of a return to war and hope for a peaceful, just and constructive future. From the hope came the visions of utopias and revolutions, but they were, in fact, to be frustrated at every turn. The successful revolution in Russia in February 1917 was to be followed in the 1930s by the massively repressive dictatorship of Stalin. With Hitler's accession to power in Germany in 1933 and then the Spanish Civil War in 1936–9 and the triumph of Franco, the international diplomacy that characterised the 1920s, with its emphasis on the cementing of alliances as a bulwark against European war, was rendered valueless, as were all the hopes vested in the League of Nations. The Wall Street Crash and the crisis that shook Europe during the early and mid-1930s extinguished the hope of economic growth and stability which had accompanied the move to reconstruction after the war. Visionaries and revolutionaries sketched out illusions of possible futures in the 1920s only to find the real world

419. OTTO DIX:
Three Women, *1926.*
Collection Otto Dix.

RIGHT 420. GEORGE
GROSZ: Cross Section,
*1920. No. 68 in 'Ecce
Homo'.*

By the close of 1919 both Grosz and Heartfield had joined the brand-new German Communist Party and, working together, were using techniques (often photographic) adapted from Cubist *collage* and *papier collé* to produce images that were utterly antagonistic to the café-table intimacy of Picasso's and Braque's pre-war experiments. Out of these came Heartfield's directly political photomontages of the later 1920s and Grosz's portfolios of drawings, for instance *Ecce Homo*, from which *Cross Section* of 1920 comes (pl. 420). Grosz uses the fragmentations and the scaffold-like structures of the Cubists to present brutal depictions of power and powerlessness, of wealth, depravity, exploitation and poverty. These are the bitter products of alienation, and they are more than that: they are images with a purpose. Grosz and Heartfield rejected what they saw as the vacuous evasions of Blaue Reiter mysticism and the abstract art of Wassily Kandinsky. To claim 'otherworldliness', wrote Grosz with the Dada author Wieland Herzefelde in 1925, was, 'automatically, a support for the class which happens to be in power at that time, and in Germany that is the bourgeoisie'. It was necessary to work in the world and to take sides. Art was valu-

increasingly subject to economic collapse, crass authoritarianism and the threat of a return to war.

GERMANY: DADA AND THE NEUE SACHLICHKEIT

In France, the immediate sequel to victory was a period of seeming stability with the election of the so-called 'sky blue' National Assembly, the most conservative since 1900. In Germany, the immediate sequel to defeat was aborted revolution. Insurrections all over the country, instigated by the revolutionary Spartakus Bund, were brutally put down by the Freikorps, an alliance of nationalist students and ex-soldiers. Revulsion against the horrors of war was combined with a passionate desire to smash the society that had made it possible, and groupings of artists were formed sympathetic to the leftist revolutionaries. Among them were the members of the Club Dada, founded in Berlin in 1918; they included George Grosz (1893–1959) and Helmut Herzefelde (1891–1968), who took the considerable risk of changing his name to John Heartfield, to provoke the nationalists.

421. MAX
BECKMANN: The
Night, *1918–19.*
Kunstsammlung
Nordrhein-Westfalen,
Düsseldorf.

able only because it could be of use to the pro-
letariat in preparing the ideological ground for
revolution; its role was to develop class-
consciousness, to *aggravate* class division. Grosz's
and Heartfield's work was not aimed at a
bourgeois market via the dealer system; it was
aimed at wide distribution, above all within the
working class. They were activists *before* they
were artists.

It was, as has been suggested, alienation, an
alienated disgust for the greed, lust and violence
of those who controlled the modern urban world,
that gave bite to the political message conveyed
by Grosz's drawings; and it was alienation too
that gave bite to the intensely realist work of
other German artists, not necessarily connected
with Dada, and based in Dresden and Karls-
ruhe as well as Berlin – artists such as Otto Dix
(1891–1969) and Georg Scholz (1890–1945). A
work such as Dix's *Three Women* of 1926 (pl. 419)
does without the primitivising stylisations of
Kirchner's pre-war representations of Berlin pros-
titutes, to render grotesque, through distortion
allied to meticulous description, women offered
up for male gratification.

By 1925 commentators were writing of a wide-
spread 'return to realism' in German painting,
variously described by the terms 'Neue Sachlich-
keit' (New Sobriety) or 'Magischer Realismus'
(Magic Realism). An important exhibition organ-
ised that year by G. F. Hartlaub, the director of
the Kunsthalle in Mannheim, marked its emer-
gence. Ironically, the artist who was seen as the
major force in the exhibition, Max Beckmann
(1884–1950), though manifestly a realist in the
new sense, was atypical of the artists represented
in that his post-war view of man and society,
albeit accepting the presence of evil, focused also
on a belief in the good, in 'the spirit'. As a medical
orderly Beckmann had seen the worst result of
mechanised warfare, and *The Night* (1918–19; pl.
421) is indeed a representation of the new world
as a torture chamber, but it is modelled on
Christian martyrdoms in the tradition of
Grünewald's Isenheim Altarpiece (pls. 186,
187), and so on another level it offers the possibil-
ity of ultimate spiritual triumph.

422. PABLO PICASSO: Two Women Running on a Beach, *1922. Musée Picasso, Paris.*

423. FRANCIS PICABIA: Tableau Dada, *1920. Published in 'Canibale', Paris, 25 April, 1920. Whereabouts unknown.*

FRANCE: NEGATION AND AFFIRMATION

Germany in defeat was very different from Britain or France in victory. In France the optimism of post-war reconstruction indelibly marked developments in the arts; but the horrors of war left their mark too. The Club Dada in Berlin was an outpost of an international movement whose brief history begins in 1916 in neutral Zürich, where artists and writers were brought together by a common determination to escape the war. Dada's other major centre (from 1920) was Paris. There its leaders included both cosmopolitans who had succeeded in avoiding the war – Tristan Tzara, Francis Picabia (1878–1953) and Marcel Duchamp (1887–1968) – and young Frenchmen who had been deeply disillusioned by their unavoidable involvement in it (André Breton above all). These French Dadaists were not necessarily politically committed, like Grosz or Heartfield; they did not see the exposure of class division as their central purpose. For them, it was the values enshrined in the institutions of the nation state that were responsible for the catastrophe of 1914–18, and ultimately what lay behind those values was the ambition of human reason with all its products: science, culture, civilised behaviour. As writers and artists, their obvious target, therefore, was art itself, and especially the belief that it could be legitimised by universal principles of truth and beauty. The ideal of art was, in as many ways as possible, to be exposed as ridiculous.

Picabia's *Tableau Dada* of 1920 (pl. 423) is a comprehensively negative statement; it was never shown in an exhibition, but appeared instead on stage as a prop in a Dada performance. Dada images were at their most effective when used in this way to make public gestures. They were meaningless without a shockable audience; sympathisers were not enough. For Picabia here, Rembrandt, Cézanne and Renoir (the most unquestioned of culture heroes) are to be summed up by a stuffed monkey which, instead of a brush, holds his tail between his legs, limply. The creativity of the 'great' artist is male and phallic, but pathetically impotent.

The negativeness of Paris Dada appears all the more extreme because of the fact that it was the counterpart to developments in French modernism that were so positive and orderly. If commentators in Germany talked of a return to reality with the Neue Sachlichkeit, in France the talk was of a return to tradition with Neoclassicism and what some called 'constructive naturalism'.

The acknowledged leaders of this return to tradition were André Derain (no longer in any sense a 'Fauve') and, most surprisingly of all, Pablo Picasso. Derain's still-lifes of the 1920s, with their dark seventeenth-century look, and his felicitously painted nudes underlined the possibility of a modern continuation of 'the art of the museums'. Picasso's heavy-limbed successors to Poussin's repertoire of classically draped figures (pl. 422) were not quite so unproblematically traditional. He used distortions (the enormous hands and feet, the sausage-like fingers) and flattenings of form that are distinctly post-Cubist, and yet in such paintings, like Derain, he sustained a deeply conservative conviction, shared by many, that French art had rediscovered order and with it retied its links with the past. As a portraitist he made no secret of the lessons he had learned from the grandest of nineteenth-century academicians, Ingres. Yet, even such developments as these in the 1920s, though they might seem to emphasise the exclusivity of art and of cultural traditions, were clearly integrated into developments that had wide social and political implications. The war and its aftermath had seen a determined attempt on every level, from the popular press to the literary *avant-garde*, to restore the image of the French as a Latin civilisation, characterised by measure, reason and lucidity, the polar opposite of that image of the Germanic that stressed Gothic excess. The links with the political right are underlined by the fact that, in Italy, the rise of Mussolini went with a revival of Italian Classicism, which, under the title 'Novecento', received official Fascist endorsement. The painting of Italian Classicists such as Mario Sironi (1885–1961) was not at all out of tune with that of the French.

Yet, as an artist, Picasso continued to be as much a radical as a new conservative, provocatively remaining a Cubist while being a Classicist, unable to endorse any suggestion that there should be one true modern style. Art for him was never a matter of absolutes; there were, as before 1914, many ways of representing things, many pictorial languages. Order, however, became the watchword for his Cubism too and indeed for the post-war Cubism of the others associated with the movement before 1914: the scruffiness and multiple references (verbal and visual) of the pre-war *collages* and *papiers collés* gave way to immaculately worked, architecturally structured compositions such as *Guitar* (1919; pl. 424). Cubism was classicised, and so became, at least for some, compatible with the orderly conservatism of the post-war return to tradition, with all its reaction-

424. PABLO PICASSO:
Guitar, *1919*.
*Rijksmuseum Kröller-
Müller, Otterlo.*

ary connotations. When Jean Cocteau coined the term 'the Call to Order' as a slogan for French art in the post-war decade, it embraced both Neoclassicism and Cubism.

Strangely then, tradition was invoked as the foundation of Cubist art, but at the same time this more disciplined Cubism was perfectly adapted to the emphasis on progress that went with post-war reconstruction. After all, the Latin virtues (measure, reason, lucidity) were thoroughly in tune with the priorities of planners, engineers, manufacturers, builders, with industry and technology. One artist in particular who had been associated both with Cubism and with Futurism (to a lesser extent) before the war, stood for this new alignment, between Cubism and Classicism, and between Cubism and the machine: Fernand Léger. He reduced the human figure to a Classical ideal, putting together limbs as simple geometrical volumes, and then treated the robotic results as if they were polished steel; and he produced also compositions which turned 'mechanical elements' into the devices of a kind of industrialised heraldry (pl. 425).

385

ABOVE 425. FERNAND LÉGER: Mechanical Elements, *1927. Private Collection.*

RIGHT 426. CONSTANTIN BRANCUSI: Endless Column, *1920, 1925, 1928 in Brancusi's studio. Brancusi Archive, Musée National d'Art Moderne, Paris.*

director was Walter Gropius (1883–1969). Le Corbusier and Gropius stood for the belief that a perfect marriage could be achieved between a totally rational approach to the problems of structure and function in architecture and a totally ideal vision of formal perfection. For them, the beautiful and the functional were attuned at the deepest level. The new studios designed for the Bauhaus at Dessau were modelled on factory buildings: the accent was on unbroken interior spaces and optimum lighting from walls entirely of glass. Yet, these new student designers for the machine age were exposed to the teaching of painters whose attitudes were rooted in the unworldly mysticism of pre-war Munich abstraction: Lionel Feininger (1871–1956), Paul Klee (1879–1940) and Wassily Kandinsky, the pre-war leader of the Blaue Reiter himself. Le Corbusier's highly influential little book *Towards a New Architecture* (1923), which became the primer of the International Style, could coin the memorable slogan, 'a house is a machine for living in', and yet define architecture in the purest of formal terms, without a mention of the functional, as 'the masterly, correct and magnificent play of masses brought together in light'. It was such figures as Gropius and Le Corbusier who suc-

THE INTERNATIONAL STYLE IN ARCHITECTURE

The rigorous post-war version of Cubism, and especially its mechanisation in the hands of Fernand Léger, was the complement to major developments in modernist architecture as well, developments that affected not only France but Germany in the mid-1920s, and then from the later 1920s the whole of Europe, including Britain, and the USA too. The impact of this Modern Movement in architecture was, predictably, still marginal by the end of the 1930s: building was still dominated by the homely regionalism of the Garden City movement and by various forms of simplified traditional Classicism. But it was sufficiently trumpeted in enough countries to be dubbed by 1932 the 'International Style'.

There were two points from which the International Style most obviously spread: one was Paris and the architect-theoretician Charles-Edouard Le Corbusier (1887–1965); the other was a school of art and design, the Bauhaus (initially in Weimar, then in Dessau), whose first

ceeded in fusing the mystical idealism of the early abstract artists with a revolutionary vision of social change. For them, the renewal of architecture and design was a fundamental prerequisite of meaningful change in society.

Le Corbusier in particular applied his architectural ideas on a vast scale. He was a self-confessed utopian. He envisaged cities dominated by the verdure of great parks in which perfectly formed towers and apartment slabs would rise upon frames of reinforced concrete, their expansive windows open to the sun. He also envisaged the low-cost mass-production of houses for all social classes using prefabricated components. In fact, until the early 1930s he built on a small scale, producing houses (which tended to cost rather more than his estimates) for a cultivated and well-off élite. Perhaps the most perfect was the Villa Savoye just outside Paris, completed in 1931 (pls 428–31). Sited on a green hill, raised on reinforced concrete columns (*pilotis*), it was consciously conceived as a domesticated descendant of the ideal Greek temple. Yet, its sheer, cement-rendered walls, horizontal strip windows, internal ramp and the glazed wall of its living-room are uncompromisingly of their time; they recall factory or steamship design far more insistently than the Classical orders. *Towards a New Architecture* contained a eulogy to engineers.

For Le Corbusier, 'the most beautiful forms' of all were the simple geometric solids: 'cubes, cones, spheres, cylinders or pyramids'. Architecture was an abstract art in three dimensions whose ordered perfection was seen to stand for an abstract ideal of universal equilibrium. Such beliefs and the unadorned simplicity of International Style building made it the obvious partner of abstraction in painting and sculpture as it developed after 1918 on the foundations laid by Cubism and such organisations as the Blaue Reiter before 1914.

ABSTRACT ART IN THE WEST

Many leading abstract artists of the post-1918 period were non-combatants – for instance, the Dutchman Piet Mondrian and the Romanian Constantin Brancusi (1876–1957), both of them artists who were able to continue with quiet concentration through the war years and after as if little of ultimate consequence was happening outside their studios. Mondrian, after a brief spell in Paris, was confined to the safety of his native Holland by the outbreak of the war and did not return to the French capital until 1919; it was in Holland that he took the penultimate steps towards the mature geometric style that he reached

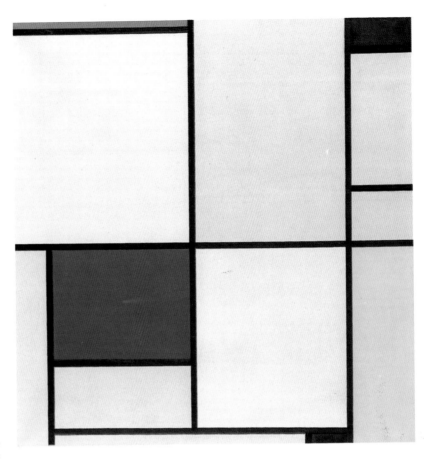

in 1920–1 (pl. 427). Brancusi, a highly innovative sculptor with a sound academic training behind him, stayed in Paris throughout the war; he had developed a very abstracted figure style by 1914, and during the war pared this down even further while at the same time extending upwards what had been the idea for a pedestal for his sculpture to form a totally abstract pillar-like work, later dubbed in its various versions (usually carved in wood) *Endless Column* (pl. 426).

Mondrian worked with what he considered the basic elements of painting: the primary colours (red, yellow and blue), non-colour (white, grey and black), and verticals and horizontals crossing in a rectangular relationship. The oppositions between these elements he thought of as equivalent to, indeed as embodying, the oppositions fundamental to all existence: active and passive, male and female, spirit and matter. To place them in an unbalanced, asymmetric relationship and then intuitively to bring them into equilibrium was to give visual expression to the ideal reconciliation of the forces fundamental to history and life. Mondrian thought of such purified visual balance as so totally satisfying to the human psyche that its achievement in the building of a coloured geometric environment would render painting obsolete. He was a utopian

427. PIET MONDRIAN: Composition in Red, Yellow and Blue, *1921.* *Haags Gemeentemuseum, The Hague.*

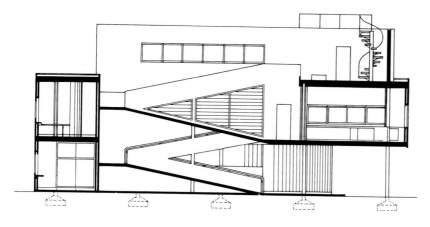

LE CORBUSIER, THE VILLA SAVOYE

Le Corbusier's thinking was geared to the city, to mass-housing on an enormous scale. His actual designing in the 1920s, however, was almost exclusively for well-to-do private clients.

The villa that he built at Poissy near Paris as a summer house for the wealthy Savoye family quickly became the Corbusian model International Style house, imitated throughout the world. In many ways it was not at all typical of his house-designing at the time: it was an unusually ideal commission. The Savoyes, he later said, were without 'prejudices', and hardly intervened in matters of aesthetics and design. The site was not hemmed in by other buildings or boundaries, but was an open meadow on a hilltop. Designed and constructed between 1928 and 1931, the villa summed up a decade of careful investigation, giving exemplary form to Le Corbusier's 'Five Points of the New Architecture', which he had first articulated in 1927: reinforced concrete supports (*pilotis*), roof-garden, free-plan, horizontal windows and the free façade. The main volume of the house is lifted off the ground by a regular arrangement of slender *pilotis* (*see plan, left*) which continue through the structure vertically, freeing the walls both inside and out from load-bearing. Within the elevated volume of the house are 'hanging gardens' at first-floor and roof level, with curving walls above to protect sunbathers from the wind (*right*). The regular four-façade exterior frames an interior which is irregular and highly complex in plan. Long horizontal windows ensure an even distribution of light everywhere inside, and sweep unbroken, 'freely', right across each façade at first-floor level.

All the 'five points' were based on structural and functional considerations, but the villa was conceived more as an aesthetic composition. Its external walls were coloured, using a restrained range from green (below the main volume of the first floor) to pink and blue (for the curved walls of the solarium above), and the entire design was organised around an ideal route into and then up through the house which would provide a continuously unfolding experience of forms in space. Le Corbusier talked of an 'architectural promenade'. In formal terms his conception was of a succession of Cubist-related compositions, some incorporating views of sky and landscape, fusing one into the next.

The house was not to be entered on foot. Its ground-level hall and service-

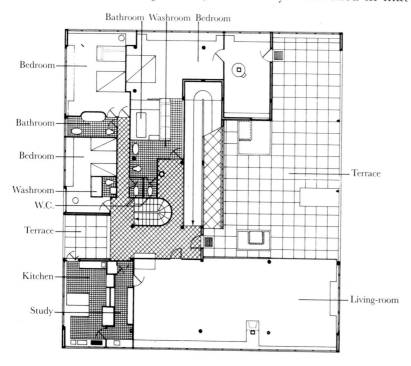

Bathroom Washroom Bedroom

Bedroom

Bathroom

Bedroom

Washroom

W.C.

Terrace

Kitchen

Study

Terrace

Living-room

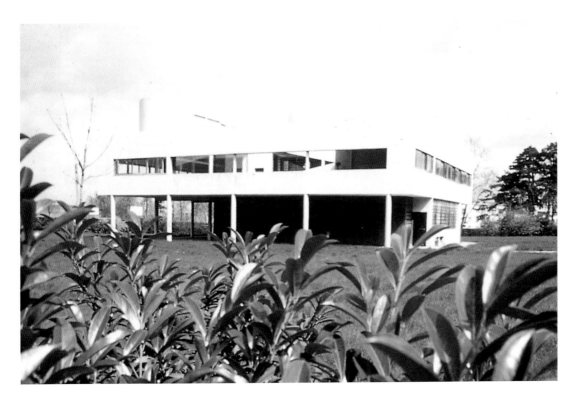

areas (including garages) were shaped to accommodate the turning circle of the chauffeur-driven cars which were to sweep in under the overhang of the first floor, delivering their passengers to the main entrance. Out of the hall rises a ramp up which the visitor walks to the *piano nobile* first-floor (*see plan, far left*), where all the sleeping, living and entertaining areas of the house are arranged. There the living-room and the terrace (an outdoor room with its own horizontal windows) open into one another (*right*), and the ramp continues from the terrace to the roof, the sky and the splendid view over the Ile-de-France.

The Villa Savoye makes unmistakable allusions to Classical precedents. It was in the fullest sense designed as a modern classic. Le Corbusier repeatedly stressed the links between the 'new architecture' and the principles that he believed essential to all major architecture. For him, the temples of the Parthenon and Paestum were as important as anything twentieth-century engineering could produce. Here he seems to have responded espe-

cially to the example of the Palladian villa. The columns, the four-façade symmetry and the impeccable proportions of the house have all encouraged comparison with Andrea Palladio's Villa Rotunda.

For architects and historians the reputation of this building is immense; but for the clients its success was qualified. The cost was almost double the final estimate, and repairs were already needed in the year of its completion.

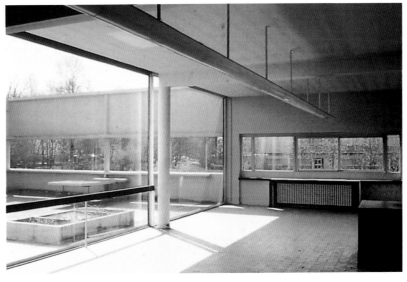

of a still more rarefied kind than Le Corbusier. By turning his own Montparnasse studio into a composition of coloured rectangles on white, he sought to perfect his own environment, but he could go little further. Even after 1925, when his importance began to be widely acknowledged, his austere compositions were never easy to sell to others.

Brancusi thought in terms of Platonic essences. He believed his schematised heads captured the essence of the head (at rest or in rêverie) and his birds in marble and bronze (pl. 432), rubbed and smoothed down to a single ascending convergence of long curves, that of the bird (soaring into flight). For him, further, the craft of the sculptor preserved in the modern world a respect for ancient verities: a feeling for the rightness of certain forms in certain materials, and an appreciation of hand techniques that had more to do with his Romanian peasant beginnings than with the machine age. He lived with his tools and sculpture about him, his furniture roughly made by his own hand, hidden away in a ramshackle wooden studio well off the boulevards. The image he cultivated was of the peasant surviving in the city, and yet the streamlined calm of his sculpture was and is never out of place in the immaculately severe spaces of the International Style interior (pl. 426). Paradoxically, he survived largely because of the support of highly urban, rich American collectors such as John Quinn and Katherine Dreier.

Abstraction between the wars in painting and sculpture was itself international. By the mid-1930s the art of Mondrian and Brancusi was known by *avant-garde* artists everywhere. In Budapest, London and New York there were 'schools' of geometric abstraction along with several varieties of very late Cubism. When finally war threatened again in Europe, Mondrian was persuaded by a British admirer, Ben Nicholson (1894–1982), to come to London (in 1938), where he stayed until the first air-raids drove him off to New York; there he found still more admirers, artists such as George L. K. Morris (b. 1905), Fritz Glarner (1899–1972) and Ilya Bolotowski (b.1907), who had formed the American Abstract Artists association.

Within *avant-garde* circles during the 1930s, the question of the relative merits of abstraction and figurative art, and of the geometric and the organic varieties of abstraction, became central. The organic (or 'biomorphic', as it was called) was associated with the instinctive and the natural; it found its model in the work of the Alsace-born artist Hans Arp (1887–1966), who was based in

Paris. The geometric was associated with calculation, the intellectual, with science as well as mysticism. Few artists were thought capable of fusing the organic and the geometric, though Morris in the United States argued for it, and the critic Herbert Read in Britain advocated the validity of both kinds of abstraction. For Read, if Nicholson stood for the geometric in British modernism, the sculptor Henry Moore (1898–1986) stood for the organic; he championed both with equal vigour. In certain sculptures of 1936–7 Moore succeeded in combining the organic and the geometric (pl. 417), but his love of natural materials (stone, wood) carved directly, and his engagement with natural forms (bones, pebbles, landscape, the human figure) never allowed his work to appear calculated or intellectually abstracted.

Moore traced the origins of his sculpture back to Brancusi, but, most importantly, to 'primitive' sculpture: Egyptian, Cycladic, African, pre-Columbian. The international geometric abstractionists looked above all to Europe and the twentieth century. They looked, however, not just to Paris, Holland and Mondrian, but, perhaps more significantly, to Berlin, Dessau and Russia, especially Russia.

RUSSIAN CONSTRUCTIVISM: 'THE SLENDER CHILD OF AN INDUSTRIAL CULTURE'

Russia was, of course, a very special case. After February 1917, this vast country experienced years of debilitating civil war, but also saw the first hopeful if confused steps towards the building of a new post-revolutionary society with its own economic and social structures, and its own institutions. Artists involved themselves with indefatigable energy, and at first those members of the *avant-garde* who had worked so inventively on the margins of pre-revolutionary society saw the determination to sweep away the old institutions and attitudes as cause for optimism. The experimental abstract painting which Kasemir Malevich had developed between 1913 and 1917 under the title 'Suprematism' seemed for some to point the way to the future, and, when post-revolutionary Soviet art was shown for the first time in the West in 1922 (at the Galerie Van Dieman in Berlin), it was Malevich's painting and that of others deeply affected by his example that made the most telling impact. For abstract artists in the West, the counterpart to the flat primary coloured rectangles in stable relationships that typified Mondrian's mature work was the far more varied coloured shapes floating in a

432. CONSTANTIN BRANCUSI: Bird in Space, *1925. National Gallery of Art, Washington DC.*

measureless white expanse that characterised Malevich's more complex Suprematist compositions (pl. 433): they opened the way to an abstraction that was both more charged with energy and less spatially confined.

Yet, when such works were shown in Berlin in 1922, Malevich's stance had already been under attack within the Russian *avant-garde* for several years, and post-revolutionary Russian modernism is not to be understood merely as offering inspiration to Western abstract artists. Indeed, it offered a powerful antidote to abstraction. Malevich's was a quasi-religious approach to painting and to his role as an artist, one that was closely in tune with that of Mondrian or Kandinsky: he believed abstract painting capable of inspiring a kind of contemplative awe which was essentially spiritual. For those *avant-garde* artists in Russia who were intent on finding a new role for the artist compatible with Marxist materialism and with the rise to power of the proletariat, such beliefs were retrograde and ultimately 'bourgeois'. Led by such artists as Vladimir Tatlin (1885–1953), Alexander Rodchenko (1891–1956) and Varvara Stepanova, (1894–1958), and such writers as Alexei Gan and Anatole Brik, these progressive critics of abstraction took a view of its 'otherworldliness' that was not far from George Grosz's and John Heartfield's in Berlin; but the fact that their vantage point was post-revolutionary Russia meant that their view of the possible role of artists and the future for art was very different. For them, the point was not to expose class distinction, but to build for a Communist future, for what seemed in the early 1920s a *possible* utopia. Significantly, whereas Grosz and Heartfield associated themselves with a movement designated by a nonsense word 'Dada', to underline its subversive, critical character, Tatlin, Rodchenko and Stepanova were known as 'Constructivists': their task was to build, as well as to attack, the spiritual idealism of such painters as Malevich.

Like the Dadaists, the Constructivists began by rejecting altogether art as it had been known hitherto. For Alexei Gan, 'Art is indissolubly linked with theology, metaphysics, and mysticism'; born of 'the hypocrisy of bourgeois culture', it had 'crashed against the mechanical world of our age'. With the first working-group of Constructivists in 1920 he announced, 'We declare uncompromising war on art!' Since the artist was seen now as a worker building for the future after 'the victory of materialism', his new role was to bring his understanding of form, material and technique to bear on the practical

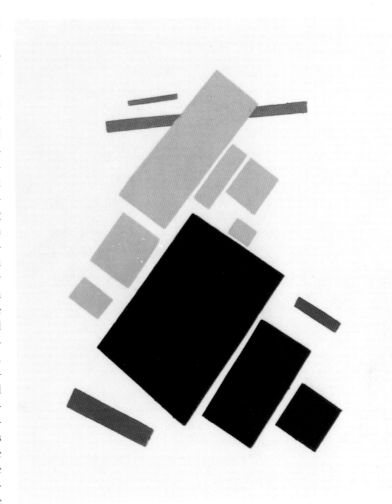

problems of design. Tatlin turned from constructing post-Cubist sculptures suspended on wires across the corners of rooms (in 1915), and exhibiting a project for a visionary communications tower and party headquarters as a *Monument to the Third International* in 1920, to designing workers' clothing and cheap stoves; Rodchenko and Stepanova designed posters (pl. 434), workers' furniture and even sweet-wrappers. Artists threw themselves into working with architects and for industry. Gan wrote not of artistic creativity but of 'artistic labour', and saw Constructivism as 'the slender child of an industrial culture'. The new society seemed to offer the opportunity for escaping the marginalisation that went with the eccentricity and the alienation of the *avant-garde*; Constructivists hoped for a role of central importance, where their knowledge and their imagination would count for the collective good.

In fact, they miscalculated. In the early 1920s they achieved representation in state institutions, and became dominant in two of the faculties of the state art school in Moscow; but even then the

433. KASEMIR MALEVICH: Suprematist Composition: Aeroplane Flying, *1914. Museum of Modern Art, New York.*

434. ALEXANDER
RODCHENKO: Poster
for Dziga Vertov's film
'Kino Glaz' (Cinema
Eye), *1923*.

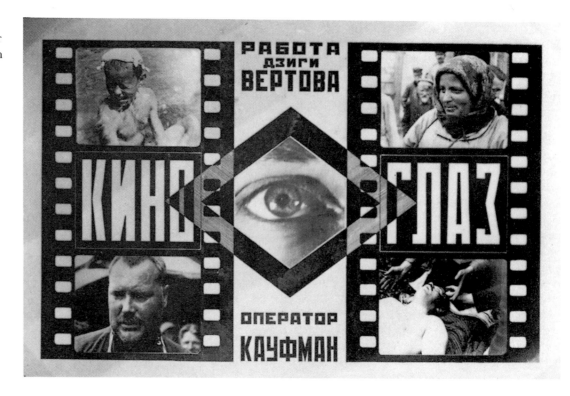

more conventional artists, especially those still working in realist idioms, remained in favour (predictably, they were dominant in the faculties of painting and sculpture at the state art school), and by the late 1920s and early 1930s it was they who were to take control, at the Constructivists' expense. The self-immolation of the artist in the role of servant to industry proved in the end just as utopian a vision as any dreamed up by the 'mystics' of Western abstract art. The new Soviet society proved even more ruthlessly adept at marginalising *avant-garde* artists than did the old liberal democracies of Europe.

SURREALISM

During the 1920s a Western Constructivist movement grew up, especially in Germany, to supplement the Russian original, and involved in it were the Russian *émigrés* Naum Gabo (1890–1978) and Antoine Pevsner (1886–1969). But outside Russia, Constructivism lacked the stark revolutionary sense of purpose maintained inside Russia; the making of art was its purpose, art understood in the European modernist sense as formal perfection. The fused functionalism and idealism of the International Style in architecture was found to be utterly compatible with it. But in the West between the wars a radical opposition to the positive modern view of art arose which went beyond the bitter nonsense of Dada and which can be compared in its seriousness, its effectiveness and its grandeur of vision to Constructivism

in Russia. In *avant-garde* circles, at least, it provided an antidote to the Classicist 'Call to Order' and to the metaphysical invocation to abstraction. This was Surrealism.

Paris Dada was the preface to this movement, and it engaged writers as much as artists. Its founder and leader was the one-time Dada writer André Breton, who in 1924 published a Surrealist Manifesto and to accompany it a book of essays entitled *Les Pas Perdus (Lost Steps)* to show how he had written his way out of Dada into his new position. To a degree Breton remained Dadaist: he always distrusted the notion of 'art' and the pretensions of artists; above all he rejected the tendency to place art and artists in some special category insulated from the other aspects of life. But he departed from Dada in his belief that the imagination could arrive at positive results of profound value, and could do so especially in poetry and the visual arts. The arts were not mere nonsense and neither were they the means for revealing some spiritual truth. What is more, they were certainly not open to compromise with the functional demands of modern technology. They were the route to what Breton called the 'marvellous' or the 'surreal'. They could demonstrate how the material world and all 'normal' relationships could be transformed by the imagination. As he defined it, the marvellous entailed the unprecedented conjunction of otherwise disassociated or distant 'realities'. He used as a key instance the poet Lautréamont's unforgettable simile

'beautiful as the chance encounter of an umbrella and a sewing machine on a dissecting table', but also the well-worn cliché 'lips of coral', which fuses together the softness of lips and the brittle redness of coral. For Breton, the role of the poet or artist was not to offer classically perfect or abstractly beautiful compositions, but to release the imaginations of others by offering 'marvellous' images, verbal or visual. The central problem was how to ease the way to the discovery of such images.

In the 1920s the major routes to the 'marvellous' advocated by Breton and the Surrealists were two: the dream and what they called 'automatism'. The belief was, following Freud and psychoanalytic theory, that images of a special power were available only if the repressive control of reason could be evaded, something that happened in dreams and also when one let oneself imagine (in writing or drawing) without conscious direction. The accurate and honest recall of dreams or the totally undirected release of the imagination were both, of course, over-ambitious aims, but for a while the Surrealists worked as if they were attainable. Giorgio de Chirico's (1888–1978) deserted piazzas peopled by statues or shadows (pl. 435), his bizarre collections of toys, scientific instruments and biscuits were taken as the models for a credible painting of dreams, pointing the way to such works as *Celebes*, by Max Ernst (1891–1976; pl. 418). Freudian free-association techniques in analysis were used for experiments in automatic writing which in turn showed the way to the more or less automatic drawings of André Masson (1896–1987) and Joan Miró (1893–1983). In various ways these artists tried to draw without conscious direction, hoping that new and surprising conjunctions of images would occur on the paper; the results were then transferred to make paintings. Miró's enormous *The Birth of the World* (1925; pl. 438) is one of a series of over 100 pictures painted in the mid-1920s on the basis of such drawings.

The title here, added by a poet friend of Miró's, is telling, for it fixes attention, both on the new 'world' to be created by the imagination and on the actual process of its 'birth'. In an inchoate swirl of clouds, mists and precipitations, we encounter a sperm-like organism and a figure. But the point is not merely that we can regard these images as images of birth and origin; it is also that we can see the very way in which they have been *made* as a process of birth. Although it is known that drawings did precede the work, the effect is given of painting as a spontaneous (automatic)

series of acts; it almost seems as if we can relive those acts and the very moments of the 'discovery' of each image. *The Birth of the World* is a statement about the power of the imagination released from a real world far too subject to reason; it is a statement about the new world of the 'marvellous', a statement made against the measurable, graspable, material factuality of a world controlled by the engineer and the scientist. It offers no Classical or metaphysical ideal, but it is a work whose largeness of ambition equals anything produced by Malevich or Mondrian or Tatlin.

Between 1928 and the mid-1930s both André Breton and the Surrealist movement made changes, and amongst others Masson found himself excluded from the 'approved' roll of adherents. Breton was not nicknamed 'the Pope' for nothing; he persistently purged his group. Most noticeably, there was a swing in Surrealist art away from 'automatic' drawing and painting, with its tendency to near-abstraction, towards what was termed 'the hand-painted dream

435. GIORGIO DE CHIRICO, The Philosopher's Conquest, *1914. Art Institute of Chicago. Joseph Winterbotham Collection.*

JOAN MIRÓ,
THE BIRTH OF THE WORLD

The Birth of the World, painted in 1925, is the largest of Miró's so-called 'dream paintings', a series of over 100 canvases, produced between 1924 and 1927, which deploy simple signs, somewhere between drawing and writing, in pictorial environments often suggestive of a limitless atmospheric space. The imagery in these works combines the explicit and the evocative so that the spectator can decipher and respond to it in many ways. Here only the reclining figure, delineated in the simplest of stick-man signs, is at all explicit. The smudges and dribbles of paint that cover most of the picture surface create an atmosphere of indeterminacy and suggestion that, like the other far more vestigial signs, invite a play of the imagination. The title, added by one of Miró's many poet-friends, endorses the invitation; it is the spectator who is to give works of this kind meaning.

This picture was from the beginning admired by the Surrealist leader André Breton and his friends as an unusually free display of painterly spontaneity, or, to use the Surrealists' term, 'automatism'. The figure, the black triangle, the red blob with yellow tail and the spider-like asterisk below, superimposed as they are on the drifting mists of the ground, seem to have been summoned by Miró out of the very process of sponging and dripping the thinned oil paint on to the canvas. It is as if a world of creatures or organisms emerged spontaneously as Miró worked. For the Surrealists this *appearance* of automatism was enough.

In fact, Miró preserved sketch-books from the 1920s that demonstrate how all the 'dream paintings', including this one, had their beginnings in drawings. Sometimes these drawings were relatively automatic: Miró allowed his hand to

move with the pencil on the paper with a minimum of control, or jotted and scribbled in response to the cracks and smudges on the walls of his studio, or the knots and grain in wood. Sometimes, as in this case, Miró began with simple sketches that set a scene or tell a story. There is a very exact pencil study for the painting, which anticipates dots and streaks of the most seemingly random kind (*left*), but behind this there lies a far more elementary and at the same time explicit first sketch (*far left*). *The Birth of the World* began as a scene of innocence, a moment perhaps before the Fall: a figure, either man or woman, rests under a tree which bears a single fruit. The erect head signals an alert expectancy, as if something is about to happen.

439. RENÉ
MAGRITTE: The
Double Secret, *1927.*
*Musée National d'Art
Moderne, Paris.*

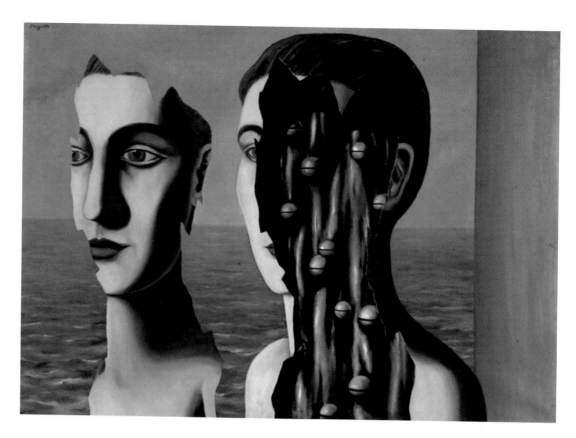

picture' (though dreams were only ever partly alluded to) and the transformation of the real, of actual things, by photography or by assembling objects in startling combinations. The new Surrealist figures included Salvador Dalí (1904–89), René Magritte (1898–1967) and the sculptor Alberto Giacometti (1901–66); the new, more tangible manifestations of the 'marvellous' included Dalí's *Soft Construction with Boiled Beans* (pl. 440) and Magritte's *The Double Secret* (pl. 439). But the goal remained ultimately the same: the conquest of reason and fact by imagination.

In true Dada spirit the Surrealists derived great satisfaction from shocking the conventions of the bourgeoisie. Breton consistently damned the dealer system on which modernist art still depended, as it had before 1914. He affected to despise the way that art works of whatever kind became mere commodities exchanged for profit once they entered the gallery world, even that of such committed dealers as D. H. Kahnweiler (who took up Masson). And yet the Surrealists themselves depended on the openness and volatility of the dealer system, and, just as Cubist art began to attain real commercial success during the 1920s, so did Surrealist art by the end of that decade. Indeed, artists such as Max Ernst and Joan Miró achieved real worldly success remarkably fast (representation by the fashionable galleries of the right bank in Paris, the Galerie

Georges Bernheim for instance), and by 1930 the movement had acquired patrons amongst the most fashionable of the rich, the Comte and Comtesse de Noailles most glamorous of all. The Surrealist campaign was in deadly earnest, and was pursued as a sort of sacred (or rather sacrilegious) trust; but it initiated one of the first epidemics of 'radical chic' in Western cultivated society.

On a different level from that of the smart public, Surrealism had an enormous impact on European and, in the 1930s, on the British and American *avant-gardes*. It is not an exaggeration to say that its impact came close to equalling that of Cubism. Indeed, even Picasso was affected, allowing himself to be celebrated by Breton almost as if he had always been a Surrealist and, from 1925, turning to themes and modes of pictorial expression obviously related to the new movement: themes of violence and sexuality above all. Surrealism became by 1936 'International Surrealism', propagating itself worldwide by means of exhibitions whose panache has rarely been rivalled, amongst them the International Surrealist Exhibition in London, and 'Fantastic Art: Dada and Surrealism' at the Museum of Modern Art, New York (both in 1936). It was the other side of the international abstract-art coin; it was both extravagantly successful and a genuinely disruptive alternative.

MODERNISM IN CRISIS:
ART AND POLITICS

By the end of the 1930s, the utopians, the mystics, the revolutionaries and the subversives of the Western *avant-garde* movements had generated a remarkable range of ideas and images; but everywhere they were under attack, often from new, more formidable opponents. Just as Stalin's Russia put the entire modernist enterprise in question, so too did major political developments in western Europe. The themes of violence and catastrophe that dominated especially Surrealist-related art during the decade were distinctly apt in the circumstances: violence on an international scale was once again in the air, and among the lesser catastrophes that threatened was the extinction of all that the moderns had hoped for and achieved. The modern art movements of the West grew up with the progressive liberalisation and the economic expansion of capitalist Europe and America. Many abstract artists, most International Style architects and all the Surrealists (some of the time) asserted an explicit allegiance with the Communist left, yet, ironically, they depended for their futures on the survival of the liberal democracies. Both Fascism and totalitarian socialism shut out innovation in the arts.

The great adversary of modernism in all its guises was realism, but realism dignified with a new scope and purpose and above all empowered by the easy popularity of its appeal. Though too many historians of 'modern art' fail to recognise the fact, realist styles have, of course, continued throughout the twentieth century. There have, moreover, been moments when their status and public impact have been especially widely significant; such a moment came in the 1930s. The conservative revival of Classical styles in France and Italy after 1918 was a prelude to developments on a much larger scale whose central themes were far less limiting than the appeal to a Mediterranean past characteristic of the 1920s. And these new, rampant realisms were often entirely to lack the bitterness and the critical bite of, say, Grosz or the German artists of the Neue Sachlichkeit. Especially when sanctioned by authoritarian régimes, these affirmative rivals to modernism were often to be heavy-handed and predictable, but noble realist images which are truly impressive were also to be produced; a genuine challenge was offered.

It was realism along with Neoclassicism that took over as the official art not only of the Soviet Union but also of the new Nazi state, and in the Germany of the Third Reich this much-vaunted return to 'wholesomeness' was directly set against the 'degeneracy' of the moderns, of Dada, abstract art and Expressionism. Artists who celebrated the earthy virtues of the peasant or the ideal physical perfection of the (Aryan) body supplied the cultural sustenance for Hitler's new society. In 1937 their work was shown in Munich at the so-called 'Great German Art Exhibition', in opposition to a massive official exhibition given the title 'Degenerate Art', which brought together literally thousands of works by the moderns as the butt of public ridicule and contempt. The prospects for those who would not toe the Classical or realist line under Nazism or Fascism could not have been asserted more chillingly.

Yet in the West there were instances where realism given official backing did not produce mere complacency or vainglory. In France, the election in 1936 of the country's first socialist administration, the Popular Front under Léon Blum, went with a campaign for a new Socialist Realism, led by intellectuals on the left sympathetic to the Soviet Union – notably, the one-time Surrealist writer Louis Aragon. In the United States, one of President Roosevelt's New Deal initiatives, the provision of public commissions all over the country for unemployed artists, the Workers Progress Administration, tended to promote Regional or Social Realist styles. But most compelling of all as a demonstration of what a

440. SALVADOR DALÍ: Soft Construction with Boiled Beans: Premonition of Civil War, *1936. Philadelphia Museum of Art.*

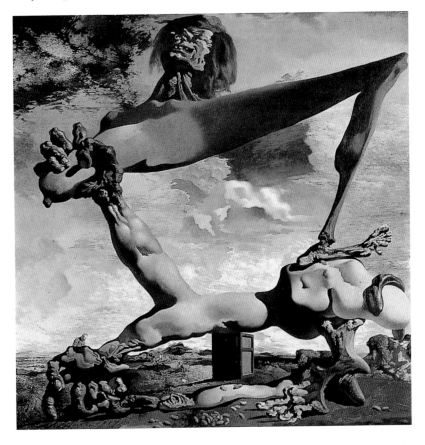

441. PABLO PICASSO:
Guernica, *1937. Museo
del Prado, Madrid.*

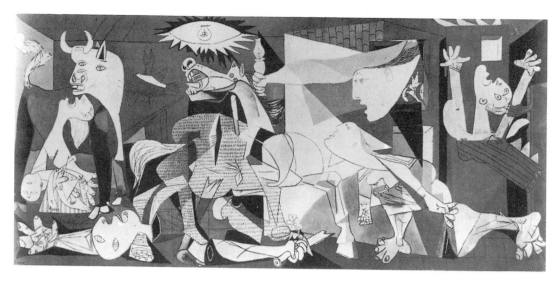

modern realist art could achieve was the work of the Mexican muralists José Clemente Orozco (1883–1949), David Siqueiros (1898–1974) and, especially, Diego Rivera (1886–1957), the official painters of a régime at least partly directed by Marxist ideals, which was the beneficiary of the Mexican Revolution of 1910–17.

Rivera had been a Cubist of great inventive talent in Paris between 1911 and 1917, but by the date of his return to Mexico in 1921 he had dropped his *avant-garde* identity, 'in the belief', as he put it, 'in the need for a popular and socialised art'. He combined a grasp of flattened compositional structures derived from his Cubist work with a firm understanding of the eloquence of Renaissance figure styles, their monumental simplicity and their range of gesture; alongside this, he applied lessons well learned from Aztec and Mayan art. It is all there to be seen in his fresco cycles for the Ministry of Education (1923–8) and for the National Autonomous University of Chapingo (1924–6), in his American cycles in

442. DIEGO RIVERA:
Man at the Crossroads
(detail), *1932–4. The
Palace of Arts, Mexico
City. This is the repainted
and final version of
Rivera's mural.*

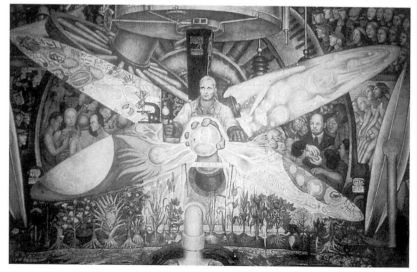

San Francisco and Detroit, and in his *Man at the Crossroads* of 1932–4 (pl. 442). These murals give force to a view of the world, Mexico and its history which was confident, enormously hopeful and resolutely Marxist.

Surprisingly perhaps, *Man at the Crossroads* was commissioned by the American arch-capitalist J. D. Rockefeller Jr, to adorn the Rockefeller Center in New York. Edsdell Ford had already financed the murals for the Detroit Art Institute. But on this occasion Rivera revealed his socialist purpose so plainly that, as the painting neared completion (speeded by the number of assistants working on it), the press latched on to the possibility of scandal and precipitated Rockefeller's withdrawal. Rivera's subject was, in his own words, 'the workers of the cities and country inheriting the earth'. At the heart of the teeming yet highly organised composition, with Lenin to his right, a worker in overalls sits with his hands on the controls, finally in command of the means of production; directing history.

Rivera's work as a muralist had begun in 1922 in the context of a state-backed campaign for education and literacy. At a time when mass political movements held such sway, the question of art and its public function was central to the issue of realism in the 1930s. The questions asked, even by modernists, were the following. Should art be ultimately concerned with the individual psyche? Should it be above all a matter of 'genius', expression or personal invention, or should it address a mass public on issues of major social and political moment? Should it deliver a collective message and help mould society?

One artist who tried to come to terms with these questions without betraying or even compromising firmly held modernist principles was Fernand Léger. In the optimistic if increasingly

443. FERNAND LÉGER: Composition with Two Parrots, *1935–9. Musée National d'Art Moderne, Paris.*

anxious atmosphere of France under the Popular Front, Léger attempted to develop his own modern art for the masses. He worked with teams of his students to provide the décor for enormous public spectacles in sports stadia and vast murals for the 1937 International Exhibition in Paris. His easel painting changed at the same time, as is clear in the mural-scale *Composition with Two Parrots* painted with the help of assistants between 1935 and 1939 (pl. 443). Léger did not use painting to educate or to persuade by propaganda (like Rivera), and he was still patently a modern: his figures float, careless of gravity despite their weight, conceived as swelling pictorial masses contrasted against the geometry of posts and frameworks. His aim was to distort and to manipulate his subject matter in order to create powerful formal contrasts. But his subject matter is popular (acrobats and gymnasts) and he is straightforward in its presentation. For him, too, obscurity and élitism have become unacceptable.

Even Picasso tried his hand as a modern with a popular mission. Deeply affected by the Spanish Civil War, he accepted a commission from the Spanish Republican government (before its final defeat) to paint a mural for its pavilion at the Paris Exhibition of 1937. The result was *Guernica* (pl. 441), perhaps the single most famous anti-war image produced by a painter of the twentieth century. Cubist distortion and the Surrealist fascination with the most violent of the Classical myths (especially the myth of Theseus and the Minotaur) combine in highly emotional response to the bombing by Hitler's Luftwaffe of the little Basque town of Guernica and the massacre of its inhabitants. Critics on the Marxist left saw this as too generalised, too disengaged a response; others saw the work as a 'universal' expression of rage against war, capable of transcending the moment of 1937. Whatever the case, it is an image whose horror and drama is in no sense obscure.

The inter-war period began with revolution in Russia and reconstruction in the West; it ended with crisis and disintegration. On the brink of the Second World War many futures were in the balance including that of every modern movement in the arts to have been produced in the first four decades of the century. The outcome of the war would allow their continuation, even open the way to fresh starts; or not. In 1939 nothing was certain.

399

17
THE LAST MODERNS

ROSALIND KRAUSS

INSET 444. FRANK
STELLA: Die Fahne
Hoch!, *1959. Private
Collection.*

OPPOSITE 445.
WILLEM DE
KOONING: Women
Singing II, *1966. The
Tate Gallery, London.*

The rise of Fascism and the struggle to arrest it convulsed the world in a second global war. For those who lived through it, that war could not be seen as a rupture with the past but, instead, as a prómise to continue: to continue the values of a liberal, humanist culture; to carry on progressive dreams for a better, more open society; to sustain the culture that espoused those values and dreams, the culture of modernism. That the war, decisively won by the Allies in 1945, might none the less have prepared a ground in which those values and dreams could not flourish as before was the last thing imagined by the spokesmen and women for the culture they believed it was fought to preserve – the supporters, that is, of internationalism, of a unity of nations.

Modernism is, of course, a *style* of cultural expression. It appeals to a formalisation of what could be called the rules of a given medium of artistic practice. Arnold Schoenberg's twelve-tone rows, Piet Mondrian's grids and primary colours, James Joyce's multilingual wordplays, all announce the way these rules both derive from and are used to operate on the building-material of a given medium: musical pitches, colour and surface, language's restricted phonetic palette. But, beyond the matter of styles and formalisms, modernism also entails a political *belief*, the belief that this rationalisation of the very medium of creation would open nations up to one another, would produce a kind of algebra of expression

that could cross state boundaries, creating a language everyone could speak.

The war itself produced conditions that reinforced an experience of internationalism – especially in the United States, to which a massive number of European intellectuals and artists had fled for safety, beginning in the mid-1930s and with increasing urgency after 1939. Intellectuals such as Theodor Adorno and Hannah Arendt, writers such as Thomas Mann and Bertolt Brecht, composers such as Schoenberg and Darius Milhaud transplanted themselves to New York or to Hollywood. And the rather provincial American art world received an injection of internationalism that was to transform it utterly. Not only were great figures within abstract art, most notably Mondrian, now foxtrotting in Manhattan nightclubs and making paintings called *Broadway Boogie-Woogie*, but major figures of the Surrealist movement, from its leader André Breton to painters such as Max Ernst and Yves Tanguy (1900–55), installed themselves in New York City and disseminated their ideas in exhibitions such as 'First Papers of Surrealism' or magazines such as *VVV*.

That the politics of modernism continued to seem self-evident well into the New York of the 1960s can be illustrated by a debate that crosses art with ideology. It is a debate a major art historian (Meyer Schapiro) insisted on having with a famous philosopher (Martin Heidegger) at the time of the death in 1966 of an important psy-

chologist (Kurt Goldstein). In 1936 Heidegger, who held a high university post in Nazi Germany, had written *The Origin of the Work of Art*, an examination of art's particular way of revealing truth. In that essay Heidegger, speaking of a painting of a pair of shoes by Vincent van Gogh, sees these shoes as connecting the picture's viewer with the experience of peasant labour, of a struggle with the earth that is that of farmer and homeland. Schapiro's objection, made in honour of the German refugee Kurt Goldstein, attacked this reading as limited by an ideology of the soil and the nation state. The painting, he replied, shows us Van Gogh's own shoes, the shoes of a man who had left the soil of rural Holland to emigrate to Paris, there to espouse another version of culture for which the internationalism of the great urban centres is the symbol, a culture in which pulling up one's roots allows for another kind of freedom.

ABSTRACT EXPRESSIONISM

Schapiro's argument addressed a painting of 1886, but it was pronounced in 1968 against a statement of 1936. These dates bracket for us the extension of that period of a continuing faith in the politics of modernism, a faith that for many intellectuals was not to be shattered until the end of the 1960s. To work as a painter in New York in the 1940s and 1950s was thus to operate under the umbrella of that faith, to gather in a large urban centre, having come either from a European background – Willem De Kooning, (b. 1904) and Mark Rothko (1903–70) – or from the far Western prairies – Jackson Pollock (1912–56) and Clyfford Still (1904–81) – in a commitment, once again, to the melting-pot culture of modernism. The very name Abstract Expressionism, through which the work of these painters came to be known, is a kind of credo of the ambitions of this late, high-modernist efflorescence.

'Expressionism' stood for speech, for communication, for people talking to one another across the cultural boundaries this undertaking would collapse as it fused European visual forms with those that were native-born, mixing Surrealism with North-west Coast Indian pictograms, fusing early-twentieth-century abstraction with Navajo sand-painting, amalgamating the cry of the land with the beat of the city. 'Abstract', of course, was the modernist appeal to those rules of formalisation that would make this amalgam possible, that would give rise – as Rothko, Barnett Newman (1905–70) and Robert Motherwell (b. 1915) described it in the name of the school they opened in 1948 – to the 'Subjects of the Artist', the inner meaning of modernism.

But how do we find the 'subject of the artist' in a given painting by an Abstract Expressionist? How do we characterise its *particular* inner meaning?

Jackson Pollock painted *Lavender Mist* (pl. 446) in 1950. It came at the end of a progression that had been building in his work since the early 1940s, when he abandoned a kind of stylised realism of Western farmscapes for the shallow space and schematic figuration of mythic and totemic images, in a personal mixture of Surrealism and Cubism. Gradually these recognisable figures had been engulfed by a rhythmic encrustation of paint, first in an overlapping of shallow curving planes (*Gothic*, 1944), then in an interlace of thick, viscous strokes (*Shimmering Substance*, 1946). Then, in the winter of 1946–7, Pollock placed his canvas – increasingly vast fields of it – directly on the floor of his studio and began to apply his paint in far-reaching twists and arcs of liquid line, flinging runs of housepaint from the sticks he flailed above the pictorial surface like an overwrought conductor whipping his orchestra into waves of sound. These were the 'drip' paintings that flowed from Pollock's working-method from 1947 to 1950: seemingly vast webs of interlaced line, a tangle of black and brown and red and green lassoes of colour set against the ground of raw canvas, some lines soaking into the cloth, others forming ridges that rode its surface next to splashes of glowing aluminium paint.

The unity, the size, the sheer assertion of these paintings stunned their viewers, exhilarating some, bewildering others. In the attention they commanded there was also a demand that some-

446. JACKSON POLLOCK: Number 1, 1950 (Lavender Mist). *National Gallery of Art, Washington DC. Ailsa Mellon Fund.*

one formulate their meaning. If here was *Lavender Mist* – pulsatile, aloof, inchoate, seductive – then what was the 'subject of its artist'? 'A leap into the void,' said Harold Rosenberg, a highly visible American critic from the 1940s and '50s, 'an arena in which to act', a place from which the result will not be painting so much as 'metaphysical wallpaper'. The plausibility of this explanation was bolstered by two contemporary phenomena. The first was an article called 'Pollock Paints a Picture', illustrated with photographs of the artist at work on *Lavender Mist*, his seemingly weightless body suspended in mid-air over the supine canvas or vaporised by the blur of his insistent motion (pl. 447). He appeared a dancer, a boxer – restless, tense, dishevelled – a vagrant on the move, the Jack Kerouac of painting, a member of the Beat Generation. The second source was the very philosophical movement on which the Beat poets had drawn – the philosophy of Existentialism, which had been disseminated through novels such as Jean Paul Sartre's *Nausea* and Albert Camus's *The Stranger*, or plays such as Sartre's *No Exit*, and had reached a kind of French bistro popularisation in the songs of Juliette Greco. In *Nausea*, the hero Roquentin stares at the roots of a chestnut tree as into a kind of snakepit of endless organic procreativity, the image of the meaninglessness of animal existence. He compares this to the timeless essences of geometric abstractions, such as circles and spheres, or of formal relations, such as the melodic lines of songs. Feeling the feebleness of existence when compared with the timeless power of 'being', Roquentin is philosophically sick to his stomach. Existentialism, counting the cost of the fact that man's choices can nowhere be underwritten by this timeless realm of being (by God, Truth, Eternity) focused instead on 'becoming', on what it means to choose in the absence of absolute law. Following the model of Roquentin, the poet Kerouac had decided to explore the ever-retreating horizon of Sartre's philosophy of 'becoming' by hitting the open road.

Pollock's open road, Rosenberg reasoned, was a canvas that was no longer the surface of a picture, but, rather, spread like the mat of a boxing-ring, an arena in which to act. It was the space of decisions that could not be secured before the event but only in the active present of the unfolding activity – which is to say, in its becoming. 'Action Painting', he called it.

But there was another critic, committed like Schapiro to the idea of the continuity of modernist culture, who waved aside what he called Rosenberg's recourse to 'a fashionable metaphy-

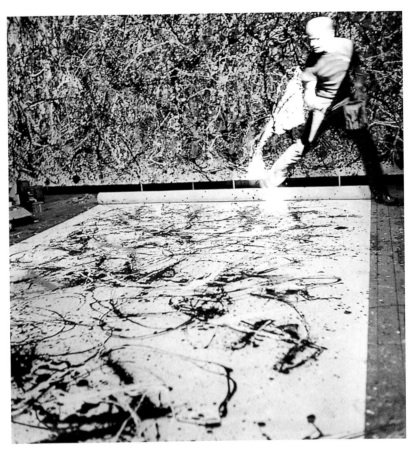

447. HANS NAMUTH: Abstraction, *1950*. *Photograph of Jackson Pollock painting.*

sics of despair' as an explanation for pictures such as *Lavender Mist* or *Number 1, 1948* (pl. 450). Clement Greenberg refused to see these paintings as merely the dust that had settled after a tussle with doubt about the meaning of existence. If they *were* paintings, Greenberg argued, it was because they had organised some kind of experience that continued to be valid as it hung on the wall, and had done so, as with any other modernist painting, by recourse to the formulatable rules of the pictorial medium. But which rules? And what experience?

One of the first rules of painting is that by its very nature it exists on a two-dimensional field, a surface that is resolutely, inexorably flat. No matter what expanses of sun-struck meadows or twisting intricacies of dungeon-like interiors the artist-illusionist might depict as though extending 'behind' this surface, we cannot really walk into that space. But another law would seem to contradict this first. We may not be able to enter the space in *fact*, but our very perceptual equipment – our eyes – works in such a way that any mark upon a surface triggers the game of illusion by setting up the fiction that it is a figure lying on top of a field, that it is thus a thing in front while the surface – its background – is behind. It was, Greenberg asserted, through the resolution of

JACKSON POLLOCK,
NO. 1, 1948

In 1948, confronting the linear abstractions that made up the current Jackson Pollock exhibition, the critic Clement Greenberg thought of the reaction they were sure to elicit from most of the art world. 'I already hear: "wallpaper patterns",' he wrote. He was referring of course to the widespread attitude that abstraction is simply a form of decoration, that if a painting is not *of* something, then it is not *about* anything; it is merely pleasing, like a stretch of tiled floor or a beautifully woven carpet. By 1948 Pollock was facing this problem of abstraction's 'subject' in relation to his titles. To call a work *Springtime* or *White*

Cockatoo was to invite his viewers to find 'things' within the pictures' surfaces ('look, there's the blossoming tree, there's the bird!'). He therefore chose, as Mondrian had before him, to give his paintings numerical titles. 'I decided to stop adding to the confusion,' he explained in 1950. 'Abstract painting is abstract. It confronts you.'

No 1, 1948 (*opposite*) confronts its viewer with approximately 1.7 m × 2.7 m of flung paint, looping, twisting skeins of colour, some of it bleeding into, some of it riding atop, the canvas surface. Interspersed within this network are amorphous puddles of colour: white, earth tones, green, black, and, more arrestingly, silver (*detail, left*). Pollock had first exploited the silvery surface of aluminium paint in his 1947 'drip' picture *Cathedral*. There, he had translated the formal vocabulary of his 1944 *Gothic* – where shallow, interlaced planes seemed to adapt the forms of medieval carving from such places as Moissac and Souillac Cathedrals – into a vehemently abstract space. But the name 'cathedral' inevitably endows the silver whorls with religious overtones. To the question 'what's in a name?' the answer is that it is the name which conditions the reading of the

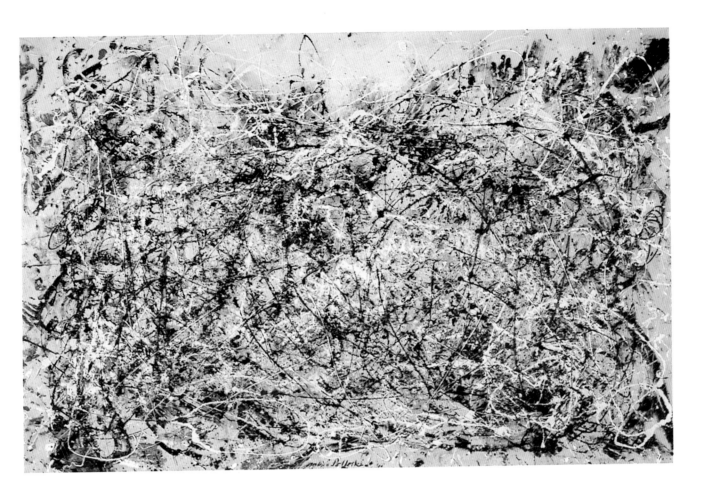

work. The luminosity of this silver surface takes on the connotations of disembodiment, of matter transforming itself into spirit.

Although *No. 1, 1948* does not reject these associations, neither does the noncommittal character of the title give them priority over others also suggested by the aluminium that point in a more earthward direction. The title allows for the full ambiguity of the associations one might have to these silver pools, as now they seem like the flashing chrome of a modern, industrial object, now like the metallic backgrounds of icons or of illuminated manuscripts, ricocheting between surface and transcendence, between the vulgar glitter of things and the ethereal glow of pure light.

This idea of 'between' – between line and colour, between figure and ground, between matter and light – is the dynamic of Pollock's art, of what he once de-scribed as 'energy made visible'. This is to say he was not interested in a *picture* of energy – neutrons spinning within their atomic orbits – but rather in an *experience* of transformation. If something could be seen to be both itself *and* its opposite, and to be all the more strongly the first by virtue of also being a function of the second, then that dynamic would open on to something like a pure experience of change, not change of any given *thing*, but the abstract thought of change, change as such.

451. JACKSON POLLOCK: Moon Woman Cuts the Circle, *1943. Musée National d'Art Moderne, Paris.*

this seeming contradiction between the material fact of flatness and the perceptual fact of projection that modernist painting could both discover its own, medium-specific, rules – 'entrench[ing] it more firmly in its area of competence', he termed it – and use them as a mode of expression. In works such as Pollock's, as in earlier types of art, there was 'a kind of third dimension. Only now it is a strictly pictorial, strictly optical third dimension ... one into which one can look, can travel through, only with the eye.'

Paradoxically, it is Pollock's very activity with line in the elaborated skeins of the drip paintings that produces the almost unimaginable experience of this 'strictly optical' space. That its medium should·be line is paradoxical, because line of course is the traditional conveyor of the depicted object. Pollock's line, however, bounds nothing. Looping constantly back on itself, creating whorls and nodes and tangles, it does not allow us to locate a figure; we cannot, that is, follow the 'thread' of this line to find what is on its inside, as

body, and what is on its outside, as space. Instead there is a vibration, a sense of luminosity, a kind of light generated by all those linear fragments, like the atmosphere suggested by Rembrandt in the flecks of bright pigment dragged against the darkness of his grounds to form so many dust motes, or by Seurat in the little pointillist dots of spectrum colour set dancing in an imitation of sun striking haze. Indeed this line, having deserted its normal duty as the producer of locatable, touchable form, has leapt over the barricades into the aesthetically enemy camp of colour, the creator of atmosphere, of space. It is, however, the very impact of that jump over the barricades that creates the unimaginable, optical space. The line that refuses to bound a form also refuses to exist like the coloristic backgrounds of older paintings. It refuses, that is, to be a latency or stage waiting to be peopled with objects.

In working with line to generate the experience of light, in working with the medium of the figure to annihilate its very possibility, Pollock's canvases succeed in synthesising what had always been held to be polar opposites – line and colour. The traditional wisdom said that they were bound to be in conflict, that surface pattern destroys the illusion of space. *Number 1, 1948* and *Lavender Mist*, however, were stunning demonstrations of a space that arose precisely from its presumed opposite – precisely, that is, from the surface pattern of line. Only it was a space that never imitated that of the three-dimensional, real world. Resolutely abstract, it was shaped to expose the mode of painting's very existence – namely, its exclusive address to the eyes.

To the question 'But what is the *subject* of the artist, here?' the reply Greenberg or Schapiro would make is that it is a conceptual subject. It is a subject that turns on the painter's capacity to analyse illusion, but an illusionism which is not that of *things* (this still-life, that portrait sitter) but instead that of *modalities* (to use Greenberg's term for the very avenue of experience through which things themselves can be known) – here the modality of vision. When we encounter the analysis through the painter's own language, we have an onset of understanding which is also a rush of pleasure, of awe, of wonderment. In short, the *subject* of the artist is a modernist subject.

But, as modernism began to fade as the pre-eminent form of cultural experience, battered first in the early 1960s by Pop Art in England and America and by the New Realism in France, and then into the 1970s by all those forms of image saturation which collectively make up what would come to be called post-modernism, the grip of Greenberg's and Schapiro's (and Rothko's and Newman's) version of the 'subject' began to slacken, its conceptual edge began to dull. Wave after wave of reinterpretation of Pollock's 'subject', by critics and art historians from the 1970s and after, is revealing about the fate of modernism in a culture organised more and more around the media image, as purveyed by television, newspapers, magazines and advertising.

These were really landscapes, one explanation ran. With names such as *Springtime* or *Autumn Rhythm*, these light-struck expanses followed an option that had long been the practice of artists of a northern, puritan turn of mind, who sought to represent God not in the image of a Holy Family but in those vast reaches of his creation. Continuing a landscape tradition extending back into the nineteenth century in Germany (Caspar David Friedrich) and America (Frederic Church), this depiction of a sublime immensity, it was argued (by Robert Rosenblum, for instance), could now be found in the luminous colour-fields painted by Mark Rothko, Barnett Newman and Clyfford Still, as well as Jackson Pollock.

These were really a cycle of images illustrating the ideas of Carl Jung, ran another type of interpretation. Pollock, who underwent four years of psychoanalysis with Jungian doctors, had made drawings to be used in his analysis at the request of one of his physicians. This material encouraged various scholars throughout the 1970s to read the 'subject' of a given painting as the illustration of those master figures of the collective unconscious posited by Jung, figures which he called archetypes. Working like the art historian searching through the Neoplatonic texts of the sixteenth century to recover the specific iconographic meanings of a work by Michelangelo, these writers insisted that Pollock, too, operated with a consciously Jungian programme, as they tried to find the source for his 'subjects' in a specific text by Jung. For example, *Moon Woman Cuts the Circle* (1943; pl. 451) was linked to Jung's analysis of primitive myth, specifically to an illustration from one of Jung's books, but more generally to the Jungian theme of man's primal struggle to free himself from the devouring mother and thereby to achieve his own wholeness. The development of a rather traditional notion of iconography with respect to Pollock's art – egg, womb and circle shapes, magic numbers, sacred animals – was at first confined to the figurative work. But it finally pushed deep into the domain of the drip paintings, as the 1947 canvas *Alchemy* was interpreted through a Jungian scheme of

numerology, and it was assumed that under Pollock's webs of paint were in fact hidden secret 'images' the artist had chosen to veil.

RAUSCHENBERG AND JOHNS

Twenty years after the event, scholarship had thus literalised the 'subjects of the artist' in a way the original Abstract Expressionists would probably have found incomprehensible. But the move to transform their meaning precisely by literalising it had occurred already in the late 1950s, although from an entirely different quarter and to wholly other ends. It happened when in 1957 Robert Rauschenberg (b. 1925) painted the twin pictures *Factum I* (pl. 453) and *Factum II*, each one seeming to take utterly seriously Rosenberg's talk of Action Painting, the leap into the void, and the 'becoming' that left one naked before moral choice – taking it seriously, as we shall see, only to make it blow up in one's face.

The *Factum* paintings, with their smears and splashes and drips of paint, and their collaged bits and pieces of detritus from the artist's studio (a page from a calendar, a newspaper clipping, and so on), gave out the quality that had become the cliché about Abstract Expressionism. They seemed indeed to come, as Rosenberg had put it, 'from the biography of the artist', so that 'the painting itself is a "moment" in the adulterated mixture of his life'. The logic of this connection,

according to this action-painting formula, was that each gesture of the painter, in its very openness to chance, to the rhythms of emotion, the unexpected rushes of anxiety, was like a depth charge of the artist's feelings erupting on to the surface. Each gesture, being extremely personal, was like a signature: unique, unrepeatable, authentic. For Rosenberg, surveying the 'existentially' charged fields of smeared and scumbled surfaces left by Willem De Kooning's (pl. 445) or Franz Kline's 'action'-packed encounters, the depths displayed were not Greenberg's 'opticality' but rather the depths of the inner, individual man.

Seeming to accept this idea about the 'subject' of the artist – a subject that boiled down to the artist's own inner self – Rauschenberg turned around and mocked it. For *Factum I* and *Factum II* are twins. The supposedly unrepeatable gesture whose authenticity rested precisely on its spontaneity, its embrace of chance, reappears from one canvas to the next in exact facsimile. And, to underscore the way Rauschenberg was, indeed, rewriting the action-painting gesture to expose the degree to which it could be faked, and thus, could be repeated again and again like so many photographs printed from a single negative, each *Factum* sported photographic duplicates on its surface. Side-by-side the same news photo clipped from duplicate copies of the same

452. JASPER JOHNS: Flag, *1955. Museum of Modern Art, New York.*

magazine or newspaper declares that the fact of mechanical reproduction and of replication has somehow entered the equation.

With the paintings that he was making at the same time, Jasper Johns (b. 1930) joined his friend Rauschenberg in using this combination of the mechanical and the gestural to repudiate the whole idea of Action Painting. Starting with his *Flag* and *Target* paintings (1955 onward) and his *Maps* (beginning 1961), Johns exploited what could be called replica imagery in works built on the armatures of standardised, mass-produced elements. *Flag* (1955; pl. 452) was indeed just that: an American flag that stretched with inexorable flatness from frame to frame, radiating a kind of platitudinous banality. This flatness, far more inexorable than any grid-and-square composition by Mondrian, refused to yield up that projected depth about which Greenberg had spoken when he said that any mark on a surface would visually destroy that surface's flatness. For the impenetrability of Johns's surfaces came from the fact that they were coextensive with *objects* already known to be flat. The target one buys and pins on the wall, the map one sees in the schoolroom, the flag one encounters in official buildings are all two-dimensional things. Therefore, though their surfaces may be divided and scored in different ways, those surfaces do not read pictorially. We do not, for example, think of the white stripes in the American flag as the background against which the red stripes appear. We are programmed to see these as alternating stripes, all at the same level. The use of replica imagery secured two things at the same time for Johns. First, it was clear that he himself had made *no* choices in drawing the image, for the image's design was prepackaged, as it were, and all he could do was repeat it. Second, the image acted to squeeze out all illusion of depth.

That was the mechanical aspect of *Flag* or *Target with Four Faces*. The gestural side arose from the way the paintings were actually produced, as Johns built up his surfaces from collaged strips of newsprint covered over with encaustic (a wax medium). This means that the actual field is layered and, because the colours of the flag's stripes or the target's circles were laid on in strokes of waxen pigment, each brushstroke leaving the trace of its path in the thick incrustations of the impressionable surface, the painting carries a kind of visual overtone or buzz of expressive gesture. It is the very impotence of this gesture, its powerlessness to break the grip of the replica image's hold on the surface and thereby to create a sense of pictorial depth, that gives it – and the painting as a whole – its haunting beauty. The 'macho' posturings of the great Abstract Ex-

pressionists, their claims to portray the inner man, are here pitted against the literal superficiality of the flag or target or map of mass imagery. The tragic poetry of Johns's pictures comes from their demonstration of the way mass imagery wins.

If Abstract Expressionism produced a modernist experience of the picture as a window through which we are invited to look, no matter how abstract an idea of depth there might be projected as its 'beyond', Johns and Rauschenberg were slamming that window shut. It was because of this that

453. ROBERT RAUSCHENBERG: Factum I, *1957. Museum of Contemporary Art, Los Angeles. The Panza Collection.*

454. RAYMOND HAINS: Torn Poster on Sheet Metal, *1960. Courtesy Galerie Beaubourg, Paris.*

the important art historian and then-critic Leo Steinberg coined the adjective 'post-modernist' to refer to Rauschenberg's art of the 1950s and 1960s. Although post-modernism as a stylistic category is generally reserved for work of the late 1970s and the 1980s, Steinberg's prescient recourse to this term demonstrated the absolute break he felt in this art with what had come before. He described this as a shift 'from nature to culture' that was paralleled, in Rauschenberg's work, as a rotation from vertical to horizontal.

For a painting to be modelled on the idea of a window means that, as we look through it we, the vertical, standing viewers relate to it as a frame 'let into' the vertical wall. This vertical opening always posits, Steinberg argued, a view out into nature. But Rauschenberg's surfaces substitute a horizontal field for the picture, like a desktop piled with books and papers, or a table top littered with plates and napkins; and this horizontality, in its view on to the man-made, the cultural field, meant that there was no viewpoint from which to look past it into the depths of nature.

The painting *Small Rebus* (1956; pl. 456) is filled exactly with the clutter Steinberg was referring to – the clippings, the postcards, the child's drawing, the colour swatches, the map fragment – all arrayed on a surface that must now be understood as horizontal. The 'flatbed picture plane' Steinberg dubbed it, using as his model the printing-press – 'a horizontal bed on which a horizontal printing surface rests'. Horizontal and flat, the depth of Abstract Expressionism is gone and with it the possibility of inwardness or individual feeling that had seemed to swell those surfaces. In its place *Small Rebus* was constructing, however, another model of the individual, one that, like Johns's *Flag* or *Target with Four Faces*, addressed the individual within mass culture.

But the clutter on someone's desk, we could object, in its record of what that person has been reading, or with whom he has been corresponding, or his list of appointments, *is* quite personal. The flatness of the desktop does not necessarily preclude a model of the individual. We do not need a notion of depth – the 'inner' man – to construct a model of the unique self. The claim of *Small Rebus*, however, goes beyond the mere issue of flatness to the question of the effects of the image culture. For, while it is, indeed, constructing a model of the self, its construction is a display of the non-unique, the impersonal character of that self. Built from reproduced elements of a wide variety of kinds, *Small Rebus* concatenates these within its field to set up a kind of scanning through the image repertory of our post-war media culture. So it is suggested that our minds are filled with what is beamed at us from the external field of newspapers, advertisements, television, art books. If we have selves, then, they are not what the Abstract Expressionists were depicting – a welling up of inwardly generated choices and unique feelings. They are instead a kind of crossroads of entirely public languages – fragments from what we have read, seen and heard, the collaging-together of encounters of the most external kind.

THE NEW REALISM

The war that Johns and Rauschenberg were declaring with Abstract Expressionism and what they saw as its sentimentality about the individual and inspiration, its refusal to take a hard look at the image culture of mechanical reproduction, was occurring, and along similar lines, in Europe as well. It was reflected in the declaration signed at the Paris studio of Yves Klein (1928–62) by the group that had been developing what came, by virtue of this announcement, to be called 'Nouveau Réalisme'. 'Thursday, 27 October, 1960', it read; 'the New Realists have become aware of their collective singularity. New Realism = new perceptual approaches to the real.' The signatures of five artists in addition to Klein – Armand Arman (b. 1928), François Dufrêne (1930–82), Raymond Hains (b. 1926), Jean Tinguely (b. 1925), Jacques de La Villeglé (b. 1926) – plus one critic, Pierre Restany, appeared below this statement, the whole inscribed in chalk on a large sheet of paper painted with an ultramarine pigment that Klein had patented as International Klein Blue. The uniformity of this surface, painted with a roller and commercial housepaint, affirmed the war that these artists, as they emerged during the 1950s, had declared on the expressive gesture.

During the early post-war years the French movement *tachisme* had consolidated as an expressive abstract style, as the work of Jean Fautrier (1898–1964), Georges Mathieu (b. 1921), or Wolfgang Schulze Wols (1913–51) was understood as addressing the painful physical and moral experiences of war-torn Europe. By the late 1950s a new generation, however, was experiencing a set of changed economic and political circumstances that led them to brand *tachisme*, with its pitted and slashed surfaces, its ragged smears of torpid paint, as so much nostalgia. The industrial base of Europe had begun to be reconstructed, an economic boom had set in, the space age had opened with the launching of Sputnik, the Russian satellite, followed by the American hysteria to beat the Soviets to the moon. Landscape, or nature, had receded for this generation as surely as it had for their American colleagues, to be replaced by culture: the opacity of industrial and urban surfaces, surfaces they now characterised as 'concrete' – which is to say, palpable, thickened, real. The New Realism was an art of those concrete things, an art of objects.

It was also, in the strange, literalising, sardonic way that we saw with Rauschenberg and Johns, an art of gesture. Carried out on or by the real objects mobilised by the artists of the movement, this sense of gesture was meant both to complete and to transform *tachiste*, Expressionist gesture, by extending it into the new space of industrialised urbanism: concrete and anonymous. When Hains and Villeglé removed the dense stratifications of layer upon layer of huge advertising-posters from the hoardings to which they had been affixed, the gestures they made by tearing away parts of the image surface to reveal lower strata of images created something like the

455. ARMAN: My Grandmother's Village, 1962. Sliced coffee grinders in a red wooden box. Private Collection.

ROBERT RAUSCHENBURG, SMALL REBUS

Let us say you tell your friend, 'We'll meet at the bank', to which the reply comes, 'What did you have in mind? The savings bank? The river bank? Let us say you spoke absent-mindedly. But now that you are asked, you have a picture of sunlight on water. 'At the river,' you say, 'we'll take a boat out.' This transaction can be described as playing the language game 'having something in mind', that very phrase drilling over the commonsense notion of a mental event that occurs prior to speech, an event we could refer to as intention. The notion of the language game as devised by the philosopher Ludwig Wittgenstein however, is to promote a scepticism about our commonsense ideas of meaning and intention, to hint that they are the result of years of playing this game rather than the actuality of the mental space with its ideal forms which they seem to suggest.

Rauschenberg's *Small Rebus* is itself a form of pictorial scepticism. This does not mean that Rauschenberg was familiar with ordinary language philosophy. He did not need Wittgenstein to be able to attack the mentalist notion of a private, internal space that is associated with Abstract Expressionism. The popular wisdom about Abstract-Expressionist pictures was that they are the residue of what the artist experienced, of what he had in mind.

With its clutter of material – post-cards, stamps, maps, children's drawing, photographs, magazine clippings (*see details below*) – *Small Rebus* fills the field of experience, what for Abstract Expressionism had been mental experience, with found objects ('ready-mades'). To the question 'What's on you mind?' he answered by pointing to all the detritus that makes up one's life, material that is not inside the brain, but outside it, on billboards, in newspapers, in museums, on television.

Sigmund Freud had compared dreams to that kind of puzzle made up of both pictures and words called a rebus. The rebus form is a method of ciphering, of putting ideas into a code. And the dream, too, codes its thoughts through a process of ciphering. But it uses the most ordinary of images and words to perform this coding; it employs the bits and pieces of talk heard the day before, of plots taken from popular novels or fairy-tails, of catch-words and popular sayings. Although the dream's syntax is strange, it is a concatenation of ready-mades.

If *Small Rebus* can be thought of in relation to the psychoanalytic description of the dream, this is because it, too, is a concatenation of the most heterogeneous things, their relationship given its bizarrely chaotic coherence by the single field upon which they occur. Like the space of the dream, Rauchenberg's canvas becomes the place where these ready-mades, too, can be suspended: the ciphering in a manifestly external, public space, of 'What's on my mind.'

tachiste or Abstract Expressionist stroke (pl. 454). But at the same time it affirmed this lacerating motion as a public act, an anonymous gesture, taken on behalf of and in concert with everyone who, in distraction or rage or annoyance, might vandalise these complacent commercial sermons.

When Arman broke up ready-made objects and reassembled them in the densely packed repetitions he called accumulations (pl. 455), that act of smashing the coherent surface of things was a similar kind of gesture; only, it was gesture objectified, concretised, reified. Tinguely, who assembled bizarre machines out of scraps of metal and outmoded industrial parts, reified gesture in his own way. Called *Méta-matics*, these were machines that drew and painted; robots that mockingly performed 'expressive' gesture.

But for Pierre Restany, the New Realism's most active theorist and critic, it was Yves Klein whose work was most central to this movement. Since Klein's art was in fact abstract – in 1957 he had launched his 'monochromes' by showing eleven identical canvases all painted in deadpan International Klein Blue – this might at first seem a contradiction. Yet Klein had also automated the gesture. More than that, he had automated abstraction itself, forcing it out of its preserve as a sphere of idealisations – Mon-

drian's harmonics and Pollock's opticality – and objectifying it, presented the abstract picture, the cornerstone of modernism, as a ready-made.

Perhaps the most spectacular concretisation of gesture took place on 9 March 1960 with the presentation of Klein's *Anthropométries de l'époque bleu* (pl. 459). The picture as the deposit of paint from 'living brushes', the *Anthropométries* were made by dousing a nude body with liquid paint which would then be deposited on to a spread of canvas through the gestural activities of that body: rubbing, rolling, pressing. On this occasion the *Anthropométries* were performed by three nude women for an audience of 100 to the accompaniment of Klein's *Symphonie Monotone*: twenty musicians and twenty singers emitting a single note for twenty minutes and for the following twenty minutes presenting silence. For Klein as for Restany this was a perfect dramatisation of that experience of shock and rupture brought by a gesture that can only be understood as (in Restany's words) 'a direct appropriation of the real': the nude enters the picture the way the prisoner enters a jail, and leaves a literal trace of her passage in the imprint of her body.

Needless to say, there was in this situation a wide latitude for misunderstanding. And when Jacopetti Productions juxtaposed the film foot-

459. YVES KLEIN: *Performance of* Anthropométries de l'époque bleu (Anthropometries of the Blue Period) *at the Galerie Internationale d'Art Contemporain, Paris, 9 March 1960.*

age it had made of this performance with other experiences it presented as the weird disruptions of a disoriented post-war society, packaging all of this in the film *Mondo Cane (A Dog's World*, 1963), it was displaying Klein's ideas as just one more symptom of modern savagery.

POP ART

The British version of *Mondo Cane* was Anthony Burgess's 1962 novel *A Clockwork Orange* (later made into a film by Stanley Kubrick). It, too, wants to depict culture running amok, but this time a specifically British, post-war, welfare-state culture, the culture constructed on the ruins of both a bombed-out urban fabric and a disintegrated empire. Burgess's heroes are savages in leather jackets and motorcycle boots, children of the alienating new towns and brutalist architecture of post-war British social recon-struction. The slates of their memories wiped clean by the break with the past effected by the war's devastation, they face the new culture of a stepped-up consumption economy as a band of utterly destructive primitives.

This experience of the new landscape of Britain as radically modernised and reorganised around an ethos of consumption had already been investigated – although with a very different outlook – in the 1956 exhibition called 'This Is Tomorrow'. The Independent Group, which mounted this manifesto exhibition, contained, among others, the architects Peter and Alison Smithson, the critic and historian Lawrence Alloway and Raynor Banham, and the artists Richard Hamilton (b. 1922) and Eduardo Paolozzi (b. 1924). Like its French counterparts, the Independent Group distanced itself from the earlier generation of artists such as Francis Bacon (b. 1910) or Graham Sutherland (1903–80) who had found an Expressionist language to register the brutality and violence of the war years (pl. 460). Instead, 'This is Tomorrow' hailed the new era of media proliferation as a medium for the collapsing of class divisions in Britian, class divisions which they saw élitist, high culture serving as a snobbish handmaiden. Built of large-scale murals and fun-house pavilions, the exhibition staged the image repertory of a post-war culture in which the industrial *moderne* of sleek 1950s design codes was married to the formulations of desire expressed in mass-cultural images, whether from advertisements or from Hollywood films. The film images were displayed within the exhibition at billboard scale, as a whole repertory of made-in-America movie images was collaged on the surfaces of curving

460. FRANCIS BACON: Two Figures Wrestling, *1953. Private Collection.*

walls. And the advertisements put in a spectacular appearance in the collage that Richard Hamilton made for the exhibition's poster. Titled *Just what is it that makes today's homes so different, so appealing?* (pl. 462), it imitated the visual rhetoric of post-war magazines and advertisements aimed at both appealing to and constructing the woman-as-home-maker. For she, worrying about how to clean her oven, or which wax to use on her new linoleum, was being reprogrammed for the 1950s. She had now moved out of the munitions plants of the war era and back into the home. It was up to advertising to teach her how to consume.

Needless to say, a Britain ravaged by war and struggling to rebuild was particularly vulnerable to the invasion of its economic and cultural space by American consumer goods and American consumer hype. But Hamilton, like the rest of the Independent Group and other figures such as David Hockney (b. 1937; pl. 461), was not intent

415

461. DAVID HOCKNEY: Peter Getting out of Nick's Pool, *1966. Walker Art Gallery, Liverpool.*

on rejecting these emissaries of the Pax Americana. Instead he welcomed the levelling effect of this popular imagery, which he saw as combating the old hierarchies built on élitist cultural decorum, fighting them in the most powerful way possible – namely, a release into public space of a blatant, indecorous form of desire: the desire to consume. In the interior presented by Hamilton's collage, with its up-to-date domestic space decorated with American love comics, television commercials and product logos, 'mom' and 'dad' erupt erotically: the first in the image of Charles Atlas, the muscle man, the second in the guise of a striptease artist – both incarnations of an overt fetishism of the body.

It had been a member of the Independent Group who, in 1958, first called this collective embrace of popular imagery by the name that would stick to it ever after, in both its English and American versions. 'Pop Art' was Lawrence Alloway's term, and in 1963, transplanted to New York as a curator for the Guggenheim Museum, Alloway mounted the first large-scale exhibition of Pop Art in the United States. This was entirely drawn from American work, with Johns and Rauschenberg being joined by Jim Dine (b. 1935), Roy Lichtenstein (b. 1923), James Rosenquist (b. 1933) and Andy Warhol (1931–87). Although the work of these and others, such as Claes Oldenberg (b. 1929) and Robert Indiana (b. 1928), had been known within the gallery world for several years, Alloway's 'Six Painters and the Object' forced this phenomenon on to the awareness of a larger public.

The 'object' on which Alloway's six painters focused was, of course, the object of consumption. But it was not a luxury object. Rather, like the Campbell's soup cans Warhol began to paint in 1962, or the Brillo boxes he presented in 1964,

stacked six feet high in the gallery and looking for all the world just like the cardboard cartons from the supermarket, this was the object of *mass* consumption. As such it was also, unmistakably, presented as a function of mass production: of endless, relentless, mind-numbing, serial repetition. *200 Soup Cans* (1962; pl. 464) or 124 Coca-Cola bottles, wedged one next to the other horizontally and vertically to form a grid of identical units marching across the surface, resurrected, within the field of Pop Art, Duchamp's lesson of the ready-made.

This is not an accumulation like Arman's doll parts or coffee grinders, their mutilated bodies still speaking of the violence of mass culture against an older craft sensibility. Nor is it a collage like Hamilton's *Just what is it that makes today's homes so different, so appealing?* with the artist at work to analyse the field of the new. Still less is it a layered field like Johns's *Flag*, contrasting the tenderness of the artist's touch with the empty cliché of the ready-made form. Circling back nearly half a century, to 1917, Warhol's presentation far more resembles that of Marcel Duchamp's *Fountain*, the urinal he up-ended on a pedestal in the Salon of the New York Independents group and, without the slightest modification, presented as a sculpture.

Against art's condition of uniqueness – there is only one *Mona Lisa* by Leonardo da Vinci – the ready-made pits the assembly line's method of repetition, a process in relation to which a discussion of uniqueness simply makes no sense. In 1936 the German theorist Walter Benjamin had begun to think about the effect that an industrialised society would have on the very role of art it produced. Reasoning that the process of production must change the function of the object so produced, he looked at the process that since the mid-nineteenth century had become available to image-making in general, and to art in particular. That process, photography, is like the assembly line in that an endless number of prints can be made from the same negative, a fact that deprives any one of those prints of the old aesthetic's condition of uniqueness. In his essay *The Work of Art in the Age of Mechanical Reproduction*, Benjamin presented the logic of this new condition of what could be called the multiple-without-an-original.

Older art functioned in relation to the object's genuineness, its authenticity, Benjamin argued, because that art had a ritual role to play. It mattered whether the cult object, vested with magical or sacred powers, was the *real* object or not; it mattered that the great artist had in fact touched

it or that the great patron – pope or king – had in fact housed it. Such an object carries around it a kind of halo of this authentic being – what Benjamin called its 'aura'. Mechanical reproduction divests the work of its aura. None of the millions of postcards of the *Mona Lisa* sold by the Louvre possesses the aura of the original. The mechanical reproduction of an older work of art, however, interested Benjamin far less than the profounder effect on the making of new art that the multiple-without-an-original as a system of cultural production was bound, increasingly, to have.

The condition of aura, of the original, of the artist's caress, still clings to the work of Johns and Rauschenberg as to that of Arman or Hains. It is gone in Warhol. In its place is the deadpan affect-lessness, the autistic emptiness of the robot's relation to the assembly line or the distracted shopper's to the supermarket shelves. Mechanical reproduction in Warhol's work is handled in such a way that it and its human operator are experienced as reflections of one another: two empty, shiny mirrors face to face. With aura given no place to lodge, no interior in which to settle, the maker of the work betrays not the slightest resonance, not the smallest depths to sound.

462. RICHARD HAMILTON: Just what is it that makes today's homes so different, so appealing?, *1959. Kunsthalle Tübingen. Collection Professor Dr Georg Zundel.*

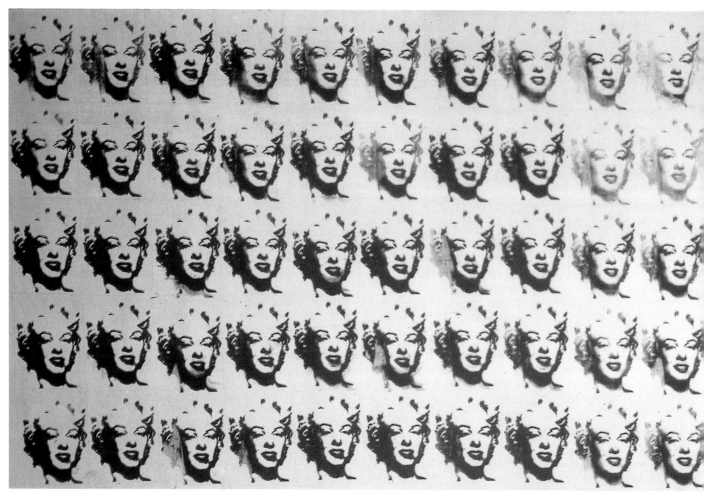

Warhol's posture was that of a programmatic shallowness that seemed to outdo even Duchamp's notorious 'indifference': 'all is pretty,' he would say, if anyone asked him to choose.

But perhaps his most celebrated saying was 'In the future everybody will be world famous for fifteen minutes.' This was a future of media saturation, of mass production of the photographic image in magazines, newspapers, movies, television, a mass production now focused on generating 'personalities', 'celebrities', 'stars', rather than consumer products. But the logic of this production, of course, was to erase the difference between the human vehicle of stardom and the tube of toothpaste: the media celebrity *is* a consumer product. And this truth appeared in the canvases of Andy Warhol. With its title, the work *Marilyn × 100* (1962; pl. 463) says it all: the movie actress Marilyn Monroe equated to the marketing of beer or soda pop. And in all the various Marilyn pictures – her face replicated serially on the canvas through the process of silkscreen printing: four times, six times, twenty times, fifty times – we feel ourselves to be far, far away from a traditional notion of portraiture,

with its old-fashioned concept of personhood. This is instead the human subject as it is marketed, processed through the vehicle that will first turn it into an image, and then, by means of its own serial logic, disseminate it. It will be sold on news stands, broadcast on television, printed on cereal boxes. It will become famous. And its logic, utterly promiscuous, can apply to everyone: every sweepstakes winner, every game-show contestant, every petty criminal. Except that each of those instant celebrities will be pared down to that paper-thin condition of the mask of their visual imprint.

Warhol's canvases construct this imprint in its thinness, its artificiality, its disarticulation. Imitating the crudest process of colour reproduction, his Marilyns appear through the layering of different colour screens on the black-and-white photograph, each colour a garish blob harshly abutting its neighbouring tint, most of the colour areas strangely off-register with the anatomical part they are supposed to define. Marilyn's lips, her eye-shadowed lids, her bleached hair are each registered in a stain of colour more vivid than she, each stain sitting atop the surface like a

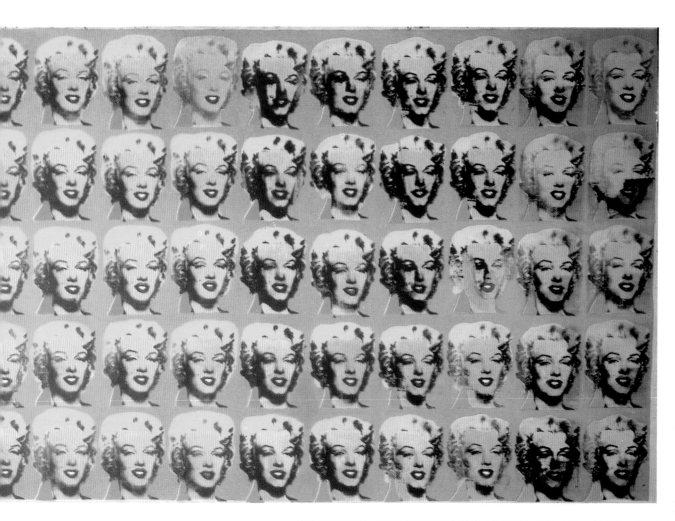

greasy spot, all working together to make her face – in its ghostly photographic foundation for the image – their victim, their product. Elvis Presley, Marlon Brando, Elizabeth Taylor, the *Mona Lisa*: all receive the same treatment.

It is a treatment that produces an especially startling effect when applied to Jacqueline Kennedy as the newly made widow of the assassinated American president, or to the empty electric chair awaiting its next famous murderer from death row, or to the newspaper and magazine images of policemen with clubs and dogs attacking the civil-rights protesters marching in Selma, Alabama (pl. 465). For these subjects are not media 'stars', but participants in and witnesses of real events, real tragedies, real history. Yet Warhol's replication, his deadpan insistence that, as the media analyst Marshall McLuhan would say, 'the medium *is* the message', works to question this notion of 'real'. We know it through its media form, the canvases seem to be saying; we know it only as this manipulated, processed image; the medium is our message. There is no independently real person. He or she *is* that image.

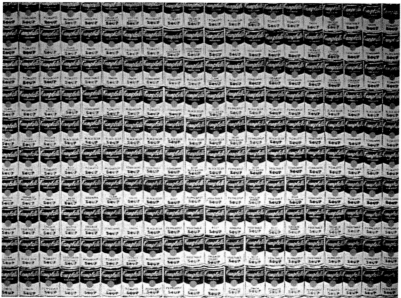

465. ANDY WARHOL:
Red Race Riot, *1963.*
Museum Ludwig,
Cologne.

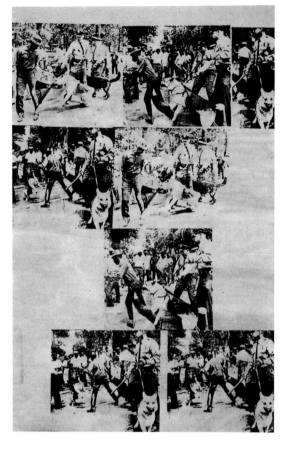

466. ROBERT
MORRIS: (Untitled)
L-Beams, *1965.*
Courtesy Leo Castelli
Gallery, New York.

MINIMAL ART

There is no inside to us as people, only an outside. This may have its terrifying Orwellian aspects, but understood from another point of view, it has – as Sartre had already proposed – its liberating possibilities. For us, creatures of time and change, there are no perfect circles or absolute colours. Those are housed in something like Pla-

to's world of ideal forms, but we take up residence in a condition of flux. Minimalism, an abstract, mainly sculptural art that ran parallel to Pop in the 1960s, explored this flux with a sense of its power to liberate. What Minimal Art celebrated about this new perception of art-as-a-matter-of-surfaces was that it released the human body into the real space and real time of its lived experience.

Like Johns, the Minimalist sculptors Robert Morris (b. 1931), Sol LeWitt (b. 1928) and Donald Judd (b. 1928) were resolved to make clear that their concern was not with invention, with a creative source inside that wells up towards the outside. Using the simple, three-dimensional geometries of cubes, pyramids, lattices, beams, they withdrew from the Romantic competition of personal invention as insistently as had Johns with his American *Flag*. Their shapes, it is clear, are ready-made.

This condition of being ready-made, insofar as we are speaking here of geometry and not of Coca-Cola bottles, could of course drive such sculpture right out of the arena of Romantic inspiration and into the arms of Classicism – which is to say, into the embrace of just those ideal images of perfection, those essential forms, that the laws of geometry legislate. But the Minimalists were not interested in the essential, the *a priori*. They were celebrating the contingent.

Robert Morris's *(Untitled) L-Beams* (pl. 466) is made to appear in triplicate, one L sitting upright, one lying on its side, one perched on its two ends like an arch. Each of these identical volumes establishes its own relation to its situation in space: to the way light hits it, to the way it either hugs or rises from the ground. The result is that the prone L-beam appears compressed, heavy, squat, while the upright one seems far more slender and elongated, and the arched one tends to approach another condition of shape altogether. These, then, are *not* immutable absolutes existing somewhere in an idealist realm as though in the mind of God. These are forms as they are conditioned by the way they appear within a situation, within what the phenomenologist Maurice Merleau-Ponty would call a lived perspective. Geometrical perspective, Merleau-Ponty said in *The Phenomenology of Perception*, tells us how the world would look to God, who sees it from all places at once; it does not tell us how *we* see it. And, he went on to argue, it is only from within the lived perspective, the one that we as carnal, three-dimensional bodies actually inhabit, that the perceptual world takes on not only its density, but its meaning.

The world rises into meaning as it surfaces into the perceptual field. We do not know this meaning beforehand, and yet, Merleau-Ponty insisted, the coordinates of our own bodies give us some kind of fundamental experience on the basis of which we approach the world as a field of expected meaning – for example, the fact that we have no direct visual experience of ourselves from behind provides us with the most intimate understanding of the meaning of density and thickness. Refusing either the rationalist view that we check our experience against the ideal forms we already know about, before we look at the world, or the empiricist view that we know nothing beforehand and experience can only be tested against memories of earlier encounters, Merleau-Ponty insisted on a kind of meaning that arises at the interface of the body and the world around it. And it is this notion that meaning is a function of the surface – the interface between the work's interior and its ambience – that Morris's sculpture conveys.

The extraordinary balance between determinacy (I did not invent this, it is a condition of something already thought of, already made) and contingency (if meaning occurs at all, it occurs here, at this moment, in the patterns arranged on this surface) occurs in Minimalist painting as well as sculpture. In 1959 Frank Stella (b. 1936) made a series of black paintings generated through this principle. *Die Fahne hoch!* *(Flag Up!*, pl. 444), tall, rectangular, is like the series as a whole in being executed in bands of evenly brushed, four-inch-wide black stripes which leave narrow channels of raw canvas – a kind of 'reserve' drawing – between their unvarying swathes. Like all the paintings in the series, this one begins as an exercise in determinacy. The L bands of the stripes, arranged in a double mirror-symmetry around the two central axes, which bisect the rectangular field horizontally and vertically, radiate outward from those mid-lines in strict concentricity. As such, the bands or stripes seem to be doing nothing but reiterating the basic facts about the geometry of that field. 'Deductive structure' was the term the critic Michael Fried found for this procedure.

Constructed to present the geometrical givens of its surface, the picture secures its relation to the already known. And thus, though each of the compositions within the series of black paintings is different, each is manifestly 'deduced'. In this way, Stella's paintings maintain a flatness equal to that of Johns, even though his ready-mades are not, like Johns's *Flag*, found in the social field, but found rather in the geometrical field of the very

surface one is observing. They are a function of that field.

As they repeat the 'facts' of this field in their banal way, however, the stripes of Stella's paintings within the various series he made in the early 1960s begin to do something else. They begin to organise the surface in relation to that very conventional sign or symbol which is made by intersecting a horizontal with a vertical – namely, the cross-sign or cruciform. This is not to say that all along *Die Fahne hoch!* was a picture of a cross. Rather it is a painting that releases us, its viewers, into an experience of the way that both cross and picture (rectangular format) are conventional forms, mutually determining each other, both of them, at their distant cultural origins, logically deduced from a set of very simple, material facts.

One of the most moving of these early Stellas is the picture *Luis Miguel Dominguin* (1960; pl. 467), executed in aluminium paint. Departing very slightly from the regular rectangle, the work's physical shape has a notch removed from the centre of its upper edge and two four-inch slices subtracted from part of its lower sides. True to form, the bands, beginning by symmetrically cupping the shape of the central notch, radiate outward. And, as if by magic, something of the majesty of the dead bullfighter emerges from this seemingly mechanical work, something of the mystery surrounding the fallen toreador in whose honour the picture is named. Once again the cruciform orga-

467. FRANK STELLA: Luis Miguel Dominguin, *1960. Private Collection, Switzerland.*

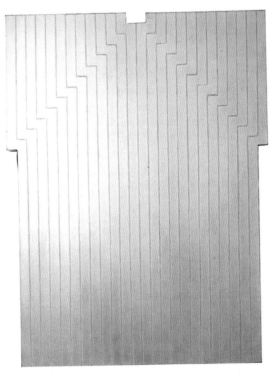

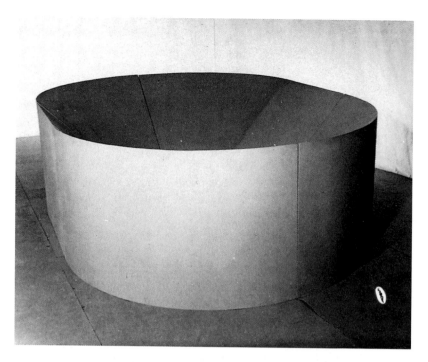

ABOVE 468. ROBERT MORRIS: (Untitled) Sectional Fibreglass Pieces, 1967. Courtesy Leo Castelli Gallery, New York.

OPPOSITE ABOVE 469. ROBERT SMITHSON: Spiral Jetty, 1970. Great Salt Lake, Utah.

OPPOSITE BELOW 470. MAYA YING LIN: Vietnam Memorial, 1982. Washington DC.

nises itself, this time taking on the quality of an outstretched cape, a cape now with an added resonance, as its impossible 'folds' are radiant with a strange, silver light. The point, however, is that the painting is not so much an icon as a meditation on the logic of the icon, on how such a form might have come into being as a vehicle of cultural meaning.

If Stella was analysing the surfacing-into-meaning of the icon, of the conventional sign, in canvases whose shapes determined and were determined by such signs – stars, interlocked rings (like the five linked circles of the Olympic flag), and so on, Morris was analysing the body as a field which, like Stella's pictorial surface, is the external plane on which meaning occurs. In 1967 he made a group of sectional fibreglass objects, among them an eight-section piece in the shape of a large, inert, stadium-shaped doughnut (pl. 468). Going further than the L-Beams in its refusal of the power of geometry to predetermine the coherence of the form, this work refused the residual coherence given by the L-shape's armature and instead constituted the simple geometrical wholes from sections that fit together to make the whole. But these sections could also be re-adjusted to make other forms as well. Indeed, the sectional condition of this work allowed Morris to reassemble it differently each day of its month-long period of exhibition. And this performed a statement not just about the object's contingency, its body's surfacing-into-meaning, but also that of its viewer.

A three-dimensional, free-standing medium, sculpture naturally mirrors the body of the person confronting it, working through the identification between bodies, counting on how we sense through our own corporeal selves the meaning of this represented gesture, of that sculpted stance. No matter how abstract a sculpture may be, it none the less occurs in the field of the body. This had been the lesson taught by half a century of modernist 'abstract' sculpture, in which, no matter how perfect, how crystalline the geometry of the object became, no matter how smooth the curvature of its elegant shell, in the field of meaning it always served to mirror the person regarding it. Modernist sculpture had held up a mirror of fixed forms, models of rationality, of organic coherence, of technological mastery. Morris's model reflected none of these. Neither the geometry nor the meaning is fixed beforehand: no rules, no laws, no universals. And this applies to the bodies on both sides of the mirror.

Nothing in the mood of the times would have contradicted Morris. As the civil-rights marchers in the American South were joined by the protesters of the Vietnam war, a generation was uniting against the rule of a 'universal' which appeared daily more strongly grounded in ideology, race and economics. Intellectual and technical 'mastery' were seen as so many code words for the imposition of power, so many rationalisations of self-interest. In capitals around the world, the tension was mounting that would explode in the protests of 1968. Within the more limited world of artistic practice, 1968 served to erode the last footholds of a modernist sensibility. Even in the centres of power the icons of a pre-war culture were understood to be no longer plausible.

When a government committee met to choose a monument to commemorate the American servicemen fallen in Vietnam, it selected the scheme presented by Maya Ying Lin, a young architecture student who had clearly been looking hard and long at Minimal Art. Most particularly she had assimilated the late-1960s development of Minimalist site works, those ambitious schemes to marry simple, abstract geometries to the conditions of specific natural sites such as Robert Smithson's spiral flung on to the expanse of the Great Salt Lake in Utah (pl. 469). Lin's scheme was a vast earth-mound sectioned by a granite wall in the shape of a long sloping pyramid, a surface on which to inscribe the lists of names of war dead (pl. 470).

In the nineteenth century a similar committee would have set aside an important battlefield and commissioned a sculpture representing a general on his horse. Like earlier monuments, this en-

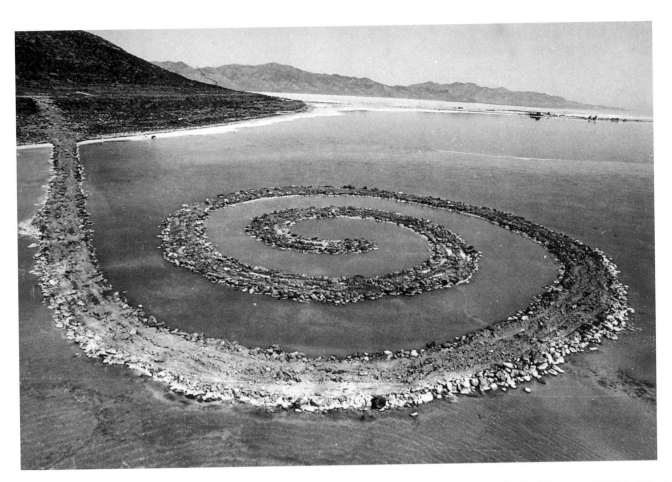

semble would have operated with the clearest logic: it would be both married to the site that gives it its significance and elevated above that field by means of a pedestal, locating the representation in a world of absolute meanings – justice, liberty, salvation.

The modernist sculpture of the first half of the twentieth century had been intent on taking those absolute meanings and showing the degree to which they do not depend on location in the world of time and place. Sculptors were interested in breaking the pedestal's tie with the ground, and declaring the sculptural form to be autonomous, self-reflexive. The Minimalist logic, refusing such autonomy, had begun by making the experience of sculpture once more dependent upon its site, its situation. But there was now no more pedestal and there were no more assumptions about a world of representation independent of the changing conditions of the present. Yet, like the older logic, Minimalism could open itself to the situations of real time and real place, and it began to produce, after the long, modernist intermission, monumental sculpture.

The Vietnam Memorial depends on this development of the 1960s. A combination of necropolis and wailing wall, the meeting of geometry

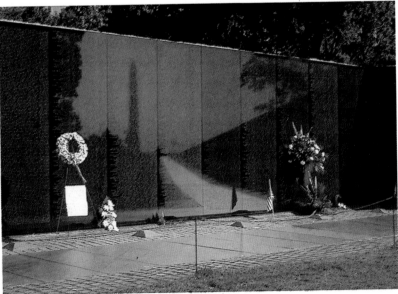

and of shapelessness, it is also a witness to the impossibility of representing the 'lessons' to be drawn from this national tragedy. Its silence is testimony to how hollow and presumptuous a lecture would seem, resonating with the certainties of universals and of truth, and to how a generation had looked at the absolutes of reason and found them suspect.

18

POST-MODERNISM: WITHIN AND BEYOND THE FRAME

ROSALIND KRAUSS

INSET 471. ROBERT SMITHSON: Non-site, Mica from Portland, Connecticut, *1968. Courtesy John Weber Gallery, New York.*

OPPOSITE 472. MICHAEL GRAVES: *The Portland Building, 1980. Portland, Oregon. View from Fifth Avenue.*

To be a university student during the 1960s was to have been born in the 1940s, a child of the war years and their immediate aftermath. It was thus to have inherited the promises of the war effort for a juster, freer society and, riding the crest of the post-war economic expansion, to expect that the rising tide of prosperity could be made to flow towards the most disadvantaged members of the human community. It was, in the broadest application of the term, to have been born into the social ideals of twentieth-century modernism.

But the late 1940s, the 1950s and the 1960s were also the years of the Cold War's transformation of international politics into a battle between two hostile super-powers – the United States and the Soviet Union – to build impregnable arsenals of nuclear weapons and to limit each other's territorial expansion or 'spheres of influence'. In the West this meant American support for those régimes in Latin America, Asia and Africa that were viewed as effective in stopping the spread of Communism – often régimes which, headed by military dictatorships (or sometimes 'presidents-for-life'), were themselves undemocratic and highly repressive.

The frustration youthful idealists might feel about the Cold War's implementation of what leaders called *Realpolitik* but they regarded as cynicism was enhanced by the way the political agenda itself was increasingly viewed as a cover for economic exploitation. Industrial expansion

depends not only on sources of raw material but also on ever newer and bigger markets for finished products. And the countries contested in the Cold War struggle – the under-developed or developing countries of the 'Third World' – were the battlegrounds not only of political ideology but of economic systems as well. Democracy's open society could thus, viewed in the crassest, most exploitative of terms, the terms youth imputed to Western corporate executives, be translated into markets – areas of the world permeable to penetration by capitalism, groups not so much of potential voters as of potential consumers.

Throughout the 1960s, youthful ideals measured against experience of official cynicism created the collision course that eventuated in the uprisings of 1968, when, in protest against the Vietnam War, student movements throughout the world – California, Berlin, Milan, Paris, Tokyo – erupted into action, to be, in the case of France, joined by ten million striking workers. A student leaflet circulating in Paris in May 1968 declared the conflict between social goals. 'We refuse,' it began, 'to become teachers serving a mechanism of social selection in an educational system operating at the expense of working-class children, to become sociologists drumming up slogans for governmental election campaigns, to become psychologists charged with getting "teams of workers" to "function" according to the best interests of the bosses, to become scientists whose

473. MARCEL
BROODTHAERS:
*Museum, children not
admitted, 1968. Plaque.
Wide White Space
Gallery, Antwerp.*

473. MARCEL
BROODTHAERS:
*Museum, children not
admitted, 1968. Plaque.
Wide White Space
Gallery, Antwerp.*

research will be used according to the exclusive interests of the profit economy.'

Behind this refusal was the accusation that the university, long thought to be the precinct of an autonomous, disinterested, 'free' search for knowledge, had itself become an interested party in the kind of social engineering the leaflet imputed to both government and industry. The terms of this indictment could not but have repercussions beyond the boundaries of the university. They immediately affected the art world as well, and in Brussels, for example, Marcel Broodthaers (1924–76) and other Belgian artists joined their student comrades by occupying the Palais des Beaux-Arts and temporarily 'liberating' it from its former administration into their own control. Further, in a gesture that was also patterned on the action of the student movements, Broodthaers co-authored statements that were released to the public in leaflet form. One of them announced, for example, that the Free Association (as the occupiers identified themselves) 'condemns the commercialisation of all forms of art considered as objects of consumption'.

This form of public address was to become the basis of Broodthaers's work, as, for the rest of his career, he was to carry out his art in the name of a fictitious museum – the 'Musée d'Art Moderne' – under the aegis of whose imaginary departments (such as the Department of Eagles) exhibitions of

his own making were mounted (pls 473 and 474), and in the service of whose supposed section chiefs he addressed the public through a series of 'open letters'. The former separations within the art world, between producers (artists) and distributors (museums or galleries), between makers and critics, between the ones who speak and the ones who are spoken for, were radically challenged by Broodthaers's museum fictions, in a profound parody of the 'interests' that run through cultural institutions, as the far-from-disinterested accessories of power.

This attitude of refusing to be spoken for by seizing the right to speak, and consequently of challenging the institutional and social divisions that support these separations of power, had other sources besides the politics of the student movement. The premises of the various disciplines collectively called the 'human sciences' had been subjected to re-evaluation, and around 1968 this crystallised into what has been termed 'post-structuralism'.

Structuralism – the dominant French methodological position against which post-structuralism fought – had viewed a given human activity (language, for example, or kinship systems within a society) as a rule-governed system whose laws operate according to certain formal principles of mutual opposition within a self-maintaining structure which is more or less

autonomous. This idea of a self-regulating, autonomous structure, one whose ordering-operations derive from, even while they organise, the system itself, is clearly echoed in the modernist conception of the different and separate artistic disciplines. And, in so far as this parallel obtains, the intellectual and theoretical battles of 1968 are highly relevant to the developments in the world of art into the 1970s and 1980s.

Post-structuralism grew out of a refusal to grant structuralism its premiss of the autonomy of each system, and thus of rules and operations that begin and end *within* the boundaries of that system. In the field of linguistics this attitude expanded the limited study of linguistic structures to those modes through which language issues into action, the forms called 'shifters' and 'performatives'. Language, it was argued, is not simply a matter of the transmission of messages or the communication of information. It also places the one addressed under the obligation to reply. It imposes on that person a role, a whole system of rules of behaviour and of power, as well as of coding and decoding. Quite apart from the content of any given verbal exchange, then, its very enactment implies the acceptance (or rejection) of the whole institutional frame of that exchange. This is what the linguist Oswald Ducrot, early in 1968, called its presuppositions:

'In rejecting the presuppositions of my interlocutor,' he argued, 'I disqualify not only the utterance itself, but also the enunciative act from which it proceeds.... Either the interlocutor, fearing to aggravate the argument, will accept without discussion the intellectual frame one is holding out to him, or – and here is the risk run by the speaker – he will undertake a refutation that can explicitly put the very legitimacy of the given speech act at stake.'

Unlike the idea of the autonomous discipline (or work of art) whose institutional frame is thought to be necessarily external to it – a kind of non-essential appendage – this notion of language places the frame at the very heart of the speech act. For the verbal exchange, it was being argued, is from the beginning the act of imposing (or failing to impose) a set of presuppositions on the partner in that exchange. Speech is thus more than the simple transmission of a message. It is also the enactment of a relation of force, a move to modify the addressee's right to speak.

Broodthaers's seizing of the right to speak, in his guise as 'museum director', performed the kind of challenge to institutional frames that post-structuralism was theorising. Indeed, Broodthaers made his art out of those very frames, by enacting the rituals of administrative compartmentalisation and by parodying the way those compartments in turn create collections of 'knowledge' – as in the celebrated exhibitions put on by his Department of Eagles, in which an extraordinary heterogeneity of eagles, from actual stuffed birds to nineteenth-century paintings of them and late Roman fistulae in eagle form, was presented ('The Eagle from the Oligocene to the Present', Städtische Kunsthalle, Düsseldorf, 1972; pl. 474). And, as the frames were made to

474. MARCEL BROODTHAERS: Museum of Modern Art, Department of Eagles, Figure Section, *1972. Installation at the Städtische Kunsthalle, Düsseldorf.*

become apparent not outside the work but at its very centre, what took place was the putting of 'the very legitimacy of the given speech act at stake'. Under each of the museum's exhibits, the Department of Eagles affixed the label 'This is not a work of art.'

WITHIN AND BEYOND THE FRAME

Broodthaers was not alone in this decision to make artistic practice out of the framing, as it were, of the institutional frames. The French artist Daniel Buren (b. 1938) had also adopted a strategy to challenge the power of the frames by refusing to leave their presuppositions alone, implicit, unremarked. Instead his art, emerging in the 1970s, drew attention to all those divisions through which power operates. In 1973 he exhibited *Within and Beyond the Frame* (pl. 475). A work in nineteen sections, each a suspended, grey-and-white striped canvas (unstretched and unframed), Buren's 'painting' extended 190 feet, beginning at one end of the Leo Castelli Gallery in New York and gaily continuing out the window to wend its way across the street, like so many flags hung out for a parade, finally attaching itself to the building opposite. The frame referred to in the title of the work was, obviously, the institutional frame of the gallery, a frame that functions to guarantee certain things about the objects it encloses. Attributes such as rarity, authenticity, originality and uniqueness are part of the value of the work implicitly asserted by the space of the gallery. These values, which are part of what separates art from other objects in our culture, objects which are neither rare nor original nor unique, operate then to declare art an autonomous system within that culture.

Yet rarity, uniqueness, and so forth, are also the values to which the gallery attaches a price tag, in an act that erases any fundamental difference between what it has to sell and the merchandise of any other commercial space. As the identically striped paintings (themselves barely distinguishable from commercially produced awning-fabric) breached the frame of the gallery to pass beyond its confines and out the window, Buren seemed to be asking their viewer to determine at what point they ceased being 'paintings' (objects of rarity, originality, and the rest) and started being part of another system of objects: flags, sheets hung out to dry, advertisements for the artist's show, carnival bunting. He was probing, that is, the legitimacy of the system's power to bestow value on work.

The question of frames was also at the heart of

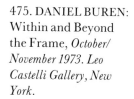

475. DANIEL BUREN: Within and Beyond the Frame, *October/ November 1973. Leo Castelli Gallery, New York.*

476. CHRISTO:
Running Fence,
Sonoma and Marin
Counties, State of
California, *1972–6*.

Robert Smithson's thinking about the relation between the natural site and its aesthetic container, which Smithson (1938–73) himself labelled 'non-site'. In a series of works called *Non-Site* Smithson imported mineral material – rocks, slag, slate – drawn from specific locations into the space of the gallery by placing this material into geometrically fashioned bins, each bin visually connected, by means of its form, to that segment of a wall map indicating the area of the specimen's origin (for example, *Non-Site, Mica from Portland, Connecticut*, 1968; pl. 471). The obvious act of aestheticising nature, and of turning the real into a representation of itself through the operations of the geometrical bin to construct the raw matter of the rocks into a sign – trapezoid – that comes to 'stand for' the rocks' point of extraction, and thus for the rocks themselves, is what Smithson consigns to the system of the art world's spaces: its galleries, its museums, its magazines.

The ziggurat-like structures of Smithson's bins and maps might imply that it was only an ironic formal game that was at issue in this aspect of his art. But Smithson's graduated bins were also addressing a kind of natural history which he could read in the landscape: the successive stages of extracting its ore – from the initial bounty to barrenness and a final exhaustion of supply. It was this natural history which could not be represented within the frames of the art world's discourse, concerned as they are to set off quite

another kind of story – one of form, of beauty, of *self*-reference. Therefore part of Smithson's strategy was to smuggle another, foreign mode of representation into the frame of the gallery, a mode he took from the natural history museum (as opposed to the art museum), where rocks and bins and maps are not freakish, aestheticised abstractions, but the basis of a different system of knowledge: a way of mapping and containing ideas about the 'real'.

The effort to escape from the aesthetic container, to break the chains of the institutional frame, to challenge the assumptions (and indeed the implicit power relations) established by the art world's presuppositions was thus carried out in the 1970s in relation to specific sites – gallery, museum, quarry, the Scottish Highlands and the Californian coast (Christo's *Running Fence*; pl. 476) – which the work of art functioned to *reframe*. The aesthetic ideas which the sites used to frame (although invisibly, implicitly) now hovered over these real places like so many exorcised ghosts, while the site itself – its white wall, its Neoclassical porticoes, its picturesque moors, its rolling hills and rocky outcrops – became the material medium (the way paint and canvas or marble and clay used to be) for a new kind of representation. This representation was the image of the institutional frames themselves, now forced into visibility as though some kind of powerful new developing fluid had unlocked from an inert

429

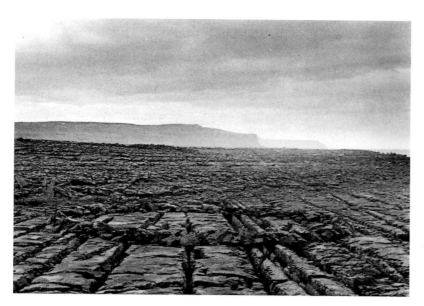

477. RICHARD LONG:
A Circle in Ireland,
1975.

photographic negative previously confidential information. Christo Javacheff's *Running Fence*, an effort the Bulgarian-born, American artist (b.1935) undertook in 1972 but only achieved in 1976, was a project of this kind. Running twenty-four and a half miles from an inland town in Sonoma County, California, over the open pasturelands of scores of ranches and through or around the villages in its path, to pitch itself finally into the Pacific Ocean at the rocky coast of Bodega Bay, in Marin County, Christo's *Running Fence* was in fact an airy curtain of thick woven nylon that, during the brief, two-week span of its existence, formed a dazzling white foil to the reddish-brown hills, the light and shadow, and the spectacular sunsets of California. At the same time, of course, the ghostly reminders of aesthetic discourse haunted its picturesque form snaking over the land like an endless river – its ever-retreating horizon a marker of sublimity, its interplay with the landscape forming configurations of almost abstract colour and line. Yet in actual fact its configuration – the result of so many interminable negotiations with fifty-nine ranchers and property owners for a temporary right of way – made *Running Fence* the representation of those specific boundaries or frames that underpin, even while they riddle, the American social fabric; for the shape of the work is the marker of all those claims to ownership, all those specific acts of privatisation, which criss-cross, dividing and appropriating that vast abstraction to which we all imagine we have the right of access, unimpeded and unquestioned: the 'landscape', 'our country', embracing ideas of 'beauty', 'heritage' and other similar concepts.

If landscape had always been a part of the

tradition of Western art – the site of so many aesthetic categories: the pastoral, the sublime, memory, time – the site-specific work of such artists as Christo, or Richard Long (b. 1945; pl. 477), and Hamish Fulton (b. 1946) in Britain, or Smithson, Michael Heizer (b. 1944) and Richard Serra in the United States, reproduced the landscape in terms of those other abstractions, involving property, power and privacy, that underwrite the institutional frames.

POLITICS OF CULTURE

Landscape, as we have seen, was not the only site selected for this kind of analysis. Indeed, the work of the German-born artist Hans Haacke (b. 1936), choosing as it did cultural sites in a demonstration of how they can be used as a respectable front for more dubious activities, met repeated and specific resistance from the managers of those cultural institutions. The first instance was in 1971, when the Guggenheim Museum cancelled a Haacke exhibition because the artist refused to allow two of his works to be suppressed. These works, to which he gave the general name *Real Time Social Systems*, were combinations of maps, photographs and diagrams showing the way slum landlords – the holders of massive amounts of poorly maintained tenement property in New York – hid their private identities behind elaborate smokescreens of anonymous holding-companies. And in certain cases these owners, the secret of their socially dubious sources of income intact, could complete their public transformation by obtaining appointments to important positions of cultural trust, such as membership of the board of trustees of the Guggenheim Museum.

Intent on making the political uses of culture apparent, Haacke went on to produce *Manet: Projekt '74* (pl. 478) in response to the invitation of the Wallraf-Richartz Museum in Cologne to contribute a work designed for a group exhibition of 'installation (or site-specific) works'. Based on Edouard Manet's *Bunch of Asparagus* (1880), which the museum had acquired in 1968, Haacke's *Manet* was intended to introduce the original painting in the context of a series of wall panels tracing its history, each panel devoted to a brief biography of one of the painting's former owners, the whole recounting the social and economic narrative forged by this chain that led from Manet's studio to the museum's walls. It was the biography of the penultimate owner of the picture, the person from whom the museum had acquired the work, and who still served as a respected member of its executive committee,

that caused the Wallraf-Richartz to ask Haacke to remove *Manet* just before the exhibition's opening. For that figure, Hermann J. Abs, had a past shadowed by the Third Reich, but a present, like so many other German industrialists, aglow with honour and success. It was the museum's role in contributing to this aura of present-day honour that Haacke's work was meant to examine.

Each of these occasions of museum censorship of Haacke's work had an immediate aftermath that is worth considering. In the latter case the repressive action was countered by Daniel Buren, himself a contributor to Projekt '74. Buren, who had arranged a corridor of the museum with his subversive grey and white stripes, invited Haacke to hang his *Manet* there, incorporating it into the field of Buren's own work, which the museum had not thought to cancel. In the case of the Guggenheim cancellation, Haacke's experience elicited an independent 'work' from Broodthaers in the form of one of his open letters, addressed not to Haacke, but to another German artist: Joseph Beuys (1921–86).

Beuys, along with Broodthaers, was a participant in the Guggenheim Museum's 'Amsterdam-Paris-Düsseldorf', an exhibition organised in 1972, one year after the cancelled Haacke show. Beuys's contributions to the exhibition were two works that emanated directly from his conception of art (developed over many years) as the creative outpouring of the energies contained within everyone, and so the true expression of direct democracy and a form of political practice. Art's 'magic', Beuys maintained, could directly enter the political arena in the form of what he called 'social sculpture': everybody is an artist, the nurse at work in the hospital as well as the artist at work in the studio. At the Guggenheim he demonstrated the artist's version of this magic in a sculpture constructed of a primitive flag and a fir tree trunk, titled *Gundfana of the West – Genghis Khan's Flag*. His other contribution was an object that detailed the social programme of his Organisation für direkte Demokratie durch Volksabstimmung (Organisation for Direct Democracy through Referendum). Broodthaers, however, was suspicious of the nature of Beuys's political claims for art, particularly since, having decided to withdraw his own work from the Guggenheim in solidarity with Haacke, he saw that Beuys had no intention of doing the same. It therefore occurred to him that Beuys's equation of art and politics might be naturally connected to, rather than in conflict with, the kind of power relations set up by the museum's institutional frame.

478. HANS HAACKE: Manet: Projekt '74, *1974. Installation at the Wallraf-Richartz Museum, Cologne.*

Broodthaers's open letter to Beuys purported to be a copy of a letter, discovered in an old attic, from the composer Jacques Offenbach to Richard Wagner. In it 'Offenbach' questions Wagner's willingness to accept the patronage of Ludwig II of Bavaria and draws a comparison between his and Wagner's conception of art's relation to politics. The letter's allusions to the Guggenheim issue are not hard to grasp:

King Louis [Ludwig] II had Hans H. sent away (from) his castles. His Majesty prefers you to this specialist of compositions for the flute.

I can understand – if it is a matter of artistic choice. But is not the enthusiasm that His Majesty displays for you motivated by a political choice as well? I hope this question disturbs you as much as it does me. What ends do you serve, Wagner? Why? How?

The parallel hinted here between Beuys and Wagner could be filled in as follows. Wagner, in exile for his participation in the Revolution of 1848, had formulated his idea of the total work of art, or *Gesamtkunstwerk*, as an overthrow of capitalism and its system based on the division of labour; society as a whole – its boundaries eroded by direct participation in its rebuilding – was to be transformed into a work of art. But, as Wagner's career flourished and the overthrow of the state seemed less and less likely, he reconceived his idea of the *Gesamtkunstwerk* as a substitute for the revolution, not its medium. The total work of art became a magic world – a totality indeed – a spectacle into which one entered, its completeness both imitating and *replacing* the totality of

479. JOSEPH BEUYS:
Plight, *1958–85.*
Environmental sculpture
with felt, piano,
blackboard and
thermometer. Anthony
d'Offay Gallery, London.

the social fabric. And in that effacement-replacement of the social whole, the real conditions of political power disappear as well as their historical determinations. These are supplanted by a world of German myth that is not prehistory but, in fact, the theatrical form of ahistory. Coursing through this world is the mythic energy of art as an act of primal creation understood, in this ahistorical universe, as a function of pure, individual will.

Beuys's notion of an individual creativity that would reinvent the state and society as artistic forms, out of the sheer energy of its own desire (pl. 479), followed Wagner in this belief in the power of individual will, independent of all social preconditions. The concept of the state as a work of art and the importance of the mythic persona of the artist were all, Broodthaers was saying – following the many critical analyses of Wagner as reactionary – deeply regressive. And he was implying, further, that Beuys's recurrence to myth, with its avoidance of historical reality, was what made his work acceptable – even valuable – to the cultural establishment.

THE MEDIUM IS THE MASTERPIECE

The questions that Broodthaers posed for Beuys continued into the 1980s to plague the reception of Beuys's most gifted pupil, the painter Anselm Kiefer (b. 1945). Conceiving of the painting as a kind of earthwork transposed from the real coun-tryside back on to the surface of the canvas, where straw, mud and molten lead replace the conventional medium of paint, Kiefer brings the specificity of the natural site ('Germany') back under the dominion of the artistic frame, re-endowing the image of the place with the ideas of the autonomy of the work of art, the power of individual creativity, and the resonance of myth (pl. 480). On the one hand Kiefer has recourse to the ancient field of Teutonic epic poetry, setting many of his landscapes in the world of the Edda, and on the other he portrays the monumental spaces of Third Reich ritual, the parade grounds and palaces built for Hitler by Albert Speer.

In a sense, Kiefer's reception was prepared by Beuys's own career: from leader of the student movement in the Düsseldorf Academy in 1968 to the increasingly powerful embodiment of the 'magic' of art, a magic released by the primitivist, fetish objects of Teutonic myth. This development led on the one hand to a reacceptance of those aesthetic categories that much of post-war modernism had, supported by post-structuralist theory, rejected – the idea of genius, of the masterpiece, of oil painting as a valid, historically self-aware, medium; and on the other hand to a renewal of the idea of national (and racial) traditions as the legitimate source of artistic meaning.

In Germany in the 1980s, Georg Baselitz (b. 1938) and Markus Lüpertz (b. 1941), among others, joined Kiefer on the roster of painters

whom museums and collectors were celebrating as proof of a return to painting, and, moreover, to a kind of painting related not to the internationalist ideas of modernism but to the recognisable roots of German feeling and expression. In Italy a similar phenomenon occurred as artists such as Francesco Clemente (b. 1952) and Sandro Chia (b. 1946) returned to traditional media such as fresco (pl. 481), oil painting, bronze casting (pl. 483) and miniature illumination, and re-evoked local traditions of figuration, hailing through quotation the Italian anti-modernist styles of 'Pittura Metafisica' (Metaphysical Painting) and the late work of Giorgio di Chirico. Like the German phenomenon, the Italian return to a more traditional notion of painting brought with it a curious attitude towards history, one in which eclecticism – a willingness to borrow from various historical styles and even to combine different ones within the same painting – became the norm. The justification for this practice came from the critic Achille Bonito Oliva, who coined the term '*trans-avant-garde*' to describe the new group's resistance to the modernist *avant-garde*'s obsession with the burden of history and with progress towards utopianist social goals. Since the world is going to end, Oliva argued, we can return to history as a kind of entertainment, a preserve where everything has the same meaning and in which we are relieved of the problem of responsibility; art is a matter of individual will, individual desire.

DECORATING THE SHED

This return to figuration by means of quotation from historical styles, this reconception of the work as a more traditional form of creation, this emphasis on national themes in an explicit rejection of the International Style of modernism had been developing in architecture since the late 1960s in a movement the English architectural critic Charles Jencks termed 'post-modernism'. Citing the failure of the social ambitions of modernist architecture – the tendency for glass and steel towers to destroy the organic unity of older cities built on a more human scale, or for the cleared acres newly striped by the impersonal slabs of public housing to become crime- and trash-ridden wastelands – architects had begun to preach 'contextualisation'. This meant imitating older building styles rather than turning one's back on them, welcoming ornament rather than continuing to echo the modernist battle cry sounded by Adolf Loos at the turn of the century: 'Ornament is crime.' It meant also giving up the modernist idea that a modern architecture

should state on a building's exterior the real facts of its internal construction and organisation, making it an expressive, organic whole.

Robert Venturi, rejecting this idea in his book *Complexity and Contradiction in Architecture* (1966), derided the building-style it entailed as a 'duck' (referring to a roadside poultry stand on Long Island built in the shape of a duck), and suggested the alternative (long taboo) of the 'decorated shed'. Michael Graves (b. 1934), perhaps the leading practitioner of architectural post-modernism, won an international competition in 1980 for a new municipal building in Portland, Oregon, that answered this description (pl. 472).

With the simplest possible traditional structure – no cantilevered floors, no catapulting of the building off the ground on to columnar *pilotis*, no

ABOVE 480. ANSELM KIEFER: Meistersinger, *1982. Oil and straw on canvas. Saatchi Collection, London.*

BELOW 481. FRANCESCO CLEMENTE: Roots, *1982. Fresco. Private Collection.*

482. RICHARD ROGERS and RENZO PIANO: *Centre Georges Pompidou, 1971–9. Paris. West elevation.*

costly curtain walls of glass or sculpted masses of raw concrete – Graves designed a large rectilinear box, clad in coloured tile, rhythmically punctured by standard, conventional windows. The drama of the building is vested, indeed, in its decoration, in this case the monumental design of the front façade, where the major 'architectural' phenomenon is the image of a column. Rising seven storeys, its shaft is given by two ornamental pilasters, faced in dark red, which in turn make contact with the dark-red shape of an inverted trapezoid, itself four storeys in height. Announcing through its utter flatness its complete divorce from the actual problems of weight and support, this trapezoid none the less takes the shape of a Doric capital in a game of creating a *sign* of architectural structure: a capital transferring horizontal loads on to the vertical support of a column. But it is a sign not without its own ambiguities. For its shape is also that of the familiar keystone, that trapezoidal member of an arch that plays a major role in quite a different structural system. Indeed, the ability of this dramatic visual element – its shape set off against the cream and blue of the building's cladding – to read ambiguously as part of two different support

systems echoes its capacity to refer as well to two different stylistic vocabularies; for it is equally convincing as part of a Classical world of reference and as part of an Egyptian one.

Emerging from this play of shape in Graves's building is the experience that the real object – taking up an entire city block – has been converted into a sign independent of the actual relations of space and time. It is a sign something like a corporate logo, implying nothing about the identity of what it signifies, and in that similar to so many signs in the world of late capitalism: the advertising messages of multinational corporations, the information flows of internationally linked stock exchanges, the surges of electronically managed data.

The idea of architecture as participating in the disembodied, weightless, massless condition of electronic information rather than the seemingly outmoded form of mechanical, industrial culture had been the explicit message of the English Archigram movement of the late 1960s and early 1970s. Buildings were conceived of as combinations of systems, rather than masses, and fashioned to look like giant circuitry. The movement's most notable project is the Centre

Georges Pompidou in Paris (pl. 482), designed by the team Richard Rogers (b. 1938) and Renzo Piano (b. 1935). The exterior sheathing of this immense five-storey cultural centre is a spaghetti of 'systems': the people-moving 'system' of the escalators in their plastic tube-like casings that snake up the west façade; the colourful stacks of the air-conditioning 'system' that rise up the eastern front, accompanied by the syncopation of open-caged freight elevators; the structural 'system' itself that gives the whole envelope of the building the quality of having been assembled from a construction kit.

But this notion of having a building look like the inside of a computer or telephone exchange had a brief career. The post-modernism that replaced it understood information culture otherwise. It was not the wiring of the computer that was at issue, but the image culture generated by that technology. Architecture was to be a matter not of tubes and circuits but of pictures. Another British firm enacted this conviction when, much in the manner of Michael Graves, James Stirling (b. 1926) produced the Neue Staatsgalerie in Stuttgart in 1982 as a 'picture' of Karl Friedrich Schinkel's Altes Museum in Berlin (1830), the Neoclassical monument that set the tone for museum culture in the nineteenth century. One example will illustrate Stirling's conversion of the older building into the immateriality of an image. Schinkel's museum is built around a grand central opening, a rotunda into which the visitor is ushered upon entry and out from which he or she may proceed to the surrounding galleries (pl. 486). The function of the rotunda, its alcoves filled with Classical sculpture, was to prepare the visitor with an experience of the acme of aesthetic beauty before continuing on a journey into art's specific history, as displayed in the galleries of the museum. Stirling's museum is also built around a grand central opening, since its groundplan is almost identical to Schinkel's. Yet that opening connects at no point to the museum itself; it is rather a courtyard through which people outside the museum can only pass, and on to which anyone inside can only look. For the visitor to the museum, that is, this core of the beautiful is available only as 'picture'. It is in this sense that Stirling's museum joins hands with Michael Graves's Portland Building.

If the Graves design is a celebration of the architecture of the sign, behind its eclectic gaiety – the sides of the building are decorated with massive bronze swags – it has an air of being so much gilding and pasteboard, a stage representation of an object whose actual presence no one was willing to pay for. Indeed, as Graves has repeatedly demonstrated, architectural post-modernism is far cheaper than its modernist predecessor, for it involves the simplest of structural solutions. And what the municipality or corporation receives for its money is the impact of the two-dimensional logo writ large over a building.

The fact of the building-as-sign, of its cheapness and its relation to a waste economy of disposable objects, conditions the entirely different attitude Frank Gehry (b. 1929) has had towards architecture in the age of post-modernism. Gehry's own house (pl. 484) was fabricated by wrapping an asbestos-shingled, 1950s California bungalow in an expanded second skin of corrugated sheet metal and chain-link fencing, to create the indeterminacy of a domestic space in which outside and inside, public and private, are felt constantly to be fusing. Gehry's thinking about architecture in terms of demolition as well as construction, of decay as well as renewal, was influenced by the site sculptor Gordon Matta-Clark (1943–78), who during the 1970s attacked the abandoned shells of condemned buildings

483. SANDRO CHIA: Figure with Tear and Arrow, *1982. Private Collection.*

ABOVE: 484. FRANK GEHRY: *Gehry Residence, 1978–9. Santa Monica, California.*

BELOW 485. GORDON MATTA-CLARK: Threshold – Blue Piece. *Floor piece– doorway, 1973. Courtesy Holly Solomon Gallery, New York.*

with a chainsaw, to re-create the decrepit physical structure in terms of a visually imploding, vertiginous space (pl. 485).

Economic realities are naturally a greater force in the realm of architecture than in that of painting or sculpture. In bowing to the demands of the logo culture, architecture was both admitting and denying those realities. On the one hand it admitted the degree to which architectural design was now in the service of corporate advertising, and on the other it denied the real social and historical facts that would lead to this loss of professional autonomy, masking that loss behind the façade of 'personally' chosen ornament.

THE FINE ART OF APPROPRIATION
The post-modernist painting that developed in the United States as an heir to the kind of post-

modernist architecture just discussed and parallel to the European *trans-avant-garde* was equally aware of its relation to and denial of the logo culture of the 1980s world of corporate advertising and international media. David Salle (b. 1952), whose work perhaps best typifies that painting, developed as one of a number of young artists highly critical of art's traditional claims to transcend mass-cultural conditions. This group – initially including such figures as Robert Longo (b.1945), Cindy Sherman (b. 1954), Barbara Kruger (b. 1945) and Sherrie Levine (b. 1947) – was fascinated by the reversal in the traditional relations of reality and its representation that was being effected by the late-twentieth-century information culture.

Representations, it was argued, instead of coming *after* reality, in an imitation of it, now preceded and constructed it. Our 'real' emotions imitate those we see on film and read about in pulp romances; our 'real' desires are structured for us by advertising images; the 'real' of our politics is prefabricated by television news and Hollywood scenarios of leadership; our 'real' selves are a combination and repetition of all these images, strung together by narratives not of our own making. In an attempt to analyse this situation, artists began asking themselves probing questions about the mechanics of the image culture: its basis in mechanical reproduction, its function as serial repetition, its status as multiple without an original.

In an early reception of the work of the new group, the critic Douglas Crimp designated it 'Pictures' (the title of his article on the subject in *October*, 1979). He examined, for example, the way Cindy Sherman, posing for a series of 'self-portraits' (pl. 488) in a variety of costumes and settings each with the look of a 1950s movie still and each projecting the image of a stereotypical film heroine – career girl, high-strung hysteric, Southern belle, outdoor girl – had projected her very self as always mediated by, always constructed through, a 'picture' that preceded it. The ideas that Crimp, and other critics versed in theories of post-structuralism, came to identify with such work involved a serious questioning of notions of authorship, originality and uniqueness, the foundation stones of institutionalised aesthetic culture. Reflected in the facing mirrors of Sherman's photographs, creating as they did an endlessly retreating horizon of quotation from which the 'real' author disappears, these critics saw what Michel Foucault and Roland Barthes had analysed in 1968 as 'the death of the author'.

The work of Sherrie Levine was set in this same

486. JAMES STIRLING: *Neue Staatsgalerie, Stuttgart, 1982. View of the rotunda.*

487. DAVID SALLE:
Landscape with Two
Nudes and Three
Eyes, *1986. Private
Collection.*

context, as she rephotographed photographs by Elliot Porter, Edward Weston or Walker Evans (pl. 489), and presented these as her 'own' work, questioning by her act of piracy the status of these figures as authorial sources of the image. Folded into this challenge is an implicit reading of the 'original' picture – whether Weston's photographs of the nude torso of his young son Neil, or Porter's wild technicolor landscapes – as itself always already an act of piracy, unconsciously but inevitably borrowing from the great library of images (the Greek Classical torso, the windswept picturesque countryside) by which our eyes have been educated. To this kind of radical refusal of traditional conceptions of authorship and originality, a critical stance made unmistakable by its position at the margins of legality, the name 'Appropriation Art' has come to be affixed. And this type of work, building a critique of forms of ownership and fictions of privacy and control, came to be identified as post-modernism in its radical form.

If David Salle began his work in the context of

the 'Pictures' variety of radical post-modernism, he developed in the direction of the *trans-avant-garde*'s celebration of the repertory of historical images and architecture's acceptance of the logo world. On to increasingly vast canvases he painted pastiches of a range of pictorial styles, juxtaposing the frenzied brushwork of Abstract Expressionism with the Impressionist image of Monet's painting-barge, or bringing a quotation from a seventeenth-century landscape by Hobbema into collision with the muscularity of 1930s realism – all of these criss-crossed with strangely feathery, monochrome renderings of nude women (pl. 487). Although this *mélange* of styles cannot but acknowledge the pervasiveness and artificiality of the image world of late-twentieth-century commercial culture, it does so with reassurances about the way the aesthetic space can be consolidated anew by the creative artist. For Salle calls for the reappearance of the author as the orchestrator of the image world he appears to be summoning at will, and for the reconstitution of the masterpiece in the oil paintings he appears

to be composing and containing within the autonomous space of their frames.

That same course of development is evident in the work of the British team of artists Gilbert (b. 1942) and George (b. 1943), who began in 1969 by challenging the gallery and museum culture through the impermanence of their 'work', which at that time consisted simply of themselves posed in the gallery as 'sculpture'. By the early 1970s Gilbert and George had resorted to a permanent form for their images: enormous, vividly coloured canvases combining photographs of themselves with photographic material implying settings ranging from the pastoral to the urban (pl. 490). But, unlike Cindy Sherman, who used mass-media photographic settings to engulf her own image – transforming whatever autonomous 'self' we might imagine her to have into mere stereotype – Gilbert and George retain their independent personae in these works, generating themselves as iconic figures, emerging through the rubble of the contemporary world.

The question of where to place this widely practised 1980s tactic of 'appropriation' of the image – whether in a radical camp, as a critique of the power network that threads through reality, always structuring it, or in a conserva-

ABOVE 488. CINDY SHERMAN: Untitled Film Still: 59, *1980. Private Collection.*

LEFT 489. SHERRIE LEVINE: Untitled (after Walker Evans: 6), *1981. Private Collection.*

tive one, as an enthusiastic return to figuration and the artist as image-giver – takes on another dimension when we view the strategy through the eyes of feminist artists.

Working with both photographic material appropriated from the mass-cultural image bank and the form of direct address to which advertising often has recourse – as it cajoles or hectors or preaches to its viewers and readers, addressing them as 'you' – Barbara Kruger elaborates yet another of the presuppositions of the aesthetic discourse, another of its institutional frames. This is the frame of gender, of the unspoken assumption set up between artist and viewer that both of them are male. Articulating this assumption in such a work as *Your Gaze Hits the Side of My Face* (1981; pl. 492), where the typeface of the message appears in staccato against the image of a classicised female statue, Kruger fills in another part of the presuppositional frame: the message transmitted between the two poles classical linguistics marks as 'sender' and 'receiver', and assumes is neutral but presupposes as male, is a message put in play by something we could call an always-silent partner: namely, the symbolic form of woman. Following a post-structuralist linguistic analysis of language and gender, Kru-

ger's work is therefore interested in woman as one of those subjects who does not speak but is, instead, always spoken for. She is, as Laura Mulvey wrote in an article in *Screen* (1975), structurally 'tied to her place as bearer of meaning, not maker of meaning'.

This is why Kruger, in this work, does not seize the right of speech in the way Broodthaers did in his open letters, but turns instead to 'appropriation'. Woman, as the 'bearer of meaning', is the locus of an endless series of abstractions – she is 'nature', 'beauty', 'motherland', 'liberty', 'justice', all of which form the cultural and patriarchal, linguistic field; she is the reservoir of meanings from which statements are made. As a woman artist Kruger acknowledges her position as the silent partner through her act of 'stealing' her speech, of never claiming to have become the 'maker of meaning'.

This question of woman's relation to the symbolic field of speech and the meaning of her structural dispossession within that field is the subject of other major works by feminists. One of these, *Post-Partum Document* (1974–9; pl. 491) by Mary Kelly (b. 1943), tracks the artist's own connection to her infant son through five years of his development and 135 exhibits recording that

490. GILBERT AND GEORGE: We, *1983*. *Anthony d'Offay Gallery, London.*

491. MARY KELLY: Post-Partum Document (detail): Documentation III: Analysed Markings and Diary – Perspective Schema, *1975. Tate Gallery, London.*

441

BARBARA KRUGER,
YOUR GAZE HITS
THE SIDE OF MY FACE

Deep within the nineteenth century, Edouard Manet had broken the unwritten codes of painterly decorum and set his depicted nudes to gazing directly out at the spectator. Whether we want to interpret those hectoring stares of *Olympia* (pl. 354) or the nude in *Le Déjeuner sur l'herbe* (pl. 352) as scornful, or brazen, or aloof, they uniformly take note of the viewer, addressing him (for it is certainly a male - client, protector, solicitor – to whom they respond) as 'you'.

With the words written down the surface of *Your Gaze Hits the Side of My Face* (1981), Barbara Kruger revises that modernist-pictorial game of 'you'. For the calmly sculptural object of the gaze does not look out at the viewer and the exchange between the two subjects – one inside, the other outside the picture – is choreographed instead through the medium of language. It is along this axis between the first- and second-person pronouns – I/you – that Kruger traces the presuppositional framework for that very institution that we call subjecthood.

In this she is following the analysis of a linguist like Emile Benveniste, who wants to show how the experience of 'subjectivity', 'individuality', 'the uniqueness of the speaking subject', is constructed by language, being in that sense an *effect* of linguistic structure. We can imagine linguistic structure as a set of rules and relationships, like that of a card-game – bridge, say – where there are rules about how the game is played and values given to the cards that establish the relationships among them. There are also formal slots given to the players who take up the positions at the bridge table: north, south, east and west. Any person who sits down for a given game assumes the character of 'north' or 'south' but does so only temporarily. *I*

and *you* are like that temporary assumption of a place at the table, only now we are engaged in something much more all-encompassing than a game of cards – namely language, the very ambience of our existence. Benveniste's argument is that by making a place for an individual player to carry out the unique gestures of this or that act (speech, or cards), the structure produces a *sense* of individuality. But this is only the effect, he maintains, of an impersonal system, one purpose of which is to create this effect.

Subjects (those who say 'I') are thus made, not born. And they are made in the context of various institutions in which the language game is played. Art is one such institution, but another, which Kruger adds to that of art, is the more modern one of advertising. For Kruger's image, combining photography with the short, punchy language of its text, speaks with the directness and familiarity of the voice of the advertising agent, hearty but seductive at the same time. Subjectivity is produced along an axis in which one of the poles is occupied not by a human speaker but by a commodity: a beauty-aid, a household appliance, a breakfast food. The advertisement ventriloquises through the product. 'Buy me', 'love me', 'eat me', it says. And the subject who is located along the axis of this relationship between *I* and *you* (the photographed sculpture in the work and the viewer standing in front of the work) is constructed along the lines of the inorganic, lifeless condition of the commodity which he is nonetheless solicited to desire.

493. RICHARD SERRA: Tilted Arc, 1981. Federal Plaza, New York.

mother-child relationship. At the same time the work explicitly records the woman's experience of the developing autonomy of the male child as he comes into possession of language. It wants to examine the way the child himself is fetishised by the mother through her own sense of lack.

FRAMING ABSENCE

Two kinds of absence structure the field of aesthetic experience as the twentieth century draws to a close. One of them we could describe as the absence of reality itself as it retreats behind the mirage-like screen of the media, sucked up into the vacuum tube of a television monitor, read off like so many print-outs from a multinational computer hook-up. The other is the invisibility of the presuppositions of language and of institutions, a seeming absence behind which power is at work, an absence which artists from Mary Kelly, Barbara Kruger and Cindy Sherman to Hans Haacke, Daniel Buren (pls. 495–8) and Richard Serra attempt to bring to light.

A final example of this question of institutional frames is provided by a framing-device in the very television series, *Art of the Western World*, to which this text serves as companion. The last programme in the series opens in the Storm King Art Center, a farmland area in upstate New York that has been made into a sculpture park. And, balancing this pastoral opening, the film closes with a presentation of *Roden Crater* (pl. 494), a vast earthwork by James Turrell (b. 1943) fashioned by levelling the top of a volcanic crater into a perfectly circular plane from which to con-

template the open skies. The circle this narrative symmetry draws around the art of the last two decades, reframing its often confrontational and political rhetoric within a placid, neutral space already coded as 'aesthetic', has its own interpretative subtlety within the context of the half-hour of film. For example, the director filmed Storm King on a rainy day, to suggest the park's isolation from the living centres of contemporary reality as something anomalous and disturbing. Similarly, *Roden Crater* is treated with a certain ambivalence. Its very distance from any place the viewer is likely to be, its very condition as a 'pilgrimage' site, is used to underscore the problematic nature of our contemporary relation to art – its growing unnaturalness.

But, whatever the aims of the individual filmmaker, this half-hour cannot help but be read in the context of the narrative sweep of the series as a whole, the momentum of which is far more powerful than the message of any single one of its parts, whether it be the complexities that reign at the end of the twentieth century or those presented as riddling the rise and fate of Classicism. That narrative shape is conditioned by the tendency for television programming as such to simplify the outlines of stories and provide conclusions that resolve, with satisfying neatness, the problems set out at the beginnings. It is further conditioned by the interests of the very institutions much of post-war art has begun to question, institutions which are most comfortable when the message of this narrative is the idea of the naturalness of our relation to art.

In this context, *Roden Crater* becomes a device to reintegrate and reframe the story of Western art. And so Turrell's work is swept up into a larger symmetry which means that it will inevitably be seen in the most overarching, universalising of terms: solemn, monumental, sublime, like the mastabas of Ancient Egypt or the rings of Stonehenge. This retrospectively imposed frame, which joins the images of two windswept acropolises – one in Athens and one in the Arizona desert – also establishes both of them as pleasantly far away, remote in time (a relic of Classical antiquity) or in space (in a place few of us will ever visit). Art is secured as resolutely separate from the problems that confront a citizen of the late twentieth century. And the narrative, institutional frame set up by the television-education system will work to recontain the art of the 1980s within the borders of a supposed autonomy.

But as this book is going to press a battle is being waged in the US courts over a decision to remove a work from the public, urban space for

which it was made and to place it in the sculpture park at Storm King, thereby locating it in what its maker views as a meaningless no-man's-land of empty, aesthetic contemplation. The work in question, *Tilted Arc* (pl. 493) by Richard Serra (b. 1939), is a canted, curving, 120-foot (36.5 metre) wall of steel commissioned for Federal Plaza, the entry court to a complex of government buildings in downtown New York. There it has stood since 1981. Like other, earlier works by Serra, this sculpture is involved in projecting the lived relationship of the viewer to his or her own body and the gestures and movements through which it expresses itself. For the spectator of *Tilted Arc*, the sculpture is constantly mapping a kind of projectile of the gaze that starts at one end of Federal Plaza and charts the visitor's path across the plaza. In this sweep which is simultaneously visual and corporeal, *Tilted Arc* describes the body's relation to forward motion, to the fact that, if we move ahead, it is because our eyes have already reached out in order to connect us with the place to which we intended to go.

Five years after its installation, a public hearing was held to discuss to what uses the Plaza might be more profitably put. The aim was to effect the removal of the sculpture: officials argued that *Tilted Arc* was preventing the space from being put to any use and so was merely an obstruction. The hearing turned on the various 'public' functions the Plaza might serve. That it might already have an aesthetic 'use' hardly entered the discussion.

One of the features of late-twentieth-century Western culture is its rapid diminution of truly public space. The variety of public shopping-streets has increasingly given way to the homogeneity of the private shopping-mall; the public exchanges of a shared civic life have been shattered by so many private relations to individual television sets. That the very idea of public space may be in danger, as a suburban society seeks to destroy what it fears as the urban ghetto, was never raised by the pious arguments made for picnic tables and bandstands for Federal Plaza.

Tilted Arc maps the relationship between the individual user of the Plaza and the site itself, and at the same time exposes the presuppositions of so-called 'public art', in which large pieces of outdoor sculpture are used to signify the public nature of spaces from which – barren, windswept, uncared-for – any such nature has long been stripped. To transplant *Tilted Arc* to a sculpture park is to annul the question it is asking about art's relation to the public, and, similarly, to frame the concluding programme of *Art of the Western World* with the reconstituted, abstract image of a desert-locked acropolis is to avoid the last quarter-century's repeated challenges to the presuppositions of the institutional frame in art.

The term *trans-avant-garde* was coined to reassure us that the *avant-garde* – so noisy, so uncouth, so demanding – is dead. It has been, we are told, simply transcended. But the work of artists to expose the presuppositional frames of all the institutions of our society is the work of an *avant-garde* which, in the midst of the cultural confusion at the end of the twentieth century, lives on.

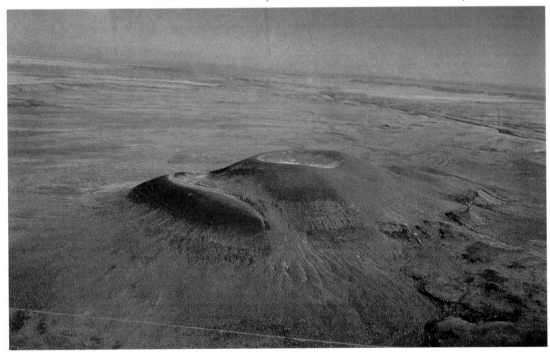

494. JAMES TURRELL: Roden Crater. *Work in progress, Arizona.*

DANIEL BUREN, LES DEUX PLATEAUX

In 1988 Daniel Buren completed *Les Deux Plateaux* (The Two Levels), a site-work filling the Courtyard of Honour of the Palais-Royal in Paris; the seventeenth- and eighteenth-century former palace that now houses various French government ministries and part of the supreme court. The doubleness of *Les Deux Plateaux* refers to the two levels on which the work exists – the level of the courtyard at which its 460 columns make their appearance, and the level of the underground plane from which they jut into the field of visibility, a subterranean level made insistently audible by the water rushing along channels stationed beneath the grating that trisects the court.

But the doubleness also addresses the grandeur of the Classical colonnades which frame this context with all its tradition and pomp; for Buren's columns are appearing and disappearing at the same time, rising and sinking from an underground that also has a strong hold on the French historical imagination. That underground is the world of the sewers and the catacombs, reminders of the beginnings and ends of historical entities, of both people and states. Something like a stump-filled acropolis, *Les Deux Plateaux* projects the ruins of a Classical culture. Something like an airstrip – for it is illuminated after dark by running strip-lights – it projects the ceremonial space of a primitive people's cargo cult. Only we are now those people, setting out flags for the return of a displaced past.

Buren's work is a striking example of the distance that separates the post-modern *avant-garde* – those critics of the institutional frames of culture – and the post-modern historicists – the pasticheurs and eclecticists mimicking Classical and other traditional historical styles. For if Buren constructs his work

out of columns which rhyme with and extend the Classical colonnade that bounds the courtyard of the Palais-Royal, it is not to declare the seamless continuity of past and present. Indeed the aggressively Minimalist look of Buren's columns with their stark black-and-white vertical stripes, their arrangement on a grid-like configuration that guarantees their dispersal through the space, and their quality of being fabricated like a piece of modern design rather than carved like a fragment of antiquity, all these things proclaim the historical break that separates the present from the past. But by echoing the older columns in form and arrangement the new work can orient its spectator towards history itself, giving him or her a perspective on the way the historical site frames one's experience with a sense of permanence, stability, changelessness. *Les Deux Plateaux* cuts into that enclosure of the official frame, smuggling in a different image: transience, frailty, the past passing.

FURTHER READING

CHAPTER 1

GENERAL

J. Boardman, *Greek Art* (London, 1985).
J. J. Pollitt, *Art and Experience in Classical Greece* (Cambridge, 1972).
Art of the Hellenistic Age (Cambridge, 1986).
M. Robertson, *A History of Greek Art* (Cambridge, 1975).
A Shorter History of Greek Art (Cambridge, 1981).

SPECIALIST AREAS

B. Ashmole, *Architect and Sculptor in Ancient Greece* (London, 1972).
J. Boardman, *Greek Sculpture, Archaic Period* (London, 1978).
Greek Sculpture, Classical Period (London, 1985).
Athenian Black Figure Vases (London, 1974).
Athenian Red Figure Vases, Archaic Period (London, 1975).
Athenian Red Figure Vases, Classical Period (London, 1989).
Greek Gems and Finger Rings (London, 1970).
R. M. Cook, *Greek Painted Pottery* (London, 1972).
J. J. Coulton, *Greek Architects at Work* (London, 1977).
R. A. Higgins, *Greek Terracottas* (London, 1967).
Greek and Roman Jewellery (London, 1961).
A. W. Lawrence, *Greek Architecture* (Harmondsworth, 1957).
G. M. A. Richter, *The Portraits of the Gods* (Oxford, 1984).
D. Strong, *Greek and Roman Gold and Silver Plate* (London, 1966).
R. E. Wycherley, *How the Greeks Built Cities* (London, 1962).

CHAPTER 2

R. B. Bandinelli, *Rome: The Center of Power* (New York, 1970).
Rome: The Late Empire (New York, 1971).
R. Brilliant, *Roman Art from the Republic to Constantine* (London, 1974).
N. Hannestad, *Roman Art and Imperial Policy* (Aarhus, 1986).
W. L. MacDonald, *The Architecture of the Roman Empire*, 2 vols (New Haven, Conn., and London, 1965, 1986).
D. Strong, *Roman Art* (Harmondsworth, 1976).
W. F. Volbach, *Early Christian Art* (New York, 1961).
J. B. Ward-Perkins, *Roman Imperial Architecture* (Harmondsworth, 1981).
K. Weitzmann (ed.), *Age of Spirituality: Late Antique and Early Christian Art Third to Seventh Century* (New York, 1979).

CHAPTER 3

GENERAL WORKS

J. Beckwith, *Early Medieval Art* (London, 1964).
R. G. Calkins, *Monuments of Medieval Art* (London, 1979).
C. R. Dodwell, *Painting in Europe: 800–1200*, Pelican History of Art (Harmondsworth, 1971).
G. Duby, *The Age of the Cathedrals: Art and Society 980–1420* (London, 1981).
G. Henderson, *Early Medieval* (London, 1972).
G. Holmes (ed.), *The Oxford Illustrated History of Medieval Europe* (Oxford, 1988).
P. Kidson, *The Medieval World* (London, 1968).
E. Kitzinger, *Early Medieval Art* (London, 1983).
P. Lasko, *Ars Sacra, 800–1200*, Pelican History of Art (Harmondsworth, 1972)
R. W. Southern, *The Making of the Middle Ages* (London, 1984).
H. Swarzenski, *Monuments of Romanesque Art* (London, 1974).
O. K. Werkmeister, *Medieval Art History: A Short Survey* (Los Angeles, 1980).

EARLY CHRISTIAN AND BYZANTINE ART

J. Beckwith, *Early Christian and Byzantine Art*, Pelican History of Art (Harmondsworth, 1970).
P. Brown, *The World of Late Antiquity: From Marcus Aurelius to Muhammad* (London, 1971).
R. Cormack, *Writing in Gold: Byzantine Society and its Icons* (London, 1985).
R. Krautheimer, *Early Christian and Byzantine Architecture*, Pelican History of Art (Harmondsworth, 1965).
Rome: Profile of a City 312–1308 (Princeton, NJ, 1980).

W. MacDonald, *Early Christian and Byzantine Architecture* (London, 1968).
S. Runciman, *Byzantine Style and Civilization* (London, 1975).
M. Schapiro, *Late Antique, Early Christian and Medieval Art* (London, 1980).

NORMAN ENGLAND

R. H. C. Davies, *The Normans and their Myths* (London, 1976).
C. R. Dodwell, 'The Bayeux Tapestry and the French Secular Epic', *Burlington Magazine*, 108 (1966) 549–90.
C. H. Gibbs-Smith, *The Bayeux Tapestry* (London, 1973).
C. M. Kaufmann, *Romanesque Manuscripts 1066–1190* (London, 1975).
G. Zarnecki (ed.), *English Romanesque Art 1066–1200* (London, 1984).

INSULAR ART IN THE BRITISH ISLES

J. J. G. Alexander, *Insular Art from the Sixth to the Ninth Centuries* (London, 1978).
J. Backhouse, *The Lindisfarne Gospels* (Oxford, 1981).
R. L. S. Bruce-Mitford, *The Sutton Hoo Ship Burial: A Handbook* (London, 1979).
C. Nordenfalk, *Celtic and Anglo-Saxon Painting* (London, 1977).

CAROLINGIAN AND OTTONIAN ART

D. Bullough, *The Age of Charlemagne* (London, 1965).

ROMANESQUE IN WESTERN EUROPE

J. J. G. Alexander, *The Decorated Letter* (New York, 1978).
W. Braunfels, *The Monasteries of Western Europe* (London, 1972).
C. N. L. Brooke, *The Twelfth Century Renaissance* (London, 1969).
K. J. Conant, *Carolingian and Romanesque Architecture*, Pelican History of Art (Harmondsworth, 1959).
M. F. Hearn, *Romanesque Sculpture: The Revival of Monumental Stone Sculpture in the 11th and 12th centuries* (Oxford, 1981).
H. E. Kubach, *Romanesque Architecture* (New York, 1972).
E. Male, *Religious Art in France: The Twelfth Century* (Princeton, NJ, 1978).
M. Schapiro, *Romanesque Art* (London, 1977).
Theophilus, *The Various Arts*, ed. C. R. Dodwell (Oxford, 1986).
O. K. Werkmeister, 'The Lintel Fragment Representing Eve from Saint-Lazare, Autun', *Journal of the Warburg and Courtauld Institutes*, 35 (1972) 1–30.
G. Zarnecki and D. Grivot, *Gislebertus, Sculptor of Autun* (London, 1961).

CHAPTER 4

J. Bony, *French Gothic Architecture of the 12th and 13th Centuries* (Berkeley, 1983).
L. S. Colchester, *Wells Cathedral* (London, 1987).
(ed.), *Wells Cathedral: A History* (Shepton Mallet, Somerset, 1982).
S. Crosby, *The Royal Abbey of Saint-Denis from its Beginnings to the Death of Suger, 475–1151*, ed. and completed by P. Z. Blum (New Haven, Conn., 1986).
G. Duby, *The Europe of the Cathedrals, 1140–1280* (Geneva, 1966).
J. Evans (ed.), *The Flowering of the Middle Ages* (London, 1967).
P. L. Gerson (ed.), *Abbot Suger and Saint-Denis* (New York, 1986).
J. Gimpel, *The Cathedral Builders*, new edn (London, 1981).
L. Grodecki and C. Brisac, *Gothic Stained Glass* (Ithaca, NY, 1985).
J. Harvey, *The Medieval Craftsmen* (London, 1975).
The Gothic World, 1100–1600, new edn (New York, 1969).
The Medieval Architect (London, 1971).
D. Kimpel and R. Suckale, *Die gotischen Kathedralen: nordfranzösische Architektur 1135–1270* (Munich, 1986).
R. Mark, *Gothic Structural Experimentation* (Cambridge, Mass. 1982).
N. Pevsner and P. Metcalfe, *English Cathedrals* (collected entries from *The Buildings of England*), 2 vols (London, 1986).
W. Swaan, *The Gothic Cathedral* (New York, 1969).

CHAPTER 5

M. Baxendall, *Painting and Experience in Fifteenth Century Italy* (Oxford, 1972).
J. R. Hale, *A Concise Encyclopaedia of the Italian Renaissance* (Oxford, 1981).
F. Hartt, *A History of Italian Renaissance Art*, 3rd edn (London, 1987).
D. Hay, *The Italian Renaissance in its Historical Background* (Cambridge, 1977).
L. H. Heydenreich and W. Lotz, *Architecture in Italy 1400–1600*

(Harmondsworth, 1974).
M. Levey, *The Early Renaissance* (Harmondsworth, 1967).
J. Pope-Hennessy, *Italian Gothic Sculpture*, 2nd edn (London, 1972).
Italian Renaissance Sculpture, 2nd edn (London, 1971).
J. White, *Art and Architecture in Italy 1250–1400*, (Harmondsworth, 1987).

CHAPTER 6

F. Anzelewsky, *Dürer, his Art and Life* (Fribourg, 1980).
M. Baxandall, *The Limewood Sculptors of Renaissance Germany* (Yale, 1980).
L. Campbell, *Rogier van der Weyden* (London, 1974).
E. Dhanens, *Hubert and Jan van Eyck* (New York, 1980).
M. J. Friedländer, *From Eyck to Bruegel* (London, 1965).
W. S. Gibson, *Hieronymus Bosch* (London, 1973).
T. Müller, *Sculpture in Germany, the Netherlands, France and Spain 1400–1500*, Pelican History of Art (Harmondsworth, 1968).
G. von der Osten and H. Wey, *Painting and Sculpture in Germany and the Netherlands, 1500–1600*, Pelican History of Art (Harmondsworth, 1969).
E. Panofsky, *Early Netherlandish Painting*, 2 vols (Cambridge, Mass. 1953).
G. Ring, *A Century of French Painting* (London, 1944).

CHAPTER 7
ART

A. Bruschi, *Bramante* (London, 1977).
K. Clark, *Leonardo da Vinci*, rev. edn, intro. M. Kemp (Harmondsworth, 1988).
H. von Einam, *Michelangelo* (London, 1973).
S. J. Freedberg, *Painting in Italy 1500–1600* (Harmondsworth, 1979).
M. Giacometti (ed.), *The Sistine Chapel: The Art, the History, and the Restoration* (New York, 1986).
C. Gilbert and R. N. Linscott, *Complete Poems and Selected Letters of Michelangelo* (Princeton, NJ, 1980).
L. H. Heydenreich and W. Lotz, *Architecture in Italy 1400–1600* (Harmondsworth, 1974).
J. Pope-Hennessy, *Italian High Renaissance and Baroque Sculpture*, 3 vols (London, 1980).

HISTORICAL BACKGROUND

B. Mitchell, *Rome in the High Renaissance: The Age of Leo X* (Norman, Okla., 1973).
P. Partner, *Renaissance Rome, 1500–1559: A Portrait of a Society* (Berkeley, Calif., 1976).
C. L. Stinger, *The Renaissance in Rome* (Bloomington, Ind., 1985).

CHAPTER 8
THE ARTS

J. S. Ackerman, *Palladio* (Harmondsworth and New York, 1966).
H. Burns, L. Fairbairn and B. Boucher, *Andrea Palladio 1508–1580: The Portico and the Farmyard*, exhibition catalogue (London, 1975).
C. Hope, *Titian* (London, 1980).
D. Howard, *The Architectural History of Venice* (London, 1980).
Jacopo Sansovino: Architecture and Patronage in Renaissance Venice (New Haven, Conn., and London, 1975).
J. Martineau and C. Hope (eds), *The Genius of Venice 1500–1600* (London, 1983).
E. Panofsky, *Problems in Titian, Mostly Iconographic* (New York, 1969).
L. Puppi, *Andrea Palladio* (London, 1975).
D. Rosand, *Painting in Cinquecento Venice: Titian, Veronese, Tintoretto* (New Haven, Conn., and London, 1982).
Titian (New York, 1978).
Titian: His World and his Legacy (New York, 1982).
F. Valcanover and T. Pignatti, *Tintoretto* (New York, 1985).
R. Wittkower, *Architectural Principles in the Age of Humanism*, 3rd edn (London, 1962; New York, 1971).

HISTORICAL CONTEXT

W. J. Bouwsma, *Venice and the Defense of Republican Liberty: Renaissance Values in the Age of the Counter–Reformation* (Berkeley, Calif., and Los Angeles, 1968).
D. S. Chambers, *The Imperial Age of Venice 1380–1580* (London, 1970).
J. R. Hale (ed.), *Renaissance Venice* (London, 1973).
F. C. Lane, *Venice: A Maritime Republic* (Baltimore and London, 1973).
O. Logan, *Culture and Society in Venice 1470–1790* (London, 1972).
E. Muir, *Civic Ritual in Renaissance Venice* (Princeton, NJ, 1981).
J. J. Norwich, *A History of Venice* (London, 1982).

B. Pullan, *Rich and Poor in Renaissance Venice: The Social Institutions of a Catholic State to 1620* (Oxford, 1971).

CHAPTER 9

H. Aurenhammer, *J. B. Fischer von Erlach* (London, 1973).
Father Bacci, *The Life of Saint Philip Neri, Apostle of Rome, and Founder of the Congregation of the Oratory*, ed. F. I. Antrobus (London, 1902).
G. P. Bellori, *Le Vite de' Pittori, Scultori e Architetti Moderni*, ed. E. Borea (Turin, 1976).
P. F. de Chantelou, *Diary of the Cavaliere Bernini's Visit to France*, ed. A. Blunt and G. C. Bauer (Princeton, NJ, 1985).
R. Engass and J. Brown, *Italy and Spain 1600–1750: Sources and Documents* (Englewood Cliffs, NJ, 1970).
F. Haskell, 'The Role of Patrons: Baroque Style Changes', in R. Wittkower and I. B. Jaffe (eds.), *Baroque Art: The Jesuit Contribution* (New York, 1972) 51–62.
Patrons and Painters: A Study in the Relations between Italian Art and Society in the Age of the Baroque, rev. and enlarged edn (New Haven, Conn., and London, 1980).
H. Hibbard, *Caravaggio* (London, 1983).
I. Lavin, 'Bernini's Death', *Art Bulletin*, LIV (1972) 158–86.
Bernini and the Unity of the Visual Arts (New York and London, 1980).
T. Magnuson, *Rome in the Age of Bernini* (Stockholm and NJ, 1982–6).
J. Montagu, 'The Painted Enigma and French Seventeenth-Century Art', *Journal of the Warburg and Courtauld Institutes*, XXXI (1968) 307–35.
E. P. Pillsbury and L. S. Richards, *The Graphic Art of Federico Barocci: Selected Drawings and Prints* (Cleveland, Ohio, and New Haven, Conn., 1978).
C. Robertson, 'The Artistic Patronage of Cardinal Edoardo Farnese', in *Les Carrache et les décors profanes. Actes du colloque organise par l'Ecole Francaise de Rome* (Rome, 1988) 359–72.
W. Vitzthum, 'A Comment on the Iconography of Pietro da Cortona's Barberini Ceiling', *Burlington Magazine*, CIII (1961) 427–33.
R. Wittkower, 'Francesco Borromini, his Character and Life', in *Studies in the Italian Baroque* (London, 1975) 154–76.
Gothic versus Classic: Architectural Projects in Seventeenth-Century Italy (London, 1974).

My greatest debts in this chapter are to Elizabeth McGrath and Clare Robertson, although they may not recognise the results.

CHAPTER 10
SPAIN

J. Brown, *Velázquez, Painter and Courtier* (London and New Haven, Conn., 1986).
J. H. Elliott, *The Count-Duke of Olivares. The Statesman in an Age of Decline* (London and New Haven, Conn., 1986).
J. A. Maravall, *Culture of the Baroque. Analysis of a Historical Structure*, originally published as *La Cultura del Barocco*, 1985, translated by T. Cochran (Minneapolis and Manchester, 1986).
Royal Academy, London & Museo del Prado, Madrid, *Murillo* (exhibition catalogue) (1982–3).

SOUTHERN NETHERLANDS

J. Burckhardt, *Recollections of Rubens*, originally published posthumously as *Erinnerungen aus Rubens*, 1898, translated by M. Hottinger (London, 1950).
H. Gerson and E. H. Ter Kuile, *Art and Architecture in Belgium, 1600–1800* (Harmondsworth, 1960).
The volumes by various authors of the *Corpus Rubenianum Ludwig Burckhard* (London, 1968 onwards; in progress).

NORTHERN NETHERLANDS

C. Brown, *Scenes of Everyday Life. Dutch Genre Painting of the Seventeenth Century* (London, 1984).
B. Haak, *The Golden Age. Dutch Painters of the Seventeenth Century*, translated by E. Willems-Treeman (London, 1984).
H. H. Rowan, *John de Witt, Grand Pensionary of Holland, 1625–1672* (Princeton, NJ, 1978).
S. Schama, *The Embarrassment of Riches. An Interpretation of Dutch Culture in the Golden Age* (New York and London, 1987).
G. Schwartz, *Rembrandt, His Life, His Paintings* (Harmondsworth and New York, 1985).

CHAPTER 11

A. Braham, *The Architecture of the French Enlightenment* (London, 1980).
A. Brookner, *Jacques-Louis David* (London, 1980).
P. Conisbee, *Painting in Eighteenth-century France* (Oxford, 1981).
T. E. Crow, *Painters and Public Life in Eighteenth-century Paris* (New Haven, Conn., and London, 1985).
M. Fried, *Absorption and Theatricality: Painting and Beholder in the Age of Diderot* (Berkeley, 1980).
H. Honour, *Neoclassicism* (Harmondsworth, 1968).
R. Middleton and D. Watkin, *Neoclassicism and Nineteenth-century Architecture* (New York, 1980).
Summerson, J. *Architecture in Britain 1530–1830* (Harmondsworth, 1953, 7th edn, 1983).

CHAPTER 12

A. Drexler (ed.), *The Architecture of the Ecole des Beaux Arts* (New York, 1977).
L. Eitner, *Géricault: his Life and Work* (London, 1983).
W. Friedlaender, *David to Delacroix* (Cambridge, Mass., 1952).
J. Gage, *J. W. M. Turner: 'A wonderful range of mind'* (New Haven, Conn., and London, 1987).
H. R. Hitchcock, *Architecture: Nineteenth and Twentieth Centuries* (Harmondsworth, rev. edn, 1971).
H. Honour, *Romanticism* (Harmondsworth, 1979).
R. Middleton (ed.), *The Beaux-Arts and Nineteenth-century French Architecture* (London, 1982).
R. Middleton and D. Watkin, *Neoclassicism and Nineteenth-century Architecture* (New York, 1980).
M. Rosenthal, *Constable: the Painter and his Landscape* (New Haven, Conn., and London, 1982).

CHAPTER 13

T. J. Clark, *Image of the People: Gustave Courbet and the 1848 Revolution* (London, 1973).
The Painting of Modern Life: Paris in the Art of Manet and his Followers (London, 1985).
Robert L. Herbert, *Impressionism: Art, Leisure, and Parisian Society* (London and New Haven, Conn., 1988).
John House, *Monet: Nature into Art* (London and New Haven, Conn., 1986).
Charles S. Moffett *et al.*, *The New Painting: Impressionism 1874–1886* (Oxford, 1986).
Linda Nochlin, *Realism* (Harmondsworth, 1971).

CHAPTER 14

R. Brettel, *The Art of Paul Gauguin* (New York, 1988).
F. Orton and G. Pollock, *Vincent van Gogh, Artist of His Times* (Oxford, 1978).
'Les Données Bretonnantes . . .' Brittany and the Post-Impressionists in *Modern Art and Modernism*, ed. C. Frascina and C. Harrison (New York, 1982).
B. W. Ovcharov, *Vincent van Gogh à Paris* (Paris, 1988).
G. Pollock, *Mary Cassatt* (London, 1980).
J. Rewald (ed.), *Cézanne Letters*, translated by M. Kay (Oxford, 1976).
M. Roskill, *Van Gogh, Gauguin and the Impressionist Circle* (London, 1970).
Royal Academy, London, *Post-Impressionism* (London, 1979).
M. Schapiro, *Cézanne* (New York, 1965).
C. Stuckey and W. Scott, *Berthe Morisot Impressionist* (New York, 1987).
B. Thomson, *The Post-Impressionists* (Oxford, 1983).
R. Thomson, *Seurat* (Oxford, 1985).

CHAPTER 15

U. Appollonio, *Futurist Manifestos*, (London and New York, 1973).
E. Fry, *Cubism*, (London, 1966).
M. Giry, *Fauvism: Origins and Development*, (New York, 1981).
J. Golding, *Cubism: A History and an Analysis, 1907–1914*, (London, 1989).
D. E. Gordon, *Expressionism: Art and Idea*, (New Haven, Conn., and London, 1987).
M. W. Martin, *Futurist Art and Theory, 1909–1915*, (Oxford, 1968).
R. Rosenblum, *Cubism and Twentieth Century Art*, (New York, 1976).
F. Russell, *Art Nouveau Architecture*, (London, 1979).

CHAPTER 16

D. Ades, *Dada and Surrealism Reviewed*, (London, 1978).
P. R. Banham, *Theory and Design in the First Machine Age*, (London, 1962).
E. C. Coppler (ed.), *Picasso's Guernica*, (New York, 1988).
K. Frampton, *Modern Architecture: a Critical History*, (London, 1985).
C. Green, *Cubism and its Enemies: Modern Movements and Reaction in France, 1916–1928*, (New Haven, Conn., and London, 1987).
B. Hinz, *Art in the Third Reich*, (Oxford, 1979).
C. Lodder, *Russian Constructivism*, (New Haven, Conn., and London, 1983).
D. Rochford, *The Murals of Diego Rivera*, (London, 1987).
W. S. Rubin, *Dada and Surrealist Art*, (London, 1969).
N. J. Troy, *The De Stijl Environment*, (Cambridge, Mass., and London, 1983).

CHAPTER 17

L. Alloway, *American Pop Art* (New York, 1974).
W. Benjamin, *Illuminations*, translated by H. Zohn (New York, 1969).
G. Battock (ed.), *Minimal Art* (New York, 1968).
H. Geldzahler (ed.), *New York Painting and Sculpture: 1940–1970* (New York, 1969).
C. Greenberg, 'Modernist Painting' in G. Battcock, *The New Art* (New York, 1966).
Art and Culture (Boston, 1961).
Institute for Art and Urban Resources, *This Is Tomorrow Today* (New York, 1987).
R. Krauss, *Passages in Modern Sculpture* (New York, 1977).
L. Lippard, *Pop Art* (London, 1966).
M. MacLuhan, *Understanding Media* (New York, 1964).
Musée d'Art Moderne de la Ville de Paris, *1960: Les nouveaux réalistes* (Paris, 1986).
H. Rosenberg, *The Tradition of the New* (New York, 1959).
W. Rubin, 'Jackson Pollock and the Modern Tradition' in *Artform*, V (New York, 1967).
W. Seitz, *Abstract-Expressionism in America* (Princeton, NJ, 1955).
L. Steinberg, *Other Criteria* (New York, 1972).

CHAPTER 18

R. Barthes, *Image, Music, Text*, trans. S. Heath (New York, 1977).
C. Tisdall (ed.), *Joseph Beuys*, (New York, 1989).
B. Buchloh (ed.), *Marcel Broodthaers*, (Cambridge, Mass., 1988).
H. Foster, *Recodings*, (Washington, 1985).
Hans Haacke: Unfinished Business (New York, 1986).
R. Krauss, *The Originality of the Avant-Garde and Other Modernist Myths*, (Cambridge, Mass., 1985).
A. Michelson, R. Krauss, D. Crimp, J. Copjec, (eds.), *October: The First Decade*, (Cambridge, Mass., 1987).
G. de Vries (ed.), *On Art*, (Cologne, 1972).
N. Holt (ed.), *The Writings of Robert Smithson*, (New York, 1979).
B. Wallis (ed.), *Art After Modernism: Rethinking Representation*, (New York, 1984).
H. Szeemann (ed.), *When Attitudes Become Form*, (Berne, 1969).

GLOSSARY

(Note: words in bold type within definitions are listed as separate entries).

Acropolis The citadel, or highest point of an ancient Greek city.

Action painting A technique involving pouring, spattering and dripping paint – conveying the idea that a picture should be a record of the process of its creation. (Sometimes called gestural painting.)

Ambulatory An aisle carried round the eastern end of a church.

Amphitheatre An oval or circular structure with a central arena surrounded by tiers of seats; originally used for displays of gladiatorial combat.

Apse The vaulted, semicircular or **polygonal** termination to a church or chapel.

Aqueduct An elevated masonry structure for the conveyance of water.

Architrave In architecture, the lowest of the three sections of the **entablature**; more generally, the moulding around a door or window frame.

Archivolt The moulding, plain or decorated, which follows the contour of an arch; also, the undersurface of an arch.

Atrium 1. The inner court of an ancient Roman house, open to the sky.
2. An open court in front of a church, in Early Christian and medieval architecture.

Attic storey Top storey above the main **entablature** of a building.

Automatism In twentieth-century art, a drawing or painting prompted by the unconscious.

Avant-garde (French: vanguard)
In art history, used for group of persons whose ideas are considered to be in advance of their time.

Baldacchino (Baldachin) Originally, a cloth canopy over a throne; later used to describe the structure, supported by columns, built over an altar.

Balustrade A series of short pillars supporting a rail; usually found on balconies, bridges and at parapet level.

Basilica 1. In Roman architecture, a rectangular building with double colonnades inside and an **apse** at one end.
2. In Early Christian and medieval architecture, an aisled church in which the **nave** is higher than its aisles.

Bays Compartments of the interior of a building separated by divisions in the side walls (columns, **pilasters**) or in the ceiling (beams, etc.). Also, external divisions marked by windows or **buttresses**.

Boss An ornamental knob covering the intersection of ribs or groins in a vault.

Buttress A mass of masonry or brickwork projecting from or built against a wall, to provide reinforcement.

Cabinet picture A small, meticulously finished easel painting, usually intended for private display in a picture gallery (cabinet).

Caduceus A winged staff with two serpents entwined; the attribute of the Greek god Hermes and his Roman counterpart, Mercury.

Cantilever A projecting beam or girder supported at one end only.

Capital The crowning feature of a column or **pilaster**. See **Orders**.

Carpet page In illuminated manuscripts, a full page consisting of abstract patterns, coloured and embellished with gold-leaf.

Cartouche (Italian: *cartoccio*, scroll of paper)
An ornamental panel in the form of a scroll with curling edges, often bearing an inscription; an ornate frame.

Caryatid A draped female figure that acts as a column supporting the **entablature**.

Catacomb A subterranean place for the burial of the dead; an arrangement of underground galleries and cavities for tombs.

Catafalque A temporary ornamented structure used to carry the coffin or effigy of the dead person in funeral ceremonies.

Cella The main body of a Classical temple, excluding the **portico**.

Chevet The area covering the east end of a church, including the **choir**, **apse**, **ambulatory** and radiating chapels.

Chiaroscuro (Italian: light-dark)
The disposition of light and shade in a picture; usually of works that are predominantly dark in tone.

Choir The part of a church where divine service is sung.

Circus In Roman architecture, an oval or oblong building surrounded by tiers of seats on three sides, for the exhibition of races and public spectacles.

Cire perdue (French: lost wax)
An ancient bronze-casting technique. The wax model is formed around a core of clay and then enclosed in a clay mantle; the wax is melted away to be replaced by an equal quantity of molten bronze.

Clerestory Upper part of the walls of a church **nave**, pierced by windows, above the roofs of the aisles.

Coffering Decoration of a ceiling vault or dome with sunken panels, square or **polygonal**.

Collage (French: *coller*, to stick)
A picture partly or entirely composed of different materials (paper, cloth) stuck on to canvas, card or paper.

Composite See **Orders**.

Contrapposto (Italian: opposed)
Used to describe a pose in which one half of the body is twisted in the opposite direction to the other.

Corinthian See **Orders**.

Cornice The top, projecting section of the Classical **entablature**; more generally, any projecting, ornamental moulding at the top of a wall or arch.

Crossing The intersection of the **nave**, **choir** and **transepts** of a church.

Crypt Underground chamber, usually below the east end of a church.

Cupola A small **polygonal** or circular dome crowning a roof.

Curtain wall In medieval architecture, the outer wall that connects the towers of a castle. In twentieth-century architecture, a non load-bearing outer wall used to clad the framework of a building.

Diptych A picture or **relief** composed of two parts, usually hinged together. (See also **triptych**.)

Disegno (Italian: drawing, design)
Draughtmanship or design.

Doric See **Orders**.

Dressings Stone blocks worked to a smooth or moulded finish, for use on a building face (windows, doorways, angles).

Elevation Drawing of an external face of a building.

Encaustic wax This painting process was developed in antiquity, and consists of mixing **pigments** with wax.

Entablature In Classical architecture, a horizontal beam linking a series of columns and forming the upper part of an **Order**. It comprises the **cornice, frieze** and **architrave**.

Etching A form of engraving on metal in which the plate, covered in a resinous layer, is incised with a needle. It is then dipped in acid which etches, or eats into the exposed metal, thus creating lines ready for inking.

Façade (French: face)
The face or front of a building, especially the principal front.

Fête champêtre (French: outdoor feast)
Genre scene showing romantic figures dallying in an idealised pastoral setting, usually eating, drinking or listening to music.

Fête galante (French: festive gathering)
In painting, especially in early eighteenth-century France, the depiction of small-scale courtly figures in ball dress or masquerade disporting themselves with amorous intent in a parkland setting.

Flying buttress A half arch transmitting the lateral thrust of a vault or roof from the upper part of a wall to an outer support or **buttress**.

Forum In ancient Rome, the place of assembly for public business; thus, a central open space surrounded by public buildings.

Fresco (Italian: cool, fresh)
Wall painting in a form of watercolour on plaster which can either be dry (*fresco secco*) or damp (true fresco or *buon fresco*). See p.121

Fret A geometric pattern composed of continuous combinations of straight lines meeting at right angles (e.g. key pattern).

Frieze In Classical architecture, the middle division of an **entablature**, between the **architrave** and **cornice**; more generally, a strip of decoration.

Gable The triangular upper portion of a wall, to carry a pitched roof.

Gallery In church architecture, an upper storey above an aisle, opening in arches on to the **nave**.

Gargoyle (Old French: *gargouille*, throat)
A waterspout projecting from a roof or the parapets of a wall or tower, and carved into a grotesque human or animal head.

Genre painting (French: type, variety)
A type of painting specialising in a particular kind of subject matter eg. still-life, portraiture, history painting; small-scale picture depicting anecdotal scenes from everyday life.

Gesso (Italian: gypsum)
The dense and brilliantly white ground used in egg tempera painting and in certain types of oil painting. In Italy gesso was usually gypsum, and in northern Europe usually chalk, mixed with size.

Glaze In oil painting, a thin coat of transparent colour laid over another colour.

Helical In the form of a spiral.

Hipped roof A roof with sloped instead of vertical ends.

Illumination The decorations and illustrations found in medieval and later manuscripts.

Impasto (Italian: mixture)
In oil painting, colour thickly applied to a canvas or a panel.

Intaglio (Italian: incision)
The process of cutting forms out of a surface, especially on gems, hard stones or glass, as on a seal-ring. The opposite of **relief**.

Ionic See **Orders**.

Keystone The central stone of an arch or a rib vault. (See **vaults**.)

Kouros (Greek: youth; *kore*: maiden)
The name given to full-length statues of young men of the Greek Archaic period.

Lancet window A tall, narrow window crowned with a pointed arch.

Lantern In architecture, a small circular or **polygonal** turret with windows all around, crowning a roof or a dome.

Lights The openings between the **mullions** of a window.

Lintel A horizontal beam or stone bridging an opening.

Loggia (Italian: open-sided gallery)
A gallery open on one or more sides; it may also be a separate structure.

Lunette (French: diminutive of moon)
A semicircular opening, or flat surface, framed by an arch or a **vault**.

Mandorla (Italian: almond)
Sometimes called *vesica piscis* (Latin: bladder of a fish).
The elliptical frame of light surrounding the persons of the Holy Trinity and the Virgin Mary, in medieval paintings and sculpture.

Mastaba Ancient Egyptian tomb in the form of a rectangle with sloping sides.

Medium In painting, the liquid used to bind powdered colour to make paint, e.g. oil, egg yolk, gum arabic.

Metope In Doric architecture (see **Orders**), a square panel which alternates with the triglyphs (three-grooved tablets) in the **frieze**. Often decorated with a sculptured **relief**.

Monochrome A painting or drawing executed in shades of a single colour.

Mullion Vertical posts or uprights dividing a window into **lights**.

Nave The body of a church, extending from the inner door to the **choir**, and usually separated from the aisles by pillars.

Necropolis A cemetery.

Niche (Italian: *nicchio*, shell) A semicircular arched recess. This Graeco-Roman device was used to contain statues, fountains and other decorative objects.

Obelisk A tapering shaft of stone, usually monolithic, with a pyramidal apex. Originally the symbol of the sun god of Heliopolis in Egypt.

Octastyle A building or **portico** with eight columns.

Oculus A small round window.

Orders In Classical architecture: column with a base, **shaft, capital** and **entablature** according to the following styles: **Doric (Greek, Roman, Tuscan), Ionic, Corinthian** and **Composite**. The Doric (pl.25) and Ionic (pl.24) Orders originated on mainland and eastern parts of sixth-century BC Greece respectively. The Corinthian Order (pl.29) was an Athenian invention of the fifth century BC. The Roman version of the Corinthian capital provided the prototype for this Order in Classical revivals. The Composite Order combined elements of the Ionic and Corinthian Orders, and was also developed by the Romans.

Orthogonal Right-angled, rectangular.

Papier collé (French: stuck paper) A form of **collage** built up from layers of paper stuck on a ground such as canvas.

Parterre (French: on, or over the ground) A level area in a garden, usually facing south or the best front of a house, laid out in ornamental flower beds.

Pattern books Collections of ornamental designs by artists and architects produced for the guidance of builders and craftsmen of all kinds, from the fifteenth to nineteenth centuries.

Pavilion A subdivision of a larger building projecting from the main **façade** or terminating a wing. Also a summerhouse in a garden.

Pedestal In architecture, the base supporting a column or colonnade; more generally, the base of a statue.

Pediment The triangular gable crowning a Greek temple front; a similar triangular or curved form used decoratively over a **portico**, door or window.

Pendentive A concave triangle of masonry; one of the two ways of effecting the transition between a cubical structure and a dome.

Photomontage A composite image produced by the juxtaposition of photographs or fragments of photographs.

Piano nobile (Italian: principal storey) The floor containing the reception rooms of a house; usually the first floor.

Pictogram A simple pictorial element symbolising a particular object or concept (e.g. a road sign).

Pier A free-standing masonry support, usually square or rectangular (as distinct from a column).

Pietà 1. (Italian: pity). The representation of the Virgin Mary bearing the dead Christ on her lap, alone or with other mourners.
2. Lamentation. The scene following the Descent from the Cross, when the body of Christ is surrounded by mourners.

Pigment The dry (usually powdered) form of a colour or dye.

Pilaster A rectangular column form projecting only slightly from a wall. Its function is only superficially that of support. Its **capitals** conform to the **Orders**.

Pilotis (French: stakes, posts) The name given to the piles that, supporting and raising a building to first floor level, allow the ground floor to be open.

Poesia (Italian: poem) Paintings, especially sixteenth-century Italian, in which the lyrical composition and handling possess a quality akin to poetry.

Polychromy Painting in several colours, on sculpture, architecture, etc.

Polygonal Many-sided.

Portico (Italian: porch)

The centre-piece of a house or of a church, with Classical detached or attached columns and a **pediment**.

Presbytery The part of the church which lies east of the **choir** reserved for the use of the clergy.

Primary colours These are three: red, blue and yellow. The colours from which all others are derived. A mixture of two primary colours produces a secondary colour, e.g. blue + yellow = green.

Pulpit In a church, the elevated structure from which the preacher delivers the sermon.

Putto (Italian: child, boy) The name given to the winged infants in religious imagery; may sometimes refer to Cupid's attendants, in secular works.

Refectory The dining hall.

Régence (French: regency) An architectural and decorative style, heavily influenced by the Baroque, prevalent during the regency of Philippe duc d'Orléans (1715–33).

Relief sculpture Carving which is not free-standing, but projects from a background.

Reliquary A vessel in which the relic or relics of a saint are kept; usually ornate and made of precious metals.

Retable A painted or carved panel, standing at the back of an altar.

Retrochoir The space behind the high altar in a large church.

Rose window A circular window with patterned tracery arranged to radiate from the centre.

Rotunda A circular structure, sometimes surrounded by a colonnade.

Roundel A decorative circular panel, plate, medallion, etc.; more generally, a small disc.

Rustication The use of heavy masonry blocks with a rough surface finish and sunk joints.

Salon The official French art exhibition held regularly from 1667 in the Salon d'Apollon in the Louvre. It was administered by the government until 1881 when it was reorganised as the Société des Artistes Français with a jury elected by the previous year's exhibitors.

Sarcophagus A stone coffin, often decorated with **relief sculpture**, and bearing inscriptions.

Screen In architecture, the partition (wooden or stone and pierced by doors) separating the altar and east end from the rest of the church.

Scriptorium The room in a monastery, cathedral or secular workshop in which manuscripts were written.

Scumbling In painting, the overlaying of various thin coats of opaque or semi-opaque oil paint, to produce an uneven veiled effect. The opposite of **glazing**.

Segmental arch An arch in the form of a segment of a circle (i.e. not a complete semicircle).

Shaft In architecture, the trunk of a column between the base and the **capital**.

Slip A mixture of fine clay and water used on vessels of coarser clay to render them less porous; also used as relief decoration on pottery.

Sounding board The acoustic canopy over a **pulpit**; sometimes called a tester.

Spandrel The triangular area between the shoulder of one arch and the next or between an arch and a wall.

Stiff-leaf Sculptured foliage found on **capitals** and **bosses** of a type peculiar to twelfth- and thirteenth-century Gothic carving in Britain.

Stucco A fine plaster usually composed of gypsum and pulverised marble, especially used for making decorative features, e.g. mouldings, **cornices**.

Swag A carved piece of cloth, or ornamental festoon of flowers, foliage and fruit fastened up at both ends and hanging down in the centre.

Tabernacle An ornamented **niche** or receptacle reserved for the Holy Sacrament or relics; also may mean a free-standing canopy.

Tachisme (French: *tache*, spot, stain) A type of abstract painting akin to **action painting**. Tachiste artists attach greater importance to the expressive power of each area or blot of paint than to the methods of its application.

Tectonic Pertaining to building and construction in general.

Tesserae The small cubes of glass, stone or brick used in mosaic.

Thermal window A semicircular window divided into three **lights** by two vertical **mullions**.

Topography The practice of describing a particular place; the description of a locality, region, etc.

Tracery In Gothic architecture, intersecting rib-work in the upper part of a window. Tracery is also used decoratively in blank arches and **vaults**.

Transept The transverse (north-south) arms of a cross-shaped church.

Trapezoid An irregular figure whose four sides are not parallel.

Triforium In churches, the arcaded wall passage or blank arcading facing the **nave**, at the height of the aisle roof and below the **clerestory** windows.

Triptych A picture or **relief** which is made up of three panels. The central panel is usually twice the width of the wings so that these can be folded over to protect it. (See also **diptych**)

Trumeau The vertical stone post supporting the **tympanum** of a wide doorway.

Tympanum The area between the **lintel** of a door and the arch above it.

Underpainting The preliminary laying-in of the tones and design of a picture, often executed in **monochrome**, prior to the introduction of colour in the picture.

Vanitas A type of still-life painting. The objects depicted (skull, hourglass, clock, candle, upturned bowls, coins, flowers, etc.) are intended to symbolise ephemerality and the inevitability of death.

Vaults **Barrel** (or **tunnel**) **vault**: vault of semicircular section. **Domical vault**: dome-like vault with segments rising to a point from a square or **polygonal** base. **Groin** (or **Cross**) **vault**: vault of two tunnel-vaults of identical shape intersecting each other at right angles (pl.99). **Rib vault**: vault with diagonal ribs projecting along the groins (pl.100).

Volute A spiral scroll, as on an Ionic **capital** (see **Orders**), but often curling in different directions at either end, and used as a linking ornament.

Ziggurat (zikkurat) A Sumerian temple with steps and ramps ascending in an angular spiral around the diminishing stages of the tower.

LIST OF PLATES AND ACKNOWLEDGEMENTS

The publishers gratefully acknowledge the help of Norwich Union in producing this book.

The publishers wish to thank the museums, libraries,
galleries and individuals who have supplied illustrations.

FRONTISPIECE: VINCENT VAN GOGH: Peach Trees in Blossom
(Souvenir de Mauve). 1888. Oil on canvas, 73 x 59.5cm. Collection:
State Museum Kröller-Müller, Otterlo, The Netherlands

CHAPTER 1

1. The Auxerre goddess, c.625 BC. Limestone, ht 65cm. Musée du Louvre,
Paris. (Hirmer Verlag, Munich).
2. Painting of Hades seizing Persephone, in the Tomb of Persephone at Vergina
(N. Greece), c.300 BC. Ht 1m (Ekdotike/John Bastias, Athens).
3. Map of ancient Greece.
4. Kouros, from Tenea (S. Greece), c.550 BC. Marble, ht 135cm. Glyptothek,
Munich. (Hirmer).
5. The Berlin goddess. Marble figure of a woman, from Keratea (near Athens),
c.570–560 BC. Ht 193cm. Staatliche Museen, East Berlin.
6. Dionysos, from the east pediment of the Parthenon (figure D), c.435 BC.
Marble, over life-size. Reproduced by Courtesy of the Trustees of the British
Museum.
7. Bronze statue A from Riace. Detail of the head. (Scala, Florence).
8. Bronze statue A from Riace. Back view. (Scala).
9. Bronze statue A from Riace, 5th century BC. Bronze with bone, glass-paste,
silver and copper inlaid, ht 200cm. Museo Archeologico, Reggio Calabria.
(Scala).
10. POLYCLITUS: The Doryphoros (spear-bearer); imperial Roman marble
copy of a bronze original of c.440 BC, ht 198cm. Museo Nazionale, Naples.
(Hirmer).
11. Marble gravestone from Athens, near the Ilissos, c.340 BC. National
Museum, Athens. (Hirmer).
12. Aphrodite. Roman copy of a marble original of c.100 BC. Museo Nazionale
Romano, Rome (Hirmer).
13. Marble statue of Mausolus, a Carian prince, c.350 BC. Ht 300cm.
Reproduced by Courtesy of the Trustees of the British Museum.
14. The Gods fight Giants. Detail from the Great Altar of Zeus at Pergamum,
c.160 BC. Staatliche Museen, East Berlin.
15. Victory building a trophy. Chalcedony engraved gem, c.350 BC. Ht 3.3cm.
Reproduced by Courtesy of the Trustees of the British Museum.
16. Clay crater from Athens, c.740 BC. National Museum, Athens (Hirmer).
17. Clay jug from Aegina, c.650 BC. Ht 39cm. Reproduced by Courtesy of the
Trustees of the British Museum.
18. AMASIS PAINTER: Athenian black figure amphora, showing Dionysos and
women, c.540 BC. Cabinet des Médailles, Paris. (Hirmer).
19. EUPHRONIOS: Detail of Athenian red figure calyx crater, showing the
death of Sarpedon, c.510 BC. Metropolitan Museum of Art, New York.
(Sheridan Photo Library, London).
20. MEIDIAS PAINTER: Detail of Athenian red figure hydria, showing the
rape of the daughters of Leucippus, c.410 BC. Reproduced by Courtesy of the
Trustees of the British Museum.
21. Fragment of a painted ivory plaque from a tomb at Kul Oba (S. Russia),
c.400 BC. Hermitage Museum, St Petersburg. (Society for Cultural Relations
with the U.S.S.R.).
22. GNOSIS: Mosaic showing a stag hunt, in the palace at Pella (N. Greece),
c.300 BC. (Ekdotike/John Bastias, Athens).
23. Temple of Hera (the 'Basilica' temple) at Paestum (S. Italy), c.550 BC.
(Hirmer).
24. The Ionic order. Column from the temple on the Illisus, Athens.
25. The Doric order. Column from the Hephaisteion, Athens.
26. Relief from Slab II west frieze from the Parthenon. c.440 BC. Marble, ht
109.2cm. Reproduced by Courtesy of the Trustees of the British Museum.

27. Plan of the Parthenon.
28. The Parthenon, Athens, 447–438 BC. (Scala).
29. The Corinthian Order. Capital from the Choragic Monument of Lysicrates,
Athens.
30. The Erechtheum on the Acropolis at Athens, c.410 BC. (Hirmer).
31. Reconstruction of the tomb of Mausolus, king of Caria (the 'Mausoleum') at
Halicarnassus (SW. Turkey), mid 4th century BC. (Drawing by Peter Jackson).

CHAPTER 2

32. Portrait bust of the Emperor Decius, AD 250. Marble, life-size. Capitoline
Museum, Rome. (Alinari, Florence).
33. Detail of the Little Hunt Mosaic from the Imperial Villa of Casale, Piazza
Armerina, Sicily. 3rd–4th centuries AD. (Sonia Halliday Photographs).
34. View of the Roman Forum from the Capitoline Hill. (Scala).
35. The Roman Empire, AD 211.
36. Statue of Augustus from Prima Porta. Early 1st century AD. Marble, ht
203cm. Vatican Museums, Rome. (Scala).
37. Ara Pacis Augustae: Imperial Procession and Floral Frieze, 13–9 BC.
Marble. Rome. (Scala).
38. Relief from the Arch of Titus: Triumphal Procession of the Emperor, AD 81.
Rome. (Scala)
39. Portrait bust of an unknown Flavian lady, c.AD 90. Marble, life-size.
Capitoline Museum, Rome. (Alinari).
40. Portrait of the Emperor Hadrian on a Roman coin, the sestertius. 2nd
century AD. Reproduced by Courtesy of the Trustees of the British Museum.
41. Arch of Constantine, AD 315. Rome. (Scala).
42. Column of Trajan, helical relief, AD 113. Marble, ht of relief band c. 127cm.
Rome. (Scala).
43. Arch of Constantine (north façade). Relief showing Constantine addressing
the Romans in the Forum. Early 4th century AD. Marble, frieze 102cm high.
Rome. (Alinari).
44. Ixion Room in the House of the Vettii, Pompeii. 1st century AD. (Sheridan
Photo Library).
45. The Sanctuary of Fortuna Primigenia at Palestrina, (Praeneste), Italy, c.80
BC (Scala).
46. Reconstruction model of the Sanctuary of Fortuna. (Fototeca Unione at the
American Academy in Rome, neg no. F.U. 4348).
47. The Colosseum, AD 70–82. Rome. (Sheridan Photo Library).
48. The Maritime Theatre at Hadrian's Villa, Tivoli, AD 118–25. (Sheridan
Photo Library).
49. The Pantheon, Rome, c.AD 118–128. Plan.
50. The Pantheon, sectional diagram.
51. The Pantheon, exterior. (Scala).
52. The Pantheon, interior. (Scala).
53. The baths at Hadrian's Villa, Tivoli. 2nd century AD. (Alinari).
54. Statue of the older Tormented Centaur from Hadrian's Villa. 2nd century
AD. Dark marble, ht 1.34m. Capitoline Museum, Rome. (Alinari).
55. HAGESANDRUS, POLYDORUS and ATHENODORUS: Laocoon and
his Two Sons. Early 1st century AD. Marble, ht 244cm. Vatican Museums,
Rome. (Hirmer).
56. The Baths of Caracalla, Rome. 3rd century AD. View of the frigidarium.
(Alinari).

CHAPTER 3

57. Centula, abbey church of St Riquier, 790–99, rebuilt in 15th century.
Engraving by Pétau, 1612. Bibliothèque Nationale, Paris.
58. Book of Kells (fol.34), early 9th century. Vellum, 33 x 25cm. Trinity

Florence. Founded 1294/5. (Scala).

140. FILIPPO BRUNELLESCHI: Sacrifice of Isaac, 1401–2. Gilded bronze, 53.3 x 44.5cm inside moulding. Bargello, Florence. (Scala).

141. LORENZO GHIBERTI: Sacrifice of Isaac, 1401–2. Gilded bronze, 53.3 x 44.5cm inside moulding. Bargello, Florence. (Scala).

142. Cathedral of S. Maria del Fiore, Florence. Founded 1296. Interior of the nave. (Scala).

143. Cathedral of S. Maria del Fiore, Florence, with Brunelleschi's dome, 1420–36, and Lantern, after 1446. (Photo: University College London).

144. FILIPPO BRUNELLESCHI: Façade of the Ospedale degli Innocenti (Foundling Hospital), Florence. Begun 1419. (University College London).

145. DONATELLO: David. Probably mid-1430's. Bronze, ht 158.1cm. Bargello, Florence. (Scala).

146. DONATELLO: St George and Tabernacle, c.1416. Marble, ht 208cm. Orsanmichele, Florence, (figure now in Bargello. Photo: University College London).

147. MASSACIO: The Holy Trinity, c.1427. Fresco, 6.67 x 3.17m. S. Maria Novella, Florence. (Scala).

148. MASSACIO: The Tribute Money, c.1427. Fresco. Brancacci Chapel, S. Maria del Carmine, Florence. (Scala).

149. GIOVANNI PISANO: Prudence, 1302–10. Supporting figure from pulpit. Marble. Duomo, Pisa. (Scala).

150. MASSACIO: The Expulsion of Adam and Eve, c.1425–7. Fresco, 208 x 88cm. Brancacci Chapel, S. Maria del Carmine, Florence. (Scala).

151. ANDREA MANTEGNA: Madonna Enthroned with Saints and Angels, 1456–60. Panel, ht 219.7cm. S. Zeno, Verona. (Scala).

152. LORENZO GHIBERTI: Jacob and Esau from the 'Gates of Paradise', c.1436. Gilded bronze, 79.4cm square. Baptistry, Florence. (Photo: University College London).

153. FILIPPO BRUNELLESCHI: Interior of S. Lorenzo, Florence, 1421–5, continued 1442–6. (Scala).

154. FRA ANGELICO: Annunciation, c.1440–45. Fresco, 187 x 157cm. Convent of S. Marco, Florence. (Scala).

155. MICHELOZZO DI BARTOLOMMEO: Palazzo Medici-Riccardi, Florence. Begun 1444. (Scala).

156. SANDRO BOTTICELLI: Adoration of the Magi, c.1475. Panel, 111 x 134cm. Galleria degli Uffizi, Florence. (Scala).

157. SANDRO BOTTICELLI: Birth of Venus, c.1484–6. Canvas, 175.3 x 279.5cm. Galleria degli Uffizi, Florence. (Scala).

158. SANDRO BOTTICELLI: Primavera (detail)

159. SANDRO BOTTICELLI: Primavera (detail)

160. SANDRO BOTTICELLI: Primavera, c.1478. Tempera on panel, 203 x 315cm. Galleria degli Uffizi. (Scala).

161. DONATELLO: Resurrection, 1460–6. Bronze with traces of partial gilding, ht with frieze 123cm. North pulpit, S. Lorenzo, Florence. (Scala).

162. DONATELLO: St Mary Magdalen, c. 1455. Wood, partially gilded, ht 188cm. Baptistry, Florence. (Scala).

CHAPTER 6

163. STEFAN LOCHNER: Virgin and Child in a Rose Garden, c.1440. Panel, 51 x 40cm. Wallraf-Richartz Museum, Cologne. (Bildarchiv Foto Marburg).

164. ALBRECHT DÜRER: Self-Portrait, 1498. Oil on panel, 52 x 41cm. © Museo del Prado, Madrid. All rights reserved.

165. HUBERT and JAN VAN EYCK: The Altarpiece of The Adoration of the Lamb, 1432. Tempera and oil on panel, 3.75 x 5.17m open. St Bavo's Cathedral, Ghent. (Bridgeman).

166. ROGIER VAN DER WEYDEN: Last Judgement Altarpiece, c.1443–51. Oil on panel, 220 x 548cm. (open) Hôtel-Dieu, Beaune. (Giraudon).

167. ROGIER VAN DER WEYDEN: Last Judgement Altarpiece (closed). (Musée Hôtel-Dieu, Beaune).

168. The DE LIMBOURG brothers: New Year festivities to illustrate January in the calendar of the Très Riches Heures of the Duke of Berry, (fol.1 v), c.1416. Illumination, 24 x 15cm. Musée Condé, Chantilly. (Bridgeman).

169. CLAUS SLUTER: Well of Moses, c.1395–1403. Figures life-size. Chartreuse de Champmol, Dijon. (Sheridan Photo Library).

170. HENRI BELLECHOSE: Trinity with the Martyrdom of St Denis, 1416. Panel, 162 x 211 cm. Musée du Louvre, Paris. (Scala).

171. JAN VAN EYCK: Giovani Arnolfini and his Wife, 1434. Oil on panel, 82 x 59cm. Reproduced by courtesy of the Trustees of The National Gallery, London. (Bridgeman).

172. JAN VAN EYCK: Virgin of Chancellor Rolin, c.1435. Oil on panel, 66 x 62cm. Musée du Louvre, Paris. (Scala).

173. ROGIER VAN DER WEYDEN: Deposition, c.1440. Panel, 220 x 262cm.

© Museu del Prado, Madrid. All rights reserved.

174. DIERIC BOUTS: Sacrament Altarpiece, 1464–68. Panel, 180 x 151cm. St Pieter's Church, Louvain. (Scala).

175. ROBERT CAMPIN, the MASTER OF FLÉMALLE: St Veronica, c.1440. Panel, 151 x 61cm. Städelsches Kunstinstitut, Frankfurt (Arthothek, Munich).

176. HUGO VAN DER GOES: The Portinari Triptych, c.1475. Panel, centre 253 x 304cm, wings 252.7 x 141cm. Galleria degli Uffizi, Florence. (Scala).

177. HIERONYMUS BOSCH: The Garden of Earthly Delights, before 1516. Panel, centre 220 x 195cm, wings 219.7 x 96.6cm each. © Museo del Prado, Madrid. All rights reserved. (Bridgeman).

178. ANONYMOUS ARTIST: The Avignon Pietà, second half of 15th century. Panel, 163 x 218cm. Musée du Louvre, Paris. (© Réunion des Musées Nationaux, Paris).

179. MARTIN SCHONGAUER: Virgin and Child in a Rose Garden, 1473. Panel, 200 x 115cm. Church of St Martin, Colmar. Exhibited in the Dominican Church, Colmar. (Bridgeman).

180. ALBRECHT DÜRER: The Knight, Death and the Devil, 1513. Engraving, 24 x 19cm. Reproduced by Courtesy of the Trustees of the British Museum.

181. ALBRECHT DÜRER: The Virgin of the Rose-Garlands, 1506. Oil on panel, 162 x 194cm. Národní Galerie, Prague. (Scala).

182. JAN GOSSAERT, called 'MABUSE': Neptune and Amphitrite 1516. Panel, 188 x 124cm. Staatliche Museen Berlin, Germany. Gemaaldegaleie.

183. JEAN FOUQUET: Two leaves from the 'Chevalier Hours', c.1455. 16 x 12cm each. Musée Condé, Chantilly. (Lauros-Giraudon).

184. LUKAS CRANACH THE ELDER: Martin Luther in his Youth, c.1524. Oil and tempera on parchment fixed on panel, 43.4 x 29.5cm. Germanisches Nationalmuseum, Nuremberg. (Scala).

185. ALBRECHT ALTDORFER: Alexander's Victory over Darius, 1529. Panel, 158 x 120cm. Alte Pinakothek, Munich. (Arthotek).

186. MATTHIAS GRÜNEWALD: Isenheim Altarpiece (closed), c.1510–15. Musée d'Unterlinden, Colmar. (Scala).

187. MATTHIAS GRÜNEWALD: Isenheim Altarpiece (open). Panel, each wing 269.2 x 142.2cm. central scene 269.2 x 341.6cm. (Scala).

188. VEIT STOSS: Annunciation of the Rosary, 1517–18. Ht of Virgin 218cm. St Lorenz Church, Nuremberg. (Hirmer).

189. PIETER BRUEGEL: The Hunters in the Snow, December and January from a series of the Seasons, 1565. Oil on panel, 117 x 162cm. Kunsthistorisches Museum, Vienna. (Bridgeman).

CHAPTER 7

190. MICHELANGELO: Moses from the Tomb of Pope Julius II, 1513–16. Marble, ht 233.7cm. S. Pietro in Vincoli, Rome. (Scala).

191. Interior of the Sistine Chapel, Vatican. (Scala).

192. RAPHAEL: The Transfiguration, 1517–20. Panel, 4.6 x 2.8m. Vatican Museums, Rome. (Scala).

193. DONATO BRAMANTE: The Tempietto, 1502. St. Pietro in Montorio, Rome (Scala).

194. LEONARDO DA VINCI: Adoration of the Magi. Begun 1481. Oil and bister on panel, 243.8 x 246.4cm. Galleria degli Uffizi, Florence. (Scala).

195. LEONARDO DA VINCI: Project for a Church, c.1490. Pen drawing. Manuscript B. Institut de France, Paris. (Scala).

196. LEONARDO DA VINCI: The Last Supper, c.1495–8. Mural painting, 4.6 x 8.56m. S. Maria delle Grazie, Milan. (Scala).

197. MICHELANGELO: David, 1501–4. Marble, ht 5.5m. Galleria dell'Accademia, Florence. (Scala).

198. MICHELANGELO: St Matthew. Begun 1505. Unfinished. Marble, ht 271cm. Galleria dell'Accademia, Florence. (Scala).

199. Reconstruction of Michelangelo's 1505 design for the Tomb of Pope Julius II (after C. L. Frommel).

200. CARADOSSO: Foundation medal for the new St Peter's, 1505. Reproduced by Courtesy of the Trustees of the British Museum.

201. MICHELANGELO: Sistine Chapel ceiling, 1508–12. Fresco. Vatican, Rome. (Scala).

202. MICHELANGELO: Sistine Chapel ceiling (detail): The Creation of Adam. (Scala).

203. MICHELANGELO: Sistine Chapel ceiling. Lunette figures before restoration. Vatican, Rome. (Vatican Museums).

204. MICHELANGELO: Sistine Chapel ceiling. Lunette figures after restoration. Vatican, Rome. (Vatican Museums).

205. RAPHAEL: Madonna of the Meadow, 1505. Oil on panel, 113 x 87cm. Kunsthistorisches Museum, Vienna.

206. DONATO BRAMANTE: Belvedere courtyard in an engraving by

Cartaro. Begun 1505. Vatican, Rome. Engraving in the Lafreri collection, Avery Architectural and Fine Arts Library, Columbia University in the City of New York.

207. RAPHAEL: Disputa or Debate on the Holy Sacarament, 1509. Fresco, 7.69m at base. Stanza della Segnatura, Vatican, Rome. (Bridgeman).

208. RAPHAEL: Stanza della Segnatura, 1509–11, with The School of Athens, 1510–11. Vatican, Rome. (Scala).

209. RAPHAEL: Galatea, c.1513. Fresco, 280.4 x 223.5cm. Villa Farnesina, Rome. (Scala).

210. RAPHAEL: Baldassare Castiglione, c.1515. Oil on canvas, 82 x 67cm. Musée du Louvre, Paris. (© Réunion des Musées Nationaux, Paris).

211. MICHELANGELO: Capitoline Hill, Rome. Begun 1538. Engraved by Dupérac in 1569. (By permission of the British Library, London).

212. MICHELANGELO: The Last Judgement, 1536–41. Fresco, 14.6 x 13.4m. Sistine Chapel, Vatican, Rome. (Scala).

213. MICHELANGELO: St Peter's from the west. Michelangelo's work begun 1546. Vatican, Rome. (Scala).

214. MICHELANGELO: Rondanini Pietà, 1554–64. Marble, ht 196cm. Castello Sforzesco, Milan. (Scala).

CHAPTER 8

215. JACOPO SANSOVINO: Bronze statue of Apollo from the Loggetta, Venice. 1545. Ht 149cm. (Alinari).

216. TITIAN: Assumption of the Virgin, 1516–18. Oil on panel, 6.9 x 3.6m. S. Maria Gloriosa dei Frari, Venice. (Scala).

217. The Piazzetta, Venice. (Scala).

218. JACOPO SANSOVINO: Statues of Mars and Neptune atop the Scala dei Giganti, Doge's Palace, Venice, 1550. (Scala).

219. JACOPO SANSOVINO: The Loggetta, Venice, 1537. Rebuilt 1902. (A.F. Kersting).

220. GIORGIONE: The Tempest, 1503/4. Oil on canvas, 82.5 x 73cm. Gallerie dell'Accademia, Venice. (Scala).

221. GIORGIONE: Concert champêtre, c.1508. Oil on canvas, 109.2 x 137.2cm. Musée du Louvre, Paris. (© Réunion des Musées Nationaux).

222. GIORGIONE: Sleeping Venus, 1507–8. Oil on canvas, 107.9 x 172.7cm. Staatliche Kunstsammlung, Dresden, Gemaaldegalerie.

223. TITIAN: Venus of Urbino, 1538. Canvas, 119.4 x 165.1cm. Galleria degli Uffizi, Florence. (Scala).

224. TITIAN: Venus and the Lute-Player, c.1560. Oil on canvas, 151.8 x 186.7cm. Fitzwilliam Museum, Cambridge.

225. TITIAN: Pietà. Unfinished in 1576. Oil on canvas, 350 x 395cm. Gallerie dell'Accademia, Venice. (Scala).

226. GIOVANNI BELLINI: S. Giobbe Altarpiece, c.1480. Oil on panel, 467 x 254cm. Gallerie dell'Accademia, Venice. (Scala).

227. JACOPO TINTORETTO: Crucifixion, 1565. Oil on canvas, 5.36 x 12.3m. Sala dell'Albergo, Scuola di San Rocco, Venice. (Scala).

228. TITIAN: Madonna of the Pesaro Family, 1519–1526. Oil on canvas, 485.1 x 269.2cm. S. Maria Gloriosa dei Frari, Venice. (Scala).

229. JACOPO TINTORETTO: Last Supper, 1592–4. Oil on canvas, 365.8 x 569cm. S. Giorgio Maggiore, Venice. (Scala).

230. ANDREA PALLADIO: Church of S. Giorgio Maggiore, Venice. Begun 1565. (Scala).

231. Church of S. Giorgio Maggiore, nave interior. (Scala).

232. ANDREA PALLADIO: Villa Barbaro, c.1560. Maser, Italy. (Scala).

233. Villa Barbaro. Plan and elevation from book 2 of Palladio's 'I quatro libri dell'architettura' (Four Books of Architecture), 1570. (By permission of the British Library, London).

234. PAOLO VERONESE: Frescoes in the dome of the Sala dell'Olimpo, 1560–1. Villa Barbaro, Maser. (Scala).

235. PAOLO VERONESE: Feast in the House of Levi. Completed 1573. Oil on canvas, 5.56 x 12.8m. Gallerie dell'Accademia, Venice. (Scala).

236. PAOLO VERONESE: Apotheosis of Venice, c.1585. Oil on canvas, 904 x 580cm. Sala del Maggior Consiglio, Doge's Palace, Venice. (Scala).

237. Sala del Maggior Consiglio, Doge's Palace, Venice, 14th century, with TINTORETTO'S Paradise, 1588–92. Oil on canvas, 7.01 x 21.95m. (Scala).

CHAPTER 9

238. GIANLORENZO BERNINI: Sangue di Cristo (Blood of Christ). Engraved by Francesco Spierre, 1671. Frontispiece to Francesco Marchese, 'Unica speranza del peccatore', 1671. (Photo: Warburg Institute, London).

239. ANNIBALE CARRACCI: Vault of the Galleria Farnese, 1597–1601. Ceiling frescoes. Palazzo Farnese, Rome. (Scala).

240. GIANLORENZO BERNINI: The Baldacchino and the Cathedra Petri, 1624–33. Gilded bronze, ht 30.5m. St Peter's, Vatican, Rome. (Scala).

241. GIANLORENZO BERNINI: Fountain of the Four Rivers, 1648–51.

Granite, marble and travertine. Piazza Navona, Rome. (Scala).

242. GIANLORENZO BERNINI: First Project for the East Façade of the Louvre, 1664. Pen and ink. Cabinet des Dessins, Musée du Louvre, Paris. (Giraudon).

243. J.L. VON HILDEBRANDT: Upper Belvedere, Vienna, 1714–1722. (Austrian National Tourist Office, Photo: Mr Markowitsch).

244. FRANCESCO BORROMINI: S. Ivo della Sapienza, Rome. 1644–1655. (Alinari).

245. FEDERICO BAROCCI: The Visitation, c.1583–6. Oil on canvas, 300 x 205cm. Pozzomiglio Chapel, S. Maria in Vallicella (Chiesa Nuova), Rome. (Scala).

246. J.B. FISCHER VON ERLACH: The Karlskirche, Vienna, 1716–38. (Austrian National Tourist Office, Photo: Mr Markowitsch).

247. GIANLORENZO BERNINI: The Ecstasy of St Teresa, 1645–52. Marble, ht 3.5m (statue lifesize). (Scala).

248. FEDERICO BAROCCI: Madonna del Popolo, 1575–9. Oil on panel, 359 x 252cm. Galleria degli Uffizi, Florence. (Scala).

249. FEDERICO BAROCCI: Compositional Study for the Madonna del Popolo, c.1575. Black chalk and red chalk, pen and ink, 54.9 x 38.2cm. (Christie's, London. Photo: A.C. Cooper).

250. MICHELANGELO MERISI DA CARAVAGGIO: The Seven Acts of Mercy, 1606. Oil on canvas, 390 x 260cm. Pio Monte della Misericordia, Naples. (Scala).

251. MICHELANGELO MERISI DA CARAVAGGIO: The Flagellation of Christ, 1607 or 1610. Oil on canvas, 286 x 213cm. Museo Nazionale di Capodimonte, Naples. (Scala).

252. MICHELANGELO MERISI DA CARAVAGGIO: Madonna di Loreto, 1603–05. Oil on canvas, 260 x 150cm. Cavalletti Chapel, S. Agostino, Rome. (Scala).

253. ANNIBALE CARRACCI: Study of a male nude for the figure of Mercury in the Galleria Farnese, c.1597. Black chalk heightened with white. Musée des Beaux-Arts, Besançon. (Photo: Charles Choffet).

254. DOMENICHINO: St Cecilia distributing Alms to the Poor, 1613–14. Fresco, 340 x 340cm. Polet Chapel, S. Luigi dei Francesi, Rome. (Scala).

255. RAPHAEL: The Fire in the Borgo, c.1515. Fresco, 542cm at base. Stanza dell'Incendio, Vatican, Rome. (Scala).

256. GIANLORENZO BERNINI: Apollo and Daphne, 1622–5. Marble, life-size. Galleria Borghese, Rome. (Scala).

257. CARLO MARATTA: An Allegory of Annibale Carracci Raising up Painting, second half of 17th century. Red chalk and wash heightened with white. Cabinet des Dessins, Musée du Louvre, Paris. (© Réunion des Musées Nationaux).

258. PIETRO BERRETINI DA CORTONA: Glorification of the Reign of Urban VIII, 1633–9. Fresco. Gran Salone, Palazzo Barberini, Rome. (Scala).

259. NICOLAS POUSSIN: The Ecstasy of St Paul. Completed 1650. Oil on canvas, 148 x 120cm. Musée du Louvre, Paris. (© Réunion des Musées Nationaux).

260. NICOLAS POUSSIN: The Israelites Gathering the Manna, doc. 1639. Oil on canvas, 144 x 200cm. Musée du Louvre, Paris. (Scala).

261. PIER FRANCESCO MOLA: The Improverished Artist, before 1666. Red chalk, 28.9 x 19.4cm. The Pierpoint Morgan Library, New York (no.1965.8).

CHAPTER 10

262. DIEGO DE VELÁZQUEZ: Equestrian Portrait of Baltasar Carlos, c.1635. Oil on canvas, 208.9 x 173cm. © Museo del Prado, Madrid. All rights reserved. (Scala).

263. PETER PAUL RUBENS: Marie de' Medici as the Victor of Jülich, 1622–5. Oil on canvas, 394.7 x 295cm. Musée du Louvre, Paris. (Lauros-Giraudon).

264. The United Provinces, 1648.

265. GERARD TER BORCH: The Swearing of the Oath of Ratification of the Treaty of Münster, 1648. Oil on copper, 45.4 x 58.4cm. Reproduced by courtesy of the Trustees of The National Gallery, London.

266. GERARD TER BORCH and GERRIT VAN DER HORST (?): The Arrival of Adriaen Pauw at Münster, c.1646. Oil on canvas, 98.5 x 159cm. Westfälisches Landesmuseum, Münster.

267. GOVERT FLINCK: Marcus Curius Dentatus Refusing the Gifts of the Samnite Ambassadors, 1656. Oil on canvas, 485 x 377cm. Koninklijk Paleis, Amsterdam (Photo: Tom Haartsen).

268. SAINT-MARCEL WORKSHOP, PARIS, after PETER PAUL RUBENS: The Baptism of Constantine, 1622–5. Tapestry with gold and silk thread, 477.5 x 545.5cm. Philadelphia Museum of Art. Given by the Samuel H. Kress Foundation.

269. REMBRANDT VAN RIJN: Equestrian Portrait of Frederik Rihel, 1663. Oil on canvas, 287 x 238.7cm. Reproduced by courtesy of the Trustees of The

National Gallery, London.

270. SALOMON SAVERY after SIMON DE VLIEGER: Waterborne Entertainments for the Reception of Marie de' Medici in Amsterdam, 1638. Engraving from C. Barlaeus: 'Midicea Hospes sive Descriptio Publicae Gratulationis', Amsterdam, 1638. (Photo: Gemeentearchief, Amsterdam).

271. Arrival of Cardinal Infante Ferdinand at city gate at Antwerp. Extra engraving included in some copies of C. Gevartius: 'Pompa Introitus ...Ferdinandi', 1641 (Photo: Warburg Institute, London).

272. BALTHASAR FLORISZ: Map of Amsterdam, 1625. Detail of the Dam. Gemeentearchief, Amsterdam.

273. BALTHASAR FLORISZ: Map of Amsterdam, 1628. Detail of the Dam. Gemeentearchief, Amsterdam.

274. REMBRANDT VAN RIJN: Members of The Musketeers' Militia Company of the Second Precinct, Amsterdam (The Nightwatch), 1642. Oil on canvas, 363 x 437cm. City of Amsterdam on loan to the Rijksmuseum, Amsterdam.

275. GERRIT LUNDENS (?): Members of The Musketeers' Militia Company of the Second Precinct, Amsterdam, c.1642. Oil on panel, top and left edges irregular, 66.8–67 x 85.4–85.8cm. National Gallery, London, on loan to the Rijksmuseum, Amsterdam.

276. ROMEYN DE HOOGHE: The Amsterdam Kermis, 1686. Engraving. Atlas van Stolk, Rotterdam.

277. JUAN DE LA CORTE: Equestrian Tournament in the Plaza Mayor, Madrid, 1623. Museo Municipal, Madrid.

278. JUAN MARTÍNEZ MONTAÑÉS: Jesus of the Passion, 1612–19. Polychrome Wood. Church of San Salvador, Seville. (Bridgeman).

279. BARTOLOMÉ ESTEBAN MURILLO: The Immaculate Conception of Santa Maria la Blanca, Seville, 1665. 172 x 298cm. Musée du Louvre, Paris. (© Réunion des Musées Nationaux).

280. PETER PAUL RUBENS: The Miracles of Ignatius Loyola, 1619–20. Oil on canvas, 535 x 395cm. Kunsthistorisches Museum, Vienna.

281. PETER PAUL RUBENS: The Miracles of Francis Xavier, 1619–20. Oil on canvas, 535 x 395cm. Kunsthistorisches Museum, Vienna.

282. JAN VERMEER: Woman with a Balance, c.1662–5. Oil on canvas, 42.5 x 38cm. National Gallery of Art, Washington DC, Widener Collection.

283. PIETER DE HOOCH: Courtyard of a House in Delft, 1658. Oil on canvas, 73.5 x 60.1cm. Reproduced by Courtesy of the Trustees of The National Gallery, London.

284. DAVID BAILLY: Vanitas with a Young Painter, 1651. Oil on panel, 89.5 x 122cm. Stedelijk Museum de Lakenhal, Leiden.

285. JUAN DE VALDÉS LEAL: Allegory of Vanity, 1660. Oil on canvas, 130.7 x 99.4cm. Wadsworth Atheneum, Hartford, Connecticut. The Ella Gallup Sumner and Mary Catlin Sumner Collection.

286. DIEGO DE VELÁZQUEZ: The Infanta Margarita with Members of the Royal Household, including the Artist, (Las Meninas), detail of mirror.

287. DIEGO DE VELÁZQUEZ: The Infanta Margarita with Members of the Royal Household, including the Artist, (Las Meninas), 1656. Canvas, 321 x 281cm. Museo del Prado, Madrid (Scala).

CHAPTER 11

288. CHARLES DOMENIQUE EISEN: Frontispiece to 1755 edition of the 'Essai sur l'architecture' (Essay on Architecture) by Marc-Antoine Laugier. (Photo: Bodleian Library, Oxford: 8vo.Sigma 304).

289. ROBERT ADAM: Syon House, Middlesex, 1762. The entrance hall. (Photo: English Life, Derby).

290. LOUIS LE VAU and JULES HARDOUIN-MANSART: Palace of Versailles, 1669–85. Aerial view (Photo: Aerofilms Ltd, London).

291. FRANÇOIS MANSART: Château de Maisons, 1642–6. (Giraudon).

292. CLAUDE PERRAULT, LOUIS LE VAU and CHARLES LEBRUN: East façade of the Louvre, Paris. 1667–70. (Photo: James Austin).

293. JACQUES-GERMAIN SOUFFLOT: Ste-Geneviève (now known as the Panthéon), Paris, 1755–92, interior. (Photo: A.F. Kersting).

294. GIAMBATTISTA PIRANESI: Engraving of the Temple of Neptune at Paestum from Piranesi's 'Vues de Pestum', 1778. (By permission of the British Library, London).

295. MARIE-JOSEPH PEYRE: Design for entrance screen, Hôtel de Condé, Paris, 1763. Published in his 'Works of Architecture', 1765. (Courtesy of the Trustees of the Sir John Soane Museum, London. Photo: Godfrey New).

296. NICOLAS POUSSIN: The Funeral of Phocian, documented 1648. Oil on canvas, 114 x 175cm. National Museum of Wales, Cardiff. On loan from the Earl of Plymouth. (Scala).

297. THOMAS GAINSBOROUGH: Mr and Mrs Robert Andrews, c.1749. Oil on canvas, 69.8 x 119.4cm. Reproduced by courtesy of the Trustees of The National Gallery, London.

298. CLAUDE LORRAIN: View of Delos with Aeneas, 1672. Oil on canvas, approx. 99.7 x 134cm. Reproduced by courtesy of the Trustees of The National Gallery, London.

299. GEORGE STUBBS: Mares and Foals, 1762. Oil on canvas, 101.6 x 190.5cm. Collection of Earl Fitzwilliam, Wentworth Woodhouse. (Bridgeman).

300. ARTHUR DEVIS: John Orde and his Second Wife watching William Orde's return from shooting, c.1750–55. Oil on canvas, 94 x 96.2cm. Paul Mellon Collection, Upperville, Virginia.

301. ROBERT ADAM: Syon House, 1760–9. The vestibule. (English Life).

302. Syon House. The dining-room seen from the vestibule. (English Life).

303. Syon House. The red drawing room. (English Life).

304. Syon House. The gallery. (English Life).

305. LORD BURLINGTON: Chiswick House, c.1725. Hammersmith, London. (Bridgeman/John Bethell).

306. WILLIAM KENT: Holkham Hall, Norfolk, 1734. The entrance hall. (Photo: Geoff Dunlop, London).

307. ROBERT ADAM: View of the third drawing room, Derby House, 26 Grosvenor Square, London, 1773–4. From the 'Works in Architecture of Robert and James Adam' v.3, 1822. (By permission of the British Library, London).

308. HENRY FLITCROFT: Stourhead Gardens, Wiltshire. Laid out in 1743. View towards the Pantheon, completed in 1756. (Photo: Geoff Dunlop).

309. ETIENNE-LOUIS BOULLÉE: Design for a Monument to Newton, 1784. Ink and wash on paper, 39.3 x 65cm. Bibliothèque Nationale, Paris.

310. JACQUES-LOUIS DAVID: The Oath of the Horatii, 1781. Pen and wash drawing. Graphische Sammlung Albertina, Vienna.

311. NICOLAS POUSSIN: The Rape of the Sabine Women, c.1635. Oil on canvas, 159 x 206cm. Musée du Louvre, Paris. (© Réunion des Musées Nationaux).

312. JACQUES-LOUIS DAVID: The Oath of the Horatii, 1784. Oil on canvas, 427 x 330cm. Musée du Louvre, Paris. (© Réunion des Musées Nationaux).

313. JACQUES-LOUIS DAVID: The Oath of the Horatii, 1782. Sketch. Ecole des Beaux-Arts, Paris.

314. ANTOINE WATTEAU: Pilgrimage on the Island of Cythera, 1717. Oil on canvas, 129.5 x 194.3cm. Musée du Louvre, Paris. (© Réunion des Musées Nationaux).

315. JEAN-BAPTISTE GREUZE: The Village Bride, 1761. Oil on canvas, 91.4 x 118.1cm. Musée du Louvre, Paris. (© Réunion des Musées Nationaux).

316. ANTONIO CANOVA: Monument to Pope Clement XIV, 1783–7. Marble, 740 x 590 x 295cm. SS Apostoli, Rome. (Anderson-Giraudon).

317. JACQUES-LOUIS DAVID: The Death of Marat, 1793. Oil on canvas, 165 x 126cm. Musées Royaux des Beaux-Arts, Brussels. (Scala).

CHAPTER 12

318. JEAN-AUGUSTE-DOMINIQUE INGRES: Napoleon on his Imperial Throne, 1806. Oil on canvas, 265.7 x 160cm. Musée de l'Armée, Palais des Invalides, Paris. (Bridgeman).

319. CASPAR DAVID FRIEDRICH: The Wanderer above the Mists, c.1817–18. Oil on canvas, 74.8 x 94.8cm. Kunsthalle, Hamburg. (Bridgeman).

320. JACQUES-LOUIS DAVID: Napoleon at St Bernard, 1800–1. Oil on canvas, 272 x 232cm. Musée National du Château de Malmaison. (Lauros-Giraudon).

321. FRANÇOIS RUDE: The Departure of the Volunteers of 1792, 1833–36. Ht approx. 12.7m. Arc de Triomphe de l'Etoile, Paris. (Lauros-Giraudon).

322. FRANCISCO DE GOYA Y LUCIENTES: The Third of May 1808, 1814. Oil on canvas 260 x 345cm. Museo del Prado, Madrid. (Scala).

323. THÉODORE GÉRICAULT: The Raft of the 'Medusa', 1819. Oil on canvas, 4.91 x 7.16m. Musée du Louvre, Paris. (© Réunion des Musées Nationaux).

324. EUGÈNE DELACROIX: Scenes from the Massacres at Chios, 1824. Oil on canvas, 422 x 352cm. Musée du Louvre, Paris. (Giraudon).

325. JOHN CONSTABLE: The Haywain, 1821. Oil on canvas, 130.2 x 185.4cm. Reproduced by courtesy of the Trustees of The National Gallery, London.

326. JOSEPH MALLORD WILLIAM TURNER: Snowstorm: Hannibal and his Army Crossing the Alps, 1812. Oil on canvas, 146 x 237.5cm. The Tate Gallery, London.

327. PIERRE VIGNON: The Madeleine, Paris. Begun 1807. (Photo: A.F. Kersting).

328. LOUIS FRANÇOIS CASSAS: Reconstruction of the Gallery at

Palmyra, c.1796. Engraving. Archives of the History of Art, Getty Center for the History of Art and the Humanities, Los Angeles.
329. HUBERT ROBERT: Imaginary View of the Grande Galerie in Ruins, 1796. Musée du Louvre, Paris. (Scala).
330. CHARLES PERCIER and PIERRE FONTAINE: Napoleon's study at Malmaison, 1800. (Scala).
331. JEAN-AUGUSTE-DOMINIQUE INGRES: La Grande Odalisque, 1814. Oil on canvas, 90.2 x 161.9cm. Musée du Louvre, Paris. (© Réunion des Musées Nationaux).
332. EUGÈNE DELACROIX: Women of Algiers, 1834. Oil on canvas, 179.8 x 228.9cm. Musée du Louvre, Paris. (© Réunion des Musées Nationaux).
333. SIR JOHN SOANE: The Stock Office of the Bank of England, 1792. Perspective view. Courtesy of the Trustees of the Sir John Soane Museum, London. (Geremy Butler Photography).
334. AUGUSTUS WELBY NORTHMORE PUGIN: St Augustine's, Ramsgate, 1843–50. (Photo: Royal Commission on the Historical Monuments of England).
335. THÉODORE GÉRICAULT: Kleptomaniac, c.1822–3. Oil on canvas. 60 x 50cm. Musée des Beaux-Arts, Ghent. (Scala).
336. JULES JOLLIVET: Adam and Eve, 1860. Panels from the façade of St Vincent-de-Paul, Paris. Now in the Dépôt des oeuvres d'art de la Ville de Paris, Ivry sur Seine. (Photo: Ville de Paris, SOAE, Michot et Loty).
337. JULES L. VAUZELLE: The Thirteenth-century Room, Musée des Monuments Français, c.1815. Cabinet des Dessins, Musée du Louvre, Paris. (© Réunion des Musées Nationaux).
338. FÉLIX JACQUES DUBAN: Ecole des Beaux-Arts, Paris, 1832–58. (Giraudon).
339. PIERRE-FRANÇOIS-HENRI LABROUSTE: Bibliothèque Ste-Geneviève, Paris, 1844–50. Interior of the library. (Photo: James Austin).
340. EUGÈNE DELACROIX: The 28th July: Liberty Leading the People, 1830. Oil on canvas, 259 x 325cm. Musée du Louvre, Paris. (Giraudon).

CHAPTER 13
341. JEAN-BAPTISTE CARPEAUX: The Dance, 1869. Plaster, ht 24cm. Musée d'Orsay, Paris. (Lauros-Giraudon).
342. PIERRE-AUGUSTE RENOIR: La Loge (The Theatre Box), 1874. Oil on canvas, 81 x 65cm. Courtauld Institute Galleries, London. Courtauld Collection (reproduced by permission of the Home House Trustees).
343. The installation of the 1861 Salon, Paris. (Photo: Courtauld Institute, London).
344. GUSTAVE COURBET: A Burial at Ornans, 1849–50. Oil on canvas, 314 x 663cm. Musée d'Orsay, Paris. (Giraudon).
345. GUSTAVE COURBET: A Burial at Ornans (detail).
346. THOMAS COUTURE: The Romans of the Decadence, 1847. Oil on canvas. 466 x 775cm. Musée d'Orsay, Paris. © R.M.N.
347. GUSTAVE COURBET: The Artist's Studio, 1855. Oil on canvas, 361 x 598cm. Musée d'Orsay, Paris. (Giraudon).
348. GUSTAVE COURBET: The Bathers, 1853. Oil on canvas, 227 x 193cm. Musée Fabre, Montpellier. (Photo: Frederic Jaulmes, Montpellier).
349. GUSTAVE COURBET: The Source of the Loue, c.1865. Oil on canvas, 98.4 x 130.4cm. National Gallery of Art, Washington DC. Gift of Charles L. Lindemann.
350. JEAN FRANÇOIS MILLET: Peasant Grafting a Tree, 1855. Oil on canvas, 81 x 100cm. Besitzer Bayer-Staatsgemaldesammlung, Neue Pinakothek, Munich.
351. CHARLES GARNIER: Opéra, 1861–74. Paris. (Photo: A.F. Kersting).
352. EDOUARD MANET: Le déjeuner sur l'herbe (Luncheon on the Grass), 1863. Oil on canvas, 214 x 270cm. Musée d'Orsay, Paris. (Bridgeman).
353. ALEXANDRE CABANEL: The Birth of Venus, 1863. Oil on canvas, 132 x 228.6cm. Musée d'Orsay, Paris. (Bridgeman).
354. EDOUARD MANET: Olympia, 1863. Oil on canvas, 130 x 190cm. Musée d'Orsay, Paris. (Lauros-Giraudon).
355. EDOUARD MANET: Music in the Tuileries Gardens, 1862. Oil on canvas, 73 x 116cm. Reproduced by courtesy of the Trustees of The National Gallery, London. (Bridgeman).
356. PAUL CÉZANNE: The Hanged Man's House, 1872–3. Oil on canvas, 54.6 x 66cm. Musée d'Orsay, Paris. (Lauros-Giraudon).
357. CLAUDE MONET: Impression, Sunrise, 1872. Oil on canvas, 49.5 x 64.8cm. Musée Marmottan, Paris. (Photo: Jean-Michel Routhier).
358. CLAUDE MONET: The Promenade at Argenteuil, c.1872. Oil on canvas, 50.4 x 65.2cm. National Gallery of Art, Washington DC. Ailsa Mellon Bruce Collection.
359. CAMILLE PISSARRO: View of Louveciennes, 1870. Oil on canvas, 52.7 x 81.9cm. Reproduced by courtesy of the Trustees of The National Gallery, London.

360. PIERRE-AUGUSTE RENOIR: Luncheon of the Boating Party, 1881. Oil on canvas, 130 x 173cm. The Phillips Collection, Washington DC.
361. EDOUARD MANET: A Bar at the Folies-Bergère, 1881–2. Oil on canvas, 95.2 x 129.5cm. Courtauld Institute Galleries, London. Courtauld Collection.
362. EDGAR DEGAS: Ballet Rehearsal on the Stage, 1874. Oil on canvas, 65 x 81cm. Musée d'Orsay, Paris. (Bridgeman).
363. CLAUDE MONET: The Manneporte, Etretat, (I), 1883. Oil on canvas, 65.4 x 81.2cm. The Metropolitan Museum of Art, Boston. Bequest of William Church Osborne, 1951.
364. CAMILLE PISSARRO: Apple-Picking at Eragny, 1888. Oil on canvas, 60 x 73cm. Dallas Museum of Fine Art, Texas. (Bridgeman).
365. CLAUDE MONET: Haystack at Sunset near Giverny, 1991. Oil on canvas, 74.9 x 94cm. Juliana Cheney Edwards Collection. Bequest of Robert J. Edwards in memory of his mother. Courtesy of the Museum of Fine Arts, Boston.
366. CLAUDE MONET: Water Lilies (I), 1905–8. Oil on canvas, 89.5 x 99.7cm. Gift of Edward Jackson Holmes. Courtesy of the Museum of Fine Arts, Boston.

CHAPTER 14
367. AUGUSTE RODIN: Balzac, 1893–7. Plaster, 300 x 120 x 120cm. Musée d'Orsay, Paris. (Giraudon).
368. PAUL CÉZANNE: Woman with Coffee Pot, 1890–5. Oil on canvas, 130.5 x 96.5cm. Musée d'Orsay, Paris. (© Réunion des Musées Nationaux).
369. HENRI DE TOULOUSE-LAUTREC: At the Moulin Rouge, 1892. Oil on canvas, 123.0 x 141.0cm. Helen Birch Bartlett Memorial Collection, 1928.610. © 1988 The Art Institute of Chicago. All Rights Reserved.
370. GEORGES SEURAT: Le Chahut, 1889–90. Oil on canvas, 171.5 x 140.5cm. Collection: Statemuseum Kröller-Müller, Otterlo, The Netherlands. (Photo: Tom Haartsen).
371. EMILE BERNARD: Bridge at Asnières, 1887. Oil on canvas, 45.9 x 54.2cm. Collection of the Museum of Modern Art, New York. Grace Rainey Rogers Fund. © DACS 1989.
372. GEORGES SEURAT: Sunday Afternoon on the Island of La Grande Jatte, 1884–6. Oil on canvas, 207.6 x 308.0cm. Helen Birch Bartlett Memorial Collection, 1926.224. © 1988 The Art Institute of Chicago.
373. LOUIS ANQUETIN: La Place Clichy, 1887. Oil on canvas, 69.2 x 53.3cm. Wadsworth Atheneum, Hartford, Connecticut. The Ella Gallup Sumner and Mary Catlin Sumner Collection.
374. PAUL SIGNAC: The Road to Gennevilliers, 1883. Oil on canvas, 72.9 x 91.6cm. Musée d'Orsay, Paris (© R.M.N./SPADEM).
375. PAUL SIGNAC: Gas Tanks at Clichy, 1886. Oil on canvas, 65 x 81cm. Reproduced by permission of the National Gallery of Victoria, Melbourne. Felton Bequest 1948.
376. VINCENT VAN GOGH: Paris with Horse-Tram (View Outside the Fortifications), 1887. Watercolour, pen and pencil on watercolour paper, 24 x 31.5cm. Vincent van Gogh Foundation/National Museum Vincent van Gogh, Amsterdam.
377. GUSTAVE CAILLEBOTTE: Paris, A Rainy Day, 1876–7. Oil on canvas, 212.2 x 276.2cm. Charles H. and Mary F.S. Worcester Collection, 1964.336. © 1988 The Art Institute of Chicago. All Rights Reserved.
378. GEORGES SEURAT: La Luzerne, 1885–6. Oil on canvas, 65 x 81cm. National Gallery of Scotland, Edinburgh.
379. PAUL GAUGUIN: Among the Mangoes: Martinique, 1887. Oil on canvas, 89 x 116cm. Vincent van Gogh Foundation/National Museum Vincent van Gogh, Amsterdam.
380. EMILE BERNARD: Breton Women in a Meadow, 1888. Oil on canvas, 74 x 92cm. Private Collection. (Giraudon).
381. VINCENT VAN GOGH: Les Alyscamps, 1888. Oil on canvas, 86.4 x 109.2cm. Collection: State Museum Kröller-Müller, Otterlo, The Netherlands. (Photo: Tom Haartsen).
382. VINCENT VAN GOGH: The Crau with Peach Trees in Bloom, 1889. Oil on canvas, 65.5 x 81.5cm. Courtauld Institute Galleries, London. Courtauld Collection.
383. PAUL GAUGUIN: Vision After the Sermon (Jacob and the Angel), 1888. Oil on canvas, 73 x 92cm. National Gallery of Scotland, Edinburgh. (Bridgeman).
384. VINCENT VAN GOGH: The Starry Night, 1889. Oil on canvas, 73.7 x 92.1cm. Collection of the Museum of Modern Art, New York. Acquired through the Lillie P. Bliss Bequest.
385. PAUL CÉZANNE: Mont Ste-Victoire, 1902–6. Pencil and watercolour, 42.5 x 54.3cm. Private Collection (Photo: Malcolm Varon, NYC © 1982).
386. PAUL CÉZANNE: Mont Ste-Victoire, 1885–7. Oil on canvas, 66.6 x 91.7cm. Courtauld Institute Galleries, London. Courtauld Collection.

387. BERTHE MORISOT: Little Girl Reading (La Lecture), 1888. Oil on canvas, 74.3 x 92.7cm. Museum of Fine Arts, St Petersburg, Florida. Given in memory of Margaret Acheson Stuart by her family and friends.
388. MARY CASSATT: The Bath, 1891–2. Oil on canvas, 99.2 x 66.1cm. Robert Waller Fund, 1910.2. © 1988 The Art Institute of Chicago. All Rights Reserved.
389. SUZANNE VALADON: Self-Portrait, 1883. Pastel on paper, 45 x 32cm. Musée National d'Art Moderne, Paris.
390. PAUL GAUGUIN: Manau Tupapau – The Spirit of the Dead Watching, 1892. Oil on burlap mounted on canvas, 73 x 92cm. Albright-Knox Art Gallery, Buffalo, NY. A. Conger Goodyear Collection, 1965.

CHAPTER 15

391. VICTOR HORTA: The Tassel House, 1893. Brussels. View of the staircase. (Photo: Belgian Tourist Office, Brussels).
392. GUSTAV KLIMT: The Beethoven Frieze, 1902. (The Hostile Powers). Plaster panels painted in casein colours worked with charcoal, pencil, and pastel, and decorated with inlaid stucco, gold and semi-precious stones. Overall length, 635cm. Österreichische Galerie, Vienna. (Fotostudio Otto).
393. GUSTAV KLIMT: The Beethoven Frieze, 1902. (The Choir of Heavenly Angels and The Kiss for The Whole World). As above, overall length 510.5 plus 398.8 unpainted plus 469.9cm. Österreichische Galerie, Vienna. (Fotostudio Otto).
394. EGON SCHIELE: The Artist Drawing a Nude in front of a Mirror, 1910. Pencil, 51 x 32.5cm. Graphische Sammlung Albertina, Vienna, inv 26.276.
395. JOSEF MARIA OLBRICH: Haus der Secession, Vienna, 1898 (Austrian National Tourist Office. Photo: Mr Simoner).
396. OSKAR KOKOSCHKA: The Tempest, 1914. Oil on canvas, 181 x 222.6cm. Öffentliche Kunstsammlung, Kunstmuseum, Basel. (Bridgeman). © COSMOPRESS, Geneva, DACS, London 1989.
397. JOSEF HOFFMANN: Purkersdorf Sanatorium, Vienna, 1906. Interior of the hall. (Photo: The Manchester Public Libraries).
398. ERNST LUDWIG KIRCHNER: Four Bathers, 1909. Oil on canvas, 75 x 100.5cm. Von der Heydt Museum, Wuppertal.
399. ANDRÉ DERAIN: The Harbour at Collioure, 1905. Oil on canvas, 72 x 91cm. Musée d'Art Moderne de Troyes. © ADAGP, Paris and DACS, London 1989.
400. HENRI MATISSE: Luxe, Calme et Volupté, 1904–5. Oil on canvas, 86 x 116cm. Musée d'Orsay, Paris. (© Réunion des Musées Nationaux). © Succession H Matisse/DACS 1989.
401. PABLO PICASSO: Les Demoiselles d'Avignon, 1907. Oil on canvas, 244 x 234cm. Collection of the Museum of Modern Art, New York. Acquired through the Lillie P. Bliss Bequest. © DACS 1989.
402. GEORGES BRAQUE: The Mandolin, 1910. Oil on canvas, 72 x 58.1cm. Tate Gallery, London. © ADAGP, Paris and DACS, London 1989.
403. PABLO PICASSO: Seated Nude, 1910. Oil on canvas, 92 x 73cm. Tate Gallery, London. © DACS 1989.
404. ROBERT DELAUNAY: The City of Paris, 1912. Oil on canvas, 266.7 x 406.4cm. Musée National d'Art Moderne, Paris. © ADAGP, Paris and DACS, London 1989.
405. PABLO PICASSO: The Bottle of Suze (detail). © DACS 1989.
406. PABLO PICASSO: The Bottle of Suze, 1913. Paper, newspaper, charcoal and gouache, 65.4 x50.2cm. Washington University Gallery of Art, St Louis. © DACS 1989.
407. UMBERTO BOCCIONI: Unique Forms of Continuity in Space, 1913. Bronze, 114 x 84 x 37cm. Tate Gallery, London.
408. CARLO CARRÀ: Funeral of the Anarchist Galli, 1910–11. Oil on canvas, 198.7 x 259.1cm. Collection of the Museum of Modern Art, New York. Acquired through the Lillie P. Bliss Bequest. © DACS 1989.
409. ERNST LUDWIG KIRCHNER: Berlin Street Scene, 1913. Oil on canvas, 200 x 150cm. Brücke Museum, Berlin.
410. PIET MONDRIAN: Evolution Triptych, 1910–11. Oil on canvas, 178 x 85cm; 183 x 87.5cm; 18 x 35cm. Collection Haags Gemeentemuseum, The Hague. © DACS 1989.
411. PIET MONDRIAN: Oval Composition ('Kub'), 1914. Oil on canvas, 113 x 84.5cm. Collection Haags Gemeentemuseum, The Hague. © DACS 1989.
412. FRANZ MARC: Fates of Animals, 1913. Oil on canvas, 196 x 266cm. Öffentliche Kunstsammlung, Kunstmuseum, Basel. (Photo © Colorphoto Hinz, Allschwil, Basel.
413. HERMANN OBRIST: Tomb for the Oertel Family, 1905. (Photo: Museum Bellerive, Zurich).
414. WASSILY KANDINSKY: Painting with White Border (Moscow), 1913. Oil on canvas, 140.3 x 200.3cm. The Solomon R. Guggenheim

Museum, New York. (Photo: Carmelo Guadagno). © ADAGP, Paris and DACS, London 1989.
415. WASSILY KANDINSKY: Sketch I for Painting with White Border (Moscow), 1913. Oil on burlap canvas, 99.6 x 78.1cm. The Phillips Collection, Washington DC. Bequest of Katherine S. Dreier, 1953. © ADAGP, Paris and DACS, London 1989.
416. WASSILY KANDINSKY: Study for Painting with White Border, 1912/13. Watercolour and indian ink on paper, 30.3 x 24.1cm. Städtische Galerie im Lenbachhaus, Munich. © ADAGP, Paris and DACS, London 1989.

CHAPTER 16

417. HENRY MOORE: Head, 1937. Hopton Wood stone, ht 53.3cm. Private Collection. (Reproduced by kind permission of the Henry Moore Foundation). © Henry Moore Foundation 1989.
418. MAX ERNST: Celebes, 1921. Oil on canvas, 125.4 x 107.9cm. Purchase. Collection of the Tate Gallery, London. © DACS
419. OTTO DIX: Three Women, 1926. Oil on wood. Collection Otto Dix.
420. GEORGE GROSZ: Cross Section, 1920. No.68 in 'Ecce Homo'. Courtesy of the Grosz estate and the Grove Press. © DACS 1989.
421. MAX BECKMAN: The Night, 1918–19. Oil on canvas, 133 x 154cm. Kunstsammlung Nordrhein-Westfalen, Düsseldorf. © DACS 1989.
422. PABLO PICASSO: Two Women Running on a Beach, 1922. Gouache on plywood, 32.5 x 41.1cm. Musée Picasso, Paris. © Réunion des Musées Nationaux DACS 1989.
423. FRANCIS PICABIA: Dada Picture, 1920. Toy monkey and collage on cardboard. Published in 'Canibale', Paris, 25th April, 1920. Whereabouts unknown. (Photo: Courtesy Bibliothèque Littéraire Jacques Doucet by Jean-Loup Charmet, Paris). © ADAGP, Paris and DACS, London 1989.
424. PABLO PICASSO: Guitar, 1919. Oil and sand on canvas, 80 x 44.5cm. Collection: State Museum Kröller-Müller, Otterlo, The Netherlands. © DACS 1989.
425. FERNAND LÉGER: Mechanical Elements, 1927. Oil on canvas, 74 x 60cm. Private Collection. (Bridgeman). © DACS 1989.
426. CONSTANTIN BRANCUSI: Endless Column 1920, 1925, 1928 in Brancusi's studio. Brancusi Archive, Musée National d'Art Moderne, Paris. © ADAGP, Paris and DACS, London 1989.
427. PIET MONDRIAN: Composition in Red, Yellow and Blue, 1921. Oil on canvas, 103 x 100cm. Collection Haags Gemeentemuseum, The Hague. © DACS 1989.
428. LE CORBUSIER: Villa Savoye, Poissy, 1931. Sectional diagram.
429. Villa Savoye. Plan of 1st floor.
430. Villa Savoye. South-west façade. (Photo: Fondation Le Corbusier, Paris). © DACS 1989.
431. Villa Savoye. Living room and terrace (Photo: Fondation Le Corbusier, Paris). © DACS 1989.
432. CONSTANTIN BRANCUSI: Bird in Space, 1925. Marble, stone and wood, ht 344.6cm. National Gallery of Art, Washington DC. Gift of Eugene and Agnes E. Meyer. © ADAGP, Paris and DACS, London 1989.
433. KASEMIR MALEVICH: Suprematist Composition: Aeroplane Flying, 1914. Oil on canvas, 58.1 x 48.3cm. Collection of the Museum of Modern Art, New York. Purchase.
434. ALEXANDER RODCHENKO: Poster for Dziga Vertov's film 'Kino Glaz' (Cinema Eye), 1923. (Photo: Museum of Modern Art, Oxford).
435. GIORGIO DE CHIRICO: The Philosopher's Conquest, 1914. Oil on canvas, 125.1 x 99.1cm. Joseph Winterbotham Collection, 1939.405. © 1988 The Art Institute of Chicago. All Rights Reserved. © DACS 1989.
436. JOAN MIRÓ: Preparatory drawing for The Birth of the World (F.J.M. 703), 1925. Pencil on paper, 26.4 x 19.8cm. Fundació Joan Miró, Barcelona. © ADAGP, Paris and DACS, London 1989.
437. JOAN MIRÓ: Drawing for The Birth of the World, (F.J.M. 701), 1925. Pencil on paper, 26.4 x 19.8cm. Fundació Joan Miró, Barcelona. © ADAGP, Paris and DACS, London 1989.
438. JOAN MIRÓ: The Birth of the World. Montroig, 1925 (summer). Oil on canvas, 250.8 x 200cm. Collection of the Museum of Modern Art, New York. Acquired through an anonymous fund, the Mr and Mrs Joseph Slifka and Armand G. Erpf Funds, and by gift of the artist. © ADAGP, Paris and DACS, London 1989.
439. RENÉ MAGRITTE: The Double Secret, 1927. Oil on canvas, 114 x 162.5cm. Musée National d'Art Moderne, Paris. © ADAGP, Paris and DACS, London 1989.
440. SALVADOR DALÍ: Soft Construction with Boiled Beans: Premonition

of Civil War, 1936. Oil on canvas, 99 x 99cm. Philadelphia Museum of Art. © DEMART PRO ARTE BV and DACS, London 1989.
441. PABLO PICASSO: Guernica, 1937. Canvas, 350.5 x 782.3cm. Museo del Prado, Madrid. (Giraudon). © DACS 1989.
442. DIEGO RIVERA: Man at the Crossroads (detail), 1932–4. Mural, 4.85 x 11.45m. The Palace of Arts, Mexico City (Photo: Desmond Rochford, London).
443. FERNAND LÉGER: Composition with Two Parrots, 1935–9. Oil on canvas, 400 x 430cm. Musée National d'Art Moderne, Paris. © DACS 1989.

CHAPTER 17
444. FRANK STELLA: Die Fahne Hoch! (Flag Up!), 1959. Enamel on canvas, 308.6 x 185.4cm. Private Collection. (Photo: Courtesy Leo Castelli Gallery, New York). © Frank Stella/ARS New York. 1989.
445. WILLEM DE KOONING: Women Singing II (detail), 1966. Oil on paper, 91.4 x 60.0cm. Purchase. Collection of the Tate Gallery, London.
446. JACKSON POLLOCK: Number 1, 1950 (Lavender Mist), 1950. Oil, enamel and aluminium on canvas, 221 x 299.7cm. National Gallery of Art, Washington DC. Ailsa Mellon Bruce Fund. © Pollock/Krasner Foundation/ARS NY, 1989.
447. HANS NAMUTH: Abstraction, 1950. Photograph of Jackson Pollock painting. (Courtesy Hans Namuth).
448. JACKSON POLLOCK: Number 1, 1948, detail.
449. JACKSON POLLOCK: Number 1, 1948, detail.
450. JACKSON POLLOCK: Number 1, 1948, 1948. Oil on canvas, 172.7 x 264.2cm. Collection of the Museum of Modern Art, New York. Purchase. © Pollock/Krasner Foundation/ARS NY, 1989.
451. JACKSON POLLOCK: Moon Woman Cuts the Circle, 1943. Oil on canvas, 106.7 x 101.6cm. Musée National d'Art Moderne, Paris. © Pollock/Krasner Foundation/ARS NY, 1989.
452. JASPER JOHNS: Flag, 1955. Encaustic, oil and collage on canvas, 107.3 x 153.8cm. Collection of the Museum of Modern Art, New York. Gift of Philip Johnson in honour of Alfred H. Barr Jnr. © DACS 1989.
453. ROBERT RAUSCHENBERG: Factum I, 1957. Combine Painting, 147.6 x 85.8cm. The Museum of Contemporary Art, Los Angeles: The Panza Collection. (Photo: Squidds & Nunns). © DACS 1989.
454. RAYMOND HAINS: Torn poster on sheet metal, 1960. 100 x 200cm. Courtesy Galerie Beaubourg, Paris.
455. ARMAND ARMAN: Le Village de Grand-mère (My Grandmother's Village), 1962. Sliced coffee grinders in a red wooden box, 120.6 x 90.2 x 12.7cm. Private Collection. © DACS 1989.
456. ROBERT RAUSCHENBERG: Small Rebus, 1956. Combine painting, 88.9 x 116.8cm. The Museum of Contemporary Art, Los Angeles: The Panza Collection. (Photo: Squidds and Nunns). © DACS 1989.
457. ROBERT RAUSCHENBERG: Small Rebus, detail. © DACS 1989.
458. ROBERT RAUSCHENBERG: Small Rebus, detail. © DACS 1989.
459. YVES KLEIN: Anthropométries de l'époque bleu. Performance at Galerie Internationale d'Art Contemporain, Paris, 9 March, 1960 (Photo: Harry Shunk, NYC).
460. FRANCIS BACON: Two Figures Wrestling, 1953. Oil on canvas, 152.5 x 116.5cm. Private Collection. (Photo: Courtesy Marlborough Fine Art, London and Francis Bacon).
461. DAVID HOCKNEY: Peter Getting out of Nick's Pool, 1966. Acrylic on canvas, 214 x 214cm. National Museums and Galleries on Merseyside, Walker Art Gallery, Liverpool.
462. RICHARD HAMILTON: Just what is it that makes today's homes so different, so appealing ?, 1959. Collage, 26 x 23.5cm. Kunsthalle Tübingen. Collection Professor Dr. Georg Zundel.
463. ANDY WARHOL: Marilyn x 100, 1962. Acrylic and silkscreen on canvas, 205.7 x 567.7cm. Saatchi Collection, London. © The Estate and Foundation of Andy Warhol, 1989. Courtesy ARS NY.
464. ANDY WARHOL: 200 Soup Cans, 1962. Acrylic and silkscreen on canvas, 182.9 x 254cm. Courtesy Leo Castelli Gallery, New York. © The Estate and Foundation of Andy Warhol, 1989. Courtesy ARS NY.
465. ANDY WARHOL: Red Race Riot, 1963. Acrylic and silkscreen on linen, 350.5 x 210.8cm. Museen der Stadt, Cologne. Museum Ludwig. © The Estate and Foundation of Andy Warhol, 1989. Courtesy ARS NY.
466. ROBERT MORRIS: (Untitled) L-Beams, 1965. Painted plywood, 243.8 x 243.8 x 60.96cm. Courtesy Leo Castelli Gallery, New York. (Photo: Rudolph Burckhardt). © DACS 1989.
467. FRANK STELLA: Luis Miguel Dominguin (first version), 1960. Aluminium paint on canvas, 237.5 x 181.6cm. Private Collection, Switzerland. (Courtesy Knoedler Gallery, New York. Photo: Borel-Boissonnas, Geneva). © Frank Stella/ARS NY, 1989.

468. ROBERT MORRIS: (Untitled) Sectional Fibreglass Pieces, 1967. Six pieces: 119.65 x 215.9 x 119.65cm (x 4); 118.38 x 121.92 x 119.65cm (x 2). (Photo: Courtesy Leo Castelli Gallery, New York). © DACS 1989.
469. ROBERT SMITHSON: Spiral Jetty, 1970. Great Salt Lake, Utah. Total length 457.2m, width of jetty 4.572m. (Photo: Gianfranco Gorgoni, NYC).
470. MAYA YING LIN: Vietnam Memorial, 1982. Washington DC. Black granite. (National Park Service. Photo: W.M. Clark).

CHAPTER 18
471. ROBERT SMITHSON: Non-site, Mica from Portland, Connecticut, 1968. Courtesy John Weber Gallery, New York.
472. MICHAEL GRAVES: The Portland Building, 1980. Portland Oregon. View from Fifth Avenue. (Courtesy Michael Graves, Princeton NJ. Photo: Paschall/Taylor).
473. MARCEL BROODTHAERS: Museum, enfants non admis (Museum, Children not Admitted), 1968. Pressed plastic plaque, 84.5 x 121cm. Wide White Space Gallery, Antwerp. (Photo: Maria Gilissen-Broodthaers).
474. MARCEL BROODTHAERS: Musée d'Art Moderne, Département des Aigles, Section des Figures (Museum of Modern Art, Figure section, Department of Eagles), 1972. Installation at the Städtische Kunsthalle, Düsseldorf. (Photo: Maria Gilissen-Broodthaers).
475. DANIEL BUREN: Within and Beyond the Frame, October/November 1973. Installation at Leo Castelli Gallery, New York. (Photo: Courtesy John Weber Gallery, New York).
476. CHRISTO: Running Fence, Sonoma and Marin Counties, State of California, 1972–6. Industrial nylon, 18ft (5.486m) x 24½ miles (39.2km). (Photo: Jeanne-Claude Christo. © Christo/CVJ Corp 1976).
477. RICHARD LONG: A Circle in Ireland, 1975. (Photo: Richard Long).
478. HANS HAACKE: Manet: Projekt '74, 1974. Installation at the Wallraf-Richartz Museum, Cologne. (Photo: Courtesy John Weber Gallery, New York).
479. JOSEPH BEUYS: Plight, 1958–85. Environmental sculpture with felt, piano, blackboard and thermometer. Anthony d'Offay Gallery, London. (Photo: J. Littkemann, Berlin). © DACS 1989.
480. ANSELM KIEFER: Meistersinger, 1982. Oil and straw on canvas, 280 x 380cm. Saatchi Collection, London.
481. FRANCESCO CLEMENTE: Roots, 1982. Fresco, 200 x 300cm. Private Collection. (Photo: Prestel Verlag, Munich).
482. RICHARD ROGERS and RENZO PIANO: Centre Georges Pompidou, 1971–9. Paris. West elevation. (Courtesy Richard Rogers Partnership. Photo: Paul Wakefield).
483. SANDRO CHIA: Figure with Tear and Arrow, 1982. Bronze. Private Collection. (Courtesy Sperone Westwater, New York). © DACS 1989.
484. FRANK GEHRY: Gehry Residence, 1978–9. Santa Monica, California. (Courtesy Frank O. Gehry & Associates Inc. Santa Monica CA).
485. GORDON MATTA-CLARK: Threshold-Blue Piece. Floor piece-doorway, 1973. Courtesy Holly Solomon Gallery, New York. ·
486. JAMES STIRLING: Neue Staatsgalerie Stuttgart, 1982. View of the Rotunda. (Photo: Richard Bryant, London).
487. DAVID SALLE: Landscape with Two Nudes and Three Eyes, 1986. Acrylic and oil on canvas, 259 x 353cm. Private Collection. (Courtesy Mary Boone Gallery, New York). © DACS 1989.
488. CINDY SHERMAN: Untitled Film Still: 59, 1980. B/W photograph, 10 x 8″ (25.4 x 20.32cm). Private Collection. (Courtesy Metro Pictures, New York).
489. SHERRIE LEVINE: Untitled (after Walker Evans: 6), 1981. B/W photograph. Private Collection. (Courtesy Mary Boone Gallery, New York).
490. GILBERT AND GEORGE: We, 1983. 242 x 202cm. Courtesy Anthony d'Offay Gallery, London.
491. MARY KELLY: Post-Partum Document: Documentation III: Analysed Markings and Diary – Perspective Schema, 1975. Tate Gallery, London.
492. BARBARA KRUGER: Your Gaze Hits the Side of My Face, 1981. Photograph, 139.7 x 104.1cm. Private Collection. (Courtesy Mary Boone Gallery, New York).
493. RICHARD SERRA: Tilted Arc, 1981. Installed Federal Plaza, New York. Cor-Ten steel, 3.658 x 36.576m x 6.35cm. (Photo: Susan Swider © 1985).
494. JAMES TURRELL: Roden Crater. Work in progress. Arizona. (Photo: © Dick Wiser).
495–7. DANIEL BUREN: Les Deux Plateaux, 1987. Palais Royal, Paris. (Courtesy John Weber Gallery, New York. Photo: D.B.).
498. DANIEL BUREN: Les Deux Plateaux, 1987. (Giraudon. Photo: © Patrick Lorette).

INDEX